American Paintings
Before 1945 in the
Wadsworth Atheneum

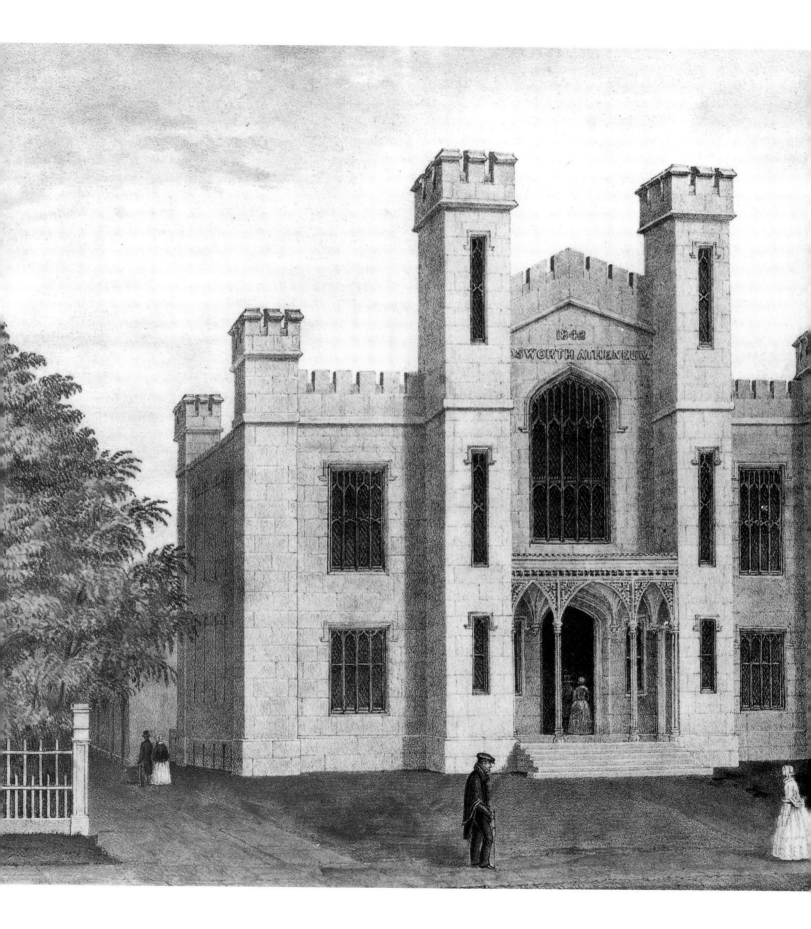

American Paintings Before 1945 in the Wadsworth Atheneum

Elizabeth Mankin Kornhauser

With Contributions by Elizabeth R. McClintock and Amy Ellis

Volume One

Wadsworth Atheneum *Hartford*

Yale University Press New Haven and London

This catalogue was made possible by generous grants from:

The Luce Fund for Scholarship in American Art at the Henry
 Luce Foundation

The National Endowment for the Arts

The Douglass Foundation

The Krieble Family Fund

The Hartford Steam Boiler Inspection and Insurance Company

Designed by Sonia L. Scanlon

Set in Century Expanded type by The Composing Room of
 Michigan, Inc.

Printed in the United States of America by Thomson-Shore,
 Inc., and Herlin Press.

Frontispiece: E. B. Kellogg and E. C. Kellogg, after Henry
Austin, *Wadsworth Atheneum, Hartford, Conn., 1846*, 1846.
Wadsworth Atheneum, gift of L. Owen Meserve, Jr., 1959.24.

Library of Congress Cataloging-in-Publication Data

Wadsworth Atheneum.

 American Paintings Before 1945 in the Wadsworth
Atheneum /

 Elizabeth Mankin Kornhauser : with contributions by
 Elizabeth R. McClintock and Amy Ellis.

 p. cm.

 Includes bibliographical references and index.

 ISBN 0-300-06672-4 (cloth : set)

 ISBN 0-300-06238-9 (cloth : vol. I)

 ISBN 0-300-06671-6 (cloth : vol. II)

 1. Painting, American—Catalogs. 2. Painting—
Connecticut—Hartford—Catalogs. 3. Wadsworth
Atheneum—Catalogs.

 I. Kornhauser, Elizabeth Mankin, 1950– .

 II. McClintock, Elizabeth R. III. Ellis, Amy. IV. Title.

 ND205.W3 1996

 759.13′074′7463—dc20 95-41875

A catalogue record for this book is available from the British
Library.

The paper in this book meets the guidelines for permanence
and durability of the Committee on Production Guidelines for
Book Longevity of the Council on Library Resources.

10 9 8 7 6 5 4 3 2 1

Contents

Foreword

The origins of the Wadsworth Atheneum lie in its American collection. The first acquisitions of American painting and the opening of the museum in 1844 occurred at the same moment. Largely through the philanthropy and patronage of Daniel Wadsworth, the cause of American art and the acknowledgment of the achievements of American artists have been shaping influences over the museum for the past 150 years.

From the beginning, a pattern of gifts and deliberate acquisitions gave the American painting collection a cohesiveness and comprehensiveness. The Wadsworth Atheneum bought its first Thomas Cole, *Mount Etna from Taormina*, in 1844 and then, on Daniel Wadsworth's death in 1848, received his celebrated group of early Thomas Cole landscapes. These pictures and others make good the claim that the Wadsworth Atheneum holds one of the primary collections of American painting in the country.

With the exception of the latter part of the nineteenth century, every generation and administration of the Wadsworth Atheneum have added significantly to the American collection. In 1903 the Ellsworth family presented the monumental double portrait by Ralph Earl, *Oliver Ellsworth and Abigail Wolcott Ellsworth*. It initiated a notable sequence of Ralph Earl paintings in the museum and has remained one of the most loved and familiar works in the Atheneum. Two years later Elizabeth Hart Jarvis Colt, the widow of Colonel Samuel Colt, bequeathed their collection to the Atheneum, thereby enriching the holdings of U.S. paintings with notable works by Frederic Church and Sanford Gifford.

The establishment of funds specifically designated for acquiring works of art for the museum began in the 1890s with the Walter and Henry Keney Fund, the first purchase from which, in 1897, was no less a work than George Inness's *Autumn Gold*. Frank Sumner's 1927 bequest of over one million dollars to create a fund for the acquisition of "choice paintings"— to be known as the Ella Gallup Sumner and Mary Catlin Sumner Collection Fund—would transform the European and American galleries and lay the foundation for the modern museum of today. Since the tenure of A. Everett Austin, Jr., every director of the Atheneum has used the fund to enrich the American painting collection. From Austin's prescient acquisition of William Harnett's *The Faithful Colt* in 1935, through the first works by Winslow Homer to enter the collection in the 1940s and 1950s at Charles Cunningham's direction, to the purchase of important early American modernists in the 1970s and 1980s, the Sumner Fund has been critical in building the American collection with central masterpieces by major artists.

Over the past ten years three new funds have also served to bolster the American collection. The Dorothy C. and Thomas L. Archibald Fund and the Krieble Family Fund are the first substantial acquisition funds to be devoted exclusively to U.S. painting and sculpture. The impact of the Douglas Tracy and Dorothy Potter Smith Fund of the Hartford Foundation for Public Giving, established in 1991, matched that of the Sumner Fund in the 1920s. The significance of these funds can easily be gauged: the backbone of the American impressionist collection has been formed over the past eight years, with major works by William Merritt Chase, Childe Hassam, and Theodore Robinson transforming an erstwhile lackluster area of the collection.

One hundred fifty years of collecting American painting has led to an accumulation of over eight hundred works. Hitherto they had never been catalogued and, indeed, were often

only recorded in a perfunctory manner. The herculean task of cataloguing the collection of paintings before 1945 fell to Elizabeth Mankin Kornhauser, first curator of American Paintings, Sculpture, and Drawings at the Wadsworth Atheneum. Her twelve-year labor shows extraordinary intellectual stamina, depth of scholarship, and profound commitment to the collections of the Atheneum and the cause of American painting in general. Dr. Kornhauser's research has yielded many important discoveries and made a fundamental contribution of new knowledge to the field. She has also played a key role in shaping the American collections over the past ten years and writes as a participant in their development.

The Wadsworth Atheneum takes great pride in Dr. Kornhauser's achievements and in this catalogue, which accomplishes a fundamental responsibility of the art museum: to make widely and readily available to scholars, students, and the lay public the most up-to-date knowledge and information regarding its collections—in this case, a rich seam in the American heritage.

Such a labor has required the support of many. The Wadsworth Atheneum would like to record its heartfelt gratitude to the Henry Luce Fund for Scholarship in American Art through the Henry Luce Foundation, whose grant in 1983 initiated this project. In 1987 the National Endowment for the Arts made critical grants that enabled the project to gain momentum. In more recent years the Douglass Foundation, the Hartford Steam Boiler Inspection and Insurance Company, and the Krieble Family Fund have made essential grants toward the final stages and publication of the work. To all these funders we express our deepest appreciation for their generosity and their understanding and patience as this major project has been brought to successful conclusion.

Lastly, the Atheneum would like to thank other scholars and institutions who cooperated in the successful completion of this catalogue, since works of this scale are shared enterprises. Many members of the staff of the Atheneum also have assisted, in one way or another, with the creation and completion of this catalogue. We hope that they will share the deep sense of institutional pride in the publication of this magisterial work and join the museum in admiration and congratulation of Dr. Kornhauser's achievement.

Patrick McCaughey, Director
Wadsworth Atheneum

Acknowledgments

The research, writing, editing, and publication of this catalogue have taken the considerable efforts of a great many people. Its production has spanned twelve years and two administrations at the Wadsworth Atheneum, first receiving the support of Tracy Atkinson, former director, and Gregory Hedberg, former chief curator. The museum's current director, Patrick McCaughey, has provided unstinting aid and encouragement in recent years that have allowed this publication to reach completion. I would like to thank him as well as the museum's board of trustees for their support.

A generous grant from the Luce Fund for Scholarship in American Art, a program of the Henry Luce Foundation, awarded in 1983, marked the beginning of the first thorough and systematic study of the American paintings collection and partially underwrote this publication. I would like to express my appreciation to the Luce Foundation for the initial funding of the project, as well as my position as project director, and for their exceptional patience in seeing the catalogue through to completion. I would also like to thank the National Endowment for the Arts for providing in 1987 crucial grant funding toward the publication, allowing the expansion of the catalogue both in scope and length. I am indebted to the Douglass Foundation and to the Krieble Family Fund for supplying the final funding necessary for the publication.

I was joined in 1985 by Elizabeth R. McClintock and in 1992 by Amy Ellis, both assistant curators in the department of American paintings, sculpture, and drawings, who assisted in the research and writing of entries and who have offered essential help in the production phase of the publication. Several interns have assisted in catalogue research over the years, including David Brigham, Melissa Cuello, Gwen De Maille, Judy Lennett, Laura Robinson, Carol Scollans, Martha Willoughby, and Deborah Zlotsky.

We would like to express our appreciation to our Atheneum colleagues who helped with the extensive research for the catalogue; these include Jean Cadogan, Charles C. and Eleanor Lamont Cunningham Curator of European Art; Cynthia E. Roman, assistant curator of European Art; Andrea Miller-Keller, Emily Hall Tremaine Curator of Contemporary Art; Linda Horvitz Roth, curator of European Decorative Art; Carol Dean Krute, curator of Costume and Textiles; William H. Hosley, curator of American Decorative Arts; Karen Blanchfield, assistant curator of American Decorative Arts. Eugene R. Gaddis, William G. DeLana Archivist and Curator of the Austin House; Ann Brandwein, archival assistant; and John Teahan, librarian and curator of Special Book Collections, lent their invaluable support. Stephen H. Kornhauser, chief conservator; Patricia Sherwin Garland, painting conservator; and Zenon Gansziniec, assistant conservator, spent endless hours examining pictures and answering questions concerning condition and treatment.

The staffs of numerous museums and historical societies provided the often obscure source material found in the artist biographies and entries in this catalogue. In particular, we would like to thank Janet R. Houghton, at the Billings Mansion Archives, Woodstock, Vermont; Linda Ferber, Barbara Dayer Gallati, and Teresa Carbone, at the Brooklyn Museum; H. Nichols B. Clark, at the Chrysler Museum, Norfolk, Virginia; Elizabeth Fox, at the Connecticut Historical Society, Hartford; Aileen Ribeiro, at the Courtauld Institute of Art, London; Marc Simpson, at the Fine Arts Museums of San Francisco; Helen Sanger, at

the Frick Art Reference Library, New York City; Carol Hevnor, at the Historical Society of Pennsylvania; Edward J. Nygren, at the Henry E. Huntington Library and Art Gallery, San Marino, California; Susan Oyama, at the Library Company of Philadelphia; Michael Quick and Ilene Susan Fort, at the Los Angeles County Museum; Mrs. John P. Hunt, Jr., at the Marblehead Historical Society, Marblehead, Massachusetts; Doreen Bolger (now director of the Rhode Island School of Design), Kathleen Luhrs, John K. Howat, H. Barbara Weinberg, Carrie Rebora, Kevin Avery, and Morrison H. Heckscher, at the Metropolitan Museum of Art, New York City; Theodore E. Stebbins, Jr., Carol Troyen, and Lauretta Dimmick, at the Museum of Fine Arts, Boston; Martha J. Hoppin, at the Museum of Fine Arts, Springfield, Massachusetts; Wendy Greenhouse, at the National Academy of Design, New York City; Nicolai Cikovsky, Jr., Franklin Kelly, Nancy K. Anderson, Deborah Chotner, and Sarah Greenough, at the National Gallery of Art, Washington, D.C.; Elizabeth Broun and William Truettner, at the National Museum of American Art, Washington, D.C.; Jacob Simon, at the National Portrait Gallery, London; Ellen Miles, Lillian Miller, and Brandon Brame Fortune, at the National Portrait Gallery, Washington, D.C.; Kenneth Neal, at the Nelson-Atkins Museum of Art, Kansas City; Mel Ellis, at the New Britain Museum of American Art, New Britain, Connecticut; Annette Blaugrund and Timothy Anglin Burgard, at the New-York Historical Society; Gilbert T. Vincent, at the New York State Historical Association, Cooperstown; Florence Levins and Mei Wu, at the Newington-Cropsey Foundation, Hastings-on-Hudson, New York; Mary C. Anderson, at the Noank Historical Society, Noank, Connecticut; James A. Ryan and Joel Swimmler, Olana State Historic Site, Hudson, New York; Betsy Lahlman, at Old Dominion University, Norfolk, Virginia; Clare Lloyd Jacob, at the Paul Mellon Centre, London; Jeremy Elwell Adamson, at the Renwick Gallery, Smithsonian Institution, Washington, D.C.; Michael Redmon, at the Santa Barbara Historical Society; Hildegaard Cummings, at the William Benton Museum of Art, University of Connecticut, Storrs; Gwendolyn Owens, at the Williams College Museum of Art; E. McSherry Fowble, at the Henry Francis DuPont Winterthur Museum, Newark, Delaware; Richard Stanislaus, at the Wyoming Historical and Geological Society, Wilkes-Barre, Pennsylvania; and Helen Cooper, at the Yale University Art Gallery. We received assistance researching pictures from several galleries and auction houses and would like to thank in particular John Paul Driscoll, at the Babcock Galleries, New York City; Russell Burke, of New York City; the Terry Dintenfass Gallery, New York City ; Bruce C. Chambers, at the Berry-Hill Galleries, New York City; Thomas Colville, of New Haven and New York City; Stuart Feld and M. P. Naud, at the Hirschl and Adler Galleries, Inc., New York City; James Maroney, Inc., New York City; and Robert C. Vose, Jr., at the Vose Galleries of Boston.

Our thanks to the many scholars who shared their knowledge and expertise on individual artists: Fred B. Adelson, M. Elizabeth Boone, Sarah Burns, Gerald L. Carr, David Driskell, Dorinda Evans, Kathleen Foster, Abigail Booth Gerdts, William H. Gerdts, Lucretia Giese, Lloyd Goodrich, Nina Gray, Patricia Hills, Susan Hobbs, Irma Jaffe, Elizabeth Johns, William Bright Jones, Paul J. Karlstrom, Nina Fletcher Little, Phoebe Lloyd, Barbara Buhler Lynes, Margaret MacDonald, Kenneth W. Maddox, Katherine Manthorne, Howard S. Merritt, Elizabeth Milroy, Barbara Novak, William T. Oedel, Anthony J. Peluso, Jules D. Prown, Ellwood C. Parry III, Ronald G. Pisano, Bruce Robertson, Daniel E. Sachs, Richard

H. Saunders, Andrew F. Smith, Will South, J. Gray Sweeney, Robert F. Trent, Alan Wallach, William L. Warren, Ila Weiss, Nelson H. White, Peter Wild, Robin W. Winks, Bryan Jay Wolf, Andrew McLaren Young, and Rebecca Zurier.

We have been fortunate to have the staff of Yale University Press as our partner in the catalogue's publication. Judy Metro, senior editor, is to be commended for taking this project on and overseeing its production. Mary Pasti and Sarah St. Onge provided tireless assistance on the manuscript. The catalogue's designer, Sonia L. Scanlon, is also to be commended.

The list of those to whom this publication owes its existence is much longer than this space can accommodate. To all who are not mentioned above, I extend sincere gratitude.

Elizabeth Mankin Kornhauser

The History of a Collection

The Wadsworth Atheneum's collection of U.S. oil paintings done before 1945 is one of the most distinguished of its kind in quality, range, and history. With masterworks from the seventeenth to the twentieth century, the collection contains major pieces by most of the leading painters in the United States, with over 275 artists represented. Boasting approximately 560 paintings, the holdings are particularly rich in the area of nineteenth-century landscape, with 13 by Thomas Cole and 11 by Frederic Church. Begun over 150 years ago, the collection is imbued with an extraordinary heritage that offers a fascinating profile of cultural development in the United States during the nineteenth century.

The Atheneum's remarkable collection of U.S. paintings owes its quality to several collector-patrons who responded to the early impetus to establish public art galleries in the United States. Its taproot is the substantial private collection amassed by Daniel Wadsworth, a gentleman-scholar who was an early connoisseur of American art and a member of the last generation of Connecticut's landed gentry, in the first three decades of the nineteenth century. This collection was then augmented by Elizabeth Hart Jarvis Colt, widow of the renowned inventor-manufacturer Samuel Colt, an entrepreneur whose social status was based on mercantile wealth. A woman of extraordinary social and cultural influence, Colt had a formal picture gallery constructed in her home, which she filled with art of the post–Civil War era. Both the Wadsworth and Colt collections, built with the active advice of contemporary artists—who also executed direct commissions for their patrons—offer present-day visitors an unparalleled vision of that era.

In the twentieth century a series of directors—beginning with A. Everett Austin, Jr., the first connoisseur-director, in the early part of the century, and followed by professional museum directors and curators in more recent decades—have built the collection of U.S. paintings according to their personal visions and their responses to changing attitudes toward U.S. art. The Colonial Revival of the late nineteenth and early twentieth centuries, born of a desire to reclaim and imitate the forms and values of that bygone period, brought the nation's past—particularly its Anglo-Saxon heritage—to the forefront and led to such major gifts as Ralph Earl's masterful Constitutional-era portrait *Oliver Ellsworth and Abigail Wolcott Ellsworth* (cat. 186). At the same time, numerous avant-garde movements looked to the future, embracing an international outlook that was fueled by social forces of the day—immigration, industrialization, and urban growth, to name a few. Works by U.S. modernists, surrealists, social surrealists, neoromantics, and abstractionists entered the collection at this time. During the 1930s and 1940s, regionalism, or American Scene painting, began to emerge as an important style. A renewed interest in scenes of the rural United States also led to an interest in American painting of the nineteenth century. In addition, U.S. folk art was embraced by the avant-garde as well as by those interested in exploring the country's past. The collection is further enhanced by a rich regional heritage, reflected in a range of works by New England artists, especially those from Connecticut. Beyond such prominent native sons as John Trumbull, Frederic Church, and Milton Avery, whose works the museum avidly sought since its foundation, many lesser-known Connecticut artists,

most of whom participated in regional artistic communities throughout the state, are also represented.

U.S. paintings constituted the very foundation of the Atheneum's collection throughout the nineteenth century. The country's oldest continuously running public art museum, the Atheneum opened its doors in 1844. It contained an unparalleled array of works by contemporary American painters: scenes from the American Revolution, portraits of recent American heroes, and American landscapes by the most prominent artists of the day. Many of these were direct commissions. The acquisition in 1844 of the collection of the defunct American Academy of the Fine Arts, which, along with important American works, included a modest selection of copies of European old masters, constituted a significant addition to the gallery's holdings. With a few pieces of sculpture by European and American artists, it filled out the gallery. Then came the bequest of Daniel Wadsworth's art collection in 1848, which greatly enhanced the group of American landscapes, making it the most important of its kind at the time. Though the Atheneum's art gallery remained static throughout much of the rest of the century, that initial collection of U.S. works, intact for over 150 years, has remained at the very heart of the Atheneum's holdings.

During the course of the twentieth century, the U.S. paintings collection has grown substantially. Important bequests from Elizabeth Hart Jarvis Colt in 1905 and Clara Hinton Gould in 1948 added masterpieces by such artists as Thomas Cole, Frederic Church, and Sanford Gifford, among others. Major gifts and acquisitions expanded the collection beyond landscape to include portraiture, figurative, and still-life painting.[1] Since the advent of professional directors and curators in the 1920s, the collections have also come to include rich holdings in European fine and decorative arts, contemporary art, African-American art, costume and textiles, and American decorative arts, as well as U.S. and European sculpture and works on paper.

Distinguished personal collections in areas other than American paintings have also been added during this century: the Horace S. Fuller and Stephen Terry collections of eighteenth- and nineteenth-century ceramics in 1905; the J. P. Morgan collection of 1,325 objects of European decorative arts given in 1917 by Morgan's son, J. P. Morgan, Jr.; the Albert Hastings Pitkin collection of American pottery in 1918; the Wallace Nutting collection of seventeenth-century American furniture in 1926, purchased for the Atheneum by J. P. Morgan, Jr.; the George A. Gay bequest of American and European prints in 1940; the first of many successive gifts of major tapestries by Elisha E. Hilliard in 1945; the Philip H. Hammerslough gift of American silver in 1955; the 1957 bequest by Anne Parrish Titzell of fourteen paintings, including works by Monet, Renoir, and Degas; the Elizabeth B. Miles collection of English silver in 1965; and a gift by the family of Atheneum director A. Everett Austin, Jr., of his Scarborough Street house and its collections in 1985. Other exceptional acquisitions that transformed the character of the museum include the Serge Lifar collection of designs for Diaghilev's Ballets Russes in 1933 and the Randolph Linsly Simpson collection of African-American memorabilia and artifacts in 1988.

A series of acquisition funds established since the beginning of this century has financed major purchases that have led to the establishment of internationally recognized collections of European old masters and modern art at the museum. Still, although acquisition of U.S.

paintings has at times ceded precedence to more international artistic interests, the collection has nonetheless continued to grow. American paintings remain a primary focus for the Atheneum as it heads into the twenty-first century. The newly renovated galleries devoted to U.S. paintings and sculpture, which opened in May 1994, are visible evidence of this collection's prominence.[2]

The position of the Atheneum's U.S. painting collection relative to others of its kind is another revealing signal of its importance. The core of the Atheneum's collection was already in place when the Metropolitan Museum of Art, the Museum of Fine Arts, Boston, and the Brooklyn Museum—to cite three great public collections of American paintings that share relatively early histories—were just being established (the Metropolitan Museum of Art and the Museum of Fine Arts in 1870 and the Brooklyn Museum in 1897). The Metropolitan Museum benefited initially from its numerous artist-trustees, including Frederic Church, Albert Bierstadt, Sanford Gifford, and their spokesperson, William Cullen Bryant, to name a few; their inclinations led the museum to collect and display U.S. paintings early on. By the end of the century, however, the interest in American art had waned, and during the twentieth century the Metropolitan has acquired U.S. paintings mainly through gifts rather than through a committed vision.[3] The Museum of Fine Arts, Boston, formed a largely regional collection of American art during the first half-century of its existence, acquiring works by such leading Boston painters as John Singleton Copley, Gilbert Stuart, Washington Allston, William Morris Hunt, Winslow Homer, and John Singer Sargent.[4] The collection did not gain great depth until 1949, when the museum was given the collection of Maxim Karolik (1893–1963), comprising 232 American paintings executed between 1815 and 1865.[5] This was followed by superb gifts (given between 1989 and 1994) from the William H. Lane Foundation of nearly 100 paintings and works on paper by American modernists, including Arthur Dove, Marsden Hartley, Charles Sheeler, and Georgia O'Keeffe.[6] By its opening, the Brooklyn Museum had inherited from the newly closed Brooklyn Institute a modest core collection of 15 American paintings that had been commissioned or had entered the institute's collection between 1855 and 1878. Since that time the museum's U.S. painting collection has grown steadily through gifts and acquisitions.[7]

In the end, what most distinguishes the group of U.S. paintings at the Wadsworth Atheneum is its history and its longevity. Although not as large in number of works or artists represented as those of the Metropolitan Museum of Art, the Museum of Fine Arts, Boston, or the Brooklyn Museum, the Atheneum's collection ranks alongside these in quality, range, and historical depth.[8]

DANIEL WADSWORTH

The quality and direction of the Wadsworth Atheneum's collection were determined by its founder, Daniel Wadsworth, whose lifelong interest in his nation's culture translated into a focus on U.S. art in the museum he established. His distinguished Puritan lineage and his ties to the American War for Independence endowed him with a profound reverence for his country's recent history. As a member of the first generation of citizens of the new republic, he saw this history and his country's vast wilderness landscape as conjoined, symbolic of the

nation's potential greatness, and these two themes defined his vision for the Wadsworth Atheneum.

In the early decades of the nineteenth century, Wadsworth's active involvement in the picturesque description of the country's wilderness—as both amateur artist and collector—helped bring the aesthetic qualities and historic associations of the New England landscape to the nation's attention.[9] One of the earliest and most important patrons of living American artists, he maintained lifelong associations with such leading painters as John Trumbull (q.v.), Thomas Sully (q.v.), Thomas Cole (q.v.), and the young Frederic Church (q.v.), who were themselves engaged in creating an artistic heritage for the new nation. These friendships helped to define Wadsworth's ambitions for the country's first permanent gallery of fine art.[10] Months before the opening of the Wadsworth Atheneum, Thomas Cole, leader of the American landscape school, applauded Wadsworth's vision, writing: "I assure you that I shall feel proud of having a picture of mine in your Gallery & hope the example you are about to set, in forming a permanent Gallery, will be followed in other places & be the means of producing a more elevated taste & a warmer love for beautiful Art than at present exists in the Country."[11]

As the son of Colonel Jeremiah Wadsworth, one of the state's most powerful and wealthy men, Daniel represented the last generation of Connecticut's eighteenth-century aristocracy. His Puritan ancestors were among the original founders of the state, travelers in the party led by the Reverend Thomas Hooker that journeyed from Massachusetts Bay colony to found Hartford and the Connecticut colony in 1636 (see cat. 111). Born during the revolutionary era, Daniel lived to see members of his family serve in the formation of the new nation. In his later life, as a witness to the ensuing rise of Jacksonian democracy, he retreated from the political arena; he saw a new role for himself—that of helping to establish an American cultural heritage.

For Wadsworth and others of his era, the American landscape became the focus of aesthetic inquiry. Landscape came to symbolize the nation's potential and was seen as a morally uplifting influence on the country's inhabitants. As a pioneering picturesque traveler; an amateur artist and architect; the creator of a country estate on lands that attracted national acclaim and served as a tourist attraction for thousands; a patron of American artists and writers; and the founder of a museum, Wadsworth devoted much of his life to the "refinement of America"—making genteel culture available to the ordinary citizens of a democratic society.[12] With the founding of the Wadsworth Atheneum he satisfied both his aristocratic instincts and his desire to share his vision of nature with the public. He promoted his values by displaying paintings of European and American history and portraits of his prominent family members and the nation's heroes; at the same time, he fostered an interest in nature by contributing his private collection of romantic American landscapes to this public institution.

In celebration of the firm moral purpose the Wadsworth Atheneum held, the poet and writer Lydia Sigourney, renowned as the "sweet singer of Hartford," praised Wadsworth's opening of the museum, declaring: "May the benevolence that projected and completed this fine structure, dedicating it to those objects that elevate national character, be rewarded by

the progress in knowledge, the refinement of taste, and the permanent improvement of this people, and their posterity."[13]

Daniel Wadsworth: Picturesque Traveler Wadsworth was born in Middletown, Connecticut, on August 8, 1771, to Jeremiah and Mehitable Russell Wadsworth. The Wadsworth family had left England and settled in America in about 1632; William Wadsworth was one of the original settlers of Hartford. Daniel's great-great-great uncle, the Connecticut legislator Joseph Wadsworth, was immortalized in local Hartford legend for hiding the colony's original charter in an oak tree on the Wyllys family property in Hartford in 1687 to protect it from the royal governor of the Dominion of New England, Sir Edmund Andros, who had arrived to take control of the colony. In Daniel Wadsworth's lifetime, the Charter Oak came to symbolize for the state's inhabitants the spirit of independence that had brought about the American Revolution, and Wadsworth played an important role in shaping the historic legend of the tree into a national symbol of American independence.[14]

During the Revolution, Daniel's father succeeded Joseph Trumbull, son of Governor Jonathan Trumbull, Sr., as commissary-general for the Continental army; following the establishment of peace, he held a similar post for the French troops in the United States. In his father's house, Daniel came in contact with the leading officers of the American army, including General Washington, the marquis de LaFayette, and the comte de Rochambeau. A contemporary, noting that Jeremiah's privileged role during the war years impressed Daniel, observed that "being in constant communication with the most distinguished actors in that memorable era, his mind was early imbued with patriotism and with admiration of the devoted men who under God, wrought out that great redemption."[15]

With the profits he made as commissary, Jeremiah became Hartford's leading financier and manufacturer, as well as a state representative in the Assembly. At the time of his death in 1804, he left an estate worth $124,767 that included a library of one thousand volumes, three farms, two houses, numerous stocks in banks and public-improvement companies, and a brewery.[16] Daniel was left with the financial means to pursue the genteel life of an amateur artist, art patron, and philanthropist.

In 1783–1784, as a young boy of twelve, Daniel accompanied his father on a trip to Europe, where, according to his friend Thomas Day, he experienced "favorable opportunities of cultivating and refining his natural taste for the fine arts—especially architecture, drawing, and painting."[17] He attended school in both England and France, during which time he learned French, which he spoke throughout his life and "which made his society peculiarly interesting to the French travellers, who in considerable numbers visited this country" following their own revolution.[18]

In London Jeremiah greatly expanded his library, acquiring over one hundred books and James Cook's popular *Voyage to the Pacific Ocean; Undertaken by Command of His Majesty, for Making Discoveries in the Northern Hemisphere* (London, 1784), which included a portfolio of engravings.[19] At the same time, father and son had their portrait painted by John Trumbull (see cat. 452), who produced a sophisticated composition reminiscent of the popular English conversation-piece format. A gifted student of Benjamin West (q.v.), Trumbull became America's leading history painter; the artist also demonstrated a great knowledge of

architecture, and his work served as a precursor to the American landscape school. He proved to have a crucial effect on Wadsworth's growing interest in the arts. Exposure to the British convention of picturesque travel also exerted a strong influence on Wadsworth; as a contemporary noted, it produced in him "strong impressions of natural and cultivated scenery."[20]

When Daniel Wadsworth returned home in 1784, his "extremely delicate" health precluded his attending Yale College, as many of his relations had. As his memorialist later noted, "he did not encounter the labors of a public education"; instead, he worked "very successfully" in his father's various business endeavors, providing such services as transporting "large sums of money in gold" between Hartford and Philadelphia and working in one of his father's numerous shops in Hartford.[21] He also pursued his interest in art, resuming his relationship with John Trumbull, who returned to the United States in 1789.

John Trumbull spent considerable time with the Wadsworth family in Hartford in 1790 and 1791, taking portraits of family members and sketching and painting landscapes of the region. One landscape, *View on West Mountain* (fig. 1), captured the picturesque possibilities of the land that Wadsworth later turned into his country estate.[22] Trumbull was familiar with the English writers who defined contemporary picturesque theory—his ease with these conventions is apparent in this carefully formulated composition that incorporates irregularity and variety—and undoubtedly imparted this knowledge to Wadsworth.

1. John Trumbull, *View on West Mountain*, c. 1791. Yale University Art Gallery, gift of Marian Cruger Coffin in memory of her mother, Mrs. Julian Coffin (Alice Church).

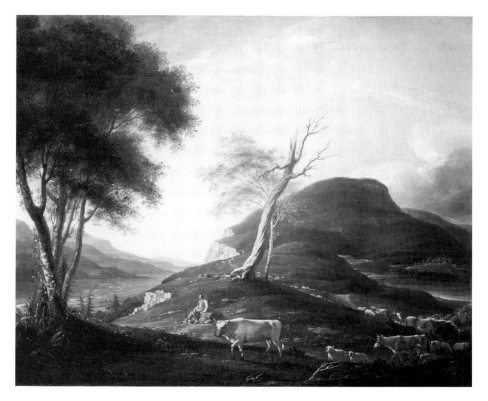

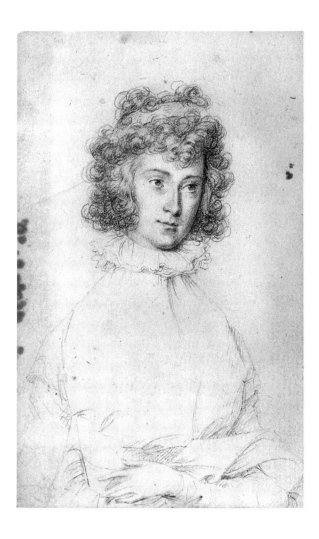

2. John Trumbull, *Harriet Wadsworth*, c. 1790–1791. Wadsworth Atheneum, source unknown.

The Trumbull and Wadsworth families, who shared similar beliefs and backgrounds, had been closely associated for three generations. During his visit with the Wadsworth family, Trumbull fell in love with and courted Daniel's sister, Harriet Wadsworth. (He took a pencil portrait drawing of Harriet at this time [fig. 2], two years before her death from consumption.) Then, in 1794, Daniel married Faith Trumbull (1769–1846), the artist's niece, which further solidified his connection to the prominent artist. In 1795 Daniel's father built the couple a stately brick house between Prospect and Main Streets immediately behind his own; this later became the site of the Wadsworth Atheneum.

Following the death of Jeremiah Wadsworth, in 1804, Daniel managed his father's affairs from a distance and took responsibility for his relatives. But he neither pursued the public career of his father nor devoted his life to business; rather, as Thomas Day noted at the end of Wadsworth's life, "uniformly and firmly declining office, (unless it were one of charity), his life has been that of a *private gentleman*."[23]

A witness to the rise of landscape art as a mode of high artistic expression, Wadsworth was among an elite group of landscape tourists at the turn of the century who, educated in the contemporary aesthetic theories of the picturesque, sketched and wrote about the

American landscape during their travels.[24] He began taking pencil sketches of American scenery in 1799. His memorialist recalled that "he travelled extensively in the summer seasons, and his accurate eye and skillful pencil enabled him to preserve on the cards of his portfolio faithful sketches of the beauty and grandeur of landscape for which he had a quick perception, and in which he experienced intense delight."[25] Like his fellow travelers, he followed the advice of such contemporary English writers as William Gilpin, who in 1792 published his influential treatise *An Essay on Picturesque Travel*, which became widely available in America in the following year.[26] According to Gilpin the object of picturesque travel was the discovery of beauty in the "scenery of nature" by contrasting with each other the ingredients of landscape—trees, rocks, and so forth—and viewing these scenes as if in a frame, thus organizing the landscape along the lines developed by seventeenth-century landscape painters such as Claude Lorrain.[27] To accomplish this ordering of nature, Gilpin recommended that the traveler sketch. As one of his followers explained: "Words will naturally fail to impress on the imagination a clear idea of the scenery. . . . Neither can a proper idea of them be formed unless we can present a 'perfect whole' at once to the view. The pencil may supply what words are unable to express; but still that does not equal nature."[28] The picturesque tourist was a partner to the landscape painter, pointing the way to popular wilderness scenery that would become the subject of American landscape art and sharing a range of associations and a new lens through which to perceive nature. The experience proved invaluable in shaping Wadsworth's eye as a leading collector of landscape art.

The approximately ninety surviving drawings taken by Wadsworth include landscape renderings that chronicle his trips to such well-known wonders of the New World as Niagara Falls and the Natural Bridge in Virginia's Shenandoah Valley; his pioneering travels to such unexplored wilderness territory as the White Mountains of New Hampshire and the Susquehanna River Valley; and his jaunts in celebration of local scenery in the Connecticut River Valley.[29] He took many of these sketches during trips with the New England travel writers Benjamin Silliman and Theodore Dwight, who reproduced them as engravings or lithographs to illustrate accounts of their picturesque tours. Wadsworth also published his own travel writings, accompanied by engravings after his sketches, in various journals and books. In addition, he often shared his small sketches—or cards, as they were called—with friends and relations. For instance, Wadsworth wrote to his cousin Peter Colt in Rome, New York: "I was much pleased to find . . . that my little drawings, imperfect as they were, had delineated the fine Elms on the lake at Geneva, & the ruined trunk of a tree fallen across [?] the dark glen at Niagara, with sufficient accuracy to produce a sentiment like which we feel in meeting with an old acquaintance."[30]

In the summer of 1805 Wadsworth accompanied John Trumbull and his wife, along with several land investors, on a trip to the Genesee Valley, where a branch of the Wadsworth family had settled on lands acquired from their cousin Jeremiah.[31] Wadsworth took a number of sketches on the trip, including one, entitled *The Genesee River* (fig. 3), that depicts the gorge; he later wrote of the scene that the considerable falls "sink to *nothing*, compared with the Extraordinary *Walls* of the River by which they are enclosed—These walls are absolutely perpendicular—sometimes impending [?] & for several miles 300-to-500 high bending in curves a [?], in the solid limestone, as if the River had only been obliged to cut its way thro'

a bank of sand."[32] Following another trip to the area, Wadsworth published an article on the falls of the Genesee River in Benjamin Silliman's *American Journal of Science and Arts* (vol. 17, 1830).

Wadsworth traveled to Niagara Falls during the summer of the following year, a relatively early date for an American traveler.[33] He produced a number of sketches and in a letter to a friend offered a description of the falls evocative of Edmund Burke. Arriving on horseback, his party first encountered the falls after nightfall: "It was now ten o'clock, and one can scarcely witness a scene; unconnected with danger more truly sublime than that which was exhibited to our view. The awful majesty of this black and mossy column, standing apparently almost within our reach, of such vast diameter, its base upon the waters, the towering to an immeasurable height, with accompaniments so appropriate; the solemn calm of the atmosphere, the sullen roar of the cataract, and the deathlike stillness of the night. We had never heard of this part of the Show of Niagara." The next day, Wadsworth observed, "We expected a vast, uniform torrent, whose overwhelming thunder would confuse the senses, and leave no other impressions than those of astonishment or terror. The grandeur of the cataract is, doubtless, superior to anything of the kind in the world. Yet at first view, its

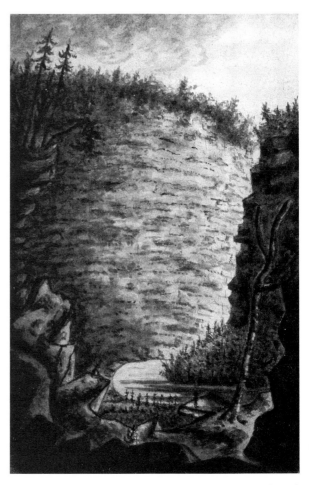

3. Daniel Wadsworth, *The Genesee River*, c. 1805–1821. Wadsworth Atheneum, William A. Healy Fund, 1931.71.

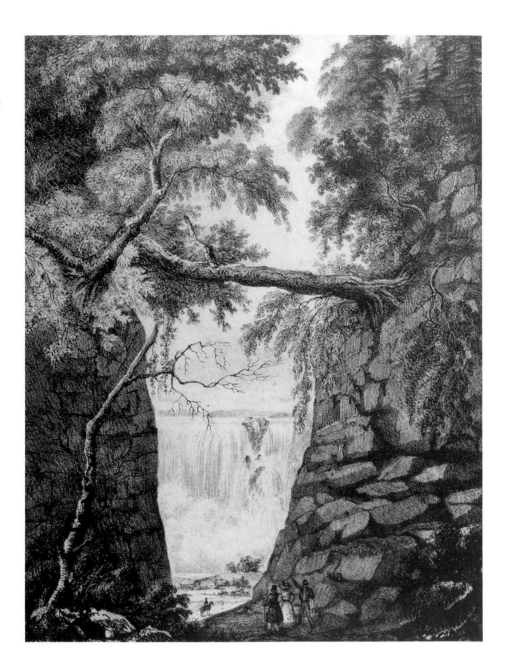

variety and beauty are striking characteristics."[34] Wadsworth later published a lithograph
of one of his drawings of the falls, entitled *Part of Niagara Falls on the U.S. Side of the River
Seen from the Canada Side Drawn June 1806* (fig. 4).

Daniel Wadsworth: Collector As one of the nation's leading history painters and president
of the New York (later American) Academy of the Fine Arts, John Trumbull was able to
introduce Wadsworth to some of the foremost artists in the United States. In 1807 Thomas
Sully (q.v.), then a promising young portrait painter, stopped in Hartford to paint a series of
family portraits for Wadsworth at his brick mansion house on the corner of Prospect Street

and Wadsworth Alley. Sully had recently visited Trumbull in New York City and Gilbert Stuart in Boston to observe the great artists at work, and it is likely that Trumbull suggested that he pay a call on Wadsworth.[35] Sully's portrait of Daniel (cat. 428) shows the strong-featured, patrician profile of his sitter, whose pensive gaze conveys his aesthetic sensibility. Wadsworth commissioned many other portraits of himself over the course of his lifetime, an indication of his awareness of himself as an important arbiter of taste. His commission of Sully's *Self-Portrait* (cat. 429) for his collection is a further indication of the artistic ambitions that led Wadsworth to form his impressive art collection.

At this time, Wadsworth began buying land on Talcott Mountain, in nearby Avon, in preparation for one of his greatest artistic achievements: the creation of Monte Video, a country estate that he modeled with the hand of a connoisseur. His years of picturesque travel and the lessons he had learned from Trumbull were the springboard for the undertaking, and his growing interest in architecture is evident in the design. Monte Video is one of the country's earliest Gothic Revival estates, and a highlight of the property was the fifty-five-foot hexagonal wooden tower completed in 1810 (cat. 126). Wadsworth also put together a collection of paintings to complement the exquisite views from the windows of his neo-Gothic house, acquiring contemporary American landscapes, including works by Jane Stuart (cat. 425), John Trumbull (cats. 450, 458–468)—among these, Trumbull's *Lady of the Lake*, for which he paid $600, the largest sum he ever spent for a single painting[36]—Alvan Fisher (q.v.), and Thomas Cole (cats. 122–127).

John Trumbull initially served as a partner in the endeavor, as a contemporary account mentioned:

> Col. Trumbull united with Mr. Wadsworth in the design to adorn this picturesque mountain top—with each a rural lodge and corresponding cultivation. Col. Trumbull's part was never executed, but Mr. Wadsworth carried out his plan even more fully than he at first intended. A beautiful villa—shaded walks surrounding a crystal lake—a commanding tower on the highest rock, with a horizon of a hundred miles in diameter, forms an object of attraction for all the surrounding country—a gratifying excursion from the town for its citizens and strangers, and a source of pleasure and of improvement in taste for thousands. When so many hug their wealth for the mere pleasure of amassing and possessing, who will be forward to censure the indulgence of a cultivated taste in bringing out in bold relief the beauties of a part of God's creation.[37]

On its completion, the widely acclaimed estate attracted thousands of tourists, numerous guests of the family, and a number of artists, who depicted various scenes of the house and surrounding lands. Alvan Fisher produced a sketch as early as 1817 (Museum of Fine Arts, Boston, Alvan Fisher Sketchbook, T. L. 6371.4) and later, during intermittent stays between 1822 and 1825, he executed four paintings of the estate.[38]

In addition to enjoying his property, Wadsworth continued to explore the northeastern landscape. In September 1819 he and Benjamin Silliman, at Wadsworth's insistence, set off on a journey to Canada in the hope of relieving the depression Silliman was suffering owing to the recent deaths of his two children. Silliman was among Wadsworth's closest friends; the men were married to the Trumbull sisters, Faith and Harriet, and spent a great deal of time

together. A professor of chemistry and natural history at Yale, Silliman shared Wadsworth's aesthetic sensibility regarding the importance of the American landscape. Wadsworth helped finance many of Silliman's scientific ventures and publications, providing advice, editorial comments, and financial assistance for Silliman's *American Journal of Science*, to which he occasionally contributed articles and illustrations (figs. 5, 6).[39]

The two men traveled for five weeks by horseback and carriage, exploring the states of Connecticut and New York and the cities of Montreal and Quebec. The conjoining of the nation's landscape and its history—ultimately, Wadsworth's vision for the Atheneum—became a theme of the journey. Silliman kept a notebook of his observations on geology and mineralogy, while Wadsworth sketched the various sites along the way. The trip resulted in the publication of Silliman's *Remarks, Made on a Short Tour between Hartford and Quebec, in the Autumn of 1819*, which was illustrated with engravings after nine of Wadsworth's sketches. In the preface, Silliman conveyed his belief, shared by Wadsworth and others of the day, that "national character often receives its peculiar cast from natural scenery. . . . Thus, natural scenery is intimately connected with taste, moral feeling, utility and instruction." The book began with a lengthy and exalted description of Monte Video and ended with the comment "Indeed, the full illustration of the beauties of this mountain . . . would form a fine subject for the pencil of a master."[40] (In 1827 Thomas Cole accepted Silliman's challenge and created a panoramic view of the mountaintop and its surroundings [cat. 126].) Silliman's travelogue describing the highlights of the trip was filled with references to the recent history of the Revolution noting the sites he and Wadsworth had visited of great battles, historic houses, and even, in connection with the legend of the murder of Jane McCrea (cat. 473), historic trees.

5. Nathaniel Rogers, *Benjamin Silliman*, 1818. Yale University Art Gallery, gift of Maria Trumbull Dana.

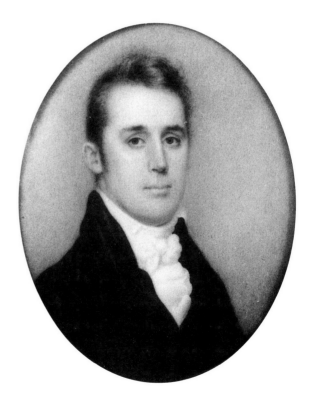

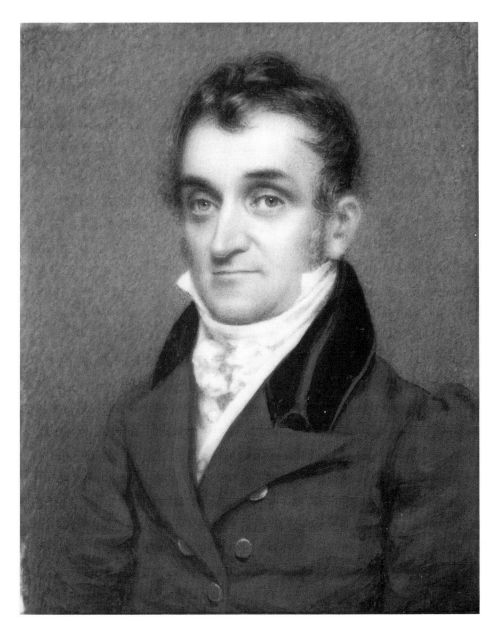

6. Nathaniel Rogers, *Daniel Wadsworth*, 1829. Wadsworth Atheneum, 1935.46.

In 1826, six years after his journey with Silliman, Wadsworth traveled with Theodore Dwight, a writer and member of the Hartford Wits, to the White Mountains of New Hampshire, a New England region that had not yet been explored. Dwight used the sketches Wadsworth took on this trip to illustrate several of his publications.[41] About *Avalanches in the White Mountains*, which he reproduced in a lithograph described as "sketched by Wadsworth" (fig. 7), Dwight wrote: "[It] will give a correct idea of the singular appearance of the avalanches of that mountain up which the shower ascended; as it is from a drawing made by a gentleman distinguished for his taste and accuracy, who visited the spot a few months after

the catastrophe. The observer stands among the avalanches which fell behind the Notch House."[42] Wadsworth's sketch—considered the first on-site view of the White Mountains[43]—depicts the site of the massive landslide that had destroyed the Willey family, pioneer settlers of Crawford Notch, in August 1826, a tale that had quickly entered the realm of popular legend, along with such lurid sagas as that relating the murder of Jane McCrea, adding a sense of history and drama to the American landscape.

Dwight's travelogues drew attention to the New England landscape at a time when Catskill Mountain scenery and the famed Catskill Mountain House reigned as the focus of tourist attention,[44] and Wadsworth's early sketches signaled the beginning of the popularization of White Mountain scenery. A year after his trip, he introduced the region to Thomas Cole (cat. 124), who began to feature White Mountain scenery in his landscapes.

Daniel Wadsworth and Thomas Cole It was undoubtedly John Trumbull who brought Cole's landscapes to Wadsworth's attention. As president of the American Academy of the Fine Arts, Trumbull was in a position to advance Cole's career, which he did through introductions to his associates at the academy and other wealthy potential patrons outside the New York City area, most important of whom were Robert Gilmor, Jr., of Baltimore, and Daniel Wadsworth.[45]

Wadsworth and Gilmor—who may have met in 1799, when both had begun to take an interest in picturesque travel[46]—were Cole's major patrons between 1826 and 1828. From his letters, Wadsworth appears to have been a fatherly figure who was rarely critical of Cole's judgment, did not question the prices of Cole's canvases, generally praised his finished works, and did not offer opinions regarding Cole's career. Gilmor, on the other hand, appears to have been far more demanding in the negotiation of commissions, subject matter of works, and price of finished landscapes.[47]

7. Lithograph after a sketch by Daniel Wadsworth, *Avalanches in the White Mountains*, illustration for Theodore Dwight, *Sketches of Scenery and Manners in the United States* (1829).

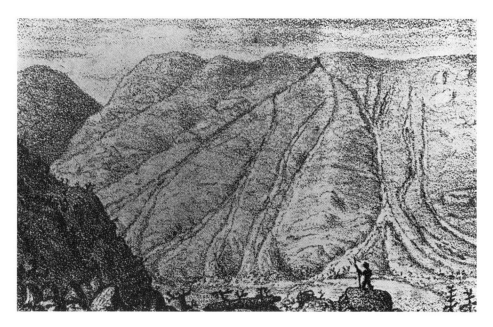

By the time Wadsworth became acquainted with the landscape paintings of Cole in 1826 (the same year as his trip to the White Mountains), he had spent over twenty-five years exploring the U.S. landscape in his travels, writings, and sketches. A shared exposure to British landscape theory—Cole was a native of England—proved a strong bond between him and the artist. Their close relationship is documented in their extensive correspondence, which has recently been the subject of scholarly interest.[48] Wadsworth eventually acquired seven landscapes from Cole. He first commissioned a variation of a landscape Trumbull had purchased in 1825; Cole sent the painting, *Kaaterskill Falls* (cat. 122), to Hartford in November 1826. Pleased with the work, Wadsworth commissioned a series of additional landscapes—at the same time that Cole was negotiating sales of his paintings to Robert Gilmor[49]—and bought two imaginary landscapes, *St. John in the Wilderness* (cat. 123) and *Scene from "The Last of the Mohicans," Cora Kneeling at the Feet of Tamenund* (cat. 125), which were among the artist's most ambitious works to date. In mid-July, after its exhibition at the National Academy of Design in New York City, Cole took *Saint John* by steamboat to Hartford in order to visit Wadsworth at Monte Video. Cole was suitably impressed with the country estate and always carried with him fond associations of the time he spent there (cat. 126).

During Cole's visit to Hartford, Wadsworth convinced him to explore the White Mountains. Although Wadsworth was unable to participate in the journey, he provided Cole with a complete itinerary based on his own trip the year before. Cole followed Wadsworth's instructions carefully and, like Wadsworth, developed a love for the mountain scenery there that soon overshadowed, for a time, his previous interest in the Catskills.[50] After the trip, he incorporated views of the White Mountains into a number of important landscapes, including several for Wadsworth: *The Last of the Mohicans, View in the White Mountains* (1827, cat. 124), and *View on Lake Winnipiseogee* (1828, cat. 127), the last being paired with the panoramic vista *View of Monte Video, the Seat of Daniel Wadsworth, Esq.* (1828; cat. 126).

A letter Wadsworth wrote to Cole on August 27, 1827, following the artist's return from the White Mountains, reveals much about their friendship and Wadsworth's passion for Cole's art:

> I received your lines, informing me of your safe arrival . . . & assure you that my mind was very much relieved, from a sense of responsibility.—Having urged you to go off alone, & to a wild country, where some perils were to be encountered,—in contradiction to your previous plans, & your own Father was not well. . . .
>
> Ever since you went from here, I have felt that it would be impossible for me to resist the temptation, of having a picture of the *Coroway Peak* with the little lake. I think it is one of the most beautiful of your subjects.—I will therefore thank [you] to Paint one for me, of the same size as the other mountain scenes, & let it come along in regular succession, as you find time & health to prosecute your charming art.—I presume you will do the large picture of the Cascade first,—& let the others follow—I shall pay for them, as fast as they are done, of this I think you will not doubt.[51]

The two men continued to share a love for the region. Two years later, for example, Cole, unable to accompany Wadsworth on a second trip to the White Mountains, wrote to him: "I

was happy to hear of your safe return. . . . Many times during your absence, fancy has placed me by your side in the region of sublimity—I have beheld you amidst the ruins of mountains in the Notch, gazing awe-struck, and amazed on its death-like desolation—I have pictured you watching the dense clouds that enveloped M Washington and waiting as anxiously for their unfolding as for the revealing of a mystery. . . . I am in hopes you made a number of sketches and if you did I am anxious to see them."[52]

Wadsworth visited Cole's New York studio in the fall of 1827, noting the artist's progress on several of his pictures.[53] In 1828 he acquired *View of l'Esperance on the Schoharie River* (fig. 8).[54] That same year he purchased Trumbull's pair of views of Niagara Falls for $400 (cats. 460, 461) and gratified his interest in the early history of the Hartford region by buying a late seventeenth-century armchair owned by the Wyllys family, of which he then commissioned eight copies (Connecticut Historical Society). Earlier he had commissioned George Francis, a local artist, to produce *The Charter Oak* (1818; cat. 232), a painting of the famous oak tree that stood on the Wyllys property. Wadsworth hung his impressive collective of Cole's landscapes, both real and imaginary scenes, in the rooms of Monte Video. After filling his houses with his collection of American landscapes, portraits, and history paintings, as well as objects of antiquarian interest, Wadsworth apparently felt he had completed his collection. He did not make any additional major purchases until late in his life, when plans for the Wadsworth Atheneum were under way.

The Founding of the Wadsworth Atheneum As part of his patronage of the arts, Wadsworth, like his father before him, was a supporter of the Hartford Gallery of Fine Arts, which had been opened by the painter and minister Joseph Steward (q.v.) in 1797, on the third floor of the newly completed Hartford Statehouse. As one of the first public museums in America, it was patterned on the more famous museum recently opened by Charles Willson Peale in Philadelphia and was intended to instruct and entertain. The Hartford Gallery boasted "three hundred and fifty feet of paintings," as well as "natural curiosities." By 1808, having outgrown its space and with the help of a loan from Wadsworth, it moved to rented rooms on Main Street, just blocks from the Wadsworth mansion. Steward operated the gallery until his death, in 1822, after which the museum continued under an "association of gentlemen" that likely included Wadsworth, finally closing in 1840.[55]

Ten years earlier, the aged John Trumbull had proposed donating his paintings to Yale College, in return for an annuity. Wadsworth became interested in a similar arrangement in Hartford and suggested building a new fireproof gallery there. According to his plan, the two institutions would then exchange paintings on an annual basis (see cat. 453). No agreement with Yale could be reached, but Wadsworth did not abandon the project.

In 1841, one month after his seventieth birthday, Wadsworth made formal plans to found a public institution that would house his art collection. He and Faith were childless, and both were in declining health. The time had come to decide the future of his collection, as well as to figure out a way to meet Hartford's need for a permanent gallery. He announced his intentions to build "a Gallery of Fine Arts, by making a free gift of his valuable lot of land on Main Street."[56] The project grew more ambitious, probably with the encouragement of friends "whose taste inclined more toward literature and history" (and on whom Wadsworth was

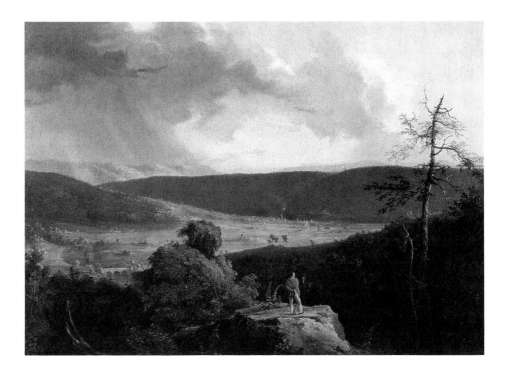

8. Thomas Cole, *View of l'Es-perance*, 1826–1828. Private collection.

dependent for funds for building), to include several additional Hartford institutions: the Connecticut Historical Society, founded in 1825; the Young Men's Institute, begun in 1838 as a literary society and library; and the Natural History Society, formed in 1839.[57]

Wadsworth certainly intended to bequeath his own collection to the gallery, but he took steps to acquire additional works of art as well. Having learned of the imminent closing of the American Academy of the Fine Arts, in late 1841 he put together a small group of subscribers to acquire that institution's collections, which comprised over fifty paintings. One subscriber—his close friend, the prominent lawyer Alfred Smith—negotiated the purchase, while Wadsworth contributed the majority of the funds.[58] In the end, they paid only $1,500 for the collection, which included *Benjamin West* (fig. 9), the famed, grand-scale portrait by Sir Thomas Lawrence. Ithiel Town, architect of the Wadsworth Atheneum and the last vice president of the academy, wrote Smith in March 1842, congratulating him on the acquisition of "the most valuable portrait in the Country—of its greatest native Artist and painted, as one of the best works, by the greatest modern Artist, in this department of Art, in Europe."[59] The collection also contained many other important works by American painters, some of whom had been students of West. The most significant were John Vanderlyn's *The Murder of Jane McCrea* (cat. 473) and Rembrandt Peale's *Self-Portrait by Candlelight* (cat. 354).

At about this time, Alfred Smith wrote to John Trumbull in an effort to acquire for the gallery that artist's five half-life-size history paintings of events of the Revolution (cats. 453–57). Describing the plan for the "gallery of Arts," he wrote:

From the first starting of this project, several months ago . . . I have not ceased to wish and hope that proper means would be found to secure your five great national paintings for our gallery. Many motives and associations give to Hartford a peculiar interest in those pictures. The Artist is a native of Connecticut. Governor Trumbull was at the helm of State during the times that tried men's souls. Washington, LaFayette and other beloved and venerated men whose deeds are commemorated in your paintings, were here during the revolution, they were guests at the mansion which is now to be removed, and to give place to the proposed Gallery.[60]

The sale was completed after Trumbull's death, the paintings commanding an astonishing price that exceeded three times what the subscribers had paid for the entire American Academy collection. The price shows the importance placed on these works, which became a focal point of the gallery throughout the nineteenth century. Other works by Trumbull were acquired at this time, including *General David Humphreys, Governor Jonathan Trumbull, Infant Savior and St. John*, and possibly *Arthur Wellesley, Duke of Wellington* (cats. 463, 464, 458, 462).[61]

A second important acquisition was the major contemporary painting by Thomas Cole *Mt. Etna from Taormina*, purchased by Wadsworth and the subscribers for $400 (cat. 134). Knowing that the Atheneum would eventually receive his remarkable collection of Cole's American landscapes, Wadsworth, along with the subscribers, felt that Cole's masterful Italian scene provided a balance between the Old World and the New—a balance that Cole had maintained throughout his career and that would be respected in the collection of the new Wadsworth Atheneum. In a letter of February 6, 1844, Cole discussed the sale of his *Mt. Etna* and went on to suggest that the subscribers acquire what he viewed as among his most important works: "I should esteem it one of the most fortunate circumstances of my life, if I could have an opportunity of executing for you one of my subjects in series. I have several now dwelling in my mind and am longing for the opportunity to embody them. With respect to the 'Voyage of Life' should I conclude to dispose of them I will inform you of the terms. . . . I should be happy to lend you my picture of the 'Angels Ministering to Christ' on the opening of your Gallery."[62] The subscribers were unable, or perhaps unwilling, to pursue these offers.

When the Wadsworth Atheneum opened its doors to the public in 1844, the picture gallery displayed about eighty paintings, one miniature, two marble busts, and a bronze sculpture. The impressive array of American paintings was placed within the broader concept of European art, alongside copies after Titian (cat. 468), Rubens, and Rembrandt. The collection was housed in the central nave of the Gothic Revival building designed by Ithiel Town and Alexander Jackson Davis, while the Connecticut Historical Society, the Young Men's Institute (to become the Hartford Public Library in 1893), and the Natural History Society were housed in separate wings.

When Thomas Day gave the opening address for the Wadsworth Atheneum in 1843, he associated the museum with the great Charter Oak, suggesting a joined heritage and predicting that the Atheneum would carry on long after the tree fell: "When all its boughs shall become withered like those of the fig tree in the gospel . . . and when the charter-oak, like

9. Sir Thomas Lawrence, *Benjamin West*, 1818–1821. Wadsworth Atheneum, purchased by subscription, 1855.1.

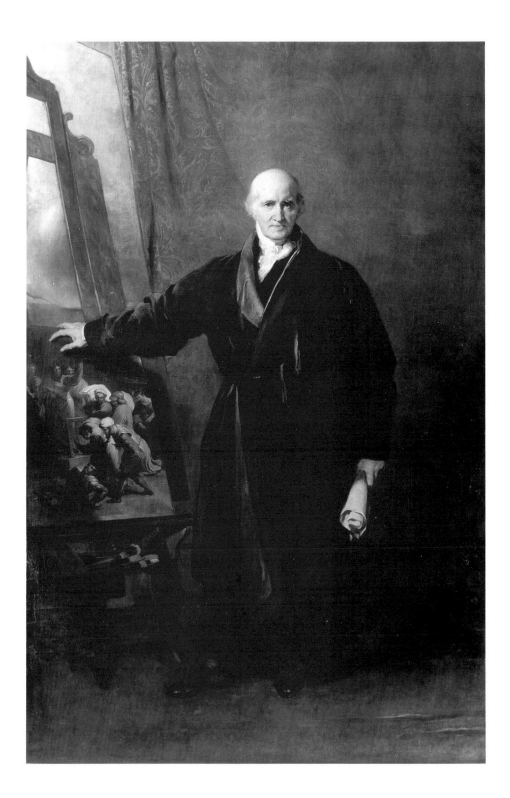

the charter itself, shall live only in history—those walls, those towers, those battlements, will endure changeless as the perpetual hills."[63]

In his final years, Wadsworth took an interest in several local artists' careers, among them, the painter Ralph Isham (q.v.) and the sculptor Edward Sheffield Bartholomew (1822–58), who served as the Atheneum's first gallery attendants from 1844 to 1848. In 1847 Wadsworth contributed toward the purchase of a marble bas-relief of Lydia Sigourney (Wadsworth Atheneum), the first recorded sale by Bartholomew. Following that artist's death, in 1858, the contents of his studio were acquired by subscription for the Atheneum collections.[64] Wadsworth also commissioned works from the sculptor Chauncey B. Ives (1810–94), of Meriden, Connecticut.[65] In addition, to provide visual references to his distinguished lineage in the new gallery, Wadsworth commissioned the local portrait painter Henry Bryant (q.v.) to make copies of family portraits that hung in Wadsworth's Prospect Street house; these copies after Sully, Trumbull, and Charles Ingham (cats. 63–68), were included in the opening exhibition of the art gallery.[66]

The most significant development of this period was Wadsworth's encouragement of the young local artist Frederic Church (q.v.). Invoking their long-standing friendship, Wadsworth convinced Cole, the nation's leading artist, to take Church as his pupil between 1844 and 1846. Church returned briefly to Hartford after his study and painted his first major work, which followed the precepts of Cole, an advocate of a "higher style of landscape."[67] *Hooker and Company Journeying through the Wilderness from Plymouth to Hartford* (cat. 111) was purchased by the Wadsworth Atheneum the year it was completed for $130. Wadsworth undoubtedly appreciated the vision expressed in the painting; like his own, it found spiritual meaning in the merging of history and landscape. As he had with Cole, Wadsworth shared his drawings with Church, who used them as the basis for several early landscapes (cats. 109, 110). Church continued to maintain his ties to Hartford, sketching local scenery and producing a sketch of Wadsworth wearing spectacles (fig. 10), and he returned numerous times to the subject of Connecticut's colonial history, painting several depictions of the Charter Oak (cat. 111). In later years, Church, by then a renowned artist, guided the formation of the private picture gallery of Elizabeth Hart Jarvis Colt, of Hartford.

Following Wadsworth's bequest in 1848, the Hartford gallery boasted one of the finest collections of works by contemporary U.S. artists in the country. Among the impressive landscapes, views of New England by Fisher, Cole, and Church were featured, a tribute to Wadsworth's lifelong interest in creating a cultural context for his region. With Wadsworth's death, however, the institution languished.[68] In 1855 the *Crayon*, the leading art journal of the day, encouraged Hartford residents to provide support for the art gallery, pointing out that the Atheneum "gives Hartford a rank which few places in this country can aspire to; for such an institution devoted to the Fine Arts is a mark of enlightenment and progress." Urging the city's inhabitants to take action, the journal expostulated: "Citizens of Hartford, do not neglect the Art Gallery of the Wadsworth Atheneum! Procure works of art and be choice in your selection. A little effort will secure to your city in its Art Gallery a unique and valuable object of interest, for works of art being symbolic of a love for the true and beautiful, their abiding place will be loved and respected accordingly."[69]

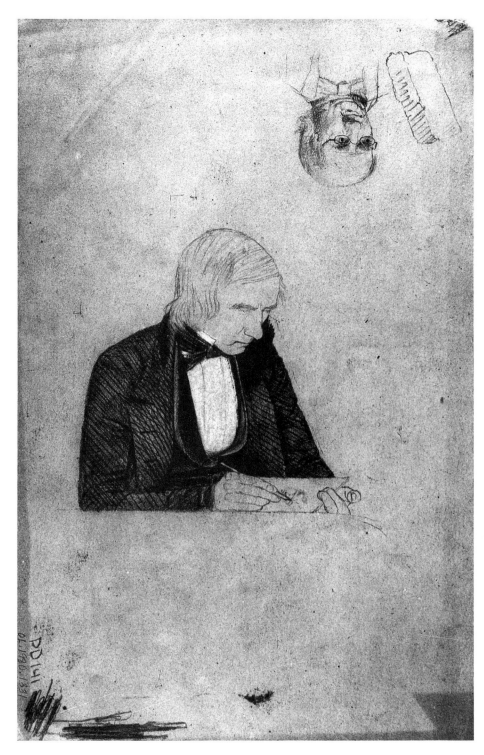

10. Frederic E. Church, *Daniel Wadsworth (and a Young Man, Possibly A. H. Emmons)*, April 1846. Olana State Historic Site, Hudson, New York.

In the next decade, a great private collector emerged in the city—Elizabeth Hart Jarvis Colt (1826–1905), who formed a major art collection that she housed in a specially constructed private gallery in her mansion on Wethersfield Avenue, just south of the Atheneum. Following the earlier example set by Wadsworth, in the late 1860s she formed one of the most impressive private painting collections in the United States—and was the first woman to do so. In 1905 she bequeathed the collection to the Wadsworth Atheneum, but during her lifetime, her picture gallery, though not officially open to the public, came to rival the Atheneum as a major attraction for the exhibition of art.

A member of a prominent Connecticut family, Elizabeth Hart Jarvis shared roots with Wadsworth, whom she undoubtedly knew as a girl. Her forebears had settled in the Connecticut River valley in the seventeenth century. Portraits of her Middletown ancestors by such American artists as John Durand (cats. 175, 176) and Gilbert Stuart (cat. 424) entered the collections of the Wadsworth Atheneum, a testament to the social status of the family. All the male members, including her father, the Reverend William Jarvis, were influential Episcopal clergymen. Her mother, Elizabeth Miller Hart, was affluent in her own right, having inherited extensive lands in the Ohio Western Reserve. Raised in a religious and cultivated household, when Elizabeth married the renowned arms manufacturer Samuel Colt in 1856 (figs. 11, 12), she provided her husband with the respectability he needed to advance his position in Hartford.[70]

At midcentury, Samuel Colt was internationally famous as an inventor, manufacturer, and purveyor of arms. In Hartford he built the largest private armory in the world, along a two-hundred-acre stretch of land on the banks of the Connecticut River. Elizabeth's first exposure to her husband's worldly and extravagant life-style took place during their honeymoon—a six-month trip abroad that included an invitation to the coronation of Czar Alexander II of Russia. On their return, Sam and Elizabeth built Armsmear, one of the most elaborate residences in the country. A showplace for the couple's enormous wealth, the Italianate villa overlooked the Colt armory and boasted a glass-domed solarium and the most elaborate greenhouses of the time, surrounded by five hundred acres of land maintained by thirty gardeners.

Having worked at a remarkable pace for several decades to expand his armory, with the intent of meeting the huge demands of both the North and South as war inevitably approached, Sam died in 1862, at the age of forty-seven. Elizabeth became one of the richest women in New England, inheriting approximately fifteen million dollars as well as a controlling interest in the Colt Arms Manufactory stock. Outliving her husband by forty-three years, she maintained close control over the factory, placing several members of her immediate family in key positions. At the same time, she assumed roles suitable to a model Victorian woman—serving as the keeper of her domestic world and as a leading volunteer and benefactor of the many religious, social, and charitable organizations in her community.[71]

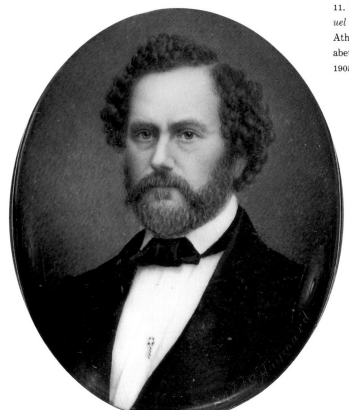

11. Gerald S. Hayward, *Samuel Colt*, c. 1856. Wadsworth Atheneum, bequest of Elizabeth Hart Jarvis Colt, 1905.65.

12. Richard Staigg, *Elizabeth Hart Jarvis Colt*, c. 1856. Wadsworth Atheneum, bequest of Elizabeth Hart Jarvis Colt, 1905.67.

In 1864 Colt put aside her mourning clothes to take on a number of highly public roles. Early that year, the Colt Arms Manufactory nearly burned to the ground, possibly because of arson. Colt immediately organized a plan to move the operation to an adjacent building and set about rebuilding the armory. The reconstruction was accomplished in record time, allowing the company to increase its production of arms after the Civil War.

Following in the tradition of her husband, who had made a point of exhibiting his arms at expositions worldwide, Elizabeth lent Colt arms for display at a number of the fairs in major northern cities held to raise funds for the relief efforts of the United States Sanitary Commission, charged with overseeing medical services for the Union forces.[72] She also agreed to represent Hartford at the New York Metropolitan Sanitary Fair, a blockbuster cultural event. Her father related that as president she worked hard, "making various articles that she thinks will be saleable."[73] In March, when the fair opened to the public, the *New York Times* reported: "The Hartford Table is presided over by Mrs. Colt. . . . Of particular interest is the elegant carved and polished Charter oak piano valued at $1500."[74] (The Colts had appropriated the symbol of the Charter Oak for their arms manufactory, linking their efforts as industrialists to the historic progress of the state.) The *Hartford Times* praised Colt and the other Hartford women for "selling the Connecticut contributions rapidly, loaf cake and Colt's revolvers being the articles most readily bought, the latter being all disposed of on the first night of the opening."[75]

While at the fair, Elizabeth Colt visited the art gallery, the most popular of the many exhibits at the fair. Organized by the Committee on the Fine Arts, which comprised cultural leaders from the National Academy of Design, the Union League Club, and the Century Association, the gallery featured paintings from thirty-six private collections in New York City and paintings donated for sale from over two hundred living American and European artists. Not only did it provide a survey of popular taste of the period, it allowed a rare public forum for both established and lesser known artists. Although over half the paintings were by French, German, and English artists, the most popular works were by U.S. painters, the most acclaimed being Frederic Edwin Church's *Niagara* (cat. 114), lent by railroad magnate John Taylor Johnston; Albert Bierstadt's *Rocky Mountains, Lander's Peak* (see cat. 38), lent by publisher Emil Seitz; and Church's *Heart of the Andes* (see cat. 116), lent by real estate tycoon William T. Blodgett.[76] Other leading businessmen also exhibited major works from their private collections, thereby affirming their status as arbiters of taste.[77]

Apparently impressed by the art at the Metropolitan Fair, the next year Colt conceived her ambitious plan to build a formal gallery on the second floor of Armsmear. At the time, ventures such as the gallery and the numerous other civic projects Colt carried out were considered unsuitable for a woman without the support of a man. To ward off criticism, she astutely justified her endeavors as fitting memorials to her husband's memory, thereby both enhancing her husband's not altogether favorable reputation and gaining the freedom to pursue her own interests in his name.

Frederic Church, by then the country's leading artist, whose parents and sister were close friends and neighbors of Colt, served as her chief adviser in the planning and design of the gallery at Armsmear and the acquisition of suitable works. Colt also drew on the contacts she had made in New York to fulfill her scheme. For example, many of the artists involved in

the exhibition, whether as organizers or contributors, had studios in the Tenth Street Studio Building, which housed many of America's best known artists of the period, including Church and Bierstadt.[78] Colt probably attended the special receptions held in the Studio Building at this time; the majority of her American paintings were later acquired from these artists.

Colt may already have had notions of creating a picture gallery when she wrote to Frederic Church in December 1863 to thank him for contacting the noted portrait painter Charles Loring Elliott (q.v.) on her behalf to negotiate a commission and price for a portrait of her recently deceased husband. Church had indicated that the portrait would cost the substantial sum of $3000. Undeterred, Elizabeth Colt responded that "the price does seem a large one for a portrait to be sure, but if he can make it such a one as I have in mind, twice the sum would not be enough to make me relinquish it."[79] Colt was looking for a grand conception of her husband that would convey his great accomplishments, and Elliott carried out this vision, working from photographs and pictures she supplied and including in the composition depictions of personal possessions that symbolized Sam Colt's role as a great American inventor and industrialist (cat. 195). On the portrait's completion, Elizabeth invited over one thousand people to Armsmear for a viewing.[80] She also commissioned Elliott to paint an equally grand portrait of herself and her only surviving child (four others had died), her son Caldwell (cat. 196). The elegant portrayal bore a marked resemblance to the many portraits of Queen Victoria and her children, a point not lost on Colt's Hartford admirers. For the paintings, she commissioned Frederic Church's New York frame maker to produce massive gilt frames crowned with carved rampant colts, the symbol Sam Colt had adopted for his arms manufactory.

In 1865 Colt began visiting the private picture galleries of a number of New York's leading collectors whose works she had seen on display at the Metropolitan Sanitary Fair. With a letter of introduction from Church, she visited the gallery of John Taylor Johnston, where she saw such major works as Cole's series of four paintings entitled *Voyage of Life*, Church's *Niagara* and *Twilight in the Wilderness*, both of which had been on view at the fair, and Elliott's portrait *Asher Durand*.[81] During this trip, she was careful to note details of the presentation, furnishings, and lighting in preparation for her own gallery.

In 1866 the second floor of Armsmear was torn up—several bedrooms were dismantled, including those of her elderly parents who were moved to other quarters in the house—to accommodate skylights: construction of the gallery had begun. As architect, Colt hired Richard Morris Hunt, who had recently served on the Metropolitan Sanitary Fair Commission and had also built the Tenth Street Studio Building. In May Colt wrote to Church that she had recently visited Hunt in New York to discuss various matters, including lighting for the gallery. She asked Church for his advice "upon the mode of lighting the gallery at night. Mr. Hunt recommended Frink's Reflectors—there is one in Mr. [Samuel] Avery's Gallery. . . . Mr. Hunt proposes putting these above the ground glass." She went on to question Hunt's judgment, wondering if the reflectors "might somewhat obstruct the light in day time."[82] Church was qualified to assist in this matter, having had experience with dramatic lighting techniques in numerous exhibitions.[83]

Church advised Colt not only on lighting but on nearly every aspect of the gallery,

including furnishings and wall construction: "For an upholstered Picture Gallery it is very desirable to have the walls covered with narrow matched boards in preference to plaster. . . . It is a good idea to tack thin strips of wood over the plaster. . . . [Church provided a drawing in the letter.] The object is to have some wood work behind the cloth to screw eyes into, to hold the pictures."[84] He also recommended that Colt use his New York City upholsterer and frame maker, concluding: "I believe that you will have the most charming gallery in the country—I am anxious to see it."[85] Before the gallery was completed, Church sent Colt a tree fern to complete the decor.[86]

With construction under way, Colt began acquiring paintings and sculpture, again using Church as an adviser. Her collection came to reflect the popular taste of the time and was clearly influenced by the types of paintings she had seen at the Sanitary Fair: with few exceptions, she bought works by European and American artists who had exhibited there. She commissioned a number of important U.S. landscapes from artists in the Tenth Street Studio Building and also bought a number of works by popular European painters of the period from such leading New York dealers as Samuel Avery and Michael Knoedler, director of the Goupil Art Gallery; both men had served on the art committee of the Metropolitan Fair.[87]

As construction of the gallery proceeded, Colt acquired paintings rapidly. In October 1866, for example, she wrote to Church seeking his approval for a major work she had just purchased: "Please go to Goupils [Gallery] to see *The Angels Offering* by Merle, which I have bought. I like it better than any Madonna I have ever seen & the infant is beautiful beyond expression."[88] This painting by the French artist Hugues Merle may have held special meaning for both Colt and Church, who had recently lost two children to diphtheria and had just experienced the birth of a son. In her letter, Colt made a reference to this shared sorrow. She also inquired about the status of a major landscape she had commissioned from Church, *Vale of St. Thomas, Jamaica* (cat. 116), which he did not complete until 1867 and for which he charged $4000. Church imbued his great tropical landscape with a deeply spiritual meaning, and it became a focal point of the gallery.

Colt both commissioned and purchased several other landscapes from leading Tenth Street Studio artists, such as Albert Bierstadt's *In the Yosemite Valley*, a work very similar to the Yosemite landscape he had included in the art gallery at the fair (cat. 38). An important commission was from Sanford Gifford, who wrote to Colt while painting *A Passing Storm in the Adirondacks* for her gallery in 1866, giving her a poetic description of his intentions for the work (cat. 237). That same year, she bought *Alpine Scenery—Lake Gosau* (cat. 233) from the German artist Hermann Fuechsel, who was then in residence in the Tenth Street Building and corresponded with her that year. In 1867 she bought *Mount Washington from the Conway Valley* (cat. 310) from John Kensett for the substantial sum of $1,450. She also acquired *Landscape with a Round Temple* (cat. 131), by Thomas Cole, probably purchased from the Cole family through Frederic Church (cat. 118); James Hamilton's *Evening on the Seashore* (cat. 255); William Beard's *Mountain Stream and Deer* (cat. 18); and William Bradford's *Coast of Labrador* (cat. 50); as well as several genre paintings by such artists as Jared B. Flagg (cat. 226) and J. Beaufain Irving (cats. 290, 291)—all in time for the opening of her gallery in 1868.

With these purchases, her gallery at that time consisted of sixteen works by U.S. artists and twenty-five by Europeans, many of them French. Many of the European paintings she had purchased from Samuel Avery and from the Goupil Art Gallery, including the large Merle, Louis Gallait's *At the Prison Door* (1864), and Adolphe-William Bouguereau's *Manon Lescaut*. Works by Dutch, Flemish, and German painters included Petrus van Scendel's *Marketplace* (1864), Eugene Verboeckhoven's *Mountain Pasture*, August Zimmerman's *Return of the Flock* (1863), and Adolf Schreyer's *Well in the Desert*, respectively.

The presentation of the works of art at the art gallery at the Metropolitan Fair clearly influenced the arrangement of paintings in Colt's gallery. At the fair, for example, the juxtaposition of the two monumental landscapes—Church's *Heart of the Andes* and Bierstadt's *Rocky Mountains*—had prompted critical debate regarding the comparative merits of these two paintings by leading rivals.[89] Colt displayed paintings in similar juxtaposition, with Church's *Vale of St. Thomas* centered on the east wall (fig. 13) and Merle's *Madonna* and Bierstadt's *Yosemite* on the west (fig. 15). On the north and south walls Elliott's enormous portraits of Sam and Elizabeth Colt faced each other (figs. 13, 15).

Upon completion, the Colt gallery became one of the most important places to visit in Hartford and undoubtedly overshadowed the Atheneum's gallery, which had fallen into disrepair in the postwar years owing to neglect (fig. 16). The space served as a public reception area for major social events, one of the grandest of which was the wedding of Elizabeth Colt's beloved sister, Hetty Jarvis, in December 1867. As the *Hartford Courant* reported: "A portion of the gallery immediately in front of the magnificent full length portrait of the late Colonel Colt was fitted up as an altar for the purpose and around this the bridal party stood. Over their heads was suspended a marriage bell fashioned of rare flowers hung with festoons of exotics which filled the air with perfume."[90] The *Art Journal* later noted that the couple stood in front of Sam Colt's portrait "while taking the solemn oaths of marriage, so he might still seem to assist—to 'give her away' as he would have done fondly and proudly; for he loved her with a father's and a brother's love."[91] Although Colt allowed her husband's posthumous image to remain a focal point of the gallery, she assumed a regal appearance for such affairs; in this instance, she reportedly wore "a magnificent robe of black velvet; a coronet of diamonds in her hair, a superb necklace formed of star-like clusters of diamonds—bracelets and other ornaments to match. She received her visitors (of which there were several thousand) with that queen-like grace and ease and affability of manner for which she has always been noted."[92]

Residents and visitors to the city made a point of seeing Colt's creation, among them, Samuel Clemens and General Philip Henry Sheridan, a Civil War hero, who toured the picture gallery during his visit to Hartford in 1873.[93] In 1876 Armsmear was the subject of an extensive article in the prestigious *Art Journal*, which mentioned that Colt's "stately picture-gallery—the noble room, used as a reception and ball room, has several good pictures and many family portraits."[94]

In contrast to the excitement generated by the Colt picture gallery, the Wadsworth Atheneum's gallery had remained virtually unchanged since the middle of the century, attracting only modest numbers of visitors. By the latter part of the century most of the founders of the Wadsworth Atheneum had died, and owing to extreme financial pressure the

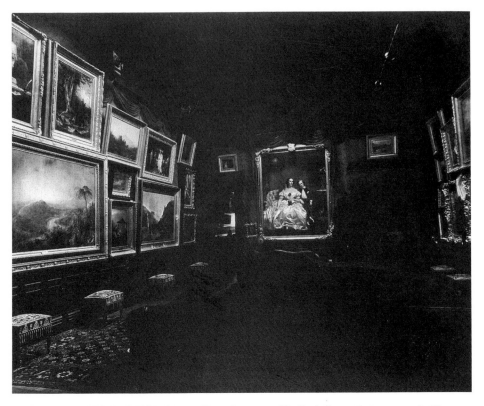

13. South view of Elizabeth Colt's picture gallery, Armsmear, Hartford, Connecticut, c. 1880. Archives, Wadsworth Atheneum.

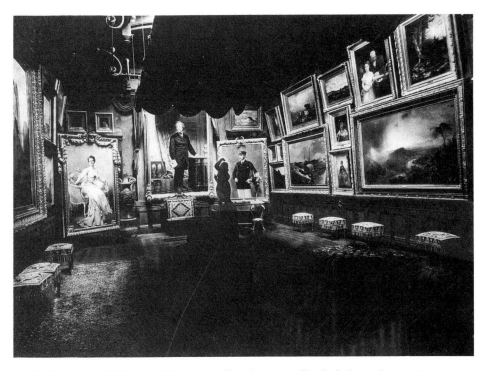

14. Northeast view of Elizabeth Colt's picture gallery, Armsmear, Hartford, Connecticut, c. 1880. Archives, Wadsworth Atheneum.

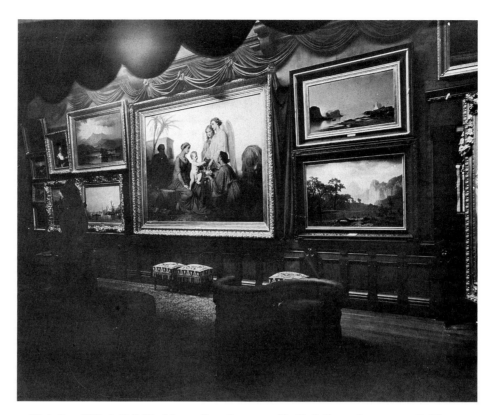

15. West view of Elizabeth Colt's picture gallery, Armsmear, Hartford, Connecticut, c. 1880. Archives, Wadsworth Atheneum.

museum was forced to close during 1884–1885. Although unable to serve on its board (women were not appointed to such positions until the middle of the next century), Elizabeth Colt did assist the Atheneum financially.[95] One of her many civic activities involved leadership of the Art Society of Hartford (forerunner of the Hartford Art School), which, beginning in 1886, provided funds to reopen the galleries at the Atheneum two days a week, free of charge, in exchange for permission to hold art classes in the museum on the remaining days.[96] She also gave $5,000 to the museum's building fund in 1890.[97]

At the end of her life, Elizabeth Colt bequeathed her collection to the Wadsworth Atheneum, becoming one of the first women in America to leave a major art bequest to a public museum in her own name, rather than that of her husband.[98] In her will, she specified that her paintings, sculpture, and decorative arts, nearly six hundred objects in all, be "kept separate and apart," displayed as the Elizabeth Hart Jarvis Colt Collection in the Elizabeth Hart Jarvis Colt Gallery.[99] She also had the foresight to leave a $50,000 endowment for the construction and maintenance of a wing to house the collection.

Colt's painting collection reflected the taste of the years immediately following the Civil War, just before the demise of the Hudson River school, which started to fade in the 1870s. The pictures provided a continuation of Wadsworth's earlier preference for depictions of the U.S. landscape. But rather than the romantic vision of Wadsworth and Cole, who saw art as a moral force, Colt's works by Church, Bierstadt, Kensett, Gifford, and Bradford, all painted

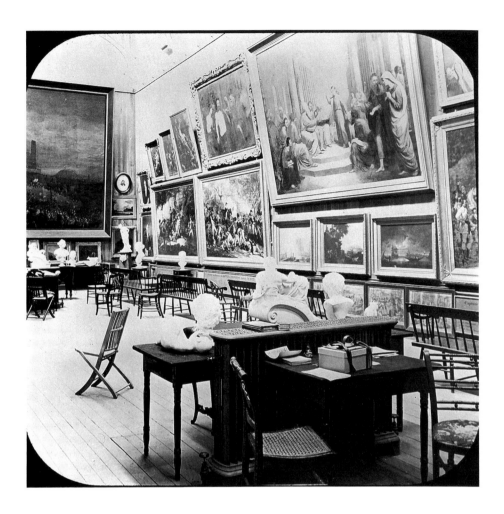

16. Wadsworth Atheneum paintings gallery, c. 1890, with two John Trumbull Revolutionary War scenes visible. Archives, Wadsworth Atheneum.

between 1866 and 1868, represented the scrupulous naturalism, the search for ever grander and more exotic locales, and the post–Civil War concerns that characterized the second generation of American landscape artists.

In 1910, when the Colt Memorial building was completed, the *Hartford Courant* stressed the importance of the bequest as a tribute to Sam Colt's memory, with only a passing mention of the great art collection assembled by Elizabeth Colt: "Although her gifts to the Wadsworth Atheneum, and thus to the city, include many paintings and other art treasures, it is no exaggeration to say that the most important feature of it, in her estimation, are such things as go to show the place Colonel Colt occupied in the affairs of his times"; the things in question were his gun collection, his medals of honor, and the other commemorative objects that were placed on display. No mention was made of the great landscapes by Hartford's native son, Church, or other prominent Americans; rather, the paper commented that "considering the time they were collected they form a good exhibit. Some of the pictures are well deserving of mention from an artistic standpoint," going on to note only works by the Europeans Ziem and Merle.[100]

One of the special guests attending the opening of the Colt Memorial, which coincided with the opening of the new Morgan Memorial built by J. Pierpont Morgan (cat. 444), was George H. Story (q.v.). In addition to painting professionally, he also served as the curator of paintings at the Metropolitan Museum of Art from 1889 until 1906 and as honorary curator of the Wadsworth Atheneum from 1897 until his death, in 1922. During his tenure at the Metropolitan, he organized a major exhibition of early American paintings, in 1895, and a memorial exhibition of the works of Frederic Church, in 1900. At the Atheneum he served as an adviser on displays and acquisitions, recommending the purchase of numerous works, including George Inness's *Autumn Gold* (cat. 288); John Singleton Copley's *Mrs. Seymour Fort* (cat. 146), which Story offered the Atheneum after it had been rejected by the Metropolitan; Gilbert Stuart's *General Aquila Giles* (cat. 421); and a number of English and European paintings. He left several paintings to the Atheneum, including Stuart's *Unfinished Portrait* (cat. 422) and several of his own works (cats. 416–18).

J. Pierpont Morgan also consulted Story on the purchase of paintings.[101] In 1917, following Morgan's death, his son left the Atheneum his father's superb European decorative arts collection of over thirteen hundred objects.

In 1896 the $50,000 Henry and Walter Keney Fund (cat. 330) was established, the earliest such endowment given to the museum. For the first time since its founding, the Atheneum was able to make major purchases, such as Inness's *Autumn Gold* and Copley's *Mrs. Seymour Fort*. In 1915 a second endowment fund for the purchase of works of art was set up when Mrs. James Junius Goodwin gave $50,000 in memory of her husband.

THE ADVENT OF THE MUSEUM DIRECTOR

A series of museum directors at the Wadsworth Atheneum has defined the varied directions the Atheneum's collections have taken over the course of this century. Frank B. Gay, head of the Watkinson Library, was appointed the Atheneum's first director in 1911, and in 1918 Florence Paull Berger, the first professionally trained museum staff member, was appointed general curator. Though the American painting collection has continued to expand in this century, the vision for the museum has grown broader with each director. Moreover, with one extraordinary exception—the 1948 bequest of Clara Hinton Gould—paintings purchased through the establishment of acquisition funds, rather than bequests of major collections, have characterized the expansion of the Atheneum's American painting collection in this century. The Art Committee, consisting of members of the board of trustees, made a number of major purchases. The most notable was through the bequest given by Susie Healy Camp as a memorial to her father, which allowed the committee to purchase Whistler's celebrated *Coast of Brittany* (cat. 492) for $30,000 in 1925.[102]

A. EVERETT AUSTIN, JR.

Whereas Daniel Wadsworth established a vision for the Wadsworth Atheneum in the nineteenth century, A. Everett Austin, Jr. (1900–1957), who was appointed director of the Atheneum in 1927 and served for eighteen years, arguably set a vision for the twentieth.

Like Wadsworth, he demonstrated a broad interest in the arts of his time, which in his case also encompassed music, theater, dance, photography, and film.

Trained in the graduate program at Harvard's Fogg Art Museum, Chick Austin (as he was familiarly known) was only twenty-six at the time of his appointment but had a supreme confidence in his modern approach, proclaiming upon his arrival: "The new policy of the Atheneum will be that of acquiring distinguished works of art rather than pictures of historical and decorative interest."[103] He did not attempt to veil his disdain for the bulk of the paintings in the permanent collection, going so far as to eliminate, on October 15, 1928, over thirty paintings, mainly copies after old masters that had been part of the American Academy of the Fine Arts collections, as well as four works from Wadsworth's bequest.[104]

Austin quickly found himself in a position to indulge his taste and vision in building the collections. In 1928 Frank Sumner, a Hartford banker, left the museum a bequest of over one million dollars for the purchase of "choice paintings." To be known as the Ella Gallup Sumner and Mary Catlin Sumner Collection Fund, named for Sumner's sister-in-law and his wife, the fund permitted Austin to expand the Atheneum's holdings, moving in new directions and largely shaping the now-renowned European and twentieth-century collections.[105]

In spite of his individualistic approach, Austin adhered to the traditional hierarchy of the fine arts, placing his greatest emphasis on the acquisition of old master paintings, followed by modern European works, and allocated the available acquisition funds accordingly. Although he seemed unwilling to spend more than a modest amount for American paintings— on average, three or four hundred dollars for a single work—he nonetheless made an impressive number of inspired acquisitions, as well as hosting several pioneering exhibitions that dealt with American art.[106] He steadfastly avoided works by the recognized canon of U.S. artists of the time—major figures who were already enshrined in museum collections, such as John Singleton Copley, Gilbert Stuart, Winslow Homer, and George Inness, most of whom were already represented in the Atheneum collections. Instead, Austin's purchases focused more on little-known painters whose art seemed to parallel the interests and themes he explored in depth within the traditions of European art, such as still-life painting, surrealism, and romanticism. His American acquisitions thus reflected his eclecticism in general (fig. 17).

During his first year as director, Austin assessed the museum's collections in a magazine article, summarizing what he saw as the important American works, singling out "first-rate examples of early American paintings, notably the group [portrait] of Oliver Ellsworth and his wife, by Ralph Earle [sic] . . . three very well painted Stuarts [cats. 419, 421, 422] and an especially magnificent portrait of Mrs. Seymour Fort, by John Singleton Copley."[107] He skipped over the nineteenth-century landscapes that make up the bulk of the collections, completely ignoring the extensive selection of Hudson River school paintings, which had fallen from popular favor in the previous century and would not regain broad scholarly or popular interest until the 1950s.[108] Austin went on to note a number of late nineteenth-century American works, including a Mary Cassatt pastel, *Child Holding a Dog* (Wadsworth Atheneum), as well as paintings by Whistler (cat. 492), William Merritt Chase (cat. 99), and George Inness (cat. 288). He then defined his intentions for acquisitions: "It will be the policy of the Atheneum in the future, to build up a very small but very distinguished

17. A. Everett Austin, Jr., performing as "The Great Osram," c. 1940. Archives, Wadsworth Atheneum.

collection of works of art, buying only one important picture a year without much reference to the filling out of any given school. At the same time, it is hoped that a collection of watercolors by modern Americans can be formed, as in this medium the American artist appears to find the ability to express himself more completely and characteristically than in the field of oils. To this end, a number of watercolors have been bought this year."[109] In his first year, Austin purchased watercolors by John Singer Sargent (q.v.), Charles Demuth, Preston Dickinson, Dodge McKnight, and Edward Hopper, and held a one-artist show of Hopper's watercolors in the same year.[110] This policy of acquiring watercolors by American modern masters, which were considerably less expensive than oils, allowed Austin to reserve the larger portion of the acquisition funds for old master paintings.

Austin's acquisitions of American paintings tended to parallel the lively exhibition program he had instituted. The shows were groundbreaking and eclectic, ranging from his 1930 Italian baroque exhibition, the first of its kind in the United States (Austin nearly single-handedly formed the Atheneum's great collection of Italian paintings during his tenure), to a number of thematic exhibitions. These included "Landscape Painting," in 1931; "Forty-Three Portraits," in 1937; "Painters of Still Life," in 1938; and "Men in Arms," in 1943, to name a few. In many of his thematic exhibitions, Austin attempted to define for the public how contemporary movements fit into art of the past. As he explained: "Contemporary art has always a double importance. Besides its own intrinsic interest, it is perpetually leading us into some new part of the past which has been forgotten."[111] This belief led to his interest in American art of the past.

In the fall of 1930, Austin borrowed an exhibition of eighteenth-century English portraits from the Robert C. Vose Gallery in Boston. In conjunction with the exhibition, he bought three American colonial portraits (perhaps to please the Atheneum's board members): Jeremiah Theus, *Portrait of a Lady* (cat. 440); Joseph Blackburn, *Sir Francis Bernard;* and John Smibert, *Joseph Crawford*. In 1931 he purchased Blackburn's *Lady Amelia Bernard*, the companion to the portrait purchased the previous year, from the Macbeth Gallery in New York City. (These were among his largest expenditures for U.S. art, and the latter three proved to be false attributions, works by unknown English artists.)[112]

More indicative of his eclectic style were the exhibitions he organized in the 1930s promoting modernism in all its forms—the fine arts, theater, dance, and film. One of the first was the exhibition in 1931 of the neoromantic painters—Kristians Tonny, Pavel Tchelitchew (q.v.), Christian Bérard, and the brothers Leonid and Eugene Berman (q.v.)—who had first been shown together in Paris in 1926. Austin brought them together for the first time in the United States and championed their lyrical, nostalgic, and occasionally decadent style. For the next ten years he proceeded to buy works from these artists (mainly on paper) and commissioned them to contribute their skills in stage design and mural painting for the many events he organized in the new Avery theater, part of the Avery Memorial wing—considered the first modern museum space in the United States—which Austin added to the Atheneum in 1934.[113]

In 1931 Austin also mounted the first U.S. exhibition of the surrealists, entitled "Newer Super-Realism," showing works by Salvador Dalí, Giorgio De Chirico, Joan Miró, and Pierre Roy.[114] He went to great lengths to provide programs that would enhance his audience's understanding of the exhibition. Using the media, he offered a definition: surrealism "is essentially an attempt to exploit, in terms of paint, the more exquisite reality of the imagination, of the dream, even of the nightmare—the desire to push reality beyond the visual actualities of most paintings."[115] The exhibition inspired a number of Connecticut artists by giving them the opportunity to view surrealist works; these artists in turn began working in a surrealist vein that attracted Austin's support. During the "Newer Super-Realism" show, Austin displayed the social-surrealist paintings of James Guy (q.v.), of Hartford, in the Annex gallery of the museum; he continued to promote Guy's career throughout the 1930s, purchasing works by him (cat. 252). Austin also acquired pieces by two other local surrealist painters, Walter Quirt (q.v.) and George Marinko (q.v.), among others. All these works became part of the museum's permanent collection in the 1930s.

Austin developed a productive relationship with the New York dealer Edith Gregor Halpert, who began operating the Downtown Gallery in 1926.[116] Specializing in contemporary American artists, Halpert introduced many of their works to Austin. Austin began corresponding with her in 1929, the year Halpert opened a parallel venture, the American Folk Art Gallery, where she pioneered an interest in the works of American folk artists. Austin maintained contact with her throughout his years as director of the Atheneum, eventually buying a number of important U.S. paintings from her.[117]

Austin's attraction to surrealism influenced the way he viewed art of the past and, in part, led to the acquisition of major trompe l'oeil still-life paintings by William Harnett (q.v.),

John Peto (q.v.), and others at a time when these now famous painters were virtually unknown. Halpert assisted Austin in acquiring these works and often offered him others by American painters that related to his interest in surrealism, but it was not until 1933 that he expressed interest in buying one—Raphaelle Peale's *Venus Rising from the Sea—A Deception (After the Bath)*. Unfortunately, his protests over the cost stymied this major acquisition: Halpert wrote to Austin in February 1934, informing him that the Nelson Gallery in Kansas City had purchased the work.[118] Austin had tied up the Sumner Fund for two years (1931–1932) with his $100,000 acquisition of Piero di Cosimo's *Finding of Vulcan*, which may partially explain the museum's lack of funds; he did, however, manage to make other major purchases using the Keney and Goodwin Funds and in November 1933 bought the great Serge Lifar collection, *Designs for the Russian Ballet*.[119] Austin later borrowed the Peale painting for his 1935 exhibition "American Painting American Sculpture Three Centuries," which surveyed American art to show, as he wrote, the "direct tradition of American realism" and the "influence of imported traditions on the painting of American artists."[120]

Halpert finally succeeded in selling Austin a painting in 1935, when she offered him William Harnett's *Faithful Colt*, reducing the price from $475 to $300; as she wrote with some exasperation, she made the accommodation "in order to place one of our pictures in the Wadsworth Atheneum Collection."[121] At the time, Harnett was little known, and this painting was his first work to enter a museum collection, sparking the artist's rediscovery (cat. 256). Astutely appealing to Austin's interest in surrealism, Halpert related the Harnett painting to the work of the French surrealists and suggested that the piece could "be well hung next to the Pierre Roy."[122] (Austin had purchased Roy's *Electrification of the Country* in 1931.) In 1938, for the show "The Painters of Still Life," Austin exhibited both the Harnett and the Roy, along with Peale's *After the Bath*, among others. Austin later wrote of the Harnett painting: "Despite what appears at first glance to be an approach to supreme realism in Harnett, and not withstanding the commonplaceness of the subject matter, an antirealistic and almost fantastic result is achieved."[123] His interest persisted, and in 1938 he purchased Joseph Cornell's *Soap Bubble Set* from Julien Levy for $60—the first Cornell box to enter a museum collection (cat. 149).

As founder of the American Folk Art Gallery, Halpert also introduced Austin to American folk art, offering him a wide variety of paintings. Austin made several purchases in this area, among them Joseph Whiting Stock's *Child with Spoon* (cat. 414), Thomas Chambers's *Niagara Falls* (cat. 97), and John and James Bard's *Armenia* (cat. 16). The funds used were often earmarked as the "Sumner (Modern) Fund," a clear indication that Austin looked at these works with a modernist eye.[124] In the foreword to the catalogue for his 1942 exhibition "Twenty-Five American Paintings from the Revolution to the Civil War," he wrote that "through an understanding of contemporary forms, we are permitted to discover in the past new values implicit in works which at first we hardly knew existed,—values which, as a matter of fact, may never have existed at all, at least in the minds of their inventor or contemporary observer. . . . It is indeed unfortunate that the label 'primitive' attached to painters like these (and Rousseau) should so often connote the implication that they could do no better, when they have done so much."[125] Between 1957 and 1960 Halpert gave nearly

forty folk paintings and sculptures to the Wadsworth Atheneum; the gift included both anonymous works, such as *Girl in a Plaid Frock* (cat. 537), and paintings by well-known artists, such as Edward Hicks's *Apollo and Marsias* (cat. 271).

In preparation for his exhibition "The Painters of Still Life," Austin bought a large number of European still-life paintings. He also bought several American still lifes that he had borrowed for the show, such as *The All-Seeing Eye* (cat. 511), an anonymous work (purchased as a work by Nathaniel Peck) that he bought from Edith Halpert's Folk Art Gallery for $200. After the show, Austin continued to build this area of the collection, buying John Peto's *Reminiscences of* 1865 (cat. 361), James Peale's *Watermelon and Grapes* (cat. 352), Raphaelle Peale's *Still Life with Fruit and Vegetables* (cat. 353), Sarah Miriam Peale's *A Slice of Watermelon* (cat. 358), and Ferdinand Danton's *Time Is Money* (cat. 157).

By the 1940s the members of the acquisition committee had limited Austin's access to the acquisition funds, allocating a certain amount for their own purchases; John Kensett's *Coast Scene with Figures (Beverly Shore)* (cat. 311) was one of these, as was Winslow Homer's *Rocky Coast* (cat. 277), purchased for the considerable sum of $12,000.[126] After a year's sabbatical in 1943, Austin returned briefly and then resigned on January 1, 1945. That year, the art committee purchased John Singleton Copley's masterful colonial portraits of Jeremiah and Martha Lee (cats. 144, 145). This and other of the committee's acquisitions reflected the growing interest in the history of American painting from the colonial period through the nineteenth century, as seen in such major exhibitions as "Life in America," organized by the Metropolitan Museum of Art in 1939.

During the 1930s and 1940s, the Atheneum acquired a number of private collections of models and paintings of ships, scrimshaw, and other maritime objects, all of which came to form the museum's Marine Collection. The interest in maritime art coincided with an interest in American folk art. This material was also clearly viewed as part of the Anglo-Saxon and New England heritage shared by the Atheneum and its board members. Significant additions in this area came from Captain Hugh Ferry, of Essex, Connecticut, who gave his marine collection to the museum in 1938 (see cat. 333), and Horatio Armstrong, who donated his collection of ship portraits in 1947 (see Appendix).

CUNNINGHAM, ELLIOTT, ATKINSON, AND MCCAUGHEY:
CONTINUING EXPANSION OF THE COLLECTION

Charles C. Cunningham, who succeeded Austin in 1946 and served as director for twenty years, established professional curatorial standards in the museum. This resulted in the first efforts to research objects in the collections. In the field of U.S. art, Cunningham wrote to artists represented in the collection, gathering vital information on their works. He also pursued the provenance of many earlier paintings, writing leading scholars and dealers for help in his investigations. This catalogue has benefited greatly from Cunningham's early scholarship.

Like Austin, Cunningham had been trained at Harvard and the Fogg Art Museum, and like Austin, he adhered to the traditional hierarchy in his purchases, keeping European old masters as the top priority, though he also made an impressive number of important acquisi-

tions of American paintings. Unlike his predecessor, however, Cunningham purchased canonical artists such as Homer and Eakins, who were well established in major museum collections. He expanded the existing strengths of the museum, showing his appreciation for the Hudson River school collection by adding important works by Albert Bierstadt (cat. 37), Asher B. Durand (cat. 174), Thomas Doughty (cat. 168), Martin Johnson Heade (cat. 266), Sanford Gifford (cat. 238), and George Durrie (cat. 180). His choices mirrored those of the Museum of Fine Arts in Boston at this time, particularly the collection of paintings formed by Maxim Karolik that the MFA received in 1949.[127]

Cunningham's selections may also have been inspired by the extraordinary events of 1948 at the Atheneum, beginning with the bequest of the American painting collection of Clara Hinton Gould. Composed largely of Hudson River school landscapes, the Gould paintings remain the single most important addition to the Atheneum's American painting collection in this century.

Clara Hinton Gould (1858–1948) was born in New York City to Sarah Ellsworth and Dr. John H. Hinton. In 1897 she married Dr. Frederic Saltonstall Gould, a Harvard-trained physician whose ancestors were the Boston Saltonstalls. Having moved to Santa Barbara, California, for Dr. Gould's health, the couple in 1906 created a spectacular estate on their vast lands at San Leandro Ranch, in Montecito; the large mansion and extensive gardens became famous in the region.[128] When her husband died, in 1920, Gould became a major collector and a patron of the arts and music. A founding trustee of the Santa Barbara Museum of Art (1941–1948), she both lent and gave works, in addition to establishing the Gould Gallery at the museum in her husband's memory.[129] She also put together a sizable private collection of largely eighteenth- and nineteenth-century U.S. paintings, buying many from the Dalzell-Hatfield Galleries, which was located in the Ambassador Hotel in Los Angeles.[130]

The initial arrangements for the Atheneum bequest were made in 1937 (over a decade before Gould's death), when she wrote to the museum offering her three Frederic Church paintings, along with other works. Writing from Middlebury College, where she was studying Italian, Gould recounted how she had met a young woman from West Hartford; having asked her about the museum there, inquiring if she was familiar with the city's famous native artist, Frederic Church, Gould was surprised to learn that the young woman "had never heard of him nor of his paintings." She then explained to Austin why she chose not to leave them to her local California museum: "In this section almost no one knows anything about these scarce & choice works and because there is no gallery of any description in which to house them [the Santa Barbara Museum did not open until 1941] . . . I wish to leave [the paintings] by will to your Museum if you feel that the people of Hartford will appreciate and be proud of them."[131] She also mentioned that the Church painting of the "Andes" mountains (cat. 113), as she called it, had been in her family for "over fifty years," and made it clear that she had studied Church's life and works.[132]

Gould's bequest of forty-five paintings included the three Frederic Church landscapes *Coast Scene, Mount Desert* (cat. 115), *Evening in the Tropics* (cat. 118), and *Mountains of Ecuador* (cat. 113); Thomas Cole's *Roman Campagna* and *Evening in Arcady* (cats. 132,

133); Thomas Birch's *Landscape with Covered Wagon* (cat. 42); Alvan Fisher's *Niagara Falls* (cat. 205); Sanford Gifford's *Lake Scene* (cat. 239); David Johnson's *Franconia Mountains* (cat. 305); Jasper Cropsey's *Peaceful Valley* (cat. 155); and John William Casilear's *Lake George* (cat. 95), among other Hudson River landscapes. Other important works were Benjamin West's *Saul and the Witch of Endor* (cat. 485), Eastman Johnson's *The Party Dress* (cat. 306), and William Merritt Chase's *Portrait of a Woman* (cat. 100). The Gould paintings were installed in the Avery Court gallery in the fall of 1948.[133]

The collection could not have come at a more appropriate moment, its arrival having coincided with "Thomas Cole, One Hundred Years Later," a comprehensive retrospective that represented the first major exhibition of Cole's work since his memorial show of 1848 (the Albany Institute had mounted a more modest show of Cole's work in 1941). The Atheneum under Cunningham thus played an important role in stimulating a renewed interest in the American landscape school. Among the other impressive exhibitions organized under Cunningham were several significant American shows that highlighted the richness of the permanent collections. Some of the most notable were "John Trumbull: Painter-Patriot," mounted in 1956; "Paintings of Edward Hopper" and "Maurice Prendergast Retrospective," in 1960; "Samuel Colt Presents," in 1961; and "Milton Avery," in 1964.

After the Gould bequest, Cunningham continued to expand the nineteenth-century collections with such major works as Homer's *Nooning* (cat. 275), Eakins's *John McLure Hamilton* (cat. 184), John Haberle's *Chinese Firecrackers* (cat. 254), and Julius Stewart's *Yacht "Namouna"* (cat. 413). In addition, he added a number of early-twentieth-century works, the most notable being John Sloan's *Hairdresser's Window* (cat. 401) and Maurice Prendergast's *Red-Headed Nude* (cat. 366), as well as works on paper by Hopper, Ben Shahn, Charles Burchfield, and Arthur Dove.

As the century progressed, the purchasing power of the Sumner Fund did not keep pace with the increasing value of U.S. paintings. Thus, when James Elliott succeeded Cunningham in 1966, the museum's focus took a decidedly contemporary turn, a shift in focus that also mirrored the climate of the times. In addition to making groundbreaking purchases for the Atheneum's expanding department of contemporary art, Elliott's acquisitions included early-twentieth-century American paintings, some of them now considered to be among the collection's greatest works: Marsden Hartley's *Military* (cat. 260) and Willem de Kooning's *Standing Man* (cat. 314) come to mind. Elliott's exploration of contemporary concerns in art further expanded the collection. His interest in the work of African-American artists, for example, resulted in the exhibition "Through Young Black Eyes," held in 1970, and led to the museum's first purchases of works by African-American artists for the American painting collection: Henry Ossawa Tanner's *Virgin and Child* (cat. 433) and Charles Porter's *Still Life of Flowers* (cat. 364).

As part of the nation's bicentennial celebration, the museum mounted an important exhibition of the Atheneum's Hudson River school painting collection in 1976. In the accompanying handbook, which was written by Theodore Stebbins, Jr., and his students at Yale University, Elliott acknowledged the "growing appreciation" of the Hudson River school.[134]

After a decade of service, Elliott was succeeded in 1977 by Tracy Atkinson, who launched

a number of initiatives in recognition of the growing size and importance of the museum's collections. In concert with a major renovation of the buildings, the galleries were modernized, with the intent of putting many more works on view. New galleries devoted to U.S. art opened in 1982, followed by a series of exhibitions focusing on various aspects of the permanent collections.[135] The curatorial staff also grew under Atkinson, allowing for full-scale research into the permanent collection and resulting in the publication of the museum's first comprehensive collection catalogues (of which this is one).

During this period the range of acquisitions was broadened, in part to remedy the nearly complete lack of works by U.S. impressionists—a paradox in that the major artist colonies of Old Lyme and Cos Cob, both in Connecticut, had been flourishing centers of impressionism. Works such as John H. Twachtman's *Emerald Pool, Yellowstone* (cat. 472) and Willard Metcalf's *Breath of Autumn* (cat. 334) led the way to filling this gap. Outstanding additions in other areas included Georgia O'Keeffe's masterful painting *The Lawrence Tree* (cat. 346), a purchase made with the artist's encouragement in 1979, and Emanuel Leutze's *Storming of the Teocalli* (cat. 320), a painting that has received substantial scholarly attention since it entered the collection in 1985. Perhaps the most significant acquisition under Atkinson was the Randolf Linsly Simpson Collection (now known as the Amistad Foundation Collection), consisting of art, artifacts, and documents relating to African-American life; this addition has allowed the Atheneum to lead the way among public institutions in giving pride of place to African-American art.

When Patrick McCaughey, the current director, took over in 1988, he set about to achieve greater recognition of the museum's superb holdings by reaching out to the local community, while at the same time courting a national and international audience. He has achieved his goal through an ambitious program of exhibitions, publications, acquisitions, and gallery renovations. Acquisition funds have increased dramatically under McCaughey with the establishment in 1990 of the Dorothy C. and Thomas L. Archibald Fund for the purchase of American paintings and the Douglas Tracy and Dorothy Potter Smith Fund of $5.7 million for the purchase of art, set up in 1991. This expansion has allowed the museum to participate in a highly competitive market, in which prices for American paintings have soared in recent years.

In 1989 McCaughey formed a department of African-American art with the appointment of the museum's first curator in this field—the first such appointment in the nation. Since its inception, the department has opened galleries to house segments of the Amistad Collection and to exhibit the growing permanent collection of African-American art. Acquisitions include such major works as Robert Duncanson's *Recollections of Italy* (cat. 172) and Jacob Lawrence's *Rain*.

The museum has aggressively pursued other important additions to the American painting collection, particularly works from the late nineteenth and early twentieth centuries. The acquisition of a number of important impressionist paintings, such as Childe Hassam's *Road in the Land of Nod* (cat. 263) and *The Flag Outside Her Window (Boys Marching By)* (cat. 264), William Merritt Chase's *Shinnecock Hills* (cat. 101), and Theodore Robinson's *Beacon Street, Boston* (cat. 379), and of early modernist paintings including Arthur B. Davies's *Protest Against Violence* (cat. 159) and Arthur Dove's *Approaching Snow Storm*

18. Ralph Earl, *Houses Fronting New Milford Green*, 1795 or 1796. Wadsworth Atheneum, The Dorothy Clark Archibald and Thomas L. Archibald Fund, The Ella Gallup Sumner and Mary Catlin Sumner Collection Fund, The Krieble Family Fund for American Art, The Gift of James Junius Goodwin and The Douglas Tracy Smith and Dorothy Potter Smith Fund, 1994.16.1.

(cat. 169) has prompted the museum to install new galleries that treat both American impressionism and American modernism. In addition, a new gallery devoted to eighteenth-century American paintings has recently led to the purchase of a major work: Ralph Earl's *Houses Fronting New Milford Green* (fig. 18).[136]

U.S. paintings have continued to feature strongly in the exhibition program, beginning with an international showing of major works from the permanent collection in 1989: "Two Hundred Years of American Painting: From the Collection of the Wadsworth Atheneum" was exhibited at the Galeries Lafayette, in Paris, to celebrate the bicentennial of the French Revolution. That same year, "Connecticut Masters, Connecticut Treasures: The Collection of the Hartford Steam Boiler Inspection and Insurance Company" showcased a great regional collection. The Atheneum also organized the groundbreaking show "Ralph Earl: The Face of the Young Republic," which opened at the National Portrait Gallery in 1991. In 1994 the museum came full circle, hosting the major retrospective "Thomas Cole: Landscape into History," organized by the National Museum of American Art.

As this essay and the catalogue that follows demonstrate, the Wadsworth Atheneum's collection of American art is one of great distinction. Its history is extraordinary, with associations going back to the era of Trumbull, Wadsworth, Cole, and Church, and it is rich in masterpieces by leading artists of the eighteenth, nineteenth, and twentieth centuries. At the same time, the collection contains an exceptional number of important regional works by New England painters, with Connecticut artists particularly well represented. It continues to grow, with a number of private collections promised and future purchases assured by numerous and ample acquisition funds. Housed in expanded and newly renovated galleries, the American painting collection's place within the museum is a visible testimony to its prominence. As the museum nears the end of its second century, there is no doubt that Wadsworth's early vision still informs the spirit of the collection, one of the greatest of its kind.

Elizabeth Mankin Kornhauser

NOTES

1. Major gifts included Ralph Earl, *Oliver Ellsworth and Abigail Wolcott Ellsworth*, given in 1903; Thomas Wilmer Dewing, *The Days*, in 1944; and Winslow Homer, *Red Feather*, in 1975. Major acquisitions included George Inness, *Autumn Gold*, purchased in 1897; Frederic Church, *Grand Manan Island, Bay of Fundy*, in 1898; James McNeill Whistler, *Coast of Brittany (Alone with the Tide)*, in 1925; William Michael Harnett, *The Faithful Colt*, in 1935; Joseph Cornell, *Soap Bubble Set*, in 1938; John F. Kensett, *Coast Scene with Figures (Beverly Shore)*, in 1942; John Singleton Copley, *Jeremiah Lee* and *Mrs. Jeremiah Lee (Martha Swett)*, in 1945; Winslow Homer, *The Nooning*, in 1947; John Sloan, *Hairdresser's Window*, in 1947; Asher B. Durand, *View Toward the Hudson Valley*, in 1948; George Inness, *Etretat*, in 1956; Julius Stewart, *On the Yacht "Namouna," Venice*, in 1965; Willem de Kooning, *Self-Portrait*, in 1967; Marsden Hartley, *Military*, in 1973; Georgia O'Keeffe, *The Lawrence Tree*, in 1981; and Arthur Dove, *Approaching Snow Storm*, in 1992.

2. For an overview of the collections of the Wadsworth Atheneum, see Linda Ayres, ed., *"The Spirit of Genius": Art at the Wadsworth Atheneum*, with essays by Patrick McCaughey and Eugene R. Gaddis (New York: Hudson Hills Press, in association with the Wadsworth Atheneum, 1992). Publications dealing with specific areas of the Atheneum's collections include *Col. Samuel Colt's Collection of His Model Arms and Other Weapons* (Hartford: Wadsworth Atheneum, 1940); Mary C. Palmer and Samuel J. Wagstaff, *The Serge Lifar Collection of Ballet Set and Costume Designs in the Collection of the Wadsworth Atheneum* (Hartford: Wadsworth Atheneum, 1965); Herbert J. Callister, *Dress from Three Centuries: Wadsworth Atheneum* (Hartford: Wadsworth Atheneum, 1976); Elizabeth B. Miles, *English Silver: The Elizabeth B. Miles Collection* (Hartford: Wadsworth Atheneum, 1976); Theodore E. Stebbins, Jr., *The Hudson River School: Nineteenth-Century American Landscapes in the Wadsworth Atheneum* (Hartford: Wadsworth Atheneum, 1976); Phillip Johnston, *Art in Seventeenth-Century New England* (Hartford: Wadsworth Atheneum, 1977); Egbert Haverkamp-Begemann, ed., *Wadsworth Atheneum Paintings*, vol. 1, *The Netherlands and German-Speaking Countries, Fifteenth–Nineteenth Centuries* (Hartford: Wadsworth Atheneum, 1978); Dwight P. Lanmon, *Glass from Six Centuries: Wadsworth Atheneum* (Hartford: Wadsworth Atheneum, 1978); Jean Bennett-Keith, *An Introduction to Ancient Art at the Wadsworth Atheneum* (Hartford: Wadsworth Atheneum, 1980); Richard Saunders, with Helen Raye, *Daniel Wadsworth: Patron of the Arts* (Hartford: Wadsworth Atheneum, 1981); Eugene R. Gaddis, ed., *Avery Memorial, Wadsworth Atheneum: The First Modern Museum* (Hartford: Wadsworth Atheneum, 1984); Andrea Miller-Keller and John B. Ravenal, *From the Collection of Sol LeWitt* (New York: Independent Curators Incorporated, in association with the Wadsworth Atheneum, 1984); Judith A. Barter, *American Drawings and Watercolors from the Wadsworth Atheneum* (New York: Hudson Hills Press, in association with the American Federation of Arts, 1987); Linda Horvitz Roth, ed., *J. Pierpont Morgan, Collector: European Decorative Arts from the Wadsworth Atheneum* (Hartford: Wadsworth Atheneum, 1987); Elizabeth Kornhauser and Patrick McCaughey, *Deux Cents Ans de Peinture Américaine: Collection du Musée Wadsworth Atheneum* (Paris: Galeries Lafayette, 1989); Jean K. Cadogan, ed., *Wadsworth Atheneum Paintings*, vol. 2, *Italy and Spain, Fourteenth through Nineteenth Centuries* (Hartford: Wadsworth Atheneum, 1991); Patrick McCaughey and Eugene R. Gaddis, with Randi Joseph Brandt, *Goya to Matisse: Paintings, Sculpture, and Drawings from the Wadsworth Atheneum of Hartford, Connecticut* (Tokyo: Yomiuri Shimbun, 1991).

3. Although there is no formal history of the formation of the collection, the U.S. paintings collection at the Metropolitan Museum has been published in three comprehensive catalogues, which provide the provenance for individual works: John Caldwell and Oswaldo Rodriguez Roque, with Dale T. John-

son, *American Paintings in the Metropolitan Museum of Art*, vol. 1, ed. Kathleen Luhrs, assisted by Carrie Rebora and Patricia R. Windels (Princeton, N.J.: Princeton University Press, in association with the Metropolitan Museum of Art, 1994); Natalie Spassky, *American Paintings in the Metropolitan Museum of Art*, vol. 2, ed. Kathleen Luhrs (Princeton, N.J.: Princeton University Press, in association with the Metropolitan Museum of Art, 1985); and Doreen Bolger Burke, *American Paintings in the Metropolitan Museum of Art*, vol. 3, ed. Kathleen Luhrs (New York: Metropolitan Museum of Art, 1980).

4. Carol Troyen, "The Boston Tradition: Painters and Patrons in Boston, 1720–1920," in *The Boston Tradition: American Paintings from the Museum of Fine Arts, Boston*, exh. cat. (New York: American Federation of the Arts, in association with the Museum of Fine Arts, Boston, 1980), 5–42.

5. In 1938 Karolik's wife, Martha Codman Karolik (1859–1948), offered the museum a major collection of primarily American decorative arts of the eighteenth century. This was followed in 1962 by the donation of a second major collection numbering about three thousand objects, most works on paper; sculpture, decoys, and other ornamental objects were also included, the great strength being folk art. For an insightful discussion of the formation of the Karolik collections and their impact on the Museum of Fine Arts, see Carol Troyen, "The Incomparable Max: Maxim Karolik and the Taste for American Art," *American Art* 1 (summer 1993), 64–87.

6. Theodore E. Stebbins, Jr., and Carol Troyen, *The Lane Collection: Twentieth-Century Paintings in the American Tradition*, exh. cat. (Boston: Museum of Fine Arts, 1983). My thanks to Carol Troyen, who provided information on the Lane Foundation gift.

7. Linda Ferber, introduction to *The Brooklyn Museum: American Paintings* (Brooklyn, N.Y.: Brooklyn Museum, 1979), 11–13. A complete catalogue of the Brooklyn Museum's U.S. painting collection by artists born before 1876, with an extensive essay on the history of the collection by Terry Carbone, is forthcoming.

8. According to John K. Howat in his preface to Spassky's *American Paintings*, the Metropolitan Museum of Art has about "950 paintings by approximately 400 artists born before 1876" (2:ix). The Museum of Fine Arts, Boston, holds about 1,850 paintings by 560 artists painted by 1955 (my thanks to Carol Troyen, associate curator of American paintings, for this information). The Brooklyn Museum has about 725 paintings by approximately 325 artists born by 1876 (my thanks to Terry Carbone, assistant curator of American paintings, for providing this information). The Atheneum has approximately 565 paintings by about 285 artists painted before 1945.

9. For a discussion of landscape art in America at this time, see Edward J. Nygren, with Bruce Robertson, eds., *Views and Visions: American Landscape Before 1830*, exh. cat. (Washington, D.C.: Corcoran Gallery of Art, 1986).

10. Wadsworth's roles as amateur artist, patron of the arts, and founder of the Wadsworth Atheneum are discussed in Saunders, with Raye, *Daniel Wadsworth*, and Eugene R. Gaddis, "Foremost upon This Continent: The Founding of the Wadsworth Atheneum," in *Connecticut History* 26 (November, 1985), 99–115.

11. Thomas Cole to Alfred Smith, February 6, 1844, archives, Wadsworth Atheneum. Alfred Smith, Daniel Wadsworth's friend and lawyer, often served as his mouthpiece as well as a go-between for Wadsworth's artistic and business dealings.

12. Richard L. Bushman, *The Refinement of America: Persons, Houses, Cities* (New York: Knopf, 1992), discusses the introduction of gentility into the life of the new nation.

13. Lydia Sigourney, *Scenes in My Native Land* (Boston: James Munroe, 1945), 237, quoted in Jane B. Davies, "The Wadsworth Atheneum's Original Building: I. Town and A. J. Davis, Architects," *Wadsworth Atheneum Bulletin*, 5th ser., no. 1 (spring 1959), 15.

14. Robert F. Trent, "The Charter Oak Artifacts," *Connecticut Historical Society Bulletin* 49 (summer 1984), 125–139.

15. Obituary of Daniel Wadsworth, *Hartford Daily Courant*, July 31, 1848, 2.

16. Thomas Day, *A Historical Discourse Delivered before the Connecticut Historical Society and the Citizens of Hartford, 26th December, 1843* (Hartford: Case, Tiffany and Burnham, 1844); *DAB*, 19:309–310, s.v. "Jeremiah Wadsworth"; Margaret E. Martin, "Merchants and Trade of the Connecticut River Valley, 1750–1820," *Smith College Studies in History* 24 (October 1938–July 1939), 74–88; Chester McArthur Destler, "The Gentleman Farmer and the New Agriculture: Jeremiah Wadsworth," *Agricultural History* 46 (January 1972), 135–157; and Probate Inventory, Jeremiah Wadsworth, Hartford, 1804, Connecticut State Library, Hartford.

17. Day, *Historical Discourse*, 30.

18. Obituary of Daniel Wadsworth.

19. Saunders, with Raye, *Daniel Wadsworth*, 12.

20. "A Note on Trumbull's Architecture," in Irma B. Jaffe, *John Trumbull* (Boston: New York Graphic Society, 1975), 290–296.

21. Obituary of Daniel Wadsworth

22. See Bryan Wolf, "Revolution in the Landscape: John Trumbull and Picturesque Painting," in *John Trumbull: The Hand and Spirit of a Painter*, ed. Helen A. Cooper (New Haven: Yale University Press, 1982), 206–215, 220–221.

23. Day, *Historical Discourse*, 33.

24. For example, Wadsworth's contemporary Robert Gilmor, who also became an early patron of Thomas Cole, engaged in picturesque travel. While touring the East Coast in 1797, he sketched and kept a journal and may have paid a visit to Wadsworth; see Gilmor, "Memorandums Made in a Tour to the Eastern States in the Year 1797," *Bulletin of the Boston Public Library*, n.s., 3 (April 1892), 72–92.

25. Obituary of Daniel Wadsworth.

26. William Gilpin, *Three Essays:—on Picturesque Beauty; —on Picturesque Travel; and, on Sketching Landscape: to which is added a Poem, on Landscape Painting* (1792).

27. Quoted in Bruce Robertson, "The Picturesque Traveler in America," in Nygren, with Robertson, *Views and Visions*, 189–211.

28. Francis Baily, *Journal of a Tour of Unsettled Parts of North America, 1794–1795,* quoted in Bruce Robertson, "The Picturesque Traveler in America," 189–190.

29. There are approximately thirty small sketches by Wadsworth in the Atheneum. The Connecticut Historical Society, in Hartford, has a portfolio of approximately sixty drawings. Both collections also have engravings after several of the drawings.

30. Daniel Wadsworth to Peter Colt, November 13, 1808, Daniel Wadsworth Papers, Connecticut Historical Society.

31. James Wadsworth and his brother, William, had taken over an enormous tract of land near the town of Geneseo. See Alden Hatch, *The Wadsworths of Geneseo* (New York: Coward-McCann, 1959). To promote the development of this land, they traveled to England in 1796, where they used John Trumbull's connections to sell parcels to William Beckford, the owner of Fonthill Abbey, and Benjamin West (q.v.). The transaction to Beckford fell through, however, following a negative report by West's son Raphael, who visited the site; see Irma B. Jaffe, *John Trumbull* (Boston: New York Graphic Society, 1975), 216.

32. Daniel Wadsworth to Charles Chauncey, November 6, 1827, Daniel Wadsworth Business Papers, Connecticut Historical Society, quoted in Saunders, with Raye, *Daniel Wadsworth*, 75.

33. Ralph Earl (q.v.), who visited Niagara in the fall of 1799, was the first American-born artist to travel there; in the following year he completed a panorama entitled *Stupendous Falls of Niagara*, which he placed on public view in Northampton, Massachusetts; it then toured throughout the United States and in England. Wadsworth may well have seen the panorama. See Elizabeth Mankin Kornhauser, with Richard L. Bushman, Stephen H. Kornhauser, and Aileen Ribeiro, *Ralph Earl: The Face of the Young Republic*, exh. cat. (New Haven: Yale University Press, 1991), 63–64. Earl's trip to the falls was followed by those of John Vanderlyn in 1801 and John Trumbull in 1805; see Jeremy Elwell Adamson, with Elizabeth McKinsey, Alfred Runte, and John F. Sears, *Niagara: Two Centuries of Changing Attitudes, 1697–1901*, exh. cat. (Washington, D.C.: Corcoran Gallery of Art, 1985).

34. L. H. Sigourney, ed. *The Religious Keepsake* (1835; rpt., Hartford, 1839), 190, 192–193.

35. Saunders, with Raye, *Daniel Wadsworth*, 16.

36. The painting is unlocated and may have been destroyed as a housekeeping measure in 1928 because of its poor condition; see Eugene R. Gaddis, "'Foremost upon This Continent': A History of the Wadsworth Atheneum," in *"The Spirit of Genius": Art at the Wadsworth Atheneum*, ed. Linda Ayres (New York: Hudson Hills Press, in association with the Wadsworth Atheneum, 1992),16.

37. Obituary of Daniel Wadsworth.

38. In "Codicil to Last Will and Testament of Daniel Wadsworth," 1848, Connecticut State Library, Hartford, four paintings by Alvan Fisher are listed as follows: (1) "A View of what is called the house rock, on the Turnpike near the road leading to Monte Video, done by Mr. Fisher"; (2) "A View from the east side of the lake of D. Wadsworth's house at Monte Video. No. 1 / by Mr. Fisher"; (3) "A view from the south end of the lake of the tower at Monte Video. No. 2 / By Mr. Fisher"; and (4) "A view from the east side of the lake half way down (at Monte Video) No. 3 / By Mr. Fisher."

39. For a discussion of Silliman's friendship with Wadsworth, see the fine biography by Chandos Michael Brown, *Benjamin Silliman: A Life in the Young Republic* (Princeton, N.J.: Princeton University Press, 1989).

40. Benjamin Silliman, *Remarks, Made on a Short Tour between Hartford and Quebec, in the Autumn of 1819* (1820; rpt., New Haven, Conn.: Converse, 1824), 18, 17.

41. Robert L. McGrath, "The Real and the Ideal: Popular Images of the White Mountains," in Donald D. Keyes, with Catherine H. Campbell, Robert L. McGrath, and R. Stuart Wallace, *The White Mountains: Place and Perceptions*, exh. cat. (Hanover, N.H., and London: University Press of New England, for the University Art Galleries, University of New Hampshire, 1980), 60–62. Lithographs after sketches by Wadsworth also appear in the following Dwight publications, with Wadsworth listed as the source for the lithographs in some cases: *Northern Traveler* (New York: Wilder and Campbell, 1826), *Sketches of Scenery and Manners in the United States* (New York: Goodrich, 1829), and *Things as They Are; Notes of a Traveler through Some of the Middle and Northern States* (New York: Harper, 1834).

42. Dwight, *Sketches of Scenery*, 69–70.

43. McGrath, "The Real and the Ideal," 60.

44. For histories of the Catskill region, see Roland Van Zandt, *The Catskill Mountain House* (1966; rpt., Cornwallville, N.Y.: Hope Farm Press, 1982); and Kenneth Myers, *The Catskills: Painters, Writers, and Tourists in the Mountains, 1820–1895*, exh. cat. (Yonkers: Hudson River Museum, 1987).

45. See Alan Wallach, "Thomas Cole and the Aristocracy," *Arts* 56 (November 1981), 96–97.

46. Robert Gilmor, "Memorandum on a Tour to the Eastern States in the Year 1799," *Bulletin of the Boston Public Library* 2 (April 1892), 72–91. My thanks to Alan Wallach for bringing this reference to my attention.

47. Saunders, with Raye, *Daniel Wadsworth*, 26; J. Bard McNulty, ed., *The Correspondence of Thomas Cole and Daniel Wadsworth* (Hartford: Connecticut Historical Society, 1983), xiii; and Ellwood

C. Parry III, "Thomas Cole's Early Career: 1818–1829," in Nygren, with Robertson, *Views and Visions*, 173–174.

48. See McNulty, *Correspondence*. Additional correspondence is found in the Cole and Wadsworth correspondence, New York State Library, Albany, N.Y. See also J. Bard McNulty, "Daniel Wadsworth's Style as Patron of the Arts," *Connecticut History* 26 (November 1985), 93–99.

49. Gilmor and Cole's extensive correspondence is published in Howard S. Merritt, ed., *Annual II: Studies on Thomas Cole, An American Romanticist* (Baltimore: Baltimore Museum of Art, 1967).

50. Parry, "Thomas Cole's Early Career," 178.

51. Daniel Wadsworth to Thomas Cole, August 27, 1827, in McNulty, *Correspondence*, 14.

52. Thomas Cole to Daniel Wadsworth, June 5, 1828, in McNulty, *Correspondence*, 41.

53. Ellwood C. Parry III, *The Art of Thomas Cole: Ambition and Imagination* (Newark: University of Delaware Press, 1988), 375.

54. For the date that Wadsworth acquired the work from Cole, see Parry, *The Art of Thomas Cole*, 34. This is the only work by Cole in Wadsworth's possession that did not enter the collection of the Wadsworth Atheneum. He later willed it to Joseph Trumbull, with the title *Picture of Schoarie Creek*. Likely the same painting listed in Wadsworth's probate inventory as *Scene in the Valley of the Mohawk*, it was identified as hanging in the library at Monte Video with *Last of the Mohicans* (cat. 125), with each landscape valued at $150.

55. For a history of the Hartford Gallery of Fine Arts, see Thompson R. Harlow, "Joseph Steward and the Hartford Museum," *Connecticut Historical Society Bulletin* 18 (January–April 1953). For Wadsworth's association with the museum, see Saunders, with Raye, *Daniel Wadsworth*, 14.

56. Wadsworth Atheneum Trustee Records, vol. 1, p. 1, archives, Wadsworth Atheneum, quoted in Gaddis, "'Foremost upon This Continent'" (1985), 99.

57. Gaddis, "'Foremost upon This Continent'" (1992), 13.

58. Saunders, with Raye, *Daniel Wadsworth*, 34.

59. Ithiel Town to Alfred Smith, March 12, 1842, archives, Wadsworth Atheneum. For a discussion of the significance of this painting, see Carrie Rebora, "Sir Thomas Lawrence's *Benjamin West* for the American Academy of the Fine Arts," *American Art Journal* 21, no. 3 (1990), 18–47.

60. Alfred Smith to Col. John Trumbull, December 10, 1841, archives, Wadsworth Atheneum.

61. Saunders, with Raye, *Daniel Wadsworth*, 35–36.

62. Thomas Cole to Alfred Smith, February 6, 1844, archives, Wadsworth Atheneum.

63. Day, *Historical Discourse*, 36.

64. William G. Wendell, "Edward Sheffield Bartholomew, Sculptor," *Wadsworth Atheneum Bulletin*, 5th ser., no. 12 (winter 1962), 1–18.

65. Saunders, with Raye, *Daniel Wadsworth*, 38.

66. Ibid. See also *Catalogue of Paintings in the Wadsworth Gallery* (Hartford: Elihu Greer, 1844).

67. Thomas Cole to Robert Gilmor, Jr., May 21, 1828, quoted in Louis L. Noble, *The Life and Works of Thomas Cole*, ed. Elliot S. Vesell (Cambridge: Harvard University Press, 1964), 64.

68. A modest man, Wadsworth "expressly enjoined upon his minister to abstain entirely from the language of a eulogy" (obituary of Daniel Wadsworth).

69. "Sketchings," *Crayon* 1 (May 23, 1855), 331.

70. See "Death of Col. Colt," *Hartford Weekly Times*, January 18, 1862. A definitive biography of Samuel Colt has yet to be written; however, several books have dealt with his role as an inventor and manufacturer of arms. One of the best sources is Henry Barnard, with Elizabeth Hart Jarvis Colt, *Armsmear: Memorial to Samuel Colt* (Hartford: private printing, 1866). See also *DAB*, 4:318–319, s.v. "Samuel Colt"; Phyliss Kihn, "Colt in Hartford," *Connecticut Historical Society Bulletin* 24 (July 1959),

74–87; Ellsworth S. Grant, *The Colt Legacy: The Story of the Colt Armory in Hartford, 1855–1980* (Providence: Mowbray, 1982); R. L. Wilson, *Colt: An American Legend* (New York: Abbeville Press, 1985). Virtually nothing has been written about Elizabeth Colt. For information on her, I have relied on primary materials, including correspondence in the Wadsworth Atheneum archives; the Frederic Church Papers, Olana State Historic Site, Hudson, N.Y.; and the Jarvis Family Papers, Connecticut Historical Society. In addition, the following provide basic biographical information: George Jarvis, ed., *The Jarvis Family* (Hartford: Case, Lockwood, and Brainard, 1879); obituary, *Hartford Courant*, August 24, 1905; Ellsworth S. Grant, "Sam Colt's Father-in-Law," *Connecticut Historical Society Bulletin* 32 (April 1967), 40–47; and Janet T. Murphy, "Union for Home Work: Nineteenth-Century Hartford Philanthropy," *Connecticut Historical Society Bulletin* 55 (winter–spring 1990), 83–114. I presented much of the information on the Colts at a talk entitled "Elizabeth Hart Jarvis Colt's Picture Gallery" (annual meeting of the American Studies Association, Costa Mesa, Calif., November 1992).

71. Kathleen D. McCarthy, *Women's Culture: American Philanthropy and Art, 1830–1930* (Chicago and London: University of Chicago Press, 1991). Although Elizabeth Colt is not mentioned in this book, McCarthy provides a profile of prominent women benefactors that reflects the direction taken by Elizabeth Colt, who became a leader in such charitable, historic, and art-related organizations as the Union for Home Work (founded in 1872), Board of Missions, Women's Auxiliary of the Episcopal Church (which she built), Women's Centennial Association of Hartford, Bureau of Relief for the Hartford Episcopal Church, Hartford Orphan Asylum, Decorative Arts Society, Daughters of the American Revolution, and Colonial Dames of Hartford. Her bold move in building a picture gallery, as well as an Episcopal church and other edifices, was not typical, however, and sets her apart from other prominent women of her day.

72. For a discussion of women's role in organizing the Sanitary fairs, see Rejean Attie, "'A Swindling Concern': The United States Sanitary Commission and the Northern Female Public, 1861–1865" (Ph.D. diss., Columbia University, 1987).

73. Rev. William Jarvis to William Jarvis (his nephew), February 1, 1864, Jarvis Family Papers, Connecticut Historical Society.

74. "The Metropolitan Fair, Second Week," *New York Times*, April 12, 1864, 1.

75. *Hartford Times*, April 14, 1864.

76. A complete discussion of the art gallery will be provided in Charlotte Emans Moore, "The Art Gallery of the Metropolitan Sanitary Fair, New York City, 1864" (Ph.D. diss., Boston University, forthcoming).

77. For a discussion of collectors and collections in America during this period, see Charles H. Hart, "Public and Private Galleries in the United States," *American Art Review* 1 (April 1880); Walter Montgomery, *American Art and American Art Collecting* (Boston: E. W. Walker, 1889); Frederick Baekeland, "Collections of American Painting, 1813–1913," *American Art Review* 3 (November–December 1976), 120–166; and Lois Marie Fink, "French Art in the United States, 1850–1870," *Gazette des Beaux-Arts*, ser. 6, 92 (September 1978), 87–100.

78. Annette Blaugrund, "The Tenth Street Studio Building: A Roster, 1857–1895," *American Art Journal* 14, no. 2 (1982), 64–71; idem, "Tenth Street Studios: Roster Update," *American Art Journal* 17, no. 1 (1985), 84–86.

79. Elizabeth Colt to Frederic Church, December 18, 1863, Frederic Church Papers, Olana State Historic Site.

80. On February 16, 1865, Elizabeth Colt's father wrote to his nephew: "Mr. Elliott the great artist, is painting a full length portrait of Col. Colt from several pictures, photographs and busts taken of him in his life time. It will be a splendid affair" (Rev. William Jarvis to William Jarvis, February 16, 1865, Jarvis

Family Papers). After the portrait was finished, he wrote again, reporting that "more than a thousand persons came to see it yesterday by invitation" (Rev. Jarvis to William Jarvis, March 10, 1865, Jarvis Family Papers).

81. Elizabeth H. Colt to Frederic Church, May 15, 1866, Olana Historic Site.

82. Ibid.

83. Kevin J. Avery, "'The Heart of the Andes' Exhibited: Frederic E. Church's Window on the Equatorial World," *American Art Journal* 18, no. 1 (1986), 52–72.

84. Frederic Church to Elizabeth H. Colt, September 7, 1866, archives, Wadsworth Atheneum.

85. Ibid. In this letter, Church also wrote, "The upholsterer I referred to is engaged with Mr. Charles Schmit at no. 426—6th Avenue. Mr. Schmit makes all my wooden frames & fancy wood work. . . . I will gladly write or do anything I can for you in this matter."

86. Elizabeth H. Colt to Frederic Church, October 26, 1866, Olana State Historic Site.

87. The *Catalogue of the Art Exhibition at the Metropolitan Fair in Aid of the U.S. Sanitary Commission* (New York, 1864) provides a complete listing of works loaned to the exhibition as well as works given by artists for sale.

88. Elizabeth H. Colt to Frederic Church, October 26, 1866, Olana State Historic Site.

89. Gordon Hendricks, "Bierstadt and Church at the New York Sanitary Fair," *Antiques* 102 (November 1972), 892–898.

90. Newspaper clipping, "Grand Wedding in Hartford," *Hartford Courant*, December 5, 1867, 1, Mary P. Morris scrapbooks, vol. 2, Connecticut Historical Society.

91. "The Homes of America: Armsmear," *Art Journal* 2 (November 1876), 322.

92. "Grand Wedding in Hartford," 2.

93. Elizabeth Jarvis (mother of Elizabeth Colt) to her nephew, William Jarvis, August 18, 1873, Jarvis Family Papers, Connecticut Historical Society.

94. "The Homes of America: Armsmear," 322.

95. Kathleen D. McCarthy, *Women's Culture: American Philanthropy and Art, 1830–1930* (Chicago and London: University of Chicago Press, 1991), 114–115. The first women appointed to the board of the Wadsworth Atheneum were Elizabeth Cathles and Georgette Koopman, in 1969.

96. Gaddis, "Foremost upon This Continent" (1992), 16.

97. Wadsworth Atheneum Trustee Records, "Ledger," 1890, p. 4, archives, Wadsworth Atheneum.

98. McCarthy, *Women's Culture*, 149–173, discusses Isabella Stewart Gardner's museum, which was begun in 1899 and opened in 1903.

99. *Last Will and Testament of Elizabeth H. Colt* (Hartford, 1905), 16–23, Connecticut State Library (copy in curatorial painting file, Wadsworth Atheneum).

100. "Colt Memorial Dedicated Today," *Hartford Courant*, November 16, 1910, 1.

101. *Bulletin of the Wadsworth Atheneum* 1 (October 1923), 5, 10; and *Metropolitan Museum of Art Bulletin* 18 (January 1923), 18. See also correspondence between George Story and Frank Gay, archives, Wadsworth Atheneum.

102. *Bulletin of the Wadsworth Atheneum* 3 (July 1925), 1.

103. Quoted in Gaddis, "Foremost upon This Continent" (1992), 19.

104. The registrar records of 1928 list these paintings as having been "destroyed." According to tradition, many works in very poor condition that were thought to be beyond repair were burned rather than being discarded (conversation with David Parrish, 1987, who had discussed this practice with Margie Ellis, a colleague of Florence Paull Berger).

105. Austin's tenure at the Atheneum is discussed in: *A. Everett Austin, Jr.: A Director's Taste and Achievement*, exh. cat. (Hartford: Wadsworth Atheneum, 1958); Gaddis, *Avery Memorial*; Jean K.

Cadogan, "Introduction: The Formation of 'a Small but Distinguished Collection'" in *Wadsworth Atheneum Paintings*, vol. 2, *Italy and Spain, Fourteenth through Nineteenth Centuries*, ed. Cadogan (Hartford: Wadsworth Atheneum, 1991), 11–21. A complete biography of A. Everett Austin by Eugene Gaddis is forthcoming.

106. The Wadsworth Atheneum's acquisition records for the years 1928–1944 clearly demonstrate the hierarchy of spending, with European old master works receiving the lion's share of funds, followed by contemporary European works. Although some major European paintings, such as Piero de Cosimo's *Finding of Vulcan*, bought in 1932, cost $100,000, most of the American works cost an average of $350 and rarely exceeded $2,000.

107. A. Everett Austin, Jr., "Hartford's Art Museum," *Hartford* 13 (April 1928), 4.

108. Kevin J. Avery, "A Historiography of the Hudson River School," in *American Paradise: The World of The Hudson River School*, exh. cat., ed. John K. Howat (New York: Metropolitan Museum of Art, 1987), 3–20.

109. Austin, "Hartford's Art Museum," 4.

110. See "Exhibition of the Watercolors of Edward Hopper," November 25–December 9, 1928, Morgan Memorial, Hartford. In 1928, Austin used the Sumner Fund to acquire Preston Dickinson's pastel *Power Station-Night*, for $700, and the following watercolors: Edward Hopper, *Captain Strout's House*, from the Kraushaar Art Galleries, New York City, for $300, Hopper's *Rockland Harbor, Maine*, from the Rehn Gallery, New YorkCity, for $300; and Charles Demuth's *Still Life*, from the Kraushaar Art Galleries, for $1,200. These works are published in Judith Barter, *American Watercolors from the Collection of the Wadsworth Atheneum* (New York: American Federation of the Arts, 1987).

111. Quoted in Cadogan, *Wadsworth Atheneum*, 16.

112. The three works, which had all originated from the Macbeth Gallery, were returned. See acquisition records, Wadsworth Atheneum.

113. See Gaddis, *Avery Memorial*.

114. For a discussion of the exhibition, see Deborah Zlotsky, "'Pleasant Madness' in Hartford: The First Surrealist Exhibition in America," *Arts* 60 (February 1986), 55–61.

115. "Surrealisme Has Its Day at Hartford Art Gallery," *Springfield Union Republican*, November 15, 1931, Florence Berger scrapbook, reel 2554, archives, Wadsworth Atheneum.

116. For information on Halpert, see *Edith Halpert and The Downtown Gallery*, exh. cat, introduction by Marvin Sadik (Storrs: University of Connecticut, 1968); and Carol Troyen, "After Stieglitz: Edith Gregor Halpert and the Taste for Modern Art in America," in *The Lane Collection*, 34–59.

117. See Edith Halpert to A. Everett Austin, Jr., December 28, 1929, archives, Wadsworth Atheneum. In this letter Halpert indicated that she was handling the following American artists: Max Weber, Walt Kuhn, Abraham Walkowitz, Stuart Davis, Anne Goldthwaite, William Zorach, and Marguerite Zorach, among others.

118. Edith Halpert to A. Everett Austin, Jr., February 3, 1934, archives, Wadsworth Atheneum. Halpert went on to offer paintings to Austin by the patroon painter Pieter Vanderlyn and several versions of *Peaceable Kingdom* by Edward Hicks. The Nelson-Atkins Museum of Art acquired Peale's *Venus Rising from the Sea—A Deception* in 1934 for $2,500. My thanks to Kenneth Neal, research assistant, Nelson-Atkins Museum of Art, for this information.

119. Austin purchased the collection for $10,000 from the Julian Levy Gallery, New York City.

120. A. Everett Austin, Jr., *American Painting American Sculpture Three Centuries*, exh. cat., introduction by Henry-Russell Hitchcock, Jr. (Hartford: Wadsworth Atheneum, 1935), 4.

121. Edith Halpert to A. Everett Austin, Jr., May 29, 1935, archives, Wadsworth Atheneum.

122. Edith Halpert to A. Everett Austin, Jr., April 13, 1935, archives, Wadsworth Atheneum.

123. *A. Everett Austin, Jr.*, 84.

124. Acquisition records, Wadsworth Atheneum.

125. A. Everett Austin, Jr., *Twenty-Five American Paintings from the Revolution to the Civil War*, exh. cat. (Wadsworth Atheneum, 1942), 2, 4.

126. The policy was described by James Thrall Soby: "During most of Chick's career in Hartford, purchases were submitted to an Art Committee consisting of: Mr. Robert W. Huntington, Chairman; Mr. Arthur P. Day; Mr. George A. Gay; Mr. Charles F. T. Seaverns; Chick Austin and myself. . . . Occasionally there were rather stormy-polite sessions. . . . In 1941 Mr. Huntington, characteristically fair, decided that these wrangles should be ended by allocating each of the five members $2,000 annually to spend on his own from Atheneum funds." See *A. Everett Austin, Jr.*, 32. The acquisition records begin to show "allocations" for Soby and Huntington; e.g., John F. Kensett's *Coast Scene with Figures* (*Beverly Shore*), purchased in 1942 from A. F. Mondschein for $475, is listed as a Sumner purchase with funds allocated by R. W. Huntington. Homer's *Rocky Coast* was purchased in November 1944.

127. See Troyen, "The Incomparable Max," 74–82.

128. See David F. Myrick, *Montecito and Santa Barbara: The Days of the Great Estates* (Glendale, Calif.: Trans-Anglo Books, 1980), 259–262. Biographical information was provided by Michael Redmon, librarian, Santa Barbara Historical Society. See obituary, Santa Barbara newspaper, March 5, 1948, clipping, curatorial painting file, Wadsworth Atheneum.

129. Annual reports, Santa Barbara Museum of Art, 1941–1944.

130. The gallery had got many of the paintings they sold Gould from the Macbeth Gallery; see Dalzell-Hatfield Galleries to Charles C. Cunningham, June 30, 1948, registrar's files, Wadsworth Atheneum.

131. Clara Hinton Gould (Mrs. Frederic Saltonstall Gould) to the Director of Paintings, Wadsworth Atheneum, July 14, 1937, archives, Wadsworth Atheneum.

132. Clara Hinton Gould to A. Everett Austin, Jr., February 5, 1938, archives, Wadsworth Atheneum.

133. Esther I. Seaver, "Gould Bequest of American Paintings," *Wadsworth Atheneum Bulletin*, 2d ser., no. 1 (September 1948), n.p.; see also "The Gould Collection at Hartford," *Antiques* 54 (November 1948): 362–363, which contains a variation of this account.

134. Stebbins, *The Hudson River School*, 3.

135. "Daniel Wadsworth: Patron of the Arts" opened in 1981, and "The Great River: Art and Society of the Connecticut River Valley, 1635–1820" followed in 1985.

136. This painting has no entry in the catalogue because it was purchased in 1994, after our cutoff date of 1993.

Reader's Guide to the Catalogue

This catalogue lists works that entered the Wadsworth Atheneum collection from 1844 to 1993. Entries are arranged alphabetically by artist. Works by a given artist are arranged chronologically, with those of the same date arranged alphabetically. With the exception of works by unknown artists, a biography of the artist, followed by a select bibliography, precedes each group of entries. Works by unidentified artists are listed at the end of the alphabetized entries. Each work is reproduced; secondary illustrations are included where appropriate.

BIOGRAPHIES OF THE ARTISTS

The biographies begin with the artist's familiar name (by which the artist is usually known) followed by location and date of birth and death, if known. Where appropriate, the first paragraph mentions the artist's full name. In the case of artists for which up-to-date scholarly monographs are available, biographies are relatively brief. For lesser-known artists, the authors of this catalogue have constructed more lengthy biographies. Sources for quoted matter are given in full in the text, unless they are cited in the bibliography, in which case they are abbreviated.

BIBLIOGRAPHIES

The select bibliographies are arranged in chronological order. Reference works were chosen on the basis of usefulness and reliability. In some cases, however, the list includes all the sources that are available. In both bibliographies and notes, *DAB* refers to the *Dictionary of American Biography* (New York, 1926–1936).

CROSS-REFERENCES

When a painter listed in the catalogue is mentioned in the biography or an entry for another artist, the name is followed by "(q.v.)." When a biography or entry refers to a specific painting listed elsewhere in the catalogue, the mention is followed by "(cat. 000)."

TITLES OF PAINTINGS

Each painting is listed under the original title the artist gave it or the title under which it was first exhibited or published. For portraits, the subject's proper name is used as the title. When a popular title exists for a painting, it follows the more original title, enclosed in parentheses. Varying titles are chronicled in the exhibition history section, where they appear within quotation marks; in some instances, they are also discussed within the body of the entry.

MEDIA AND SUPPORTS

This catalogue includes paintings defined as works in oil, tempera, or mixed media done on canvas, wood, metal, paper, or composition-board supports. Descriptions of supports exclude backings and linings added by restorers.

MEASUREMENTS

The dimensions of the support are given in inches followed by centimeters, in parentheses. Height precedes width.

SIGNATURES, DATES, AND INSCRIPTIONS

Artist's signatures, dates, and inscriptions, where available, along with their locations on the supports are given. Canvasmakers, manufacturers' stamps, and in some cases label information are also transcribed. A firm date, or an approximate date based on documentary and stylistic evidence and listed as "circa," is supplied whenever a work was not inscribed with a date by the artist.

TECHNICAL NOTES

Technical notes are included when the condition of works has markedly affected their appearance. They also document technical examinations involving X-rays, radiographs, wood samples, and the like. Discussions of these examinations are found in the body of the entry, where relevant.

EXHIBITION HISTORY

Listings of exhibitions in which paintings have appeared are selective. All verifiable exhibitions, including those before a painting's acquisition by the museum, are given in chronological order. The listings exclude, however, all displays other than conventional art exhibitions; loans to private borrowers or residences, for example, do not appear. The city where the exhibition took place appears first—unless it is obvious from the venue's name—followed by the name of the institution, gallery, or exhibition hall, the title of the exhibition, and the year. If a catalogue was published for the exhibition, the number assigned to the painting in the catalogue is provided. In addition, when a painting has been exhibited with a title different from the one by which it is listed in this catalogue, the alternate title is provided, sometimes with information on early owners, based on exhibition catalogue information; where possible, the earliest reference/references to the original title/titles are also noted.

COLLECTION HISTORY

The names of previous owners of a painting are listed from the earliest known to the last, along with their places of residence and the years they are known to have had possession of the painting, when this information is available. When the work passed from one family member to the next, their relationships are indicated. When a painting was consigned to a

dealer, the preposition *with* appears before the name. When information has been located in a secondhand source, the word *probably* or *possibly* is used to qualify the listing. The date of a painting's inclusion in the Atheneum's collections is noted only when it differs from that given in the accession number or when the circumstances of the transfer of ownership are somehow noteworthy.

CREDIT LINE

The Wadsworth Atheneum's official credit line indicates the donor/donors who made a gift or bequest of the work or the fund/funds used to purchase the painting. The year of acquisition and the work's accession number follow (accession numbers were first assigned to paintings in 1850).

CONTRIBUTING AUTHORS

The initials of the author of the biography and entry or entries for each artist follow each entry for that artist. The three coauthors are Amy Ellis, Elizabeth Mankin Kornhauser, and Elizabeth R. McClintock.

Catalogue of Paintings

Willis Seaver Adams

Born near Suffield, Conn., in 1844; died in Greenfield, Mass., in 1921

Adams was born to a farmer and tavern keeper whose property was on the Connecticut River. He attended the Connecticut Literary Institute (now Suffield Academy) from 1857 to 1862. Sometime before 1868 he moved to Springfield, Massachusetts, where a wealthy doctor took an interest in him and sponsored one year of study at the Royal Academy, Antwerp. The doctor became ill before a year was out, however, and Adams was forced to return to Massachusetts. He soon found work at Moore's Photograph Studio, coloring enlargements. After three years at Moore's, he left to establish his own studio.

Adams made a summer trip to Cleveland in 1876 and ended up staying two years. He became involved in the arts community there, exhibiting his own work and helping to found the Cleveland Art Club and the Cleveland Academy of Fine Arts. He became codirector of the academy and was a member of the board of trustees. In 1878 he returned to Europe, this time on money earned through the sale of his work in Cleveland, and traveled to Cherbourg, Paris, and then Antwerp, where he resumed his studies. He made a number of sketches and paintings on this trip. At some point, Adams went to Venice, where he took a studio directly under that of James McNeill Whistler (q.v.), with whom he roamed the city streets and sketched. He was soon joined by two other artists, Otto Henry Bacher (1856–1909), a former student from Cleveland, and S. L. Wenban (1818–1897), and the three traveled to England, France, Germany, and Italy. In 1881 Adams returned to the United States only briefly before setting off for Europe again, this time for Florence, where he set up a portrait studio and offered art lessons for three years.

Adams listed a Springfield address in 1882, when he exhibited *Morning in Venice* (n.d., unlocated), priced at $800, at the National Academy of Design in New York City. In 1887 he began exhibiting with Gill's Art Galleries in Springfield; like Alfred T. Bricher (q.v.), he showed there for the rest of his life. Adams also taught art for the Springfield Art Association. Around this time, he started painting small landscapes that he called miniatures.

In spite of several exhibitions in his later years, such as those at the Boston Art Club and Art Institute of Chicago, Adams was increasingly reclusive and lacked recognition. In 1906 he moved to Greenfield, Massachusetts, where he taught art lessons and set up a studio, but he had few customers. He died there an embittered invalid, leaving behind paintings that reflect his loneliness and isolation.

Adams participated in five recorded exhibitions in Hartford: at Vorce's Galleries in 1890; at the home of Mrs. Arthur C. Perry in 1892; at the J. C. Ripley Art Co. in 1904; and at the Atheneum Annex, now the Wadsworth Atheneum, in 1912 and 1917.

SELECT BIBLIOGRAPHY

Roger Black, *Willis Seaver Adams/Retrospection*, exh. cat. (Deerfield, Mass.: American Studies Group, Hilson Gallery, Deerfield Academy, 1966) / Jane Connell and Pamela McCarron Ellison, *Of Town and River: Art of Springfield's First Golden Era*, exh. cat. (Springfield, Mass.: George Water Vincent Smith Art Museum, 1979)

1

WILLIS S. ADAMS
The Historian, c. 1881–1884
Oil on canvas; 27⅛ × 19 in. (68.9 × 48.3 cm)
Signed at lower right: Willis Seaver Adams
Inscribed on back: "The Historian" / Willis Seaver
 Adams— / (Conn. painter) / Gift of / Norman[d?]
 F. Allen esq. / of Hartford

EXHIBITED: Hartford, Atheneum Annex, "Willis S. Adams," 1917, no. 15 / Deerfield, Mass., Deerfield Academy, "Willis Seaver Adams, American Artist, 1844–1921," 1966, no. 17 / Springfield, Mass., George Walter Vincent Smith Art Museum, "Of Town and River: The Art of Springfield's First Golden Era," 1979, no. 1

EX COLL.: Normand F. Allen, Esq., Hartford, by 1896

Gift of a Hartford Friend, 1918.4

1

Jan Vermeer van Delft, *The Geographer*, 1669. Städelsches Kunst-institut und Städtische Galerie, Frankfurt.

The Historian, unusual among Adams's works, features a Dutch interior. Adams visited the Netherlands at least twice, once in 1868 and again in 1878 or early 1879, studying at the Royal Academy at Antwerp both times.[1] While there, he must have studied Dutch and Flemish masters and probably became acquainted with the work of Vermeer, Rembrandt, and others who painted the subject of the scholar amid his books and globes.[2] Adams's use of the casement window as the only source of light is reminiscent of Vermeer, while the single-corner interior is typical of Dutch paintings from the seventeenth century, as is the profile figure bent over his work. The figure is dressed in seventeenth-century Dutch costume, and the window itself, as well as furnishings in the room, also recall Vermeer's work.

Two paintings by Vermeer compare closely with Adams's *The Historian: The Astronomer* (1668, Louvre, Paris) and *The Geographer* (1669). It is unclear whether Adams had the opportunity to see either of these paintings, but both were available in reproduction: *The Astronomer* was engraved by Garreau and reproduced in volume 2 of J. B. P. Lebrun's *Galerie des Peintres Flamands, Hollandais et Allemands* (1792), and an engraving of *The Geographer* appeared in volume two of Charles Blanc's *Histoire des Peintres: Ecole Hollandaise* (Paris, 1863).[3] AE

1. Roger Black, *Willis Seaver Adams/Retrospection*, exh. cat. (Deerfield, Mass.: American Studies Group, Hilson Gallery, Deerfield Academy, 1966), 7–9.
2. Albert Blankert, John Michael Montias, and Gilles A. Ailland, *Vermeer* (New York: Rizzoli, 1988), 141–142.
3. See ibid., 141–142, 187–190, cat. nos. 23 and 24.

Ernest Albert

Born in Brooklyn, N.Y., in 1857; died in New Canaan, Conn., in 1946

After a long and distinguished career in theater design and scenic painting in Boston, St. Louis, Chicago,

Philadelphia, London, and New York City, in 1905 Ernest Albert Brown turned his attention to a serious career in painting landscapes and still lifes. Since 1896 he had spent summers in Old Lyme, Connecticut, with his son E. Maxwell Albert, boarding with Florence Griswold, whose colonial mansion became famous for housing the art colony the town had attracted. Albert painted the Connecticut countryside with the other artists who resided at the Griswold house, fondly called "the Holy House." In 1916 he established a permanent residence and studio in New Canaan with his son and son-in-law, Thaddeus A. DuFlon.

Albert exhibited in New York City, Philadelphia, and Chicago. In 1914, having trouble getting his work exhibited at New York's National Academy of Design, he founded the Allied Artists of America. He was actively involved in art organizations, such as the Lyme Art Association and the Salmagundi Club; in 1922, he was elected an associate of the National Academy of Design.

SELECT BIBLIOGRAPHY

Jane Hayward and William Ashby McCloy, eds., *The Art Colony at Old Lyme, 1900–1935*, exh. cat., introduction by Robin Richman (New London, Conn.: Lyman Allyn Museum and Connecticut College, 1966) / *Ernest Albert, A.N.A.*, exh. cat., introduction by Robert C. Vose III (Boston: Vose Galleries, 1981) / *Ernest Albert, A.N.A.*, exh. cat., introduction by Robert C. Vose III and Abbot W. Vose (Boston: Vose Galleries, 1987)

2

ERNEST ALBERT
Connecticut Snow, c. 1935
Oil on canvas; 36 × 40 in. (91.4 × 101.6 cm)
Signed at lower right: Ernest Albert A.N.A.

EXHIBITED: Boston, Vose Galleries, "Ernest Albert A.N.A.," 1981, no. EA9

2

EX COLL.: with Vose Galleries by 1981; to Mr. and Mrs. Thomas L. Archibald, Hartford, in 1982

Gift of Mr. and Mrs. Thomas L. Archibald, 1986.72

Connecticut Snow represents Albert's postimpressionist landscape style. Drawing from the tradition of the Old Lyme colony of artists, he captured the beauty of the Connecticut winter landscape in a palette of blues, whites, and grays. ERM

Ivan Albright

Born in North Harvey, Ill., in 1897; died in Woodstock, Vt., in 1983

Ivan Le Lorraine Albright received early artistic training from his father, Adam Emory Albright, a painter who had studied under Thomas Eakins (q.v.). He attended Northwestern University in 1915–1916 and studied architecture at the University of Illinois in 1916–1917. During World War I he served as a medical illustrator, making surgical drawings of wounds, an experience that later influenced his preoccupation with human flesh.

Following the war, Albright studied at the Art Institute of Chicago, the Pennsylvania Academy of the Fine Arts, and the National Academy of Design in New York City. In 1927 he settled in Warrenville, Ill., and with his twin brother, Malvin Marr Albright (1897–1983), a sculptor and painter (known professionally as "Zsissly"), set up a studio. There Ivan began to perfect a realistic but eccentric figural style that contained both gruesome and humane elements. His fascination with decaying flesh and his ability to depict the grotesque in rendering humans led to his being selected to paint *The Portrait of Dorian Gray* (1943–1944, Art Institute of Chicago) for the movie of the same name.

Albright showed his magic realist works in group and solo exhibitions and received numerous honors, including prizes from the Pennsylvania Academy of the Fine Arts, Metropolitan Museum of Art, Art Institute of Chicago, and National Academy of Design.

SELECT BIBLIOGRAPHY

Frederick A. Sweet, *Ivan Albright, A Retrospective Exhibition*, exh. cat. (Chicago: Art Institute of Chicago, 1964) / Barbara Rose, ed., *Readings in American Art since 1900* (New York: Praeger, 1975) / Michael Croydon, *Ivan Albright*, foreword by Jean Dubuffet (New York: Abbeville Press, 1980)

3 (see plate 1)

IVAN ALBRIGHT
*I Slept with the Starlight in My Face
 (The Rosicrucian)*, 1930
Oil on canvas; 30¼ × 20⅛ in. (76.8 × 51.1 cm)
Signed at lower left: Ivan Le Lorraine Albright

EXHIBITED: Art Institute of Chicago, "Ivan Albright: A Retrospective Exhibition," 1964–1965, no. 11

EX COLL.: purchased from artist by William Benton, Encyclopaedia Britannica Collection, New York City, in 1945; given to the Wadsworth Atheneum in 1969, in exchange for Albright's *Maker of Dreams*, which had been an earlier gift by William Benton

Gift of Senator William Benton, 1969.104

In 1926 Albright rented a house in Oceanside, California, where he painted *I Slept with the Starlight in My Face (The Rosicrucian)*. He often incorporated religious or mystical elements in his numerous portraits. The Rosicrucians, or the Brothers of the Rosy Cross, a seventeenth-century brotherhood of hermetic philosophers that was revived at various times in later centuries, promoted the union of science and religion to end blind faith and to ensure human well-being through methodical research. Albright later recalled the model for this painting: "In the past I have painted herrings that changed from purple to an orange oxide, women whose torrid flesh folds resembled corrugated mush, lemons and imitation fur, purple glazed leaves that exuded a funereal odor, and tawdry costume rings whose size all but covered actor-less hands. My models' idiosyncrasies have varied. . . . There was the long-haired flaxen Canadian, a Rosicrucian in the electrically heated basement which he tended, who extolled his sliding Adam's apple as a

mark of great spirituality."[1] In this early portrait Albright began to demonstrate his interest in realism and surfaces, such as the subject's flesh, hair, and clothing, using dark grays and browns against which the natural flesh tones appear illuminated. The subject's nose, forehead, and cheeks are flushed red, indicating his heated environment. ERM

1. Dorothy C. Miller and Alfred H. Barr, Jr., eds., *American Realists and Magic Realists*, exh. cat. (New York: Museum of Modern Art, 1943), 25.

Cosmo Alexander

Born in Aberdeenshire, Scotland, in 1724; died in Edinburgh, Scotland, in 1772

Cosmo Alexander was the son of John Alexander and the great-grandson of George Jameson, both prominent Scottish portrait painters. His father named him after Cosimo III, grand duke of Tuscany, whom he had painted. As Jacobites, Cosmo and his father lost their social position after the Scottish effort to defeat George II failed in 1745. Cosmo then began pursuing a career as a portrait painter, living in Italy between 1745 and 1751. In 1754 James Gibbs, the prominent Scottish architect, bequeathed him his London house. In 1763–1764 Cosmo traveled to Holland, where he held a membership in the painter's guild at The Hague.

In spite of Gibbs's generous bequest, the young painter remained in debt and planned to leave for America to improve his financial prospects. His only extant letter, written in 1769, alludes to his plight: "It's true we have sometimes bad payers & for some pictures are never acknowledged at all; but have not Merchants their losses & bad debts, Bankruptcy's [sic] &c? All situations of life have their conveniency's & inconveniency's, but its [sic] from our own mind we must seek relief & in our selves alone we can find that content which makes us support every disappointment" (Cosmo Alexander to Peter Remon, June 16, 1769, Miscellaneous Etting Papers, 1:129, Historical Society of Pennsylvania, Philadelphia).

Alexander arrived in America in 1766 and spent six years painting portraits in the major centers on the East Coast. He traveled continuously until 1771, working in Philadelphia, Burlington, New Jersey, Boston, Newport, and possibly Virginia. Most of his patrons were of Scottish descent, probably because he gravitated toward the Scottish communities in each town, as he had done in Europe. In New York and Philadelphia, Alexander joined the St. Andrew's Society, a charitable organization, which led to portrait commissions of fellow members. While in Newport, Rhode Island, he agreed to take the fourteen-year-old Gilbert Stuart (q.v.) as his pupil. In 1772 the two traveled to Edinburgh, where Alexander died at the age of forty-eight.

SELECT BIBLIOGRAPHY

Gavin L. M. Goodfellow, "Cosmo Alexander: The Art, Life, and Times of Cosmo Alexander (1724–1772), Portrait Painter in Scotland and America" (master's thesis, Oberlin College, 1961) / Pam McLellan Geddy, "Cosmo Alexander's Travels and Patrons in America," *Antiques* 60 (November 1977), 972–977 / Richard Saunders and Ellen Miles, *American Colonial Portraits, 1700–1776*, exh. cat. (Washington, D.C.: National Portrait Gallery, 1987)

4

COSMO ALEXANDER

Mrs. Francis Marschalk (Christine Farmer), 1765
Oil on canvas; 30⅝ × 25³⁄₁₆ in. (77.8 × 64.0 cm)
Signed and dated at lower right: C Alexr pingebat
AD 1765
Technical note: Traction crackle is evident throughout the surface, as is a yellowed, discolored varnish.

EX COLL.: Mrs. Abraham Jarvis (Anne Billhop Farmer), sister of the subject, Middletown, Conn., to 1801; descended to Ellen A. Jarvis, Cambridge, Mass., by 1957

Gift of Miss Ellen A. Jarvis, 1957.177

Alexander painted the portrait of a subject thought to be Christine Farmer, later Mrs. Francis Marschalk, in 1765, one year before his arrival in America. Because this sitter lived in New York, it has been suggested that the artist may have arrived in America one year earlier

4

than previously thought.[1] However, the existence of two signed and dated works of Scottish sitters painted in 1766 points to the artist's arrival in this country after their completion.[2] Thus it must be supposed that if the sitter is correctly identified as Christine Farmer Marschalk, she may have been painted in England, the year before Alexander came to America, although there is no evidence to that effect. The other possibility is that the sitter has been identified incorrectly.

The portrait was given to the Atheneum by the family of the subject's sister. Other portraits of members of the Jarvis family—among them a portrait of the sitter's sister, *Hannah Farmer* (cat. 177), painted by John Durand about 1768–1772—were given at the same time, with correct identities for the subjects. The donor identified Alexander's portrait as being of Christine Farmer, the daughter of Samuel Farmer and Christina Peck Farmer of New York City. Her grandfather was Benjamin Peck (d. 1751), after whom Peck Slip, New York, is named. The portrait is characteristic of Alexander's treatment of female sitters. His subject, holding a rose in her right hand, is shown seated in an upholstered side

chair with her left arm leaning on a table. The sitter is presented in a pleasing likeness and is placed against Alexander's favored pale green background. EMK

1. Pam McLellan Geddy, "Cosmo Alexander's Travels and Patrons in America," *Antiques* 60 (November 1977), 973.
2. The two Scottish portraits, *James Drummond, 10th Earl of Perth* and *Lady Rachel Drummond*, are in the collection of Drummond Castle, Scotland. This information appears in Richard Saunder's entry for Cosmo Alexander, in Saunders and Ellen Miles, *American Colonial Portraits: 1700–1776*, exh. cat. (Washington, D.C.: National Portrait Gallery, 1987), 300 n. 7.

Washington Allston

Born in Wacamaw, S.C., in 1779; died in Cambridgeport, Mass., in 1843

Born into a wealthy slave-owning family in the South, Allston credited his southern Gothic background with his predilection for the supernatural and the fantastic and with helping to form the romantic sensibility that would find expression in such early works as *Tragic Figure in Chains* (1800, Addison Gallery of American Art, Phillips Academy, Andover, Mass.). By the time he painted *Tragic Figure*, he had already become an admirer of the work of the Swiss artist Henry Fuseli.

In 1801, the year after his graduation from Harvard College, Allston left to study art in London. He attended the Royal Academy for three years, during which time Benjamin West (q.v.) was president and Fuseli was a professor of painting. In 1803 he traveled with John Vanderlyn (q.v.) through Holland and Belgium on his way to Paris. From there, he went on to Italy, spending almost four years in Rome. Particularly influenced by the works of the Italian old masters, he emulated painters such as Raphael, Titian, Correggio, and Michelangelo. He drew especially on Titian's use of color—so much so that he was often referred to as the "American Titian"—and on the force and massive strength of Michelangelo's figures. He also adopted Venetian glazing techniques dating from the Renaissance. While in Rome, Allston met Washington Irving and Samuel Taylor Cole-

ridge, whose knowledge of Shakespeare became an important thematic influence in his work.

Allston returned to America in 1808 to marry Ann Channing, and in 1811 the couple, along with Samuel F. B. Morse (1791–1872), traveled to London. Ann Channing died there in 1815, but Allston remained until 1818, when he returned to Boston. That year, Allston was made an honorary member of the American Academy of Fine Arts in New York City and was elected an associate at the Royal Academy in London. In 1820–1821 he painted *Saul and the Witch of Endor* (Amherst College, Amherst, Mass.), a subject West had painted in 1777. West's *Saul and the Witch of Endor* (cat. 485) is in the collection of the Wadsworth Atheneum.

In 1830 Allston married Martha Dana. The couple lived a secluded life in Cambridge, Mass., where the artist worked obsessively on *Belshazzar's Feast* (1817–1843, Detroit Institute of Arts), a painting for which he had made studies as early as 1817. He was unable to resolve the composition of the painting after Gilbert Stuart (q.v.) criticized its perspective in 1820. When well-meaning supporters established a fund for his support, guilt over his inability to finish the work compounded his difficulty with the composition. He never finished it, as was the case with many of his works.

The fund, incorporated as the Washington Allston Trust, held the paintings that remained unsold after the deaths of Allston and his wife. The trustees also used money from the fund to purchase four other works by Allston, and much of the material was placed on deposit at the Boston Museum of Fine Arts. One of the purposes of the trust was to bring Allston's works to a wide audience by placing them on public view. This was accomplished by 1956 with the dispersal of the works to a variety of museums around the country, including the Wadsworth Atheneum, which received the three pictures in this catalogue.

Allston's subject matter was wide-ranging: along with portraits, he painted historical, religious, and allegorical subjects. He published a volume of poetry in London and Boston in 1813 and wrote lectures on art theory. Before 1821 Allston wrote a novel, *Monaldi,*

which was not published until 1842. Henry T. Tucker-man said: "The writings and paintings of Allston exquisitely illustrate each other. By their mutual contemplation we perceive the individuality of the artist and the pure spirit of the man; and realize that unity whereby genius harmonizes all expression to a common and universal principle, making form and color, words and rhyme, express vividly and truly what exists in the artist's nature" (quoted in Clement, *Painters*, 33).

SELECT BIBLIOGRAPHY

Washington Allston, *Lectures on Art and Poems*, ed. Richard Henry Dana, Jr. (New York: Baker and Scribner, 1850) / William Ware, *Lectures on the Works and Genius of Washington Allston* (Boston: Phillips, Sampson, 1852) / James Jackson Jarves, *The Art-Idea*, ed. Benjamin Rowland, Jr. (1864; rpt., Cambridge, Mass.: Harvard University Press, Belknap Press, 1960), 172–175 / Clara Erskine Clement, *Painters, Sculptors, Architects, Engravers, and Their Works* (New York: Hurd and Houghton; Cambridge, Mass.: Riverside Press, 1874), 30–33 / M. F. Sweetser, *Artist-Biographies: Allston* (Boston: Houghton, Osgood, 1879) / Elizabeth P. Peabody, *Last Evening with Allston, and Other Papers* (Boston: D. Lothrop, 1886) / Jared B. Flagg, *The Life and Letters of Washington Allston* (New York: Scribner's, 1892) / Edgar Preston Richardson, *Washington Allston: A Study of the Romantic Artist in America* (Chicago: Chicago University Press, 1948) / Thomas W. Leavitt, "The Disposition of the Washington Allston Trust," *Art Quarterly* 19 (winter 1956), 415–417 / E. H. T[urner], "Three Paintings by Washington Allston," *Wadsworth Atheneum Bulletin*, 2d ser., no. 61 (January 1956), 1 / Henry H. Hawley, "Allston's Falstaff Enlisting His Ragged Regiment," *Wadsworth Atheneum Bulletin*, 3d ser., no. 3 (winter 1957), 13–16 / Regina Soria, "Washington Allston's Lectures on Art: The First American Art Treatise," *Journal of Aesthetics and Art Criticism* 18 (March 1960), 329–444 / Barbara Novak, *American Painting of the Nineteenth Century: Realism, Idealism, and the American Experience* (New York: Harper and Row, 1969), 44–60 / Kenyon C. Bolton III, *The Paintings of Washington Allston*, exh. cat. (Coral Gables, Fla.: University of Miami, Lowe Art Museum, 1975) / William H. Gerdts and Theodore E. Stebbins, Jr., *"A Man of Genius": The Art of Washington Allston (1779–1843)*, exh. cat. (Boston: Museum of Fine Arts, 1979) / David Bjelajac, *Millennial Desire and the Apocalyptic Vision of Washington Allston* (Washington, D.C.,

and London: Smithsonian Institution Press, 1988) / Nancy Rivard Shaw, ed., *American Paintings in the Detroit Institute of Arts* (New York: Hudson Hills Press, in association with the Founders Society, Detroit Institute of Arts, 1991), 1:16–24 / Nathalia Wright, introduction to Washington Allston, *Autobiographical Works of Washington Allston: Monaldi and "The Angel and the Nightingale"* (Delmar, N.Y.: Scholars' Facsimiles and Reprints, 1991)

5

WASHINGTON ALLSTON
Falstaff Enlisting His Ragged Regiment at Justice Shallow's, 1806–1808
Oil on canvas; 25¼ × 32½ in. (64.1 × 82.6 cm)

EXHIBITED: Boston Athenaeum, 1827, no. 140 / Boston, Harding's Gallery, 1839, no. 41 / Boston Athenaeum, 1853, no. 192 / Charleston, S.C., South Carolina Interstate and West Indian Exposition, "Exhibition of Fine Arts," 1901–1902, no. 433, as "Falstaff Enlisting His Ragged Regiment" / Boston, Museum of Fine Arts, "A Man of Genius: The Art of Washington Allston," 1980, no. 18 / Montgomery, Ala., Montgomery Museum of Fine Arts, and Chicago Public Library Cultural Center, "A Brush with Shakespeare, The Bard in Painting: 1780–1910," 1985–1986, no. 4

EX COLL.: William Sullivan, Boston, by 1827, at least through 1839; to J. E. Lodge by 1853; sold for $2,000 by unknown seller to unknown purchaser, Charleston, S.C., in 1860; reported unlocated by Moses Sweetser in *Artist-Biographies: Allston* (Boston: Houghton, Osgood, 1879); to W. H. Welch, Esq., Charleston, S.C., by 1901; in Richard Dana Collection, Cambridge, Mass., by 1948

Gift of the Allston Trust, through Henry L. de Rahm, Trustee, 1955.98

In 1860, when this painting was sold in South Carolina for $2,000, a writer in the *Cosmopolitan Art Journal* criticized its cold color and stiff drawing but went on to say, "Nevertheless, it was a curious and remarkable picture."[1] Another writer, reviewing an exhibition of Allston's pictures in 1839, was also critical and wrote, "Falstaff never seems to me so funny when I absolutely see his fat, broad face, as when I only have his words in my mind."[2]

5

Allston's literary source for *Falstaff* is act 3, scene 2, in Shakespeare's *Second Part of King Henry IV*, when Sir John Falstaff, having sold discharges from military service to those who could afford them, enlists poor country workers to fill the empty ranks.[3] Allston painted most—if not all—of the picture in Italy, where, in Rome in 1805, he met the poet and Shakespearean scholar Samuel Taylor Coleridge, who may have influenced his choice of subject.[4] Washington Irving, whom Allston also met in Rome at that time, published his own satiric tribute to Falstaff in 1820, "The Boar's Head Tavern, Eastcheap."[5] In a letter to John Vanderlyn (q.v.), written from Leghorn in 1808, Allston wrote that he would be departing Europe sooner than planned because of the Napoleonic wars and added, "I shall take only 'Cupid and Psyche' and the little 'Falstaff.'"[6]

Allston's chief pictorial source for *Falstaff Enlisting His Ragged Regiment* is an engraving after William Hogarth's painting of the same subject, published in 1799 in Samuel Ireland's *Graphic Illustrations of Hogarth*. Drawing on other sources as well, he borrowed physiognomy, dress, and posture for his figures from engravings in the *Boydell Shakespeare Gallery*, with which he first became acquainted in a Charleston, S.C., library in 1800–1801 and probably saw again in 1801–1803 in London and in 1803 in Italy, when a book of the engravings was published.[7]

Falstaff Enlisting His Ragged Regiment at Justice Shallow's is one of a number of comic works Allston painted. Among the others is another picture of Falstaff, titled *Falstaff Playing the Part of the King* (1806–1808, unlocated), and *Poor Author and the Rich Bookseller* (1811, Museum of Fine Arts, Boston), in which the bookseller bears some physical resemblance to the Atheneum's *Falstaff*.[8] AE

1. "Art at the South," *Cosmopolitan Art Journal* 4 (September 1860), 132. In the June 1860 issue of *Cosmopolitan Art Journal*, an announcement advertised an engraving after a painting entitled *Falstaff Mustering His Recruits*, by a Düsseldorf artist named Adolf Schroedter (1805–1875); from the description, the scene depicted appears to have been the same as that Allston chose for his work. The engraving was offered for sale to subscribers and the general public. See

Samuel Ireland, from *Graphic Illustrations of Hogarth*, engraving after William Hogarth, *Falstaff Examining His Recruits*, 1799. Print Collection, Miriam and Ira D. Wallach Division of Art, Prints and Photographs, New York Public Library, Astor, Lenox and Tilden Foundations.

George Whiting Flagg, *Falstaff Enacting Henry IV*, c. 1834. New-York Historical Society.

"The New Engraving: Falstaff Mustering His Recruits," *Cosmopolitan Art Journal* 4 (June 1860), 85. I am grateful to David Brigham, who, in his research on this painting, uncovered this article while he was an intern at the Wadsworth Atheneum.

2. Elizabeth P. Peabody, "Exhibition, in Boston, of Allston's Paintings," in *Last Evening with Allston, and Other Papers* (Boston: D. Lothrop, 1886), 55–56. When this picture was exhibited as no. 41 at Harding's Gallery, Boston, 1839, the following words were printed in the catalogue: "'Falstaff. Come, prick me Bullcalf till he roar again. / Bullcalf. Oh Lord! good my lord captain— / Falstaff. What, dost though roar before thou art prick'd? / Bullcalf. Oh, Lord, sir, I am a diseased man.' Second Part of King Henry IV. Act III." See James L. Yarnall and William H. Gerdts, *The National Museum of American Art's Index to American Art Exhibition Catalogues from the Beginning through the 1876 Centennial Year* (Boston: Hall, 1986), 1:87.

3. See Lucy Oakley, "Words into Pictures: Shakespeare in British Art, 1760–1900," in Montgomery Museum of Fine Arts, *A Brush with Shakespeare: The Bard in Painting, 1780–1910*, exh. cat. (Montgomery, Ala.: Montgomery Museum of Fine Arts, 1985), 10, 38.

4. Henry H. Hawley, "Allston's Falstaff Enlisting His Ragged Regiment," *Wadsworth Atheneum Bulletin*, 3d ser., no. 3 (winter 1957), 13–16.

5. The essay is included in Washington Irving, *The Sketch Book of Geoffrey Crayon, Gent.* (1819–1820; rpt., New York: New American Library, 1961), 116–129.

6. Jared B. Flagg, *The Life and Letters of Washington Allston* (New York: Scribner's, 1892), 78–79; and Edgar Preston Richardson, *Washington Allston: A Study of the Romantic Artist in America* (Chicago: University of Chicago Press, 1948), 84, 192. Allston's letter to Vanderlyn is dated April 23, 1808. Richardson cites an 1839 exhibition catalogue for Harding's Studio, Boston, which gives the date of the painting as 1806, and an 1827 catalogue for the Boston Athenaeum, which gives the date as 1809. Richardson dates the work from 1806–1808 (192–193).

7. Hawley, "Allston's Falstaff," 14. See John Boydell and Josiah Boydell, *A Collection of Prints from . . . the Dramatic Works of Shakespeare*, 2 vols. (London, 1803), which included engravings after commissioned paintings by a variety of British artists. Hawley suggests that Allston based his Falstaff's face on an engraving after Henry Fuseli's painting of Falstaff based on a different scene from *The Second Part of King Henry IV* and the scribe on a figure from a painting by Robert Smirke drawn from a scene from *Much Ado about Nothing*.

8. Richardson, *Washington Allston*, 192–193; and William H. Gerdts and Theodore E. Stebbins, Jr., *"A Man of Genius": The Art of Washington Allston (1779–1843)*, exh. cat. (Boston: Museum of Fine Arts, 1979), 54, 59, 83. *Falstaff Playing the Part of the King* is mentioned in letters from Charles Robert Leslie to Richard Henry Dana dated January 25,

1844, and September 6, 1844: "In Italy he painted a picture of Falstaff playing the part of the King, the figures the size of life, an unusual mode of treating a comic subject" (quoted in Richardson, *Washington Allston*, 193). Allston's nephew, George Whiting Flagg, also painted this subject and may have been influenced by his uncle's depiction of the comic character. His *Falstaff Enacting Henry IV*, c. 1834, is in the collection of the New-York Historical Society, New York. See Ella M. Foshay, *Mr. Luman Reed's Picture Gallery: A Pioneer Collection of American Art*, exh. cat. (New York: Abrams, in association with the New-York Historical Society, 1990), 152–153.

6

WASHINGTON ALLSTON
Girl in Persian Costume (A Troubadour), c. 1832
Oil on linen; 35¼ × 27½ in. (89.5 × 69.9 cm)

EXHIBITED: possibly Boston Art Association, 1844, no. 118, as "Unfinished Sketch—Female in a Wood" / Boston Athenaeum, as "The Troubadour—Outline," 1857, nos. 198, 220; 1858, no. 207; 1859, no. 253; 1861, no. 207; 1862, no. 198; 1863, no. 155; 1864, no. 142; 1865, no. 143; 1866, no. 143; 1867, no. 146; 1868, no. 146; 1869, no. 146; 1870, no. 276 / Boston, Museum of Fine Arts, "A Man of Genius: The Art of Washington Allston," 1980, no. 65

EX COLL.: Mrs. Allston to 1870; deposited at the Museum of Fine Arts, Boston, by the heirs of Washington Allston; to Richard Dana Collection, Cambridge, Mass., by 1947

Gift of the Allston Trust, through Henry L. de Rahm, Trustee, 1955.100

Allston's large drawing *Girl in Persian Costume*, in umber on linen, is so complete in conception that the artist may have intended to continue working on the composition directly on this canvas.[1] The composition as it stands—a figure playing a lute in the woods near a stream—is probably close to a finished painting by Allston called *Young Troubadour*, now unlocated. This painting is mentioned by many of the contemporary sources on Allston and his work; *Girl in Persian Costume*, though exhibited, is not mentioned, probably because of its unfinished state. A poem by the artist, "The Troubadour," is connected with *Young Troubadour*.[2]

The Persian costume in the painting is an unusual element for an American painting from this period but is in keeping with Allston's romantic exoticism.[3] One scholar has suggested that the choice of a Persian theme is related to a character of that nationality in Tasso's poem "Jerusalem Delivered."[4]

Allston painted a number of pictures with figures playing musical instruments, several with the lute.[5] They are usually placed in the woods and near water, where they play, sing, or listen to music.[6] Many of these paintings from the last decade of Allston's life are complex idealized composite portraits of his first wife, Ann Channing, whom he called Rosalie, and Charlotte Dana, the niece of his second wife and a favorite. The features of the figure in *Girl in Persian Costume* compare with those of the figure in *Rosalie* (1835, Society for the Preservation of New England Antiquities, Boston) and the figure in *Evening Hymn* (1835, Montclair Museum, Montclair, N.J.) and may well represent Ann Channing.[7]

The Atheneum's picture was engraved by John and Seth Cheney and was published in 1850, as *Girl in Male Costume*, in *Outlines and Sketches by Washington Allston*.[8] An engraving is in the collection of prints and drawings at the Atheneum. AE

6

1. William H. Gerdts and Theodore E. Stebbins, Jr., *"A Man of Genius": The Art of Washington Allston (1779–1843)*, exh. cat. (Boston: Museum of Fine Arts, 1979), 141.

2. Gerdts and Stebbins, *"A Man of Genius,"* 141; and Edgar Preston Richardson, *Washington Allston: A Study of the Romantic Artist in America* (Chicago: University of Chicago Press, 1948), 211.

3. Gerdts and Stebbins, *"A Man of Genius,"* 141.

4. Allston painted *A Roman Lady Reading Tasso* around 1831 (Newark Museum, Newark, N.J.). Torquato Tasso was a sixteenth-century Italian poet. See Nathalia Wright, introduction to *Autobiographical Works of Washington Allston: Monaldi and "The Angel and the Nightingale"* (Delmar, N.Y.: Scholars' Facsimiles and Reprints, 1991), 27.

5. The earliest-known depiction of a lute player in Allston's work is *Italian Landscape* (c. 1828–1830, Detroit Institute of Arts), exhibited in 1830 at the Boston Athenaeum (Gerdts and Stebbins, *"A Man of Genius,"* 142).

6. Wright, introduction, 27.

7. Ibid., 20–22.

8. Seth W. Cheney was a Boston engraver and portrait draftsman. See Gerdts and Stebbins, *"A Man of Genius,"* 298, 240.

7 (see plate 2)

WASHINGTON ALLSTON

The Death of King John, 1838

Oil on millboard; 28 × 37³/₄ in. (71.1 × 95.9 cm)

Technical note: Unfinished: as with many of Allston's works, the flat areas of pure pigment have been laid in, but the subsequent glazes were never added.

EXHIBITED: Boston Athenaeum, 1847, no. 138; 1850, no. 110; 1851, no. 162; 1852, no. 27; 1853, no. 185; 1854, no. 185; 1855, no. 47; 1856, nos. 174 and 227; 1857, nos. 309 and 357; 1859, no. 94; 1861, no. 187; 1862, no. 178; 1863, no. 135; 1864, no. 139; 1865, no. 141; 1866, no. 141; 1867, no. 144; 1868, no. 144; 1869, no. 144; 1870, no. 271 / Boston, Museum of Fine Arts, "Exhibition of the Works of Washington Allston," 1881, no. 247 / Boston, Museum of Fine Arts, "A Man of Genius: The Art of Washington Allston," 1980, no. 68 / Atlanta, Ga., High Museum of Art, "Arts in America: The Colonies and Early Federal Republic," 1986

EX COLL.: Mrs. Allston at least to 1850; deposited at the Museum of Fine Arts, Boston, by the heirs of Washington Allston by 1879; to Richard Dana Collection, Cambridge, Mass., by 1948

Gift of the Allston Trust, through Henry L. de Rahm, Trustee, 1955.99

The Death of King John is one of a number of Allston's paintings in the so-called grand manner, a European tradition in painting that drew on the works of old masters.[1] Allston's sources for the figure of King John, for example, have been traced to the cartoons of Raphael and to the Elgin marbles.[2]

Although Allston employs such neoclassical conventions as sculptural drapery, contouring, and studied groupings of figures in *The Death of King John*, the subject of the painting is the psychological moment. Allston's advance over the academic tradition, as one scholar sees it, is his romantic twist on the neoclassic and his particular interest in the psychological and emotional tensions of the moment depicted.[3] Contemporary viewers also valued this tension in Allston's work. In 1852 William Ware wrote of the painting, "The work of Mr. Allston, which, as I think, was his most successful one, in point of expression of emotion and state of mind through the countenance, is that which is called the Death of King John."[4] Allston's early biographer, Moses F. Sweetser, wrote in 1879, *"The Death of King John,* though unfinished, was Allston's masterpiece in the expression of emotion in faces, varying from the utter misery of the conscience-stricken sovereign to the deep compassion of the people about his bedside. The design is true and simple, and the composition is complete."[5]

Allston's painting takes its subject from act 5, scene 7, of Shakespeare's *King John,* an unusual iconographical choice in nineteenth-century American painting and possibly the only American example.[6] The setting, Swinstead Abbey, is rendered with historical accuracy with regard to its Gothic architecture. A monk has administered poison to King John, who lies dying.[7] As King John turns his head in anguish and reaches out to one of the figures at his side, the empathy of those watching this sinner prepare to meet his fate overcomes their hatred.[8]

The painting was in Allston's studio when the English historian and author Anna Jameson visited the artist. She later wrote, "When I saw him in 1838 . . .

he was at that time painting on two great pictures, the 'Death of King John,' and 'Belshazzar's Feast.' The first he declined showing me, because he said that 'to exhibit his pictures to any other eye in certain stages of their progress always threw cold water on him.'"[9] Although unfinished, the painting did not fail to impress critics who had the opportunity to view the painting after Allston's death. One wrote, "This is an unfinished picture . . . but, the heads of both the principles and the subordinates, with the lines of expression [are] finished, almost to the very final touches; at least, had it lain with me to determine, I should not have dared to allow even the artist himself, to have either added or subtracted a line, or a point of light, shade, or form, so felicitous already, are the countenances of the different groups, in the various shades of their expression."[10]

Allston's working method was to outline his composition in chalk, paint over the outlines with a brush, and then apply broad masses of color that he would let dry— sometimes as long as a year. After drying the artist would add glazes and paint details into the glaze. *The Death of King John* is complete up to the point of the glazes and final details, making the painting slightly harsher in color than it might have been if finished.[11] This stage was a common stopping point for Allston.[12]

The Death of King John may have been painted for a Mr. Phillips in repayment for a loan of $500 Phillips made to Allston at some earlier time.[13] AE

1. See Wayne Craven, "The Grand Manner in Early Nineteenth-Century American Painting: Borrowings from Antiquity, the Renaissance, and the Baroque," *American Art Journal* 11, no. 2 (1979), 4–43, especially 5–9 and 20–34. Allston probably first absorbed the tenets of painting in the grand manner at Harvard, where he likely read seventeenth-century writers such as Charles du Fresnoy and Roger de Piles, as well as eighteenth-century theorists such as J. J. Winckelmann, whose *Reflections on the Painting and Sculpture of the Greeks* was available in an English translation by Henry Fuseli (London, 1765). Undoubtedly, he had also read Sir Joshua Reynolds's *Discourses*. Craven writes that it was Reynolds's writings and the Royal Academy tradition that helped Allston formulate his desire to become a painter of historical and literary subjects and ultimately drew him to London to study (21–22).

2. William H. Gerdts and Theodore E. Stebbins, Jr., "A Man of Genius": *The Art of Washington Allston (1779–1843)*, exh. cat. (Boston: Museum of Fine Arts, 1979), 153. Gerdts and Stebbins also link *The Death of King John* to other Allston paintings, such as *The Dead Man Restored to Life by Touching the Bones of the Prophet Elisha* (1811–1814, Pennsylvania Academy of the Fine Arts, Philadelphia) and *Belshazzar's Feast* (1817–1843, Detroit Institute of Arts).

3. Kenyon C. Bolton III, *The Paintings of Washington Allston*, exh. cat. (Coral Gables, Fla.: University of Miami, Lowe Art Museum, 1975), 8.

4. William Ware, *Lectures on the Works and Genius of Washington Allston* (Boston: Phillips, Sampson, 1852), 42.

5. M. F. Sweetser, *Artist-Biographies: Allston* (Boston: Houghton, Osgood, 1879), 113. I am grateful to David Brigham, former intern at the Wadsworth Atheneum, who did much of the research in nineteenth-century sources on this painting.

6. Gerdts and Stebbins, "A Man of Genius," 154.

7. Ibid., 153.

8. Ware, *Lectures*, 44–45. David Bjelajac discusses this painting in terms of the anti-Catholic bias of the play. Shakespeare's *King John* is based on an earlier, anonymous play, *The Troublesome Reign of John King of England*, which presents King John, dying of poison in Swinstead Abbey, as a hero who opposed papal authority. Shakespeare defangs the play somewhat by questioning John's motives in opposing the pope. Despite this adjustment, the original interpretation of the play stuck, and in the nineteenth century Shakespeare's *King John*, too, was seen as a protest against Catholic intervention in politics. Allston presents John as Shakespeare did, as a sinner rather than a hero. Bjelajac points out, however, that by presenting John as a sinner, Allston condemns John as an opponent of the Church, and so Bjelajac suggests interpreting the painting as Allston's reproach—rather than endorsement—of anti-Catholicism. See David Bjelajac, *Millennial Desire and the Apocalyptic Vision of Washington Allston* (Washington, D.C., and London: Smithsonian Institution Press, 1988), esp. 172–177.

9. Anna Brownell Jameson, "Washington Allston," *Atheneum (London)* (January 13, 1844), 39; and Gerdts and Stebbins, "A Man of Genius," 153–154.

10. Ware, *Lectures*, 42–43.

11. Richardson, *Washington Allston*, 150–153. Richardson suggests that without the final glazes "the sketch achieves a stern and tragic mood that is interesting" (152).

12. Gerdts and Stebbins suggest that Allston may so often have stopped painting at this state because of a mix of pride and humility: pride in that his success would precipitate his parting with the painting and humility concerning his emulation of the techniques of the old masters ("A Man of Genius," 153).

13. Jared B. Flagg, *The Life and Letters of Washington Allston* (New York: Scribner's, 1892), 271.

Ezra Ames

Born in Framingham, Mass., in 1768; died in Albany,
N.Y., in 1836

Most of the known biographical information on Ezra
Ames comes from the artist's own account books, which
he kept intermittently from 1790 to 1834. His family,
who were farmers, may have moved from New England
to Staatsburgh, N.Y., when Ames was a child. How-
ever, the first reference to his early years as an artist-
craftsman places him in Worcester, Massachusetts, in

1790. Seemingly self-taught, Ames began his career
as a painter in Worcester executing mainly miniature
portraits as well as carrying out a variety of decora-
tive tasks, such as painting signs, coaches, sleds, fire
buckets, clock faces, window shades, carpets, Masonic
aprons, and houses.

In 1793, after a brief visit to New York City, Ames
established himself as a portrait painter in Albany, even-
tually becoming the city's leading artist. He gained
national recognition when his portrait of Vice-President
George Clinton (1812, unlocated) was shown at the

8

Pennsylvania Academy of the Fine Arts in 1812. One reviewer noted of the work: "We are equally pleased and astonished, as well at the excellence of the picture, and the correctness of the likeness, as that it was painted by a person little known as an artist, and who has never had any regular instructions in art" (Bolton and Cortelyou, *Ezra Ames*, 63).

Ames's connection with Albany's Masonic Lodge, where he served as grand high priest for twenty-six years, brought him many portrait commissions. As his account book indicates, he painted more than 450 portraits during his career, faithfully recording most of the notable contemporary political and social figures of Albany. He also produced a number of copies of portraits by more famous artists, such as John Singleton Copley (q.v.) and Gilbert Stuart (q.v.), and painted a small number of landscapes and still lifes. In addition to his profession as a painter, Ames was made director of Albany's Merchants and Farmers Bank in 1814 and became the president of the bank in 1834. At the time of his death, he left an estate valued at more than $65,000, a tribute to his diverse skills as a businessman and artist.

SELECT BIBLIOGRAPHY

Theodore Bolton and Irwin F. Cortelyou, *Ezra Ames of Albany: Portrait Painter, Craftsman, Royal Arch Mason, Banker and a Catalogue of His Works* (New York: New York Historical Society, 1955)

8

EZRA AMES
Richard Dusenbury, c. 1815–1820
Oil on canvas; 30⅛ × 23¾ in. (76.5 × 60.3 cm)

EX COLL.: with Robert C. Vose Galleries, Boston, by 1965

The Ella Gallup Sumner and Mary Catlin Sumner Collection Fund, 1965.38

Ezra Ames painted this portrait of Richard Dusenbury (1758–1830), a prominent merchant from Albany, N.Y., in a straightforward manner. The elderly subject is presented with bold features and set against a plain background, with his shadow cast against the right wall. A red drapery is seen at the upper left. Although the artist kept three detailed account books, this particular portrait does not appear in his records.[1]

Dusenbury is listed as a lumber merchant in the Albany city directories for the years 1815 to 1829. In 1801 he married Fanny Dusenbury, his cousin. Ames painted a portrait entitled *Miss Dusenbury* (unlocated), possibly the couple's daughter; this portrait remained with the artist and was listed as part of his estate in 1836, its value set at $15.[2] EMK

1. "References to Paintings in the Account Books (1790–1834) of Ezra Ames" appears in Theodore Bolton and Irwin F. Cortelyou, *Ezra Ames of Albany: Portrait Painter, Craftsman, Royal Arch Mason, Banker and a Catalogue of His Works* (New York: New-York Historical Society, 1955), 147–190.
2. Ibid., 227.

Abraham Archibald Anderson

Born in Peapack, N.J., in 1847; died in New York City, in 1934

Abraham Anderson began his artistic training in 1873 in Paris, under Léon Bonnat and others. He remained there for several years and exhibited at the Salon and at the Universal Exposition in 1899. Anderson painted portraits of prominent Americans, including Thomas A. Edison, Bishop Cleveland Coxe, and Elihu Root. He also painted genre scenes, and many of his finest are of Parisian life. Anderson was active in the founding of the American Artists Association in Paris, an organization that supported young American art students.

SELECT BIBLIOGRAPHY

Colonel A. A. Anderson, *Experiences and Impressions (An Autobiography)* (New York: Macmillan, 1933) / E. Bénézit, *Dictionnaire des Peintres, Sculpteurs, Dessinateurs et Graveurs* (Paris: Librairie Grund, 1976), 1:169 / Mantel Fielding, *Dictionary of American Painters, Sculptors and Engravers* (New York: Apollo, 1985), 20 / William H. Gerdts, *Revealed Masters: Nineteenth Century American Art*, exh. cat. (New York: American Federation of Arts, 1989), 47–48

9

ABRAHAM ANDERSON

The Boulevard Café, 1889

Oil on canvas; 37 × 50½ in. (94.0 × 128.3 cm)

Signed and dated at lower right: A. A. Anderson— /

 Paris— / 1889

EXHIBITED: Wadsworth Atheneum, "Off for the Holidays," 1955, no. 11 / Sarasota, Fla., John and Mable Ringling Museum of Art, "The Art of Eating," 1956, no. 29 / Wadsworth Atheneum, "A Second Look: Late Nineteenth Century Taste in Paintings," 1958, no. 42 / Wadsworth Atheneum, "Harvest of Plenty," 1963, no. 2 / Wadsworth Atheneum, "The Academics," 1974 / Brooklyn, N.Y., Brooklyn Museum, "The American Renaissance 1876–1917," 1979, no. 194

EX COLL.: Dr. Eleanor Anderson Campbell

Gift of Eleanor Anderson Campbell, 1942.326

Anderson painted *The Boulevard Café* during his most successful period in Paris.[1] In his *Autobiography* he discussed the Parisian scene of the 1880s, reminiscing about the gaiety, color, and sophistication of the men and women of the day. *The Boulevard Café* represents a scene in which fashionable Parisians take refreshments and linger in an equally fashionable café. A soldier leans against the entrance to a "fumoir," a smoking room primarily for men. Four of the figures have been identified: the couple seated at the table are the president of France and his mistress; the woman descending the staircase is "well known," as is her "amant de moment," the gentleman following her.[2] ERM

1. Eleanor A. Campbell to Mr. Austin, Director, May 22, 1942, curatorial painting file, Wadsworth Atheneum.
2. Note from Alexander Crane to the Wadsworth Atheneum, November 1951, curatorial painting file, Wadsworth Atheneum.

Victor Gifford Audubon

Born in Louisville, Ky., in 1809; died in New York City, in 1860

A wildlife and landscape painter as well as miniaturist, Victor Audubon was the elder of two sons of John James Audubon (1785–1851), the famous naturalist

painter. His early interest in his father's profession led him to begin art school in Henderson, Kentucky, as a child. Financial trouble caused him to give up his studies for a time and to take up work as a clerk in a mercantile house in Louisville.

In 1832 Victor went to London to oversee the British publication of his father's *Birds of America*. There he painted and studied with John Wilson and exhibited at the Royal Academy. He toured Europe before returning to South Carolina sometime between 1838 and 1840 to marry Mary Eliza Bachman, a daughter of John Bachman, an amateur naturalist and friend and collaborator of his father's. Victor's younger brother, John Woodhouse Audubon (1812–1862), also married one of Bachman's daughters.

The brothers worked together on a number of canvases—Victor painting the backgrounds and John Woodhouse working on the animals—as part of such projects as John James Audubon's *Viviparous Quadrupeds of North America*, conceived around 1837 and published in three volumes in Philadelphia between 1845 and 1854. Together, these volumes contained 150 plates, which, unlike *Birds of America*, were reproduced by lithography. John Bachman collected specimens and wrote most of the text for the plates. Victor Audubon executed most of the drawings of the animals and acted as business manager, while John Woodhouse did those drawings and wrote the text that the others did not (Cunningham, "Audubon's Studies," 3).

John James's sons were elected associates of the National Academy of Design in 1841; one year later Victor became an academician. In 1843 he moved to New York City, where he exhibited at the academy for the next seven years, as well as at the Apollo Association and the American Art-Union. After their father's death in 1851, the brothers continued their collaboration, working on new editions of *Birds of America* and *Quadrupeds*. After a long illness, Victor died at his mother's home in Washington Heights, in upper Manhattan.

The Atheneum's collection holds six works by the Audubons, all connected with *Viviparous Quadrupeds*, including the finished lithograph of *Soft Haired Squirrels*. Four of these are by John James Audubon: three

studies for *Soft Haired Squirrels* and a watercolor of *Pennant's Marten*. The Atheneum's *Marten*, originally called a pekan or fisher by Audubon, was drawn for *Quadrupeds* but was not selected for use in the final publication.

SELECT BIBLIOGRAPHY

Francis Hobart Herrick, *Audubon the Naturalist: A History of His Life and Time*, 2d ed. (New York and London: Appleton-Century, 1938) / "Two Original Drawings by Audubon," *Old Print Shop Portfolio* 3 (December 1943), 74–77 / "Four Original Drawings by Audubon," *Old Print Shop Portfolio* 4 (November 1944), 55–57 / "Plates from the 'Quadrupeds' Owned by Audubon's Son," *Old Print Shop Portfolio* 5 (October 1945), 26–29 / John I. H. Baur, *M. and M. Karolik Collection of American Paintings, 1815–1865* (Cambridge: Harvard University Press, for the Boston Museum of Fine Arts, 1949), 67–69 / Alice Ford, ed., *Audubon's Animals: The Quadrupeds of North America* (New York: Studio Publications, in association with Thomas Y. Crowell, 1951) / George C. Groce and David H. Wallace, *The New-York Historical Society's Dictionary of Artists in America, 1564–1860* (New Haven: Yale University Press; London: Oxford University Press, 1957), 16 / Charles C. Cunningham, "Audubon's Studies for the Quadrupeds," *Wadsworth Atheneum Bulletin*, 5th ser., no. 1 (spring 1959), 3–6 / Alice Ford, *John James Audubon* (Norman: University of Oklahoma Press, 1964) / Gary A. Reynolds, *John James Audubon and His Sons* (New York: Grey Art Gallery and Study Center, 1982)

10

VICTOR GIFFORD AUDUBON
Study of Branch and Leaves, c. 1845
Oil and pencil on canvas; 21 1/4 × 18 3/8 in. (54.0 × 46.7 cm)
Technical note: The surface is damaged with cracks, and areas of paint loss are visible in the lower left quadrant.

EX COLL.: J. M. McCormick, Tottenville, N.Y.; probably with the Old Print Shop, N.Y., by 1944; to Henry Schnakenberg, Newtown, Conn., by 1951

Gift of Henry Schnakenberg, 1958.164

10

John James Audubon, *Soft Haired Squirrel* (facing right), plate 19, no. 4, c. 1845. Wadsworth Atheneum, gift of Henry Schnakenberg.

John James Audubon, *Soft Haired Squirrel* (facing left), c. 1845. Wadsworth Atheneum, gift of Henry Schnakenberg.

Henry Schnakenberg (q.v.), an artist and generous patron of the Atheneum, presented the museum with Victor Audubon's *Study of Branch and Leaves*, along with three drawings by Victor's father of the soft-haired squirrel—or *Redwood Chickeree/Red Squirrel*, as it was later identified by the American Museum of Natural History in New York.[1] Two of these are watercolors and date from about 1845, the year of the *Study*, and one is in pencil and is dated 1841. The two watercolors of the squirrels show the animals in the positions indicated in pencil in the *Study of Branch and Leaves*.

Study of Branch and Leaves is clearly the background for John James Audubon's *Soft Haired Squirrel*, published in lithograph as plate 19 in *Quadrupeds*, a lithograph of which was also given to the Atheneum by Henry Schnakenberg. In 1843 John James Audubon wrote to his wife, Lucy, "I hope Victor will have begun painting backgrounds. Now the blossoms and the leaves of the oaks are perfectly beautiful and would look well with species of squirrels."[2] Apparently Victor did not take his father's advice: the Atheneum's drawing is an

John James Audubon, *Soft Haired Squirrel*, 1841–1842. Wadsworth Atheneum, gift of Henry Schnakenberg.

autumn or winter study, in which the outlines of the squirrels cavort on the branches of an oak tree to which only a few brown leaves cling.

John James Audubon had to speculate with regard to the habits of the soft-haired squirrel. He worked from a specimen sent him from Northern California but never visited the animal's native habitat himself and never saw a live soft-haired squirrel. He and his collaborators assumed that the squirrel's habits were similar to those of the Carolina gray squirrel.[3] AE

1. Charles C. Cunningham, "Audubon's Studies for the Quadrupeds," *Wadsworth Atheneum Bulletin*, 5th ser., no. 1 (spring 1959), 5.
2. As quoted in Alice Ford, ed., *Audubon's Animals: The Quadrupeds of North America* (New York: Studio Publications, in association with Thomas Y. Crowell, 1951), 31, 216; and Cunningham, "Audubon's Studies," 5.
3. "Four Original Drawings by Audubon," *Old Print Shop Portfolio* 4 (November 1944), 55–57.

Milton Avery

Born in Altmar, N.Y., in 1893; died in New York City, in 1965

Milton Avery moved with his family to Hartford in 1905. In 1923 he began his only formal training, at the Connecticut League of Art Students, under the direction of Charles Noel Flagg (q.v.). Determined to be an artist but uninspired by Flagg, Avery left the school and became a self-taught artist. In 1925 he went to Gloucester, Massachusetts, to join the artist's colony there, and in the fall of that year he moved to New York City, where he married Sally Michel, an artist and illustrator, in 1926. Supported by his wife, Avery was able to begin his career as an artist.

In 1932 the couple had a daughter, March, who became one of Avery's most popular subjects. He regularly attended sketch classes in Greenwich Village, taking off summers to travel with his family throughout New England. He exhibited his works at the Wadsworth Atheneum in 1930 and in 1952, the year he made his first trip to Europe. Throughout his career, color was the central concern in his paintings, and he emphasized the

lyrical rather than the literal. His work influenced such abstract painters as Mark Rothko and Adolph Gottlieb. Fresh, original, and imaginative, Avery's paintings have been compared to those of Matisse.

SELECT BIBLIOGRAPHY

Hilton Kramer, *Milton Avery: Paintings, 1930–1960* (New York: A. S. Barnes, 1962) / Adelyn D. Breeskin, *Milton Avery*, exh. cat. (Washington, D.C.: National Collection of Fine Arts, 1970) / Stephanie Terenzio, *Milton Avery and the Landscape* (Storrs, Conn.: William Benton Museum of Art, University of Connecticut, 1976) / Bonnie Lee Grad, *Milton Avery* (Royal Oak, Mich.: Strathcona, 1981) / Robert Hobbs, *Milton Avery* (New York: Hudson Hills Press, 1990)

11 (see plate 3)

MILTON AVERY
The Green Settee, 1943
Oil on canvas; 27⁷/₈ × 36 in. (70.8 × 91.4 cm)
Signed at lower right: Milton / Avery

EXHIBITED: New York City, Paul Rosenberg Gallery, 1943 / Palm Beach, Fla., Society of Fine Arts, 1944

EX COLL.: with the Society of Fine Arts, Palm Beach, Fla., by 1944; to Mrs. Alexis Zalstem-Zalessky by 1944

Gift of Mr. and Mrs. Alexis Zalstem-Zalessky, 1964.280

Discussing *The Green Settee* in a letter, Avery wrote that he "made the sketch for this painting one evening at a friend's apartment. She [the friend] is sitting holding her little terrier—and beside her is my daughter March."[1] Figures, usually drawn directly from a model, dominated Avery's work throughout his career.[2] Most of his subjects were women engaged in conversation, reading, or daydreaming.

Avery simplified his subjects to flat, cutout shapes (note the outlines of the sofa, two figures, table, and plant) and provided no detail, instead using different colors to create emotion in his paintings. In *The Green Settee*, the green, pink, yellow, and blue come alive against the brown walls and maroon floor. March's pale skin in-

dicates her youth. The energetic black-and-white terrier the woman holds immediately draws the viewer's attention. Although the scene is amiable, it is not clear whether the two women are conversing or waiting. ERM

1. Milton Avery to Charles Cunningham, September 26, 1955, curatorial painting file, Wadsworth Atheneum.
2. Hilton Kramer, *Milton Avery: Paintings, 1930–1960* (New York: A. S. Barnes, 1962), 16.

Thomas Badger

Born in South Reading (now Wakefield), Mass., in 1792; died in Cambridge, Mass., in 1868

The itinerant portrait painter Thomas Badger was the son of Benjamin and Naomi Emerson Badger and the grandson of the Boston portrait painter Joseph Badger (1708–65). Along with the artist Alvan Fisher (q.v.), he received early artistic training from John Ritto Penniman (1782–1841) of Boston, and by 1814 he was painting miniature portraits in oil. In 1818 he married Rebecca Melendy, with whom he had five children.

Badger greatly admired the works of Gilbert Stuart (q.v.), Boston's leading portrait painter, and copied a number of his works. Between 1817 and 1845 he exhibited his own portraits and occasional still lifes at the American Academy of the Fine Arts in New York City, the Boston Athenaeum, and the National Academy of Design.

After Stuart's death in 1828, Badger competed for portrait commissions with Boston's two leading artists, Chester Harding (1792–1866) and Francis Alexander (1800–1880). Between the 1830s and 1860, he traveled frequently to Maine; he found ample portrait commissions in Kennebunk and Kennebunkport, and in New Brunswick he painted the faculty of Bowdoin College, including Henry W. Longfellow (1829, Wadsworth-Longfellow House, Portland). At the time of his death, he was not well known but was admired by many for his accomplishments as a portrait painter. As one memorialist wrote: "His paintings were remarkable for the directness of their perspective, for neatness and accuracy of their delineation; and for faithful representations of life"

(*New England Historical and Genealogical Register*, October 1868, as quoted in Barry, *Thomas Badger*, n.p.).

SELECT BIBLIOGRAPHY

Thomas Badger (1792–1868): Boston Portrait Painter in Kennebunk (Kennebunk, Maine: Brick Store Museum, 1964) / William David Barry, *Thomas Badger (1792–1868): Portrait of an American Painter*, exh. cat. (Kennebunk, Maine: Brick Store Museum, 1993)

12

THOMAS BADGER
Reverend George Wadsworth Welles, 1831
Oil on canvas; 26³/₄ × 22³/₈ in. (67.9 × 56.8 cm)
Signed and dated on the back: Rev. George W. Welles / Painted by T. Badger 1831

EX COLL.: Fenton Brown, Essex, Conn., to 1988

Gift of Fenton L. B. Brown, 1988.74

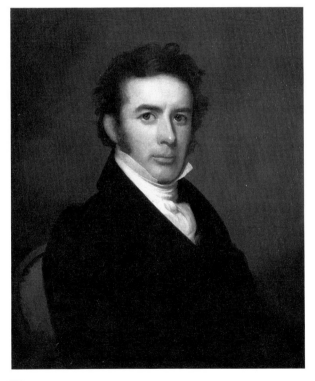

12

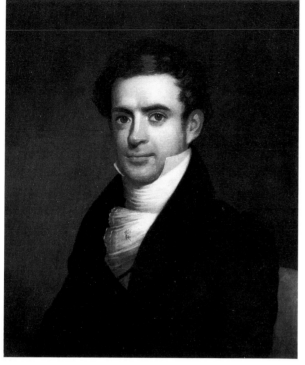

13

William Baptiste Baird

Born in Chicago, in 1847; died in Paris, after 1899

William Baptiste Baird spent most of his artistic career painting in London, Paris, and Brittany. Little is known of his early artistic training beyond the fact that he received instruction in Paris from the French artist Adolphe Yvon (b. 1817), the drawing instructor at the Ecole des Beaux-Arts from 1863 to 1883. Baird was a frequent exhibitor at the Salon exhibitions from 1872 until 1899, showing works on nearly a yearly basis. Many of these works were paintings of the Fontainebleau forest. While still living in Europe, Baird also exhibited genre and landscape paintings—among them, several views of Brittany—at the Chicago Academy of Design (1871–1875), the National Academy of Design (1875–1879), and the Royal Academy in London (1877–1899).

SELECT BIBLIOGRAPHY

James Yarnell and William Gerdts, *The National Museum of American Art's Index to American Art Exhibition Catalogues from the Beginning through the 1876 Centennial Year* (Boston: Hall, 1986), 1:158–159 / Christopher Wood, *Dictionary of Victorian Painters* (London: Antique Collector's Club, 1989), 6 / Lois Marie Fink, *American Art at the Nineteenth-Century Paris Salons* (Cambridge: Cambridge University Press, 1990)

13

THOMAS BADGER
James Welles, c. 1831
Oil on canvas; 26⅝ × 22¼ in. (67.6 × 56.5 cm)

EX COLL.: Fenton Brown, Essex, Conn., to 1988

Gift of Fenton L. Brown, 1988.75

Badger painted competent and attractive portraits of the two Welles brothers in 1831. Reverend George Welles is presented in a dignified manner, suitable to his role as minister; he wears a black coat and is seated in a red upholstered chair. His brother, James, in a somewhat livelier portrayal, is similarly attired, though his white ruffled shirt and pearl-and-gold pin make him appear more fashionable. EMK

14

WILLIAM B. BAIRD
Hens and Chicks, 1878
Oil on panel; 8¼ × 6¼ in. (21.0 × 15.9 cm)
Signed and dated at lower right: W. B.
Baird / Paris / 187[last digit illegible]
Inscribed on reverse: W B Baird / Paris 1878

EX COLL.: Mr. and Mrs. Charles Dudley Warner, Hartford; to Mary Barton, Hartford, by 1938

Gift of Miss Mary Barton from the collection of Mr. and Mrs. Charles Dudley Warner, 1938.186

Baird was living in Paris when he painted *Hens and Chicks*, as the artist's inscription on the painting indi-

14

cates. Farmyard scenes were favorite subjects of the artist and popular during the period. The genre of animal painting and portraits of animals had been made popular at midcentury by Rosa Bonheur and other European artists.[1] The prominent Hartford author and editor Charles Dudley Warner (1829–1900; cats. 181, 182) bought the painting and bequeathed it to his close friend Mary Barton.[2] EMK

1. Lois Marie Fink, *American Art at the Nineteenth-Century Paris Salons* (Cambridge: Cambridge University Press, 1990), 227.
2. Curatorial painting file, Wadsworth Atheneum.

George C. Baldwin

Born in Thompson, Conn., about 1818; died (probably) in Thompson, Conn., after 1879

The little-known artist George Baldwin was included in H. W. French's history of artists working in Connecticut, published in 1879. He is thought to have spent most of his life in his hometown, where he attended the local schools. After purportedly studying portraiture in nearby Norwich, he worked as a portrait painter in the region. Several signed works by Baldwin are known, including *Child with Whip* (1841, Boston, Museum of Fine Arts).

SELECT BIBLIOGRAPHY

H. W. French, *Art and Artists in Connecticut* (Boston: Lee and Shepard; New York: Charles Dillingham, 1879), 162

15

GEORGE C. BALDWIN
Grace Weld (Young) Weatherby, c. 1853
Oil on canvas; oval 24 × 19⅞ in. (61.0 × 50.5 cm)

EX COLL.: descended in the sitter's family, Jewett City, Conn., to the sitter's son, C. Alfred Weatherby, and his wife, before 1957

Bequest of Mrs. C. Alfred Weatherby, 1957.650

15

The subject of this portrait was Grace Young (1852–1928), the daughter of Alfred Avery Young and Sarah Atwood Young of Jewett City, Connecticut. The child, who was one or two at the time, is presented unclothed, emerging from clouds in the sky. The unusual composition is reminiscent of the many posthumous images of infants and young children produced in the nineteenth century by such itinerant portrait painters as Joseph Whiting Stock (q.v.). However, given that the subject lived to the age of seventy-six, perhaps the artist simply wished to present her as a cherub. EMK

James Bard

Born in New York City, in 1815; died in White Plains, N.Y., in 1897

John Bard

Born in New York City, in 1815; died in Blackwell's Island, N.Y., in 1856

Born in a house overlooking the Hudson River, the Bard twins, John and James, painted their first portrait of a steamboat as a joint effort when they were twelve. As prolific marine artists during the heyday of shipbuilding in New York City, they were single-minded, focusing exclusively on ship portraits, mainly steamboats but also tugs and sailing craft that plied the Hudson and East Rivers. They painted together until 1849, generally cosigning their works, many of which were watercolors. In 1846 the Bards painted depictions of sixteen steamboats owned by the Union Ferry Company of Brooklyn. The entire group of paintings hung in the Fulton Street offices of the company's director until 1890, when they were loaned to the Long Island Historical Society—now the Brooklyn Historical Society—where they have remained.

John experienced a mysterious decline, disappearing from records in 1850, and ended up on Blackwell's Island, a penal colony in the East River, where he died in an almshouse six years later. James continued to paint, mainly in oil, until the end of the century. His patrons included shipowners, shipbuilders, and captains. At the time of James's death, his close friend Samuel Ward Stanton, a fellow steamboat artist and historian, wrote a highly informative obituary, calling him the "last of New York's old-time marine artists" and noting that in the course of his long career Bard "made drawings of almost every steamer that was built or owned around the port of New York." Stanton estimated James's total production at four thousand works, an astonishing figure given the artist's meticulous attention to detail. "Before making his drawing," Stanton wrote, "Mr. Bard would measure the boat to be pictured end to end, and not a panel, stanchion, or other part of the vessel, distinguishable from the outside, was omitted; each portion was measured and drawn to scale" (Stanton, obituary, 86). His latest signed work, the watercolor *Saugerties* (private collection), was executed in 1890 and signed "J. Bard N. Y. 75 years." Despite his lengthy, productive career, however, the artist was buried in the White Plains Cemetery in a section reserved for indigents. The Bards remained little known as marine painters until the middle of this century, when collectors of folk art began taking an interest in their paintings.

SELECT BIBLIOGRAPHY

Samuel Ward Stanton, obituary, *Seaboard Magazine*, April 1, 1897, 86 / Harold S. Sniffen and Alexander C. Brown, "James and John Bard: Painters of Steamboat Portraits," *Art in America* 37 (April 1949), 58–78 / Anthony J. Peluso, Jr., *J. and J. Bard: Picture Painters* (New York: Hudson River Press, 1977) / Harold S. Sniffen, "James and John Bard," in *American Folk Painters of Three Centuries*, ed. Thomas Armstrong and Jean Lipman, exh. cat. (New York: Whitney Museum of American Art, 1980), 52–57 / Elizabeth Mankin Kornhauser, entries for John and James Bard, in Linda Ferber and E. M. Kornhauser, *Brooklyn Before the Bridge: American Paintings from the Long Island Historical Society*, exh. cat. (Brooklyn, N.Y.: Brooklyn Museum, 1982), 30–43, 126–127

16 (see plate 4)

JAMES BARD AND JOHN BARD

The Armenia, 1848

Oil on canvas; 29³/₁₆ × 49³/₁₆ in. (74.1 × 125.0 cm)

Signed in yellow script at lower right: James & John
 Bard N. Y. / Painters / 1848

Signed in white block letters at lower right: Jas. Bard.
 Painter. 1848. NY

Inscribed and dated in yellow script at bottom left:
 Thomas Collyer Builder N Y 1848

Inscribed in yellow script at bottom center: John F.
 Tallman Commander

Inscribed in yellow script at bottom right: Ridgeway
 Joiner

Canvas stamp on back: Prepared / By / EDwd. Dechaux /
 New York

Technical note: Extensive damage and overpaint are
 visible throughout the sky and to a lesser extent
 in other areas of the canvas, especially along the
 bottom edge.

EXHIBITED: Wadsworth Atheneum, "The Hudson River
School: Nineteenth-Century Landscapes in the Wadsworth
Atheneum," 1976, no. 28

EX COLL.: with Arnold Seligmann, Rey and Co., New York
City, by 1943

The Ella Gallup Sumner and Mary Catlin Sumner Collection
Fund, 1943.102

Captain John Tallman, a notorious New York steamboat captain and owner, co-owned with his colleague Thomas Collyer the steamboat *Armenia*, which they launched in 1848.[1] The Bards (or possibly James Bard alone) painted the *Armenia* in the same year.

The Bards' paintings of ships always show the vessel in profile and usually from the port side. Although the background appears static, the artists insinuate the vessel's movement with sprays of water shown as white dots emanating from the churning paddle wheel and at the bow. Black smoke billows from the tall smokestack. Here, in typical fashion, passengers and crew, wearing black top hats and long black coats, are awkwardly placed along the decks either enjoying the view or at key positions to operate the boat. Great care is taken in the depiction of the vessel, which is identified by the inscription across the side of the boat and the banners flying at bow and stern.

The Bards gave only modest attention to the backgrounds of their paintings, in this case, faintly depicting a distant shoreline. Sailboats and a second steamboat dot the distant river, and an expansive, cloud-filled blue sky is seen above. The artists typically provided detailed information on the shipowners and captain—and in this case the joiner—in inscriptions across the bottoms of their paintings. The work is signed jointly as well as singly by James; thus it remains unclear whether this painting was a truly collaborative effort or completed mainly by James.

James Bard, *Armenia.* Courtesy Mariners' Museum, Newport News, Virginia.

Two other versions of this painting are known (Shelburne Museum, Shelburne, Vt., and private collection). A working drawing for the Atheneum's painting carries the following pencil inscription by the artist(s): "188 feet 28 foot wheel 14 foot stack."[2] EMK

1. Anthony J. Peluso, Jr., *J and J Bard: Picture Painters* (New York: Hudson River Press, 1977), 24, 29–32, 113.
2. Anthony Peluso to the Wadsworth Atheneum, January 3, 1983, curatorial painting file, Wadsworth Atheneum.

Gifford Beal

Born in New York City, in 1879; died in New York City, in 1956

After graduating from Princeton University in 1900, Gifford Beal received early artistic instruction under William Merritt Chase (q.v.) at his school in Shinnecock, Long Island. He later studied with Henry Ward Ranger (q.v.) at the Art Students League in New York City and briefly with Frank Vincent DuMond, attending his life class at the Art Students League in 1903. Beal became a member of the league in 1916, serving as its president from that date until 1930; later he taught there as well. He became a member of the National Academy of Design in 1914.

Beal painted vivid images of favored motifs, including circus themes, New York's Central Park, and maritime scenes. He became a teacher at the Hartford Art School in the 1920s, and in 1927 an exhibition of his paintings and watercolors was held in the Morgan Memorial at the Atheneum. After Beal's death he was honored with a memorial exhibition at the Kraushaar Art Galleries in New York City.

SELECT BIBLIOGRAPHY

Gifford Beal: Paintings and Watercolors, exh. cat. (Washington, D.C.: Phillips Collection, 1971) / *Gifford Beal, 1879–1956: A Centennial Exhibition* (New York: Kraushaar Art Galleries, 1979) / Ronald G. Pisano, *The Art Students League*, exh. cat. (Huntington, N.Y.: Heckscher Museum, 1987)

17

17

GIFFORD BEAL
Sea Gulls, c. 1926
Oil on canvas; 54¼ × 36⅛ in. (137.8 × 91.8 cm)
Signed at the lower right: Gifford Beal

EXHIBITED: New York City, Kraushaar Art Galleries, and Andover, Mass., Phillips Academy, "Gifford Beal," 1932

Gift of George Gay, 1926.1264

Probably painted near his summer home in Rockport, Massachusetts, *Sea Gulls* is an exuberant depiction of gulls flying over the ocean, a favorite motif of Beal's. The artist considered the work to be "the best gull picture" he had painted and requested that it be included in an exhibition at the Kraushaar Art Galleries in 1932.[1] His son, William R. Beal, later wrote of his father's work: "He was completely engrossed in the American scene, though never bothering about making any social commentary."[2] EMK

1. Gifford Beal to A. Everett Austin, November 28, 1931, curatorial painting file, Wadsworth Atheneum.
2. Quoted in *Gifford Beal: Paintings and Watercolors*, exh. cat. (Washington, D.C.: Phillips Collection, 1971), 13.

William Holbrook Beard

Born in Painesville, Ohio, in 1824; died in New York
City, in 1900

William Holbrook Beard and his older brother,
James Henry Beard, were specialists in animal painting.
Both the Beards' paintings, and William's in particular,
were humorous, sometimes satirical commentaries on
human foibles. Henry Tuckerman wrote that this was
"the peculiar kind of genre painting in which Beard ex-
cels; his perception of animal character and expression
is sympathetic and acute; and the result of this faculty
united to his original comic vein is a unique combination
of the naturalist and the humorist in art" (Tuckerman,
Book of the Artists, 498). William's work was often com-
pared by his contemporaries with that of the English
animal painter Sir Edwin Landseer (1802–73) (Ben-
jamin, *Our American Artists*, and Sheldon, *American
Painters*).

Beard spent the first twenty-five years or so of his
life in Ohio, where he was educated and began painting
portraits. He was not successful at portrait painting,
however; he made little attempt to flatter his sitters and
often exaggerated their unfortunate characteristics to
the delight of all but the subjects themselves.

At around twenty-five, he moved to Buffalo, N.Y.,
where he set up a studio. There he made a number of ac-
quaintances, including artist Thomas LeClear (1818–
1882)—who in 1863 became his father-in-law—Lars
Sellstedt, Matthew Wilson, and William John Wilgus, all
of whom were expatriates. In 1856 the artist traveled to
Europe, visiting Düsseldorf, Switzerland, and Rome.
In Italy, he met a number of American artists, among
them, Sanford Gifford (q.v.), Worthington Whittredge
(1820–1910), and Albert Bierstadt (q.v.). In Düsseldorf,
where genre painting was held in high esteem, he un-
doubtedly met Emanuel Leutze (q.v.).

Beard returned to Buffalo in 1858 and began sending
his animal and fantasy pictures to the National Academy
of Design in New York City. During this period he also
exhibited at Snedicor's Art Gallery, on Broadway. The
following year, he married his first wife, Flora Johnson,
who was the granddaughter of the first mayor of Buf-
falo. Her early death—she died only months after their
marriage—may have prompted Beard to leave Buffalo
for New York City the following winter. He moved into
the Tenth Street Studio Building, remaining there for
the rest of his career, and continued to exhibit at the
National Academy and Snedicor's, as well as at Samuel
P. Avery's and William and Everett's. He also exhibited
at the Boston Athenaeum and at the Pennsylvania Acad-
emy, in Philadelphia. In 1873 he exhibited in Hartford,
at the Connecticut School of Design.

Beard was elected an academician at the National
Academy in 1862. He wrote two books, *Humor in Ani-
mals* (1885) and *Action in Art* (1893), and a long poem,
The Spade (1894). In *Action in Art*, he expressed his in-
terest in the animal locomotion studies of Eadweard
Muybridge: "The question is not, How does Nature do
it? but, How does she *seem* to do it? The first is the
question of science, the latter that of art" (quoted in
Haverstock, *An American Bestiary*, 167). In 1866 he
traveled west to Colorado with writer Bayard Taylor,
but this trip seems to have had little effect on his choice
of subject matter for painting. In 1871 he designed a se-
ries of animals sculpted out of rock, which was to have
been part of an underground entrance to a museum
planned for the site where the Museum of Natural His-
tory in New York City now stands. He also completed
some small models of animals in preparation for his
paintings and designed at least two large sculptural
monuments that were never executed.

Although he was best known as "a painter of bears
and monkeys" (Sheldon, *American Painters*, quoted
in Gerdts, *William Holbrook Beard*, 12), Beard also
painted such diverse subjects as Native Americans,
scenes from fairy tales and Charles Dickens, and, par-
ticularly in his later years, religious and allegorical
subjects.

SELECT BIBLIOGRAPHY

DAB, 2:95–96 / James Jackson Jarves, *The Art-Idea*, ed. Ben-
jamin Rowland, Jr. (1864; rpt., Cambridge: Harvard University
Press, Belknap Press, 1960), 183 / Henry T. Tuckerman, *Book
of the Artists: American Artist Life* (New York: Putnam, 1867),

498–501 / G. W. Sheldon, *American Painters*, rev. ed. (New York: D. Appleton, 1881), 56–60 / S. G. W. Benjamin, "An American Humorist in Paint: William H. Beard, N.A.," *Magazine of Art* 5 (1882), 14–19 / Clara Erskine Clement and Laurence Hutton, *Artists of the Nineteenth Century and Their Works*, rev. ed. (1884; rpt., St. Louis: North Point, 1969), 1:43–44 / Mary Sayre Haverstock, "An American Bestiary," *Art in America* 58 (July–August 1970), 38–71 / S. G. W. Benjamin, *Our American Artists*, 1879; *Our American Artists*, 1881, ed. H. Barbara Weinberg (New York and London: Garland, 1977) / Mary Sayre Haverstock, *An American Bestiary* (New York: Abrams, 1979) / William H. Gerdts, *William Holbrook Beard: Animals in Fantasy* (New York: Alexander Gallery, 1981) / Matthew Baigell, *Dictionary of American Art* (New York and London: Harper and Row, 1982), 29 / Richard J. Koke, *A Catalog of the Collection, Including Historical, Narrative, and Marine Art* (Boston: G. K. Hall, for the New-York Historical Society, 1982), 1:32–33 / Annette Blaugrund, *The Tenth Street Studio Building* (Ann Arbor: University Microfilms International, 1992), 361–62

18

WILLIAM H. BEARD

Mountain Stream and Deer, 1865

Oil on canvas; 37 × 29 in. (94.0 × 73.7 cm)

Signed at lower left on rock: W. H. Beard / 1865

EXHIBITED: possibly New York City, Century Association, November 7, 1874, no. 2, as "Autumn (with Deer)"

EX COLL.: Elizabeth Hart Jarvis Colt, Hartford, to 1905

Gift of Elizabeth Hart Jarvis Colt, 1905.16

Mountain Stream and Deer is typical of the animal paintings American academic painters were making in the nineteenth century; it draws on the American landscape painter's use of animals to help convey mood and idea. When pictured singly, deer symbolized solitude and, in conjunction with such elements as a mountain stream and unspoiled forest wilderness, communion with nature.[1] Beard's painting, which includes two deer, may suggest interrupted solitude.[2]

Beard painted a few landscapes early in his career, and this painting is as much about the vivid autumn landscape as it is about the animals in it. Given the popularity of landscapes at this time, it is likely that he painted this work with the intention of selling it quickly. Elizabeth Colt, who gave this painting to the Atheneum, bought a number of paintings from artists in New York City and may well have purchased this work at Beard's Tenth Street Studio. *Mountain Stream and Deer* hung on the east wall of her picture gallery, over Frederic Church's *Vale of St. Thomas, Jamaica* (cat. 116) and next to John F. Kensett's *Mount Washington from the Conway Valley* (cat. 310). AE

1. Mary Sayre Haverstock, "An American Bestiary," *Art in America* 58 (July–August 1970), 52, 57.
2. If *Mountain Stream and Deer*, dated 1865, is a picture of interrupted solitude, then one could speculate that its meaning is related to the Civil War, which ended in 1865 and severely disrupted the way Americans viewed their country. William H. Gerdts has made a connection between one of Beard's paintings, *Power of Death* (undated, Alexander Gallery, New York City), and the Civil War but does not believe the Atheneum's painting to be so connected. See William H. Gerdts, *William Holbrook Beard: Animals in Fantasy* (New York: Alexander Gallery, 1981), 11, and Gerdts to Amy Ellis, May 26, 1993, curatorial painting file, Wadsworth Atheneum. Henry Tuckerman mentioned another painting of deer by Beard, exhibited at the National Academy of Design in New York City: "A fine buck is listening with that vigilant timidity peculiar to these wild and beautiful creatures; his antlers are thrown back, his ears forward; his eyes protrude, his tail is stiffened; it seems as if he heard from afar the echo of a hunter's horn or the stealthy tread of an enemy; a doe and fawn seem patiently and tenderly to await the result of this intent listening" (*Book of the Artists: American Artist Life* [New York: Putnam, 1867], 49). This is probably *Startled Deer*, exhibited at the National Academy in 1863, in the middle of the Civil War, as no. 197.

19

WILLIAM H. BEARD

The Dog Congress (Candidates for Bench Show), c. 1876

Oil on canvas; 19½ × 29⅜ in. (49.5 × 74.6 cm)

Signed at lower left: W. H. Beard.

EXHIBITED: Wadsworth Atheneum, "In Memoriam, an Exhibition of Paintings under $1000," 1942, no. 6 / New York City, Alexander Gallery, "William Holbrook Beard: Animals in Fantasy," 1981, no. 36

18

CATALOGUE NUMBER 19

19

EX COLL.: with Arnold Seligmann, Rey and Co., New York City 1941

Purchase, 1942.443

The subject of this grisaille—which was engraved—is probably the contemporary political scene; the painting appears to liken congressional elections to the judging of a dog show. Beard painted a number of satires of American institutions: Wall Street was the subject of at least two of his paintings, *Bulls and Bears of Wall Street* (1879, New-York Historical Society) and *The Bear Dance* (or *The Wall Street Jubilee*, undated, New-York Historical Society).[1]

In this presumed lampoon of Congress (it could be either local or federal), Beard depicted that august legislative body as a disorganized mob rent by factions and individual petty disputes. One dog has caught the attention of one of the presiding animals, but the other three appear distracted or attentive to other activities in the room. Other dogs on the floor face off contentiously, while some try to see over the crowd by getting up on their hind legs and leaning on their neighbor's backs; others turn their backs on the stage. In an ample display of his talent for anthropomorphizing, Beard has given each dog a distinct character and personality.[2]

Beard's pictorial satire of contemporary politics was in keeping with the increasing use of animals in political cartoons in the editorial and comic pages of newspapers and relates to the much older tradition of caricature.[3] It drew criticism, however, from the contemporary press, which called his painting "the veriest dregs of a peculiarly repulsive species of presumptive ethical teaching."[4] George Sheldon criticized both Beard's and Sir Edwin Landseer's use of dogs as a metaphorical example of what he considered to be the weakness in their animal paintings: "Each of these artists has fallen into the error of ascribing human emotions and thoughts to animals, when a profounder study would have shown them that a dog's ways are not a man's ways."[5] With this remark, Sheldon missed the point of a painting like *Dog Congress*, which uses animals only as a vehicle for satirizing human behavior, not as a point of comparison. AE

1. William H. Gerdts, *William Holbrook Beard: Animals in Fantasy* (New York: Alexander Gallery, 1981), 11–12. Gerdts discusses two other paintings by Beard that may or may not have political themes: *The Witches' Convention* (1876, private collection) and *The Wreckers* (1874, Museum of Fine Arts, Boston). He suggests that the former could be a comment on one of the political conventions of that election year and that the latter might be an editorial on the political and social distress in Boss Tweed's New York City.

2. S. G. W. Benjamin described another painting by Beard, *The Mass Meeting*, the crowd scene of which may be similar to *The Dog Congress:* "'The Mass Meeting' is a mild satire on the political gatherings which are such a prominent feature of politics in America. We see before us a crowd of monkeys in men's garb, who are so skilfully [*sic*] and individually rendered that each represents a type of human character. Some are collected in knots sagely discussing the questions at issue, while others, again, are listening to the harangue of a demagogue ape who, from the desk on the platform, vehemently hurls a volley of partisan arguments at his audience" ("An American Humorist in Paint: William H. Beard, N.A.," *Magazine of Art* 5 [1882], 18).

3. Thomas Nast was the most prominent cartoonist of Beard's day and frequently lambasted Tammany Hall through a character known as the "Tammany Tiger." See Gerdts, *William Holbrook Beard*, 12; and Mary Sayre Haverstock, "An American Bestiary," *Art in America* 58 (July–August 1970), 62.

4. As quoted in Haverstock, "American Bestiary," 62. No source for the quote is given in Haverstock's article. S. G. W. Benjamin seemed to defend Beard against his critics when he wrote, "The prominence he has acquired as a satirist or teacher of morals does not, however, lead him to transgress the great law which so many painters of our time, as well as such critics as Taine, insist upon as fundamental—the principle that the true artist has no business to be a teacher, that is, to paint with a direct moral purpose in view. . . . It is no disparagement to his art, but rather an evidence of the extent of his powers, that . . . he has by his pictorial apologues allied himself to the great school of teachers and observers of which Aesop, Lafontaine, and Gay are such illustrious examples" ("An American Humorist," 19).

5. G. W. Sheldon, *American Painters*, rev. ed. (New York: D. Appleton, 1881), 60.

Cecilia Beaux

Born in Philadelphia, in 1855; died in Gloucester, Mass., in 1942

Cecilia Beaux was the daughter of a French silk manufacturer and his wife, Cecilia Kent Leavitt, a woman from a highly cultivated Philadelphia family. When his wife died, only twelve days after the birth, Cecilia's father returned to France, leaving the baby and her sister in the care of her maternal grandmother and two aunts. In this environment, Beaux's creative abilities and interest in the arts were nurtured. Perhaps her earliest lessons in drawing were provided by her aunt Eliza Leavitt; later, when Beaux was sixteen, Catherine Drinker (whose brother would later marry Cecilia's sister) gave her lessons in drawing and copying art.

Beaux attended a class in Philadelphia led by a Dutch artist, Adolf Van der Whelen, in 1872 or 1873, where she learned to copy lithographs and make drawings from antique casts and animal bones. Around 1875 she was hired to make drawings of fossils for the United States Geological Survey. Also during this time, she learned overglaze painting on porcelain, a technique she used to help support herself through commissions for children's portraits on ceramic plaques. By the end of the decade, Beaux was teaching art at a girls' school in Philadelphia.

Although she is listed as having registered for the years 1877 and 1878–1879, Beaux later denied having been enrolled at the Pennsylvania Academy of the Fine Arts, where Thomas Eakins (q.v.) was teaching during this period. Beaux's first exhibition at the Pennsylvania Academy took place in 1879.

Between 1881 and 1883 Beaux and a friend worked from models and received criticism from William Sartain (1843–1924) every two weeks. In 1884 Beaux completed her first important painting, *Les Derniers Jours d'Enfance* (Mrs. Henry Saltonstall, Stratham, N.H.), a portrait of her sister, Aimée Drinker, and her nephew, which in 1885 received the Mary Smith Prize from the Pennsylvania Academy. Beaux was awarded this prize three more times during her career: in 1887, 1891, and 1892.

Beaux made her first trip to Europe in 1888. Enrolling in the Académie Julian in Paris, she attended classes taught by William Bouguereau and Tony Robert-Fleury. After spending the summer in Brittany, where she painted landscapes and peasants alongside Alexander Harrison (1853–1930), Arthur Hoeber (1854–1915), and Charles A. C. Lasar (1856–1936), she traveled to Switzerland and Italy, finally returning to Paris in 1889 to study at the Atelier Colarossi with Pascal Adolphe Jean Dagnan-Bouveret and Gustave Courtois and privately with Jean Joseph Benjamin-Constant.

Back in Philadelphia in August 1889, Beaux took portraits in oil and pastel. After the death of her grand-

mother in 1892, she spent more time in New York City, where she stayed with her friends, the writer and editor Richard Watson Gilder and the artist Helena de Kay (c. 1846–1916) and met critics Mariana Van Rensselaer and Leila Mechlin and artists John La Farge (1835–1910) and Augustus Saint-Gaudens (1848–1907). In 1893 she was elected to the Society of American Artists and received the Gold Medal of the Philadelphia Art Club and the Dodge Prize from the National Academy of Design. In 1895, while visiting her cousin Julia Leavitt in Washington, Connecticut, she painted her portrait, the well-known *New England Woman*. That same year, she began teaching drawing and painting at the Pennsylvania Academy of the Fine Arts, continuing intermittently until 1915.

It was during the 1890s that Beaux achieved her mature painting style, characterized by originality in composition and fluid brushwork. She returned to Europe in 1896, visiting France, where she had five paintings on view at the Champs de Mars exhibition, and England, where, at the Royal Academy, she saw works by John Singer Sargent (q.v.), with whose work her own is often compared. That year, she was elected an associate of the Société Nationale des Beaux Arts. In 1897, at the St. Botolph Club in Boston, she had her first major exhibition.

Beaux went on to receive a number of prestigious awards, including the Gold Medal of Honor from the Pennsylvania Academy (1898), the Gold Medal from the Carnegie Institute (1899), and the Gold Medal from the Paris Exposition (1900), as well as an honorary master of arts degree from Yale University (1912) and the Gold Medal from the Chi Omega Club (1933), in recognition of her contribution to world culture. In addition, she was awarded important portrait commissions, among them, a double portrait of Mrs. Theodore Roosevelt and her daughter (1901–02). In 1917, she painted a portrait of Robert Bolling Brandegee (q.v.), a painter then living and working in Farmington, Connecticut; the portrait hangs today in the Village Library in Farmington. In 1919 she was appointed official portraitist by the United States War Portraits Commission to paint portraits of Cardinal Mercier, Admiral Beatty, and Georges Clemen-

ceau. In 1924 she was invited by the Ministry of Public Instruction to paint a self-portrait for the Uffizi Gallery, a work she completed in 1925.

Beaux did not complete many paintings after 1924, when she broke her hip in Paris and found it increasingly difficult to get around; she also suffered from cataracts. Among those she did execute were the Atheneum's portrait of George Dudley Seymour (cat. 20) and a portrait of A. A. Welch, then president of the Phoenix Mutual Life Insurance Company of Hartford. She also worked on her autobiography, *Background with Figures*, which was published in 1930. In 1935 a large exhibition of her work was held at the American Academy of Arts and Letters, from which she received the Gold Medal in 1925 and to which she had been elected in 1933.

SELECT BIBLIOGRAPHY

Letters from George Dudley Seymour to Leila Mechlin, Archives of American Art, roll P14, Philadelphia Archives of American Art Papers / Mrs. Arthur Bell, "The Work of Cecilia Beaux," *International Studio* 8, no. 32 (October 1899), 215–222 / Cecilia Beaux, *Background with Figures: Autobiography of Cecilia Beaux* (Boston: Houghton Mifflin, 1930) / Royal Cortissoz, *A Catalogue of an Exhibition of Paintings by Cecilia Beaux* (New York: American Academy of Arts and Letters, 1935) / Thornton Oakley, *Cecilia Beaux* (Philadelphia: Howard Biddle Printing, 1943) / Henry S. Drinker, *The Paintings and Drawings of Cecilia Beaux*, exh. cat. (Philadelphia: Pennsylvania Academy of the Fine Arts, 1955) / Frederick D. Hill, "Cecilia Beaux, the *Grande Dame* of American Portraiture," *Antiques* 105 (January 1974), 160–168 / Barbara Whipple, "The Eloquence of Cecilia Beaux," *American Artist* 38 (September 1974), 174 / Frank H. Goodyear, Jr., *Cecilia Beaux: Portrait of an Artist*, exh. cat. (Philadelphia: Pennsylvania Academy of the Fine Arts, with Museum of the Philadelphia Civic Center and Indianapolis Museum of Art, 1974) / Elizabeth Graham Bailey, "Cecilia Beaux: Background with a Figure," *Art and Antiques* 3 (March/April 1980), 59–60 / Doreen Bolger Burke, *American Paintings in the Metropolitan Museum of Art*, ed. Kathleen Luhrs (New York: Metropolitan Museum of Art, 1980), 3:200–206 / Gail Levin, Alessandra Comini, and Wanda M. Corn, *American Women Artists 1830–1930*, exh. cat. (Washington, D.C.: National Museum of Women in the Arts, 1987), 8–10 /

Diana Strazdes, *American Paintings and Sculpture to 1945 in the Carnegie Museum of Art* (New York: Hudson Hills Press, in association with the Carnegie Museum of Art, 1992), 60–62

20

CECILIA BEAUX
The Green Cloak, 1925
Oil on canvas; 72 × 45½ in. (182.9 × 115.6 cm)
Signed at lower left: Cecilia Beaux

EXHIBITED: Pittsburgh, Pa., International Exhibition, Carnegie Institute, 1925 / Philadelphia, Pennsylvania Academy of the Fine Arts, 1926, "One Hundred Twenty-first Annual Exhibition," no. 166, as "The Green Cloak" / Buffalo, N.Y., Albright Gallery, 1926 / New York City, American Academy of Arts and Letters, 1935, "Exhibition of Paintings by Cecilia Beaux," no. 8, as "George Dudley Seymour" / Philadelphia, Pennsylvania Academy of the Fine Arts, 1955, "The Paintings and Drawings of Cecilia Beaux"

EX COLL.: George Dudley Seymour, New Haven, Conn., to 1945; on loan to Mrs. Morton C. Treadway, Bristol, Conn., to 1983

Gift from the Estate of George Dudley Seymour, 1983.683

In her autobiography, Beaux writes about meeting the subject of this painting, George Dudley Seymour, on her return trip from Europe to the United States in 1889. The artist describes her first meal on the ship with humor and then continues, "At the next meal, three unexceptionable persons sat in line next us, profiles turned straight out." One of these was Seymour, whom Beaux goes on to characterize as "a lifelong friend."[1]

The Atheneum's portrait of Seymour shows Beaux's friend seated in profile in a room furnished with, among other objects, two silver candlesticks, perhaps a reference to Seymour's collections.[2] Seymour objected to their inclusion in the picture and wrote to the critic Leila Mechlin, a friend of both his and Beaux's, "You will see my portrait at Pittsburg [*sic*]. . . . I want her to paint out the Charles II candlesticks."[3]

Other aspects of the painting also bothered Seymour. In another letter to Mechlin, he wrote, "I am far from the dreamer portrayed by Miss B. but when was a man or a woman pleased with his or her portrait?" He continued, "I am painted in the cloak and hat wh[ich] Mr. [John Singer] Sargent so raved about when he came to see me at the B.-P. with Alden Weir."[4] Seymour's green cloak, for which the portrait is named, was described by him as "an ancient linsey-woolsey riding cloak found long ago in a garret in Nut Plain, Guilford [Connecticut]." Seymour showed the cloak to Beaux, who, in Seymour's words, "insisted on having the author wear it when sitting for his portrait."[5]

Royal Cortissoz wrote, "'The Dreamer,' the 'Man with a Cat,' the 'Ernesta,' the 'Sita and Sarita,' the 'New England Woman,' 'the George Dudley Seymour,' all testify to this gift of [Beaux's] for lifting a portrait out of convention and giving it the accent of life instead of that of the studio."[6] Cortissoz, who knew both Beaux and Seymour well, saw the picture by early November 1925 and wrote that he "was delighted with it, partly on [Seymour's] account and partly for its own sake as a painting. In that latter capacity it struck me right off. . . . [Beaux] made a picture out of her portrait—which she doesn't always do—and it is really 'The Green Cloak,' making the most of that motif. It is well painted, too, altogether a successful and admirable piece of work."[7]

Beaux painted Seymour's portrait late in her career, and *The Green Cloak* does not exhibit the variety of fabric textures and patterns characteristic of her earlier paintings. However, the fact that she pays particular attention to the cloak itself, with its deep blue collar and green cape—even going so far as to name the portrait for it—is in keeping with other paintings in her oeuvre. An oil sketch for the Atheneum's painting, dated 1924–1925, reveals that the candlesticks to which Seymour objected were not part of her original conception. Other changes include the table, which is round in the sketch, and Seymour's hat, which the artist moved from the floor to a chair in the final portrait. The subject's seated position, in profile, remains the same.[8]

Seymour, who worked as a patent attorney in New Haven as well as being a historian and collector, was born in Bristol, Connecticut, in 1859, and died in New

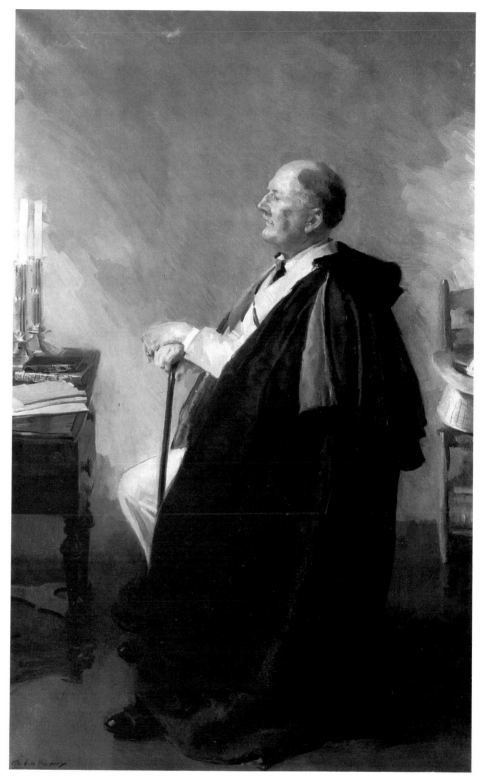

20

Cecilia Beaux, *Sketch for Portrait of George Dudley Seymour*, 1924–1925. Fogg Art Museum, Harvard University Art Museums, gift of Dr. Cecil K. Drinker.

Haven in 1945. He belonged and contributed to many cultural institutions in Connecticut, among them, the Connecticut Historical Society, for which he served as vice president for several years, and the Wadsworth Atheneum, of which he was a trustee. AE

1. Cecilia Beaux, *Background with Figures: Autobiography of Cecilia Beaux* (Boston: Houghton Mifflin, 1930), 193.
2. Seymour was a well-known collector of American antiques and had a particular interest in the decorative arts. He possessed a collection of colonial silver. See Elizabeth Stillinger, *The Antiquers* (New York: Knopf, 1980), 90, 92.
3. George Dudley Seymour to Leila Mechlin, September 25, 1925, Archives of American Art, roll P14, frame 341, Philadelphia Archives of American Art Papers.
4. Seymour to Mechlin, December 28, 1925, frames 342–343. "The B.-P." refers to "The Birth-Place," Seymour's name for Nathan Hale's homestead in Coventry, Connecticut. Seymour bought the abandoned Hale mansion in 1914 and restored it as a memorial to Hale. Seymour also purchased Hale's grandmother's house, which stood just across the street from "The Birth-Place," and kept it as a country home for years. See Stillinger, *The Antiquers*, 92. Seymour devoted much of his scholarly activity to Hale and wrote, among other things, *A Documentary Life of Nathan Hale* (New Haven, 1941). See Stillinger, *The Antiquers*, ch. 9, 88–94; and Mary E. Baker, "A Born Antiquarian: George Dudley Seymour, 6 October 1859–21 January 1945," *Connecticut Antiquarian* 41, no. 1 (winter 1990), 11–28.
5. George Dudley Seymour, "'The Green Cloak,' Portrait of the Author, Painted in 1925 by Cecilia Beaux," typed on Seymour's monogrammed stationery, curatorial painting file, Wadsworth Atheneum. Seymour noted that this type of cloak was worn by mounted officers during the American Revolution, information he learned from the artist Francis Davis Millet (1846–1912). A number of photographs of Seymour picture him in the attire he wears in Beaux's portrait: a white linen suit, the green cloak with the blue velvet collar, his cane, and top hat. On holidays and in the summer, Seymour dressed in colonial costume and gave visitors tours through the house. See Baker, "A Born Antiquarian," 11, 14–15.
6. Royal Cortissoz, "The Portraiture of Miss Cecilia Beaux," unidentified source, article on the 1935 exhibition at the American Academy, curatorial painting file, Wadsworth Atheneum.
7. Royal Cortissoz to John Walter Cross, November 6, 1925, Bound Scrapbooks, Archives of American Art, roll N54, frame 19, New York Public Library Art Division.
8. Two other drawings of Seymour by Beaux exist, both in the collection of one of Seymour's descendants in 1955. See Henry S. Drinker, *The Paintings and Drawings of Cecilia Beaux*, exh. cat. (Philadelphia: Pennsylvania Academy of the Fine Arts, 1955), 95.

James Carroll Beckwith

Born in Hannibal, Mo., in 1852; died in New York City, in 1917

Carroll Beckwith, as he preferred to be known, began his art training in 1868 at the Chicago Academy of Design, under Walter Shirlaw (q.v.). In 1871 he went to New York City to study at the National Academy of Design, where he became a student of Lemuel Wilmarth (1835–1918). Two years later, Beckwith moved to Paris, where he joined the studio of Emile Auguste Carolus-Duran. He also studied at the Ecole des Beaux-Arts and with Léon Bonnat. In Paris Beckwith lived and worked with fellow student John Singer Sargent (q.v.) from 1874 to 1878, and in 1877 the two helped Carolus-Duran paint

a ceiling at the Louvre. The same year Beckwith exhibited successfully at the Paris Salon.

Returning to America in 1878, Beckwith set up a studio in New York City in the Sherwood Studio building at 58 West Fifty-seventh Street, owned by his uncle, John H. Sherwood. He taught antique classes at the Art Students League from 1878 to 1882 and from 1886 to 1897 and became an active member of the Society of American Artists and of the Century Association in 1886.

Throughout his career, Beckwith concentrated on portraits and figure studies, which he exhibited at the National Academy of Design, the Pennsylvania Academy of the Fine Arts, and the Brooklyn Art Association. Such works as his portrait of artist and writer William Walton (1886, Century Association, New York City) gained him recognition as one of New York's most popular portrait painters. In 1894 Beckwith became a full member of the National Academy of Design.

Interested in idealized female imagery, Beckwith designed allegorical figures of women, representing electricity, for murals for the World's Columbian Exposition in 1893. Beginning in 1910 he traveled in Italy, returning to New York City in 1914 to set up a studio in the Hotel Schuyler, where he painted until his death.

SELECT BIBLIOGRAPHY

DAB, 2:120–122 / Robert J. Wickenden, "The Portraits of Carroll Beckwith," *Scribner's* 47 (April 1910), 449–460 / Ronald G. Pisano, with biographical essays by Beverly Rood, *The Art Students League* (Huntington, N.Y.: Heckscher Museum, 1987) / Annette Blaugrund, with Albert Boime, D. Dodge Thompson, H. Barbara Weinberg, and Richard Guy Wilson, *Paris 1889: American Artists at the Universal Exposition*, exh. cat. (New York: Abrams, in association with the Pennsylvania Academy of the Fine Arts, Philadelphia, 1989) / Lois Marie Fink, *American Art at the Nineteenth-Century Paris Salons* (Washington, D.C.: National Museum of American Art, Smithsonian Institution; Cambridge: Cambridge University Press, 1990) / H. Barbara Weinberg, *The Lure of Paris: Nineteenth-Century American Painters and Their French Teachers* (New York: Abbeville Press, 1991)

21

J. CARROLL BECKWITH

Mr. Isaacson, c. 1889

Oil on canvas; 48 × 28 in. (121.9 × 71.1 cm)

Signed at upper left: Carroll Beckwith

EXHIBITED: New York City, Society of American Artists, 1889, no. 8, as "Portrait of Mr. Isaacson" / Paris Salon, 1890 / Chicago, World's Columbian Exposition, 1893 / Charleston, S.C., Charleston Exposition, 1902 / St. Louis, Mo., St. Louis Exposition, 1904

EX COLL.: artist, New York City, to 1917; sold at "Finished Pictures and Studies Left by the Late Carroll Beckwith, N.A.," American Art Galleries, New York City, March 1918, no. 177, and purchased by Herbert L. Satterlee (son-in-law of J. Pierpont Morgan), New York City[1]

Gift of Herbert L. Satterlee, 1918.26

Carroll Beckwith openly acknowledged Emile Auguste Carolus-Duran's influence on the portraits that were the mainstay of his successful artistic career in New York City.[2] His years studying under Carolus-Duran had taught him the principles of a painterly manner and an appreciation for the old masters, including Velázquez, Hans Holbein, Rembrandt, and Van Dyck.[3] Both of these qualities are evident in *Mr. Isaacson*. Beckwith followed the practice of his master in emphasizing the form of his subject through the use of light and shade and color rather than lines. This can particularly be seen in the hands and face, which are modeled carefully against the dark background. Responding to the tenets of French realist Léon Bonnat and his schooling in academic realism at the Ecole des Beaux-Arts, Beckwith produced a direct and engaging image of Mr. Isaacson.[4] Placing the subject in a natural pose and avoiding a distracting background, the artist focuses on the physiognomic details of his subject.[5]

Mr. Isaacson reflects Beckwith's interest in ethnic types. In the late nineteenth century artists shared a growing interest in anthropology and in depicting primitive and foreign peoples.[6] Artists could find foreign subjects in their own backyard—in Beckwith's case, in New York City's growing population of Jews. In his di-

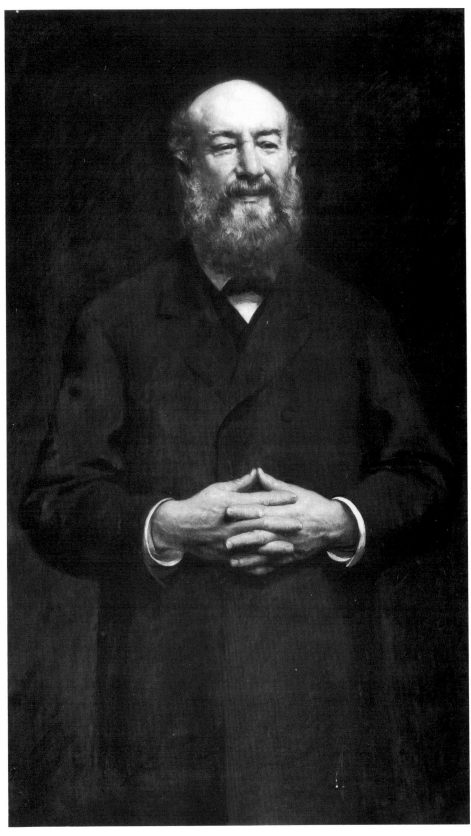

21

ary, the artist frequently refers to Isaacson as his "old jew" and writes confidently about successfully painting his subject's "semitic mug."[7] Beckwith enjoyed his subject's company and remarks on Isaacson's intelligence and entertaining "curious talk."[8] (Isaacson also sat for Beckwith's portrait *The Diamond Broker* [1889, location unknown] the same year.)[9]

Beckwith appreciated the wide spectrum of society depicted by Hals and Rembrandt, as well as Carolus-Duran's portrayals of the modern French.[10] Believing that only American artists "can portray truthfully the characteristics of our race," he considered himself a painter of the "American racial type." *Mr. Isaacson* is a product of this belief. The subject was one "racial type" of many whom Beckwith painted, including military men, writers, artists, and members of the elite. A multi-linguist who worked as a translator for the Baron Hirsch fund, the middle-class Isaacson typified for Beckwith the ethnic or authentic Jew. The portrait is a study of Jewish character, the focus on the subject's intellectual and clever-looking face. Beckwith also captures the good humor of his Jewish subject.

Beckwith was very pleased with the finished portrait, commenting that it was "one of [his] best things."[11] When not exhibiting *Mr. Isaacson*, he prominently displayed the portrait in his studio as a "particularly fine example of his work"; however, he always believed the painting belonged in a museum as a "portrayal of character."[12] The portrait earned Beckwith a gold medal at the Charleston Exposition in 1902. ERM

1. "Finished Pictures and Studies Left by the Talented American Artist the Late Carroll Beckwith, N.A.," sale cat. (New York: American Art Galleries, 1918). *Mr. Isaacson* was sold to Satterlee for $80 (curatorial painting file, Wadsworth Atheneum).
2. H. Barbara Weinberg, *The Lure of Paris: Nineteenth-Century American Painters and Their French Teachers* (New York: Abbeville Press, 1991), 201.
3. Ibid., 195, 202.
4. Ibid., 202.
5. Ibid., 160.
6. Lois Marie Fink, *American Art at the Nineteenth-Century Paris Salons* (Washington, D.C.: National Museum of American Art, Smithsonian Institution; Cambridge: Cambridge University Press, 1990), 18, 196. See also Mary Cowling, *The Artist as Anthropologist: The Representation of Type and Character in Victorian Art* (Cambridge: Cambridge University Press, 1989). My thanks to Brandon Brame Fortune of the National Portrait Gallery, Washington, D.C., for bringing this second source to my attention.
7. *James Carroll Beckwith Diaries*, National Academy of Design, New York City, entries for March 11, March 20, March 22, March 25, and March 25, [1889]. I thank Brandon Brame Fortune, National Portrait Gallery, for bringing this diary to my attention.
8. *James Carroll Beckwith Diaries*, entry for October 21, [1889].
9. Robert J. Wickenden, "The Portraits of Carroll Beckwith," *Scribner's* 47 (April 1910), 456.
10. "Portraying the American Racial Type," *Peterson Magazine* 5, no. 8 (August 1895), 812–821.
11. *James Carroll Beckwith Diaries*, entry for March 18, [1889].
12. Bertha Beckwith to Frank B. Gay, Esq., June 4, 1918, curatorial painting file, Wadsworth Atheneum.

George Bellows

Born in Columbus, Ohio, in 1882; died in New York City, in 1925

George Wesley Bellows first studied from 1904 to 1906 under Robert Henri (q.v.), leader of "The Eight," at William Merritt Chase's (q.v.) New York School of Art. Henri was a considerable influence. Like his teacher, Bellows chose urban dwellers, life, and streets as his subject matter and used a dark palette and vigorous brushstrokes. He also followed Henri's lead in his involvement with America's avant-garde. He helped organize the Armory Show in 1913 and was one of the founders of the Society of Independent Artists. From 1912 to 1917 he worked for the socialist journal *The Masses* under John Sloan (q.v.). Bellows also taught at the Art Students League.

Intent on mastering the painter's craft, Bellows experimented throughout his painting career with various color and compositional theories, including those of Hardesty Maratta. Challenged by the modernist works exhibited in the Armory Show, Bellows became increasingly concerned with systems for organizing color and compositions in his urbanscapes, landscapes, and portraits. A skilled lithographer, he revived popular interest in this medium.

Early on in his career, Bellows's lively and direct depictions of street life, boxing clubs, building excavations, and docks enjoyed popularity and success. At the age of twenty-seven he was elected to the National Academy of Design, the youngest person so honored to that point. Bellows regularly showed his works in national exhibitions and received numerous awards. Bellows died prematurely from a ruptured appendix.

SELECT BIBLIOGRAPHY

Frank Seiberling, Jr., "George Bellows, 1882–1925: His Life and Development as an Artist" (Ph.D. diss., University of Chicago, 1948) / Charles H. Morgan, *George Bellows: Painter of America* (New York: Reynal, 1965) / Donald Braider, *George Bellows and the Ashcan School of Painting* (Garden City, N.Y.: Doubleday, 1971) / Mahonri Sharp Young, *The Paintings of George Bellows* (New York: Watson-Guptill, 1973) / Marianne Doezema, *George Bellows and Urban America* (New Haven: Yale University Press, 1992) / Michael Quick, Jane Myers, Marianne Doezema, and Franklin Kelly, *The Paintings of George Bellows* (New York: Abrams, 1992)

22 (see plate 5)

GEORGE BELLOWS

Pulpit Rock, 1913

Oil on wood panel; 15 × 19½ in. (38.1 × 49.5 cm)

Inscribed on back: Pulpit Rock. / Geo. Bellows / 14 E 19 NY / A 201

EX COLL.: estate of the artist; estate of Emma Bellows; sold to Paul Mellon (via H. V. Allison Galleries, New York City) in 1967; to Susan Mellon, Guilford, Conn., by 1975

Gift of an anonymous donor, 1975.18

George Bellows was introduced to Monhegan Island, Maine, by Robert Henri (q.v.), who first visited the island in 1903. Henri encouraged several other of his students, including Rockwell Kent (q.v.), Leon Kroll, and Edward Hopper, to spend summers on Monhegan. Bellows visited Monhegan during the summers of 1911, 1913, and 1914 and painted a series of land- and seascapes that exhibit bold, broad brushstrokes and an increasingly daring use of vibrant color (both Henri and Bellows were influenced by the seascapes of Winslow Homer [q.v.] and his powerful interpretations of the sea through composition).

Bellows's second summer on Monhegan was a period of intense productivity, during which he executed nearly a hundred small panels measuring 15 by 19½ inches (38.1 × 49.5 cm), including *Pulpit Rock*.[1] Wanting to exhibit his panels, Bellows described them to William Macbeth: "I am painting on panels 15 × 20 and getting some very complete pictures which are a decided departure on my part in color. I am delighted with some of them. . . . These panels are twice as big as the old ones and a long way removed from quick sketches."[2] Using bolder color with more freedom and expression to create a stronger emotional impact,[3] Bellows's close-up studies of the ocean capture its drama and power and convey his new celebratory attitude toward the sea.[4] The artist wrote of his work that summer: "I painted a great many pictures and arrived at a pure kind of color which I never hit before."[5]

In *Pulpit Rock*, Bellows applied single thick layers of paint to depict a close-up view of the rocks along the Monhegan coast. Broken strokes indicate the waves, and strong angular strokes evoke the ruggedness of the rocks. Bellows outlined the distant hills in single strokes of a bluish gray. The dominant color is a deep blue green that he mixed with white to convey the waves crashing against the rocks and that recurs in the clouds. The strong vertical positioning of the rock is balanced by the horizontal plane of the ocean. *Pulpit Rock* is a lively and fresh study of the forces and movement of the ocean. ERM

1. Michael Quick, "Technique and Theory: The Evolution of George Bellow's Painting Style," in Michael Quick, Jane Myers, Marianne Doezema, and Franklin Kelly, *The Paintings of George Bellows* (New York: Abrams, 1992), 44.
2. Quoted in Franklin Kelly, "'So Clean and Cold': Bellows and the Sea," in Quick et al., *The Paintings of George Bellows*, 152.
3. Quick, "Technique and Theory," 45.
4. Kelly, "'So Clean and Cold,'" 155.
5. Quoted in Charles H. Morgan, *George Bellows: Painter of America* (New York: Reynal, 1965), 13–174.

Eugene Berman

Born in St. Petersburg, Russia, in 1899; died in Rome, in 1972

Eugene Berman had an early aptitude for drawing and painting, as well as an interest in architecture, which he studied in St. Petersburg. In 1918 he joined his family in Paris. The following year, Berman entered the Académie Ranson, where he studied under Edouard Vuillard and Maurice Denis. His artistic older brother Leonid (q.v.) and Christian Bérard also attended. In 1922 Eugene made his first trip to Italy, a country that inspired his work, to which he would regularly return, either alone or in the company of Bérard and his brother Leonid, almost annually until 1938 and where he would settle permanently in 1958.

Eugene first exhibited in Paris in 1924, at the Galerie Druet, and by 1926 he was identified with the neoromantics, the group of young painters with whom he exhibited. Stylistically, however, Berman and his colleagues, among them, his brother Leonid, Pavel Tchelitchew (q.v.), Christian Bérard, and Kristians Tonny, had nothing in common. Most likely, they were drawn together because of their friendship, their love of music, the theater, and literature, and their shared ideas—a rejection of cubism and an admiration for the melancholy of Picasso's Blue period combined with the calm pathos of the Rose (James Thrall Soby, *After Picasso*, 31).

In 1930 Eugene made his American debut at the Julien Levy Gallery in New York City. The following year A. Everett "Chick" Austin, Jr., promoted Berman and his colleagues as the neoromantics in his exhibition "Tonny Tchelitchew Berard Berman Leonide," held at the Wadsworth Atheneum. In 1935 Berman traveled to America for the first time, where he met Austin and visited the Wadsworth Atheneum; that year Austin held a one-artist show of Berman's works. Berman developed friendships with Austin and his associates Julien Levy, Kirk Askew (cat. 435), and James Thrall Soby. Soby was the largest collector of Berman's works.

Berman continued to exhibit his works in solo shows in Paris and New York City. He settled in America in 1940, first in New York and then in Los Angeles, and in 1944 he became an American citizen. In 1947 and 1949 he visited Mexico on Guggenheim fellowships. Beginning in 1950 Berman began to return periodically to Europe and eight years later settled in Rome. There, he amassed a large collection of drawings, ceramics, sculpture, and other decorative objects from around the world. He continued to paint and draw, inspired by his love for Italian architecture, scenery, and art.

SELECT BIBLIOGRAPHY

James Thrall Soby, *After Picasso* (Hartford: Edwin Valentine Mitchell, 1935) / *Eugene Berman: Retrospective Exhibition* (Boston: Institute of Modern Art, 1942) / *A. Everett Austin, Jr.: A Director's Taste and Achievement* (Hartford: Wadsworth Atheneum, 1958) / *The Graphic Work of Eugene Berman* (New York: Clarkson N. Potter, 1971) / Leonid Berman, *The Three Worlds of Leonid Berman* (New York: Basic Books, 1979) / Robert L. B. Tobin, *Eugene Berman and the Theatre of Melancholia* (San Antonio, Tex.: Marion Koogler McNay Art Museum, 1984)

23

EUGENE BERMAN
Ponde Mer aux Voiles Croisées, 1928
Oil on canvas; 28⅞ × 36¼ in. (73.3 × 92.1 cm)
Signed at lower left: E Berman 1928
Inscribed on back: E Berman / Paris 1927–1928 / "Ponde mer aux Voiles croisées"

EXHIBITED: Arts Club of Chicago, "Eugene Berman," 1942, no. 2 / Boston, Institute of Modern Art, "Berman Retrospective," 1942, no. 2

EX COLL.: with the Julien Levy Gallery, New York City, in 1937

The Ella Gallup Sumner and Mary Catlin Sumner Collection Fund, 1937.209

Italian architecture and architects including Brunelleschi, Bramante, and Vignola had a large impact on the works of Berman. As a young art student in Russia, he had developed an interest in architecture, which he

23

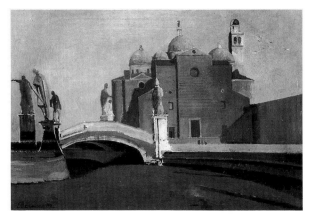

24

maintained throughout his career. In 1928, a year when he made repeated trips to Italy, Berman abandoned his figure studies for landscapes "peopled with architectures."[1] He had also developed an interest in coastal scenes and farms.

Returning to Paris, Berman painted *Ponde Mer aux Voiles Croisées* (Seaport with Crossing Sails), an imaginary architectural arrangement. By this time, Berman had shifted to a darkened and gloomy palette, and the work is executed entirely in gray tones. *Ponde Mer aux Voiles Croisées* also reflects Berman's emphasis on line; he believed that the line was the foundation of art.[2] Though depicting an oceanside scene—in the distance there are subtle indications of sailboats—the painting's focus is on architectural form and design (he did many similar drawings).[3] The paint is thickly applied, creating an atmosphere in which neither air nor light circulates. ERM

1. Waldemar George, "Eugene Berman, The Call of Italy," in *Formes* 3 (1930), 7.
2. See *The Graphic Work of Eugene Berman* (New York: Clarkson N. Potter, 1971), xi–xiii.
3. George, "Eugene Berman," 7.

24

EUGENE BERMAN
Italian Landscape with Basilica and Bridge, 1931
Oil on canvas; 22 × 32 in. (55.9 × 81.3 cm)

EX COLL.: Genevieve Harlow Goodwin
Estate of Genevieve Harlow Goodwin, 1989.43

Italian Landscape with Basilica and Bridge again reflects Berman's strong interest in Italian architecture. ERM

25

EUGENE BERMAN
Apollo and Daphne (La Vallée), 1933
Oil on canvas; 25¼ × 39⅜ in. (64.1 × 100.0 cm)
Signed and dated at lower right: E Berman 1933
Inscribed on back: E. Berman / Paris Février 1933
 Apollo et Daphne (La Vallé)

EX COLL.: with the Julien Levy Gallery in 1934

The Ella Gallup Sumner and Mary Catlin Sumner Collection Fund, 1934.8

In 1933 Berman spent much of his time in Versailles. The group sculptures in the gardens there resulted in his *Apollo and Daphne* series. In this series of six paintings, Berman filled landscapes with imaginative reconstructions of Apollo and Daphne and other sculptures. In *Apollo and Daphne (La Vallée)*, Berman shows the lower torso of a classical sculpture set above a valley. In the far distance is a building set on a hill. According to one writer, the sculpture subjects of this series "writhe and twist with a new intensity."[1]

25

in Dalí's technique than in his spirit, which he roman-
ticized in his work. It was his admiration for Dalí's
technique that led him to paint the statue in *Apollo and
Daphne* (*La Vallée*) with "an almost gruesome liveli-
ness" against the dead landscapes. Like those of Dalí,
Berman's landscapes also stretch on indefinitely, though
bounded on the sides with realistic brown cliffs.[2] ERM

1. James Thrall Soby, *After Picasso* (Hartford: Edwin Valen-
 tine Mitchell, 1935), 41, 42.
2. Ibid., 42, 41.

26

EUGENE BERMAN
Scène de la Vie des Bohémiens, 1936
Oil on panel; 46⅛ × 30 in. (117.2 × 76.2 cm)

EX COLL.: James Thrall Soby, Farmington, Conn., in 1936

Gift of James T. Soby in memory of his father, Charles Soby,
1954.95

27

EUGENE BERMAN
Scène de la Vie des Bohémiens, 1936
Oil on panel; 30 × 46¼in. (76.2 × 117.5 cm)

EX COLL.: James Thrall Soby, Farmington, Conn., in 1936

Gift of James T. Soby in memory of his father, Charles Soby,
1954.96

27

26

In this and the rest of the series, Salvador Dalí's
early influence on Berman is visible in the barren, silent
landscapes scattered with his obsessions: the sculptures.
Not a surrealist, however, Berman was more interested

28

EUGENE BERMAN

Scène de la Vie des Bohémiens, 1936

Oil on panel; 59³/₄ × 49 in. (151.8 × 124.5 cm)

EX COLL.: James Thrall Soby, Farmington, Conn., in 1936

Gift of James T. Soby in memory of his father, Charles Soby, 1954.97

28

29

29

EUGENE BERMAN

Scène de la Vie des Bohémiens, 1936

Oil on panel; 46³/₁₆ × 30 in. (117.3 × 76.2 cm)

EX COLL.: James Thrall Soby, Farmington, Conn., in 1936

Gift of James T. Soby in memory of his father, Charles Soby, 1954.98

30

EUGENE BERMAN

Scène de la Vie des Bohémiens, 1936

Oil on panel; 46¼ × 30 in. (117.5 × 76.2 cm)

EX COLL.: James Thrall Soby, Farmington, Conn., in 1936

Gift of James T. Soby in memory of his father, Charles Soby, 1954.99

James Thrall Soby's Greek Revival residence, Farmington, Connecticut, 1936. Archives, Wadsworth Atheneum.

Berman painted the series of panels *Scènes de la Vie des Bohémiens* for the dining room of James Thrall Soby's Greek Revival residence located on Mountain Spring Road in Farmington, Connecticut. Soby commissioned the panels in 1935, and later that year Berman began working on them in his New York studio, painting each as carefully as an easel painting. That winter he completed the borders of the panels in Soby's house. Alexander Calder was completing a large mobile, designed as a wellhead for the grounds, at the same time. According to Soby, the two artists got along well, though temperamentally they were very different.[1] Although Berman admired the other's work, Calder did not care for Berman's "deliberate clutter" and kept insisting, "Let me get some fresh air."[2]

The panels were inspired by Berman's visit to Sicily and the Bay of Naples area in 1935. He depicts desolate vistas of the beaches near Naples crowded with shelters erected from driftwood and the hoarded rags of beggars. The figures, representing the poor and homeless, have forlorn expressions on their faces as they look off in the distance. They are part of a separate world, imaginary, yet recalling the bitter realities of the Second World War and the dispossessed.

The metal hoops that hang amid the ragged draperies were inspired by Calder's mobile settings for Erik Satie's *Socrate*, which was performed at the First Hartford Festival at the Wadsworth Atheneum in January 1936.[3] Berman painted a border around each of the panels, creating a formal effect. In other less formal panels that he painted for patrons including his American dealer Julien Levy, Berman used trompe l'oeil effects to create illusionary frames and wall surfaces.[4] ERM

30

1. See James Thrall Soby, "Eugene Berman Panels," *Wadsworth Atheneum Bulletin*, 2d ser., no. 50 (October 1954): 1.
2. James Thrall Soby to Charlie Cunningham, June 2, 1954, curatorial painting file, Wadsworth Atheneum.
3. Soby, "Eugene Berman Panels," 1.
4. Julien Levy, *Eugene Berman, Paintings, Drawings and Decor* (New York: American Studio Books, 1953), xii.

31

EUGENE BERMAN
The Broken Column (La Colonne Antique), 1936
Oil on canvas; 12¼ × 8¾ in. (31.1 × 22.2 cm)
Signed and dated at lower right: E.B. 1936
Inscribed on back: New York 1936

EXHIBITED: Arts Club of Chicago, "Eugene Berman," 1942, no. 29 / Boston, Institute of Modern Art, "Berman Retrospective," 1942, no. 27

EX COLL.: with the Julien Levy Gallery in 1944

31

The Ella Gallup Sumner and Mary Catlin Sumner Collection Fund, 1944.243

Berman painted *Broken Column (La Colonne Antique)* in New York City the year of his first visit to America. In this work, which depicts a torn and tattered painting, he incorporates passages of trompe l'oeil. Along with the tear, two nails tack the painting to another surface. The imaginary scenery reflects his lifelong interest in Italian architecture. To the right of the scene is a curtain, suggesting a stage. Around the time Berman painted this work, he became actively involved in designing theater and ballet sets and costumes in France—in Paris—and in the United States, including some A. Everett Austin, Jr., commissioned for the Wadsworth Atheneum's Hartford Music Festival in 1936. ERM

32

EUGENE BERMAN
Tobie et L'Ange Cheminant Vers la Nuit (Tobias and the Angel Trudging Towards the Night), 1938
Oil on canvas; 31¹⁵⁄₁₆ × 45¹¹⁄₁₆ in. (81.1 × 116.0 cm)
Signed at lower center: E. Berman 1938
Inscribed on back: E. Berman Paris Mars–Juin 1938
"Tobie et l'Ange cheminant vers la Nuit"

EX COLL.: Charles P. Cooley, Hartford, in 1953; to Anne Parrish Titzell, Georgetown, Conn., in 1957

Bequest of Anne Parrish Titzell, 1957.619

Using his familiar flat, eerie landscape, Berman depicts a scene from the biblical story of Tobias and the angel. The angel helped Tobias catch a miraculous fish, part of which, when placed in the eyes of his blind father, enabled him to regain his eyesight. The artist presents an otherworldly situation in which two poor bedraggled boys are changed into the characters of the biblical story. The clouds behind the boy in the foreground create an appearance of wings on his shoulders, and the long cloud behind the second boy forms a plume trailing off the top of his hat. ERM

32

Leonid Berman

Born in St. Petersburg, Russia, in 1896; died in New
York City, in 1976

Leonid Berman left Russia with his family in 1917
and settled in Paris the following year. In 1920 he en-
tered the Académie Ranson with Eugene, where he
studied under Vuillard, Bonnard, Maurice Denis, and
Felix Valloton. From 1922 to 1924 he painted full-time
in a studio he shared with his brother and Christian
Bérard. During that time he exhibited at the Salons
d'Automne, des Tuileries, and des Indépendants. In 1926
Leonid showed his works at the Galerie Druet with his
contemporaries Eugene, Bérard, Pavel Tchelitchew
(q.v.), Kristians Tonny, and several others. This group
was dubbed the neoromantics by art critic Waldemar
George, a misleading collective since none of the artists
shared anything either stylistically or in terms of sub-
ject matter. Leonid was included in another neoromantic
show held at the Wadsworth Atheneum in 1931, which
brought him popular success in America.

In 1933 Leonid began to exhibit at the Julien Levy
Gallery in New York City, and in 1946 he visited Amer-
ica for the first time. Two years later he became an
American citizen and settled in New York City. He con-
tinued to travel, paint, and exhibit his works. He also
completed several mural projects. In 1976 he was elec-
ted a member of the National Institute of Arts and
Letters.

SELECT BIBLIOGRAPHY

James Thrall Soby, *After Picasso* (Hartford: Edwin Valentine
Mitchell, 1935) / Mario Amaya and John Russell, *Leonid and
His Friends*, exh. cat. (New York: New York Cultural Center,
1974) / J. Daniel Selig, *The Lyric Landscape of Leonid*, exh.
cat. (Reading, Pa.: Reading Public Museum, 1974) / Leonid
Berman, *The Three Worlds of Leonid* (New York: Basic Books,
1979)

33

LEONID BERMAN
Beach with Fishermen, 1934
Oil on canvas; 20 × 32 in. (50.8 × 81.3 cm)
Signed and dated at lower right: Leonid 34

EXHIBITED: New Britain, Conn., Art Museum of the New
Britain Institute, "Contemporary American Paintings from the
Collection of the Wadsworth Atheneum, Hartford," 1953 /

33

Hartford, G. Fox and Company (in connection with the Wadsworth Atheneum), "A. Everett Austin, Jr.: A Director's Taste and Achievement," 1958

EX COLL.: with the Julien Levy Gallery, New York City

The Ella Gallup Sumner and Mary Catlin Sumner Collection Fund, 1935.36

34

LEONID BERMAN
Etretat, The Capstan, 1935
Oil on canvas; 19 × 31½ in. (48.3 × 80.0 cm)
Signed at lower right: Leonid
Inscribed on back: 1935

EXHIBITED: Winstead, Conn., Litchfield County Art Association, Inc., 1956 / Hartford, G. Fox and Company (in connection with Wadsworth Atheneum), "A. Everett Austin, Jr.: A

34

Director's Taste and Achievement," 1958 / Williamstown, Mass., Lawrence Art Museum, Williams College, "Carnegie Slide Project," 1960 / New York City, New York Cultural Center, "Leonid and His Friends," 1974, no. 4 / New Britain, Conn., New Britain Museum of American Art, "Harvests of Seas," 1977

EX COLL.: with Jacques Bonjean and Cie., Paris

Purchased through the gift of James Junius Goodwin, 1935.255

Berman painted *Beach with Fishermen* and *Etretat* in Normandy, France, where he found romantic subject matter in the seacoast villages and the fisherfolk. In the early 1930s his palette lightened, and in 1934 his landscapes became horizontal in composition. The figures also became more diminutive, the gray-brown tones of the long stretches of beach and the vast blue expanses of sea emphasizing their small size. The patterns of the waves create a decorative element, as do the fishing lines in *Etretat.*[1]

Berman knew his subject intimately. He lived among the fisherfolk, the clamdiggers, and the shrimpers and learned the different methods of fishing and how salt marshes were built. He also studied the tides carefully. However small his figures, Berman perceived his human subjects in harmony with nature. ERM

1. James Thrall Soby, *After Picasso* (Hartford: Edwin Valentine Mitchell, 1935), 55.

George Biddle

Born in Philadelphia, in 1885; died in Croton-on-Hudson, N.Y., in 1973

George Biddle was a leader of the regionalist, or American Scene, art of the 1930s. As a young man he attended Groton School; Franklin Delano Roosevelt was a classmate. After graduating from Harvard University, he entered Harvard Law School in 1908 and was admitted to the Pennsylvania Bar in 1911. However, in 1911 Biddle left for Europe, where he studied at the Académie Julian in Paris until 1912. Returning to Philadelphia in 1917, he spent two years studying at the

Pennsylvania Academy of the Fine Arts and began painting and printmaking. Biddle served in the cavalry during World War I and in 1920 began traveling extensively to escape his wartime memories. In Tahiti he sought inner peace, experimenting with sculpture and pottery.

In 1928 Biddle traveled with Diego Rivera through Mexico, where he became acquainted with that country's government-supported mural program. He attempted to create a similar art, using a realistic style to depict specifically regional views of America.

Biddle painted regional landscapes of the Pennsylvania Dutch country near Lancaster, views of Croton-on-Hudson, where he built a home and settled in 1927, as well as midwestern and western landscapes. Biddle developed a plan to gain public support and recognition for American artists in the 1930s, presenting his ideas to former schoolmate Roosevelt in 1933:

> The Mexican artists have produced the greatest national school of mural painting since the Italian Renaissance. . . . [They] express on the walls of government buildings the social ideals of the Mexican Revolution.
>
> The younger artists of America are conscious as they have never been of the social revolution that our country and civilization are going through; and they are eager to express these ideals in a permanent art form if they were given government's cooperation. (quoted in Baigell, *The American Scene*, 46)

The plan resulted in the Public Works of Art Project, which was established by Roosevelt in December 1933.

Biddle would create murals in Washington, D.C., Mexico, and Brazil. He continued to paint regional landscapes and still lifes, which were widely exhibited during his lifetime. In addition, he was the author of seven books and numerous articles stating his opinions on art, notably his book *The Yes and No of Contemporary Art* (Cambridge, Mass.: Harvard University Press, 1957) and an article entitled "Drawing and Tradition" (*Reality* 3 [summer 1955], 3).

SELECT BIBLIOGRAPHY

Matthew Baigell, *The American Scene* (New York: Praeger, 1974), 46, 51, 70 / Greta Berman and Jeffrey Wechsler, *Realism and Realities: The Other Side of American Painting 1940–1960*, exh. cat. (New Brunswick, N.J.: Rutgers University Art Gallery, 1982), 5–6, 49 / Deedee Wigmore, *George Biddle: Regional Landscapes and Still Lifes 1930–1948*, exh. cat. (New York: D. Wigmore Fine Art, 1993)

35

GEORGE BIDDLE
Spring Landscape, Hessian Hills, 1934
Oil on canvas; 24⁷/₈ × 30¹/₈ in. (63.2 × 76.5 cm)
Signed and dated at lower left: Biddle 1934.

EX COLL.: Dr. Barnet Fine, Stamford, Conn.

Gift of Dr. Barnet Fine, 1957.678

As a leading exponent of the regionalist landscape movement in America in the 1930s, Biddle painted views of his nation that portrayed the unique character of the regions in which he lived or spent time traveling. In this pastoral depiction, *Spring Landscape, Hessian Hills*, likely representing the Pennsylvania countryside of his native state, Biddle captures the softness of the spring season. The fertile lands and comfortable farmstead, set within a gently rolling hillside, offer an idyllic view of the American landscape. EMK

35

Albert Bierstadt

Born in Solingen, Prussia, in 1830; died in New York City, in 1902

Born in humble circumstances near Düsseldorf, Germany, at age two Bierstadt emigrated with his family to America. Apparently self-taught, he advertised himself in 1850 as an instructor in monochromatic painting in New Bedford, Massachusetts. For the next three years, he worked with a daguerreotypist producing theatrical presentations of American scenery, an experience that initiated a lifelong interest in photography.

In 1853 Bierstadt returned to Europe to study at the Düsseldorf Art Academy; he also traveled extensively. His encounters in Düsseldorf with American colleagues Emanuel Leutze (q.v.) and Worthington Whittredge (1820–1910), as well as the contemporary German painters Carl Friedrich Lessing (1807–1880) and Andreas Achenbach (1827–1905), prompted him to emulate the highly finished style of their heroic landscape paintings. In 1856 he traveled with Whittredge to Rome and to the mountains of Germany, Switzerland, and Italy. Returning to New Bedford in July 1857, Bierstadt began organizing an exhibition of paintings, including fifteen of his own works based on his European sketches; it opened in March of the following year, and the exposure brought him national attention.

In April 1859 Bierstadt joined the company of a United States government survey expedition, headed by Colonel Frederick W. Lander, to the territories of Colorado and Wyoming. The artist intended to make sketches for a series of large-scale landscapes of the American West. With the spectacular scenery of the Alps still fresh in his mind, he wrote to the *Crayon* from the Rocky Mountains: "The mountains are very fine; as seen from the plains, they resemble very much the Bernese Alps, one of the finest ranges in Europe, if not in the world. They are of a granite formation, the same as the Swiss mountains and their jagged summits, covered with snow and mingling with the clouds, present a scene which every lover of landscape would gaze upon with unqualified delight" (*Crayon* 6 [September 1859], 287).

On his return to New York City in the fall, Bierstadt moved into the Tenth Street Studio Building and began to paint a series of landscapes that secured his position as America's leading painter of Western scenery. The success of *The Rocky Mountains, Lander's Peak* (1863, Metropolitan Museum of Art), exhibited at the art gallery of the Metropolitan Sanitary Fair in New York City in 1864—an event at which the artist served as a proprietor of the "Indian Department," which featured live performances by a troupe of Native Americans—established the artist as a major rival of Frederic E. Church (q.v.). In 1863, accompanied by the author Fitz Hugh Ludlow, he undertook another, more extensive trip west that provided materials for his paintings of California's Yosemite Valley.

Bierstadt enjoyed enormous success for the next decade. In 1863 he married Rosalie Ludlow and completed building Malkasten, a spectacular mansion overlooking the river at Irvington-on-Hudson in New York. He spent 1867 to 1869 touring Europe, continuing meanwhile to paint Western scenery—commanding the highest prices for an American artist at that time—which he exhibited in the United States and abroad. Praised by critics in America and England for his application of Ruskinian observation and Turnerian grandeur to the little-known scenery of the American West, Bierstadt's paintings appealed to the new industrial upper middle class, who valued their great size and virtuoso workmanship as well as their celebration of America's seemingly limitless natural resources. In 1867 the artist received a commission to paint two landscapes for the Capitol Building in Washington; he completed *The Discovery of the Hudson* in 1875.

Bierstadt was among the most productive and internationally honored American artists of the nineteenth century. In the post–Civil War era, however, his paintings began to receive adverse criticism, and by 1880 his reputation had declined rapidly. The artist also suffered a series of misfortunes, including the destruction of Malkasten by fire in 1882 and the death of his wife in 1893.

SELECT BIBLIOGRAPHY

Gordon Hendricks, "The First Three Western Journeys of Albert Bierstadt," *Art Bulletin* 46 (September 1964), 333–365 /

Gordon Hendricks, *Albert Bierstadt: Painter of the American West* (New York: Abrams, 1974) / Matthew Baigell, *Albert Bierstadt* (New York: Watson-Guptill, 1981) / Gerald L. Carr, "Albert Bierstadt, Big Trees, and the British: A Log of Many Anglo-American Ties," *Arts Magazine* 60 (summer 1986), 60–71 / Nancy K. Anderson, *Albert Bierstadt: Cho-Looke, The Yosemite Fall*, exh. cat. (San Diego, Calif.: Timkin Art Gallery, 1986) / Nancy K. Anderson and Linda S. Ferber, with Helena E. Wright, *Albert Bierstadt: Art and Enterprise*, exh. cat. (New York: Hudson Hills Press, in association with the Brooklyn Museum, 1990)

36

ALBERT BIERSTADT

Capri Beach, c. 1857

Oil on composition board; 10³/₄ × 13 in. (27.3 × 33.0 cm)

Signed at lower left (partial monogram): ABierstadt

Technical note: The canvas may have been cut down, as most of the artist's oil studies of Capri measure 13 by 19 inches (33 × 48.3 cm). Although an infrared examination of the signature did not yield any evidence

to suggest that it was not authentic, many of the works that passed through Rholfs Gallery in Brooklyn acquired false signatures much like the one on this work.[1]

EXHIBITED: Newport, R.I., The Art Association of Newport, Rhode Island, "The Coast and the Sea: A Loan Exhibition Assembled from the Collections of the Wadsworth Atheneum," 1964, no. 4 / Düsseldorf, Germany, Kuntsmuseum, and Berlin, Academy of Fine Arts, "The Hudson and The Rhine," 1976, no. 10

EX COLL.: purchased from the artist's estate by Rholfs Gallery, Brooklyn, N.Y.; with John Nicholson Gallery, New York City, by 1947

The Ella Gallup Sumner and Mary Catlin Sumner Collection Fund, 1947.112

Bierstadt executed this oil study while he was on the island of Capri from May 30 until June 26 of 1857, during his first visit to Italy, which lasted from September 1856 to July 1857. In the company of Sanford Gifford (q.v.), Bierstadt journeyed into Campania as far as Capri and

36

the Amalfi coast. Gifford's letters, journals, and sketches document the trip, which took place under spartan conditions, with the two artists sketching and at times camping outdoors.[2] To his mother Gifford wrote:

> The island [Capri] is about four miles long, and ten around. The shores are very precipitous. There are only two places to land—Marina Grande on the Naples side, and the Piccola Marina on the other. The village of Capri is on the top of the ridge between them. . . . Natural arches and grottos abound. . . .
>
> The groups of fishermen with their boats and nets on the little beach are very picturesque. . . . Sketched all day at the "Piccola Marina." We have spent fifteen days sketching there. Since the fifteenth we have been at the Marina Grande sketching boats, figures, etc. . . . We take a bath in the bright sea every day.[3]

Capri Beach shows a beached fishing boat with canvas sails pulled over it. The representations of the fisherfolk and their animals are cursory, with the most attention paid to the colorful costumes, baskets, and nets. Children play with a toy boat at the water's edge, a man seated at left repairs baskets, and two soldiers observe the work going on around them. The detailed scene is set against a brilliant blue and aqua sea, with an interesting arched rock formation at the right.

One of many oil studies remaining in Bierstadt's studio at the time of his death, *Capri Beach* shares details and a similar provenance with the related work *Fishing Boats at Capri*, inscribed "Capri / june 14 1847 / A Bierstadt" (Museum of Fine Arts, Boston), which was acquired by Rholfs Gallery in Brooklyn and later by the John Nicholson Gallery in New York City in 1946. Its subject matter also relates to that of *Capri* (c. 1857, Garzoli Gallery, San Rafael, Calif.), which bears a similar signature of questionable origin.[4]

Bierstadt produced a large number of color studies in oil on paper (with slight pencil underdrawing) of the landscape and people of the Amalfi coast. His attentiveness to the details of the landscape provided preparatory models for what he "would later see on California's Pacific shore."[5] Based on the many sketches he made of

Capri, Bierstadt produced a major studio painting in 1859, *The Marina Piccola, Capri* (Albright-Knox Art Gallery, Buffalo, N.Y.), which he gave to the Buffalo Fine Arts Academy.[6] Several details seen in *Capri Beach*, including the fishing nets and round-bottom baskets, appear in the Albright-Knox painting. EMK

1. Nancy Anderson to Elizabeth Kornhauser, January 19, 1993, curatorial painting file, Wadsworth Atheneum.
2. The trip is described in Theodore E. Stebbins, Jr., with William H. Gerdts, Erica E. Hirshler, Fred S. Licht, and William L. Vance, *The Lure of Italy: American Artists and the Italian Experience, 1760–1914,* exh. cat. (New York: Abrams, in association with the Museum of Fine Arts, Boston, 1992), 50, 213, 438; and Nancy K. Anderson and Linda S. Ferber, with Helena E. Wright, *Albert Bierstadt: Art and Enterprise,* exh. cat. (New York: Hudson Hills Press, in association with the Brooklyn Museum, 1990), 121.
3. Sanford Robinson Gifford to his mother, June 25, 1857, Sanford Robinson Gifford Letters, Archives of American Art, quoted in Anderson and Ferber, *Albert Bierstadt,* 132–133.
4. Both related Capri oil sketches appear in Anderson and Ferber, *Albert Bierstadt,* 132, 133.
5. Anderson and Ferber, *Albert Bierstadt,* 113.
6. Ibid., 151.

37

ALBERT BIERSTADT
Toward the Setting Sun, 1862
Oil on paper mounted on canvas; 7³/₄ × 14 in. (19.7 × 35.6 cm)
Signed and dated at lower left (partial monogram):
ABierstadt / 62

EXHIBITED: Wadsworth Atheneum, "Framing Art: Frames in the Collection of the Wadsworth Atheneum," 1982

EX COLL.: Cassius Welles, 645 Prospect Avenue, Hartford; to his wife, Susan Russell Welles, Hartford; to her nephew, William B. Russell, Hartford; to his daughter, Edith Russell Wooley, Hartford; to J. Harold Williams, Hartford, by 1977

Gift of Mr. J. Harold Williams, in memory of Edith Russell Wooley, 1977.74

In January 1859 the artist's hometown paper in New Bedford reported that Bierstadt was about to start for the Rocky Mountains "to study the scenery of that wild

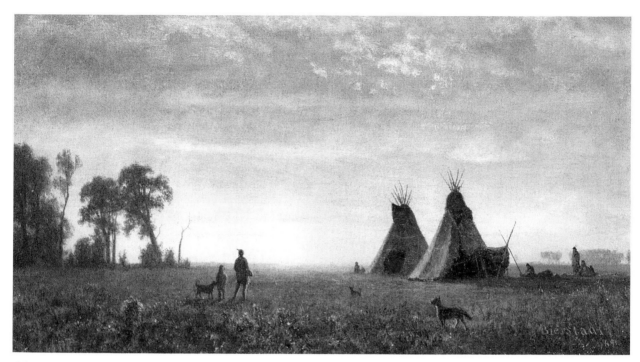

37

region, and the picturesque facts of Indian life, with reference to a series of large pictures."[1] As a member of Frederick W. Lander's survey party bound for the Rocky Mountains, he completed studies of the Wind River, the Wasatch ranges, and the Black Hills. In an oft-quoted letter he wrote from the Rocky Mountains on July 10, 1859, which was published in the *Crayon*, Bierstadt expressed his desire to record the Native American people while it was still possible to do so: "For a figure-painter, there is an abundance of fine subjects. The manners and customs of the Indians are still as they were hundreds of years ago, and now is the time to paint them, for they are rapidly passing away; and soon will be known only in history. I think that the artist ought to tell his portion of their history as well as the writer."[2] Bierstadt returned to New York City in September 1859 with a sizable number of drawings and sketches, stereopticon photographs of Native Americans and Western landscape, and an impressive collection of Native American artifacts. Within three months he had moved into the Tenth Street Studio Building in New York City, where he placed his artifact collection on display and began to paint large canvases of the West.

Unlike many of his sketches of Native Americans, which document their physiognomy and dress, *Toward the Setting Sun* was painted three years after the artist's return from his trip and carries a sentimental message of impending extinction. In a suffusion of golden red light, the Native Americans and their dogs are placed in dark shadow in a flat plains landscape. With their backs to the viewer, the Native Americans gaze at the setting sun in the distant landscape.

Although Bierstadt did a number of other pictures after his 1859 trip that have Native American figures in them, there is some irony to his claim of being "a figure-painter." Bierstadt knew his gifts did not lie in this area but rather in landscape. Of the paintings he produced as a result of this trip, his most ambitious to include Native American figures was *Indians Traveling near Fort Laramie* (1861, Manoogian Collection), which includes a detailed figural group in the foreground of the canvas, unlike *Toward the Setting Sun*, where the figures are placed at a distance that makes them indistinct. In his major work *The Rocky Mountains, Lander's Peak* (1863, Metropolitan Museum of Art), Bierstadt also includes a detailed Native American frieze in the foreground.

Here, for the first time, the artist's early interest in Native Americans and his developing interest in grand landscape are joined, although after this work, Native American figures serve largely as stuffage for his grand landscapes.[3] EMK

1. *Mercury*, New Bedford, January 7, 1859, reproduced in Nancy K. Anderson and Linda S. Ferber, with Helena E. Wright, *Albert Bierstadt: Art and Enterprise*, exh. cat. (New York: Hudson Hills Press, in association with the Brooklyn Museum, 1990), 143.
2. *Crayon* 6 (September 1859), 287.
3. Anderson and Ferber, *Albert Bierstadt*, 173.

38 (see plate 6)

ALBERT BIERSTADT

In the Yosemite Valley, 1866

Oil on canvas; 35⅛ × 50 in. (89.2 × 127.0 cm)

Signed and dated at lower right (partial monogram):
 ABierstadt, 1866

Canvas stamp on back: 56 50 / Prepared by / Edw. Dechaux / New York

EXHIBITED: Wadsworth Atheneum, "A Second Look: Late Nineteenth Century Taste in Paintings," 1958, no. 21 / Wadsworth Atheneum, "The Hudson River School: Nineteenth-Century American Landscapes in the Wadsworth Atheneum," 1976, no. 42 / New York City, Whitney Museum of American Art (Downtown Branch), "Nineteenth Century American Landscape Painting," 1980

EX COLL.: purchased from the artist by Elizabeth Hart Jarvis Colt, Hartford, probably in 1866

Bequest of Elizabeth Hart Jarvis Colt, 1905.22

Traveling with Bierstadt to California in the spring of 1863, New York writer Fitz Hugh Ludlow chronicled the journey in a series of letters and articles and in a book, *The Heart of the Continent*, in 1870.[1] In San Francisco, Ludlow and Bierstadt were joined by the artists Virgil Williams (1830–1886) and Enoch Wood Perry (q.v.) on their trip to Yosemite. After an arduous journey, Ludlow described the party's wonder at their first view of the valley: "We did not so much seem to be seeing from that crag of vision a new scene on the old familiar globe as a new heaven and a new earth into which the creative spirit had just breathed. . . . Never were words so beggared for an abridged translation of any Scripture of Nature."[2] The men stayed at Yosemite for approximately seven weeks, spending their days on sketching expeditions. Bierstadt wrote of the beauty of

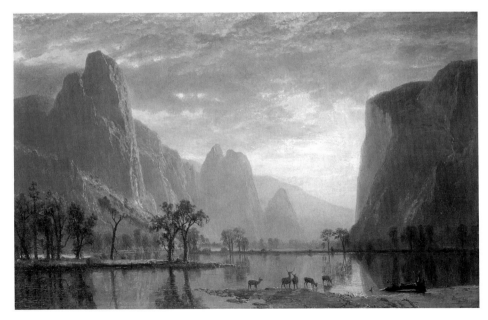

Albert Bierstadt, *Valley of the Yosemite*, 1864. Gift of Mrs. Maxim Karolik for the Karolik Collection of American Paintings, 1815–1865, courtesy Museum of Fine Arts, Boston.

his surroundings: "We are now here in the garden of Eden I call it. The most magnificent place I was ever in, I employ every moment painting from nature. . . . We camp out altogether, get no news, and do not care for any for we are perfectly happy with the fine scenery, trout, ducks, deer, etc."[3]

Bierstadt correctly predicted that scenery of the Yosemite Valley would be popular and, on his return to New York City, working from his portfolio of drawings and sketches, he began to depict the grandeur of the valley in a series of major oil paintings. He offered his first Yosemite painting, *Valley of the Yosemite*, a small work (11¾ × 19¼ in. [29.8 × 48.9 cm]) at the fine art auction held at the Metropolitan Sanitary Fair in New York City in 1864. The painting went to "Mr. Davis," for $1,600—the highest price paid for a painting at the sale—the proceeds going to the Sanitary Commission.[4]

Elizabeth Colt, who served as the head of the Hartford Table at the Metropolitan Sanitary Fair (see Introduction), later acquired (or more likely, judging from the large size of the work, commissioned) *In the Yosemite Valley* for her private picture gallery, under construction beginning in 1865 and completed in 1868. The painting, completed in 1866, depicts an afternoon scene along the Merced River, the view looking southwest rather than toward the east, which was more common for this artist. Also unlike his practice in other works, Bierstadt places a greater emphasis on the picturesque foreground details—the deer and a fallen tree trunk—diminishing the impact of the distant mountains. Interestingly, these foreground details also appear in an earlier work, painted before the artist's trip to Yosemite, entitled *Wind River Mountains, Nebraska* (1862, private collection).[5]

Colt hung her Yosemite landscape opposite a much larger tropical scene, *Vale of St. Thomas, Jamaica* (cat. 116), which she had commissioned from Frederic Church, thereby recreating the juxtaposition of the works of these two great rivals that she had earlier seen at the art gallery of the Metropolitan Fair. EMK

1. His letters appear in the New York *Evening Post* and the San Francisco *Golden Era*, and his articles appear in the *At-*

lantic Monthly, reproduced in Nancy K. Anderson and Linda S. Ferber, with Helena E. Wright, *Albert Bierstadt: Art and Enterprise*, exh. cat. (New York: Hudson Hills Press, in association with the Brooklyn Museum, 1990), appendix B, 306–322.

2. Fitz Hugh Ludlow, *The Heart of the Continent: A Record of Travel across the Plains and in Oregon, with an Examination of the Mormon Principle* (New York: Hurd and Houghton, 1870), 426.

3. Albert Bierstadt to John Hay, August 22, 1863, *John Hay Collection*, John Hay Library, Brown University, Providence, R.I., quoted in Anderson and Ferber, *Albert Bierstadt*, 178.

4. Anderson and Ferber, *Albert Bierstadt*, 180; and Gordon Hendricks, "Bierstadt and Church at the New York Sanitary Fair," *Antiques* 102 (November 1972), 893.

5. My thanks to Nancy Anderson for this observation; see reproduction in Anderson and Ferber, *Albert Bierstadt*, 149.

39 (see plate 7)

ALBERT BIERSTADT
In the Mountains, 1867
Oil on canvas; 36³⁄₁₆ × 50¼ in. (91.9 × 127.6 cm)
Signed and dated at lower right: A Bierstadt 67.
Technical note: Craquelure surface is seen in areas of dark pigment.

EXHIBITED: Fort Worth, Tex., Amon Carter Museum of Art; Washington, D.C., Corcoran Gallery of Art; New Bedford, Mass., Whaling Museum; New York City, Whitney Museum of American Art; and Philadelphia, Pennsylvania Academy of the Fine Arts, "A Bierstadt," 1972–1973, no. 44 / Düsseldorf, Germany, Kunstmuseum, and Berlin, Germany, Academy of Fine Arts, "The Hudson and the Rhine," 1976, no. 14 / Wadsworth Atheneum, "The Hudson River School: Nineteenth-Century American Landscapes in the Wadsworth Atheneum," 1976, no. 43 / Paris, Galeries Lafayette, "Deux Cents Ans de Peinture Américaine: Collection du Musée Wadsworth Atheneum," 1989

EX COLL.: probably Junius Spencer Morgan, London; to his daughter, Juliet Pierpont Morgan, in 1890; to her son, John Junius Morgan, in 1923

Gift of John Junius Morgan in memory of his mother Juliet Pierpont Morgan, 1923.253

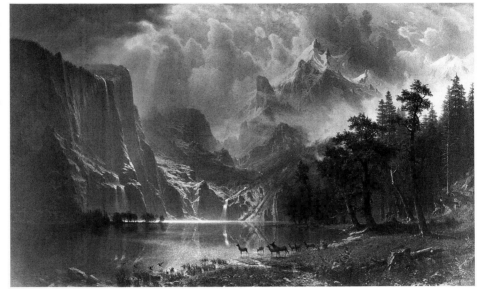

Albert Bierstadt, *Among the Sierra Nevada Mountains, California*, 1868. National Museum of American Art, Smithsonian Institution, Bequest of Helen Huntington Hull, granddaughter of William Brown Dinsmore.

In June 1867 Bierstadt left for Europe, and, according to Tuckerman, the trip was inspired by the recent commission to paint two panels for the Capitol Building in Washington.[1] More likely, however, the artist went in order to attend the recently opened "Exposition Universelle" in Paris where his work *The Rocky Mountains, Lander's Peak* (1863, Metropolitan Museum of Art) was on view.[2] The artist traveled to Rome, London, and Paris during his two-year trip in an effort to establish an international reputation and to garner new commissions.

In the Mountains was painted either just before Bierstadt crossed the Atlantic or shortly after his arrival abroad, where he sought and found a buyer for the painting. The work is a smaller version of *Among the Sierra Nevada Mountains, California*, which was painted in Rome during the winter of 1867–1868. Gerald Carr has suggested that the larger canvas, which measured 72 by 120 inches (182.9 × 304.8 cm), was painted as a traveling demonstration piece for the artist's European tour.[3] It received positive reviews when shown in London with two other important works in the summer of 1868.[4] His reputation in England reached its height when he was granted a royal interview with Queen Victoria and the Prince of Wales in July 1868. He exhibited

Among the Sierra Nevada Mountains a second time in London and again in 1868 in Berlin, at the Royal Academy, where it received a gold medal. It was sold to the Boston collector Alvin Adams for a reported sum of $15,000 shortly after Bierstadt's return to the United States in 1869.

In the Mountains and *Among the Sierra Nevada Mountains* differ markedly in size. Another striking difference is the absence of foreground detail in the first painting; the flock of ducks landing on the water and the herd of deer present in the grand-scale painting are not found in the smaller work. Otherwise, the cool silvery tones, dense trees at the right, reflections on the water, majestic snowcapped mountain peaks, and billowy storm clouds are found in nearly identical formations in both, and both sparkle with a freshness that imbues them with a spiritual quality. It is possible that *In the Mountains*, firmly dated 1867 by the artist, served as a preliminary work for the larger and more complex landscape dated 1868 and intended as a "Great Picture" for public exhibition.[5] The large painting in turn inspired several other canvases, including *Landscape*, which has similar mountain formations. Nancy Anderson has observed that "unlike the artist's earlier western landscapes, *Among*

the Sierra Nevada Mountains, California carried a nearly generic title. No name was applied to the distant peak, and no claim was made for a specific site. The painting was a construct from start to finish."[6] The massive cliff that appears at the left in both *In the Mountains* and *Among the Sierra Nevada Mountains* is a reconfiguration of Yosemite's El Capitan, which appears in a number of the artist's paintings, and the distant snow peak in both works is seen in *The Rocky Mountains, Lander's Peak* and *Storm in the Rocky Mountains, Mt. Rosalie* (1866, Brooklyn Museum). Upon its public exhibition, some critics faulted the artist for not producing a topographically accurate portrait of the landscape, while others praised him for his "power of combination . . . an ideal union of the most splendid and characteristic features of our western mountains . . . a perfect type of the American idea of what our scenery ought to be, if it is not so in reality."[7]

The Atheneum's painting was formerly titled *Yosemite Valley*, but the name was changed when scholars were unable to identify the exact site and speculated that the mountains suggested the Sierra Nevadas or the Rockies.[8] We now know that this work is a composite drawn from various sources, intended by the artist not to be topographically faithful to any one site but to interpret the mood of the landscape by combining various details.

Junius Spencer Morgan (1813–1890), grandfather of John Junius Morgan, was probably the purchaser of this painting. Son of Joseph and Sarah Morgan, he was raised in Hartford and grew up to expand the family's business ventures to international importance. In 1836 he married Juliet Pierpont (1816–1884), the daughter of a prominent Boston family. He and his father, Joseph, were the original incorporators of the Wadsworth Atheneum, contributing to the building fund. In 1854 Junius Spencer Morgan moved with his family to London, where he remained for the rest of his life. There, he became a partner in the international banking house of fellow Yankee George Peabody; the firm, which made

Albert Bierstadt, *Landscape,* 1868. Fogg Art Museum, Harvard University Art Museums, gift of Mr. and Mrs. Frederic H. Curtiss.

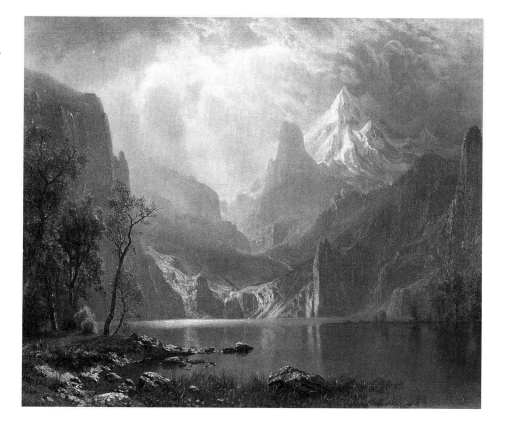

investments to American businesses, was eventually called J. S. Morgan and Company. Morgan lived at 13 Princes Gate and had a country house where he indulged his interest as a collector of English paintings and silver. He may well have encountered Bierstadt during the artist's stay in London in 1868, when he was widely received by English society and successfully sought English patrons.[9]

Morgan's daughter was Juliet Pierpont Morgan (1847–1923), who married John B. Morgan.[10] She may have inherited the painting from her father (she was one of five children including J. P. Morgan). Her son gave it to the Atheneum upon her death; at the time, it was simply referred to as a landscape by Albert Bierstadt.[11] EMK

1. Tuckerman writes that "having received a Government commission," Bierstadt made the trip "to make some studies for a picture of the discovery of the North River by Henry Hudson" (Henry T. Tuckerman, *Book of the Artists: American Artist Life* [New York: Putnam, 1867], 396).
2. Nancy K. Anderson and Linda S. Ferber, with Helena E. Wright, *Albert Bierstadt: Art and Enterprise*, exh. cat. (New York: Hudson Hills Press, in association with the Brooklyn Museum, 1990), 45.
3. Gerald L. Carr, "Albert Bierstadt, Big Trees, and the British: A Log of Many Anglo-American Ties," *Arts Magazine* 60 (summer 1986), 64.
4. For a series of contemporary reviews of this work, see Anderson and Ferber, *Albert Bierstadt*, 208.
5. "Great Picture" was a contemporary term originating in England that described large paintings intended to be shown to the public. See Carr, "Albert Bierstadt," 60–71.
6. Anderson and Ferber, *Albert Bierstadt*, 93.
7. *Boston Morning Post*, October 11, 1869, quoted in Anderson and Ferber, *Albert Bierstadt*, 93–94.
8. Theodore E. Stebbins, Jr., *The Hudson River School: Nineteenth-Century American Landscapes in the Wadsworth Atheneum* (Hartford: Wadsworth Atheneum, 1976), 72.
9. See Carr, "Albert Bierstadt," 60–71, which documents Bierstadt's reception by English society and English patrons.
10. Gregory Hedberg, "The Morgans of Hartford," in *J. Pierpont Morgan, Collector*, exh. cat., ed. Linda Horvitz Roth (Hartford: Wadsworth Atheneum, 1987), 11–12.
11. *Hartford Times*, January 24, 1924, lists gifts to the Wadsworth Atheneum for the year; see Scrapbooks, archives, Wadsworth Atheneum.

40 (see plate 8)

ALBERT BIERSTADT
The Hetch-Hetchy Valley, California, c. 1874–1880
Oil on canvas; 37⁵/₁₆ × 58⁵/₁₆ in. (94.8 × 148.1 cm)
Signed at lower left: A Bierstadt

EXHIBITED: New London, Conn., Lyman Allyn Museum, "Romantic Painting," 1955 / Santa Barbara, Calif., Santa Barbara Museum of Art, "Albert Bierstadt, 1830–1902," 1964 / Fort Worth, Tex., Amon Carter Museum of Art; Washington, D.C., Corcoran Gallery of Art; and New Bedford, Mass., Whaling Museum, "A Bierstadt," 1972–1973, no. 63

EX COLL.: with Eckhardt's Art Gallery (in business from 1872 to 1903), Hartford; purchased by Theodore Lyman, Hartford, before 1920; to his wife Laura M. (Sherman) Lyman, Hartford, in 1920

Bequest of Laura M. Lyman, in memory of her husband Theodore Lyman, 1925.618

The Hetch Hetchy Valley, once located in Yosemite National Park on the Tuolumne River, no longer exists as a valley. In 1938 the O'Shaunessy Dam, built in 1923, was enlarged, turning the valley into a lake about nine miles long that is used to supply San Francisco with water via a 156-mile aqueduct.

The valley first came to public attention in 1867 when geologists provided descriptions and stereoscopic views of what was described as a "new Yosemite" by a writer for the *San Francisco Bulletin*. Because the West was so closely identified with Bierstadt's renditions of the landscape, this newspaper writer correctly predicted that "as Bierstadt visited and painted Yosemite, so he will doubtless visit and paint Hetch-Hetchy."[1] Bierstadt, his wife, and three friends spent six weeks camping in and about the Hetch Hetchy Valley in the summer of 1873, during an extended trip in California that began in July 1871.[2] The *San Francisco News Letter and California Advertiser* of August 23, 1873, reported that Bierstadt had returned "laden with sketches, from a spot which as yet is almost untrodden soil, the Hetch-hetch-y Valley, twelve miles from Yosemite."[3]

The Atheneum's painting is one of the largest views

"Bierstadt's Hetch-Hetchy Valley," pamphlet for viewers. Archives, Wadsworth Atheneum.

of Hetch Hetchy Valley produced by Bierstadt. In the landscape Bierstadt includes the figure of a man, probably the artist himself, holding what appears to be a sketchpad. The figure stands on an elevation at the left, behind a rock, and looks out toward the distant smoke of an Indian encampment. The Tuolumne River flows through the center of the valley. The artist conveys the season with high-keyed autumnal foliage and a thick haze that pervades the lower valley region, making the distant mountain forms indistinct. The work was accompanied by a printed pamphlet describing the painting.

An unidentified "Hartford gentleman" who was a friend of the artist first admired this painting in Bierstadt's studio and arranged for its exhibition at Eckhardt's Art Gallery in Hartford, which had handled other paintings by Bierstadt, selling them locally.[4] It was acquired at an undetermined date by Theodore Lyman of Hartford.[5]

Bierstadt's depictions of the Hetch Hetchy Valley have not received any in-depth scholarly attention, thus dating the known works, none of which is dated by the artist, is difficult. Several contemporary sources, however, mention landscapes of Hetch Hetchy Valley by Bierstadt. The earliest known reference occurred in 1875 in the *Daily Evening Bulletin* (San Francisco), which mentioned "pictures in Mr. Bierstadt's studio on which he is now engaged," including "a view in the recently discovered valley of Hetch-Hetche [*sic*] [that] is also nearly finished."[6] The *New York Evening Post* of January 10, 1876, noted that Bierstadt exhibited "a large and brilliant sunset in the Hetch Hetchy Valley" at the Century Club in New York. Probably the same picture, owned by Bierstadt and described in the *New York Evening Post* on January 21, 1876, as "a sunset in the Hetch Hetchy Valley, California," was exhibited in the same year at the Union League Club.[7] Known Bierstadt paintings of this subject, which may in fact represent the paintings mentioned in the contemporary references above, include *Hetch Hetchy Canyon, California* (Mount Holyoke College Art Museum), *The Hetch Hetchy Valley, California* (Springfield Museum of Fine Arts, Massachusetts), *Sunrise in the Hetch Hetchy Valley, California* (George Walter Vincent Smith Museum, Springfield, Mass.), and the study *Hetch Hetchy*, a small version of which appeared in Sotheby's New York catalogue for May 24, 1989 (lot 63). EMK

1. *San Francisco Bulletin*, October 24, 1867, 3; my thanks to Nancy Anderson for supplying this reference.
2. For a description of the artist's trip west from 1871 to 1873 (but with negligible information on the trip to the Hetch Hetchy Valley), see Gordon Hendricks, "The First Three Western Journeys of Albert Bierstadt," *Art Bulletin* 46 (September 1964), 333–365.
3. Quoted in Nancy K. Anderson and Linda S. Ferber, with Helena E. Wright, *Albert Bierstadt: Art and Enterprise*, exh. cat. (New York: Hudson Hills Press, in association with the Brooklyn Museum, 1990), 227.
4. One documented sale took place in 1879 when John James McCook, who lived a few houses up from Eckhardt's Gallery on Main Street in Hartford, purchased Bierstadt's *Italian Village Scene (Olevano)* of 1860 for $315 after his wife, Eliza Butler McCook, had admired the painting in the gallery win-

dow. See Diary of John James McCook, vol. 19, April 7, 1879, to April 9, 1879, Butler-McCook House, Hartford.

5. Theodore Lyman lived at 22 Woodland Street in Hartford and died on August 10, 1920, leaving the painting to his wife, Laura Sherman Lyman (1855–1925).

6. *Daily Evening Bulletin*, December 3, 1875, from the Gordon Hendricks Papers, San Francisco Public Library; my thanks to Nancy Anderson for this reference.

7. My thanks to Nancy Anderson for these newspaper references.

George Caleb Bingham

Born in Augusta County, Va., in 1811; died in Kansas City, Mo., in 1879

As one of the foremost American genre painters of the nineteenth century, George Caleb Bingham is celebrated for his renderings of frontier life, which were informed by his active participation in Missouri politics. When he was a boy, his family had moved from Virginia to the frontier town of Franklin, Missouri, where his father became a prominent local businessman and politician.

After the death of his father, Bingham served an apprenticeship to a cabinetmaker in Booneville, Missouri, in 1827 and 1828. He developed an interest in painting at this time, first painting shop signs and by 1833 executing portraits. For much of his career, Bingham gained his livelihood as a portrait painter.

In 1838 Bingham sought artistic training in Philadelphia, where he studied at the Pennsylvania Academy of the Fine Arts. He was exposed to works of the old masters as well as to those of contemporary American artists, including the portraits of Gilbert Stuart (q.v.) and Thomas Sully (q.v.) and the genre paintings of William Sidney Mount (1806–1868).

Showing marked improvement in his painting after his brief experience in Philadelphia, Bingham spent 1841 to 1844 in Washington, D.C., where he painted portraits of such national figures as John Quincy Adams. His growing interest in genre painting then led the artist to return to his native region, where he spent a decade recording and interpreting life along the Missouri and Mississippi rivers. His depictions of fur traders, boat-

men, and politicians quickly found a market among eastern collectors. In New York City, for example, the American Art-Union distributed engravings of Bingham's genre paintings through their lotteries. Works such as *Fur Traders Descending the Missouri* (1845, Metropolitan Museum of Art), *The Jolly Flatboatmen* (1846, Senator Claiborne Pell, Washington, D.C.), and *The County Election* (1851–1852, St. Louis Art Museum) established the artist's reputation.

In the later years of the 1850s Bingham made several trips abroad to Düsseldorf, Germany, where he absorbed to some degree the academic teachings of the Düsseldorf Academy. His later works, which include history paintings and historical portraits, are thought to lack the freshness of his more celebrated earlier genre paintings and have not received the same acclaim.

Bingham's involvement in Missouri politics led to his election to the state legislature in 1848 and his appointment as state treasurer in 1862. In the final years of his life, he served as professor of art at the University of Missouri.

SELECT BIBLIOGRAPHY

Fern Helen Rusk, *George Caleb Bingham: The Missouri Artist* (Jefferson City, Mo.: Hughes Stephens Co., 1917) / E. Maurice Bloch, *George Caleb Bingham: The Evolution of an Artist*, 2 vols. (Berkeley, Calif.: University of California Press, 1967) / Albert Christ-Janer, *George Caleb Bingham, Frontier Painter of Missouri* (New York: Abrams, 1975) / E. Maurice Bloch, *The Paintings of George Caleb Bingham: A Catalogue Raisonné* (Columbia: University of Missouri Press, 1986) / Michael Edward Shapiro, Barbara Groseclose, Elizabeth Johns, Paul C. Nagel, and John Wilmerding, *George Caleb Bingham*, exh. cat. (New York: Abrams, in association with the Saint Louis Art Museum, St. Louis, 1990) / Nancy Rash, *The Paintings and Politics of George Caleb Bingham* (New Haven: Yale University Press, 1991)

41 (see plate 9)

GEORGE CALEB BINGHAM
The Storm, c. 1852–1853
Oil on canvas; 25 1/16 × 30 1/16 in. (63.7 × 76.4 cm)

EXHIBITED: St. Louis, Mo., City Art Museum, 1934 / New York City, Museum of Modern Art, and Wadsworth Atheneum, "George Caleb Bingham, The Missouri Artist, 1811–1879," 1935, no. 16 / M. Knoedler and Co., "American Painting," 1944, no. 3 / Hagerstown, Md., Washington County Museum of Fine Arts, "American Romantic," 1947, no. 3 / St. Louis, Mo., "Westward the Way," 1954, no. 18 / Kansas City, Mo., William Rockhill Nelson Gallery of Art, and St. Louis, Mo., City Art Museum, "George Caleb Bingham Sesquicentennial Exhibition," 1961, no. 19 / Washington, D.C., National Collection of Fine Arts; Cleveland, Ohio, Cleveland Museum of Art; and Los Angeles, Art Galleries, University of California at Los Angeles, "George Caleb Bingham 1811–1879," 1968, no. 19 / Seattle, Wash., Seattle Art Museum, "Lewis and Clark's America: A Voyage of Discovery," 1976, no. 8 / New York City, Museum of Modern Art, "The Natural Paradise: Painting in America 1800–1950," 1976, no. 62 / Wadsworth Atheneum, "The Hudson River School: Nineteenth-Century American Landscapes in the Wadsworth Atheneum," 1976, no. 29 / Wellesley, Mass., Wellesley College Museum, "Salvator Rosa in America," 1979, no. 83

EX COLL.: private collection, St. Louis, Mo.; Antiques Shop, St. Louis, Mo.; to Oscar Thalinger by 1934; to Meyric Rogers, St. Louis, Mo., in 1934; with M. Knoedler and Co., New York City, in 1944; purchased by Henry E. Schnakenberg, New York City, 1944

Gift of Henry E. Schnakenberg, 1952.74

From about 1840 to the early 1850s, when, at mid-career, he extended his artistic interests to include genre painting, Bingham also created a sizable number of landscapes. His interest in landscape was likely first ignited during his stay in Philadelphia in 1838, when he was exposed to the works of Thomas Cole (q.v.), among others, and furthered during the time he spent in the East, when, in an effort to gain patrons, he pursued the most popular art form of the day in America—landscape. He began sending his landscapes and genre paintings to New York City for exhibition beginning in 1845. Although his landscapes were not viewed as exceptional, paintings such as *The Jolly Flatboatmen*, which he exhibited in 1847 and which was engraved and widely distributed by the American Art-Union, gained the artist his greatest recognition.[1]

Around 1852 or 1853, Bingham honored the memory of the recently deceased artist Thomas Cole by painting the landscapes *The Storm* and *Deer in Stormy Landscape* (The Anschutz Collection, Denver, Colorado).[2] Rather than featuring his favored pastoral and agrarian themes, these companion pieces were inspired by such sublime landscape paintings as Cole's much earlier *Lake with Dead Trees* (1825, Allen Memorial Art Museum, Oberlin College, Ohio).[3] *The Storm* is a dramatic scene of untamed nature, containing the blasted tree, stormy sky, and sharp contrasts of light and dark that Bingham undoubtedly observed in the works of Cole. A deer frightened by the storm runs toward the rushing waters of a river. In the companion painting *Deer in Stormy Landscape* the storm has cleared, and the sky has opened up to reveal in the distance a majestic mountain just perceptible in *The Storm*.

These two sublime works are among the last landscapes Bingham painted; he executed only a few more over the course of his career. It is not known if he painted them for a client or for his own interest. EMK

1. For a thoughtful discussion of Bingham's landscape paintings, see Elizabeth Johns, "The 'Missouri Artist' as Historian," in Michael Edward Shapiro, Barbara Groseclose, Elizabeth Johns, Paul C. Nagel, and John Wilmerding, *George Caleb Bingham*, exh. cat. (New York: Abrams, in association with the Saint Louis Art Museum, 1990), 93–111.
2. *Deer in Stormy Landscape* is reproduced in ibid., 107, plate 25.
3. Ibid., 103–104.

Thomas Birch

Born in Warwickshire, England, in 1779; died in Philadelphia, in 1851

Thomas Birch, considered the earliest American specialist in marine painting, was born in landlocked central England, in a pastoral area noted for its agricultural resources. At fifteen, he traveled to America with his father, William Russell Birch (1755–1834), a painter and line engraver who made baked-enamel miniatures as well as landscape paintings. The two settled in Philadelphia, where Birch went to work for his father, producing topographical views of the city for William to

engrave. This series of engravings stands as an important document of postcolonial Philadelphia.

Around the turn of the century, Thomas Birch began to paint portraits, beginning with watercolor profiles in miniature, many of which survive, and later painting large oils. William Birch's collection of Dutch paintings, including works by Van Goyen and Ruisdael, exerted a strong influence on his son's landscape painting from the beginning. By about 1806 he was painting landscapes and seascapes and was achieving success with a series of pictures of American victories in naval battles in the War of 1812. Birch painted other marine pictures as well, including ship portraits, harbor and river views of Philadelphia and New York City (and one of Narragansett), and shipwrecks. His landscapes consist of views around the Philadelphia area, some New England and foreign scenes, which may be imaginary or based on verbal description, and after 1830 snow scenes.

From 1812 to 1817, Birch was keeper of the Pennsylvania Academy of the Fine Arts, and he exhibited there from 1811 to the end of his life. It was at the academy that the young Thomas Cole (q.v.) first saw and admired the work of Thomas Birch.

Birch died in Philadelphia at the age of seventy-one, never having strayed far from his first port of call in America.

SELECT BIBLIOGRAPHY

William Dunlap, *History of the Rise and Progress of the Arts of Design in the United States*, vol. 3 (1834; rpt., New York: Benjamin Blom, 1965), 25–26 / James Thomas Flexner, *History of American Painting*, vol. 2, *The Light of Distant Skies, 1760–1835* (1954; rpt., New York: Dover, 1969), 186–187 / Marian Carson, entry for Thomas Birch, in *The One Hundred and Fiftieth Anniversary Exhibition—The Pennsylvania Academy of the Fine Arts*, exh. cat. (Philadelphia: Pennsylvania Academy of the Fine Arts, 1955), 32–36 / William H. Gerdts, "Thomas Birch: America's First Marine Artist," *Antiques* 89 (April 1966), 528–534 / William H. Gerdts, *Thomas Birch, 1779–1851, Paintings and Drawings*, exh. cat. (Philadelphia: Philadelphia Maritime Museum, 1966) / John Wilmerding, *American Marine Painting*, 2nd ed. (1968; rpt., New York: Abrams, 1987) / *Philadelphia: Three Centuries of American Art*, exh. cat. (Philadelphia: Philadelphia Museum of Art, 1976) / Matthew Baigell, *Dictionary of American Art* (New York: Harper and Row, 1982), 38 / Edward J. Nygren, with Bruce Robertson, eds., *Views and Visions: American Landscape before 1830,* exh. cat. (Washington, D.C.: Corcoran Gallery of Art, 1986)

42 (see plate 10)

THOMAS BIRCH

Landscape with Covered Wagon, 1821
Oil on wood panel; 15³⁄₄ × 25 in. (40.0 × 63.5 cm)
Signed and dated at lower left: T Birch 1821

EXHIBITED: Wadsworth Atheneum, "Gould Bequest of American Paintings," 1948 / Philadelphia Maritime Museum, "Thomas and William Birch," 1966, no. 47 / Wadsworth Atheneum, "The Hudson River School: Nineteenth-Century American Landscapes in the Wadsworth Atheneum," 1976, no. 3

EX COLL.: Clara Hinton Gould, Santa Barbara, Calif., by 1948

Bequest of Clara Hinton Gould, 1948.207

It is tempting to compare the Atheneum's painting by Birch with an earlier and better-known painting by the artist entitled *Conestoga Wagon on the Pennsylvania Turnpike*. The Shelburne painting has been described as an early nineteenth-century representation of the mobility of American society, anticipating the physical growth and expansion of the population westward, a theme that would preoccupy American artists from around 1850 through 1875.[1]

In both paintings, a wagon fitting the structural description of a Conestoga wagon travels down a dirt lane past a pair of figures. In the Atheneum's painting, however, the wagon is driven by four horses rather than the six usual for a Conestoga wagon. In addition, the wagon in the Shelburne painting is headed away from the viewer, past the stationary figures and into the painting, toward the horizon, justifying an interpretation linking its theme with westward expansion. The wagon in the Atheneum's painting, on the other hand, travels toward the viewer, past figures who are moving

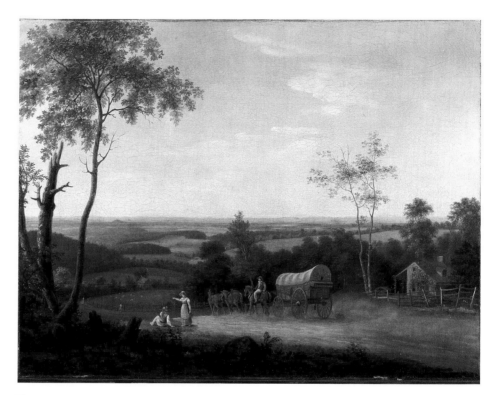

Thomas Birch, *Conestoga Wagon on the Pennsylvania Turnpike,* 1816. Shelburne Museum.

themselves. Too much should not be made of the composition, however, which is essentially formulaic: the eye is drawn into the painting via the figures at the lower right, and the diagonal lane acts as a repoussoir, guiding the viewer to the barn and house at the middle left.[2]

Pentimenti in the Atheneum's painting reveal that Birch's original composition included a third pair of horses. With this additional pair, the wagon would have been a standard Conestoga wagon, fitted out to carry a heavy load, as if moving from one place to another. The artist's decision to change the composition is significant: the connotation of the wagon changes from mobility to farming, a functional change that occurred in the eighteenth century. It is curious that the later painting should feature the earlier purpose of the Conestoga wagon, and the earlier painting, the later meaning. Other pentimenti show a building where the lane now curves back toward the barn and more branches on the tree in the right foreground.

Generally set in the Philadelphia area, Birch's landscapes are often topographical. Elements of *Landscape with Covered Wagon,* however, such as the foliage and the balanced composition, could be said to reflect the influence of the English rustic tradition in landscape painting, and the changes the artist made in the composition suggest that he was not adverse to making small adjustments in his representations of a given locale. Even so, the painting includes details that place the scene in an indubitably American context.[3] AE

1. Edward J. Nygren, with Bruce Robertson, eds., *Views and Visions: American Landscape before 1830,* exh. cat. (Washington, D.C.: Corcoran Gallery of Art, 1986), 37, 217.
2. Theodore E. Stebbins, Jr., *The Hudson River School: Nineteenth-Century American Landscapes in the Wadsworth Atheneum,* exh. cat. (Hartford: Wadsworth Atheneum, 1976), 13.
3. William H. Gerdts provides a brief general discussion of Birch's landscape paintings in *Thomas Birch, 1779–1851, Paintings and Drawings,* exh. cat. (Philadelphia: Philadelphia Maritime Museum, 1966), 15–16.

Isabel Bishop

Born in Cincinnati, Ohio, in 1902; died in Riverdale, N.Y., in 1988

Before she was two, Isabel Bishop moved with her family to Detroit, where her father took a job as principal of a high school and wrote Greek and Latin textbooks. Her mother was an unpublished writer and a women's rights activist. At fifteen, Isabel graduated from high school and entered Wicker Art School in Detroit. One of her relatives sponsored her move to New York City, where she entered the School of Applied Design for Women to study commercial art. Already an experienced student of art, she was able to enroll in life drawing classes. Before long, however, she became caught up in the excitement surrounding the development of modern art, and, in 1920, she transferred to the Art Students League. There, she studied with Kenneth Hayes Miller (q.v.), became friends with Guy Pène du Bois (q.v.), and met Reginald Marsh (q.v.) and Moses Soyer (1899–1975), and his twin, Raphael (q.v.).

Miller's emphasis on the forms and palette of the Italian old masters influenced a number of the American urban realist school artists, including Bishop, who drew on the work of Peter Paul Rubens in particular. Rubens's technique of applying underpainting in uneven and transparent washes on a white ground and adding drawing and glazes in such a way that the underpainting and ground are visible in places impressed Bishop, and she employed it in her own works, giving them a glowing, luminous quality.

In 1926 Bishop began living and working at 9 West Fourteenth Street, where she and her colleagues, including Marsh and the Soyers, became known informally as the Fourteenth Street Group. Although Bishop is traditionally associated with this school, however, her treatment of urban life is significantly different, lacking the overt political overtones of the social realists' work. Bishop's interest in the figure was in capturing something of the truth of life and the possibility of change. She said, "I try to limit content, to limit everything in order to get down to something in my work. What I ask of a painting is that it speak back to me. If it doesn't, it's no good and I have to start over" (Isabel Bishop, as quoted in Newsom, "Isabel Bishop," 44).

In 1934 Bishop married Dr. Harold G. Wolff, a neurologist, and the couple moved to Riverdale, New York, from where she daily commuted to a rented studio in Union Square. Bishop remarked, "Union Square interests me in a way that I don't understand myself. I think it has to do with a deep association from the time of my childhood, when my family lived one street from the 'good' neighborhood in Detroit, and there was a kind of appetite that I developed for the other direction, toward the slum region. It seemed warmer to me. It seemed more human, and I liked it better" (Bishop, as quoted in Yglesias, *Isabel Bishop*, 66). From 1936 to 1937, she taught at the Art Students League.

Bishop continued to paint and sketch the people of Union Square, but in 1932, in her painting *Dante and Virgil in Union Square* (Delaware Art Museum), a scene of passing crowds, she introduced a new theme, which she termed her subjective reality, that led to her subsequent "walking pictures." The first of these walking pictures was based on a scene in the subway under Union Square, where two levels were visible at once and the columns and vaults of the tunnel were exposed. Back in the studio, she did a study of the movement of a model walking, using her pencil as Eadweard Muybridge (1830–1904) had used his camera.

Although Bishop concentrated on the figure engaged in an act, she also painted nudes and still lifes. A printmaker as well, she executed etchings and aquatints, often as studies for paintings. She had her first one-artist show in 1933 at Midtown Galleries, New York City, where she continued to exhibit her work over the years. Bishop received a number of honors and awards, including the National Arts Club Gold Medal of Honor in 1968 and the Outstanding Achievement in the Arts award in 1979.

SELECT BIBLIOGRAPHY

Archives of American Art, Isabel Bishop Papers, microfilm rolls NY59–4, NY59–5 / Isabel Bishop, "Genre Drawings," *American Artist* 17, no. 6 (summer 1953), 46 / Una E. Johnson

and Jo Miller, *Isabel Bishop: Prints and Drawings 1925–1964,* exh. cat. (Brooklyn, N.Y.: Brooklyn Museum, 1964) / Sheldon Reich, *Isabel Bishop,* exh. cat. (Tucson: University of Arizona Museum of Art, 1974) / Lawrence Alloway, "Isabel Bishop, the Grand Manner and the Working Girl," *Art in America* 63, no. 5 (September–October 1975), 61–65 / Karl Lunde, *Isabel Bishop* (New York: Abrams, 1975) / Eleanor Munro, *Originals: American Women Artists* (New York: Simon and Schuster, 1979), 145–153 / Susan Teller, ed., *Isabel Bishop: Etchings and Aquatints. A Catalogue Raisonné* (New York: Associated American Artists, 1981) / Charlotte S. Rubenstein, *American Women Artists* (New York: Avon, 1982), 227–231 / Patricia Hills, *Social Concern and Urban Realism: American Painting of the 1930s* (Boston: Boston University Art Gallery, 1983), 36 / Patricia Paull Newsom, "Isabel Bishop," *American Artist* 49, no. 518 (September 1985), 42–45, 90 / Gregory Galligan, "Isabel Bishop: Early Drawings," *Arts* 61, no. 8 (April 1987), 42–43 / Catherine Barnett, "A Woman of Substance: Remembering Isabel Bishop," *Art and Antiques* (December 1988), 65–70 / Ellen Wiley Todd, "Isabel Bishop: The Question of Difference," *Smithsonian Studies in American Art* 3, no 4. (fall 1989), 25–41 / Helen Yglesias, *Isabel Bishop* (New York: Rizzoli, 1989)

43

ISABEL BISHOP
Waiting, 1942
Oil on composition board; 19⅞ × 15⅛ in. (50.5 × 38.4 cm)

EX COLL.: with Midtown Galleries, New York City; purchased by Anne Parrish Titzell, Georgetown, Conn., in 1950

Bequest of Anne Parrish Titzell, 1957.623

The year after Bishop painted the Atheneum's *Waiting,* she described her subjects: "The people I paint are clearly defined as a class. But they are not bound to that class. There's no limitation to what they may do and no telling where they may wind up. So when you paint them you can't make anything definite. The colors have to be muted. It comes out that way. I struggle to get them into a more defined scheme. But they can't be more defined because of what I am trying to do."[1]

The figure of the woman in *Waiting* is not defined as to class; she is simply a mother with her child, probably waiting for a train in a station. The implications of the title, however, fit with the period idea of the female worker as someone whose ultimate goal—marriage and redemption from the workplace or social mobility—was one that she waited for rather than actively sought.[2] The image, however, undoubtedly stems from Bishop's observations of people in New York City, where waiting was (and is) a part of life.

Bishop's usual method of working was first to execute a drawing of the subject, then an etching, and finally the painting. All three stages of her composition of *Waiting* have been located. A 1935 pen-and-ink drawing, also titled *Waiting,* is in the collection of the Whitney Museum of American Art in New York City. An etching titled *Delayed Departure,* dated 1935, is in a private collection.[3] Bishop made a finished painting of the subject three years later, now in the collection of the Newark Museum, New Jersey. That the Atheneum's version followed after four years and is on composition board, appearing less finished than the 1938 work, suggests that Bishop was rethinking the composition. Pursuant to this, the look on the face of the woman in the Atheneum's painting is a noticeable departure from the set expression of the figure in the Newark painting.

The Atheneum owns two drawings by Bishop, a gift of Henry Schnakenberg (q.v.), an artist and friend of Bishop. One of these, *Head No. 5,* is a study in pencil and red conté crayon for the child in the Newark painting[4] and consequently relates to *Waiting* as well.

Anne Parrish Titzell (q.v.), the donor of this painting and *Preoccupied* (cat. 44), was a painter, novelist, and children's book author and illustrator. AE

1. Isabel Bishop, quoted in Adelaide Kerr, "She Paints Plain People," *Wilmington Morning News,* April 28, 1943, Archives of American Art, roll NY59–4, Isabel Bishop Papers.
2. See Ellen Wiley Todd, "Isabel Bishop: The Question of Difference," *Smithsonian Studies in American Art* 3, no. 4 (fall 1989), 37, 40.
3. *Delayed Departure* is reproduced in Helen Yglesias, *Isabel Bishop* (New York: Rizzoli, 1989), 75.
4. Isabel Bishop to Charles C. Cunningham [then director of the Wadsworth Atheneum], August 9, 1954, curatorial painting file, Wadsworth Atheneum. The child in the drawing does not resemble the depiction in the final version.

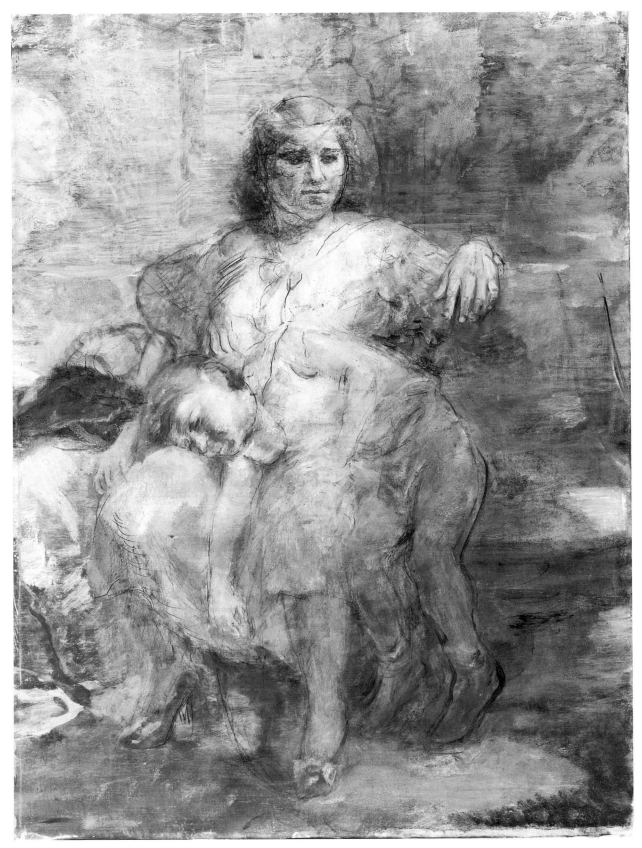

43

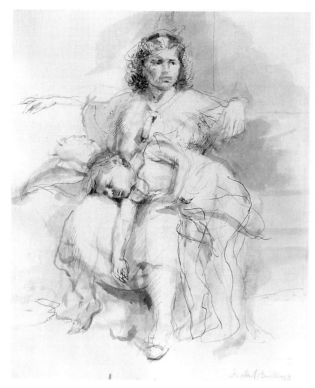

Isabel Bishop, *Waiting*, 1935. Collection of Whitney Museum of American Art, New York, purchase.

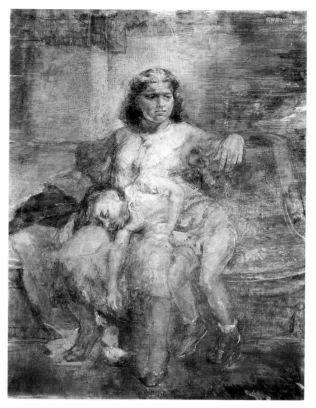

Isabel Bishop, *Waiting*, 1937–1938. Purchase 1944 The Arthur F. Egner Memorial Fund, Newark Museum.

44

ISABEL BISHOP

Preoccupied, 1953

Oil on composition board; 10⁵/₈ × 12³/₄ in. (27.0 × 32.4 cm)

Technical note: Concave cleavage accompanied by paint loss appears in the region of the woman's hair and right wrist, and there is minor paint loss in all four quadrants.

EXHIBITED: Wadsworth Atheneum, "Anne Parrish Titzell Memorial Exhibition," 1958, no. 38 / Newington, Conn., The Church of Christ Congregational, "Festival of Arts," 1971 / Tucson, Ariz., University of Arizona Museum of Art; Wichita, Kansas, Edwin A. Ulrich Museum of Art, Wichita State University; New York City, Whitney Museum of American Art; Memphis, Tenn., Brooks Memorial Art Gallery; and Athens, Ga., Georgia Museum of Art, University of Georgia, "Isabel Bishop Retrospective," 1974–1975, no. 2 / West Hartford, Art Study Gallery, Mercy Hall, St. Joseph College, "Images of Women," 1987–1988

EX COLL.: with Midtown Galleries, New York City; purchased by Mrs. Josiah (Anne Parrish) Titzell, Georgetown, Conn., in 1955

Bequest of Anne Parrish Titzell, 1957.624

Bishop's usual subjects were single figures or pairs of women, but occasionally she sketched and painted couples, as in *Preoccupied*.[1] The couple seems to be conversing seriously, and the very title of the work suggests their remove from the world around them. As in *Waiting* (cat. 43), the figures do not engage with the viewer in any way.[2]

The artist's vigorous hand lends vitality and dynamism to the figures of the seated couple and their ambiguous surroundings. Typical of even her more finished pieces, *Preoccupied* displays a heavily worked surface, with an uneven application of veils of wash over a white ground. Pencil underdrawing shows through. Bishop uses a subtle palette highlighted with touches of yellow and green. AE

44

1. Lawrence Alloway, "Isabel Bishop, the Grand Manner and the Working Girl," *Art in America* 63 (September–October 1975), 63. Alloway believes Bishop's studies of couples are less successful and more sentimental than her treatments of women.

2. See Ellen Wiley Todd, "Isabel Bishop: The Question of Difference," *Smithsonian Studies in American Art* 3, no. 4 (fall 1989), 25–42, for a discussion of the self-absorption of Bishop's figures, with particular reference to her images of working women.

Joseph Blackburn

Active in North America from 1754 to 1763

Several scholars have suggested that Joseph Blackburn was American; this is unlikely, however, and his origins remain unknown. He is thought to have been trained in England, but his earliest known works are the portraits he painted in Bermuda beginning in August 1752. After painting many of the leading Bermudian families, Blackburn left for North America, arriving in Newport, Rhode Island, in 1754. After painting portraits there, he moved on to Boston, taking with him the following letter of introduction: "The bearor Mr. Blackburne to your favor & friendship, he is late from the Island of Bermuda a Limner by profession & is allow'd to excell in that science, has now spent some months in this place, & behav'd in all respects as becomes a Gentleman, being possess'd with the agreeable qualities of great modesty, good sence & genteel behaviour" (Stevens, "Joseph Blackburn and His Newport Sitters," 101).

Blackburn produced portraits in the fashionable rococo style popular in England, using light pastel colors and fanciful poses; his meticulously rendered costumes have suggested to scholars that the artist had training as a drapery painter. Boston's leading families quickly embraced his style. He faced little competition: John Smibert (q.v.) had died in 1751, Robert Feke (q.v.) was no longer working in this area by 1752, John Greenwood (1727–1792) had left for Surinam, and John Singleton Copley (q.v.) had only just begun his career. This left only Joseph Badger (1708–1765) and Nathaniel Smibert (1735–1756) as rivals.

In search of new portrait commissions, Blackburn left for Portsmouth, New Hampshire, in 1758, possibly in response to Copley's rising popularity in the Boston area. He remained in Portsmouth for five years, painting portraits there as well as making occasional trips to Exeter, New Hampshire, and Newburyport, Massachusetts. He left for England in 1763. There are no known signed and dated portraits after 1778.

SELECT BIBLIOGRAPHY

John Hill Morgan, "Further Notes on Blackburn," *Brooklyn Museum Quarterly* 6 (July 1919), 147–152 / Lawrence Park, "Joseph Blackburn: Portrait Painter, with a Descriptive List of His Works," *Proceedings of the American Antiquarian Society* 32 (October 1922), 270–329 / John Hill Morgan and Henry Wilder Foote, "An Extension of Lawrence Park's Descriptive List of the Works of Joseph Blackburn," *Proceedings of the American Antiquarian Society* 46 (April 1936), 15–81 / C. H. Collins Baker, "Notes on Joseph Blackburn and Nathaniel Dance," *Huntington Library Quarterly* 9 (November 1945), 33–47 / William B. Stevens, Jr., "Joseph Blackburn and His Newport Sitters, 1754–1756" *Newport History* 40 (summer 1967), 95–107 / Elizabeth Ackroyd, "Joseph Blackburn, Limner in Portsmouth," *Historical New Hampshire* 30 (winter 1975), 231–243

45 (see plate 11)

JOSEPH BLACKBURN
John Erving, Jr., 1755
Oil on canvas; 49¼ × 39¼ in. (125.1 × 99.7 cm)
Signed at left center: I Blackburn Pinxt 1755

EXHIBITED: New York City, Metropolitan Museum of Art, "The Hudson-Fulton Celebration Exhibition," 1909, no. 3 / Paris, Galeries Lafayette, "Deux Cents Ans de Peinture Américaine: Collection du Musée Wadsworth Atheneum," 1989

EX COLL.: descended in the Erving family to Shirley Erving, Boston, by 1878; to John Langdon Erving, New York City, by 1909; to Mrs. C. V. R. Hoppin by 1930; to Erving Pruyn (the sitter's great-great-great grandson), Colebrook, Conn., by 1953; on loan to the Wadsworth Atheneum from Erving Pruyn from 1953 to 1986; given to the Wadsworth Atheneum from the estate of Erving Pruyn by his daughters Carolyn P. Pruyn, Frejus, France, and Justine P. Trowbridge, New York City, in 1986

Gift of the estate of Mr. and Mrs. Erving Pruyn, 1986.287

46 (see plate 12)

JOSEPH BLACKBURN
Mrs. John Erving, Jr. (Maria Catherine Shirley), 1755
Oil on canvas; 49 × 38⅞ in. (124.5 × 98.7 cm)
Signed at right center: I Blackburn Pinxt 1755

EXHIBITED: New York City, Metropolitan Museum of Art, "The Hudson-Fulton Celebration Exhibition," 1909, no. 4 / Paris, Galeries Lafayette, "Deux Cents Ans de Peinture Américaine: Collection du Musée Wadsworth Atheneum," 1989

EX COLL.: descended in the Erving family to Shirley Erving, Boston, by 1878; to John Langdon Erving, New York City, by 1909; to Mrs. C. V. R. Hoppin by 1930; to Erving Pruyn (great-great-great grandson of the sitter), Colebrook, Conn., by 1953; on loan to the Wadsworth Atheneum from Erving Pruyn from 1953 to 1983; given to the Wadsworth Atheneum from the estate of Erving Pruyn by his daughters Carolyn P. Pruyn, France, and Justine P. Trowbridge, New York City, in 1986

Gift of the estate of Mr. and Mrs. Erving Pruyn, 1986.288

Blackburn painted the portraits of Mr. and Mrs. John Erving, Jr., not long after his arrival in Boston in 1755. They are fine examples of the fashionable rococo style the artist successfully introduced to Boston society at midcentury. Boston's affluent families were much taken with his grandiose, three-quarter-length canvases and the elaborate landscape backgrounds he borrowed from English portraiture of the period. The Ervings, who were related to a number of Blackburn's Boston sitters, were among the group who preferred Blackburn's elegant and costly portraits.

A graduate of Harvard College in 1747, John Erving, Jr. (1728–1816), was the son of the Honorable John Erving, a wealthy loyalist who was painted by Copley in 1772 (Smith College Art Museum). Like his father, John, Jr., was a prominent Boston merchant. He married Maria Catherine Shirley, daughter of Governor William Shirley, in 1754 in Boston's King's Chapel. Because of their loyalist sympathies, the couple left for England in 1776, where they remained for the rest of their lives, both dying in Bath.[1]

As Richard Saunders has suggested, "part of Blackburn's overt success may be attributable to his willingness to enhance his sitter's appearances."[2] The Ervings'

portrayals are refined and attractive rather than strong statements of character. John Erving, Jr., is attired in up-to-date fashion—the artist took great care to elaborate meticulously the details of his vest coat of embroidered silk and his ruffled sleeves. He strikes an elegant pose leaning against a stone pier on which his tricornered hat rests.

Blackburn was particularly celebrated for his flattering portraits of women. Catherine Erving is presented with pale flesh tones, rosy cheeks, and a small, delicate head, accentuated by an elongated neck and torso. Her aristocratic pose and gestures, as well as the landscape features in the background, are drawn from a mezzotint by John Smith after *Princess Anne*, painted by Sir Godfrey Kneller in 1692.[3] Again, the artist accentuates the luxurious costume details, rendering the luster of the silk dress and the delicate lace, bows, and flowers with great care and deftness of brush. EMK

1. For biographical information, see Temple Prime, *Some Account of the Bowdoin Family with a Notice of the Erving Family* (New York: De Vine Press, 1900), 15–16, Henry Wilder Foote, *Annals of King's Chapel*, 2 vols. (Boston: Little, Brown, 1896) 2:129, 160, 170, 210; and Gregory Palmer, ed., *A Bibliography of Loyalist Source Material in the United States, Canada, and Great Britain* (Westport: Meeker, 1982), 226.
2. Richard H. Saunders and Ellen G. Miles, *American Colonial Portraits, 1700–1776*, exh. cat. (Washington, D.C.: Smithsonian Institution Press, 1987), 194.
3. See Waldron Phoenix Belknap, Jr., *American Colonial Painting, Materials for a History* (Cambridge: Cambridge University Press, 1959), 294.

Ralph Albert Blakelock

Born in New York City, in 1847; died in Elizabethtown, N.Y., in 1919

Intending to become a doctor like his father, in 1864 Ralph Albert Blakelock registered at the Free Academy of the City of New York (now City College), where he studied for three terms before dropping out in 1866 to paint landscapes. His formal art education was brief, at the Cooper Union Art School in New York City, where he was introduced to the work of the Hudson River school. In 1867 he exhibited his first landscapes at the National Academy of Design in New York.

Blakelock went west in 1869 and is thought to have visited Kansas, Colorado, Wyoming, Utah, Nevada, and northern California before returning to New York City in 1871. This trip kindled his interest in the life of Native Americans in the wilderness, the subject of many subsequent paintings. In 1877 he married Cora Rebecca Bailey, and beginning in 1879 and through 1888 Blakelock exhibited regularly at the National Academy and four times at the Society of American Artists in New York City. Paintings from this period reveal the influence of the Barbizon school and are primarily romantic scenes, such as moonlit landscapes and scenes of Indian life.

The artist's growing family—eight of nine children survived—and his inability to sell his paintings at good prices led to severe financial difficulty. In 1891, perhaps in part because of this pressure, Blakelock had a mental breakdown and was hospitalized for a short time. The brushwork of paintings dating from the 1890s is much freer than in earlier works. His mental health worsened rather than improved in the succeeding years, and in 1899 he was committed to Long Island Hospital at Kings Park, where he remained for three years before being transferred to the Middletown State Hospital for the Insane in Middletown, New York.

Blakelock finally achieved recognition for his work after he was confined, although some critics, like Sadakichi Hartmann, offered mixed reviews. Hartmann wrote, "We may regard R. A. Blakelock as a direct descendant of Rousseau. He had a strong personality, however, and his peculiar canvases, painted with a skewer such as the butchers use, blackened with madness and illumined with a weird tearful moonlight,—insufficient as they may be in many respects,—are at least the original expression of a soul" (Hartmann, *History of American Art*, 1:108). In 1900 Blakelock received an honorable mention at the Paris Exposition, and in 1913 and 1916, respectively, he was elected associate and then academician at the National Academy of Design. During this period, the value of his paintings rose, and so many forgeries were made that authenticity is still a problem.

Thomas B. Clarke and Catholina Lambert were among Blakelock's better-known patrons, but his most loyal supporters were friends such as the vaudeville actor Lew Bloom and the artist Harry W. Watrous (1857-?).

SELECT BIBLIOGRAPHY

Sadakichi Hartmann, *A History of American Art*, rev. ed. (1932; rpt., New York: Tudor, 1934), 1:108 / Elliott Daingerfield, *Ralph Albert Blakelock* (New York: Frederic Fairchild Sherman, 1914) / Frederic Fairchild Sherman, "Blakelock's Smaller Landscapes and Figure-pieces," *Art in America* 4, no. 4 (June 1916), 235–242 / Samuel Isham, with Royal Cortissoz, *The History of American Painting*, new ed. (New York: Macmillan, 1927), 446–447, 476 / Lloyd Goodrich, *Ralph Albert Blakelock Centenary Exhibition in Celebration of the Centennial of the City College of New York*, exh. cat. (New York: Whitney Museum of American Art, 1947) / Elliott Daingerfield, "Ralph Albert Blakelock," *Art in America* 51 (August 1963), 83–86 (reprint of article from *Art in America* 2 [December 1913]) / David Gebhard and Phyllis Stuurman, *The Enigma of Ralph A. Blakelock 1847–1919*, exh. cat. (Santa Barbara, Calif.: The Art Galleries, 1969) / M. Knoedler and Co., *Ralph Albert Blakelock*, exh. cat. (New York: M. Knoedler and Co., 1973) / Sheldon Memorial Art Gallery and New Jersey State Museum, *Ralph Albert Blakelock 1847–1919*, exh. cat. (Lincoln, Nebr.: Sheldon Memorial Art Gallery; Trenton, N.J.: New Jersey State Museum, 1975) / Doreen Bolger Burke, *American Paintings in the Metropolitan Museum of Art*, ed. Kathleen Luhrs (New York: Metropolitan Museum of Art, 1980), 3:34–45 / Dorinda Evans, "Art and Deception: Ralph Blakelock and His Guardian," *American Art Journal* 19, no. 1 (1987), 39–50 / Diana Strazdes, *American Paintings and Sculpture to 1945 in the Carnegie Museum of Art* (New York: Hudson Hills Press, in association with the Carnegie Museum of Art, 1992), 74–77

47

RALPH BLAKELOCK

Moonrise, 1883–1898

Oil on wood panel; 15$\frac{1}{8}$ × 18$\frac{3}{16}$ in. (38.4 × 46.2 cm)

Signed at lower left, within arrowhead: R A Blakelock

Technical note: The panel is cracked horizontally and infused on the reverse with wax resin. Contraction crackle and severe discoloration also occur. Blakelock's use of bitumen may have contributed to or caused some of these problems.

EXHIBITED: Wadsworth Atheneum, "Paintings in Hartford Collections," 1936, no. 11 / Lincoln, Nebr., Sheldon Memorial Art Gallery, University of Nebraska, and Trenton, N.J., New Jersey State Museum, "Paintings and Drawings by Ralph Blakelock (1847–1919)," 1975, no. 59

EX COLL.: the estate of James E. Nichols, New York City, c. 1914; to Mrs. John B. Griggs, Hartford, by 1936

Gift of Mrs. John B. Griggs, 1949.229

Blakelock's friend and artist colleague Elliott Daingerfield wrote about one of "two phases of nature [that] appealed especially to Blakelock": "Moonlight and that strange, wonderful moment when night is about to assume full sway, when the light in the western sky lingers lovely, glowingly, for a space, and the trees trace themselves in giant patterns of lace against the light. All the earth is dim, almost lost in the shadows, and the exquisite drawing of limb and leaf makes noble design, design so subtle as to bring despair, almost, to an artist's soul. This was Blakelock's moment, and it took such hold upon him that his vision translated it into all his work."[1] The Atheneum's *Moonrise* is typical of Blakelock's nocturnes, the images with which the artist is most associated.[2] A large foreground tree is silhouetted against a moonlit sky, creating a flat, decorative pattern; the moonlight itself is reflected in calm water.[3] The effect is Japanese in feeling.[4] The theme of moonlit landscape dates from the years 1883 to 1898, as do the lacy effects the artist achieves in the leaves of the tree in the foreground, the limited palette, and the use of glazes.[5] The technique Blakelock uses for the leaves of the tree is characteristic and of special interest. Rather than painting the leaves over the sky, he dotted lighter paint over the dark ground to create the silhouette of the leaves against the moonlit sky.[6] Highly romantic, the moonlit landscape is expressive of solitude and a poetic and spiritual mystery, and, as one scholar has suggested, the artist's personality itself.[7]

Blakelock's signature, inscribed within an arrow-

47

head, is worth noting. At least one scholar, writing in the 1970s, has observed that the artist usually signed his name in this manner in the period from 1883 to 1898.[8] Lloyd Goodrich, writing in 1947, believed that the signature appears as early as just after the artist's trip west in 1869 to 1871.[9] Early in the twentieth century, it was thought that the signature within an arrowhead was a sign of authenticity, but, as Daingerfield has pointed out, a number of Blakelocks whose authenticity was unquestioned were not signed. In addition, according to Daingerfield, forgers were aware of the weight the arrowhead carried and signed their spurious works accordingly.[10]

Although the problem of authenticity remains, the Atheneum's *Moonrise* is generally accepted as genuine. The painting was examined in the early 1950s by Goodrich and a conservator and believed to be characteristic of Blakelock's technique and style. In addition, a comparison with the Brooklyn Museum's *Moonlight* (c. 1885–1889), a painting considered authentic, was not

negative. A radiograph of the painting was, to Goodrich's mind, "favorable for the authenticity of the picture."[11] Goodrich's suggestion was affirmed in 1975 by the Sheldon Memorial Art Gallery at the University of Nebraska, Lincoln, in the definitive study and exhibition of Blakelock's work.[12]

The Atheneum owns one pencil drawing by Blakelock, titled simply *Landscape* and dated 1866.[13] AE

1. Elliott Daingerfield, *Ralph Albert Blakelock* (New York: Frederic Fairchild Sherman, 1914), 28.
2. Sheldon Memorial Art Gallery and New Jersey State Museum, *Ralph Albert Blakelock 1847–1919,* exh. cat. (Lincoln, Nebr.: Sheldon Memorial Art Gallery; Trenton, N.J.: New Jersey State Museum, 1975), 18.
3. Lloyd Goodrich, *Ralph Albert Blakelock Centenary Exhibition in Celebration of the Centennial of the City College of New York,* exh. cat. (New York: Whitney Museum of American Art, 1947), 15–16.
4. Such effects are not uncommon in Blakelock's work. Daingerfield remarks that *Brook by Moonlight* (after 1891, Toledo Museum of Art, Toledo, Ohio) "would give joy to a Japanese. It is definitely a design,—a thing rare in our art,—and de-

pending for its balance upon the flat silhouette of a tree which fills the upper half of the canvas" (Daingerfield, *Ralph Albert Blakelock*, 35).

5. Warren J. Adelson, in M. Knoedler and Co., *Ralph Albert Blakelock 1849–1919* (New York: M. Knoedler and Co., 1973), 14.

6. Lloyd Goodrich, Whitney Museum of American Art, to Charles Cunningham, then director of the Wadsworth Atheneum, June 29, 1951, regarding his examination of *Moonrise*. See curatorial painting file, Wadsworth Atheneum.

7. Sheldon Memorial Art Gallery and New Jersey State Museum, *Ralph Albert Blakelock*, 18.

8. Adelson, in M. Knoedler and Co., *Ralph Albert Blakelock*, 16.

9. Goodrich, *Ralph Albert Blakelock Centenary Exhibition*, 13–14.

10. See Daingerfield, *Ralph Albert Blakelock* (1914), 30.

11. Goodrich stated, "In general, I would accept this as a genuine Blakelock in the present state of our knowledge of his work." See Lloyd Goodrich to the Wadsworth Atheneum, June 29, 1951. Sheldon Keck was the conservator who examined the painting with Goodrich.

12. In 1971 the Sheldon Memorial Art Gallery wrote that "the elements of style, technique, and condition revealed in the present examination do not justify any final conclusion with regard to authenticity. It remains now to compare these findings with those derived from the examination of a maximum number of other examples, and secondly, to investigate as thoroughly as possible the painting's history of ownership" (Norman A. Geske, director, Sheldon Memorial Art Gallery, to the Wadsworth Atheneum, April 19, 1971, curatorial painting file, Wadsworth Atheneum). The painting was entered as number 155 in the Nebraska Blakelock inventory. In the exhibition that resulted from the research at the University of Nebraska, the painting was exhibited as an authentic Blakelock and discussed in the catalogue essay. See Sheldon Memorial Art Gallery and New Jersey State Museum, *Ralph Albert Blakelock*, 19, 41.

13. The drawing (5⅝ × 10⅜ in. [14.3 × 26.4 cm]), a bequest of George A. Gay (1941.446), was entered in the Nebraska Blakelock inventory as number 154. See Geske to the Wadsworth Atheneum, April 19, 1971.

George H. Boughton

Born in Norwich, England, in 1833; died in Campden Hill, England, in 1905

George Boughton was born in England but emigrated with his family the following year to Albany, New York. There he opened his first studio in 1852 and was listed as a landscape painter that same year. In 1859 he went to Paris, where he studied under Edouard Frère and Edouard May. In 1861 Boughton settled permanently in London, where he exhibited at the Royal Academy, becoming an associate academician in 1879.

Although he chose to exhibit his work in the English section of the Philadelphia Centennial Exposition, Boughton maintained many ties with America through his association with a circle of American artists in England. He became a member of the Tile Club in 1877 and was elected to the National Academy of Design in 1871. The subject matter for his paintings was frequently drawn from American history and literature. During the early 1880s the Harper publishing firm in New York City sent Boughton to Holland, along with Edwin Austin Abbey, to execute a series of illustrations for *Sketching Rambles in Holland*, published in 1885. Boughton died at his home in Campden Hill, England.

SELECT BIBLIOGRAPHY

Henry T. Tuckerman, *Book of the Artists* (New York: Putnam, 1867), 454–458 / George William Sheldon, *Hours with Art and Artists* (New York: D. Appleton, 1882), 2–10 / *Catalogue of Work in Many Media by Men of the Tile Club*, exh. cat. (New London, Conn.: Lyman Allyn Museum, 1945) / Michael Quick, *American Expatriate Painters of the Late Nineteenth Century*, exh. cat. (Dayton: Dayton Art Institute, 1976), 32, 86, 147–148

48

GEORGE BOUGHTON
Faithful, c. 1870
Oil on canvas; 13⅜ × 10⅛ in. (34.0 × 25.7 cm)
Signed at lower right: GHB
Canvas stamp: Prepared by / Winsor & Newton / 33[?] Rathbone Place / London

EXHIBITED: Wadsworth Atheneum, "A Second Look: Late Nineteenth Century Taste in Paintings," 1958, no. 40

EX COLL.: Reverend Francis Goodwin, Hartford, to 1900

Gift of Reverend Francis Goodwin, 1900.1

Boughton focused on American and British religious subjects for many of his historical works. American colo-

48

nial history, a popular theme in late nineteenth-century literature and art, inspired his series of paintings illustrating the New England history of the Puritans. His most famous work, *Pilgrims Going to Church* (*Early Puritans of New England Going to Church*) (New-York Historical Society), completed in 1867, was inspired by a passage from William Henry Bartlett's *Pilgrim Fathers* (London, 1853).[1] Pursuing a similar theme drawn from the history of the British Isles, *Faithful* depicts a woman in mourning attire kneeling in the snow beside a wooden cross, possibly Celtic, with a wreath nearby. The many crosses in the ground behind her suggest a cemetery. EMK

1. Susan E. Strickler, *The Toledo Museum of Art: American Paintings* (Toledo: Toledo Museum of Art, 1979), 26; and Richard J. Koke, ed., *A Catalog of the Collection, Including Historical, Narrative, and Marine Art* (New York: New-York Historical Society, 1982), 76–79.

49

GEORGE BOUGHTON
Daughter of the Knickerbocker, 1880
Oil on panel; 14⅝ × 9½ in. (37.1 × 24.1 cm)
Signed and dated at lower right: 1880 / G. H. Boughton
Signed on back of canvas: Daughter of the Knickerbocker / G. H. Boughton

EXHIBITED: New London, Conn., Lyman Allyn Museum, "Men of the Tile Club," 1945, no. 33 / Wadsworth Atheneum, "A Second Look: Late Nineteenth Century Taste in Paintings," 1958, no. 11

EX COLL.: purchased from the artist by Charles Stewart Smith, before 1905; purchased at the Charles Stewart Smith Sale, New York City, no. 115, by Samuel P. Avery, Hartford, in 1911

Gift of Samuel P. Avery, 1920.1024

Along with depictions of the Puritan history of New England, Boughton favored subjects drawn from the Dutch heritage of colonial New York. Samuel Isham commented on the possible impact Boughton's upbringing in Albany might have had, "Even his Holland pictures . . . seemed to be a reversion to the old Dutch traditions of Albany and Knickerbocker, New York."[1]

Daughter of the Knickerbocker depicts a young New York woman of Dutch descent carrying a Bible and standing in a snow-covered landscape with Dutch architecture in the background. EMK

1. Samuel Isham, *American Painting* (New York: Macmillan, 1905), 345.

William C. Bradford

Born in Fairhaven, Mass., in 1823; died in New York City, in 1892

William Bradford was raised as a Quaker in a small town across the harbor from the port of New Bedford. A ship's outfitter, his father ran a dry-goods store catering to the shipping trade, where Bradford worked as a young man. He began his career as a painter in 1855, setting

49

up a studio in Fairhaven, Massachusetts, where he specialized in ship portraiture and harbor scenes. He received formal training from the Dutch marine painter Albert Van Beest (1820–1860), who joined Bradford in Fairhaven in 1855 and 1856. He was also exposed to the work of Robert Salmon (q.v.) and Fitz Hugh Lane (1804–1864). Like them, he pursued the tradition of English and Dutch marine painting, working in a linear and precise style and focusing on the effects of light and atmosphere. Between 1854 and 1857, he was inspired by the writings of arctic explorer Elisha Kent Kane (1820–1857) to take several trips to Labrador, where he sketched the arctic landscape.

After maintaining a studio in Boston for several years, Bradford moved to New York City in 1860. The following year he was working in the Tenth Street Studio Building, where he remained a tenant until 1877. There, he came in contact with the leading artists of the day, including fellow New Bedford artist Albert Bierstadt (q.v.). Inspired by his contemporaries, particularly Frederic Church (q.v.) who had made expeditions to the Arctic and South America, Bradford became an artist-explorer. He would become best known for his depictions of arctic subjects. In 1861 he spent four months off the coast of Labrador photographing and sketching icebergs, and (with one exception) he repeated the voyage each summer for seven years. His most famous trip took place in 1869, when he chartered a steamer and traveled to Greenland with Dr. Isaac I. Hayes, a noted arctic explorer, and two photographers. The trip resulted in the publication of Bradford's *The Arctic Regions* (1873), which contained 125 photographs.

Like Bierstadt, Bradford attracted important patrons in both America and England; in 1872 he settled in London for two years, completing an important commission for Queen Victoria, *The Panther off the Coast of Greenland under the Midnight Sun* (1873, H.R.H. Queen Elizabeth II, London), which was exhibited at the Royal Academy in 1875.

In the later years of his career, Bradford came to rely on his photographs and sketches of the Arctic for his paintings. In the 1880s he also turned his attention to the American West, maintaining a studio in San Fran-

cisco and painting in the Yosemite Valley and the Sierra Nevadas. He ended his career in New York City at the age of sixty-eight.

SELECT BIBLIOGRAPHY

William Bradford, *The Arctic Regions* (London: Sampson, Marston, Low and Sampson, 1873) / Obituary, *New York Times*, April 26, 1892 / John Wilmerding, *A History of American Marine Painting* (Boston: Little Brown, 1968), 73, 83, 132, 149, 175, 187, 191–194, 196–198 / John Wilmerding, *William Bradford, 1823–1892*, exh. cat. (Lincoln, Mass.: DeCordova Museum; New Bedford, Mass.: Whaling Museum of New Bedford, 1969) / Frank Horch, "Photographs and Paintings by William Bradford," *American Art Journal* 5, no. 2 (1973), 61–70

50 (see plate 13)

WILLIAM BRADFORD

Coast of Labrador, 1868

Oil on canvas; 25½ × 44 in. (64.8 × 111.8 cm)

Signed and dated at lower right: Wm Bradford 1868

Technical note: Oil rubbed into surface of painting has caused discoloration and uneven darkening.

EXHIBITED: Newport, R.I., Art Association of Newport, "The Coast and the Sea—A Loan Exhibition Assembled from the Collections of the Wadsworth Atheneum," 1964, no. 6

EX COLL.: purchased by Elizabeth Hart Jarvis Colt, Hartford, in about 1868

Bequest of Elizabeth Hart Jarvis Colt, 1905.18

Working from a large inventory of drawings and wash and oil sketches, as well as photographs, Bradford transformed his experiences as an artist-explorer into vivid representations of the beauty as well as the ever-present danger of the frozen landscape. *Coast of Labrador* explores his fascination with the special effects of northern light; in this instance, he portrays the arctic sun's rising (or setting), casting shadows across the calm water, backlighting the glaciers at left, and illuminating the frigid iceberg at right. Using his favored low horizon line, Bradford conveys the vastness of this cold climate of floating icebergs, the scale pointed up by the small

vessel on the water and the detailed rendering at the right of the huts and beached vessels of whalers, men he had encountered and studied during his own trips.

This work was acquired by Elizabeth Hart Jarvis Colt for her newly completed picture gallery in her mansion, Armsmear, in Hartford. Colt may have first encountered Bradford's work while she served as head of the Hartford Table at the Metropolitan Sanitary Fair, held in New York City in 1864. Bradford was the Tenth Street Studio Building's arctic specialist, and his studio was accessible to clients such as Colt. As one New York paper described his studio in 1865: "Esquimaux [*sic*] harpoons, snow shoes, seal-skin dresses, and walrus teeth" served as a backdrop to "several chilling but picturesque paintings of icebergs."[1] Colt also purchased a work by James Hamilton (q.v.), who had illustrated *Arctic Explorations in the Years 1853, 1854, 1855,* the popular book by Elisha Kent Kane that Bradford had studied as a young artist, sparking his interest in the Arctic. Colt owned copies of Kane's arctic writings (cat. 255).

Coast of Labrador hung on the west wall of Colt's gallery (see Introduction), over a western landscape by Bradford's friend Albert Bierstadt (q.v.). EMK

1. Aldrich, "Among the Studios," *Our Young Folk* (September 1865), 597, reproduced in Annette Blaugrund, *The Tenth Street Studio Building* (Ann Arbor, Mich.: University Microfilms International, 1987), 176 n. 40.

Robert Bolling Brandegee

Born in Berlin, Conn., in 1849; died in Farmington, Conn., in 1922

Robert Brandegee received his earliest artistic training from his aunt, Sarah Tuthill, in Berlin, Connecticut. He continued his studies with American Pre-Raphaelites John Henry Hill (1839–1922) in Nyack, New York, and Thomas Charles Farrer (1839–1891) in New York City, both of whom adhered to the teachings of John Ruskin (1819–1900). Ruskin, an English critic and author, expounded an art form based on principles of truth to nature, principles demonstrated in the works of the En-

glish Pre-Raphaelite Brotherhood. Brandegee was influenced by his two instructors and, in the late 1860s, exhibited watercolors of still lifes and flower compositions that reflect the vivid colors and minute details of nature characteristic of the American Pre-Raphaelites.

In 1868 Brandegee exhibited his first work at New York's National Academy of Design, where he continued to show periodically through 1880. For three years, beginning in 1869, he gave drawing lessons in Hartford based on the teachings of Ruskin. In 1872 he left for Paris accompanied by his fellow Hartford artists Charles Noel Flagg (q.v.), Montague Flagg, and William Bailey Faxon (1849–?). The four studied in the small studio of Louis-Marie-François Jacquesson de la Chevreuse (1839–1903). There, he began to experiment with different painting techniques and to explore new subject matter found in portraiture and figure studies. In 1875 he enrolled at the Ecole des Beaux-Arts and in 1878 and 1879 exhibited a portrait at the Paris Salon.

Brandegee appears to have returned to America by 1878, judging from the address he listed—108 Fifth Avenue, New York City—when he exhibited that year at the National Academy of Design. In New York he opened a studio that he maintained for fifteen years, during which time he became a member of the National Academy of Design. He also exhibited at the Society of American Artists and the Pennsylvania Academy of the Fine Arts. In 1880 he was in Berlin, Connecticut, and soon began teaching at Miss Porter's School, a secondary school for young women in nearby Farmington. He continued at Miss Porter's School until 1903 and at some point also began teaching classes biweekly at Briarcliff College in New York. He taught at Briarcliff until 1925, when, according to James Britton (q.v.), Brandegee was replaced by Frank Vincent DuMond (1865–1951). Brandegee eventually moved to Farmington, where he purchased a house on High Street.

During this time, Brandegee played a very active role in Farmington, a town that strongly supported its lively artistic community. Farmington had traditionally attracted artists to its region, including James Renwick Brevoort (1832–1918) and James McDonald Hart (q.v.) in the 1860s. Later, numerous Hartford artists were

drawn to the region, including Charles Noel Flagg, Walter Griffin (q.v.), and James Britton. Cecilia Beaux (q.v.) also visited Farmington, where she painted a portrait of Brandegee. American Pre-Raphaelites John Henry Hill and Thomas C. Farrer, Brandegee's former teachers, also traveled to Farmington. Walter Griffin, writing for the *Farmington Magazine* in 1900, called Farmington the "Barbizon of America," a town that attracted gatherings of authors, artists, musicians, and educators.

Besides painting portraits, murals, and landscapes, and teaching, Brandegee founded, published, and edited a short-lived quarterly, the *Farmington Magazine*, from 1900 to 1902. He contributed images of his paintings and essays mostly on nature (reflective of his Pre-Raphaelite tendencies); Walter Griffin wrote essays on art and artists and Charles Foster (1850–1931) contributed a section called Book Notes. Brandegee also published and wrote a book, *From the Open Book of Nature*, in 1901, and in 1918 the artist wrote an unpublished autobiography.

Brandegee also participated in the artistic community in Hartford, which colleague James Britton called, in his own unpublished autobiography, "The Florence of America." In 1872 Brandegee showed his paintings at the Hartford Art Association exhibition held at the Charter Oak Life Insurance Building, and in 1875 he had a work at the Centennial Loan Exhibition. In 1892 Brandegee helped form the Society of Hartford Artists with Charles Noel Flagg, and three years later, again with Flagg, he participated in the founding of the Connecticut League of Art Students (formerly the Flagg Night School for Men). He was a member of the Connecticut Academy of Fine Arts, founded in 1910, serving on the council and jury.

SELECT BIBLIOGRAPHY

H. W. French, *Art and Artists in Connecticut* (Boston: Lee and Shepard, 1879) / Robert B. Brandegee, ed., *Farmington Magazine* (Farmington, Conn.: November 1900–October 1902) / James Britton, "Diaries, March 1925–October 1933," in *James Britton Papers* (New York: Archives of American Art), microfilm (restricted) / James Britton, "Autobiography," June 1935, in *James Britton Papers* (New York: Archives of American Art), microfilm (restricted) / Charles B. Ferguson, *An Exhibition of the Work of Robert Bolling Brandegee, A.N.A.* exh. cat. (New Britain, Conn.: New Britain Museum of American Art, 1971) / Maria Naylor, *The National Academy of Design Exhibition Record: 1861–1900*, vol. 1 (New York: Kennedy Galleries, 1973) / Linda S. Ferber, *The New Path: Ruskin and the American Pre-Raphaelites*, exh. cat. (New York: Schocken Books, for the Brooklyn Museum, 1985) / Annette Blaugrund, with Albert Boime, D. Dodge Thompson, H. Barbara Weinberg, and Richard Guy Wilson, *Paris 1889: American Artists at the Universal Exposition*, exh. cat. (New York: Abrams, in association with the Pennsylvania Academy of the Fine Arts, Philadelphia, 1989)

51

ROBERT BRANDEGEE
The Chess Players, c. 1890
Oil on canvas; 29⅛ × 36¼ in. (74.0 × 92.1 cm)

EXHIBITED: Wadsworth Atheneum, "Loan Exhibition of Modern Paintings," 1923, no. 6 / Wadsworth Atheneum, "Fiftieth Anniversary of the Connecticut League of Art Students Exhibition," 1938 / New Britain, Conn., New Britain Museum of American Art, "Exhibition of the Work of Robert Bolling Brandegee, A.N.A. 1849–1922," 1971, no. 21

EX COLL.: Dr. and Mrs. Joel L. Wright, Hartford, by 1925

Purchased through the gift of Henry and Walter Keney, 1925.52

While in Paris, Brandegee began to focus on the human figure, a direct result of his studying with Jacquesson de la Chevreuse, who emphasized figure studies, contour, and shape.[1] On his return to America, Brandegee continued to focus on the figure in portraits and genre scenes. In Farmington he painted several portraits, mostly of his friends, colleagues, and family. In his genre scene *The Chess Players*, Brandegee depicts two of his acquaintances, Mr. Elijah Lewis and Miss Rianhard, engaged in a game of chess. The winning partner is clearly the female player, who has nearly checkmated her opponent. Brandegee chose to show only the face of the male sitter, focusing the viewer's attention on the intensity of the losing player's position. Brandegee's Hartford colleague James Britton (q.v.) discussed the work in his diaries, after the painting had been purchased by the

51

Wadsworth Atheneum: "The 'Chess Players' are grand. The color of this picture very distinguished. The figure of the old man especially fine. The old guard in the [Atheneum] gallery smiles with glee as he calls my attention to the perplexed expression on the old chess player's face. Yes, this is a good Brandegee."[2]

The work reflects Brandegee's early training under Jacquesson. The light and dark contrasts and the broad painting technique suggest Brandegee's familiarity with the works of Frank Duveneck (q.v.) and the Munich School.[3]

The painting served as a frontispiece for the October 1901 issue of Brandegee's *Farmington Magazine*. ERM

1. Annette Blaugrund, with Albert Boime, D. Dodge Thompson, H. Barbara Weinberg, and Richard Guy Wilson, *Paris 1889: American Artists at the Universal Exposition*, exh. cat. (Philadelphia: Pennsylvania Academy of the Fine Arts, 1989), 119.
2. Diary entry, November 4, 1925, James Britton, "Diaries, March 1925–October 1933," *James Britton Papers* (New York: Archives of American Art), 8, microfilm (restricted), roll 3648.
3. Blaugrund, *Paris 1889*, 119.

Alfred Thompson Bricher

Born in Portsmouth, N.H., in 1837; died in New Dorp, Staten Island, N.Y., in 1908

Alfred Bricher, born in New Hampshire to English immigrants, grew up in Newburyport, Massachusetts, where he attended school and where Fitz Hugh Lane (1804–1865) and Martin Johnson Heade (q.v.) painted. There is no record of Bricher's having known either Lane or Heade, but his early paintings are evidence of his awareness of luminist painting and its influence on his work.

In 1859 Bricher went to Mount Desert, Maine, where he met artists Charles Temple Dix (1838–1873), William Stanley Haseltine (1835–1900), and very probably Lane. Three years later he took a studio in the Boston Studio Building, where he showed his plein-air sketches and landscapes and where Lane and Heade also had studios. During the 1860s Bricher sketched at many of the sites frequented by the Hudson River school, among them Catskill Cove, Lake George, and the White Mountains. In 1868 L. Prang and Company of Boston published two lithographs after Bricher's *Early Autumn on Esopus Creek, N.Y.* (before 1866, private collection) and *Late Autumn in the White Mountains*. Enormously popular—an indication of Bricher's appeal to a wide audience—these lithographs helped establish Prang's success.

In the summer of 1866 Bricher traveled west along the upper Mississippi River from Dubuque, Iowa, through Prairie du Chien, Wisconsin, to Red Wing and Minneapolis, Minnesota. Material gathered from this trip inspired at least three paintings, which were exhibited at the National Academy in New York City in 1870.

By the end of summer 1866 Bricher was sketching on the Connecticut River near Northampton, Massachusetts, where he had worked in 1865 painting such pictures as *View of the Connecticut River* (1865, Davison Art Center, Wesleyan University, Middletown, Conn.).

By 1870 Bricher had moved from Boston to New York City, where he took a studio in the YMCA building near the National Academy of Design. That year he exhibited two paintings from his Mississippi River trip at the National Academy. His neighbors at the YMCA in the

1870s included William Hart (q.v.), David Johnson (q.v.), John F. Kensett (q.v.), Arthur F. Tait (1819–1905), George H. Smillie (1840–1921), and Alexander H. Wyant (q.v.). Bricher continued to make summer sketching trips to the Massachusetts coast and the islands off Maine, spending a lot of time at Grand Manan Island and the Bay of Fundy off New Brunswick, where Frederic Church (q.v.) took the subject for the Atheneum's *Grand Manan Island, Bay of Fundy* (1852, cat. 112). Around this time, Bricher began to specialize in seascapes and established a reputation as a marine painter.

Although famous for his marines, Bricher painted a number of paintings that included figures, particularly after 1878. A number of drawings and watercolors made during the six years following 1878 explore the human figure—usually a female stereotype like the Gibson girl—in a variety of genre scenes.

In 1878 Bricher first exhibited with Gill's Art Galleries in Springfield, Massachusetts; he continued to exhibit with Gill's for the remainder of his life. James D. Gill specialized in American paintings, and during his forty-four year career showed paintings by Albert Bierstadt (q.v.), Frederic Church, Winslow Homer (q.v.), and Eastman Johnson (q.v.), among others.

Bricher's important and only known patron was George Walter Vincent Smith, who in 1878 sponsored with gallery owner James D. Gill the first of a series of exhibitions featuring the works of contemporary American artists. The first comprised the work of forty-one American artists, among them, Bricher. Smith acquired at least fifteen works by Bricher—oils, drawings, and watercolors. Most of these are now in the collection of the George Walter Vincent Smith Art Museum in Springfield, Massachusetts.

Bricher's work from the 1880s until his death in 1908 at times reflects some influence of the Barbizon school. In these works, Bricher evokes mood through broad-brush execution and a tonalist palette. Many works from this period, however, continue to show Bricher's luminist impulses, featuring a hard, rational approach to subject, detail, and local color.

Bricher was elected associate at the National Academy in 1879 and from 1873 was an active member of the

American Society of Painters in Watercolors. He was also a member of the Brooklyn Art Association and, in the middle 1880s, of the Art Union.

SELECT BIBLIOGRAPHY

"American Painters—Alfred T. Bricher," *Art Journal* (November 1875), 340–341 / G. W. Sheldon, *American Painters*, rev. ed. (New York: D. Appleton, 1881), 144–146 / Clara Erskine Clement and Laurence Hutton, *Artists of the Nineteenth Century and Their Works*, rev. ed. (1884; rpt., St. Louis: North Point, 1969), 1:93 / John D. Preston, "Alfred Thompson Bricher, 1837–1908," *Art Quarterly* 25, no. 2 (summer 1962), 149–157 / Cushing Memorial Gallery, *The Coast and the Sea: A Loan Exhibition Assembled from the Collections of Wadsworth Atheneum, Hartford*, exh. cat. (Newport, R.I.: Art Association of Newport, 1964) / Jeffrey R. Brown, with Ellen W. Lee, *Alfred Thompson Bricher, 1837–1908*, exh. cat. (Indianapolis: Indianapolis Museum of Art, 1973) / Jeffrey R. Brown, "Alfred Thompson Bricher," *American Art Review* 1, no. 2 (January–February 1974), 69–75 / Natalie Spassky, *American Paintings in the Metropolitan Museum of Art*, ed. Kathleen Luhrs (Princeton, N.J.: Princeton University Press, in association with the Metropolitan Museum of Art, 1985), 2:517–519 / John K. Howat, ed., *American Paradise: The World of the Hudson River School*, exh. cat. (New York: Metropolitan Museum of Art, 1987) / John Wilmerding, *American Marine Painting*, rev. ed. (New York: Abrams, 1987), 142–143 / National Gallery of Art, Washington, and Detroit Institute of Arts, *American Paintings from the Manoogian Collection*, exh. cat. (Washington and Detroit: National Gallery of Art and Detroit Institute of Arts, 1989), 14, 188 / John Wilmerding, *American Light: The Luminist Movement, 1850–1875*, exh. cat. (Princeton, N.J.: Princeton University Press, in association with the National Gallery of Art, Washington, 1989) / Diana Strazdes, *American Paintings and Sculpture to 1945 in the Carnegie Museum of Art* (New York: Hudson Hills Press, in association with the Carnegie Museum of Art, 1992), 106–107

52

ALFRED BRICHER
Maillon's Cove, Grand Manan, Fog Clearing, c. 1885–1895
Oil on canvas; 18¹⁄₈ × 39¹⁄₈ in. (46.0 × 99.4 cm)
Signed at lower right (partial monogram): ATBRICHER
Inscribed on upper edge of stretcher in pencil: Maillon's Cove, Grand Manan, Fog Clearing

EXHIBITED: Springfield, Mass., "Annual Exhibition," 1898, no. 9, as "Fog Clearing, Grand Manan" / Wadsworth Ath-

52

eneum, "A Second Look: Late Nineteenth Century Taste in Paintings," 1958, no. 9 / Newport, R.I., Art Association of Newport, Rhode Island, "The Coast and the Sea: A Loan Exhibition Assembled from the Collections of the Wadsworth Atheneum," 1964, no. 7 / Indianapolis, Indianapolis Museum of Art, and Springfield, Mass., The George Walter Vincent Smith Museum, "Alfred Thompson Bricher," 1973–1974, no. 74

EX COLL.: with Gill's Art Galleries, Springfield, Mass., in 1898; to Josephine I. B. Davis, Hartford

Bequest of Mrs. Josephine Davis in memory of her husband, 1924.397

Around 1874 Bricher began to make regular trips to Grand Manan Island, New Brunswick, to sketch the coastal scenery. He painted this site throughout the remainder of his career, many of the paintings reproduced in *Harper's New Monthly Magazine*.[1] In 1876 Bricher exhibited a painting called *A Lift in the Fog, Grand Manan* (1876, private collection), which compares in theme with the Atheneum's painting.[2]

Although Bricher's choice of vantage point in the Atheneum's painting still would seem to reflect the influence of John F. Kensett (q.v.), his painterly treatment of the subject and his emphasis on atmosphere show his assimilation of Barbizon techniques and ideals and is characteristic of his late work.[3]

The driftwood in *Maillon's Cove*, as well as the clumps of seaweed on the beach, are stock motifs in Bricher's marine paintings. Since no sketchbooks chronicling travels after 1872 survive and because Bricher did not date many of his works after 1881, it is unclear whether *Maillon's Cove* was painted from memory or from sketches.[4]

Bricher showed *Maillon's Cove, Grand Manan, Fog Clearing* in the 1898 exhibition sponsored by his patron George Walter Smith and James D. Gill.[5] AE

1. For example, Bricher illustrated an article by Edward Abbott, titled "Grand Manan and Quoddy Bay," which appeared in *Harper's New Monthly Magazine* 56, no. 334 (1878), 541–556. See Jeffrey R. Brown, with Ellen W. Lee, *Alfred Thompson Bricher, 1837–1908,* exh. cat. (Indianapolis: Indianapolis Museum of Art, 1973), 20–21.
2. Brown, with Lee, *Alfred Thompson Bricher*, 21. One of Bricher's most famous paintings of Grand Manan is *Time and*

Tide (c. 1873, Dallas Museum of Art). See Barbara Buff's entry on *Time and Tide*, in John K. Howat, ed., *American Paradise: The World of the Hudson River School*, exh. cat. (New York: Metropolitan Museum of Art, 1987), 324–325. The clear, luminist atmosphere and hard detail of *Time and Tide* contrast with the Atheneum's Bricher, which is softer in execution.
3. *American Paintings and Sculpture to* 1945 *in the Carnegie Museum of Art* (New York: Hudson Hills Press, in association with the Carnegie Museum of Art, 1992), 106.
4. Brown, with Lee, *Alfred Thompson Bricher*, 20, 29. Brown and Lee note that Bricher did not usually paint from memory, however, and suggest that the artist continued to travel to Grand Manan in the late years.
5. Brown, with Lee, *Alfred Thompson Bricher;* and Jeffrey R. Brown, "Alfred Thompson Bricher," *American Art Review* 1, no. 2 (January–February 1974), 69–75.

John Bunyan Bristol

Born in Hillsdale, N.Y., in 1826; died in New York City, in 1909

John Bunyan Bristol's father, a farmer, was born in New Haven, Connecticut, and, according to H. W. French, it was this fact that first brought Bristol to Connecticut, where he discovered the Connecticut River, following it up through New England on sketching trips and stopping at one point to paint *Evening on the Connecticut at Hartford* (*Art and Artists in Connecticut*, 127).

The artist had some formal training in his profession with Henry Ary, a locally known portrait painter in Hudson, New York, with whom he studied for a short time. Although he began as a portraitist, he soon turned to landscape painting. In 1859 he traveled to Florida, sketching in the area of St. Augustine, where, later in the century, Martin Johnson Heade (q.v.) would paint and finally die. After his marriage in 1862, Bristol settled in New York City and spent most of his summers in New England, in particular Berkshire County, where he took the subject for the Atheneum's painting and where a number of other artists painted, beginning with Thomas Cole (q.v.) and the Hudson River school. During this time, Bristol made occasional trips to Lake George and Lake Champlain. He also painted in Vermont and in the White Mountains, where artists such as John F.

Kensett (q.v.), Samuel Colman (q.v.), and Aaron Draper Shattuck (q.v.) were all working.

G. W. Sheldon wrote, "Bristol's pictures are the outgrowth of a desire to express the sentiment of Nature as he feels it. . . . Not depending for success upon the technics of his art, he asks of the spectator no special artistic training as a prerequisite to appreciation. . . . Picturesqueness—that is his first criterion for a subject" (*American Painters*, 21). Bristol was often praised for his treatment of atmosphere, which lends his pictures a Barbizon quality, despite his lack of training abroad, and links his work with that of artists such as George Inness (q.v.), who also painted in the Berkshires.

In 1861 Bristol was elected a member of the Artists' Fund Society and an associate at the National Academy of Design, both in New York City, where he regularly exhibited throughout his career. Fourteen years later, he was made an academician at the National Academy. A member of the Century Club, also in New York City, he exhibited there as well. Bristol was awarded medals at the Centennial Exposition in Philadelphia (1876) and at the Pan-American Exposition in Buffalo (1901). He received an honorable mention at the 1889 Paris Exposition for *Haying Time, near Middlebury, Vt.* (unlocated).

In his day, Bristol enjoyed a certain amount of fame. A contemporary reporter remarked, "Mr. Bristol as a landscape-painter is well known all over the United States, and his pictures are in all of the leading collections" (*New York Evening Post*, April 1875, as quoted in Clement and Hutton, *Artists of the Nineteenth Century*, 1:98).

SELECT BIBLIOGRAPHY

DAB, 3:54–55 / Henry T. Tuckerman, *Book of the Artists: American Artist Life* (New York: Putnam, 1867), 557–558 / "American Painters.—John B. Bristol, N.A.," *Art Journal*, n.s., no. 210 (June 1879), 110–111 / Clara Erskine Clement and Laurence Hutton, *Artists of the Nineteenth Century and Their Works*, rev. ed. (1884; rpt., St. Louis: North Point, 1969), 1:97–98 / H. W. French, *Art and Artists in Connecticut* (Boston: Lee and Shepard; New York: Charles T. Dillingham, 1879), 127 / G. W. Sheldon, *American Painters*, rev. ed. (New York: D. Appleton, 1881), 20–23 / George C. Groce and David H. Wallace, *The New-York Historical Society's Dictionary of Artists in America, 1564–1860* (New Haven: Yale University Press; London: Oxford University Press, 1957), 82 / Annette Blaugrund, with Albert Boime, D. Dodge Thompson, H. Barbara Weinberg, and Richard Guy Wilson, *Paris 1889: American Artists at the Universal Exposition*, exh. cat. (New York: Abrams, in association with the Pennsylvania Academy of the Fine Arts, Philadelphia, 1989) / Maureen Johnson Hickey and William T. Oedel, *A Return to Arcadia: Nineteenth Century Berkshire County Landscapes*, exh. cat. (Pittsfield, Mass.: Berkshire Museum, 1990), 63–65

53

JOHN BRISTOL

On the Housatonic River near Great Barrington, Mass., c. 1880

Oil on canvas; 23 1/8 × 38 1/4 in. (58.7 × 97.2 cm)

Signed at lower left: J. B. Bristol

Inscribed on back of stretcher: On the Housatonic River Near Gr Barrington Mass / J Bristol

EX COLL.: Ambrose Spencer, Hartford

Bequest of Ambrose Spencer, 1901.16

After Bristol married a daughter of Alanson Church of Great Barrington, Massachusetts, in 1862, he began to spend increasing amounts of time in the Berkshire area, painting in the summers. He exhibited paintings set in Berkshire County and on the Housatonic at New York's National Academy of Design throughout the latter part of his career.[1]

In the Atheneum's painting, Bristol chose to depict that part of the Housatonic that lies south of Great Barrington, a farming and resort town in the late nineteenth century. The wide angle of his view is typical of his compositions from the period and reflects the influence of the Barbizon school in the United States, as does his attention to light and weather.[2] G. W. Sheldon wrote, "Bristol's sense of atmosphere and of perspective is highly stimulated, or perhaps we should say quickened. His pictures are strongest in the rendition of spaciousness, of sunshine, and of cool, transparent shadow. . . .

53

They readily catch the local effect of air and color, and they convey for the most part a general impression as of out-doors."[3] Even more to the point for this picture, perhaps, was the spectator quoted by Sheldon as commenting, "You see Nature as I see her; that picture makes me feel as I feel when I go a-fishing."[4]

The Atheneum's Bristol, donated to the museum by Hartford collector Ambrose Spencer, arrived with a plaque on the frame bearing the title *The River;* it was accessioned into the museum's collection as *The River, with Boy Fishing.* Inspection of the back of the stretcher permitted the title to be refined to its present form. The painting's large size indicates that it may have been intended for exhibition, but no exhibition history for the picture has been determined as yet. AE

1. Maureen Johnson Hickey and William T. Oedel, *A Return to Arcadia: Nineteenth Century Berkshire County Land-scapes,* exh. cat. (Pittsfield, Mass.: Berkshire Museum, 1990), 63. See also Maria Naylor, *The National Academy of Design Exhibition Record 1861–1900* (New York: Kennedy Galleries, 1973), 99–102. Exhibition records compiled by James L. Yarnall and William H. Gerdts indicate that through 1876 Bristol exhibited Berkshire scenes at the Artists' Fund Society, New York; Buffalo Fine Arts Academy, Buffalo, New York; Yale School of Fine Arts, New Haven; and Century Association, New York, among other venues. See *The National Museum of American Art's Index to American Art Exhibition Catalogues from the Beginning through the 1876 Centennial Year* (Boston: Hall, 1986), 1:452–456.
2. Hickey and Oedel, *A Return to Arcadia,* 65.
3. G. W. Sheldon, *American Painters,* rev. ed. (New York: D. Appleton, 1881), 22.
4. Ibid., 21–22.

James Britton

Born in Hartford, 1878; died in South Manchester, Conn., 1936

James Britton began his art training in Hartford as a private pupil under Charles Noel Flagg (q.v.) at the Connecticut League of Art Students and studied with Robert Brandegee (q.v.) in Farmington in 1897. He also worked briefly with Walter Griffin (q.v.). Flagg, Brandegee, and Griffin recommended that he study with George de Forest Brush (1855–1941) at the Art Students League in New York City. In 1894, at the age of sixteen, Britton worked on the staff of *Scribner's Maga-zine* under August Jacacci (1865–1930) in New York City, and in 1898 he was a staff artist for the *Hartford Times.* He edited and published the *Art Review Interna-tional.* Britton was the founder of Eclectics, an artists' group in New York City, and a charter member and founder of the Connecticut Academy of Fine Arts. He

was also a member of the Society of Connecticut Artists and the New Society of American Artists.

Besides painting portraits and landscapes, James Britton also produced several woodcuts for illustrations in posters, newspapers, periodicals, and books. Britton played his most active role, however, in promoting and advocating American art through his writings. He wrote *Artists of America* in which he discusses the major artistic figures in the history of art in America, beginning with one of his champions, John Singleton Copley (q.v.). His criticism was sought, especially of American painting, and he served as critic for *Art News*.

Britton left behind diaries and an unpublished autobiography (1935), in which he discusses the Hartford and New York artists and their activities during the late nineteenth and early twentieth centuries. He was particularly outspoken about the lack of recognition and support given to Hartford artists by the city itself. The colleagues about whom he wrote included Maurice Prendergast (q.v.), George Bellows (q.v.), Robert Henri (q.v.), William Gedney Bunce (q.v.), Charles Noel Flagg (q.v.), Robert Brandegee (q.v.), Walter Griffin (q.v.), Cecilia Beaux (q.v.), Willard Metcalf (q.v.), John Sloan (q.v.), and George Luks (q.v.). Although his views and comments are very personal and somewhat biased, Britton offers invaluable insight into American art and artists of this period.

SELECT BIBLIOGRAPHY

James Britton, "Diaries, March 1925-October 1933," in *James Britton Papers* (New York: Archives of American Art), microfilm (restricted) / James Britton, "Autobiography," June 1935, in *James Britton Papers* (New York: Archives of American Art), microfilm (restricted) / *Hartford Courant*, April 17, 1936, 33 / *Hartford Courant*, December 13, 1936, 35 / Peter Hastings Falk, ed., *Who Was Who in American Art* (Meriden, Conn.: Sound View Press, 1985)

54

JAMES BRITTON
William Gedney Bunce, 1907
Oil on canvas; 30 × 24¼ in. (76.2 × 61.6 cm)

Signed and dated at lower left: Britton / 1907 / Hartford Connecticut

Dated at upper right: 1907

Inscribed on reverse: Portrait of / W. Gedney Bunce / painted by / James Britton in Bunce Studio / Hartford Conn / 1907

EXHIBITED: Wadsworth Atheneum, "James Britton—Memorial Exhibition," 1936, no. 67 / Wadsworth Atheneum, "Paintings in Hartford Collections," 1936, no. 19 / Wadsworth Atheneum, "Connecticut Academy Memorial Exhibition," 1960

EX COLL.: artist, South Manchester, Conn., to 1930; on loan from the artist to the Wadsworth Atheneum from 1916 or 1917 through 1930[1]

Ella Gallup Sumner and Mary Catlin Sumner Collection Fund, 1930.196

James Britton painted six portraits of artist William Gedney Bunce (q.v.) while they had adjoining studios in Hartford in 1908–1909; this is the second of the series.[2] This particular version was originally for a "Merchant

54

prince of Hartford," but the commission fell through. When Britton moved to Farmington he "placed this portrait . . . face up, on the floor just inside the front door so that we as well as visitors would walk on it. The idea was not to do Bunce dishonour but to wear down the heavily painted surface and possibly soften the horrible stiff canvas."[3]

Though Britton claimed the Bunce relatives were disturbed by the picture, Bunce himself liked it and "gathered with CN Flagg, Brandegee and Montague Flagg and these veterans were good enough to congratulate me warmly on it."[4] Britton thought very highly of Bunce and wrote a small commemorative piece in which he praised Bunce's work and talents; in the same piece, he paid tribute to the other Hartford artists represented at the Metropolitan Museum of Art.[5]

The portrait's background features one of the numerous Venetian scenes painted by Bunce during his lifetime (cats. 70, 77–88), and its style is very similar to Bunce's own distinctive painting technique. Bunce, a tonalist painter and a colorist, responded to impressionism, but in a unique way that distinguishes his work. ERM

1. While the portrait was on loan to the Wadsworth Atheneum, Britton noted in his diary, "Go over to the Morgan Museum and find my portrait of Bunce hanging in one of the downstairs galleries along with the Saint-Gaudens frame with six panels by Bunce" (diary entry, November 24, 1925, in James Britton, "Diaries, March 1925-October 1933," in *James Britton Papers* [New York: Archives of American Art], 29, microfilm [restricted], roll 3648).

 A number of Britton paintings are in the Britton family collection, at St. Joseph's College, West Hartford, and in the Mark Twain Memorial, Hartford. My thanks to Ursula Britton for providing me with this information and allowing me to cite material from the Britton papers, held by the Archives of American Art.

2. James Britton, "Autobiography," June 1935, in *James Britton Papers* (New York: Archives of American Art), 71, microfilm (restricted); and James Britton, "Diaries," 1906–1908, in *James Britton Papers* (New York: Archives of American Art), 86–94, microfilm (restricted). Britton discusses this painting at length in his autobiography: "The second portrait I did of Bunce, the one in a blue painting blouse which was bought by the Morgan Art Museum from me in 1930 is similar to the first one. . . . I painted the portrait on a piece of cotton duck which had a thick coat of prime paint on either side. It was extremely stiff and difficult to work on. It had

been part of an old screen made by Noel Flagg, and I painted the head of Bunce on it because I had been told that it was wanted by a particular 'merchant prince of Hartford.'"

3. Britton, "Autobiography," 71–72.

4. James Britton to Chick Austin, April 1930, Britton file, American Paintings Department, Wadsworth Atheneum. In the same letter, Britton says, "I understand that some of Bunce's relatives do not like the red rose. I never entitled the picture 'The Man with the red rose' as red roses are or were common among artists and Bunce came by his quite naturally."

5. James Britton, "Bunce's 'Venice' in New York," *Hartford Daily Times*, February 20, 1917.

Samuel Broadbent

Born in Wethersfield, Conn., in 1810; died in Philadelphia, in 1880

Samuel Broadbent was a relation of the Wethersfield, Connecticut, portrait painter, Dr. Samuel Broadbent (1759–1828), possibly his son. Like Dr. Broadbent, he painted portraits in oil and watercolor miniature. In the early 1840s he had a studio in Hartford, where he advertised himself in local newspapers as a "daguerreotype artist," which became his specialty.

Broadbent purportedly learned the process of daguerreotyping from his friend Samuel F. B. Morse and worked as Morse's assistant in his New York City gallery. From 1843 to 1847 he traveled through the southern states working as a daguerreotypist—in Savannah, Georgia, from 1843 to 1844; in Macon and Athens, Georgia, in 1845; in Wilmot's studio in Savannah in 1847; and in Wilmington, Delaware, possibly in 1850. By 1851 he had settled in Philadelphia, where he had a gallery in partnership with a number of different individuals until 1880.

Broadbent worked mainly as a photographer during his final years, and with his partner, Mr. Phillips, he exhibited "photographs, plain, crayon, and watercolor," at the Centennial Exhibition of 1876 in Philadelphia (Yarnall and Gerdts, *Index*, 1:456).

SELECT BIBLIOGRAPHY

William Lamson Warren, "Doctor Samuel Broadbent (1759–1828)," *Connecticut Historical Society Bulletin* 38 (October

1973), 97–113 / Floyd Rinhart and Marion Rinhart, *The American Daguerreotype* (Athens, Ga.: University of Georgia Press, 1984), 383–384 / James L. Yarnall and William H. Gerdts, *The National Museum of American Art's Index to American Art Exhibition Catalogues from the Beginning through the 1876 Centennial Year* (Boston: Hall, 1986), 1:456

55

ATTRIBUTED TO SAMUEL BROADBENT
Portrait of Thomas Sully, 1864
Oil on canvas; 27⅛ × 22 in. (68.9 × 55.9 cm)

EXHIBITED: Philadelphia, Pennsylvania Academy of the Fine Arts, "Forty-Sixth Annual Exhibition," 1869, no. 58, as "'Portrait of Thomas Sully,' owner: S. Broadbent"

EX COLL.: Clara Hinton Gould, Santa Barbara, Calif.

Bequest of Clara Hinton Gould, 1948.194

Broadbent exhibited this portrait of Thomas Sully (q.v.) at the Pennsylvania Academy of the Fine Arts in 1869.[1] The portrait appears to be based on Sully's own *Self-Portrait* (1850, Corcoran Gallery of Art), one of

55

eighteen that he executed over the course of his lifetime. Sully painted the self-portrait on which Broadbent's work is based when he was sixty-five years old. It was owned by William W. Corcoran and was exhibited frequently, allowing Broadbent the opportunity to view the painting.[2]

A portrait entitled *Samuel R. Broadbent* painted by Thomas Sully in 1864 is in the collection of the Mercer Museum in Doylestown, Pennsylvania, and is mentioned in Sully's "Register of Paintings" as "no. 202 Broadbent, Mr. Painted for his father, portrait begun Feb. 15th, 1864, finished March 3rd, 1864. Head. Price $15.00." Samuel Broadbent was fifty-four years old at that time, thus the young man in the Sully portrait, who appears to be in his twenties, may have been Broadbent's son. The Mercer Museum also has a miniature portrait by Broadbent of his son.[3] EMK

1. Anna Wells Rutledge, *The Pennsylvania Academy of the Fine Arts Annual Exhibitions* (Philadelphia: American Philosophical Society, 1955), 37. A label on the reverse of the painting reads: "'Pennsylvania Academy of the Fine Arts,' Forty-Sixth Annual Exhibition 1869. 'Portrait of Thomas Sully.'"
2. Ralph E. Phillips, *A Catalogue of the Collection of American Paintings in the Corcoran Gallery of Art* (Washington, D.C.: Corcoran Gallery, 1966), 1:48.
3. Thomas Sully, *Register of Paintings*, Archives of American Art, N18. My thanks to Deborah Y. Jeffries, Catalogue of American Portraits, National Portrait Gallery, for sharing this information with me.

Alexander Brook

Born in Brooklyn, N.Y., in 1898; died in Sag Harbor, N.Y., in 1980

Brook is perhaps best remembered as one of a circle of artists known as the Fourteenth Street Group, which included such figures as Reginald Marsh (q.v.), Raphael Soyer (q.v.), Moses Soyer (1899–1975), and Isabel Bishop (q.v.).

As a teenager, Brook began studying at the Pratt Institute in Brooklyn. In 1914 he entered the Art Students League in New York City, where in 1918 he met fellow student Peggy Bacon (1895–1987; cat. 56), whom he married in 1920. (Brook and Bacon divorced in 1940;

Brook was remarried in 1945, to the artist Gina Knee.) He studied at the Art Students League for four years, working with Kenneth Hayes Miller (q.v.), among others.

Brook first worked as an interior decorator in Ridgefield, Connecticut, Bacon's hometown. He soon took a job as assistant director to Juliana Force at the Whitney Studio Club in New York City, remaining there from around 1923 to 1927. During this period, he and Bacon summered at the artists' colony in Woodstock, New York, and wintered on West Tenth Street in New York City. Brook's first exhibition was held in conjunction with Peggy Bacon at the Brummer Gallery in New York City in 1922. During this time, he began writing articles and reviews, which appeared in the *Arts*.

By the end of the 1920s Brook was working full-time as a painter of portraits, still lifes, nudes, and landscapes. Like Bishop, he avoided direct social commentary in his paintings and so remained popular throughout a period that was essentially hostile to modernism. During the early 1940s his work appeared on the cover of the *Saturday Evening Post*, and in 1943 he was commissioned to paint a series of portraits of Hollywood movie stars such as Ingrid Bergman, Bette Davis, and Merle Oberon. He won a number of prestigious prizes.

Although his work fell from critical favor with the rise of abstract expressionism, Brook continued to paint. In the forties, he spent equal time in New York and in Georgia, which inspired a series of landscape paintings and portraits. By 1952, however, he had withdrawn from active participation in the art world to concentrate on drawings and small oils.

SELECT BIBLIOGRAPHY

Archives of American Art, Alexander Brook Papers, roll 2435 / Edward Alden Jewell, *Alexander Brook* (New York: Whitney Museum of American Art, 1931) / "Brook's Show 'One Season of High Spots,'" *Art Digest* 8 (February 1934), 7 / Jeannette Lowe, "Brook: No Interference," *Art News* (June 30, 1941), 26–27 ff / Alexander Brook, *Alexander Brook* (New York: American Artists Group, 1945) / A. W. Kelly, *A Retrospective Exhibition of Paintings by Alexander Brook*, exh. cat. (New York: Salander-O'Reilly Galleries, 1980) / Tom Wolf, *Woodstock's Art Heritage: The Permanent Collection of the Woodstock Artists Association* (Woodstock, N.Y.: Overlook Press, 1987), 60–61. / Diana Strazdes, *American Paintings and Sculpture to 1945 in the Carnegie Museum of Art* (New York: Hudson Hills Press, in association with the Carnegie Museum of Art, 1992), 107–110

56

ALEXANDER BROOK
Peggy Bacon, 1924
Oil on canvas; 20¼ × 16⅛ in. (51.4 × 41.0 cm)
Signed at upper right: A. Brook—24

EXHIBITED: New Britain, Conn., Art Museum of the New Britain Institute, "Contemporary American Paintings from the Collection of the Wadsworth Atheneum," 1953 / Ogunquit, Maine, Museum of Art of Ogunquit, "Brook Retrospective," 1962, no. 1 / West Hartford, Art Study Gallery, Mercy Hall, St. Joseph College, "Images of Women," 1987–1988

EX COLL.: Mr. and Mrs. Alfred Jaretzki, Jr., New York City

Gift of Mr. and Mrs. Alfred Jaretzki, Jr., 1952.403

Brook painted several portraits of Peggy Bacon. In a review of a 1936 exhibition of Brook's paintings, the critic for the *New York Times* singled out a portrait of Bacon, writing, "Miss Bacon poses well and the artist seems to understand her perfectly, and in addition to the fact gets some of the plaintive inquiry into the work which is to be noticed also in the background of Miss Bacon's own productions."[1]

One of Bacon's chief characteristics, and one she shared with Brook, was a satirical wit. Rather than capitalize on her striking and individualistic personality, however, in this portrait, Brook drew on the conventions of the studio picture, depicting Bacon in a posed state of reverie.[2] Studio pictures, representing models as models whether they were friends or hired professionals, became popular with artists such as Brook and Bacon and others associated with the Whitney Studio Club in the twenties and thirties.[3]

Bacon was a printmaker as well as a poet and author of children's books and mystery novels. Occasionally, she painted in oils. During her long career, she exhibited

widely and taught art at a number of institutions, including the School of the Corcoran Gallery of Art, Washington, D.C., and the Art Students League, New York City. She received many awards both for her books and for her art work.[4] The Atheneum owns four drawings by Bacon. AE

1. Henry McBride, *New York Times*, January 4, 1936, quoted in A. W. Kelly, *A Retrospective Exhibition of Paintings by*

Alexander Brook, exh. cat. (New York: Salander-O'Reilly Galleries, 1980), cat. 4.
2. See Alexander Brook, "Young America: Peggy Bacon," *Arts* 3, no. 1 (January 1923), 68–69, for Brook's prose portrait of Bacon and her work.
3. See Patricia Hills, *The Figurative Tradition* (New York: Whitney Museum of American Art, 1980), 71–74.
4. See Roberta K. Tarbell, *Peggy Bacon: Personalities and Places*, exh. cat. (Washington, D.C.: Smithsonian Institution Press, for the National Collection of Fine Arts, 1975).

56

57

ALEXANDER BROOK
Pasture at Elk, 1939
Oil on canvas; 20 × 28 in. (50.8 × 71.1 cm)
Signed at lower right: A. Brook/39.

EXHIBITED: New York City, Whitney Museum of American
Art, "Contemporary American Painting," 1940–1941, no. 17 /
New York City, The Museum of Modern Art, "Romantic Paint-
ing in America," 1943–1944, no. 36 / Dayton, Ohio, Dayton Art
Institute, "Works by Alexander Brook from American Museum
Collections," 1955 / Staten Island, N.Y., Staten Island Institute
of Arts and Sciences, "Modern Realism," 1955–1956, no. 4 /
Winsted, Conn., Litchfield County Art Association, 1956

EX COLL.: with Frank K. M. Rehn Galleries, New York City,
by 1941

The Ella Gallup Sumner and Mary Catlin Sumner Collection
Fund, 1941.244

Pasture at Elk was painted during the summer of
1939 in a ghost town 150 miles north of Los Angeles.
When Brook visited the area, Elk, a former company
town for the lumber industry, was a haunting scene of
locomotives and other machinery left to rust in fields

and backyards. Later, during World War II, these aban-
doned relics were used for scrap metal, and so when the
artist returned to the site about six years later, the loco-
motive he had depicted in the Atheneum's painting had
disappeared.[1] At the time Brook painted *Pasture at
Elk*, however, the desolation and melancholy aspect of
the locomotive and the nag were all the sharper for their
seeming to have outlived their usefulness. Brook saw
the two as kindred spirits and said, somewhat humor-
ously, "Both of them are no longer good for anything but
to be put out to pasture."[2]

Brook intensifies the foreboding mood of the land-
scape with elements such as the three black crows or
hawks circling over the train and the dead tree in the
central foreground. Heavy gray clouds hang over the
field, signaling an approaching storm. The artist's sub-
dued palette adds to the effect.

When the painting was exhibited in 1940–1941 at the
Whitney Museum of American Art, the *New York Times*
called it "one of the most sensitive and full-rounded
works of [Brook's] career,"[3] and *Art Digest* described it
as "masterfully handled . . . a fabric woven with sub-
tlety of color and texture."[4] AE

57

1. Alexander Brook to Charles C. Cunningham [then director of the Wadsworth Atheneum], September 25, c. 1946, curatorial painting file, Wadsworth Atheneum.
2. Alexander Brook, quoted in "Art: Wherever He Pleases, Alexander Brook Sets Up His Easel and Makes Art Pay," *Life Magazine*, January 13, 1941, 50–51.
3. "The Whitney Museum," *New York Times*, n.d., in the Archives of American Art, Alexander Brook Papers, roll 2435.
4. "Whitney Museum Opens Its Best and Largest Painting Annual," *Art Digest* 15 (December 1940), 5–6.

J. G. Brown

Born near Durham, England, in 1831; died in New York City, in 1913

John George Brown was around fourteen when he began an apprenticeship as a glass cutter in Newcastle, England. While working there, he took night classes at the government school of design and studied with William Bell Scott, a poet and painter who knew the Pre-Raphaelite artists. In 1852 Brown moved to Edinburgh, where he had a job at the Holyrood Glass Works. There, he continued his study of painting, working with Robert Scott Lauder and winning a prize for drawing in the antique class in 1853. That same year he emigrated to the United States, where he settled in Brooklyn, New York, and took a job at the Brooklyn Flint Glass Company. Two important Brooklyn residents who were encouraging to Brown were the collector and dealer Samuel P. Avery and the artist Régis Gignoux (1816–1882).

Around 1856 Brown began painting portraits, and the following year he was enrolled in classes at the National Academy of Design, where he studied through 1859. During his first year at the National Academy, Brown studied with miniature painter Thomas Seir Cummings (1804–1894). In 1860 Brown took a studio in the Tenth Street Studio Building, where he worked until the end of his career. In 1861 he helped found the Brooklyn Art Association and was elected an associate of the National Academy, where he had been exhibiting annually since 1858, showing a genre painting owned by John F. Kensett (q.v.) the year he was elected. Brown became an academician in 1863; he was vice president of the academy from 1899 until 1903. From 1867 he was an active member of the American Society of Painters in Water Colors, serving as its president from 1887 to 1904.

Around 1863 Brown moved to Fort Lee, New Jersey, where he painted with another portrait and genre artist, Seymour Guy (q.v.), in 1865. Brown's work became increasingly popular and was made available to a wide audience through photographic reproduction by Gellatly and Leckey of New York City, who published three of Brown's paintings in 1866. Within the next seven years, seven others of Brown's paintings were published as chromolithographs by such firms as William Schaus, Williams and Everett, and Louis Prang. In 1870 Prang published more prints of Brown's work than of any other artist.

In the early 1870s, Brown began summering in areas frequented earlier in the century by the Hudson River school painters and of continuing interest to American landscapists. He visited the White Mountains in 1872 and the Catskill Mountain region the following year. In 1877 and 1878 he traveled to Grand Manan Island, New Brunswick, where he spent the summer painting fishermen at work. Alfred Thompson Bricher had been painting the coast of the island since 1874 (cat. 52), and Frederic E. Church painted the Atheneum's *Grand Manan Island, Bay of Fundy* in 1852 (cat. 112). Brown spent the summer of 1886 at Cragsmoor, an artists' colony in New York.

Brown painted pictures of street urchins throughout the 1890s but concentrated more on the fishermen of Grand Manan in his later years. By the mid-1890s the artist had begun a series of pictures of old people, including such titles as *Taking it Easy* (1894), *Twas Long Ago* (1896), and *Home Comforts* (1893), an appropriate theme for an aging painter of the sentimental.

Brown had the foresight to obtain copyrights for many of his paintings, and when they were reproduced, he reaped a significant profit. Brown's business savvy and his ability to gauge the art market led one contemporary writer to remark, "We have no more popular artist in America than J. G. Brown. He is more certain of his audience, and more direct in his appeal to it, than any other" (*Harper's Weekly* 26 [April 15, 1882]: 231;

quoted in Hoppin, *Country Paths*, 4). It is no surprise, perhaps, that Brown died a wealthy man.

SELECT BIBLIOGRAPHY

Henry T. Tuckerman, *Book of the Artists: American Artist Life* (New York: Putnam, 1867), 487 / G. W. Sheldon, *American Painters*, rev. ed. (New York: D. Appleton, 1881), 141–144 / Clara Erskine Clement and Laurence Hutton, *Artists of the Nineteenth Century and Their Works*, rev. ed. (1884; rpt., St. Louis: North Point, 1969), 1:101 / S. G. W. Benjamin, "A Painter of the Streets," *Magazine of Art* 5 (1882), 265–270 / Patricia Hills, *The Painters' America: Rural and Urban Life, 1810–1910,* exh. cat. (New York: Praeger, in association with the Whitney Museum of American Art, 1974), 115–117 / Donelson F. Hoopes and Nancy Wall Moure, *American Narrative Painting*, exh. cat. (New York: Praeger, in association with Los Angeles County Museum of Art, 1974), 139 / Philip N. Grime and Catherine L. Mazza, *John George Brown: A Reappraisal*, exh. cat. (Burlington, Vt.: Robert Hull Fleming Museum, 1975) / Katharine M. McClinton, "John George Brown: Sentimental Painter of the American Scene," *Connoisseur* 200 (April 1979), 242–247 / Linda S. Ferber, "Ripe for Revival: Forgotten American Artists," *Art News* 79 (December 1980), 68–73 / Natalie Spassky, *American Paintings in the Metropolitan Museum of Art*, ed. Kathleen Luhrs (Princeton, N.J.: Princeton University Press, in association with the Metropolitan Museum of Art, 1985), 2:337–342 / Sarah Burns, "Barefoot Boys and Other Country Children: Sentiment and Ideology in Nineteenth-Century American Art," *American Art Journal* 20, no. 1 (1988), 24–50 / Annette Blaugrund, with Albert Boime, D. Dodge Thompson, H. Barbara Weinberg, and Richard Guy Wilson, *Paris 1889: American Artists at the Universal Exposition*, exh. cat. (New York: Abrams, in association with the Pennsylvania Academy of the Fine Arts, Philadelphia, 1989) / Martha J. Hoppin, *Country Paths and City Sidewalks: The Art of J. G. Brown*, exh. cat. (Springfield, Mass.: George Walter Vincent Smith Art Museum, 1989) / Diana Strazdes, *American Paintings and Sculpture to 1945 in the Carnegie Museum of Art* (New York: Hudson Hills Press, in association with the Carnegie Museum of Art, 1992), 111–113

58

J. G. BROWN
The Boot Black, 1878
Oil on canvas; 14^{1}/$_{8}$ × 10 in. (35.9 × 25.4 cm)
Signed at lower left: J. G. Brown, N.A. / 1878

EXHIBITED: Wadsworth Atheneum, "A Second Look: Late Nineteenth Century Taste in Paintings," 1958, no. 63 / Springfield, Mass., George Walter Vincent Smith Art Museum, "Country Paths and City Sidewalks: The Art of J. G. Brown," 1989, no. 4

EX COLL.: Ambrose Spencer, Hartford

Bequest of Ambrose Spencer, 1901.9

This painting of a shoe-shine boy was executed at the height of Brown's popularity as an artist. His first shoe-shine picture, *When Greek Meets Greek* (private collection), is dated 1866, but it was not until the 1870s that Brown concentrated particularly on the bootblack as the central theme of his painting. Earlier in his career, he painted other types of poor, working city children, such as crossing sweepers, match girls, and newsboys. By 1890, however, Brown had painted so many bootblacks that they became the subject with which he was most often associated by both critics and the public.[1]

In *The Boot Black*, Brown employs his most minimal iconography of the city: the boy is seated on a packing crate on a sidewalk, and the suggestion of a plain stone wall serves as a background.[2] The figure of the bootblack holds the tools of his trade: the bootblack box and the shoe brush. The young boy looks despondent, and the composition may relate to another, earlier painting by Brown, exhibited in 1875, titled *This Corner Don't Pay* (unlocated).

Sentimental paintings of this type had special appeal in post–Civil War America, when the country shifted from an agrarian to an industrialized urban state.[3] With this shift came anxieties associated with loss of innocence and an outpouring of literature and art devoted to idealizing rural youth.[4] The counterpart to the healthy and happy country child was the poor, often homeless, urban working child, portrayed by artists such as Brown

as plucky, robust, and eminently appealing.[5] If not always happy, as is the case with the Atheneum's *Boot Black*, such children at least did not look dangerous. This pictorial myth, akin to the rags-to-riches Horatio Alger stories, reassured an uneasy public and reflected middle-class attitudes toward the poor, who, they believed, could alleviate their plight through honest hard work.[6]

G. W. Sheldon recorded Brown as saying, "Art should express contemporaneous truth, which will be of interest to posterity. I want people a hundred years from now to know how the children that I paint looked. . . . I paint what I see, and in my own way."[7] Now, more than a hundred years later, it is clear that Brown tells us less about the condition of the child bootblack in late nineteenth-century urban America than about what he and his contemporaries wanted to believe about—and what they were able to convince themselves of—the urban poor. In that, Brown does give the viewer a glimpse of a "contemporaneous truth," although different from the one intended, and as an evocation of the ideas and prejudices that ruled Victorian America, it is certainly of interest to posterity. AE

1. See Martha J. Hoppin, *Country Paths and City Sidewalks: The Art of J. G. Brown*, exh. cat. (Springfield, Mass.: George Walter Vincent Smith Art Museum, 1989), especially 17–26, for a complete discussion of Brown's bootblack paintings.
2. Hoppin, *Country Paths*, 20. Hoppin notes that sometimes Brown used a simplified background of rundown buildings and often added litter or trash to the sidewalk, as well as tattered posters and handbills to the walls behind his figures. Other artists before Brown had employed wall posters, handbills, and the packing crates on which Brown's figures sometimes sit. Brown, Hoppin points out, appropriated and developed the device of the crate as an iconographical feature, beyond its use by other artists.
3. See Patricia Hills, *The Painters' America: Rural and Urban Life, 1810–1910,* exh. cat. (New York and Washington: Praeger, in association with the Whitney Museum of American Art, 1974), especially 74–83.
4. Hoppin, *Country Paths*, 22. See also Sarah Burns, "Barefoot Boys and Other Country Children: Sentiment and Ideology in Nineteenth-Century American Art," *American Art Journal* 20, no. 1 (1988), 24–50, for a discussion of this phenomenon.
5. See Hoppin, *Country Paths*, 22. Hoppin links Brown's pictorial interpretation of the child streetworker to the ideas and attitudes of the previous generation, especially the ideas

of reformer Charles Loring Brace, who admired the independence of the streetchildren who worked to support themselves.
6. Burns, "Barefoot Boys," 43–44; and Hills, *The Painters' America*, 115–117. Hoppin believes that Brown's patrons, many of them from the middle class, were influential in the artist's idealization of his subject and points out that much social reform of the period was based on a doctrine of self-help (*Country Paths*, 23). See also Elizabeth Johns, *American Genre Painting: The Politics of Everyday Life* (New Haven and London: Yale University Press, 1991), especially ch. 6.
7. G. W. Sheldon, *American Painters*, rev. ed. (New York: D. Appleton, 1881), 141.

Mather Brown

Born in Boston, in 1761; died in London, in 1831

Mather Brown was raised in Boston, the son of a clockmaker; through his mother, he was related to the renowned New England clergymen Cotton Mather and Increase Mather. He received his earliest artistic training from Gilbert Stuart (q.v.), who provided Brown with drawing lessons while he was living in Boston in 1774 and 1775. By 1780 Brown had earned enough money painting portrait miniatures to travel to France and then England in order to receive additional artistic training.

In 1781 Brown settled in London, where he studied with Benjamin West (q.v.) and at the Royal Academy. In 1788 he was asked to serve as the official portrait painter to King George III's son, the duke of York, making him the only American artist other than West to receive a royal appointment. Two years later he was honored again, this time with an appointment as the official portrait painter to a second royal son, the duke of Clarence. Brown also painted portraits of many distinguished American visitors to London, as well as English nobility.

During the 1790s Brown competed successfully with the leading history painters of the era in producing commemorative pictures of current events. In addition to his successful depictions of such topical subjects as the British military victories in India, he also occasionally painted medieval scenes. Although Brown enjoyed success in these ventures, he was repeatedly rejected from

membership in the governing organization of the Royal Academy. In the early decades of the nineteenth century, his career declined, and he began to seek portrait commissions in the provincial cities of Liverpool and Manchester. He died, nearly destitute, in London.

SELECT BIBLIOGRAPHY

Dorinda Evans, *Mather Brown: Early American Artist in England* (Middletown, Conn.: Wesleyan University Press, 1982) / Dorinda Evans, "Mather Brown," *Catalogue of American Paintings at the Detroit Institute of Art* (New York: Hudson Hills Press, for the Detroit Institute of Art, 1992), 1:44

59 (see plate 14)

MATHER BROWN
Louis XVI Saying Farewell to His Family, c. 1793
Oil on canvas; 86 × 111 in. (218.4 × 281.9 cm)
Technical note: Areas of abrasion are seen throughout the canvas.

EX COLL.: descended in the Graves-Sawle Family, Penrice House, Cornwall, England; with Messrs. May, Whetter, and Grose, St. Austell, Cornwall, March 15, 1977, no. 375; with Somerville and Simpson, Ltd., London; with Christie's, London, June 24, 1977, no. 102; to P. and D. Colnaghi and Co., London, in 1977

The Ella Gallup Sumner and Mary Catlin Sumner Collection Fund, 1980.2

During the 1790s, Brown emerged as a leading history painter in London, commemorating current events in his pictures. As one of Benjamin West's most gifted students, he emulated his teacher's heroic painting, choosing contemporary subjects with dramatic potential and universal themes often focusing on the tragedy of war. He was one of the first major history painters to have his topical subjects immediately engraved and published shortly after the event, thereby capitalizing on and sustaining the public's interest.

In December 1792 Louis XVI of France was brought to trial for treason by the Revolutionary Commune. On January 20, 1793, he bade farewell to his family; the fol-

lowing day he was publicly executed. Ten days later Brown, hoping to capitalize on the horrified reaction of the English public to this event, advertised his intention to paint the last interview of Louis XVI with his family and announced that subscriptions for an engraving would be received by the London painter Daniel Orme and himself. Brown's advertisement appeared in the *Morning Chronicle* on February 1, coinciding with the announcement that France had declared war on England in retaliation for the cessation of diplomatic relations.[1] In addition, the press nurtured the public's outrage at the fate of the French king and his family with reports published daily.[2]

It was important for the artist to render the event accurately. He succeeded in capturing an emotional scene, which he heightened with bright, contrasting colors and a variety of theatrical poses. The tearful Louis XVI is surrounded by members of his family; his wife throws her arms toward heaven in a distraught gesture, while his children encircle him, both for his comfort and their own. The dauphin is held close and made to swear not to seek revenge. Marie Antoinette wears royal attire, a miniature portrait of her husband hangs from a chain at her breast. Her elegant dress is disheveled and torn at the sleeve. The jailers look on, their faces twisted in cruel expressions, except for one soldier's, which has grown pale with horror.

The Atheneum's painting is one of three nearly identical versions Brown painted of this subject, as Dorinda Evans has suggested, "perhaps because public interest was so great."[3] The first version (1793, Raydon Gallery, New York City), is firmly dated and measures 18 1/2 by 23 1/2 inches (47.0 × 59.7 cm). It was engraved in mezzotint by P. W. Tomkins and J. Eginton in 1795 and is nearly identical in size and composition to a replica (1793 or later, Hillwood Museum, Washington, D.C.) that measures 17 1/4 by 23 1/4 inches (43.8 × 59.1 cm). The Atheneum's version, created by the artist for exhibition purposes, is distinguished by its large size.[4]

Following an innovative form of advertisement, Brown sent the large version on an exhibition tour to several provincial English cities, including Liverpool, where local newspapers announced its showing in No-

vember 1793 and informed readers that they could subscribe locally for the engraving that was to be produced after the painting. The print cost one guinea to the subscribers, half of which was to be paid at the time of subscription. The engraving was not completed until January 1, 1795.[5]

The Atheneum has a preliminary sketch for *Louis XVI Saying Farewell to His Family*. The sketch includes the major figures of the royal family in the center of the composition. In the finished work, Brown compressed this grouping into a tighter unit of interrelated forms, centering the figure of Louis XVI, and added to the left the subscene depicting the on-looking soldiers; at the right, he turned the figure of a grieving woman with clasped hands away from the scene.

Brown evidently painted a companion to *Louis XVI* entitled *The Massacre of Madame, the Princess Lamballe, at the Prison de la Force in Paris*, which depicted the brutal murder of Marie Antoinette's friend.[6] The painting was completed before the engraving for *Louis XVI*, but it remains unlocated and apparently was never engraved.[7]

The subject of Louis XVI's farewell to his family became a popular subject in England in the 1790s, with other artists of the day treating it in paintings and engravings.[8] Brown was one of the first artists to capitalize on public taste and political interest, however, depicting this popular event on speculation to achieve financial success. EMK

1. Dorinda Evans, *Mather Brown: Early American Artist in England* (Middletown, Conn.: Wesleyan University Press, 1982), 117.
2. Cynthia E. Roman, "Mather Brown's *The Final Interview of Louis XVI with his Family*: Popular History Painting in the Grand Style" (master's thesis, Brown University, 1985).
3. Evans, *Mather Brown*, 117.
4. Ibid., 249.
5. Ibid., 120.
6. Ibid., 121 n. 33.

Mather Brown, sketch for *Louis XVI Saying Farewell to His Family*, 1793. Wadsworth Atheneum, The Ella Gallup Sumner and Mary Catlin Sumner Collection Fund. Photograph: E. Irving Blomstrann.

7. Ibid., 121.

8. See David Bindman, *The Shadow of the Guillotine*, exh. cat. (London: British Museum, 1989), 47–54.

George Elmer Browne

Born in Gloucester, Mass., 1871; died in Provincetown, Mass., 1946

The landscape painter George Elmer Browne received his early training at the Museum of Fine Arts in Boston, followed by instruction at the Académie Julian in Paris under Jules Lefebvre and Tony Robert-Fleury. On his return to the States in the late nineteenth century, the artist settled in New York City.

Although he traveled extensively in Spain, Italy, France, and Quebec, Browne is best known as an artist and teacher in Provincetown, Massachusetts, where he spent the summers from as early as 1898 to 1948. He first exhibited at the National Academy of Design in 1898, a landscape of Provincetown entitled *Crossing the Dunes, Provincetown, Cape Cod* (c. 1898, unlocated). Browne was elected a full academician in 1928.

By the summer of 1916 Browne had opened his West End School in Provincetown, which was highly successful even though there were four other summer art schools in Provincetown at the time, including those of Charles Hawthorne (q.v.) and William Zorach. Browne became one of the leading figures of the Provincetown

60

Art Association, founded in 1914, and a thriving landscape painter in both oil and watercolor. He frequently took his students on trips to Europe in the winter and held art classes for them in Paris. Browne was elected president of the Salmagundi Club in 1936.

SELECT BIBLIOGRAPHY

George Albert Perret, *George Elmer Browne, 1871–1946,* exh. cat. (New York: Chapellier Galleries, 1968) / Dorothy Gees Seckler, with Ronald Kuchta, *Provincetown Painters 1890s–1970s,* exh. cat. (Syracuse: Everson Museum of Art, 1977), 25, 29–30, 279

60

GEORGE ELMER BROWNE
The City of Hartford, c. 1920
Oil on canvas; 40¹⁄₈ × 50 in. (101.9 × 127.0 cm)
Signed at lower right: Geo. Elmer Browne, N.A.

EX COLL.: Fred E. Dayton, New York City, by 1946

Gift of Fred E. Dayton, 1946.374

The City of Hartford depicts a steamer of the same name built in 1852. The boat ran on the Connecticut River between Hartford and New York City until 1876, when it collided with the Middletown Bridge. Browne's nostalgic rendition shows the steamer on the river with figures in period costume in the foreground. EMK

61

GEORGE ELMER BROWNE
Harbor Scene, c. 1935
Oil on composition board; 15 × 18 in. (38.1 × 45.7 cm)
Signed at lower left: Geo. Elmer Browne

EX COLL.: Fred E. Dayton, New York City, by 1947

Gift of Fred E. Dayton, 1947.155

Browne's lively depiction of fishing boats docked in a harbor, entitled *Harbor Scene,* appears to be a view of Provincetown and is reminiscent of the artist's post-

61

impressionist landscapes painted during the many summers he spent in this artist colony.[1] EMK

1. Dorothy Gees Seckler, with Ronald Kuchta, *Provincetown Painters 1890s–1970s*, exh. cat. (Syracuse: Everson Museum of Art, 1977), 29–30.

Charles DeWolf Brownell

Born in Providence, R.I., in 1822; died in Bristol, R.I., in 1909

In 1824 Dr. Pardon Brownell and his wife, Lucia DeWolf, an amateur artist, took their young son to East Hartford, where he would grow up. Charles Brownell trained to become a lawyer, and in 1843 he was admitted to the bar and began practicing law in Hartford. His career was to be short-lived, however; in 1853, citing the corruption of the profession as a cause, Brownell gave up law to become an artist.

Brownell was still a lawyer when in 1847 he took a studio in a house directly across from where the Charter Oak stood. There he made what is believed to be his first watercolor of the tree. He began taking sketching trips in the Connecticut Valley with Henry Bryant (q.v.) and studied first in the studio of Julius Busch (1821–1858); later he received private instruction from Joseph Ropes (q.v.) in Hartford. Although he was primarily occupied with landscape subjects during this time, he also made copies of still lifes. A man of varied interests and accomplishments, Brownell wrote *The Indian Races of North and South America*, which was published in Hartford and Boston in 1853 and earned him an honorary master of arts from Trinity College, Hartford, in 1854. At some point in the 1850s, Brownell made a pencil sketch of Daniel Wadsworth's tower on Talcott Mountain (c. mid- to late 1850s, Kennedy Galleries, New York City) (see Introduction). Around this time, Brownell also began exhibiting at the Hartford County Agricultural Society Fair, receiving favorable notices in the local papers. One article read, "The works of Charles DeW. Brownell of East Hartford, landscape-painter, are deservedly prominent. He paints from nature very honestly, without exaggeration or over-coloring. His pieces bear close examination and evidence a very high order of talent in his line" ("Second Day of the Fair," 2).

In part because of a health condition, the artist spent seven consecutive winters in Cuba, where the DeWolf family owned sugar plantations. In 1860 he moved to New York City and kept a studio at 658 Broadway until 1865, exhibiting nearly every year at the National Academy of Design and the Artists' Fund Society. In New York, he also met Hudson River School artists such as John William Casilear (q.v.), Sanford Gifford (q.v.), and John Frederick Kensett (q.v.), as well as Frederic Church (q.v.), with whom he carried on a long correspondence.

Brownell returned to Connecticut in 1865 and took a studio across from the Wadsworth Atheneum. There, he executed a small watercolor called *The Den (Self-Portrait in Studio)*, from *The Album: "The Unwritten Poem"* (1860–1865, Kennedy Galleries, New York City). Through the window in the watercolor, the Gothic Revival facade of the Atheneum is visible.

Brownell married Henrietta Knowlton Angell Pierce in Bristol, Rhode Island, in 1865, and in 1866 they had their first child. That winter the artist returned to Cuba alone, sketching the tropical scenery. The Brownells had two more children before 1871, when the family traveled to Europe, remaining there for six or seven years. In 1877 Brownell visited Egypt. The artist recorded his trip abroad in a series of sketchbooks.

In 1888 the artist began traveling again, sketching in the West Indies, the Hudson River valley, the American West, Mexico, and Cuba. In 1894 he visited Jamaica. After his wife's death in 1897, Brownell sailed around the world, stopping in Japan, Singapore, and Algiers, among other places. From 1901 to 1904, he traveled in Jamaica, Venezuela, and Chile.

Despite his extensive travels, Brownell was best known in his own day, as now, for his paintings of the Charter Oak, his earliest known subject.

SELECT BIBLIOGRAPHY

Alumni files, Trinity College Library, Hartford (copies in curatorial painting file, Wadsworth Atheneum) / "Second Day of the Fair," *Hartford Daily Courant*, October 2, 1856, 2, col. 3 / Clara Erskine Clement and Laurence Hutton, *Artists of the Nineteenth Century and Their Works*, rev. ed. (1884; rpt., St. Louis: North Point, 1969), 1:105 / H. W. French, *Art and Artists in Connecticut* (Boston: Lee and Shepard; New York: Charles T. Dillingham, 1879), 118–120 / "The Charter Oak," *Connecticut Historical Society Bulletin* 21, no. 3 (July 1956), 65–70 / Bristol Art Museum, *Paintings by Charles DeWolf Brownell*, exh. cat. (Bristol, R.I.: Bristol Art Museum, 1965) / Maria Naylor, *The National Academy of Design Exhibition Record 1861–1900* (New York: Kennedy Galleries, 1973), 114 / Theodore Stebbins, Jr., *The Hudson River School: Nineteenth-Century Landscape Paintings in the Wadsworth Atheneum*, exh. cat. (Hartford: Wadsworth Atheneum, 1976), 64–65 / Robert F. Trent, "The Charter Oak Artifacts," *Connecticut Historical Society Bulletin* 49, no. 3 (summer 1984), 125–157 / James L. Yarnall and William H. Gerdts, *The National Museum of American Art's Index to American Art Exhibition Catalogues from the Beginning through the 1876 Centennial Year* (Boston: Hall, 1986), 1:498 / Ita G. Krebs, *Charles DeWolf Brownell: Explorer of the American Landscape*, exh. cat. (New York: Kennedy Galleries, 1991)

62 (see plate 15)

CHARLES DEWOLF BROWNELL
The Charter Oak, 1857
Oil on canvas; 43$\frac{1}{8}$ × 54$\frac{5}{16}$ in. (109.5 × 138.0 cm)
Signed and dated at lower right: CD W Brownell / 1857

Technical note: Three punctures with chipped paint loss—around the bottom edge and slightly to the left of the signature, at the left edge near the middle, and on the top edge, 8$\frac{1}{2}$ in. from the right corner—have been repaired.

EXHIBITED: New London, Conn., Lyman Allyn Museum, "Eighty Eminent Painters of Connecticut," 1947, no. 85 / Bristol, R.I., Bristol Art Museum, "Paintings by Charles DeWolf Brownell," 1965, no. 1 / Wadsworth Atheneum, "The Hudson River School: Nineteenth-Century American Landscapes in the Wadsworth Atheneum," 1976, no. 36 / Hartford Architecture Conservancy and Wadsworth Atheneum, "Trees—A Tribute to Frederick S. Brown," 1975 / Wadsworth Atheneum, "'The Spirit of Genius': Art at the Wadsworth Atheneum," September 1992–January 1993

EX COLL.: Governor Marshall Jewell, in 1857; to Josephine Marshall Dodge and Marshall Jewell Dodge by 1898

Gift of Mrs. Josephine Marshall Dodge and Marshall Jewell Dodge, in memory of Marshall Jewell, 1898.10

H. W. French wrote of this painting, "Among [Brownell's] valuable works in Connecticut is the best painting ever made of the old Charter Oak, now owned by Ex-Gov. Jewell."[1] Marshall Jewell, the original owner of the painting and governor of Connecticut from 1869 to 1873, published a pamphlet, "The Story of the Charter Oak," in 1883, detailing the legend surrounding the oak, where the Connecticut charter, guaranteeing the colony's right to self-government, is said to have been hidden when the new British governor of New England attempted to seize it in 1687. The hiding of the charter in the hollow of the oak is credited to Daniel Wadsworth's great-great-great-uncle, Joseph Wadsworth (see Introduction). In August 1856 the tree fell in a storm.[2]

A posthumous portrait, Brownell's iconic image of the historic tree dwarfs another powerful Hartford symbol, the onion dome of the Colt firearms factory (see Introduction). The oak is seen from the side of the Wyllys property on which it stood (cat. 231). A dead branch sticking out of the otherwise leafy tree may be Brownell's hint at the tree's impending doom.

About the Atheneum's *Charter Oak*, Brownell wrote

to Jewell in 1882, "By reference to my journal, I see that your picture was commenced July 27, 1857. My impression is that it was not painted by order, but was sold by me . . . whether on the stocks or after it was finished, I cannot remember. . . . [Of the versions painted,] Yours is not only much the largest, but by far the most elaborate. I remember working out upon it, by the assistance of a photograph, of the trunk, much of the distinguishable markings of the bark."[3] This meticulous attention to detail is one indication of Brownell's affinity with his contemporaries, the second generation of Hudson River school artists, such as Asher B. Durand (q.v.) and Frederic Church (q.v.), who made scientific studies of plants and rocks.[4]

The frame on *The Charter Oak* was carved by Stuart Blinn of wood from the Charter Oak. Blinn (1850–?) was a descendant of Peter Blinn, also a carver and known in the Hartford area for his sunflower chests.[5]

The Atheneum's version of *The Charter Oak* was engraved for reproduction and appeared as the illustration for a poem by Ellen Brainerd Peck titled "The Charter Oak" in 1895.[6]

In 1883 the artist wrote to Jewell about the sketch he had made of the Charter Oak when he was boarding across the street from where it stood, describing it as a watercolor of the tree in autumn, as seen from his window, and offering to make a larger copy of the composition for Jewell's collection.[7] AE

Charles DeWolf Brownell, *The Charter Oak Tree—Hartford*, 1857. Connecticut Historical Society, Hartford.

1. H. W. French, *Art and Artists in Connecticut* (Boston: Lee and Shepard; New York: Charles T. Dillingham, 1879), 119–120. French owned a study by Brownell of the Charter Oak. In a letter to Marshall Jewell, the artist wrote, "I had previously painted a small study of the tree, about 10 × 14, on paper (now in the possession of H. W. French, author of *Art and Artists in Connecticut*)" (Charles DeWolf Brownell to Marshall Jewell, December 29, 1882, quoted in "The Charter Oak," *Connecticut Historical Society Bulletin* 21, no. 3 [July 1956], 67). A number of other artists painted the Charter Oak, including Frederic E. Church (cat. 111) and George Francis (cat. 231).

2. A copy of Jewell's "Story of the Charter Oak" is in the collection of the Wadsworth Atheneum. See also "The Charter Oak," 66–68, for a discussion of some of its contents. The nineteenth-century Hartford poet Lydia Sigourney wrote, "Charter Oak! Charter Oak! tell us a tale, / Of the years that have fled, like the leaves on the gale, / For thou bearest a brave annal on thy brown root and stem, / And thy heart was a casket for Liberty's gem" (quoted in Theodore Stebbins, Jr., *The Hudson River School: Nineteenth-Century Landscape Paintings in the Wadsworth Atheneum*, exh. cat. [Hartford: Wadsworth Atheneum, 1976], 65).

3. Charles DeWolf Brownell to Marshall Jewell, December 29, 1882. Brownell is known to have painted three versions of his portrait of the famous tree: one in the collection of the Connecticut State Library (1856), one in the Connecticut Historical Society (1857), and one in the collection of the Atheneum, all in Hartford. The dates suggest that the Connecticut State Library *Charter Oak* was the first to be painted. See correspondence between Charles C. Cunningham, then director of the Wadsworth Atheneum, and Marjorie E. Case, Connecticut State Library, dated 1954, and correspondence between Cunningham and Newton C. Brainard, dated May 1956, copies in curatorial painting file, Wadsworth Atheneum. Two articles published in *Connecticut Historical Society Bulletin*, however, claim that the version in the society's collection is the one from which the others were modeled. See "The Charter Oak," 66; and Robert F. Trent, "The Charter Oak Artifacts," *Connecticut Historical Society Bulletin* 49, no. 3 (summer 1984), 129. The Connecticut Historical Society's *Charter Oak* differs from the Atheneum's and the State Library's versions in that it features two figures by the tree.

4. See Ita G. Krebs, *Charles DeWolf Brownell: Explorer of the American Landscape*, exh. cat. (New York: Kennedy Galleries, 1991), for the influence of the Hudson River school on Brownell. See Barbara Novak, *Nature and Culture: American Landscape and Painting 1825–1875* (New York: Oxford

University Press, 1980), especially part two, for a discussion of the Hudson River school artists and their attention to recording nature.

5. My thanks to the Wethersfield Historical Society, Connecticut, for this information.

6. See Ellen Brainerd Peck, "The Charter Oak," *Connecticut Quarterly* 1 (January–December 1895), n.p.

7. Charles DeWolf Brownell to Marshall Jewell, January 29, 1883, copy in curatorial painting file, Wadsworth Atheneum.

Henry Bryant

Born in East Hartford, in 1812; died in East Hartford, in 1881

Raised in East Hartford, Henry Bryant, at the age of fifteen, received early training in the art of engraving from a Mr. E. Huntington. Five years later, he began painting portraits, having received some instruction in this art from John Coles, Jr. (1776 or 1780–1854), who had a studio in Hartford in the 1830s. As an itinerant portrait painter, he set off in search of commissions in about 1832. After spending 1834 and 1835 in Albany, New York, he established himself in New York City; by 1837 he was made an associate of the National Academy of Design. He exhibited his works at the National Academy and the Apollo Association from 1837 to 1840.

In 1840 Bryant returned to his family's home in East Hartford and painted portraits in the Hartford area. In partnership with James Willard, he became an early daguerreotypist and traveled to Virginia in 1844 to 1846, pursuing this new vocation. Bryant then returned to Hartford and by 1850 began painting landscapes of regional scenery and popular sites such as Lake George. In September 27, 1855, the *Hartford Daily Courant* announced: "Bryant, the Artist, has been among the White Mountains, and is now painting some fine pictures, perfect portraits of the romantic spots from which they were sketched." He exhibited his landscapes and "colored photographs" at the annual Hartford County Agricultural Society Fairs.

SELECT BIBLIOGRAPHY

H. W. French, *Art and Artists in Connecticut* (Boston: Lee and Shepard; New York: Charles T. Dillingham, 1879), 79–81 /
George C. Groce and David H. Wallace, *The New-York Historical Society's Dictionary of Artists in America, 1564–1860* (New Haven: Yale University Press; London: Oxford University Press, 1957), 93 / James L. Yarnall and William H. Gerdts, *The National Museum of American Art's Index to American Art Exhibition Catalogues from the Beginning through the 1876 Centennial Year* (Boston: Hall, 1986), 1:503–504 / Hildegard Cummings, *The Hartford Art Colony, 1880–1900*, exh. cat. (Hartford: Connecticut Gallery, 1989), 16–17

63

HENRY BRYANT
Daniel Wadsworth, c. 1842–1844
Oil on canvas; 30¼ × 25⅛ in. (76.8 × 63.8 cm)
Canvas stamp: Prepared / by / J. B. Gilman / Hartford

EX COLL.: commissioned by Daniel Wadsworth, Hartford, around 1842–1844

Bequest of Daniel Wadsworth, 1848.11

The founder of the Wadsworth Atheneum, Daniel Wadsworth (see Introduction), commissioned the local portrait painter Henry Bryant to make copies of many of the portraits of his family members, including a portrait of himself painted by the more famous artist Charles Ingham (cat. 283). The copies were made so that portraits of the Wadsworth family could be prominently displayed in the new gallery, while Wadsworth kept the original portraits, by such artists as Ingham, John Trumbull (q.v.), and Thomas Sully (q.v.), which hung in his Prospect Street house in Hartford until his death in 1848.

This copy of *Daniel Wadsworth* by Bryant, along with the others that follow (cats. 64–68), was hung in the new gallery and appears in the 1844 catalogue as number 42. For Wadsworth's portrait, the following entry appeared: "Copy by Bryant, from an original by Ingham. Mr. Wadsworth is the only son of Col. Jeremiah Wadsworth, well known for his Revolutionary services, and sole donor of the admirable site on which the Atheneum, bearing his name, is erected, and forever dedicated to distinct objects of History, Literature, and Art. After contributing freely to build this edifice and collect

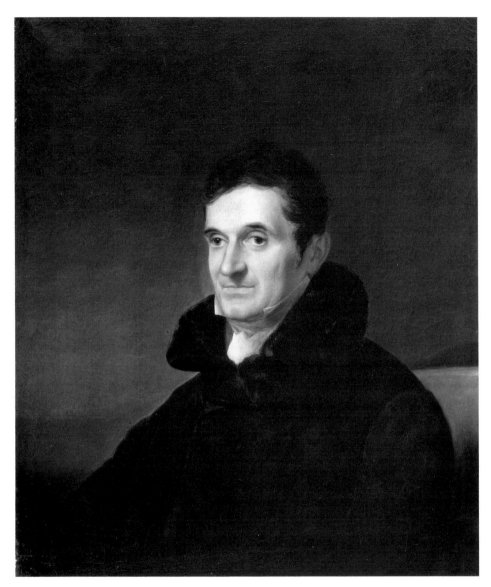

63

the paintings here exhibited, he still lives to take a lively interest in the prosperity and usefulness of the various institutions which are accommodated in the Atheneum."[1] EMK

1. *Catalogue of Paintings in the Wadsworth Gallery* (Hartford: Elihu Greer, 1844), no. 42. The portrait also appears in Wadsworth's will (1847, Wadsworth Atheneum Archive and Connecticut State Library, Hartford) as "A portrait of my-self, a copy by Bryant, from an original by Ingham."

64

HENRY BRYANT
Jeremiah Wadsworth, c. 1842–1844
Oil on canvas; 30 × 24⅞ in. (76.2 × 63.2 cm)
Inscribed on stretcher: Mr. James B. Colman, Hart-
 ford, Ct.
Canvas stamp: Prepared / By / Edwd Dechaux / New
 York

EX COLL.: commissioned by Daniel Wadsworth, Hartford, around 1842–1844

Bequest of Daniel Wadsworth, 1848.10

This portrait of Jeremiah Wadsworth (1743–1804) is a copy after a painting by John Trumbull, *Jeremiah and Daniel Wadsworth* (cat. 452). According to Daniel Wadsworth's will (1847), this portrait of his father was "copied and enlarged by Bryant from an original by Col. Trumbull."[1] In 1837 and 1838 while living with Benjamin Silliman and his wife in New Haven, Trumbull himself made an enlarged replica (unlocated) of Colonel Wadsworth based on the likeness in his earlier portrait of father and son. The work was painted for James Wadsworth.[2] Henry Bryant later copied the head of Jeremiah from the earlier double portrait by Trumbull, enlarging it, or he had access to Trumbull's later enlarged replica.

This portrait was on view in the Wadsworth Atheneum at the time of its opening in 1844 and listed in the catalogue as number 40. EMK

1. Daniel Wadsworth, will, 1847, Wadsworth Atheneum Archive. As indicated in Richard Saunders, with Helen Raye, *Daniel Wadsworth: Patron of the Arts* (Hartford: Wadsworth Atheneum, 1981), 38 n. 114, Bryant also painted a copy (private collection) of Trumbull's *Jeremiah and Daniel Wadsworth* (cat. 452).

2. See the following correspondence between Mrs. Benjamin Silliman and her daughters Faith Trumbull Wadsworth and Mrs. John Barker Church (Maria Silliman) in the collection of the Sterling Library, Yale University, New Haven. Mrs. Benjamin Silliman to Mrs. Daniel [Faith Trumbull] Wadsworth, November 6, 1837: "Thursday morning, Uncle Trumbull went up to Hartford. He has been engaged to paint a picture of Col. Wadsworth for James Wadsworth and wished to borrow the picture your uncle has to copy from." Mrs. Benjamin Silliman to Faith Wadsworth, January 24, 1838: "Your Uncle T is now spiritedly painting Col. Wadsworth." Mrs. Benjamin Silliman to Mrs. John Barker Church [Maria Silliman], February 13, 1838: "Uncle [Trumbull] . . . has also been copying a picture of Colonel Wadsworth which you may recollect seeing at Mrs. Terry's [Catherine Wadsworth] with your Uncle [Daniel Wadsworth] quite a boy leaning on his shoulder. Your Uncle is omitted and the other much enlarged; this is for Mr. James Wadsworth and I thought he did not seem to be well satisfied with the resemblance, tho the picture is a handsome one."

64

65

HENRY BRYANT

Mrs. Jeremiah Wadsworth (Mehitable Russell), c. 1840–1844

Oil on canvas; 27 × 22⅛ in. (68.6 × 56.2 cm)

Canvas stamp: Prepared by / Lynch

EX COLL.: commissioned by Daniel Wadsworth, Hartford, around 1842–1844

Bequest of Daniel Wadsworth, 1848.20

This portrait of Mrs. Jeremiah Wadsworth (1734–1817) was commissioned by her son Daniel Wadsworth and is a copy after a painting by Thomas Sully (q.v.) executed in 1807 (private collection, Philadelphia).[1] Mehitable Russell, the daughter of Rev. William and Mary (Pierpont) Russell of Middletown, Connecticut, married the prominent Hartford merchant Jeremiah Wadsworth in 1716.

65

was the brother of the artist John Trumbull and served as governor of Connecticut from 1797 to 1809.

This portrait hung in the newly opened Wadsworth Atheneum in 1844 and is listed as no. 36 in the Atheneum's *Catalogue of Paintings* (1844). EMK

1. Edward Biddle and Mantle Fielding, *The Life and Works of Thomas Sully* (1921; rpt., Charleston, S.C.: Garnier, 1969), 299. This portrait is listed in Daniel Wadsworth's will (1847) as "A Portrait of the last Governor Trumbull, being a copy by Bryant" (Wadsworth Atheneum Archive).

67

HENRY BRYANT

Mrs. Nathaniel Terry (Catherine Wadsworth), 1842–1844
Oil on canvas; 27 × 22⅛ in. (68.6 × 56.2 cm)
Canvas stamp: Prepared / by / Thos. Lynch / 68 Barclay ST. / NY

EX COLL.: commissioned by Daniel Wadsworth, Hartford, around 1842–1844

Bequest of Daniel Wadsworth, 1848.2

This portrait was on view in the Wadsworth Atheneum for its opening in 1844 and is listed as number 41 in the *Catalogue of Paintings* (1844). EMK

1. The painting is listed in the 1847 will of Daniel Wadsworth as "A Portrait of my mother, Mrs. Mehitable Wadsworth, a copy by Bryant" (Wadsworth Atheneum Archive).

66

HENRY BRYANT

Jonathan Trumbull, Sr., c. 1842–1844
Oil on canvas; 27½ × 22⅛ in. (69.9 × 56.2 cm)
Inscribed on stretcher in white chalk: H. Bryant

EX COLL.: commissioned by Daniel Wadsworth, Hartford, around 1842 to 1844; to the Wadsworth Atheneum in 1848

Bequest of Daniel Wadsworth, 1850.3

This portrait by Bryant is a copy after a painting by Thomas Sully (q.v.) executed in 1807 and now unlocated.[1] The subject, Jonathan Trumbull (1740–1809),

66

67

This portrait by Bryant is a copy after an 1807 painting by Thomas Sully (q.v.) originally in the collection of Daniel Wadsworth and now in a private collection.[1] Daniel's sister, Catherine Wadsworth (1774–1841), was the daughter of Jeremiah Wadsworth, and was married to General Nathaniel Terry, a prominent Hartford lawyer. EMK

1. This painting is listed in Daniel Wadsworth's will (1847) as "A Portrait of my late sister, Mrs. Terry, a copy by Bryant, from an original by Sully" (Wadsworth Atheneum Archive). As indicated in Richard Saunders, with Helen Raye, *Daniel Wadsworth: Patron of the Arts* (Hartford: Wadsworth Atheneum, 1981), 38 n. 114, this painting was exhibited at the Atheneum and is listed as number 43 in the Atheneum's *Catalogue of Paintings in the Wadsworth Gallery* (Hartford: Elihu Greer, 1844).

68

HENRY BRYANT

Mayor Henry Hudson, c. 1842–1844

Oil on canvas; 27¹/₁₆ × 22 in. (68.9 × 56.0 cm)

EX COLL.: Source unknown, 1850.2

Henry Hudson served as the mayor of Hartford from 1836 to 1840. This portrait, possibly listed as *Portrait of a Young Man,* no. 35, in the Atheneum's *Catalogue of Paintings* (1844), may have been part of the series of portraits commissioned by Daniel Wadsworth that were hung in the gallery of the Atheneum at the time of its opening in 1844.[1] EMK

1. H. W. French, *Art and Artists in Connecticut* (Boston: Lee and Shepard, New York: Charles T. Dillingham, 1879), 79–81.

69

HENRY BRYANT

Connecticut River at Westminster, Vermont, c. 1850

Oil on canvas; 9¹/₄ × 12 in. (23.5 × 30.5 cm)

Signed on stretcher: Conn River Westminster Vt.
 Bryant Westminster / #15

Technical note: The surface is discolored with yellowed varnish and grime and has large traction cracks throughout.

68

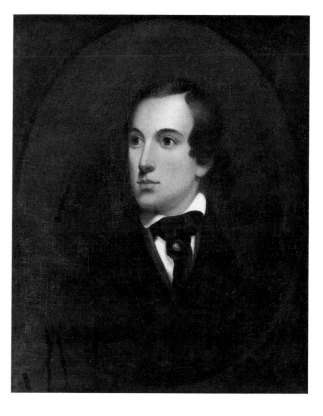

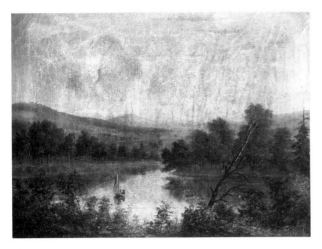

69

Bequest of Mrs. Alfred Tyler Perry and Mrs. Charles S. Mills,
1915.8

Although Bryant mainly painted portraits in the
Hartford area, he occasionally turned his hand to land-
scape. Here the artist depicts a bend in the Connecticut
River at Westminster, Vermont, including a sloop on the
river in the foreground. EMK

William Gedney Bunce

Born in Hartford, in 1840; died in Hartford, in 1916

William Gedney Bunce was the son of Hartford busi-
nessman James Marvin Bunce and his second wife,
Elizabeth Huntington Chester Bunce. At the age of six-
teen, he received drawing lessons from the Dresden
artist Julius Theodore Busch (1821–1858), who had a
studio in Hartford during the 1850s. After serving in the
First Regiment, Connecticut Volunteer Cavalry, during
the Civil War, Bunce moved to New York City, where he
studied at the Cooper Union from 1863 to 1867 and took
lessons in landscape painting from William Hart (q.v.).

In 1867 Bunce left for a twelve-year stay in Europe,
settling first in Paris. There, he met another Hartford
artist, Charles Noel Flagg (q.v.), with whom he be-
came close friends. In addition to study in Munich and
Antwerp, Bunce spent six years in Rome and traveled
throughout Italy. In Rome he met the American sculp-
tor Augustus Saint-Gaudens (1848–1907), and later

the two friends shared a studio in Paris. In 1877 Saint-
Gaudens modeled a portrait relief of Bunce that was ex-
hibited at the Paris Salon of 1879.

Bunce is best known for his Venetian landscapes and
seascapes. He spent most of his summers in Venice, and
in 1876, 1878, and 1879 he exhibited his Venetian scenes
at the Paris Salon. He continued to execute such scenes
after his return to America in 1879. Bunce was initially
inspired by Felix Ziem (1821–1911), a French marine
and landscape painter, to paint Venetian harbor scenes.
In these paintings he focused on the use of color rather
than on form and detail, though he demonstrated only a
peripheral involvement with the æsthetic concerns of
the American impressionists. In his later works, Bunce
used a palette knife and his fingers to make different
colors and create a heavy impasto.

After returning to America, Bunce maintained a stu-
dio in New York City for several years. With Saint-
Gaudens, he joined the Tile Club, formed in 1887 in New
York. (The club also included Edwin Austin Abbey, Wil-

Augustus Saint-Gaudens, *Relief of William Gedney Bunce*, 1877.
Wadsworth Atheneum, gift of Mrs. Stanley W. Edwards, 1945.12.

liam Merritt Chase [q.v.], Stanford White, J. Alden Weir [q.v.], and John Twachtman [q.v.] among its members; for almost a decade, this group gathered weekly to converse and to design decorative tiles.) Bunce exhibited at the Society of American Artists and at the National Academy of Design, of which he was elected an academician in 1907. He received a bronze medal at the Paris Exposition in 1900.

By the 1900s Bunce had a studio in Hartford, along with James Britton, who painted six portraits of Bunce (cat. 54). In his later years Bunce divided much of his time between Venice and the Hartford home of his sister and brother-in-law, Ellen and Archibald Welch. At the age of seventy-six he was tragically struck by an automobile on Farmington Avenue in Hartford.

SELECT BIBLIOGRAPHY

H. W. French, *Art and Artists in Connecticut* (Boston: Lee and Shepard Publishers; New York: Charles T. Dillingham, 1879) / Samuel Isham, *The History of American Painting* (New York: Macmillan, 1905) / Dorothy Young, *Men of the Tile Club* (New London, Conn.: Lyman Allyn Museum, 1945).

70 (see plate 16)

WILLIAM GEDNEY BUNCE
Venetian Days, c. 1874
Oil on six wood panels; frame $53^{1}/_{4} \times 84^{3}/_{4}$ in. (135.2 × 215.3 cm); overall image 30 × $61^{5}/_{8}$ in. (76.2 × 156.5 cm)
Top left panel: $14^{1}/_{4} \times 16^{3}/_{4}$ in. (36.2 × 42.5 cm)
Signed at lower left: G B
Top center panel: $14^{1}/_{4} \times 25^{1}/_{4}$ in. (36.2 × 64.1 cm)
Signed at lower right: Wm G Bunce
Top right panel: $13^{7}/_{8} \times 16^{7}/_{8}$ in. (35.2 × 42.9 cm)
Signed at lower right: W.G.B.
Bottom left panel: 14 × $16^{3}/_{4}$ in. (35.6 × 42.5 cm)
Signed at lower right: W.B.
Bottom center panel: $8^{3}/_{4} \times 13$ in. (22.2 × 33.0 cm)
Signed at lower right: W G Bunce
Bottom right panel: $14^{1}/_{8} \times 16^{7}/_{8}$ in. (35.9 × 42.9 cm)
Signed at lower left: W. G. Bunce

EXHIBITED: Hartford, Trinity College, "Junior Seminar Exhibition," 1973 / Wadsworth Atheneum, "Framing Art: Frames in the Collection of the Wadsworth Atheneum," 1982

EX COLL.: artist

Gift of the Artist, 1907.1–6

Bunce painted his series of Venetian scenes for *Venetian Days* while he was in Paris. By this time he had met the American sculptor Augustus Saint-Gaudens, who in 1875 designed and made the unique and elaborate frame for *Venetian Days*. Two years later, while Bunce was sharing Saint-Gaudens's Paris studio, the sculptor made a bronze portrait relief of Bunce.

Venetian Days is an early work that exemplifies Bunce's fondness for Venice, the main subject of his work throughout his painting career. In this small grouping, Bunce illustrates various views of the city and the harbor, emphasizing the poetic mood of Venice rather than its architectural grandeur. For each scene, he made a careful sketch and then added thin, transparent layers of paint that allow the grain of the wood to show through. A colorist, he uses pastel blues and yellows and earthy oranges, browns, and greens to capture the atmospheric effects and light. ERM

71

WILLIAM GEDNEY BUNCE
Millet's Church, E. Bridgewater, Mass., 1880
Oil on wood panel; $13^{3}/_{4} \times 10^{3}/_{8}$ in. (34.9 × 26.4 cm)
Signed on the back: W. Gedney Bunce / Millet's Church / E. Bridgewater / Oct. 1880

EXHIBITED: New London, Conn., Lyman Allyn Museum, "Men of the Tile Club," 1945, no. 35

EX COLL.: Archibald A. Welch (artist's brother-in-law), Hartford, by 1935

Bequest of Archibald A. Welch, 1935.462

71

rate studio in East Bridgewater, Massachussetts. Bunce most likely met Millet while the two were in Paris, where Millet lived from 1877 to 1879 and was actively involved in the circle of American artists that included his close associate Augustus Saint-Gaudens and Bunce. Both Bunce and Millet returned to America in 1879, the latter going first to Boston. The year these works were painted, Millet left for New York City, where Bunce had a studio. Like Bunce, Millet was actively involved in the Tile Club and exhibited at the National Academy of Design.

In the fall of 1880 Bunce visited Millet in East Bridgewater and painted *Millet's Church* and *Feeney's*. In both works, he thickly applied different whites and blues in the sky and in the foreground used transparent layers that allow the wood grain to show through. *Feeney's* has a sketchy, almost unfinished look; there is only a transparent glaze over the outlines of the trees. The foreground in both paintings is brown in color, because the wood shows through the paint. ERM

72

72

WILLIAM GEDNEY BUNCE
Feeney's, E. Bridgewater, Mass., 1880
Oil on wood panel; 13¾ × 10½ in. (34.9 × 26.7 cm)
Signed on the back: Feeney's Nov. 80 / E. Bridgewater
 Mass / Wm Gedney Bunce

EXHIBITED: New London, Conn., Lyman Allyn Museum,
"Men of the Tile Club," 1945, no. 37

EX COLL.: Archibald A. Welch (artist's brother-in-law), Hartford, by 1935

Bequest of Archibald A. Welch, 1935.463

Bunce painted *Millet's Church, E. Bridgewater, Mass.* and *Feeney's, East Bridgewater, Mass.* the year after his return from Europe. Frank Millet (1846–1912) was a painter and illustrator who in 1880 built an elabo-

73

73

Bar Harbor, Maine, c. 1880
Oil on wood panel; 11¾ × 17⅜ in. (29.8 × 44.1 cm)
Signed at lower right: Gedney Bun
Signed on back of panel: Bar Harbor / Maine / Wm
 Bunce

EXHIBITED: Wadsworth Atheneum, "A Second Look: Late
Nineteenth Century Taste in Painting," 1958, no. 5

EX COLL.: Archibald A. Welch (artist's brother-in-law), Hart-
ford, by 1935

Bequest of Archibald A. Welch, 1935.465

To capture the effects of light and water (with which
he experimented throughout his career), Bunce used
thickly applied paint in the bright sky and a transparent
varnish for the water. Luminously reflected in the ocean
are the sky and the buildings of the harbor. ERM

74

Gloaming—New England, c. 1880
Oil on wood panel: 12¼ × 25⅛ in. (31.1 × 63.8 cm)

EX COLL.: Archibald A. Welch (the artist's brother-in-law),
Hartford, by 1935

Bequest of Archibald A. Welch, 1935.464

In his landscape *Gloaming—New England,* Bunce
uses yellow, one of his favorite colors, to capture the
look of the sky at dusk. ERM

74

75

WILLIAM GEDNEY BUNCE
Islands with Sailboat, c. 1880
Oil on wood panel; 12 × 17³/₈ in. (30.5 × 44.1 cm)
Technical note: A sketch appears on the back of the
 panel.

EXHIBITED: Wadsworth Atheneum, "A Second Look: Late
Nineteenth Century Taste in Paintings," 1958, no. 2

EX COLL.: Archibald A. Welch (artist's brother-in-law), Hart-
ford, by 1935

Bequest of Archibald A. Welch, 1935.466

Harbor scenes were a favorite subject of Bunce's. *Is-
lands with Sailboat* most likely represents Maine, where
Bunce spent time painting before and after his Eu-
ropean sojourn from 1867 to 1879. In this painting he
uses his familiar thick brushwork in the sky and thin,
transparent strikes in the foreground. The sailboat's
white sails are illuminated against the brown grain of
the wood, a nice effect. ERM

75

76

WILLIAM GEDNEY BUNCE
Sastucket Hillside (Watch Hill), 1880
Oil on wood panel; 13¹/₂ × 17¹/₈ in. (34.3 × 43.5 cm)
Signed and dated at lower left: W. G. Bunce 80
Signed and dated on back: W. G. Bunce October 1880

EXHIBITED: New London, Conn., Lyman Allyn Museum,
"Men of the Tile Club," 1945, no. 36

EX COLL.: Archibald A. Welch (artist's brother-in-law), Hart-
ford, by 1935

Bequest of Archibald A. Welch, 1935.461

Not interested in detail, Bunce presents an impres-
sion of a sunny day in *Sastucket Hillside*. The sky is a
mixture of thickly applied blue and white paint. Bunce's
interest in light and its atmospheric effects is apparent
in this sketchily painted scene. ERM

76

77

WILLIAM GEDNEY BUNCE
Evening, Venice, c. 1880
Oil on canvas; 34³/₄ × 55¹/₈ in. (88.3 × 140.0 cm)
Signed at lower left: Gedney Bunce
Canvas stamp: Frost & Adams Boston

EX COLL.: Archibald A. Welch (artist's brother-in-law), Hart-
ford, by 1935

Bequest of Archibald A. Welch, 1935.452

78

WILLIAM GEDNEY BUNCE
Venetian Fishing Boats, c. 1880
Oil on wood panel; 14¹/₂ × 25³/₈ in. (36.8 × 64.5 cm)

78

79

WILLIAM GEDNEY BUNCE
Public Gardens, Venice, c. 1880
Oil on wood panel; 14½ × 25 in. (36.8 × 63.5 cm)
Signed at lower right: G B
Inscribed on back: W. Gedney Bunce

79

80

WILLIAM GEDNEY BUNCE
Venice, c. 1880
Oil on composition board; 13¹⁄₁₆ × 8⁷⁄₈ in. (33.2 × 22.5 cm)
Signed at lower left: WGB Venice

77

80

81

81

WILLIAM GEDNEY BUNCE

Venice, c. 1880

Oil on canvas; 35 × 54³/₈ in. (88.9 × 138.1 cm)

EXHIBITED: Wadsworth Atheneum, "A Second Look: Late Nineteenth Century Taste in Paintings," 1958, no. 1

EX COLL.: Archibald A. Welch (artist's brother-in-law), Hartford, by 1935

Bequest of Archibald A. Welch, 1935.476

82

WILLIAM GEDNEY BUNCE

Morning, Venice, c. 1880

Oil on wood panel; 28 × 36 in. (71.1 × 91.4 cm)

Signed at lower left: Gedney Bunce

EX COLL.: Archibald A. Welch (artist's brother-in-law), Hartford, by 1935

Bequest of Archibald A. Welch, 1935.451

83

WILLIAM GEDNEY BUNCE

Venice, c. 1880

Oil on wood panel; 14¹/₂ × 17 in. (36.8 × 43.2 cm)

Signed at lower right: W Gedney Bunce Venice

EX COLL.: Archibald A. Welch (artist's brother-in-law), Hartford, by 1935

Bequest of Archibald A. Welch, 1935.456

84

WILLIAM GEDNEY BUNCE

Venice, 1881

Oil on wood panel; 14¹/₄ × 17 in. (36.2 × 43.0 cm)

Signed and dated at lower left: Wm Gedney Bunce
Venice 81

EX COLL.: Archibald A. Welch (artist's brother-in-law), Hartford, by 1935

Bequest of Archibald A. Welch, 1935.457

82

83

84

85

85

WILLIAM GEDNEY BUNCE

Venetian Houses, 1883

Oil on wood panel; 8¼ × 12⅞ in. (21.0 × 32.7 cm)

Signed at lower left: William Gedney Bunce Venice

EX COLL.: Archibald A. Welch (artist's brother-in-law), Hartford, to 1935

Bequest of Archibald A. Welch, 1935.460

86

WILLIAM GEDNEY BUNCE

Yellow Sands, 1884

Oil on wood panel; 8¼ × 13 in. (21.0 × 33.0 cm)

Signed and dated at lower right: Wm Gedney
 Bunce / Venice May 84

EX COLL.: Archibald A. Welch (artist's brother-in-law), Hartford, by 1935

Bequest of Archibald A. Welch, 1935.459

87

WILLIAM GEDNEY BUNCE

Venice, 1885

Oil on wood panel; 14¾ × 25¼ in. (37.5 × 64.1 cm)

Signed and dated at lower right: W Gedney Bunce 85

EX COLL.: Archibald A. Welch (artist's brother-in-law), Hartford, by 1935

Bequest of Archibald A. Welch, 1935.453

86

87

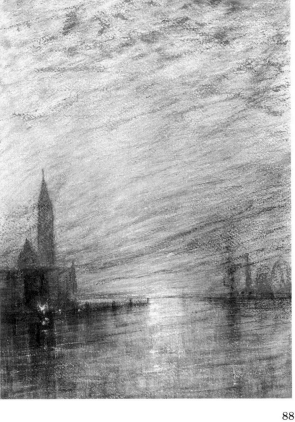

88

88

WILLIAM GEDNEY BUNCE
Venice, c. 1900
Oil on canvas; 55 × 35in. (139.7 × 88.9 cm)
Signed at lower left: Gedney Bunce
Signed on back: W. Gedney Bunce / Hartford / Conn.

EX COLL.: Archibald A. Welch (artist's brother-in-law), Hartford, to 1905

Gallery Fund, 1905.3

These views of Venice, dating from the early 1880s through 1900, represent the typical oeuvre of Bunce, who spent his entire career painting his favorite Italian city. Not interested in illustrating the architectural ensemble and splendor of Venice, Bunce focused on the atmospheric light that bathes the city. Many of his views contain no architectural references and instead are por-

traits of water and boats in a misty yellow atmosphere. Occasionally, such as in *Venice* (cat. 80) and *Venetian Houses* (cat. 85), he would depict an architectural setting, but always a simple one: the buildings are houses in a plain architectural style.

Most of the scenes Bunce painted are on mahogany panels, with the wood showing through the thinly applied paint layers and giving the work a "gracious warmth of tone."[1] The artist did not glorify Venice in splendid colors, instead choosing a subtle tonal palette of yellows, grays, browns, and oranges to convey the mists and poetic beauty of the city. According to one writer, it is because of the poetry with which Bunce imbues his numerous pictures of the city that "one seldom if ever tires of them."[2] ERM

1. Frederick Fairchild Sherman, "W. Gedney Bunce," *Art in America* 14 (1925–1926), 83.
2. Ibid.

Liberto Cardella

Born in Palermo, Italy, in 1778; died in Hartford, in 1853

It is unknown exactly when the Italian artist Liberto Cardella emigrated to America; his presence is first recorded in 1831 in Amherst, Massachusetts, where he was an instructor of Italian, music, and drawing at the Mount Pleasant Classical Institute (he remained there until the school closed in 1836). In the same year he exhibited a work at the Boston Athenaeum.

Cardella is listed as a resident of 7 Pearl Street, Hartford, across from the State House, for the years 1840 and 1841. Records later show him in Boston in 1846 and back in Hartford in 1847, when he exhibited "two paintings of the cottage supper" at the Hartford County Agricultural Fair (*Hartford Courier*, October 14, 1847). Having established a studio and residence in the city's American Hotel in 1847, Cardella painted portraits of prominent Hartford citizens. In 1848 he opened a school of drawing and painting at his studio; in the same year his young son, Raymond Cardella (c. 1837–?), made his musical debut on the piano at "Cardella's Concert," accompanied by his father and other musicians.

In 1849 the artist suffered a major loss of property when a fire in the American Hotel destroyed his studio. The sympathy for his plight was great, as one of a number of newspaper accounts reported:

> The late fire at the American Hall has called forth . . . a large share of sympathy, and a manifest desire on the part of the public to relieve the sufferers. Of those, Sig'r Liberato Cardella, was the principal. . . . His all of earthly wealth, was here concentrated . . . and he is, at the age of 68, thrown upon the cold charities of the world, with a little boy to educate.
>
> Among his (approximately 40) paintings, were many of great value and beauty. . . . As a musician, he displayed the same depth of feeling, and the same talent, and his success as a teacher, is exhibited by the exquisite performance of his son.
>
> Mr. Cardella was formerly a Romish Priest, but a copy of the Bible falling into his hands . . . he seceded from the Church . . . and he flew his native land. (*Hartford Republican*, February 22, 1849)

Following the fire, Cardella received charitable assistance from the citizens of Hartford, and he soon placed the following advertisement: "Historical and Portrait Painter, having returned to his old quarters in the American Hall Building, is now ready to paint Portraits of any size or description as cheap as any one, and as good in every respect" (Geer's *Hartford City Directory*, 1850). Cardella died in Hartford at the age of seventy-five.

SELECT BIBLIOGRAPHY

Phyllis Kihn, "Signor Liberto Cardella," *Connecticut Historical Society Bulletin* 34, no. 2 (April 1969), 54–64

89

LIBERTO CARDELLA
James Hosmer, 1841
Oil on canvas; 30 × 25⅛ in. (76.2 × 63.8 cm)
Signed and dated on stretcher: James B. Hosmer
 painted by Cardella 1841

EX COLL.: James B. Hosmer, Hartford

Bequest of James B. Hosmer, 1878.1

Liberto Cardella painted James B. Hosmer in Hartford in 1841, a year after he had established a studio in the city. In a hard, linear manner, Cardella captured a stern likeness of Hosmer, who is shown seated in a side chair, with his right arm leaning on a table top and resting on a book inscribed: "HIST / Of / AMER." Attired in a black coat, he wears a gold stick pin in his shirt front.

James Bidwell Hosmer (1781–1878) was a descendant of Stephen Hosmer, an original settler of Hartford. He made a considerable fortune as a dry-goods merchant in Hartford before retiring in 1833 to devote himself to cultural and civic affairs. As one of the original subscribers of the Wadsworth Atheneum, he oversaw the construction of the Atheneum and was its treasurer and superintendent from 1842 until shortly before his death. He was also president of the Connecticut Historical Society from 1860 to 1863. One of his greatest interests

89

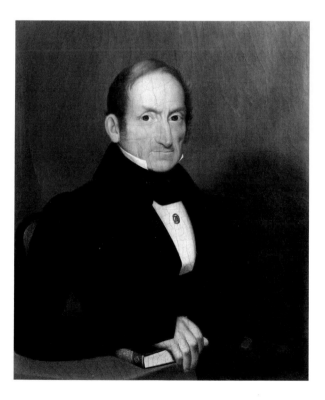

later in life was the Hartford Theological Seminary, toward the building of which he gave $100,000. He died in Hartford at the age of ninety-seven.[1] EMK

1. Marian G. M. Clarke, *David Watkinson's Library* (Hartford: Trinity College Press, 1966); and Eugene R. Gaddis, "'Foremost Upon this Continent': The Founding of the Wadsworth Atheneum," *Connecticut History* 26 (November 1985), 109.

90

LIBERTO CARDELLA

Charles Hosmer, c. 1841

Oil on canvas; 30 × 25½ in. (76.2 × 64.8 cm)

EX COLL.: to the subject's brother, James B. Hosmer, Hartford, by 1878

Bequest of James B. Hosmer, 1878.2

Cardella's portrait of Charles Hosmer may have been intended as a companion to that of his brother James (cat. 89), which displays a similar composition. Like James, Charles is seated in a chair—in this instance, a red upholstered armchair—and is shown with a book. The artist managed to convey the familial resemblance of the two brothers, while at the same time capturing the more handsome visage of Charles, who is the younger of the two Hosmers. EMK

91

LIBERTO CARDELLA

Colonel James Ward, c. 1850

Oil on canvas; 30 × 24⅞ in. (76.2 × 63.2 cm)

Canvas stamp: Prepared / By / Edwd Dechaux / New-York

EX COLL.: to the subject's granddaughter, Catherine Ward, Hartford, by 1863

Gift of Catherine Ward, 1863.5

Born in Guilford, Connecticut, James Ward (1768–1856) was the son of the silversmith Bilious Ward and grandson of the Guilford blacksmith, William Ward, Jr.

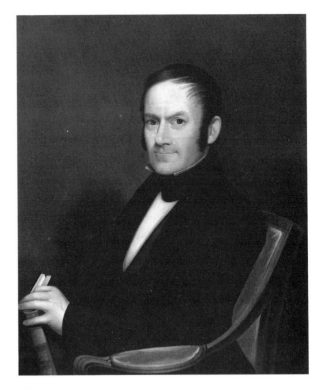

90

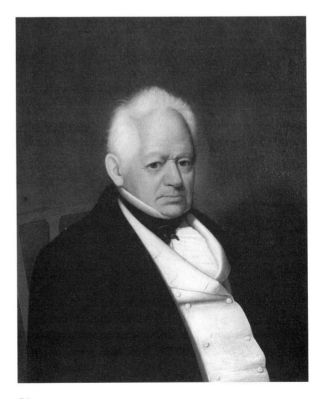

91

After serving an apprenticeship with the gold- and silversmith Miles Beach in Hartford, James became his partner by 1790, later forming his own business. Ward made gold and silver jewelry, and he also sold an extensive inventory of goods, becoming a leading merchant in Hartford. During the War of 1812, he was appointed Connecticut commissary general with the rank of colonel, an office he retained until his death. Ward, along with Daniel Wadsworth and five others, was chosen a founding member of the Connecticut Historical Society in 1839, and he became its vice president in 1840. He also served as a director of the American Asylum for the Education and Instruction of the Deaf and Dumb, located in Hartford. The Atheneum has a number of Ward's finest pieces of silver, including a silver tea service with dolphin finials (c. 1810), and several pieces of silver by Ward are in the collection of the Connecticut Historical Society. At the time of his death at the age of eighty-six, Ward left an estate worth over $100,000. Most of his personal effects were left to his son, Roswell B. Ward (cat. 135).[1]

Cardella's portrait of James Ward was painted late in the subject's life, and the artist depicts him as an aged figure with white hair, sloping shoulders, and a substantial girth. He is seated in a side chair, in a slouching pose, and stares out at the viewer. Cardella's portrait was likely executed around 1850 after the artist had reestablished his studio in the American Hotel following the destructive fire of 1848.[2] This portrait hung in the Wadsworth Atheneum in the latter part of the nineteenth century and is listed in the gallery catalogue for 1863.[3] EMK

1. Ruth C. Page, "Colonel James Ward: Silversmith and Entrepreneur," *Connecticut Historical Society Bulletin* 33 (October 1968), 105–116.
2. Phyllis Kihn, "Signor Liberto Cardella," *Connecticut Historical Society Bulletin* 34, no. 2 (April 1969), 62.
3. Listed as no. 55, "Portrait of Col. James Ward, by Cardella," *Catalogue of Paintings Now Exhibiting in the Wadsworth Gallery* (Hartford: Case, Lockwood, 1863).

Arthur B. Carles

Born in Philadelphia, in 1882; died in Chestnut Hill, Pa., 1952

A leading avant-garde painter in America, Arthur Beecher Carles was an exponent of European modernism beginning in about 1910. He painted for nearly four decades, shifting from abstract to representational styles and toward the end of his career creating works that foreshadowed abstract expressionism.

Raised in Philadelphia, the son of a craftsman, Carles attended the Pennsylvania Academy of the Fine Arts in 1900. There he received instruction from Cecilia Beaux (q.v.), Thomas Anshutz, William Merritt Chase (q.v.), and others. Having gained knowledge of the newer post-impressionist style at the academy, Carles made several trips to Europe from 1905 to 1912. He visited Gertrude and Leo Stein in Paris and began to show the influence of Henri Matisse and Paul Cézanne in his paintings, seen in his vibrant use of color. In 1912 he returned to New York to become part of Alfred Stieglitz's circle of modernists and had a solo exhibition at Stieglitz's "291" gallery. He also exhibited paintings at the 1913 Armory Show in New York.

In 1917 Carles became an instructor at the Pennsylvania Academy of the Fine Arts, where he became a vital force in bringing modernism to Philadelphia. By the 1920s his work focused on sensuous still lifes and nudes painted in vibrant colors and abstract patterns. In the later years of the decade, alcoholism began interfering with his work; he continued to paint, however, and exhibited with success at the Carnegie International exhibitions and the Pennsylvania Academy, where he won the Temple Gold Medal in 1930.

Following a trip to Europe in 1927, Carles experimented with cubism, while continuing to paint nudes and still lifes. By 1936 he was creating nonrepresentational abstract paintings that presaged the work of the abstract expressionists. A stroke brought on by alcoholism ended his career in 1941.

SELECT BIBLIOGRAPHY

Jo Mielziner, "Arthur Carles: The Man Who Paints with Color," *Creative Art* 2 (February 1928), 30–35 / Henry Gardiner, "Arthur B. Carles, 1882–1952: A Critical and Biographical Study," *Bulletin of the Philadelphia Museum of Art* 64 (January–March 1970), 139–189 / Barbara Ann Wolanin, "Arthur B. Carles, 1882–1952: Philadelphia Modernist" (Ph.D. diss., University of Wisconsin, Madison, 1981) / Barbara Ann Wolanin, *Arthur B. Carles: Painting With Color*, exh. cat. (Philadelphia: Pennsylvania Academy of the Fine Arts, 1983)

92

ARTHUR B. CARLES

Nude, 1930

Oil on canvas; 51 × 40½ in. (129.5 × 102.9 cm)

EXHIBITED: Philadelphia, Pennsylvania Academy of the Fine Arts and the Philadelphia Museum of Art, "Memorial Exhibition: Arthur B. Carles, 1882–1952," 1952, no. 50, as "Nude" / New York City, Graham Gallery, "Arthur B. Carles Retrospective," 1959, no. 59, as "Figure" / Philadelphia, Pennsylvania Academy of the Fine Arts; Washington, D.C., Corcoran Gallery of Art; and New York City, National Academy of Design, "Arthur B. Carles, Painting with Color," 1983–1984, no. 78

EX COLL.: to the artist's daughter, Mercedes Matter, by 1931; with the Graham Gallery, New York City, in 1959

The Ella Gallup Sumner and Mary Catlin Sumner Collection Fund, 1959.80

Returning to Europe in 1929, Carles took a studio in Paris and remained there until the summer of 1931. He produced nearly forty paintings during this time, including a few landscapes, some still lifes, and numerous figure studies. *Nude* is one of the finest works he painted in his Paris studio.

In 1929 Carles had stated his artistic goal as that of "painting with color so that the canvas actually is light all over with no darkness in it."[1] In *Nude* the artist began to achieve that goal. In many ways, the painting is ahead of its time; for example, it has been described as anticipating by two decades Willem de Kooning's (q.v.) series of women, including *Woman I* (1950–1951, Museum of Modern Art, New York City).[2] Carles's painting

represents a seated woman in a series of slashing strokes with the figure's breasts in the center. The artist's energetic brushwork, patterned surfaces, and vibrant colors of black, white, and a range of brilliant hues create a work of great vibrancy.

An archival photograph of the painting, taken in Paris in December 1930, provides a firm date of 1930 for the painting, which was previously dated 1931.[3] A reviewer of Carles's memorial exhibition held at the Pennsylvania Academy of the Fine Arts in Philadelphia in 1952 praised *Nude*, writing that the subject of the nude figure is here "no longer a finite silhouette. It is expanded into sumptuous color planes, segmented, shifted, and handsomely restated as a self-sustained pictorial equivalent for the subject painted."[4]　EMK

1. Arthur B. Carles to Mr. Horter, c. 1929, quoted in Barbara Ann Wolanin, *Arthur B. Carles: Painting with Color*, exh. cat. (Philadelphia: Pennsylvania Academy of the Fine Arts, 1983), 99.
2. Ibid.
3. Barbara Wolanin to Richard Saunders, June 26, 1981, with a xerox of the photograph, curatorial painting file, Wadsworth Atheneum.
4. Sam Feinstein, "Philadelphia," *Art Digest* 27 (April 1953), 13.

Emil Carlsen

Born in Copenhagen, in 1853; died in New York City, in 1932

Emil Carlsen studied architecture at the Royal Academy in Copenhagen before emigrating to America in 1872 at the age of nineteen. In Chicago he served as an architect's assistant and later taught drawing and painting at the Chicago Academy of Design (now the Art Institute of Design). Carlsen would continue to teach throughout his life. In 1887 he became director of the San Francisco Art School, and he taught at the National Academy of Design in New York City from 1906 to 1909 and at the Pennsylvania Academy of the Fine Arts from 1912 to 1918.

Serious about pursuing a career in painting, in 1875 Carlsen left for Europe, where he became familiar with the still-life works of French eighteenth-century painter

92

Jean-Siméon Chardin. Chardin had a major impact on the development of Carlsen's style and still lifes. Six months later, he returned to the United States and eventually settled in Boston in 1876, maintaining a studio there for about three years. Around 1879 financial difficulties forced him to auction his paintings and work as a designer and engraver. Moving to New York City, he continued to paint still lifes and gradually gained a reputation, attracting the attention of New York dealer

Theron J. Blakeslee in 1883. Blakeslee commissioned Carlsen to paint more of his still lifes in Paris, where the artist would have contact with French art and influences becoming popular in America. For two years, Carlsen painted in Paris, associating with French painters as well as with Americans, including Willard Metcalf (q.v.).

Tired of painting still lifes on commission, Carlsen had returned to New York City by 1886, when he exhibited at the National Academy of Design. From 1887 to

1891 he painted and taught in San Francisco. Returning to New York, he developed friendships with impressionist landscape painters J. Alden Weir (q.v.) and John Twachtman (q.v.). By the turn of the century, landscapes had become increasingly important in Carlsen's work, though he continued painting the still lifes for which he was most famous. His landscapes reflect the impact of Twachtman and Weir in the cool tonal palette and soft light, yet at the same time they are peculiarly his own. His works have a decorative quality, with thinly painted surfaces and bright atmospheric colors. His later landscapes and seascapes take on spiritual overtones. In the early 1900s, he spent more time in the countryside of Connecticut with colleagues such as Weir and Twachtman, and in 1905 he bought a home in Falls Village, Connecticut.

Carlsen became a member of the Society of American Artists in 1902, an associate of the National Academy of Design in 1904, and an academician in 1906. His numerous awards included a gold medal at the Louisiana Purchase Exposition in 1904 and a medal of honor at the Panama-Pacific International Exposition in 1915.

SELECT BIBLIOGRAPHY

F. Newlin Price, "Emil Carlsen—Painter, Teacher," *International Studio* 75 (July 1902), 300–308; Duncan Phillips, "Emil Carlsen," *International Studio* 61 (June 1917), 105–110 / Dorothy Tananbaum, *The Art of Emil Carlsen*, exh. cat. (New York: Hammer Galleries, 1977) / Doreen Bolger Burke, *American Paintings in the Metropolitan Museum of Art*, vol. 3, ed. Kathleen Luhrs (New York: Metropolitan Museum of Art, 1980)

93 (see plate 17)

EMIL CARLSEN
Summer Light, ca. 1913
Oil on canvas; 30 × 40 in. (76.2 × 101.6 cm)
Signed at lower right: Emil Carlsen

EXHIBITED: New Britain, Conn., New Britain Museum of American Art, "Three Centuries of American Art," 1981, no. 60

EX COLL.: Mr. and Mrs. Augustus Gerdes, New Canaan, Conn.

Gift of Mrs. Augustus Gerdes, 1948.167

Carlsen began to paint seascapes in the 1870s.[1] His early marine paintings show his fascination with the sea in its various states, from stormy to calm. With a dark palette and the use of dark and light contrasts, he conveyed the sense of the ocean's power.[2] In his later seascapes of the 1900s, Carlsen's vision of the ocean changed. Rather than seeking to evoke the internal forces and power of the ocean, as seen in the works of Winslow Homer (q.v.)—which were familiar to Carlsen—the artist tried to depict the sea's internal calm. In *Summer Light* the mood is trancelike, the opposite of Homer's turbulent and pounding *Rocky Coast* (cat. 277).

Carlsen's approach to marine painting was distinctive in its use of color, light, and form. In *Summer Light* he portrayed the ocean with a mixture of blues, grays, aquas, and whites. Rather than using the brilliant palette favored by his impressionist colleagues, Carlsen chose soft colors that he delicately mixed and blended. The tonal qualities of *Summer Light*, for example, contrast sharply with the vivid hues seen in *Road in the Land of Nod* (cat. 263), painted by his friend and colleague Childe Hassam. Though he shared his impressionist colleagues's fascination with the effects of light, unlike them, he sought a tranquil light unbroken by sharp transitions and sudden contrasts.[3] In *Summer Light* he created atmospheric beauty through the use of filtered light that evenly fills the canvas. Not interested in a particular place at a particular time, he focused on the lyricism and patterns of his subject matter. The fisherman set against the deep background of sea and sky is a flat and decorative element; a pattern amid other patterns. Barely discernible in the distance on the low horizon is a tall, masted ship.

Another distinctive quality in Carlsen's seascapes is the deliberately dry, granular paint surface, as can be seen in *Summer Light*. The artist applied paint in thin layers, with the canvas showing in some areas. The surface in *Summer Light* provides another contrast with

Hassam's *Road in the Land of Nod*, with its oily, shiny quality. Carlsen's colleague John Twachtman (q. v.) was also interested in creating a dry look for his paintings, which he first achieved in his pastels.[4] ERM

1. Erwin S. Barrie, Arthur E. Bye, F. Newlin Price, John Steele, Duncan Phillips, and Eliot Clark, *The Art of Emil Carlsen, 1853–1932,* exh. cat. (San Francisco: Wortsman-Rowe Galleries, 1975), 23.
2. Ibid.
3. Duncan Phillips, "Emil Carlsen," *International Studio* 61 (June 1917), 106.
4. For a discussion of this, see Richard J. Boyle, "John H. Twachtman's Mastery of the Mood," in Lisa N. Peters, William H. Gerdts, John Douglass Hale, and Richard J. Boyle, *In the Sunlight: The Floral and Figurative Art of J. H. Twachtman* (New York: Spanierman Gallery, 1989), 49, 50, 52.

John Carroll

Born in Kansas City, Kans., in 1892; died in East Chatham, N.Y., in 1959

94

John Carroll was raised in San Francisco, California, and attended the University of California. He received his earliest artistic training with Frank Duveneck (q.v.) in Cincinnati beginning in about 1915. After serving in the navy during World War I, Carroll settled in New York City and in 1922 became a member of the Woodstock Artist Colony in Woodstock, New York. He taught at the Art Students League in New York City and received a Guggenheim fellowship in 1927, which allowed him to study in Europe. Carroll taught for several years in Detroit and eventually returned to New York, where he settled on a farm in East Chatham. He married Georgia "Pinky" Finckel in 1936.

Carroll painted figural works of women, often using his wife as a model. He also executed commissioned portraits in a bold, modern style.

SELECT BIBLIOGRAPHY

Ernest W. Watson, "John Carroll," *American Artist* 23 (January 1951), 29–34 / Albany Institute of History and Art, *John Carroll: Retrospective Exhibition*, exh. cat. (Albany, N.Y.: Albany Institute of History and Art, 1963) / Frank Rehn Gallery, *John Carroll* (New York: Frank Rehn Gallery, 1969)

94

JOHN CARROLL

Rose (Hobart), c. 1935

Oil on canvas; 40 × 32 in. (101.6 × 81.3 cm)

Signed at lower right: John Carroll

EX COLL.: to Julius Weitzner, New York City, by 1955

Gift of Julius Weitzner, 1955.256

John Carroll specialized in portraits and figure studies of women, painting in a highly individualistic style. The donor of this stylized portrait identified the subject as Rose Hobart, who was a Hollywood actress in the 1930s. The artist worked in broad, geometric planes that reflect the influence of the art deco style of the 1930s. EMK

John William Casilear

Born on Staten Island, N.Y., in 1811; died in Saratoga Springs, N.Y., in 1893

A quote from a contemporary of Casilear gives some idea of the kind of person the artist was and the circle of artists in which he moved:

> Mr. Casilear is one of the most genial of artists, he is never out of humor, and though extremely critical, is seldom severe. . . . He is surrounded by his pictures and his books (he is an omnivorous reader) and his walls indicate association with nearly all the leading artists of the country. Here hangs a Kensett, a lovely little English view, there a Cropsey, larger and firmer than any he paints now-a-days, yonder a Gifford, above it a Colman, over the table a Durand, a vigorous Inness, one of Brown's earlier pictures, a Moran, a Hart, and numerous others, beside faithful copies of Claude, Teniers, and the old Dutch painters, quite equal to the originals, and whole stacks of studies and unfinished landscapes. (unidentified clipping, artist file, Metropolitan Museum of Art)

Casilear trained as an engraver, beginning an apprenticeship in Peter Maverick's studio in New York City in 1827. On Maverick's death in 1831, Casilear continued his training with one of Maverick's former partners, Asher B. Durand (q.v.). Casilear went on to form his own engraving firm with his brother. This firm later joined with several others to become the American Banknote Company, which is still in operation today.

Casilear made his "first real attempt at a landscape painting" at age twenty and noted that "Durand, when he saw it, examined it carefully, and then turning to me, said: 'Why you're a painter!'" (unidentified clipping, artist file, Metropolitan Museum of Art). The National Academy of Design in New York City elected Casilear associate in 1833 and academician in 1852. By 1857 the artist had made enough money to retire from engraving and focus on painting. He wrote that "it was 1854 before I began to paint in earnest, but from the very first I met with every encouragement. Goupil & Co. would buy al-

most anything I produced" (unidentified clipping, artist file, Metropolitan Museum of Art).

Casilear lived with John F. Kensett (q.v.) and Louis Lang (q.v.) at Waverly House, 697 Broadway, in New York City from 1854 until 1859, when he was one of the first artists to move into the Tenth Street Studio Building, where he lived until his death. Every summer Casilear and artist friends took sketching trips together, traveling to the Catskills, the Adirondacks, the White Mountains, and the Genesee valley in New York. Casilear traveled to Europe twice. He made his first trip in 1840 with Durand, Kensett, and Thomas P. Rossiter (1818–1871), spending three years in England and continental Europe, primarily France. While abroad, Durand introduced Casilear to the work of Claude Lorrain. During this trip, Casilear went on a number of sketching tours with Kensett, and that artist replaced Durand as an important influence after their return from Europe. Casilear took a second trip to Europe in 1858, spending most of his time sketching in Switzerland. These sketches became the basis for his paintings of Swiss landscapes, and he drew on them until well into the 1880s.

Casilear died of a stroke at age eighty-three.

SELECT BIBLIOGRAPHY

Artist file: John W. Casilear, American Wing, Metropolitan Museum of Art / Henry T. Tuckerman, *Book of the Artists: American Artist Life* (New York: Putnam, 1867), 521–522 / G. W. Sheldon, *American Painters*, rev. ed. (New York: D. Appleton, 1881), 154–156 / John K. Howat, ed., *American Paradise: The World of the Hudson River School*, exh. cat. (New York: Metropolitan Museum of Art, 1987), 141

95 (see plate 18)

JOHN WILLIAM CASILEAR

Lake George, 1860

Oil on canvas; 26¼ × 42½ in. (66.7 × 108.0 cm)

Signed (monogram) and dated at lower right: JWC'60

Inscribed on back stretcher: Mr. Casilear 10th St. Building

Canvas stamp: Prepared / by / Edwd. Dechaux / New York

EXHIBITED: Wadsworth Atheneum, "Gould Bequest of American Paintings," 1948 / Wadsworth Atheneum, "The Hudson River School: Nineteenth-Century American Landscapes in the Wadsworth Atheneum," 1976, no. 38 / Wadsworth Atheneum, "Framing Art: Frames in the Collection of the Wadsworth Atheneum," 1982 / Metropolitan Museum of Art, "American Paradise: The World of the Hudson River School," 1988 / Paris, Galeries Lafayette, "Deux Cents Ans de Peinture Américaine: Collection du Musée Wadsworth Atheneum," 1989

EX COLL.: Clara Hinton Gould, Santa Barbara, Calif., by 1948

Bequest of Clara Hinton Gould, 1948.183

Some remarks made fifteen years after Casilear painted *Lake George* could well describe the Atheneum's painting: "Mr. Casilear is a great lover of pastoral scenes, and some of his most notable pictures of this character have been drawn from the neighbourhood of Lake George, and the Genesee Valley in Western New York. His work is marked by a peculiar silvery tone and a delicacy of expression which is in pleasant accord with Nature in repose, and of his own poetically-inclined feelings. He finishes his canvases with great care, and in that respect shows the influence of his early training."[1]

The influence of John F. Kensett (q.v.), a sketching companion and a neighbor at Waverly House, is unmistakable in the treatment of the water and the light in the Atheneum's *Lake George*. Casilear's own background as an engraver and perhaps the influence of another friend and former engraver, Asher B. Durand (q.v.), is reflected in the highly finished quality of the canvas and the attention to detail in the foreground foliage and middle-ground hills.[2] The foreground of the painting, a series of beautifully rendered nature studies, compares with those by other artists working in the middle of the nineteenth century and may reflect in part the influence of the growing American Pre-Raphaelite movement.[3]

An unusual aspect of the Atheneum's *Lake George* is its large size. In 1876 a commentator wrote, "Mr. Casilear is no admirer of large canvases, and it is a rare event for him to execute a picture more than twenty-four by thirty-six inches in size."[4] The scale of the composition suggests that the artist painted it with a public

exhibition in mind, but the number of Lake George paintings Casilear executed, in addition to the frequent occurrence of works titled simply *Landscape* in exhibition records, makes it difficult to trace the exhibition history of *Lake George* with any certainty.

Henry Tuckerman wrote in 1867 about a painting by Casilear very similar to the Atheneum's painting: "One of his most congenial and successful American subjects. . . . The glassy surface of the lake, its smoothness disturbed only by the ripples caused by leaping trout, spreads beyond and across to the opposite hills. A small boat, propelled by one person, leaves a slender wake behind it. A few light clouds hover above the hill-tops, and summer's peace seems to pervade the scene."[5] This peace was characteristic of American landscape paintings that predate the Civil War and those that sought to heal the wounds of that bloody struggle. Painted only a year before the war began, *Lake George* offers an idealistic view of Lake George in marked contrast to that of Sanford Gifford's *Passing Storm* of 1866 (cat. 237).

Several paintings by Casilear were exhibited under the title "Lake George" in the nineteenth century. As early as 1857 two canvases identified as depicting Lake George were exhibited at the National Academy of Design in New York City, and in 1858 another, belonging to M. Knoedler, was also exhibited at the academy.[6] AE

1. "American Paintings—John Casilear," *Art Journal* 2 (1876), 16–17.
2. Sadakichi Hartmann, writing in 1901, said that Casilear was "known for his delicate finish" (*A History of American Art*, rev. ed. [1932; rpt., New York: Tudor, 1934], 58).
3. See Linda S. Ferber and William H. Gerdts, *The New Path: Ruskin and the American Pre-Raphaelites* (New York: Schocken Books, in association with the Brooklyn Museum, 1985), for a full discussion of the origin and influence of the Pre-Raphaelite movement in America.
4. "American Paintings—John Casilear," 16–17.
5. Henry T. Tuckerman, *Book of the Artists: American Artist Life* (New York: Putnam, 1867), 521–522, quoted in Barbara Ball Buff, s.v. "Lake George," in John K. Howat, ed., *American Paradise: The World of the Hudson River School*, exh. cat. (New York: Metropolitan Museum of Art, 1987), 143.
6. See artist file: John W. Casilear, American Wing, Metropolitan Museum of Art. I am grateful to Carrie Rebora of the Metropolitan Museum of Art, who generously gave me access to this file.

Mary Louise Catlin

Born in Hartford, in 1857; died in Hartford, in 1927

Mary Louise Catlin received artistic instruction in the Hartford area. She worked as an amateur painter during her lifetime and was an important donor to the Wadsworth Atheneum. She married Frank Sumner (cat. 230), president of the Connecticut Bank and Trust Company in Hartford in 1919. In 1926 the Wadsworth Athe-

96

neum received over $1 million from the estate of Frank Chester Sumner (1850–1924) for an endowment for the acquisition of paintings for the museum. The Ella Gallup Sumner and Mary Catlin Sumner Collection Fund was named for Mary Catlin and her sister-in-law, Ella Gallup Sumner, wife of Frank's brother, George Sumner.

SELECT BIBLIOGRAPHY

Curatorial painting file, Wadsworth Atheneum / "Frank C. Sumner's Bequest," *Bulletin of the Wadsworth Atheneum* 5 (October 1927), 32–33

96

MARY LOUISE CATLIN
On the Line, 1883
Oil on canvas; 17 × 8⅝ in. (43.2 × 21.9 cm)
Signed and dated at upper left: M. L. Catlin / '83

EX COLL.: descended to the first cousin of the artist, Robert M. Reynolds, Harwinton, Conn.; to his wife, Mrs. Robert M. Reynolds, Harwinton, Conn., by 1976

Gift of Mrs. Robert M. Reynolds in memory of Robert M. Reynolds, 1976.25 EMK

Thomas Chambers

Born in London, in 1808; died after 1866

Little is known about the early life of Thomas Chambers beyond the fact that he was born in London and emigrated to America in 1832. That year he is listed in the New Orleans directory for 1834 (printed in 1833) as a painter. He is next found in New York, listed in the New York City directories as a marine or landscape painter for the years 1834 to 1840. By 1843 he was in Boston, where he lived until 1851, after which he moved to Albany, New York, remaining in that city until 1857. (The New York State 1855 census records that Thomas Chambers, aged forty-seven, and his wife, Harriet, age forty-six, lived in Albany at 343 State Street in a freestone house valued at $2,500. For both, the place of birth was listed as London.) Chambers next revisited New York City, where he is listed in the directories for

the years 1858 to 1859, then lived in Boston in 1860 to 1861, and finally resettled in New York City from 1862 to 1866. After this point, no record of the artist exists.

Chambers produced imaginative marine paintings and landscapes that were often based on print sources. Rather than adhering strictly to the prints, he departed in quite original ways, employing a highly individual sense of design, a striking palette, and a bold, distinctive treatment of landscape and seascape features. Chambers relied particularly on the views produced by William H. Bartlett (1809–1854) for Nathaniel Parker Willis's *American Scenery* (London, 1840). He is also known to have used Asher B. Durand's (q.v.) and Jacques Gerard Milbert's prints for his landscapes. He based at least four views of George Washington's birthplace on one or more engravings after an oil painting by John Gadsby Chapman (1808–1889), and several of his paintings of naval battles during the War of 1812 are based on prints after the paintings of Thomas Birch (q.v.).

Although approximately seventy paintings have been attributed to Chambers, only five works are signed or dated. The painter first received attention in 1942, when the art dealers Norman Hirschl and Albert Duveen brought together eighteen works, including the Atheneum's *Niagara Falls*, all of which they attributed to "T. Chambers" based on one signed painting, in their exhibition "T. Chambers: First American Modern," held at the Macbeth Gallery in New York City. Since that time, many attributions have been made based on the few additional signed works that have surfaced and the limited knowledge of the artist's life.

SELECT BIBLIOGRAPHY

Nina Fletcher Little, "T. Chambers: Man or Myth ?" *Antiques* 53 (March 1948), 194–196 / Nina Fletcher Little, "Earliest Signed Picture by T. Chambers," *Antiques* 53 (April 1948), 285 / Nina Fletcher Little, "More About T. Chambers," *Antiques* 60 (November 1951), 469 / Howard S. Merritt, "Thomas Chambers—Artist," *New York History* 37 (April 1956), 212–222 / Howard S. Merritt, *The Genesee Country*, exh. cat. (Rochester, N.Y.: Memorial Art Gallery of the University of Rochester, 1976) / Beatrix T. Rumford, ed., *American Folk Paintings: Paintings and Drawings Other Than Portraits from*

the Abby Aldrich Rockefeller Folk Art Center (Boston: Little, Brown, with the Colonial Williamsburg Foundation, 1988), 19–21

97 (see plate 19)

THOMAS CHAMBERS
Niagara Falls, c. 1835
Oil on canvas; 22 × 30¹/₁₆ in. (55.9 × 76.4 cm)
EXHIBITED: New York City, Macbeth Gallery "T. Chambers, Active 1820–1840: First American Modern," 1942, no. 2 / New York City, Museum of Modern Art, "Romantic Painting in America," 1943–1944, no. 48 / Washington, D.C., Smithsonian Institution (traveling exhibition international tour) "American Primitive Painting," 1954–1956, no. 47 / Washington, D.C., Smithsonian Institution, "Brussels International Exhibition, Belgium, American Folk Art," 1958, no. 56 / Buffalo, N.Y., Albright-Knox Art Gallery, "Three Centuries of Niagara Falls: Oils, Watercolors, Drawings, and Prints," 1964, no. 21 / Washington, D.C., National Collection of Fine Arts, Smithsonian Institution, "American Landscape: A Changing Frontier," 1966 / Ann Arbor, University of Michigan Museum of Art, "Art and the Excited Spirit—America in the Romantic Period," 1972, no. 29 / Wadsworth Atheneum, "The Hudson River School: Nineteenth-Century American Landscapes in the Wadsworth Atheneum," 1976, no. 15 / Southbury, Conn., Pequot Library, "American Folk Art from Connecticut Collections," 1977 / Washington, D.C., The Corcoran Gallery of Art; Buffalo, N.Y., Albright-Knox Art Gallery; and New York City, New-York Historical Society, "Niagara: Two Centuries of Changing Attitudes, 1697–1901," 1985–1986, no. 43

EX COLL.: T. A. Larremore; with Arnold Seligmann, Rey and Co., New York City, by 1943

The Ella Gallup Sumner and Mary Catlin Sumner Collection Fund, 1943.99

Chambers's known landscapes tend to depict popular sites, many of American scenery, based on widely circulated prints of the day. His reliance on print sources indicates that he probably did not travel extensively. Chambers based the composition of *Niagara Falls* on a print by Isidore-Laurent Deroy after Jacques Milbert's *Niagara Falls from the American Side* (c. 1828, The New-York Historical Society), published in *Itinéraire pittoresque du fleuve Hudson et des parties latérales de l'Amérique du Nord* (Paris, 1828–1829).[1] The view was taken from Porter's stair tower, a wooden tower erected in 1818 by Augustus Porter, who owned much of the land on the American side of the falls.[2] Chambers altered the original by replacing the two minute figures of tourists seen in the print source with an overly large figure of an American frontiersman holding a rifle and gazing at the scene before him. In addition, he placed disproportionately large houses on the upper bank of the falls, to point up the settled regions that had sprung up near this popular tourist site. Finally, he adhered to his distinctively bold use of bright color and two-dimensional forms and included his distinctive treatment of foliage and sharp jutting tree forms, one of which emerges from the falls itself.

This work successfully incorporates Chambers's bold design and romantic vision of the American landscape. When it was acquired by the Wadsworth Atheneum, one year after its showing at the Macbeth Gallery, the museum's director, A. Everett Austin, Jr., who was a pioneer of modernism in all of its forms (see Introduction), wrote of this painting: "The boldly abstract patterns of this recently discovered American painter are highly exciting and 'modern' to contemporary eyes."[3] EMK

1. The print source for Chambers's *Niagara Falls* was first noted in Howard Merritt, "Thomas Chambers--Artist," *New York History* 37 (April 1956), 219. The print is reproduced in Jeremy Elwell Adamson, with Elizabeth McKinsey, Alfred Runte, and John F. Sears, *Niagara: Two Centuries of Changing Attitudes, 1697–1901*, exh. cat. (Washington, D.C.: Corcoran Gallery of Art, 1985), 34.
2. Adamson, *Niagara*, 35, 47.
3. A. Everett Austin, Jr., unpublished manuscript on the acquisitions made under his directorship, curatorial painting file, Wadsworth Atheneum.

98

ATTRIBUTED TO THOMAS CHAMBERS
Castles on the Rhine, c. 1840
Oil on canvas; 22 × 29¹⁵/₁₆ in. (55.9 × 76.0 cm)

98

EXHIBITED: Birmingham, Ala., Birmingham Museum of
Art, "Opening of the New Museum," 1951 / Hartford, Austin
Arts Center, Trinity College, "Nineteenth and Twentieth Cen-
tury Landscape Painting," 1966, no. 1

EX COLL.: with Arnold Seligmann, Rey and Co., New York
City, by 1944

The Ella Gallup Sumner and Mary Catlin Sumner Collection
Fund, 1944.36

The fanciful imaginary landscape *Castles on the
Rhine* was first attributed to Thomas Chambers by Ar-
nold Seligmann at the time of its sale to the Atheneum
in 1944. Chambers had only recently been discovered
with the 1941 exhibition of his works at the Macbeth
Gallery. This landscape is in keeping with the artist's
bold sense of design, high-key palette, distinctive treat-
ment of foliage, and fanciful architecture. The work
relates closely to a similar composition attributed to
Chambers, entitled *Baroque Landscape*, in the collec-
tion of the New York State Historical Association in
Cooperstown.[1] Both convey the romantic vision of the
landscape seen in other works by Chambers. EMK

1. Louis C. Jones and Agnes Halsey Jones, *New-Found Folk
Art of the Young Republic*, exh. cat. (Cooperstown: New
York Historical Association, 1960), no. 61.

William Merritt Chase

Born in Williamsburg, Ind., in 1849; died in New York
City, in 1916

Chase first studied with portrait painter Barton S.
Hays (1826–1914) in Indianapolis and then moved to
New York City in 1869 to continue his training with Jo-
seph Oriel Eaton (1829–1875), a genre and portrait
painter. He also took drawing classes at the National
Academy of Design, where he would exhibit his works
from 1871 through 1899. In 1871 Chase left New York
City to join his family in St. Louis, where he set up his
first professional studio, painting still lifes and portraits
there.

Supported by local businessmen and art patrons,
Chase went to Munich in 1872 to further his artistic
training. He enrolled in Munich's Royal Academy of the
Fine Arts, where he was joined by Frank Duveneck

(q.v.) and Walter Shirlaw (q.v.), with whom he developed close friendships. At the academy, he first studied with Alexander von Wagner (1838–1919) and then, in 1874, was selected to be a pupil of Karl Theodor von Piloty (1826–1886), a well-known painter of melodramatic historical scenes, the academy's most distinguished professor, and its director for two decades. At this time, Chase acquired the contemporary taste for the works of the old masters of the seventeenth and eighteenth centuries; this would affect his work throughout his career. Chase also admired and came under the influence of the work of Wilhelm Leibl (1844–1900), the young leader of the dominant German realist movement. In 1877 he went to Venice with John Twachtman (q.v.) and Duveneck for nine months; there, he studied the works of Tintoretto. Recognized for his talents and abilities, Chase was offered a teaching position at the Royal Academy, which he declined, returning to America in 1878.

Chase had established his reputation as an artist in America before returning from Munich; in 1876 he received a medal at the Philadelphia Centennial Exhibition and exhibited his works at the National Academy of Design. Arriving in New York City, he set up an elaborate studio at the Tenth Street Studio Building and began teaching at the newly formed Art Students League, remaining there until 1895. In 1878 he was elected a member of the new, avant-garde Society of American Artists, serving as president in 1880 and again from 1885 to 1895. He helped found the Society of Painters in Pastel in 1883 and in 1905 became a member of the independent exhibiting group, Ten American Painters. He became an associate member of the National Academy of Design in 1887 and an academician in 1890.

Chase quickly became one of the most admired and successful American artists, painting portraits, landscapes, and genre subjects with virtuosity in style and technique. He was also the most important teacher of his generation. In 1891 he began operating the Shinnecock Summer Art School on Long Island, New York, which lasted for twelve seasons and proved to be very popular and famous. In 1896 he opened the Chase School, later named the New York School of Art, in New York City. He also taught in Philadelphia, Brooklyn, Hart-

ford, and Chicago. From 1903 to 1913 he took students to Europe, visiting such countries as Holland, England, and Spain and such cities as Florence, Bruges, and Venice. He taught and inspired a diverse number of students who were to lead the new generation of artists, including Georgia O'Keeffe (q.v.), Joseph Stella, Arthur B. Carles (q.v.), Charles Demuth, and Rockwell Kent (q.v.).

SELECT BIBLIOGRAPHY

Katherine Metcalf Roof, *The Life and Art of William Merritt Chase*, introduction by Alice Gerson Chase (New York: Scribner's, 1917) / Abraham David Milgrome, "The Art of William Merritt Chase" (Ph. D. diss., University of Pittsburgh, 1969) / Michael Quick and Eberhard Ruhmer, *Munich and American Realism in the Nineteenth Century*, exh. cat. (Sacramento: E. B. Crocker Art Gallery, 1978) / Clarence David McCann, Jr., *The Ripening of American Art: Duveneck and Chase*, exh. cat. (Mobile, Ala.: Fine Arts Museum of the South at Mobile, 1979) / Ronald G. Pisano, *William Merritt Chase* (New York: Watson-Guptill, 1979) / Carolyn Kinder Carr, *William Merritt Chase: Portraits*, exh. cat. (Akron, Ohio: Akron Art Museum, 1982) / Ronald G. Pisano, *A Leading Spirit in American Art: William Merritt Chase, 1849–1916* (Seattle: Henry Art Gallery, University of Washington, 1983) / William H. Gerdts, *American Impressionism* (New York: Abbeville Press, 1984) / D. Scott Atkinson and Nicolai Cikovsky, Jr., *William Merritt Chase: Summers at Shinnecock, 1891–1902,* exh. cat. (Washington, D.C.: National Gallery of Art, 1987)

99 (see plate 20)

WILLIAM MERRITT CHASE
Boy Smoking (The Apprentice,) 1875
Oil on canvas; 37^{1}/$_{16}$ × 23 in. (94.1 × 58.4 cm)
Signed at upper left: Will M. Chase
Dated at upper right: Munchen 1875.

EXHIBITED: New York City, Society of American Artists Inaugural Exhibition, Kurtz Gallery, 1878, no. 57, as "Apprentice" / New York City, Lotus Club, 1878 / New York City, Metropolitan Museum of Art, "William M. Chase Memorial Exhibition," 1917, no. 3, as "The Apprentice" / San Francisco, M. H. deYoung Memorial Museum, 1935, no. 76 / Cleveland, The Cleveland Museum of Art, 1937 / Baltimore Museum of Art, "Deux Cents Ans de Peinture Américaine: Collection du Musée Wadsworth Atheneum," 1938, no. 11 / Indianapolis,

John Herron Art Institute, "William M. Chase Centennial Exhibition," 1949 / Southampton, L.I., N.Y., Parrish Art Museum, "William Merritt Chase—A Retrospective Exhibition," 1957, no. 6 / Raleigh, N.C., The North Carolina Museum of Art, "Tobacco and Smoking in Art," 1960, no. 20 / Hartford Art School, University of Hartford, "The Hartford Art School: The Early Years," 1978 / Seattle, Henry Art Gallery, University of Washington; New York City, Metropolitan Museum of Art, "William Merritt Chase Retrospective," 1983–1984, no. 31 / Paris, Galeries Lafayette, "Deux Cents Ans de Peinture Américaine: Collection du Musée Wadsworth Atheneum," 1989

EX COLL.: Noah Brooks in 1884; to Edwin Lefevre in 1917; with the Macbeth Gallery, New York City, by 1927

Purchased through the gift of James Junius Goodwin, 1927.169

During the late 1860s Munich attracted numerous American art students seeking an education from the leaders of realism in that city.[1] During this period a new generation of artists rejected pseudorealism and romanticism; the goals instead were strength of handling, straightforward painting, and the wish to reveal pure enjoyment of brushwork.[2] The period 1875–1878 witnessed the first powerful realism among American painters in which stylistic matters were more important than subject matter.[3]

Chase painted *Boy Smoking* in Munich while studying with Karl von Piloty during the most important years of his art education. Under von Piloty's guidance, the Royal Academy's teaching emphasized technique and realism that were derived largely from the Spanish Baroque masters, Rubens, Jusepe Ribera, Zurburan, and Diego Velázquez.[4] In *Boy Smoking* Chase used a murky, dark brown palette and bravura brushstroke to capture a lively and realistic portrayal of a self-assured working boy and his gritty attire. The artist applied the paint in loose strokes, giving the painting a spontaneity and evenness that brings out the inherent beauty of the work, in keeping with Wilhelm Leibl's realist philosophy.[5] Typical of the Munich artists, Chase sets the subject against a plain dark background in order to illuminate portions of the figure and to create volume. Chase furthers the illusion of a solid form through the careful use of a limited range of tonal values.[6] Although the bottom of the figure is lost to the enveloping dark-

ness, the inclusion of the earthenware jug provides the necessary balance to the composition. There is visible an outline of the red handkerchief that originally was to hang out over the subject's right lapel.

Boy Smoking is part of a series of paintings of young apprentice boys Chase and his colleagues Frank Duveneck (q.v.) and J. Frank Currier painted in order to practice and develop bravura brushstroke.[7] The models were used thematically in different ways. Chase and Duveneck painted a version of a boy dressed as a Turkish page (the idea was Chase's), the result being their most famous paintings of the series; Chase's *Unexpected Intrusion (The Turkish Page)* (c. 1876, Cincinnati Art Museum) and Duveneck's *Turkish Page* (1876, Pennsylvania Academy of Fine Arts).

The model Chase used in *Boy Smoking* was one he apparently employed in several other of his paintings, including *The Whistling Boy* (1875, Detroit Institute of Arts), *The Apprentice (Boy Eating an Apple)* (1876, private collection), and *Boy in A Fur Cap* (1875, Deerfield Academy, Deerfield, Mass.).[8] Duveneck also used this same model in several of his depictions of youth apprentices, including *He Lives by His Wits* (1878, private collection), which bears a marked similarity to Chase's *Boy Smoking*.[9] Chase's earlier version of another youth smoking, titled *The Leader*, relates most closely to *Boy Smoking* stylistically. There, too, Chase in loose brushwork depicts an overconfident boy posing and smoking a cigar. The subject in *The Leader* has his thumbs tucked into his leather apron. Although the cigar was intended as a prop, in both paintings the youth's air of confidence suggests that smoking was, in fact, a habit he pursued.

How popular *Boy Smoking* was in Munich remains unknown, but there is evidence that the American public and critics responded favorably when it was shown at the inaugural exhibition of the Society of American Artists in 1878. Clarence Cook, leading art critic for the *New York Tribune*, praised Chase's Munich works. He claimed that *Ready for a Ride* (1877, Union League Club, New York City) and *Boy Smoking* represented a new look, a new style free "from mannerism and individual tricks"; the two paintings "are never without their groups of admirers." Cook further expressed his wish

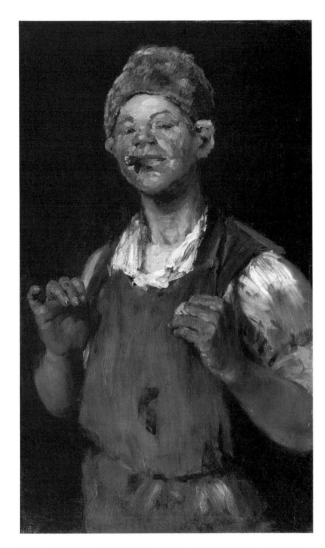

William M. Chase, *The Leader*, c. 1873. Addison Gallery of American Art, Phillips Academy, Andover, Massachusetts, gift of anonymous donor.

that the Society of American Artists would purchase the "Apprentice."[10] Critic Mariana G. Van Rensselaer found the spontaneous yet direct style of *Boy Smoking* refreshing: "I must only speak of a couple of portrait studies shown at [the Society of American Artists exhibition]. *The Apprentice* was the most striking of them. The handling was broad to excess and the canvas was full of life and 'go,'—aggressively so, if I may use such a word to make a strong contrast between this bit of intense, if unbeautiful reality, and the rapid discretion, the smooth nothingness, the sickly conventionality, of portrait studies to which our public has been most accustomed."[11] Van Rensselaer was a strong advocate for

younger artists who demonstrated technical virtuosity and ability in bravura brushwork.[12]

In *American Painters*, G. W. Sheldon discussed *Boy Smoking* (referred to as *Apprentice*) in the context of "high art." First explaining that "high art" was not considered popular art because its excellence was not obvious, Sheldon went on to state that Chase's *Apprentice* was an exception.[13] *Boy Smoking* remains one of the paintings most exemplary of Chase's Munich years. ERM

1. Clarence David McCann, Jr., *The Ripening of American Art: Duveneck and Chase*, exh. cat. (Mobile, Ala.: Fine Arts Museum of the South at Mobile, 1979), 14.
2. Robert Chapellier and Francis W. Bilodeau, *Frank Duveneck: 1848–1919*, exh. cat. (New York: Chapellier Gallery, 1972), n.p.
3. Michael Quick and Eberhard Ruhmer, *Munich and American Realism in the Nineteenth Century*, exh. cat. (Sacramento: E. B. Crocker Art Gallery, 1978), 31.
4. Ibid., 24, 31.
5. McCann, *Duveneck and Chase*, 15.
6. Quick and Ruhmer, *Munich and American Realism*, 31.
7. Ronald G. Pisano, *William Merritt Chase* (New York: Watson-Guptill, 1979), 20.
8. Ronald G. Pisano to Elizabeth McClintock, February 15, 1986, curatorial painting file, Wadsworth Atheneum.
9. Pisano, *William Merritt Chase*, 20, 84.
10. Clarence Cook, *New York Tribune* (March 16, 1878), quoted in Clara Erskine Clement and Laurence Hutton, *Artists of the Nineteenth Century and Their Works*, rev. ed. (1884; rpt., St. Louis: North Point, 1969), 1:133.
11. Mariana G. Van Rensselaer, "William Merritt Chase: First Article," *American Art Review* 2 (January 1881), 95.
12. Doreen Bolger Burke and Catherine Hoover Voorsanger, "The Hudson River School in Eclipse," in John K. Howat, ed., *American Paradise: The World of the Hudson River School*, exh. cat. (New York: Metropolitan Museum of Art, 1987), 76.
13. G. W. Sheldon, *American Painters*, rev. ed. (New York: D. Appleton, 1881), 158.

100 (see plate 21)

WILLIAM MERRITT CHASE

Portrait of a Woman, 1878

Oil on canvas; 26 1/8 × 15 7/16 in. (66.4 × 39.2 cm)

Signed at upper left: Wm. M. Chase Munich

Dated at upper right: 1878

EXHIBITED: Wadsworth Atheneum, "Gould Bequest of American Paintings," 1948 / Southampton, L.I., N.Y., Parrish Art Museum, "Retrospective Exhibition of Works of William Merritt Chase," 1957, no. 15 / Santa Barbara, Art Gallery, University of California; La Jolla, Art Center; San Francisco, California Palace of the Legion of Honor; Seattle Art Museum; and New York City, Gallery of Modern Art, "The First Retrospective West Coast Exhibition of Paintings by William Merritt Chase," 1964–1965, no. 3 / Worcester, Mass., Worcester Art Museum, "The American Portrait: From the Death of Stuart to the Rise of Sargent," 1973, no. 38 / Mobile, Ala., Fine Arts Museum of the South at Mobile, "The Ripening of American Art: Duveneck and Chase," 1979, no. 25 / Seattle, Henry Art Gallery, University of Washington, "William M. Chase Retrospective," 1983–1984 / Paris, Galeries Lafayette, "Deux Cents Ans de Peinture Américaine: Collection du Musée Wadsworth Atheneum," 1989

EX COLL.: to Clara Hinton Gould by 1948

Bequest of Clara Hinton Gould, 1948.209

Though Chase never studied directly with Wilhelm Leibl or joined his group (known as the *Leibl-Kreis*), he was influenced by his work and realist philosophy. Leibl, who became popular in 1870, reacted against drama and sentiment in paintings, seeking instead to attain an "artistic truth" or realism through technical excellence, with no attempt to flatter the subject.[1] Chase's admiration for the young German realist led him to purchase two of his works, one of which was Leibl's masterpiece *Kokotte (Die junge Pariserin)*. *Kokotte* provided Chase with a visual source of inspiration for one of his finest paintings, the Atheneum's *Portrait of a Woman*.[2] In both portraits, a young woman dressed in traditional seventeenth-century Dutch costume poses (Chase himself dressed and posed in this vintage clothing) for a three-quarter-length image. Like Leibl, Chase used a controlled balance of loose and tight brushwork and carefully rendered detail to capture the real effects of texture, skin tones, and lighting. Even the fingernails on the subject's right hand reflect the light. Reflecting his interest in the seventeenth-century old masters, Chase used a limited palette and placed the subject against a dark, undefined background that sets off the

whites of the collar and sleeves and the woman's carefully modeled face.

The tight brushwork and attention to detail in *Portrait of a Woman* differ from the loose, sketchy brushstroke that Chase used in *Boy Smoking* (cat. 99), painted three years earlier. However, both paintings directly resulted from Chase's study of the old masters and the impact of Munich realism. *Portrait of a Woman* reflects Chase's growing craftsmanship and his increasing skill in handling a variety of painting techniques, which he would continue to diversify throughout his career. ERM

1. Ronald G. Pisano, *A Leading Spirit in American Art: William Merritt Chase, 1849–1916* (Seattle: Henry Art Gallery, University of Washington, 1983), 27.
2. Michael Quick and Eberhard Ruhmer, *Munich and American Realism in the Nineteenth Century*, exh. cat. (Sacramento: E. B. Crocker Art Gallery, 1978), 21.

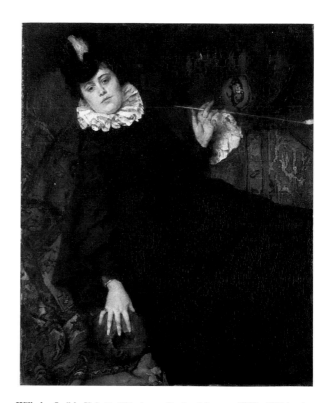

Wilhelm Leibl, *Kokotte (Die junge Pariserin)*, 1869. Wallraf-Richartz-Museum, Cologne.

101 (see plate 22)

WILLIAM MERRITT CHASE
Shinnecock Hills (A View of Shinnecock), 1891
Oil on wood; 17⅞ × 24 in. (45.4 × 61.0 cm)
Inscribed at lower left: Sketch made to ilustrate
 [*sic*] / one way to begin a study / Wm. M.
 Chase / Shinnecock Hills 1891

E X H I B I T E D : Wadsworth Atheneum, "The Spirit of Genius,"
1992

E X C O L L . : the artist's student, Caroline Demming Ostrom,
Long Island; to her son, John N. Ostrom, Jr., East Randolph,
L.I., N.Y.; purchased at "Important American Paintings,
Drawings, and Sculpture of the Eighteenth, Nineteenth, and
Twentieth Centuries," Christie's, New York City, November
30, 1990, lot 102, by the Wadsworth Atheneum

The Ella Gallup Sumner and Mary Catlin Sumner Collection
Fund and the Dorothy C. and Thomas L. Archibald Fund,
1990.60

As a virtuoso American artist who received exten-
sive European training in Munich and elsewhere in the
1870s, Chase devoted much of his later career to teach-
ing. Beginning in 1891, he taught the art of plein-air
painting to his students at a summer art school in Shin-
necock, a beach resort on eastern Long Island. In 1892
the Chase family moved into a summer house in Shinne-
cock, designed and built by the firm of McKim, Mead,
and White. Throughout the 1890s Chase painted the
gently rolling dunes, shimmering blue water, and cloud-
filled sky, in landscapes that are dotted with figures rep-
resenting members of his family. This series of Shinne-
cock pictures is considered to be his finest single
achievement and among the most beautiful impressionist
landscapes painted in America.[1]

Shinnecock Hills, a bold and direct sketch executed
during the first summer of Chase's classes on Long Is-
land, captures the artist's principles of outdoor painting.[2]
As one of the first—and one of the few—dated works
from his years at Shinnecock, it epitomizes the impor-
tance Chase placed on spontaneity. One imagines the
artist taking a wooden panel from under his arm, placing
it on an easel, and swiftly capturing in oil the beach

landscape of Shinnecock in his virtuoso manner while his
students looked on.[3] He expressed his belief in the pri-
macy of spontaneity to his students by saying, "The
successful picture ought to look as if it has been blown
on the canvas in one puff."[4] Chase described his method
as follows: "I carry a comfortable stool that can be
closed up in a small space, I never use an umbrella. I
want all the light I can get. When I have found the spot
I like, I set up my easel, and paint the picture on the
spot. I think that is the only way rightly to interpret na-
ture. . . . You must be right under the sky. You must
try to match your colors as nearly as you can to those
you see before you, and you must study the effects of
light and shade on nature's own hues and tints."[5] Chase
followed his own advice in this work, which he left in a
sketchy state that, he believed, would draw the viewer
into the composition, allowing him or her to participate
in its completion.[6] Chase frequently exhibited works de-
scribed as "Sketch," "Study" or "Unfinished Picture" as
his most important paintings, preferable to the highly
finished works of many of his contemporaries.[7]

This painting was a gift to, and descended in, the
family of one of the artist's students, Caroline Demming
Ostrom. Chase later painted a posthumous portrait of
Caroline Demming Ostrom.[8] EMK

1. Ronald G. Pisano, *A Leading Spirit in American Art: Wil-
 liam Merritt Chase*, exh. cat. (Seattle: Henry Art Gallery,
 University of Washington, 1983), 87–149; and D. Scott At-
 kinson and Nicolai Cikovsky, Jr., *William Merritt Chase:
 Summers at Shinnecock, 1891–1902*, exh. cat. (Washington,
 D.C.: National Gallery of Art, 1987).
2. Although Chase considered this work a sketch, his promi-
 nent signature indicates that he felt it to be a successful
 painting in its own right (Ronald G. Pisano to Christie's,
 New York City, October 12, 1990, curatorial painting file,
 Wadsworth Atheneum).
3. A number of photographs of the artist at work at Shinnecock
 are reproduced in Ronald G. Pisano and Alicia Grant Long-
 well, *Photographs from the William Merritt Chase Archives
 at the Parrish Art Museum* (Southampton, N.Y.: Parrish
 Art Museum, 1992), 28, 51.
4. Quoted in Ronald G. Pisano, *William Merritt Chase* (New
 York: Watson-Guptill, 1979), 74.
5. Quoted in Philip Poindexter, "A Foremost American
 Painter," *Leslie's Weekly* 80 (May 16, 1895), 319, quoted in
 Atkinson and Cikovsky, *William Merritt Chase*, 18.
6. Ronald G. Pisano, "William Merritt Chase Research Re-

port," for Christie's, October 11, 1990, curatorial painting file, Wadsworth Atheneum.

7. Ibid.

8. The portrait was sold at "American and Nineteenth-Century European Paintings, Drawings, Watercolors, and Sculpture," Christie's East, New York City, May 21, 1991, lot 568. The work was purportedly painted the year of Chase's death in 1916 and may not have been completed by him, as it does not reflect the artist's usual quality. Two letters discuss the commission for the portrait: Mr. Ostrom to William Merritt Chase, February 12, 1916, and William M. Chase to Mr. Ostrom, February 17, 1916, in which Chase writes: "Send me a copy of the photograph you have. . . . I remember your wife so well. I am sure I can make a satisfactory portrait of her for you and your son" (copies of letters in curatorial painting file, Wadsworth Atheneum).

Russell Cheney

Born in South Manchester, Conn., in 1888; died in Kittery, Maine, in 1945

Russell Cheney came from a prominent Connecticut family of artists and industrialists. His grandfather and three brothers established the Cheney silk mills in Manchester in the early nineteenth century. His two great-uncles, Seth Wells Cheney (1810–1856) and John Cheney (1801–1885), were painters and notable steel engravers.

After graduating from Yale University in 1904, Cheney studied at the Art Students League in New York City for three years, under William Merritt Chase (q.v.), Kenyon Cox (1856–1919), and Charles H. Woodbury (1864–1940). He journeyed to Paris in 1907, where he spent another three years of study at the Académie Julian under Jean Paul Laurens. Returning to the United States in 1910, Cheney was elected president of the Art Students League in 1912 and began spending his summers at Ogunquit, Maine, painting with Charles Woodbury, with whom he had become close. (Woodbury ran a summer school at Ogunquit from 1899 to 1917 and from 1924 to 1939.)

Throughout the course of his career, Cheney divided his time between Europe and the United States, painting in Italy, France, California, New Mexico, and his native New England. In his later years, Cheney settled in Kittery, Maine, painting local scenes for the last fifteen years of his life. There, Cheney shared a long relationship with F. O. Matthiessen, professor of English at Harvard University and noted author of *American Renaissance* (1941), much of which was written in Kittery. Matthiessen wrote a monograph on Cheney, published a year after the artist's death, for a memorial exhibition held at the Wadsworth Atheneum and the Ferargil Gallery in 1946–1947.

SELECT BIBLIOGRAPHY

Charles Henry Pope, *Cheney Family Genealogy* (Boston, 1897) / Herbert H. Manchester, *The Story of Silk and Cheney Silks* (South Manchester, Conn.: Cheney Brothers, 1916) / Christian Brinton, *Paintings by Russell Cheney*, exh. cat. (New York: Babcock Galleries; Hartford: Wadsworth Atheneum, 1922) / F. O. Matthiessen, *Russell Cheney, 1881–1945: A Record of His Work* (Andover, Mass.: Andover Press, 1946) / Louis Hyde, ed., *Rat and Devil: Journal Letters of F. O. Matthiessen and Russell Cheney* (Hamden, Conn.: Anchor, 1978)

102

RUSSELL CHENEY

Skungimaug—Morning, c. 1922

Oil on canvas; 39½ × 49¾ in. (100.3 × 126.4 cm)

EXHIBITED: New York City, Babcock Galleries, and Wadsworth Atheneum, "Paintings by Russell Cheney," 1922, no. 3 / New York City, Ferargil Gallery, and Wadsworth Atheneum, "Memorial Exhibition of Russell Cheney Paintings," 1946–1947, no. 4

EX COLL.: the artist's brothers, Philip and Clifford D. Cheney, by 1922

Gift of Philip and Clifford D. Cheney in memory of their mother, Ednah Dow Cheney, 1922.401

Russell Cheney frequently returned to his home in Manchester, Connecticut, where he spent time painting in the studio his family kept for him there. It was on one of these return trips, during the early years of the 1920s, that the artist painted *Skungimaug—Morning*. The scene depicts the Skungimaug Brook located near South Manchester.[1] EMK

1. F. O. Matthiessen, *Russell Cheney, 1881–1945: A Record of His Work* (Andover, Mass.: Andover Press, 1946), 17.

102

103

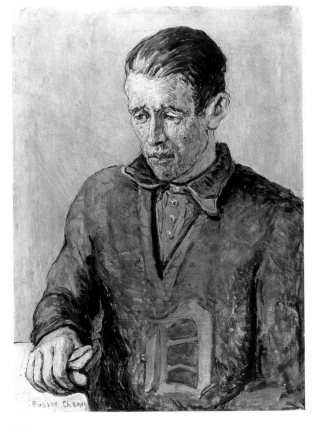

103

RUSSELL CHENEY

Portrait of Paul Hoen, 1930

Oil on canvas; 24 × 18 in. (61.0 × 45.7 cm)

Signed at lower left: Russell Cheney

Inscribed on back stretcher: Paul Hoen—by his friend
 Russell Cheney—Santa Fe 1930

EXHIBITED: New York City, Montross Gallery, "Russell
Cheney, Exhibition of Paintings," 1930, no. 12 / New York City,
Ferargil Gallery, and Wadsworth Atheneum, "Memorial Exhibi-
tion of Russell Cheney Paintings," 1946–1947, no. 13

EX COLL.: descended to Ward Cheney by 1950

Gift of Ward Cheney, 1950.522

Cheney spent the summer and fall of 1929 in Santa
Fe, New Mexico, where he encountered two brothers,
Paul and Fred Hoen, who ran a small garage and store.
While having his car worked on by the Hoens, Cheney
decided to paint their portraits. The artist's journal re-
cords his "scheme for painting" Paul: "A sort of overall
stuff jacket he wears and some kind of auto tool in his
hand. It is very 'primitive' of course, but seems to fit,
and will make a striking contrast to the quivering sensi-
tive quality of his face."[1] EMK

1. F. O. Matthiessen, *Russell Cheney, 1881–1945: A Record of
 His Work* (Andover, Mass.: Andover Press, 1946), 87. For a
 reproduction of the portrait of Fred Hoen, see ibid., 85.

104

104

RUSSELL CHENEY
Dahlias in Kittery, c. 1932
Oil on canvas; 36 × 28⅛ in. (91.4 × 71.4 cm)

EXHIBITED: New York City, Montross Gallery, "Russell Cheney, Exhibition of Paintings," 1932, no. 8

EX COLL.: descended to Ward Cheney by 1950

Gift of Ward Cheney, 1950.523

105

RUSSELL CHENEY
Portsmouth Factory, 1935
Oil on canvas; 24¼ × 37⅞ in. (61.6 × 96.2 cm)
Signed at lower right: Russell Cheney
Inscribed on back stretcher: Atlantic [] Co.—Russell / Cheney—Kittery / Maine

EXHIBITED: New York City, Ferargil Gallery, and Wadsworth Atheneum, "Memorial Exhibition of Russell Cheney Paintings," 1946–1947, no. 18

EX COLL.: artist's estate; bequeathed to Dr. Francis O. Matthiessen, Boston and Kittery, Maine, in 1945

Gift of Dr. F. O. Matthiessen, 1947.229

Cheney painted *Portsmouth Factory* after he had settled permanently in Kittery, Maine. The nearby town of Portsmouth, New Hampshire, provided scenes for many of Cheney's paintings during these years. In this particular view of a Portsmouth factory building, the artist "caught the grimness that he often felt during the depression years."[1] EMK

1. F. O. Matthiessen, *Russell Cheney, 1881–1945: A Record of His Work* (Andover, Mass.: Andover Press, 1946), 105.

106

RUSSELL CHENEY
Macaws, 1936
Oil on canvas; 36⅛ × 29⅛ in. (91.8 × 74.0 cm)
Signed at lower left: Russell Cheney
Inscribed on back stretcher: Macaws

EX COLL.: descended to Ward Cheney by 1950

Gift of Ward Cheney, 1950.521 EMK

105

106

107

RUSSELL CHENEY

Kittery Foreside, c. 1936

Oil on canvas; 20⅛ × 30 in. (51.1 × 76.2 cm)

Technical note: The poor condition of this work does not allow it to be illustrated.

EX COLL.: descended to Ward Cheney by 1950

Gift of Ward Cheney, 1950.525 EMK

108

RUSSELL CHENEY

Back of the North Church, Portsmouth, N.H., 1936

Oil on canvas; 24 × 36¼ in. (61.0 × 92.1 cm)

EX COLL.: descended to Ward Cheney by 1950

Gift of Ward Cheney, 1950.524 EMK

108

Frederic Church

Born in Hartford, in 1826; died in New York City, in 1900

The only surviving son of Joseph Edward (1793–1876) and Eliza Janes Church (1796–1883), Frederic Edwin Church had two sisters, Elizabeth Mary (1824–1886) and Charlotte Eliza (1832–1862). A successful businessman, jeweler, and silversmith, Joseph Church served on the board of several Hartford banks and an insurance company. A neighbor of Daniel Wadsworth (q.v.), he was one of the original subscribers of the Wadsworth Atheneum in 1841 and served on a committee to raise additional funds for the Atheneum building in 1842 (Record Book, Archive, Wadsworth Atheneum).

As a young man in Hartford, Frederic received artistic instruction from Alexander Hamilton Emmons (1816–1884) for six months in 1842 and from Benjamin Hutchins Coe (1799–after 1883). Although his father would have preferred that his son pursue a career in business, he allowed Daniel Wadsworth to arrange an apprenticeship for him with Thomas Cole (q.v.). (Church was to be Cole's most illustrious pupil.) On May 8, 1844, Wadsworth wrote his long-time friend Cole with the following request:

> Joseph Church, Esq. a gentleman of respectability of this town has a son between seventeen and eighteen years of age, who has evinced considerable talent for landscape painting & who has a strong desire to pur-

sue the art. . . . The young gentleman has received a good education and has considerable mechanical genius. His personal appearance and manners are prepossessing. Will it be convenient and agreeable to you to receive him into your family as a pupil . . . and give him the advantage of your instruction. His father will acquiesce in any terms you may require. . . . I think the young gentleman both worthy and amiable. . . . Young Mr Church has practiced considerably in oil and with some success by himself without instruction. (J. Bard McNulty, ed., *The Correspondence of Thomas Cole and Daniel Wadsworth* [Hartford: Connecticut Historical Society, 1983], 74)

Young Church had by this time been exposed to Wadsworth's impressive private art collection, containing works by leading American artists such as John Trumbull (q.v.), Alvan Fisher (q.v.), Thomas Sully (q.v.), and, of greatest import, Thomas Cole. And Church was certainly aware of Wadsworth's accomplishments as an amateur artist and likely viewed the large assortment of Wadsworth's landscape drawings and engravings after them.

At Cole's studio in Catskill, New York, from 1844 to 1846, Church mastered his teacher's methods of sketching outdoors, developed a love of nature, and adopted Cole's heroic style of landscape painting. Aware of the genius of his young student, Cole noted that Church had "the finest eye for drawing in the world" (Louis Legrand Noble, *The Life and Works of Thomas Cole*, ed. Elliot S. Vesell [1853; rpt., Cambridge: Harvard University Press, Belknap Press, 1964], 272).

In 1846 Church returned briefly to Hartford but soon moved on to New York City. He completed his first major works in 1846 and 1847, in the "higher style of landscape" (Cole to Robert Gilmor, May 21, 1828, quoted in Noble, *The Life and Works of Thomas Cole*, 64) advocated by Cole, for exhibition at the National Academy of Design. His 1846 *Hooker and Company Journeying through the Wilderness from Plymouth to Hartford, in 1636* (cat. 111), among other works, established his reputation as one of America's leading young artists.

By the fall of 1847 Church had set up a studio in the Art-Union Building in New York City; he was elected to the National Academy of Design in the following year, becoming its youngest associate. With the sudden death of Cole in 1848, Church became his mentor's successor: the leader of the national school of landscape. Although Cole's teachings would remain central to Church's art, by the early 1850s a variety of influences allowed the artist to forge his own manner. The works of the English artists John Martin and James Mallord William Turner and the writings of the English critic John Ruskin, as well as those of the German naturalist-explorer Alexander von Humboldt, affected the development of Church's mature style.

In 1853, following the scientific writings and explorations of Humboldt, Church became the first American artist to paint on location in South America. He continued to paint North American landscapes but returned to South America in 1857, traveling to Ecuador accompanied by the landscape painter Louis Remy Mignot (1831–1870). In the oil paintings resulting from these expeditions, Church attempted to produce works that were both scientifically accurate and spiritually uplifting.

In the succeeding years Church produced a series of masterpieces of North and South American subjects. The first, and perhaps most acclaimed, was *Niagara* (1857, Corcoran Gallery of Art, Washington, D.C.; figure at cat. 114), created in the studio based on numerous pencil sketches and oil studies taken on-site—by then a standard procedure for the artist. Following the public exhibition of this painting in New York City and London, Church became America's most famous artist. Two years later, he achieved a second triumph with *Heart of the Andes* (1859, Metropolitan Museum of Art), his greatest summary of the tropics, which was exhibited at the Tenth Street Studio Building, then Church's artistic headquarters. Dramatically presented in a cloth-draped black-walnut frame, the canvas bathed in natural light, with exotic palms in nearby pots adding further to the experience, each area of the extraordinarily detailed canvas could be scrutinized by the public through a magnifying glass.

Church made trips to Labrador in 1859 to prepare for his enormous painting *Icebergs* (1861, Dallas Museum of Fine Arts), as well as sketching trips to Jamaica in 1865, which resulted in such masterworks as *Vale of St. Thomas, Jamaica* (cat. 116), and to Europe and the Near East in 1867 to 1868. Like *Heart of the Andes*, the major works that resulted from these trips were intended as composites of botanical, geological, and meteorological renditions of landscape as well as poetic and spiritual impressions of the exotic locales the artist visited.

By 1870 Church, whose reputation had suffered attack in the post–Civil War era, became preoccupied with the creation of Olana, his architecturally eclectic mansion designed by the architect Calvert Vaux. Situated on a mountaintop near Hudson, New York, the house overlooked the Hudson River, facing Cole's earlier studio on the opposite bank and his beloved Catskill scenery to the south. Inspired by his travels in the Near East, Church and his wife, Isabel Carnes Church (whom he married in 1860), filled the house with exotic furnishings and bric-a-brac, as well as with a wide-ranging collection of paintings. A fusion of Persian and Moorish styles, the house became a retreat in which to raise his family.

Despite the declining interest in Hudson River school paintings resulting from the influx of European art and styles, Church continued to exhibit major works; for instance, *The Parthenon* (1871, Metropolitan Museum of Art) and *Morning in the Tropics* (1877, National Gallery of Art, Washington, D.C.) were shown at the Exposition Universelle in Paris in 1878. Church was also involved in the cultural activities of New York City, including serving as a founder of the Metropolitan Museum of Art in 1870.

By the final decades of the century, however, Church's activity was curtailed by failing health—he had begun to suffer from the effects of degenerative rheumatoid arthritis in 1864—and the decline in interest in the Hudson River school. With the exception of trips to Mexico, where he began wintering in 1882, he spent most of his time at Olana. He died at the age of seventy-three in New York City at the home of his friend and patron William H. Osborn. He was buried next to his wife, two of his children, and parents in Spring Grove Cemetery, Hartford.

SELECT BIBLIOGRAPHY

Frederic Edwin Church Archives, Olana State Historic Site, Hudson, N.Y. / David C. Huntington, *The Landscapes of Frederic Edwin Church: Vision of an American Era* (New York: Braziller, 1966) / Theodore E. Stebbins, Jr., *Close Observation: Selected Oil Sketches by Frederic E. Church*, exh. cat. (New York: Cooper-Hewitt Museum; Washington, D.C.: Smithsonian Institution Press, 1978) / Gerald L. Carr, *Frederic Edwin Church: The Icebergs*, exh. cat. (Dallas: Dallas Art Museum, 1980) / Katherine Manthorne, Richard S. Fiske, and Elizabeth Nielson, *Creation and Renewal: Views of 'Cotopaxi' by Frederic Edwin Church*, exh. cat. (Washington, D.C.: National Museum of American Art, 1985) / Kevin J. Avery, "'The Heart of the Andes' Exhibited: Frederic E. Church's Window on the Equatorial World," *American Art Journal* 18, no. 1 (1986), 52–72 / Christopher Kent Wilson, "The Landscape of Democracy: Frederic Church's 'West Rock, New Haven,'" *American Art Journal* 18, no. 1 (1986), 20–39 / Franklin Kelly and Gerald L. Carr, *The Early Landscapes of Frederic Edwin Church, 1845–1854*, exh. cat. (Fort Worth, Tex.: Amon Carter Museum, 1987) / Franklin Kelly, *Frederic Edwin Church and the National Landscape* (Washington, D.C., and London: Smithsonian Institution Press, 1988) / Franklin Kelly, with Stephen Jay Gould, James Anthony Ryan, and Debora Rindge, *Frederic Edwin Church*, exh. cat. (Washington, D.C.: National Gallery of Art, 1989) / Gerald L. Carr, *Frederic Edwin Church: Catalogue Raisonné of Works of Art at Olana State Historic Site*, 2 vols. (New York: Cambridge University Press, 1994)

109

FREDERIC E. CHURCH

View of Quebec, 1846

Oil on canvas; 22³/₁₆ × 30³/₁₆ in. (56.4 × 76.7 cm)

Signed and dated at lower left: F. Church / 10 / 1846

EXHIBITED: Wadsworth Atheneum, "The Hudson River School: Nineteenth-Century American Landscapes in the Wadsworth Atheneum," 1976, no. 20

EX COLL.: with the artist in 1846

Source unknown, 1850.8

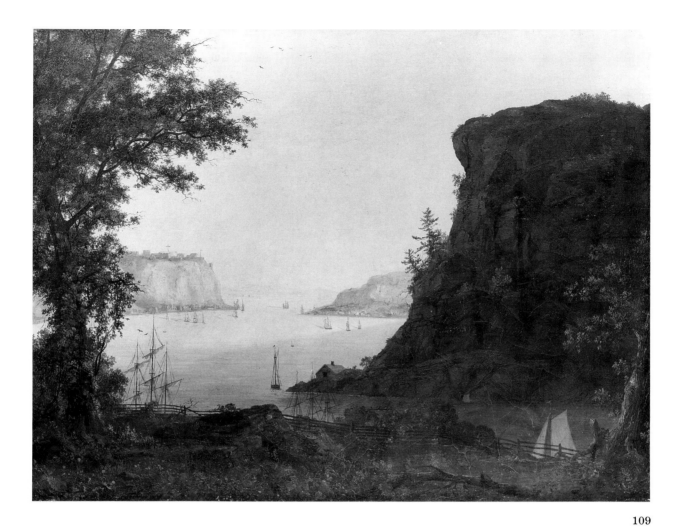

109

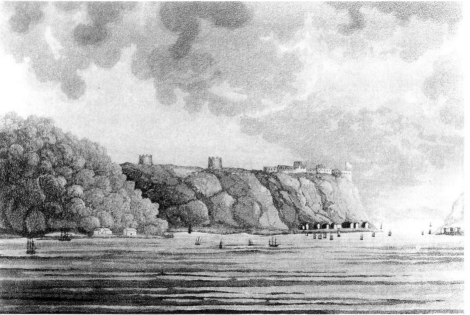

Simeon Smith Jocelyn, engraving after Daniel Wadsworth, *Quebec from the Chaudière, Setting Sun*, from Benjamin Silliman, *Remarks Made, on a Short Tour, between Hartford and Quebec* (1820).

Church painted *View of Quebec* in 1846, possibly while in his native city of Hartford. (After two years of instruction with Thomas Cole, he had taken up residence in Hartford, there briefly setting up his studio; however, by the fall of that year he had left home for New York City.)[1] The landscape is based on an engraving by Simeon Smith Jocelyn (1799–1879) after at least three drawings (Wadsworth Atheneum) by Daniel Wadsworth.[2] The engraving appears as plate 9, *Quebec from the Chaudière, Setting Sun* in Benjamin Silliman's *Remarks Made, on a Short Tour, between Hartford and Quebec in the Autumn of 1819,* published in 1820.[3]

Daniel Wadsworth and Benjamin Silliman set off on a five-week tour of upstate New York and the cities of Montreal and Quebec in the fall of 1819. The trip was made at Wadsworth's suggestion, stemming from his concern for his friend's mental state.[4] During the journey, Wadsworth sketched and painted in watercolors on small cards, taking a number of views of Quebec (Wadsworth Atheneum), while Silliman kept notes on the geology and mineralogy of the region. Church would have easily had access to Wadsworth's sketches as well as Silliman's book while in Hartford, certainly from Wadsworth's library.

In his landscape, Church followed the engraved model faithfully, depicting Quebec to the left, built on Cape Diamond; in the distance on the right is Point Levi, with the hills around Montmorency beyond. The artist did, however, enhance the picturesque aspect of the scene by heightening the contrast of light and shadow. Church consulted Silliman's description of the scene recorded by Wadsworth: "This scene, which we thought not to be exceeded in beauty by anything that we saw in Canada, was sketched from the left bank of the Chaudière river, at its mouth. . . . It was seen by the mildest, softest light, of an Indian summer afternoon—not more than two hours before sun-setting; and there was a mellowness in the tints . . . which . . . excited still stronger perceptions of beauty. These impressions were heightened by contrast, with the deep black gulf, immediately below the observer."[5] Church interpreted the notations of color and light made by Silliman and followed the compositional forms recorded

by Wadsworth, enhancing the picturesque qualities of the landscape by rendering the rocks in greater detail and adding foliage at the lower left.

At the time Church executed this work, the region was of historic significance to many Americans as the site of the death of General James Wolfe in 1759 following his victorious battle with the French army, an important moment in pre-Revolutionary history made famous by Benjamin West's *Death of General Wolfe* (1770, National Gallery of Canada, Ottawa).[6] The scene also may have held historical significance as the site of the death of General Richard Montgomery in the attack on Quebec, an event made famous by John Trumbull's *Death of General Montgomery in the Attack on Quebec* (1834), which hung in the Wadsworth Atheneum beginning in 1844 (cat. 454).

Although the provenance of this work remains unknown, it was on view in the Atheneum gallery by 1850, where it hung with Church's *Rapids of the Susquehanna* (cat. 110), a painting that also held historic associations, and with his first major historical landscape, *Hooker and Company* (cat. 111).[7] All three paintings retain their original matching frames, dating from about 1850. Although the landscape is not listed in either Wadsworth's probate inventory or his will, it is possible that Church painted the landscape at Wadsworth's suggestion or for the museum gallery. Of interest is the fact that Church's signature for this work is followed by the numeral *10* and then the date *1846*. This manner of signing his work is also seen on his painting of the same year *Hooker and Company.* The significance of this numbering system may indicate the month when the work was completed, in this instance, October. EMK

1. When Church exhibited *Hooker and Company* (cat. 111) at the National Academy of Design in 1846, the catalogue gave his address as Hartford, as it did again in 1847. See Mary Bartlett Cowdrey, ed., *National Academy of Design Exhibition Record, 1826–1860* (New York: New-York Historical Society, 1943), 1:80.
2. David Huntington first discovered the source for Church's landscape. See David C. Huntington to Charles Cunningham, May 15, 1957, curatorial painting file, Wadsworth Atheneum.
3. See Benjamin Silliman, *Remarks Made, on a Short Tour, be-*

tween Hartford and Quebec (New Haven: S. Converse, 1820), ill. opp. 252. Silliman later published an abbreviated edition, *A Tour to Quebec in the Autumn of 1819* (London: Sir Richard Phillips, 1822), but the engraving does not appear in this edition.

4. Chandos Michael Brown, *Benjamin Silliman: A Life in the Young Republic* (New Jersey: Princeton University Press, 1989), 320.

5. Silliman, *Remarks Made*, 252–253.

6. See Matthew Baigell, "Frederic Church's 'Hooker and Company': Some Historic Considerations," *Arts Magazine* 56 (January 1982), 125.

7. *Catalogue of Paintings in Wadsworth Gallery, Hartford* (Hartford: E. Gleason, 1850); and *Catalogue of Paintings Now Exhibiting in the Wadsworth Gallery* (Hartford: Case, Lockwood, 1863).

110

FREDERIC E. CHURCH

Rapids of the Susquehanna, c. 1846

Oil on canvas; 22¼ × 30³/₁₆ in. (56.5 × 76.7 cm)

EXHIBITED: Wadsworth Atheneum, "The Hudson River School: Nineteenth-Century American Landscapes in the Wadsworth Atheneum," 1976, no. 20a / Binghamton, N.Y., Roberson Center for the Arts and Sciences, "Susquehanna: Images of the Settled Landscape," 1981, no. 15

EX COLL.: with the artist, Hartford, in 1846; acquired by the Wadsworth Atheneum by 1850

Source unknown, 1863.8

Church executed *Rapids of the Susquehanna* while under the direct apprenticeship of Thomas Cole (q.v.), whose influence was pervasive in the artist's earliest works. Although it has been suggested that this work is based on an engraving, none has been found.[1] The landscape appears to be based on an undated drawing by Daniel Wadsworth entitled *Ferry at Columbia—Pens on the Susquehanna*[2] and was likely done at the same time as Church's *View of Quebec* (cat. 109) of 1846, which was also based on one or more drawings by Wadsworth or on engravings after them.

Church greatly enhanced the dramatic effects of Wadsworth's scene. On the shoreline in the foreground he includes the lone figure of a man who looks out to-ward the tiny ferry carrying a horse-drawn carriage, which appears to be at the mercy of the fast-moving white-water rapids. A line of birds flying between the shore and the raft further enhances the perspective. The atmospheric effects of the stormy dark clouds overhead—reminiscent of those found in works by his teacher, Thomas Cole (q.v.)—complete the scene, adding to the theatrical effect. The meticulous rendering of the foliage, however, is representative of Church's developing style.

Beginning in 1799 Wadsworth began taking small, topographical sketches of scenery he encountered on his travels throughout North America. All are nearly identical in size and similar in style. Wadsworth faithfully recorded his observations of the sites he visited, which he then carefully inscribed on the backs of his sketches, along with the title, often a date, and his signature.[3] It is likely that he allowed the young Church to view his sketches. It is also possible that Church executed this work at the suggestion of Wadsworth, although it does not appear in Wadsworth's probate inventory or will. Another possibility is that it was done for the new Wadsworth Atheneum gallery, which opened to the public in 1844 through the generous contributions of the Hartford subscribers, including Joseph Church, the artist's father. This painting was on view in the Atheneum gallery by 1850 and hung with Church's *View of Quebec* (cat. 109) and *Hooker and Company* (cat. 111).

In all three works, Church treated subjects of historical significance that deal with the colonial history of America. *Rapids of the Susquehanna* depicts a region with historic associations for Connecticut citizens, particularly those who participated in the long battle with Pennsylvania settlers in the Wyoming Valley over land claims dating back to the seventeenth century. The conflict began with the first attempt at a permanent settlement by inhabitants from Connecticut in 1769 at Forty Fort, which led to the Pennamite Wars, followed by the Wyoming Massacre of 1778, and was finally settled by the Compromise Act of 1799. This act secured a means of legal settlement for Connecticut claimants who created a flourishing settlement in the valley in the first decades of the nineteenth century.[4] In his landscape, Church, following Wadsworth's drawing, depicted the

110

Daniel Wadsworth, *Ferry at Co-
lumbia*. Wadsworth Atheneum,
William A. Healy Fund. Photo-
graph: David Stansbury.

CATALOGUE NUMBER 111

point where the ferry crossed the Susquehanna River in Columbia County, a short distance southeast of the earliest Connecticut settlement at Forty Fort. EMK

1. Theodore E. Stebbins, Jr., *The Hudson River School: Nineteenth-Century American Landscapes in the Wadsworth Atheneum* (Hartford: Wadsworth Atheneum, 1976), 41; and Roger Stein, *Susquehanna: Images of the Settled Landscape*, exh. cat. (Binghamton, N.Y.: Roberson Center for the Arts and Sciences, 1981), 51.
2. Richard Saunders, with Helen Raye, *Daniel Wadsworth: Patron of the Arts* (Hartford: Wadsworth Atheneum, 1981), 104–105.
3. For a discussion of Wadsworth's efforts as an amateur landscape artist, see Saunders, with Raye, *Daniel Wadsworth*, 14–15, 27. Thomas Cole used one of Wadsworth's drawings as the basis for his *View in the White Mountains* (cat. 124).
4. Stein, *Susquehanna*, 18–20.

111 (see plate 23)

FREDERIC E. CHURCH

Hooker and Company Journeying through the Wilderness from Plymouth to Hartford, in 1636, 1846

Oil on canvas; 40¼ × 60³⁄₁₆ in. (102.2 × 152.9 cm)

Signed and dated at lower left: F. Church / 8 / 1846

EXHIBITED: New York City, National Academy of Design, "Annual Exhibition," 1846, no. 114, as "Hooker and Company Journeying through the Wilderness from Plymouth to Hartford, in 1636" / Frankfurt, Munich, and Hamburg, American Federation of Arts Traveling Exhibition, "Nineteenth-Century American Painting Exhibition for Germany," 1953 / Washington, D.C., National Collection of Fine Arts, Smithsonian Institution, "Frederic Edwin Church," 1966, no. 142 / Allentown, Pa., Allentown Art Museum, "Sketches by Frederic Edwin Church," 1967 / Wadsworth Atheneum, "The Hudson River School: Nineteenth-Century American Landscapes in the Wadsworth Atheneum," 1976, no. 19 / Fort Worth, Tex., Amon Carter Museum, "The Early Landscapes of Frederic Edwin Church," 1984, no. 2 / Washington, D.C., National Gallery of Art, "Frederic Edwin Church," 1989, no. 1 / Wadsworth Atheneum, "The Spirit of Genius," 1992

EX COLL.: purchased by the Wadsworth Atheneum in 1846 from the artist

Museum purchase, 1850.9

After completing nearly two years of study with Thomas Cole (q.v.) in his Catskill, New York, studio from 1844 to 1846, Church returned briefly to his native Hartford. There, he painted his first ambitious landscape composition, following Cole's precept to paint the "higher style of landscape."[1] The work was exhibited in the spring of 1846 at the National Academy of Design with the title listed here.[2]

The large size of this work and its ambitious subject clearly made it one of the most important works in the artist's early career (he was twenty when he painted it). The subject, a heroic event drawn from colonial history, was probably suggested by Cole, who himself had included it on a working list of possible subjects as no. 74, "The migration of the settlers from Massachusetts to Connecticut—through the wilderness—see Trumbull's history of Connecticut—history of the U.S."[3] This was a natural subject for Church, a native of Hartford and sixth-generation Connecticut Yankee whose ancestor Richard Church had been a member of Hooker's party.

Thomas Hooker, a free-thinking Puritan preacher, arrived in Massachusetts in 1633 and was elected pastor of the Newtown parish. In May 1636 he led a band of members of his congregation through the wilderness from Newtown (now Cambridge) to found an independent settlement in Hartford.[4] Taking Cole's suggestion, Church may well have consulted Trumbull's history of Connecticut (readily available to him while in Hartford), which contained a detailed description of the historic event, providing the necessary information on which to base his painting:

> About the beginning of June, Mr. Hooker, Mr. Stone, and about a hundred men, women and children, took their departure from Cambridge, and travelled more than a hundred miles through a hideous and trackless way over mountains, through swamps, thickets and rivers, which were not passable but with great difficulty. They had no cover but the heavens, nor any lodgings but those which simple nature afforded them. They drove with them a hundred and sixty head of cattle, and by the way, subsisted on the milk of their cows. Mrs. Hooker was

borne through the wilderness upon a litter. The people generally carried their packs, arms and some utensils. They were nearly a fortnight on their journey.[5]

Church recreated the scene with historical veracity but allowed the party to travel on a sunlit path, unopposed by the "hideous and trackless" wilderness described by Trumbull. He did, however, make reference to the wilderness in the foreground details of gnarled branches, roots, which assume anthropomorphic forms, and rocks, which are placed in shadow. A large profile of a human face is seen in the rock at the far right, similar to those found in Cole's art (cat. 123). The party passes the calm river before them and in the distance sunlight illuminates the Connecticut River valley; the stylized rays of sunlight are symbolic of divine light.[6] Further evidence of Church's care in maintaining historic accuracy is seen in the period costumes of the figures, which his sister assisted in researching.[7]

In light of the artist's desire for historical accuracy and divine symbolism, his title, *Hooker and Company Journeying through the Wilderness from Plymouth to Hartford in 1636,* which is factually inaccurate (Hooker left from Newtown, not Plymouth), may have been intended to carry a larger meaning. Church wanted his audience to grasp the theme of Manifest Destiny, relating the first arrival of the Pilgrims in Plymouth to the settlement of Hartford, a theme of national significance.[8] When this painting was presented to the American public in the 1840s, the legend had achieved epic proportions "as an archetypal American experience embodying religious principles, moral courage, and the drive to settle the vast unexplored reaches of the country."[9] Like Cole, Church used human and spiritual drama to define the landscape; the figures evoke the flight of the Holy Family. The brilliant light that illumines the party's passage through the wilderness completes the allegory of divine providence at work in the Connecticut valley. The painting is one of the earliest representations of western expansion.

This historical landscape became the first of a thematic triptych in which the artist explored the roots of American democracy as manifested in the landscape and history of Connecticut.[10] (The second work is *The Charter Oak* [1847, Olana State Historic Site, Hudson, New York]—of which there is a second version, *The Charter Oak, at Hartford*—and the third is *West Rock, New Haven* [1849, New Britain Art Museum].)[11] Although the others represent contemporary views of historic sites, *Hooker and Company* represents the actual historical event. In this painting, Church portrays the Charter Oak from the view opposite to that seen in *The Charter Oak.*[12] It appears at the left middle ground, with Hooker pointing toward it.

Hooker and Company was the artist's first work to be acquired by a museum and his first documented sale. After its presentation at the National Academy of Design in the spring, Church wrote to Cole the following fall, October 17, 1846, "Some of the gentlemen connected with the Wadsworth Gallery are trying to purchase my Hooker picture. This I have improved by glazing, etc."[13] The painting was purchased by the newly opened Wadsworth Atheneum in 1846 for $130.[14] The fact that Church took the work back to "improve" it may explain the numeral 8 that appears in the artist's signature, indicating the month of its final completion as August (cat. 109).

This work was later used as the source for an engraved frontispiece for W. M. B. Hartley's *Hartford in the Olden Times* (Hartford: F. A. Brown, 1853). A replica of this painting was executed in Hartford by A. L. Kinney (cat. 313).

Toward the end of his life, the artist expressed the desire to be represented in the Wadsworth Atheneum, his native city's only public gallery, by a more mature work. At the time of his death, one orator noted that *Hooker and Company* "is a boyish effort and [Church] has often lamented that he could not be better represented in a public gallery in Hartford. It is related that he once offered to replace it with a fine canvas painted expressly for the Atheneum, but that the spirit of antiquity in the board of managers at that time prevailed and the 'Hooker' remains."[15] EMK

Frederic E. Church, *The Charter Oak, at Hartford*, 1846–1847. Hartford Steam Boiler Inspection and Insurance Company.

1. Thomas Cole to Robert Gilmor, May 21, 1828, quoted in Louis Legrand Noble, *The Life and Works of Thomas Cole*, ed. Elliot S. Vesell (1853; rpt., Cambridge: Harvard University Press, Belknap Press, 1964), 64.

2. Mary Bartlett Cowdrey, ed. *National Academy of Design Exhibition Record, 1826–1860* (New York: New-York Historical Society, 1943), 1:80.

3. Howard S. Merritt, ed., *Annual II: Studies on Thomas Cole, An American Romanticist* (Baltimore: Baltimore Museum of Art, 1967), 90.

4. Perry Miller, *Errand into the Wilderness* (Cambridge, Mass.: Harvard University Press, Belknap Press, 1956), 23–24.

5. Benjamin Trumbull, *A Complete History of Connecticut, Civil and Ecclesiastical from the Emigration of Its First Planters from England in the Year 1630, to the Year 1764; and to the Close of the Indian Wars* (1818; rpt., New London, Conn.: H. D. Utley, 1898), 43. Church may also have seen John Warner Barber's *Connecticut Historical Collections* (1838), which contains an illustration of the event: "Mr. Hooker and His Congregation Traveling Through the Wilderness" (opp. 60).

6. Franklin Kelly has pointed out that Church abandoned the use of stylized rays of sunlight, which appear in this and other early works, after careful study of nature taught him that such rays cannot appear in a cloudless sky (*Frederic Edwin Church and the National Landscape* [Washington, D.C.: Smithsonian Institution Press, 1988], 140 n. 31).

7. In his "Unfinished Biography of the Artist" (1900, unpublished, Olana State Historic Site), Charles Dudley Warner relates: "One of [Church's] sisters Elizabeth's letters to him in the autumn of 1845 was devoted to an account of her efforts to look up the costumes of the period at the library in Hartford, with reference to this work" (reproduced in Franklin Kelly, with Stephen Jay Gould, James Anthony Ryan, and Debora Rindge, *Frederic Edwin Church*, exh. cat. [Washington, D.C.: National Gallery of Art, 1989], 189).

8. The painting bore an abbreviated title for its first showing at the Wadsworth Atheneum in 1850: *Journey of the Pilgrims through the Wilderness*. See *Catalogue of Paintings in Wadsworth Gallery, Hartford* (Hartford: E. Gleason, 1850).

9. Kelly, *Frederic Edwin Church*, 7–9, provides a discussion of the religious and national symbolism of this painting.

10. Matthew Baigell, "Frederic Church's 'Hooker and Company': Some Historic Considerations," *Arts Magazine* (January 1982), 124–125.

11. See Christopher Kent Wilson, "The Landscape of Democracy: Frederic Church's 'West Rock, New Haven,'" *American Art Journal* 18, no. 1 (1986), 21–39.

12. Gerald Carr, "Master and Pupil: Drawings by Thomas Cole and Frederic Church," *Bulletin of the Detroit Institute of Arts* 66, no. 1 (1990), 56–57, discusses a drawing of the Charter Oak by Church, dated August–September 1846 (Olana State Historic Site, OL. 1977.302).

13. Frederic E. Church to Thomas Cole, October 17, 1846, quoted in David C. Huntington, *Frederic Edwin Church*,

exh. cat. (Washington, D.C.: Smithsonian Institution Press, for the National Collection of Fine Arts, 1966), 182.

14. Mrs. Horace Wells wrote the following to her husband: "I called yesterday at Mr. [Joseph] Church's and unexpectedly met Frederic, he has sold his large painting The Emigration of Hooker to our Institute for $130" (Mrs. Horace Wells to Mr. Horace Wells, Hartford, December 27, 1846, Wadsworth Atheneum Archive).

15. Frederic Edwin Church, obituary, *Hartford Daily Times*, newspaper clipping file, Connecticut Historical Society.

112 (see plate 24)

FREDERIC E. CHURCH
Grand Manan Island, Bay of Fundy, 1852
Oil on canvas; 21^{13}/$_{16}$ × 31^{15}/$_{16}$ in. (53.8 × 79.5 cm)
Signed and dated at lower right: F Church / 52
Canvas stamps on the reverse: G. ROWNEY &

CO. / MANUFACTURERS / 51 [] PLACE / LONDON
[oval] and WILLIAMS & S [] / 353 / BROADWAY/NEW
YORK [oval]

EXHIBITED: New York City, National Academy of Design, 1853, no. 359, as "Grand Manan Island, Bay of Fundy" / Newport, R.I., The Art Association of Newport, "The Coast and the Sea: A Loan Exhibition Assembled from the Collections of the Wadsworth Atheneum," 1964, no.8 / Brockton, Mass., Brockton Art Center, "Three Centuries of New England Art from New England Museums," 1969, no.47 / Richmond, Virginia Museum of Fine Arts, "American Marine Painting," 1976 / Wadsworth Atheneum, "The Hudson River School: Nineteenth-Century American Landscapes in the Wadsworth Atheneum," 1976, no.21 / Washington, D.C., National Gallery of Art, "American Light: The Luminist Movement," 1980, no. 63 / Washington, D.C., National Gallery of Art, "Frederic Edwin Church," 1989, no. 14

EX COLL.: with William Kemble, New York City, by 1853, to 1881; purchased for the Wadsworth Atheneum at James P. Silo Auction House (Fifth Avenue Art Galleries) in 1898

Gallery Fund purchase, 1898.6

Church made his first summer visit to the coast of Maine in 1850; he would return frequently to his favorite sketching sites in the state over the next thirty years. In 1878 he purchased land and built a permanent camp on the shores of Lake Millinocket. As one scholar has recently pointed out, although Church "was the greatest painter of Maine landscapes before Winslow Homer," he was following in the footsteps of a number of important artists who sought out the dramatic and rugged scenery of the Maine coast.[1] Thomas Cole visited the coast of Maine in the summer of 1844, when Church was his student, and would execute a number of sublime renditions of the scenery he found there. In addition to his teacher's work, Church may also have been inspired by the 1849 exhibition at the American Art-Union in New York City of two Maine seascapes by Fitz Hugh Lane (1804–1865).[2] Of greater importance to Church, however, was the impact of the seascape by Andreas Achenbach, *Clearing Up, Coast of Sicily* (1847; figure at cat. 115), which was also on view at the 1849 American Art-Union exhibition and, according to a contemporary account, "seems to have directed the attention of our younger men to the grandeur of Coast scenery."[3]

In addition to sketching in the region of Mount Desert Island, Church sought even more remote scenery, sailing to the island of Grand Manan, Canada, located twenty miles offshore of the easternmost point in Maine, making two trips in the summers of 1850 and 1851. In August 1851 he made a series of geological studies of the rugged cliffs and shoreline. *Grand Manan Island, Bay of Fundy* is based on at least two of Church's sketches of this northern coastal site, *Sharp Rocks off Grand Manan* and *Cliffs at Grand Manan* (Cooper-Hewitt Museum, New York City, 1917-4-658).[4] These and other sketches Church made on the island indicate that he chose to work on clear days when the sea was calm.

In the finished painting, the artist creates a view of this remote scenery characterized by rough forms, broken surfaces, and jagged contours. The scene is dramatically lit by the setting sun, an early attempt at this effect, with shadows cast by the clouds in the upper sky. In the foreground Church introduced the somewhat awkward figure of a fisherman, who looks away from the spectacular vista behind him. Church's decision to include the figure and long rocky shore was perhaps a tribute to fellow-artist Fitz Hugh Lane (1804–1865), as these elements are signatures of Lane's coastal paint-

ings. The viewer stands apart from the scene, the foreground diminishing the immediacy of the rugged coastline in the distance. Eleven years later, Church's mature vision thrust the viewer into a far more spectacular and immediate seascape in *Coast Scene, Mount Desert* (cat. 115).

Grand Manan Island was first owned by William Kemble (?–1881), an honorary member of the National Academy of Design from 1855 until 1860 and an amateur artist himself, as well as a collector of paintings by American and European painters.[5] The work was purchased during Church's lifetime by the Wadsworth Atheneum in 1898, for $300. The artist had lamented the fact that in the only public art gallery in his native city, he was represented by "a boyish effort," referring to his 1846 *Hooker and Company* (cat. 111). The addition of this second early work probably did not completely satisfy Church, who had earlier "offered to replace [*Hooker and Company*] with a fine canvas painted expressly for the Atheneum."[6] EMK

1. Franklin Kelly, *Frederic Edwin Church and the National Landscape* (Washington, D.C.: Smithsonian Institution Press, 1988), 34.

2. Mary Bartlett Cowdrey, *American Academy of Fine Art and American Art-Union Exhibition Record, 1816–1852* (New York: New-York Historical Society, 1953), 221. The two works by Lane were *View on the Penobscot* (location unknown) and *Twilight on the Kennebec* (private collection). See Franklin Kelly, "Lane and Church in Maine," in John Wilmerding, *Paintings by Fitz Hugh Lane* (New York: Abrams, for the National Gallery of Art, Washington, D.C., 1988), 132–134.

3. "Church, Gignoux, and Hubbard have gone to the coast of Maine, where it is said that the marine views are among the finest in the country. None of these artists, we believe, have hitherto attempted such subjects, and we look forward to the results of this journey. The exhibition of the magnificent Achenbach last year in the Art-Union Gallery seems to have directed the attention of our younger men to the grandeur of Coast scenery" ("Chronicles of Facts and Opinions: American Art and Artists," *Bulletin of the American Art-Union* 1850 ser. (August 1850), 81, reproduced and discussed in Kelly, *Frederic Edwin Church*, 35.

4. Theodore E. Stebbins, Jr., *Close Observation: Selected Oil Sketches by Frederic E. Church*, exh. cat. (Washington,

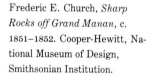

Frederic E. Church, *Sharp Rocks off Grand Manan*, c. 1851–1852. Cooper-Hewitt, National Museum of Design, Smithsonian Institution.

D.C.: Smithsonian Institution Press, in association with the Cooper-Hewitt Museum, 1978), 16–17, 58–59.

5. Mary Bartlett Cowdrey, ed., *National Academy of Design Exhibition Record, 1826–1860* (New York: New-York Historical Society, 1943), 1:274. William was the brother of Gouverneur Kemble (1786–1875), also an amateur artist and art collector but best known for his production of cannons in Cold Spring, New York (*DAB* 10:316–317).
6. Frederic Edwin Church, obituary, *Hartford Daily Times*, newspaper clipping file, Connecticut Historical Society.

113 (see plate 25)

FREDERIC E. CHURCH

Mountains of Ecuador, 1855

Oil on canvas; 24³/₁₆ × 36⁵/₁₆ in. (61.4 × 92.2 cm)

Signed and dated at lower left: F. Church. -55-

EXHIBITED: Wadsworth Atheneum, "Gould Bequest of American Paintings," 1948 / Brooklyn, N.Y., Brooklyn Museum, "Victoriana—The Arts of the Victorian Era in America," 1960, no. 183 / Wadsworth Atheneum, "The Hudson River School: Nineteenth-Century American Landscapes in the Wadsworth Atheneum," 1976, no. 22 / Philadelphia, Pennsylvania Academy of the Fine Arts, "In This Academy," 1976, no. 161 / Wadsworth Atheneum, "Framing Art: Frames in the Collection of the Wadsworth Atheneum," 1982

EX COLL.: within the family of Clara Hinton Gould (Mrs. Frederick Saltonstall Gould), Santa Barbara, Calif., by the 1880s

Bequest of Clara Hinton Gould, 1948.177

In search of ever-grander subjects, Church was drawn at midcentury to the immense mountainous peaks and exotic vegetation of South America. In the spring of 1853 Church traveled with his friend Cyrus Field to Colombia and Ecuador.[1] The trip was inspired, in part, by the German scientist Alexander von Humboldt (1769–1859), who had explored the South American tropics between 1799 and 1804, later producing colorful narratives of his travels. Church responded to Humboldt's call for an artist to journey to "the humid mountain valleys of the tropical world, to seize . . . on the true image of the varied forms of nature."[2]

During his six-month journey, Church produced many sketches that he would later use as the basis for a series of tropical landscapes. *Mountains of Ecuador* reveals the grandeur and majesty of nature, including brilliant tropical birds and vegetation in the foreground, civilization represented by the village with its domed church in the middle ground, and the immense snow-

Frederic E. Church, study for *Mountains of Ecuador*, c. 1855. Private collection.

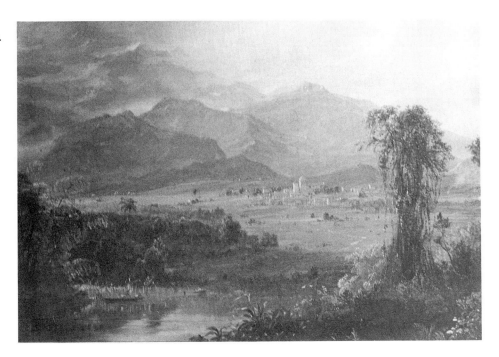

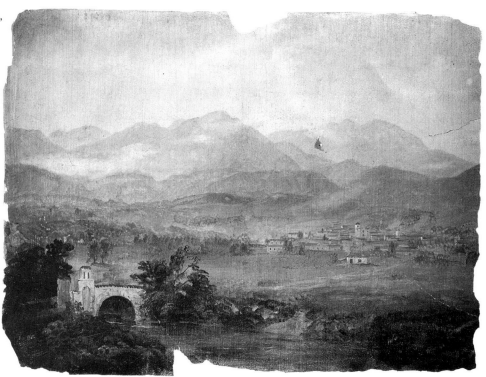

Frederic E. Church, *Zipaquira, Colombia*, 1853. Cooper-Hewitt, National Museum of Design, Smithsonian Institution.

capped mountain peaks in the distance. A glowing sun and atmospheric mists unify the landscape and suggest a spiritual presence.

Mountains of Ecuador is likely a composition drawn from a variety of sketches, two of which have recently been located. A detailed oil study for this landscape includes most of the foreground, middle ground, and background details, which are rendered in nearly finished forms. The artist gave that study to his close friend Charles Tracy (1810–1885), who traveled with him to Mount Desert, Maine, in 1855, the year *Mountains of Ecuador* was painted. A second oil study contains several elements that relate to *Mountains of Ecuador*—for example, the arched stone bridge over the river in the foreground and the configuration of buildings in the village in the middle ground. The title *Mountains of Ecuador* implies that the scene represents Ecuadorian mountains; however, the Cooper-Hewitt Museum oil study is inscribed by the artist "Zipaquira, Colombia."

Mountains of Ecuador descended in the family of Dr. Frederick Gould and was given to the Atheneum by his widow (see Introduction). EMK

1. The details of Church's trip are discussed in David C. Huntington, *Frederic Edwin Church, 1826–1900: Painter of the Adamic New World Myth* (Ph.D. diss., Yale University, 1960; Ann Arbor: University Microfilms International, 1982), 39–49; and more recently in Katherine Emma Manthorne, *Creation and Renewal: Views of Cotapaxi by Frederic Church*, exh. cat. (Washington, D.C.: Smithsonian Institution Press, for the National Museum of American Art, 1985); and idem, *Tropical Renaissance: North American Artists Exploring Latin America, 1839–1879* (Washington, D.C., and London: Smithsonian Institution Press, 1989).
2. Alexander von Humboldt, *Cosmos: A Sketch of a Physical Description of the Universe*, trans. E. C. Otté (New York: Harper and Bros., 1850), 1:33.

114 (see plate 26)

FREDERIC EDWIN CHURCH

Niagara Falls, 1856

Pencil and oil on paper mounted on canvas; $11^{15}/_{16} \times 17^{5}/_{8}$ in. (30.3 × 44.8 cm)

Signed and dated at lower right: F. Church 56

EXHIBITED: Richmond, Virginia Museum of Fine Arts, and Newport News, Va., Mariner's Museum, "American Marine

Painting," 1976 / Wadsworth Atheneum, "The Hudson River School: Nineteenth-Century American Landscapes in the Wadsworth Atheneum," 1976, no. 23

In 1857 Church produced what was considered at the time to be the finest depiction of Niagara Falls ever painted in the 160 years of pictorial explorations of America's greatest natural wonder by European and American artists. His creation of *Niagara* has been thoroughly explored in recent years by a number of scholars.[1] Following its public exhibition at the art dealers Williams, Stevens, and Williams at 353 Broadway Avenue in New York City and, in the same year, its tour in England, *Niagara* made Church internationally famous, the English critics proclaiming it "the greatest realization of moving water in the world."[2]

Church's first documented sketching trip to Niagara Falls occurred in March 1856.[3] He returned twice more that year, first in July and later in August and September. In that same year, Church read the third and fourth volumes of John Ruskin's *Modern Painters* and reread the two earlier volumes. He was impressed by Ruskin's discussion of water as a subject: "Of all inorganic substances acting in their own proper nature, water is the most wonderful. . . . It is to all human minds the best emblem of unwearied, unconquerable power."[4] On his visits to the falls, Church explored many viewpoints of the cataracts in his numerous sketches, as well as detailed aspects, including the sheer power of the rushing water.[5]

The Atheneum's *Niagara Falls*, one of only a few self-sufficient studio works Church completed in 1856, depicts the Horseshoe Falls from the American side. The artist chose a traditional vantage point below the falls, emphasizing the height and force of the rushing water, concerning himself with the downward plunge of the cataract and its changing qualities of light and density. A brilliant rainbow links the sky and water, and three minute houses dot the far shore.

At least three pencil drawings executed in July relate to *Niagara Falls;* one study, as in the painting, provides the viewer with a more intense confrontation with the water, while a second was taken from a greater distance, lessening the impact of the falls.[6] Color notes that Church had jotted on the first drawing—"Where the water washes the rock the color is lightish yellowish brown warm dry rock—grey and brownish but warm"— provided guidelines for the finished oil.

The artist's final conception for his grand-scale *Niagara* would become far more spectacular, encompassing a view on the very brink of the western edge of Horseshoe Falls, with the viewer suspended over the torrent itself. EMK

Frederic E. Church, *Niagara*, 1857. Corcoran Gallery of Art.

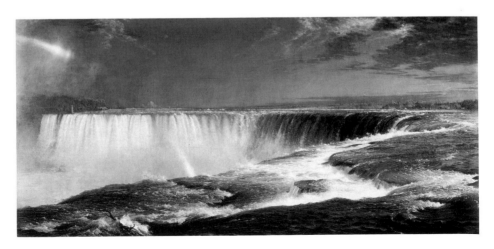

Frederic E. Church, *Niagara Falls*, 1856. Cooper-Hewitt, National Museum of Design, Smithsonian Institution. Photograph: Scott Hyde.

Frederic E. Church, *Niagara Falls*, 1856. Cooper-Hewitt, National Museum of Design, Smithsonian Institution. Photograph: Scott Hyde.

1. See David C. Huntington, *The Landscapes of Frederic Edwin Church: Vision of an American Era* (New York: Braziller, 1966), 1–4, 64–71. The more recent and most thorough discussion appears in Jeremy Elwell Adamson, "Frederic Church's 'Niagara': The Sublime as Transcendence" (Ph.D. diss., University of Michigan, 1981). Also, see idem, "In Detail: Frederic Church and *Niagara*," *Portfolio* 3 (November/ December 1981), 53–59. The history of depictions of Niagara Falls, including Church's work, has been the subject of a major exhibition and a recent study—Jeremy Elwell Adamson, with Elizabeth McKinsey, Alfred Runte, and John F. Sears, *Niagara: Two Centuries of Changing Attitudes, 1697–1901*, exh. cat. (Washington, D.C.: Corcoran Gallery of Art, 1985); and Elizabeth McKinsey, *Niagara Falls: Icon of the American Sublime* (Cambridge: Cambridge University Press, 1985).

2. Quoted in Adamson, "In Detail," 53.

3. Church may have visited the falls as early as August 1851, joined by his friend Cyrus Field (Isabella Judson, *Cyrus Field: His Life and Work* [New York: Harper Brothers, 1896], 41, noted in Adamson et al., *Niagara*, 80 n. 191).

4. Ruskin quoted in Huntington, *Landscapes*, 65–66.

5. Over seventy sketches of Niagara Falls by Church are extant, most in the collection of the Cooper-Hewitt Museum and some at the Olana State Historic Site, Hudson, N.Y.

6. Theodore E. Stebbins, Jr., *The Hudson River School: Nineteenth-Century American Landscapes in the Wadsworth Atheneum*, exh. cat. (Hartford: Wadsworth Atheneum, 1976), 46–47.

115 (see plate 27)

FREDERIC EDWIN CHURCH
Coast Scene, Mount Desert, 1863
Oil on canvas; 36⅛ × 48 in. (91.8 × 121.9 cm)
Signed and dated at lower right center: F. E.
 Church / 1863

EXHIBITED: New York City, National Academy of Design, Annual Exhibition, 1863, no. 74, as "Coast Scene, Mount Desert" / Albany, N.Y., Albany Saniitary Fair, 1864, cat. 37, no. 10 / Wadsworth Atheneum, "Gould Bequest of American Paintings," 1948 / Wadsworth Atheneum, "A Second Look: Late Nineteenth Century Taste in Paintings," 1958, no. 8 / Washington, D.C., National Collection of Fine Arts; Albany, N.Y., Albany Institute of History and Art; and New York City, M. Knoedler and Co., "Frederic Edwin Church," 1966, no. 46 / Bloomington, Indiana University Art Museum, "The American Scene: 1820–1900," 1970, no. 4 / Washington, D.C., National Collection of Fine Arts, Smithsonian Institution, "National Parks and the American Landscape: An Approach to Nature and the Nineteenth Century," 1972, no. 2 / New York City, Whitney Museum of American Art, "Seascape and the American Imagination," 1975, no. 117 / Richmond, Virginia Museum of Fine Arts, "Marine Painting in America," 1976, no. 31 / Wadsworth Atheneum, "The Hudson River School: Nineteenth-Century American Landscapes in the Wadsworth Atheneum," 1976, no. 24 / Washington, D.C., National Gallery of Art, "American Light: The Luminist Movement, 1850–1875," 1980, no. 214 / Boston, Museum of Fine Arts; Washington, D.C., Corcoran Gallery; and Paris, Réunion des Musées Nationaux, Palais du Louvre, "A New World: Masterpieces of American Painting, 1760–1910," 1984, no. 43 / Washington, D.C., Na-

tional Gallery of Art, "Frederic Edwin Church," 1989, no. 37 / Paris, Galeries Lafayette, "Deux Cents Ans de Peinture Américaine: Collection du Musée Wadsworth Atheneum," 1989 / Wadsworth Atheneum, "'Spirit of Genius': Art at the Wadsworth Atheneum," 1992

EX COLL.: purchased from the artist by Marshall O. Roberts, New York City, in 1863, to 1880; to Clara Hinton Gould, Santa Barbara, Calif., by 1948

Bequest of Clara Hinton Gould, 1948.178

Church first painted northern coastal scenery in the early 1850s, producing light-filled, expansive vistas (cat. 112). By the end of the decade he had become a national figure, winning wide popular recognition, financial gain, and critical acclaim for his spectacular wilderness views of the Northeast as well as of more exotic South American locales. During the Civil War, Church returned to the depiction of northern coastal scenery for the first time since the early 1850s, painting his masterwork of the seascape genre, *Coast Scene, Mount Desert*.

Both the influence of J. M. W. Turner, as well as the memory of the Düsseldorf-trained artist Andreas Achenbach's *Clearing Up, Coast of Sicily*, which had been on view at the American Art-Union in New York City in 1849, may have inspired his return to this subject.[1] In this mature work, Church continued to investigate qualities of light and atmosphere and the power of the sea against the rocky coast, which he had explored eleven years earlier in such works as *Grand Manan Island* (cat. 112). *Coast Scene* is set apart from his youthful efforts at seascape, however, by its compelling sense of drama and energy; the viewer is placed in direct confrontation with the sea and its sublime power.

The emotional impact of the painting was appreciated by critics of the day, who gave it generally favorable reviews after its National Academy of Design showing in the year of its completion. One reviewer proclaimed it "among the best instances of Church's power. . . . Here is magnificent force in the sea; we give ourselves up to enthusiasm for it, regarded as pure power; when it dies its final death in mad froth and vapor, tossed quite to the top of the beetling barrier crags on the right foreground, we feel ourselves in an

Andreas Achenbach, *Clearing Up, Coast of Sicily*, 1847. Walters Art Gallery, Baltimore.

Frederic E. Church, sketch, *Mount Desert Island*, c. 1851–1852. Cooper-Hewitt National Museum of Design, Smithsonian Institution.

audacious actual presence, whose passion moves us almost like a living fact of surf. We value the light effects separately, and the fine recklessness of color by itself."[2] A writer for the *Albion* praised the work for its "luminous quality of light," proclaiming it, for the most part,

a "noble work," and went on to discuss at length Church's choice of frame design, concluding that "the material [black walnut] being excellent, but the detail most unfortunate."[3] Henry Tuckerman wrote of the painting that "the peculiar yeasty waves and lurid glow [are] incident

to a dry autumnal storm in northern latitudes," relating it to John Ruskin's discussion of "yesty [sic] waves" in *Modern Painters*.[4]

The painting is largely based on a plein-air oil sketch Church executed at Mount Desert, which includes the dark brown silhouettes of the cliffs. The artist's vantage point looks out across the surf and rocks, with the spray crashing up at the lower right, seemingly at his feet.[5] The painting entered the Atheneum's collection with the title *Sunrise off the Maine Coast*, but the composition is more likely a late afternoon scene from the southern coast looking west. Church turned the sketch into a finished work almost without change, adding to the oil the spectacular effects of the yellow sun burning through the mist, an atmospheric pink and blue sky, and the pine trees on the right horizon. He succeeded in preserving the immediacy and emotional impact of the sketch in his finished oil painting. Twenty years later, Winslow Homer (q.v.) would take up this subject, exploring the elemental force of the sea.

The New York railroad and steamship financier, Marshall Owen Roberts (1814–1880) acquired this painting from Church in 1863, adding it to the substantial art collection housed in his mansion at 107 Fifth Avenue (he had already acquired Church's *Mount Katahdin* [1853, Yale University Art Gallery] and *Under Niagara* [1862, unlocated] and commissioned *Rainy Season in the Tropics* in 1866 [Fine Arts Museums of San Francisco]). At the time, he was married to his second wife, Caroline Smith Roberts, of Hartford. EMK

1. Franklin Kelly, with Stephen Jay Gould, James Anthony Ryan, and Debora Rindge, *Frederic Edwin Church*, exh. cat. (Washington, D.C.: National Gallery of Art, 1989), 61.
2. The review is reproduced in Henry T. Tuckerman, *Book of the Artists: American Artist Life* (New York: Putnam, 1867), 372.
3. "Fine Arts, National Academy of Design," *Albion* (New York), May 2, 1863, 213–214. Of the frame, the writer observed, "That Mr. Church was quite right in preferring black walnut to gold for his 'Coast Scene' we have no doubt. . . . There is an elevated and gilded rim girdling it in the pattern . . . on the border of Greek and Roman togas. . . . The cool hue of the wood is grateful, but unfortunately the designer . . . has thought fit to chop [the frame] up into small sections by transverse bars, gaining . . . a series of dainty little

squares wherein fanciful knobs and rosettes may disport themselves, but thrusting these needlessly in the way." *Coast Scene, Mount Desert*, which for many years had an inappropriate frame, likely put on in this century, has recently been put in a replica of the original frame based on the above description and study of other original frames designed by the artist, including the frame on *Vale of St. Thomas, Jamaica* (cat. 116).
4. Kelly et al., *Frederic Edwin Church*, 74 n. 140, cites the use of "yesty waves" in volume 1 of Ruskin's *Modern Painters* (New York: Wiley, 1882, ch. 3, "Of Water as Painted by Turner," sec. 5, "Of Truth of Water," 402–403): "The 'yesty waves' of Shakespeare have made the likeness familiar, and probably most readers take the expression as merely equivalent to 'foamy,' but Shakespeare knew better. Sea-foam does not, under ordinary circumstances, last a moment after it is formed, but disappears, as above described, in a mere white film. But the foam of a prolonged tempest is altogether different; it is 'whipped' foam, thick, permanent, and, in a foul or discolored sea, very ugly, especially in the way it hangs about the tops of waves, and gathers into clotted concretions about the driving wind. The sea looks truly working or fermenting." Ruskin's reference is to *Macbeth*, act 4, scene 1. The phrase "yesty billowy sea" was also used in a description of Achenbach's *Clearing Up, Coast of Sicily* in "Gallery of the Düsseldorf Artists," *Bulletin of the American Art-Union* 2 (June 1849), 12.
5. Theodore E. Stebbins, Jr., *Close Observation: Selected Oil Sketches by Frederic E. Church*, exh. cat. (Washington, D.C.: Smithsonian Institution Press, in association with the Cooper-Hewitt Museum, 1978), 21, 62.

116 (see plate 28)

FREDERIC E. CHURCH
Vale of St. Thomas, Jamaica, 1867
Oil on canvas; 48⁵/₁₆ × 84⁵/₈ in. (122.7 × 214.9 cm)
Signed and dated at lower left: F. E. Church / 1867

EXHIBITED: New York City, Goupil Art Gallery, 1870, as "Jamaica" / Hartford Municipal Art Society, c. 1885 / Metropolitan Museum of Art, "Paintings by Frederic E. Church," 1900, as "Vale of St. Thomas, Jamaica" and annotated "Painted for and loaned by Mrs. Elizabeth H. Colt" / Wadsworth Atheneum, "A Second Look: Late Nineteenth Century Taste in Paintings," 1958, no. 48 / Washington, D.C., National Collection of Fine Arts, Smithsonian Institution, "Frederic Edwin Church," 1966, no.95 / Wadsworth Atheneum, "The Hudson River School: Nineteenth-Century American Landscapes in the Wadsworth Atheneum," 1976, no. 25 / Boston, Museum of Fine Arts "The Paintings and Oil Sketches of Frederic E. Church," 1978, no. 20 / Wadsworth Atheneum, "Framing Art: Frames in

the Collection of the Wadsworth Atheneum," 1982 / Washington, D.C., National Gallery of Art, "Frederic Edwin Church," 1989, no. 42 / Paris, Galeries Lafayette, "Deux Cents Ans de Peinture Américaine: Collection du Musée Wadsworth Atheneum," 1989

EX COLL.: commissioned by Mrs. Samuel (Elizabeth Hart Jarvis) Colt, Hartford, in 1867

Bequest of Elizabeth Hart Jarvis Colt, 1905.21

In March 1865 the Churches' two young children, Herbert, aged two, and Emma, aged five months, died of diphtheria. The artist memorialized the tragedy in two small works, *Sunrise* and *Moonrise* (1865, Olana State Historic Site, Hudson, N.Y.). As Henry Tuckerman recorded, the Churches' "domestic affliction rendering a change of scene desirable," the couple sailed for Jamaica in late April 1865 in the company of several friends, including the young artist Horace Wolcott Robbins (1842–1904) and another artist, Fritz Melbye.[1] While in Jamaica, the Churches dealt with their sorrow, each differently, as Robbins noted in a letter to his mother: "Poor Mr & Mrs. Church I feel ver[y] sorry for them. She is often very sad and speaks to Sarah [a friend] about her children. He is very singular about that never likes to speak of his feelings— . . . He works away as if for dear life—& seems to be trying to forget his trouble by always keeping himself occupied."[2] *Vale of St. Thomas, Jamaica,* the painting Church conceived on this trip for his friend and patron Elizabeth Colt, embodied the spiritual nature of his journey to this island.

During his nearly five-month stay on the island, in pursuit of the renewal of hope, Church focused on the topography, botany, and meteorology of the tropical landscape in a frenzy of productivity, producing one of his greatest series of oil sketches.[3] Tuckerman noted the diversity of subjects that resulted: "The studies which he brought home . . . are admirable effects of sunset, storm, and mist, caught in all their evanescent but characteristic phases; the mountain shapes, gorges, plateaus, lines of coast, and outlines of hills: besides these general features, there are minute and elaborate studies of vegetation—the palms, ferns, canebrakes, flowers, grasses, and lizards; in a word, all the materials of a tropical insular landscape, with every local trait carefully noted."[4]

In addition to making sketches in preparation for his major work *Rainy Season in the Tropics* (1866, Fine Arts Museums of San Francisco), Church also concerned himself with taking spectacular oil studies from atop Mount Diablo, looking across St. Thomas in the valley to the Blue Mountains in the distance.[5] The sheer number and beauty of these oil studies—there are more than twenty, as well as numerous drawings in the collection of the Cooper-Hewitt Museum—indicates that he was preparing to produce a large canvas of this site when he returned to his studio.

Church had been commissioned to paint a major painting for Mrs. Elizabeth Hart Jarvis Colt (see Introduction and cat. 196), who was in the process of completing a picture gallery in her Hartford mansion. The close ties between the Church and the Colt/Jarvis families of Hartford went back several generations, and more recently Elizabeth Colt and Church had shared the grief of family deaths (Elizabeth Colt had suffered the death of her infant son, Samuel James Colt in 1857, an infant daughter, Henrietta Selden Colt, in 1860, and another daughter in July 1862, six months after the death of her husband, Samuel Colt). As one of the wealthiest women in the country, with a controlling interest in her deceased husband's arms manufactory, Mrs. Colt intended to create a picture gallery second to none—a gallery that would serve as a fitting memorial to her husband and at the same time assert her financial and social authority as Hartford's leading matron. Church was certainly aware of the importance of the commission.

After an arduous journey across the island by train, on horseback, and on foot, young Horace Robbins provided a detailed description of the moment the two artists first laid eyes on the actual scene that would inspire Church's landscape for Mrs. Colt:

A week ago last Tuesday, Mr. Church and I went off on a [*sic*] exploring expedition toward the Northern side of the island. . . . We soon began the ascent of Monte Diablo—a wild & pretty high mountain. Here the mountains however lofty seem to be covered with foliage, to the very summits—Reaching the highest

elevation we had one of the sweetest & finest views I have yet seen on the island—In the far distance was the long blue range of Blue hills and near the thickly wooded hills and down the valleys—great mosses & clouds of fogs wh[ich] seemed like lakes whilst here & there above it peeped out some tall palms.—

It was a sight never to be forgotten [*sic*] So beautiful and grand—We overlooked the Parish of "St Thomas in the Vale" wh[ich] is one of the sweetest of them all—We remained sometime enjoying the view.[6]

After returning to New York City in 1866, the artist was renewed by the national mood following the end of the war and by the birth of a son in September. Mrs. Colt corresponded with Church that fall concerning her progress with the construction of her "Picture Gallery" and concluded, "I want very much to see your picture for me & am sure it will be a never ending delight."[7] Church had begun the painting in 1866 and was still working on it the following year.[8] The Churches left for Europe and the Near East in the fall of 1867 on a two-year trip. Thus although Church finished the painting in 1867, Mrs. Colt evidently did not receive it until after its public exhibition, from April 4 to the end of May, in New York in 1870 at the Goupil Art Gallery, where it was titled simply *Jamaica*.[9] Church "retouched" the picture for the exhibition, as was his habit.[10] The work received favorable notice, one critic noting that it "combined the effect of storm and sunshine . . . with the most vivid and startling power."[11] It was loaned to the artist's memorial exhibition at the Metropolitan Museum in 1900 and is listed in Mrs. Colt's will with the title "Vale of St. Thomas, Jamaica."[12]

Aware that the painting would serve as an important focal point of Mrs. Colt's new gallery in his own native city and also that the gallery was intended to serve as a memorial tribute to Mrs. Colt's deceased husband, Church took care in imbuing his tropical landscape with a deeply spiritual meaning. He chose to depict the moment just after a storm, when the landscape glows in a lush, steamy atmosphere. The brilliant light of the rising sun emerges from behind a passing rain cloud, creating

a swirling vortex of light and atmosphere reminiscent of Turner. In this idealized landscape, a tiny monastery is placed high on the horizon, overlooking the river, symbolic of divine presence in the tropics.

It is significant that at this late date in his career, Church created a large-scale landscape that is site specific, rather than drawn from a variety of sources, as was more typical of his large-scale tropical paintings, such as *Heart of the Andes* (1859, Metropolitan Museum of Art) and *Rainy Season in the Tropics*. One critic, after questioning the artist on this point, reported, "The scene of the landscape . . . presents a view of an interior district known as 'St. Thomas in the Vale.' . . . Mr. Church . . . says that it is a representative landscape, and locally faithful to the facts of nature as characterized in one of the most brilliant features and phases of Jamaican scenery." The critic was especially struck by the turmoil seen on the left, commenting "drawn as if by inspiration, [it] is a mass of drifting vapor, and through a rift in its centre the sunlight struggles for the mastery, tinging the weird storm-clouds with its radiating hues of golden color."[13]

Church's decision to paint this subject was initially inspired by his regard for the beauty of the site after seeing it with his companion, Horace Robbins. The large number of exquisite oils he made of this site also attest to his admiration. A second factor, however, may also have influenced Church's choice of subject. Weeks after his return from Jamaica (toward the end of August), violence broke out between Jamaican blacks and British colonials in the parish of St. Thomas. The event quickly escalated into a bloody conflict described at the time as "a wholesale and indiscriminate massacre" of Jamaicans.[14] The clash became the subject of newspaper and journal articles in New York and London, which described it as the worst insurrection on the island since the emancipation of slaves in the 1830s.[15] A court martial of the British colonial governor was finally completed in 1870, the year that Church exhibited the painting to the public, dropping the site-specific title and simply calling it *Jamaica*. Church's response to this event, and

Frederic E. Church, *In the Blue Mountains, Jamaica,* 1865. Cooper-Hewitt National Museum of Design, Smithsonian Institution.

Frederic E. Church, *Philodendron Vines, Jamaica,* 1865. Cooper-Hewitt National Museum of Design, Smithsonian Institution.

its possible effect on his painting, is the subject of further research by this author.

Most of the oil sketches relating to *Vale of St. Thomas* are in the collection of the Cooper-Hewitt Museum in New York City, including *Valley and Mountain View* (1917-4-680C), *In the Blue Mountains, Jamaica*, inscribed "Jamaica / Aug / 65," *Storm in the Mountains* (1917-4-351C), and *Philodendron Vines, Jamaica*. In them, Church explored the spectacular rainstorms that crossed the valley, the brilliant sunsets, the rich colors of the Blue Mountains, and the lush tropical vegetation.

While volunteering at the Metropolitan Sanitary Fair of 1864 in New York City, Elizabeth Colt had seen Church's *Heart of the Andes* on exhibition. Its grand scale and dramatic presentation in a large black walnut frame hung with drapery would influence her own commission from Church. *Vale of St. Thomas, Jamaica* was given central prominence in Mrs. Colt's gallery, including an elaborate shadow-box frame designed by the artist (see Introduction). EMK

1. Henry T. Tuckerman, *Book of the Artists: American Artist Life* (New York: Putnam, 1867), 386. See Elizabeth McClintock, "Horace Wolcott Robbins" (master's thesis, Trinity College, Hartford, 1990).
2. Horace Robbins to Mary Eldrege Hyde Robbins, May 18, 1865, Olana State Historic Site, Hudson, N.Y.
3. David C. Huntington, *The Landscapes of Frederic Edwin Church: Vision of an American Era* (New York: Braziller, 1966), 54–59; and Theodore E. Stebbins, Jr., *Close Observation: Selected Oil Sketches by Frederic E. Church*, exh. cat. (Washington, D.C.: Smithsonian Institution Press, in association with the Cooper-Hewitt Museum, 1978), 35–38.
4. Tuckerman, *Book of the Artists*, 387.
5. Horace Robbins wrote to his mother, "We can often too see it raining on the mountains around us when it isnt quite raining where we are. It is a fine place for Mr. Church to study effects for his large picture—'The rainy season in the Tropics'" (Robbins to Robbins, May 18, 1865).
6. Ibid.
7. Elizabeth Hart Jarvis Colt to Frederic E. Church, October 26, 1866, Archives, Olana State Historic Site, Hudson, N.Y.
8. Church wrote to his patron William H. Osborn: "I am progressing in the Studio with Mrs. Colt's picture, although I find it harder to work since the Niagara is finished" (March 26, 1867, Archives, Olana State Historic Site, Hudson, N.Y.). The reference is to *Niagara Falls, from the American Side* (1867, National Gallery of Scotland).
9. A number of titles were assigned to this painting. *Hartford Daily Times*, April 11, 1870, announced, "A large new picture by the artist Church of this city, has just been put on exhibition at Goupil's art gallery. It is 'A Scene in Jamaica,' and is to grace the walls of Mrs. Col. Colt's gallery of paintings."
10. *New York Evening Mail*, April 5, 1870, announced the exhibition of Church's Jamaican composition "painted some two years since, but lately retouched."
11. "A New Tropical Landscape," *Evening Post* (New York) September 10, 1870, quoted in Franklin Kelly, with Stephen Jay Gould, James Anthony Ryan, and Debora Rindge, *Frederic Edwin Church*, exh. cat. (Washington, D.C.: National Gallery of Art, 1989), 65. My thanks to J. Gray Sweeney for bringing this review to my attention.
12. *Last Will and Testament of Elizabeth H. Colt* (Hartford, 1905), 16, Connecticut State Library, Hartford (copy in curatorial painting file, Wadsworth Atheneum).
13. "A New Tropical Landscape."
14. G. Reynolds, "The Late Insurrection in Jamaica," *Atlantic Monthly* 17 (April 1866), 481.
15. Bernard Semmel, *Jamaican Blood and Victorian Conscience* (Boston: Houghton Mifflin, 1963).

117

FREDERIC E. CHURCH
Jamaica, 1871
Oil on canvas; 14¼ × 24¼ in. (36.2 × 61.6 cm)
Signed and dated at lower right: F. E. Church 71
Technical note: Craquelure covers the paint surface.

EXHIBITED: Hartford, Connecticut School of Design, 1873, no. 1, as "In the Tropics" / Hartford Art School, "Frederic Edwin Church: The Artist at Work," 1974, no. 49 / Wadsworth Atheneum, "The Hudson River School: Nineteenth-Century American Landscapes in the Wadsworth Atheneum," 1976, no. 26

EX COLL.: to E. Hart Fenn, Wethersfield, Conn., by 1873

Gift of E. Hart Fenn in memory of his mother, Mrs. Frances Talcott Fenn, 1910.17

Church painted *Jamaica* in 1871, eight years after his visit to that tropical island. He had recently returned from a tour of Europe and the Near East and was immersed in the construction of his villa, Olana, in Hudson, New York. The small scale and diminished impact

117

of this work contrasts sharply with the epic proportions and panoramic vista of his monumental *Vale of St. Thomas, Jamaica* (cat. 116), painted four years earlier. The latter had become by 1870 a focal point of the private picture gallery of Mrs. Elizabeth Hart Jarvis Colt in Hartford. Church may have received a request from the Wethersfield, Connecticut, state senator E. Hart Fenn to paint a more modest landscape of this tropical island.

Church consulted the numerous sketches and oil studies taken during his trip to Jamaica in 1865 for this later painting. He chose a coastal scene that includes tropical vegetation and a palm tree at the left and several native fisherman in boats dominating the foreground.[1] A village is visible in the middle distance, and there are mountains beyond. Two oil studies directly relate to this work, *Jamaica* (June 1865, Cooper-Hewitt Museum, 1917-4-743A) and *Jamaica* (June 1865, Cooper-Hewitt Museum, 1917-4-674A). EMK

1. Theodore E. Stebbins, Jr., *The Hudson River School: Nineteenth-Century American Landscapes in the Wadsworth Atheneum*, exh. cat. (Hartford: Wadsworth Atheneum, 1976), 51–52.

118 (see plate 29)

FREDERIC E. CHURCH
Evening in the Tropics, 1881
Oil on canvas; $32^{1}/_{2} \times 48^{9}/_{16}$ in. (82.6 × 123.3 cm)
Signed and dated at lower right: F. E. Church / 1881

EXHIBITED: Wadsworth Atheneum, "Gould Bequest of American Paintings," 1948 / Hartford Art School, "Frederic Edwin Church: The Artist at Work," 1974, no. 50 / Wadsworth Atheneum, "The Hudson River School: Nineteenth-Century American Landscapes in the Wadsworth Atheneum," 1976, no. 27

EX COLL.: Julia Parmly Billings and Frederick Billings, New York City and Woodstock, Vermont, from 1881 to 1890; Julia Parmly Billings, from 1890 to 1914; in the Billings family estate

to 1922; in "American and Foreign Paintings," American Art Association, New York City, February 27, 1922, no. 58, as "Waterside Landscape with Figures," property of the Billings Estate Corporation; acquired by Clara Hinton Gould, Santa Barbara, Calif., before 1948

Bequest of Clara Hinton Gould, 1948.176

Church received a commission to paint a landscape for Frederick Billings (1823–1890) and his wife Julia Parmly Billings (1835–1914) in 1880; it was among the last major commissions the artist would undertake. Billings was one of the century's great builders of railroads across the country, becoming the president of the Northern Pacific Railroad Company. In addition, as a leading conservationist, he helped establish Yosemite National Park and initiated the reforestation of Vermont.[1] The Billings family had a home in Woodstock, Vermont, and in 1881 acquired a town house in New York City. The landscape was intended to hang in the new town house at 274 Madison Avenue.

Correspondence between Church and the Billingses indicates that the artist served as a broker for the sale of paintings to the couple, including three works by Thomas Cole.[2] The letters also provide detailed information of Church's progress on his own painting for the Billingses, beginning in February 1880, when Church discussed suitable sizes for the work as well as his current prices, determined by canvas size.[3] The Billings selected the largest size; Frederick Billings wrote to Church, "The order is for a *four feet* picture—The more I can have of you the better!"[4]

Church began the painting in February 1880 but had some trouble finishing this landscape. He wrote to Billings the following November asking permission to bring the canvas from his studio in the Tenth Street Studio Building in New York City to his Hudson estate, Olana, saying "I can usually work to the better advantage in my quiet country studio—besides—I have all my studies from Nature here and may have occasion to refer to a number of them to enable me to make the improvements I wish."[5] In the end, the Billingses received the landscape in February 1882 and were very pleased with it, having paid Church in the previous year the sum of

$3,000, plus $85 for the frame that Church had arranged to be made at Knoedler and Company.[6] Billings did, however, note in his diary entry of February 16, 1881: "Julia saw Church picture—-& advised him [Church] I thought too much left for imagination."[7]

Painted late in the artist's career, *Evening in the Tropics* is a nostalgic work based on drawings and observations Church made during his travels to South America in the 1850s. The landscape is suffused with a warm yellow light and heavy atmosphere evocative of a steamy tropical environment. The painting does not convey the same force and energy found in Church's earlier tropical landscapes, for example, his *Vale of St. Thomas* (cat. 116) of 1867. Instead, the artist has provided a more poetic interpretation of nature, using more subdued tones of thickly applied browns and yellows, perhaps reflecting his attempt to move toward the newly popular European landscape styles, particularly the French Barbizon school. In addition, the foreground elements dominate the canvas and are broadly treated.

The many artist changes evident on the canvas indicate that Church labored over this work. Several pentimenti appear, one of a large figure in the center foreground, and visible brush lines indicate a mountain range in the middle distance.

Church borrowed the painting briefly from the Billingses in January of 1882, placing it on view in his studio at Tenth Street. A critic admiring the work was struck by the change in the artist's style:

Church has just finished another of his famous South American scenes, representing the shores of a tropical river over hung by one of the dense southern atmospheres of which he has made a special study and in the painting of which his spirit seems to take peculiar delight. . . . One cannot but pity the three men who are lounging upon the thatched cover of a large canoe. . . . Their figures are small and insignificant by the side of the great spreading trees above them, and they seem like a part of the miasmic atmosphere that broods over the landscape. There are few who do not know the manner in which Mr. Church treats the abundant vegetation of the trop-

ics. He paints the palmetto and the fern with as much pains as Pallaijuolo of old outlined the threads of gold filigree. . . . But is Mr. Church abandoning these methods for broader ones? There is evidence of it certainly, in this, his latest work. It may be an indifference which is merely temporary, yet we feel we cannot be mistaken in the fact. The play of light upon each blade of grass, the hard outline of every spreading leaf, is less distinct, while other near objects seem characterized with unusual boldness. The colors and shadows are deeper and massed in broader quantities, by which, we think, the grandeur and magnificence of the scene has lost little or nothing.[8]

Church may have been responding to his critics, who by the mid-1870s no longer considered desirable his ability to paint in a precise and detailed style.[9] The artist's last great masterpiece, *Morning in the Tropics*, painted in 1877, retains some of the intricate detail he was famous for, as seen in the shining plants in the left foreground, but the detail is subservient to the composition as a whole. The composition itself is created on a more human scale than in his earlier expansive panoramas. The spiritual quality of light on the tropical river takes on a suggestive meaning; "The river becomes more than just a body of water; it is a fusion of air, water, and light, transcending the boundaries between earth and sky."[10]

Evening in the Tropics treats the same compositional subject as *Morning in the Tropics*, but rather than conveying the artist's own poetic interpretation of his lifelong interest in the tropical landscape, the subject matter, which includes the addition of figures in the foreground and the distinctly ominous quality of the atmosphere, was a direct reference to a specific event in the life of his patron. The landscape, which conveys the mysterious and subversive aspects of nature, served as a reminder of the difficult voyage Billings and his sister Laura had made up the Chagres River in Panama in 1849.

The two had gone out West during the California gold rush. At that time, one first had to sail to Panama and then make the treacherous journey up the Chagres River, which was noted for its unhealthful environment. The Billingses and their companions traveled in canoes, called bungoes, rowed by unclad native boatmen. Because the causes of "Panama fever," or yellow fever, and malaria were unknown at this period, the travelers ignored the swarms of mosquitoes that surrounded them

Frederic E. Church, *Morning in the Tropics*, 1877. National Gallery of Art, Washington, gift of the Avalon Foundation.

during the river trip. For lack of any other source, most drank the river water during the thirty-eight-mile journey upriver to the town of Panama. From there, they traveled by mule and ship to California, but, tragically, Laura died of what was diagnosed as "Chagres Fever," either malaria or yellow fever, which Frederick always believed she contracted during the Chagres River trip.[11] The figure of a young woman at left in Church's painting, shown holding a fishing line and encompassed by the ominous steamy yellow atmosphere, unquestionably symbolized Billing's sister Laura, thought to be the first woman to die in the gold rush. Church also included partially clad native boatmen, further documenting the memory Frederick Billings held of this tragic event. EMK

1. Robin W. Winks, *Frederick Billings: A Life* (New York and Oxford: Oxford University Press, 1991), is a definitive biography of Billings.
2. Correspondence from April 13, 1879, until January 11, 1882, between Frederic Church and Frederick and Julia Parmly Billings is in the Billings Mansion Archives, Woodstock, Vermont, and in the Frederic Church Archives, Olana State Historic Site, Hudson, N.Y. The sale of Cole paintings is discussed in Frederic Church to Frederick Billings, April 13, 1879, Billings Mansion Archives: "I have selected three or four of the most attractive of the little pictures by Thomas Cole which the family will part with—to be sent to my studio in New York for your inspection." The Billingses bought three of the Cole paintings, two of which are identified as *Niagara* and *Moonlight*. Church arranged to have the paintings cleaned and restored by "Mr. Oliver" in New York, who regilded one of the frames. Church also had the firm of Knoedler and Company provide two additional frames. See Frederic Church to Frederick Billings, June 8, 1879; and Church to Billings, June 19, 1879, Billings Mansion Archives.
3. Frederic Church to Frederick Billings, February 14, 1880, Billings Mansion Archives. Church writes: "Before commencing your picture I would like to have all the details fairly understood between us. . . . A 3 foot canvas makes a capital size, and I should expect to do myself justice on such a one. At the same time a large canvas gives greater scope, allows of a richer composition and more striking effects." Church listed his prices at $1,000 for a length of two feet, $2,000 for three feet, $2,500 for three-and-a-half feet, and $3,000 for four feet and noted, "It will give me pleasure to take off 25 per ct from the regular price."
4. Frederick Billings to Frederic Church, February 20, 1880, Frederic Church Archive, Olana State Historic Site.
5. Frederic Church to Frederick Billings, November 9, 1881, Frederic Church Archives, Olana State Historic Site.
6. Frederic Church to Frederick Billings, February 10, 1881, Billings Mansion Archives.
7. Diaries of Frederick Billings, provided by Janet R. Houghton, Billings Mansion Archives, Woodstock, Vermont.
8. "Art Notes," *New York Evening Mail and Express*, January 4, 1882, 3. My thanks to Gerald Carr for sharing this review with me.
9. Franklin Kelly, *Frederic Edwin Church and the National Landscape* (Washington, D.C.: Smithsonian Institution Press, 1988), 67.
10. Ibid., 68. Here Kelly relates *Morning in the Tropics* to the last painting, *Old Age*, in Thomas Cole's *Voyage of Life* series.
11. Winks, *Frederick Billings*, 31–35.

119

FREDERIC EDWIN CHURCH

A View in Cuernavaca, Mexico, c. 1898–1900

Oil on paper mounted on canvas; 9¼ × 12¼ in. (23.5 × 31.1 cm)

EXHIBITED: Municipal Art Society of Hartford, Conn., Annex Gallery, Wadsworth Atheneum, "Loan Exhibition of Paintings, Sculpture, Etchings, Etc.," 1915, no. 64, as "Scene in Mexico (The artist's last work)"

EX COLL.: the artist's children, Mrs. Jeremiah Black (Isabel Church) and Louis Church; to Mrs. Charles Dudley Warner and family by 1915

Gift from the estate of Mrs. Charles Dudley Warner, 1936.448

Church had begun to experience recurrent pain stemming from degenerative rheumatism as early as 1869, a condition that worsened over time.[1] In Mexico, however, he found "a climate more suited to his health," and beginning in 1880 until 1900 he spent most winters there.[2] The artist often made the trip to Mexico in the company of friends, as well as with his son Louis Palmer Church (1870–1943), who began managing his parent's property at Olana beginning in 1891. In 1896, in addition to his son, Church also traveled with Charles Dudley Warner (see cat. 181), author, editor, and close friend.

Church encouraged Warner to join him by writing, "If you wish to see the Spain of 300 years ago you must go to Mexico."[3] The artist was interested in document-

119

ing the ruins of Mexico because, as he explained, "American influence is . . . asserting itself more and more," and with the extension of rail lines "the fatal wedge will soon reach this centre and the old and picturesque will be dismembered."[4]

A View in Cuernavaca, Mexico is based on a drawing from Church's *Mexican Sketchbook* (1893–1898, Olana State Historic Site) dated February 1898. The artist's interest in recording the ancient ruins of the country is evident in this light-filled scene, in which he depicts a close-up view of an arch through which are visible a crumbling wall and a distant view of mountains be-

yond. As a late work, this is a skillfully executed landscape with beautifully rendered vegetation and subtle tones.

Warner began a biography of Church shortly before the artist's death in April 1900. Unfortunately he completed only five chapters before his own death several months later.[5] Warner moved to Hartford in 1860 and there became coeditor of the *Hartford Courant* and later of *Harper's* magazine. In addition to writing biographies of John Smith and Washington Irving, he wrote four novels, including *The Gilded Age* (1873), which he wrote with his friend and neighbor Samuel Langhorne

Frederic E. Church, pencil sketch of brick/stucco arch, inscribed "Feb/98 [Mexico]." New York State Office of Parks, Recreation, and Historic Preservation, Olana State Historic Site.

Clemens. He also wrote the catalogue for the memorial exhibition of Church's paintings held at the Metropolitan Museum in 1900.[6]

Church visited a number of archaeological sites while in Mexico, occasionally acquiring local artifacts. In one instance, in his role as a trustee of the Metropolitan Museum of Art (from 1870–1887), Church made a donation to the museum of "two earthen ware tiles or slabs—Aztec works—which were found near Tampico, Mexico, in the vicinity of extensive ruins." [7] Church felt that "the pair will add something to the meager collection of the Ancient Art of the New World in our Museum and I will be alert to capture other examples of merit."[8]

Louis Church inherited Olana and its contents at the time of his father's death. He and his sister Isabel Charlotte Church (1871–1935) gave this sketch to the Warner family. EMK

1. Franklin Kelly, with Stephen Jay Gould, James Anthony Ryan, and Debora Rindge, *Frederic Edwin Church*, exh. cat. (Washington, D.C.: National Gallery of Art, 1989), 168.
2. Frank Bonnelle, "In Summertime on Olana," *Boston Sunday Herald*, September 7, 1890, 17, quoted in Kelly et al., *Frederic Edwin Church*, 149.
3. Frederic E. Church to Charles Dudley Warner, August 16, 1884, Archives, Olana State Historic Site, Hudson, N.Y.
4. Frederic E. Church to Charles Dudley Warner, December 27, 1884, Archives, Olana State Historic Site, Hudson, N.Y.
5. A typescript of Warner's *Unfinished Biography of the Artist*

is in the Archives, Olana State Historic Site, Hudson, N.Y., and is reproduced with annotations by Debora Rindge in Kelly et al., *Frederic Edwin Church*, 174–199. The original manuscript remains unlocated.
6. *Paintings by Frederic E. Church, N.A.*, exh. cat. (New York: Metropolitan Museum of Art, 1900).
7. Frederic E. Church to Luigi DiCesnola, director, Metropolitan Museum of Art, July 10, 1893, Archives, Metropolitan Museum of Art, quoted in Katherine Emma Manthorne, *Tropical Renaissance: Northern American Artists Exploring Latin America, 1839–1879* (Washington, D.C., and London: Smithsonian Institution Press, 1989), 104.
8. Frederic E. Church to Luigi DiCesnola, September 5, 1893, Archives, Metropolitan Museum of Art, quoted in Manthorne, *Tropical Renaissance*, 105.

Nicolai Cikovsky

Born in Pinsk, Russia, in 1894; died in Washington, D.C., in 1984

As a young boy, Nicolai Cikovsky showed an aptitude for drawing and painting. He attended the Vilna Art School from 1910 to 1914 and then, from 1914 to 1920, the Penza Royal School of Art, where he met the innovative Russian painter Vladimir Tatlin. From 1921 to 1923 he studied at the progressive Moscow technical art institute with Vladimir Favorsky and Ilya Mashkow. He was exposed at this time to the many modernist styles and became a part of the Russian avant-garde.

Cikovsky left Moscow for New York City in 1923, and, having left behind his family and his work, he turned to a new artistic environment in America. He produced cubist- and futurist-inspired paintings in the 1920s and, with support from the scholar and collector Christian Brinton, began showing his works at the Charles Daniel Gallery in New York City. In the 1930s he was introduced to the social realist movement by Raphael Soyer (q.v.), who became his close friend.

In the 1930s Cikovsky's involvement with social concerns was reflected in his membership in the John Reed Club; later he participated in the Artists Union and the American Artists Congress. He painted scenes of urban and rural life, often with social content. He commented on his work in 1939: "The trend towards reality, revolutionary content, and emancipation from Paris influences

120

EX COLL.: James N. Rosenberg, New York City, to 1953

Gift of James N. Rosenberg, 1953.224

This rural landscape of a working farm, possibly in Alexandria, Virginia, is characteristic of the artist's preoccupation with realistic portrayals of scenes from everyday American life. In the vast open fields, the lone figure of a farmer is shown at work, his farmstead neatly laid out behind him. EMK

towards a pure American style, I consider an important development. I believe the future of American art will be more closely identified with the working class; that it will tend to the realistic and will gradually evolve more and more of its own form as well as its content" (Cheney, *Modern Art in America*, 1939, 133–134). During the 1930s, Cikovsky taught at the Corcoran School of Art and executed murals for the Department of the Interior (1938), as well as for several post offices.

As an American Scene painter, Cikovsky's subject matter expanded to include portraits, landscapes, still lifes, and flower paintings. Beginning in the early 1940s Cikovsky and his wife, Hortense, spent summers at their house in Southampton, New York, a region that became the subject of the artist's landscapes. He received many awards for his works during his lifetime.

William Baxter Closson

Born in Thetford, Vt., in 1848; died in Hartford, in 1926

William Closson began his artistic career as a printmaker, having first been introduced to the art of wood engraving in Boston in the 1870s. He developed a reputation for his work as an engraver and opened a studio in Boston, where he became associated with the city's leading artists, particularly George Fuller (q.v.). Closson produced engravings after paintings by Fuller, William Rimmer, and internationally recognized painters such as Jean-François Millet and Edward Burne-Jones. He also began painting figural subjects of idealized women, often depicted as angels with wings or other decorative trappings. He produced engravings after his own works as well.

In 1882 Harper and Brothers sent Closson to Europe to engrave old masters. These engravings were exhibited widely, receiving awards at the Paris Exposition of 1889, the World's Columbian Exposition in Chicago in 1893, and the Graphic Arts Exposition in Vienna in 1901.

By the end of the century, with the advent of new photoreproductive techniques, Closson devoted most of his effort to painting in oil and pastel. His works were mainly figural subjects and landscapes. Closson was a member of numerous art academies, including the Connecticut Academy of Fine Arts, where he exhibited his works. The artist married Grace Gallaudet of Hartford and is buried in that city's Cedar Hill Cemetery.

SELECT BIBLIOGRAPHY

Martha Chandler Cheney, *Modern Art in America* (New York, 1939), 133–134 / Raphael Soyer, *Diary of an Artist* (Washington, D.C., 1977), 221 / Correspondence from Mrs. Nicolai Cikovsky, July 24, 1971, curatorial painting file, Wadsworth Atheneum / Helen Harrison, *Nicolai Cikovsky*, exh. cat. (Southampton, N.Y.: Parrish Art Museum, 1980)

120

NICOLAI CIKOVSKY
Farm Near Alexandria, c. 1935–1940
Oil on canvas; 23⅞ × 37½ in. (60.6 × 95.3 cm)
Signed at lower right: Nicolai Cikovsky

SELECT BIBLIOGRAPHY

William B. Closson, "Fuller's Work Judged by an Engraver," in *George Fuller: His Life and Works* (Boston: Houghton Mifflin, 1886), 80–85 / Frank T. Robinson, *Living New England Artists: Biographical Sketches* (Boston: Samuel E. Cassino, 1888) / obituary, *Bulletin of the Wadsworth Atheneum* 4, no. 6 (October 1926), 20 / Vose Galleries, *The Closson Memorial Exhibition*, exh. cat. (Boston: Vose Galleries, 1927) / William J. Linton, *American Wood Engraving: A Victorian History*, Nancy Carlson Schrock, ed. (1887; rpt., New York: Watkins Glenn, 1976), 64–70 / Charles C. Eldredge, *American Imagination and Symbolist Painting*, exh. cat. (New York: Grey Art Gallery, New York University, 1979), 103, 143–144

121

WILLIAM BAXTER CLOSSON

The Parting, No. 2, 1919

Oil on wood; 33 × 30 in. (83.8 × 76.2 cm)

Signed and dated at lower right: Wm Baxter
Closson / 1919

EXHIBITED: Boston, Vose Galleries, "The Closson Memorial Exhibition," 1927, no. 46 / New York City, Grand Central Art Galleries, "Memorial Exhibition, William Baxter Closson," 1928, no. 9

EX COLL.: artist's estate in 1926; Grace Gallaudet Closson, Newton, Mass., 1926 to 1929

Gift of Mrs. William B. Closson, 1929.308

121

In Closson's romantic depiction, two female figures, both draped in long capes, turn away from the viewer. They are placed in a dark and mysterious landscape that includes formal architectural garden ornaments and a figurative sculpture at the upper right. A large dog in the foreground looks back at the woman moving toward the right. Shortly after the artist's death, his wife gave this painting, which she termed one of "the strongest and best examples of [his] art," to the Atheneum.[1] The collection also contains a number of Closson's prints. EMK

1. Grace Gallaudet Closson to A. Everett Austin, Jr., May 15, 1929, Archives, Acquisitions for 1928, Wadsworth Atheneum.

Thomas Cole

Born in Bolton-le-Moor, Lancashire, England, in 1801; died in Catskill, N.Y., in 1848

The preeminent member of the founding generation of Hudson River school painters, Cole was one of eight children of an English woolen manufacturer. As a young boy, Cole trained as an engraver of woodblocks used for printing calico; lacking formal artistic training, he would derive his aesthetic ideas from poetry and music. During the financial depression that followed the Napoleonic Wars, the Cole family emigrated to America in July 1818. After working briefly as a wood engraver and illustrator in Philadelphia and making a trip to St. Eustatius in the West Indies early in 1819, Cole joined his family in Steubenville, Ohio, where he worked for his father's wallpaper manufactory. At this time he learned the essentials of oil painting from an itinerant portrait painter named John(?) Stein. After moving to Pittsburgh around 1823, Cole began to make landscape studies from nature.

Determined to become a painter, Cole spent the years from 1823 until 1825 in Philadelphia, where he studied the landscapes of Thomas Doughty (q.v.) and Thomas Birch (q.v.). He then moved to New York City in 1825, that summer making his first sketching trip, financed by the merchant George W. Bruen, up the Hud-

son River. The landscapes that resulted from this trip finally brought Cole the success he sought. When John Trumbull (q.v.), William Dunlap (1766–1839), and Asher B. Durand (q.v.) each purchased one of the paintings of Hudson River valley scenery, his future as a landscape painter was assured, and legend was made. He quickly established relationships with important patrons in New York and elsewhere, including Daniel Wadsworth (see Introduction) of Hartford.

Cole continued to make regular summer sketching trips to upstate New York and New England, in 1834 settling permanently in Catskill, New York, where he met and married Maria Bartow in 1836. By the time he made his first trip to Europe in 1829, he was considered America's leading landscape painter. Traveling to London, Paris, Florence, and Rome, he visited artists, galleries, and museums. The high-minded themes and ideas of European art filled his imagination and inspired his romantic spirit. Particular influences were the paintings of J. M. W. Turner and John Constable and the engravings of John Martin. When he returned to America in 1832, he sought to elevate landscape art to the realm of history painting by imbuing his works with lofty themes and a high moral tone. In addition to his views of American scenery, Cole looked to Europe for inspiration. The landscape of Italy particularly intrigued him, offering as it did a historical prologue for America. He drew on the romantic conventions of the European masters, including Claude Lorrain, for his many old world landscapes and historical series.

Cole executed series such as *The Course of Empire* (1836, New-York Historical Society), a five-canvas cycle commissioned by the New York merchant and art collector Luman Reed that depicted the progress of society from the savage state to its ultimate extinction. This series represented the artist's magnum opus, a summary of his political and social philosophy, which held a harsh prophecy for the nation's future. By the late 1830s, the artist's deepening religious faith resulted in *The Voyage of Life* (1840, Munson-Williams-Proctor Institute), a four-part series that proffered individual salvation as a resolution to society's problems. His second trip to Europe, in 1841–1842, furthered his mastery of art and

resulted in the monumental *Mount Etna from Taormina* (cat. 134).

Cole left a formidable body of writing, including journals, poems, correspondence, and an essay on American scenery. At the end of his life, he imparted his knowledge to the young painter Frederic Church (q.v.), his most illustrious student, who would carry on Cole's landscape painting tradition. His untimely death—likely from pleurisy—shook the New York art world and inspired many posthumous tributes and an extensive retrospective exhibition in New York City in 1848. He left behind a firm artistic legacy that would be honored by the school of American landscape painters that succeeded him.

SELECT BIBLIOGRAPHY

Cole Papers, New York State Library, Albany, N.Y. / Louis L. Noble, *The Life and Works of Thomas Cole*, ed. Elliot S. Vesell (1853; rpt., Cambridge: Harvard University Press, Belknap Press, 1964) / Howard S. Merritt, *Thomas Cole*, exh. cat. (Rochester, N.Y.: Memorial Art Gallery of the University of Rochester, 1969) / Alan Wallach, "Thomas Cole and the Aristocracy," *Arts* 56 (November 1981), 94–106 / J. Bard McNulty, ed., *The Correspondence of Thomas Cole and Daniel Wadsworth* (Hartford: Connecticut Historical Society, 1983) / Ellwood C. Parry III, *The Art of Thomas Cole: Ambition and Imagination* (Newark: University of Delaware Press, 1988) / Ellen Sharp, introduction to "A Special Issue: The Drawings of Thomas Cole," *Bulletin of the Detroit Institute of Arts* 66, no. 1 (1990) / William Truettner and Alan Wallach, eds., with Christine Stansell, Sean Wilentz, and J. Gray Sweeney, *Thomas Cole: Landscape Into History*, exh. cat. (New Haven: Yale University Press, for the National Museum of American Art, 1994)

122 (see plate 30)

THOMAS COLE

Kaaterskill Falls, 1826

Oil on canvas; 25¼ × 36⁵⁄₁₆ in. (64.1 × 92.2 cm)

EXHIBITED: Rochester, N.Y., Memorial Art Gallery of the University of Rochester; Utica, N.Y., Munson-Williams-Proctor Institute; Albany, N.Y., Albany Institute of History and Art; and New York City, Whitney Museum of American Art, "Thomas Cole: One Hundred Years Later," 1948–1949, no. 5 / Wadsworth Atheneum, "The Hudson River School: Nineteenth-Century American Landscapes in the Wadsworth Atheneum," 1976, no. 5 / Manitoba, Winnipeg Art Gallery, "A Distant Harmony: Comparisons in Painting in Canada and the United States of America," 1982 / Wadsworth Atheneum, "Framing Art: Frames in the Collection of the Wadsworth Atheneum," 1982 / Wadsworth Atheneum, "'The Spirit of Genius': Art at the Wadsworth Atheneum," 1992

EX COLL.: commissioned by Daniel Wadsworth, Hartford, in 1826

Bequest of Daniel Wadsworth, 1848.15

When Cole returned to New York City after his first sketching trip up the Hudson in 1825, he completed as many as five landscapes of the river and the surrounding Catskill Mountain scenery. That autumn he placed three of them in the shop of William Colman, a book-and-picture dealer, offering them for sale at $25 each. They attracted the attention of John Trumbull (q.v.), president of the American Academy of the Fine Arts, who bought the *Catterskill Upper Fall, Catskill Mountain* (unlocated) and brought the remaining two works to the attention of the artists William Dunlap (1766–1839), who purchased *Lake with Dead Trees* (1825, Oberlin College), and Asher B. Durand (q.v.), who bought *View of Fort Putnam* (unlocated). Dunlap recorded the details of Cole's discovery by the major artists of the day in his *History of the Rise and Progress of the Arts of Design in the United States* (1834), noting that Trumbull had said of Cole's landscapes, "This youth has done at once, and without instruction, what I cannot do after 50 years practice."[1]

In December 1825 Colonel Trumbull allowed *Catterskill Upper Fall, Catskill Mountain* to be exhibited at the American Academy of Fine Arts, and the following year he lent it to the academy again. Daniel Wadsworth, who was Trumbull's nephew-in-law, was made aware of Trumbull's interest in the young artist Cole and may have viewed Cole's recent works in New York at this time. A series of letters between Cole and Wadsworth indicates that Wadsworth ordered a copy of the picture that Trumbull had purchased less than a year earlier.[2]

Cole wrote to Wadsworth on July 6, 1826, from Catskill: "I have for the last month or two been enjoying & I hope improving myself amidst beautiful scenery of Lake George & the wild magnificence of the Catskill mountains—I have made many sketches and amongst the rest that view of the Falls of Kaaterskill which you chose. It is similar to the one Col Trumbull has, but I am not quite pleased with it." Cole proposed painting a different view of the falls from one of his many sketches rather than repeating the view Trumbull had acquired.[3] Wadsworth was so taken with the original view, however, that he turned down Cole's offer. Cole executed the copy as ordered but commented in a letter to Wadsworth: "I have at last finished your picture and shall forward it in a few days. I am sorry to say that I have not pleased myself in it, and am afraid you will be disappointed—I have laboured twice as much on this picture as the one you saw: but not with the same feeling. I cannot paint a view twice and do justice to it. . . . Some parts of this may be better than Col. Trumbull[']s painting but on the whole it is not—I hope that if ever you again favour me with an order for a picture I shall be more fortunate in its execution—The view is a little different to the other."[4] Despite Cole's misgivings, however, Wadsworth was quite satisfied with the painting and ordered several other landscapes from him, thus initiating a long association as a major patron and friend of the artist.

The site Cole depicted for both Trumbull and Wadsworth, Kaaterskill Falls, was by this time considered one of the great scenic wonders of the northeast. Located in Greene County, New York, in the eastern range of the Catskill Mountains, the twin-tiered cascade falls two hundred and sixty feet into the Catskill Clove, joining the Catskill Creek about twelve miles west of the town of Catskill, and eventually flowing into the Hudson River. By the time Cole first depicted the site in 1825, a tourist hotel, the Catskill Mountain House, had been in existence for a year. The first artist of note to focus attention on the site, Cole settled permanently in the town of Catskill in 1836. In 1843 he gave the following evocative description of the falls: "There is a deep gorge in the midst of the loftiest Catskills, which is terminated at its upper end by a mighty wall of rock. As the spectator approaches from below, he sees its craggy and impending front rising to the height of three hundred feet. . . . The cataract leaps, and foaming into feathery spray, descends into a rocky basin. . . . The stream . . . a thing of life and motion . . . is sufficient, at all times, to give expression to the scene, which is one of savage and silent grandeur."[5]

In his two views of the upper fall seen from beneath the rock semidome, Cole provided a romantic vision of the American wilderness. The dark and dramatic scene includes a stormy sky and turbulent spray from the falls. Standing as though inside a huge cavern, the viewer is thrown into the scene without the benefit of a conventional foreground, rather than being presented with a full view of the natural amphitheater behind the upper portion of the falls. Drawing on his knowledge of picturesque theory, Cole used a framing element—the outer cavern walls—to heighten the painting's effect on the viewer. He evoked the season with touches of autumnal color. An Indian stands on a precipice in the center middle ground, surveying the wild beauty before him. Cole eliminated all signs of tourism. The inclusion of a Native American—even though, by this time, indigenous people were no longer settled in this part of the Northeast—was symbolic of the nation's distant past.

A drawing by Cole for Wadsworth's version of *Kaaterskill Falls* in the collection of the Detroit Institute of Arts is inscribed "Copy for Mr. Wadsworth." The painting was later engraved by Fenner Sears and published by J. H. Hinton in his *History and Topography of the United States* (London, 1832). In addition, William Guy Wall (1792–after 1863), aware of Cole's talents, was likely influenced by Cole's *Catterskill Upper Fall, Catskill Mountains*, which he could have seen when it was exhibited in 1825 and again in 1826 at the American Academy of Fine Arts. Wall's own view of the falls, *Cauterskill Falls on the Catskill Mountains, Taken from Under the Cavern*, was exhibited at the National Academy of Design in 1827 and, as John K. Howat suggests, bears a striking similarity to Cole's view in that he depicts the same scene in the same season; Wall's topographically rendered view, which includes the pres-

Thomas Cole, *Kaaterskill Falls*, 1826. Detroit Institute of Arts.

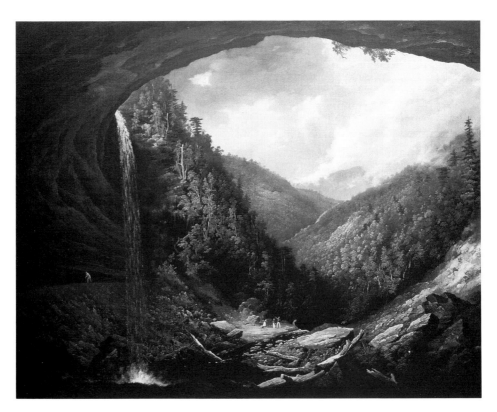

William Guy Wall, *Cauterskill Falls on the Catskill Mountains, Taken from Under the Cavern*, c. 1827. Honolulu Academy of Arts, gift of the Mared Foundation, 1969.

ence of contemporary tourists, lacks the romantic vision of Cole's earlier version, however.[6] Cole made several additional drawings of the site in 1825 or 1826 (Detroit Institute of Arts) and also painted additional canvases of Kaaterskill Falls in 1826 and 1827, indicating the artist's sustained interest in the subject.[7] (See cat. 477 for a discussion of Cole's *Falls of the Kaaterskill* [1827, private collection].)

The painting has retained its original frame. EMK

1. For the best-known account of Cole's discovery by New York artists and patrons, see William Dunlap, *History of the Rise and Progress of the Arts of Design in the United States* (1834; rpt., New York: Dover, 1969), 2:359–360. For an updated and more accurate version of the events of Cole's early years, see Ellwood C. Parry III, "Thomas Cole's Early Career, 1818–1829," in Edward Nygren, with Bruce Robertson, eds., *Views and Visions: American Landscape before 1830*, exh. cat. (Washington, D.C.: Corcoran Gallery of Art, 1986), 161–187; and idem, *The Art of Thomas Cole: Ambition and Imagination* (Newark: University of Delaware Press, 1988), 36–47.
2. J. Bard McNulty, ed., *The Correspondence of Thomas Cole and Daniel Wadsworth* (Hartford: Connecticut Historical Society, 1983), 1–6.
3. Ibid., 1.
4. Ibid., 4.
5. Quoted in John K. Howat, "A Picturesque Site in the Catskills: The Kaaterskill Falls as Painted by William Guy Wall," *Honolulu Academy of Arts Journal* 1 (1974), 58.
6. Howat, "A Picturesque Site," 58.
7. The various drawings and paintings are discussed in Gerald Carr's entry on *From the Top of Kaaterskill Falls*, in *American Paintings in the Detroit Institute of Arts*, ed. Nancy Rivard Shaw (New York: Hudson Hills Press, in association with the Founders Society, Detroit Institute of Arts, 1991), 48–50; as well as in Parry, *The Art of Thomas Cole*, 41–48.

123 (see plate 31)

THOMAS COLE

Landscape, Composition, St. John in the Wilderness, 1827
Oil on canvas; 36 × 28¹⁵/₁₆ in. (91.4 × 73.5 cm)
Signed and dated at lower left: T. Cole / 1827

EXHIBITED: New York City, National Academy of Design, "Annual Exhibition," 1827, as no. 16, *Landscape, Composition, St. John in the Wilderness* / Albany, N.Y., Albany Institute of History and Art, "The Works of Thomas Cole," 1941 / Art Institute of Chicago, and New York City, Whitney Museum of American Art, "The Hudson River School and the Early American Landscape Tradition," 1945, no. 58 / London, Tate Gallery, "American Painting from the Eighteenth Century to the Present Day," 1946, no. 42 / Wadsworth Atheneum, "Thomas Cole: One Hundred Years Later," 1948–1949, no. 7 / Birmingham, Ala., Birmingham Museum of Art, "Opening Exhibition," 1951, no. 37 / New York City, American Academy of Arts and Letters, "The Great Decade in American Writing, 1850–1860, with Paintings by Friends and Contemporaries of the Authors," 1954, no. 110 / Baltimore Museum of Art, "Thomas Cole— Paintings by an American Romanticist," 1965, no. 5 / Berkeley, Calif., University Art Museum; Washington, D.C., National Collection of American Art; Dallas Museum of Fine Arts; and Indianapolis Museum of Art, "The Hand and the Spirit: Religious Art in America, 1771–1900," 1973, no. 46 / Wadsworth Atheneum, "The Hudson River School: Nineteenth-Century American Landscapes in the Wadsworth Atheneum," 1976, no. 7

EX COLL.: Daniel Wadsworth, Hartford, in 1827

Bequest of Daniel Wadsworth, 1848.16

Executed without a commission, Cole's *Landscape, Composition, St. John in the Wilderness* was exhibited in 1827 at the National Academy of Design in New York City, along with five other landscapes, including *Landscape, Scene from "The Last of the Mohicans"* (1827, New York State Historical Association; see cat. 125). In this work, Cole freed himself from the confines of observed facts, using his imagination to compose a scene that conveyed a message. Cole's use of the word *composition* in his title for this landscape implied that he envisaged a high moral theme—what he called a "higher style"—for the work, placing it in the realm of history painting. He explained his attitude toward his art at this time to his patron Robert Gilmor:

> I do not conceive that compositions are so liable to be failures as you suppose. . . . The finest pictures which have been produced, both Historical and Landscape, have been compositions. . . . If the imagination is shackled, and nothing is described but what we see, seldom will anything truly great be

produced either in Painting or Poetry. . . . A departure from Nature is not a necessary consequence in the painting of compositions: on the contrary, the most lovely and perfect parts of Nature may be brought together, and combined in a whole that shall surpass in beauty and effect any picture painted from a single view.[1]

An intensely religious man, Cole maintained that the divine presence could be felt in the wilderness. The wilderness landscape that he devised for St. John was based on studies from nature and dealt with a passage from the Gospel according to Matthew, which begins, "In those days came John the Baptist, preaching in the wilderness of Judea, 'Repent, for the kingdom of heaven is at hand.' For this is he who was spoken of by the prophet Isaiah when he said, 'The voice of one crying in the wilderness: Prepare the way of the Lord, make his paths straight'"(Matthew 3:1–3).

The foreground of the painting is dominated by a large rock formation that serves as an altar for the figure of St. John, who stands atop the boulder. The rocky pulpit bears the profile of a human face, which hangs over the valley, seemingly defying gravity.[2] Below is an illuminated valley with a stand of palm trees and two minute figures, a man leading a woman on horseback, evoking the Holy Family's journey. A towering pinnacle of rock rises above the valley, and a waterfall cascades downward. Behind and to the left looms a high peaked mountain. The dramatic effects of the scene are further enhanced by the sharp contrasts of light and dark and the mists that rise up in a curl to meet the burst of white clouds in the sky. The figure of John the Baptist, clad only in a loin cloth and standing next to a wooden cross, appears diminutive against the dark looming forms of the rocks and valley that make up the natural landscape. Pointing to its sublime qualities, oedipal imagery, and patterns of metaphor, Bryan Wolf has explored this painting in light of Cole's romantic imagination at work.[3]

Cole's emblematic personifications of nature, seen in the anthropomorphic rock formation and the other dramatic forms, serve as images of God's presence in the unfolding historical drama of civilization. Although less didactic, this painting foreshadows Cole's three allegorical series, *The Course of Empire* (1836), *The Voyage of Life* (1840–1842), and *The Cross and the World* (begun in 1845).

This painting was probably seen by Daniel Wadsworth on a trip to New York in the late spring or early summer of 1827, for he bought it that same year for $75.[4] On November 5, 1827, Wadsworth instructed Cole to send the painting, noting, "I can have [frames] made here, for John the Baptist."[5] At Cole's request, Wadsworth allowed the painting to be exhibited the following year at the Boston Athenaeum. EMK

1. Thomas Cole to Robert Gilmor, December 25, 1826, reprinted in "Correspondence Between Thomas Cole and Robert Gilmor, Jr.," appendix 1 in *Annual II: Studies on Thomas Cole, An American Romanticist*, ed. Howard S. Merritt (Baltimore: Baltimore Museum of Art, 1967), 47.
2. J. Gray Sweeney, "The Nude of Landscape Painting: Emblematic Personification in the Art of the Hudson River School," *Smithsonian Studies in American Art* 3, no. 4 (fall 1989), 47–48.
3. Bryan Jay Wolf, *Romantic Re-Vision: Culture and Consciousness in Nineteenth-Century American Painting and Literature* (Chicago: University of Chicago Press, 1982), 228–236.
4. Ellwood C. Parry III, *The Art of Thomas Cole: Ambition and Imagination* (Newark: University of Delaware Press, 1988), 53.
5. J. Bard McNulty, ed., *The Correspondence of Thomas Cole and Daniel Wadsworth* (Hartford: Connecticut Historical Society, 1983), 17.

124 (see plate 32)

THOMAS COLE

View in the White Mountains, 1827

Oil on canvas; 25³⁄₈ × 35³⁄₁₆ in. (64.5 × 89.4 cm)

EXHIBITED: New York City, National Academy of Design, "Annual Exhibition," 1828, no. 2, as "'View in the White Mountains,' owned by D. Wadsworth" / New York City, Whitney Museum of American Art, "A Century of American Landscape Painting," 1939, no. 74 / Albany, N.Y., Albany Institute of History and Art, "The Works of Thomas Cole," 1941 / Art Institute of Chicago, and New York City, Whitney Museum of

American Art, "The Hudson River School and the Early American Landscape Tradition," 1945, no. 155 / Wadsworth Atheneum, "Thomas Cole: One Hundred Years Later," 1948–1949, no. 8 / Manchester, N.H., Currier Gallery of Art, "Artists in the White Mountains: An Exhibition Commemorating the 150th Anniversary of 'The Old Man of the Mountains,'" 1955, no. 5 / Washington, D.C., Corcoran Gallery, "The American Muse," 1959, no. 22 / Washington, D.C., National Museum of American Art, "American Landscapes: A Changing Frontier," 1966, no. 10 / Dallas Museum of Fine Arts, "The Romantic Vision in America," 1971, no. 41 / Ann Arbor, Mich., University of Michigan Museum of Art, "Art and the Excited Spirit," 1972, no. 41 / Wadsworth Atheneum, "The Hudson River School: Nineteenth-Century American Landscapes in the Wadsworth Atheneum," 1976, no. 6

EX COLL.: commissioned by Daniel Wadsworth, Hartford, in 1827

Bequest of Daniel Wadsworth, 1848.17

When Cole visited his friend and patron Daniel Wadsworth in Hartford in July 1827, Wadsworth encouraged him to visit the White Mountains of New Hampshire. As one of the first to appreciate the region's aesthetic qualities, Wadsworth himself had gone on a sketching trip there the preceding summer and was thus able to provide Cole with a written itinerary for the trip.[1] Cole followed his friend's advice, writing to Wadsworth on August 4, 1827, from Center Harbour, New Hampshire: "I am encompassed by beautiful scenery. . . . It is here in such sublime scenes that man sees his own nothingness, and the soul feels unutterable."[2] He made two trips to the White Mountains—in 1827 and 1828—accompanied by Henry Cheever Pratt (1803–1880), which resulted in diaries and sketchbooks by both artists.[3]

Returning from his 1827 trip, Cole stopped in Hartford to show Wadsworth his sketches, and by August 16 he was back in New York City. Later that month Wadsworth wrote Cole, "Ever since you went from here, I have felt that it would be impossible for me to resist the temptation, of having a picture of the Coroway Peak with the little lake.—I think it is one of the most beautiful of your subjects.—I will therefore thank [you] to Paint one for me."[4]

Cole painted *View in the White Mountains*, based on the many sketches he had executed there. In a notebook entitled "Book of Sketches from Pictures I Have Painted Since My Return from White Mountains 1827," Cole inscribed one of the sketches for this painting as follows: "A morning in spring about 10 o'clock. Clouds. windy, cool. Snow on Mt. Washington. Many parts of landscaping shaded by clouds. Water lying on road as though there had been rain. Tree in foreground having appearance of being miserably blown down."[5] In addition there is an oil study entitled *View of the White Mountains, New Hampshire (Storm near Mt. Washington)*, in which the artist included a stream in the foreground and two figures, one carrying a gun and the other a walking stick, accompanied by a dog.[6]

Although he honored most of the landscape elements in the oil sketch, Cole heightened the sublime aspects in the final painting. He added a deep perspective in the foreground, with light striking a roadway and figures placed intermittently to mark the receding space. A deep valley in the middle ground leads back toward the foothills at the base of the snowcapped Mount Washington. In the foreground, a man carrying a basket in his right hand, with an ax thrown over his left shoulder, walks toward a large vine-covered tree, a fallen branch from which lies across the road, blocking his progress. Behind the settler, along the path, can be seen a number of tree stumps—symbols of the rapid settlement of the wilderness.[7] The blasted tree branch serves as a reminder of the power of untamed nature. Large rocks and vegetation contribute balance to the composition.

On receiving the painting in December 1827, Wadsworth wrote to Cole that he found it to be "a most beautiful scene" and requested a description of the precise location, "as I shall wish when asked to say distinctly."[8] Cole replied on December 8, 1827, "The view of M Washington is taken about nine miles from Crawfords, on the road to Franconia—The yellow lines on the Mountains are the traces of slides which are numerous, particularly on M. Pleasant—the river you see in the valley is the Amonasuc rather more obvious than it is commonly in nature. I suppose the view to be taken in the morning about nine or ten, after a stormy night—

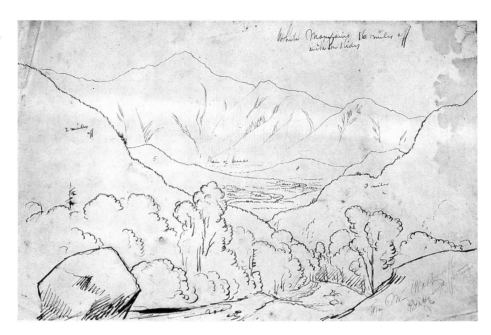

Thomas Cole, *White Mountains*, 1827. Detroit Institute of Arts, purchase, William H. Murphy Fund.

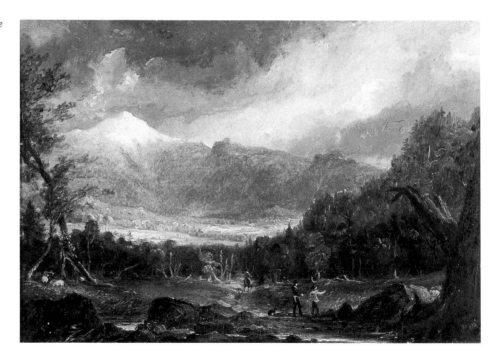

Thomas Cole, *View of the White Mountains, New Hampshire (Storm near Mt. Washington)*, c. 1825–1830. Yale University Art Gallery, Ellen Battell Stoeckel Trust.

you may see there has been rain by the pieces of water in the cart tracks."[9]

Wadsworth wrote again on December 21, 1827, describing his sister's reaction after looking at the picture: "I am sure I can walk upon that road . . . —And that Tree in its fore ground is as real as a tree in Nature, & indeed more real than anyone out doors." The painting was exhibited at the National Academy of Design in 1828.[10]

Impressed by the rugged beauty of this region, Cole made a third trip to the White Mountains in 1839 and would draw on the imagery from his three trips for numerous landscapes (cat. 127).[11] EMK

CATALOGUE NUMBER 125

1. See J. Bard McNulty, ed., *The Correspondence of Thomas Cole and Daniel Wadsworth* (Hartford: Connecticut Historical Society, 1983), 7–9.

2. Ibid., 10–12.

3. Catherine H. Campbell, "Two's Company: The Diaries of Thomas Cole and Henry Cheever Pratt on Their Walk through Crawford Notch, 1828," *Historical New Hampshire* 23 (winter 1978), 312–316. A transcription of Cole's journal, "Sketch of My Tour to the White Mountains with Mr. Pratt," appears in *Bulletin of the Detroit Institute of Arts* 66, no. 1 (1990), 27–35.

4. McNulty, *Correspondence*, 58–59n. 4.

5. See ibid., 26. The drawing is in the collection of the Detroit Institute of Art, Sketchbook No. 2, 39.559.

6. Theodore E. Stebbins, Jr., and Galina Gorokhoff, *A Checklist of American Paintings at Yale University* (New Haven: Yale University Art Gallery, 1982), 30–31.

7. Nicolai Cikovsky, Jr., "'The Ravages of the Axe': The Meaning of the Tree Stump in Nineteenth-Century American Art," *Art Bulletin* 61 (December 1979), 611–626.

8. McNulty, *Correspondence*, 22–23.

9. Ibid., 26.

10. Ibid., 27–28.

11. For a discussion of Cole's trips to the White Mountains, see Judith A. Ruskin, "Thomas Cole and the White Mountains: The Picturesque, the Sublime, and the Magnificent," *Bulletin of the Detroit Institute of Arts* 66, no. 1 (1990), 19–27.

125 (see plate 33)

THOMAS COLE

Scene from "The Last of the Mohicans," Cora Kneeling at the Feet of Tamenund, 1827

Oil on canvas; 25³⁄₈ × 35¹⁄₁₆ in. (64.5 × 89.1 cm)

Signed and dated at lower center on rock: T. Cole 1827.

Inscribed, signed, and dated on back in black paint:

> Scene from the Last of the Mohicans. 2 Vol., Chap. 12. T. Cole 1827

EXHIBITED: New York City, National Academy of Design, "Annual Exhibition," 1828, no. 31, as "Scene from 'The Last of the Mohicans,' Cora Kneeling at the Feet of Tamenund" / New York City, Museum of Modern Art, "Romantic Painting in America," 1943–1944, no. 51 / Wadsworth Atheneum, "Thomas Cole: One Hundred Years Later," 1948–1949, no. 6 / Cooperstown, N.Y., New York Historical Association, "James Fenimore Cooper Centennial Exhibit," 1951 / Denver, Colo., Denver Art Museum, "Art Tells the Story," 1953 / Hartford, Trinity College, "Euphorion or Aspects of Romanticism in Art and Literature at Home and Abroad," 1955, no. 1 / Geneseo, N.Y., State University of New York, "Hudson River School," 1968 / Chapel Hill, N.C., William Hayes Ackland Memorial Art Center, "The Age of Dunlap: The Arts of the Young Republic," 1968, no. 105 / New York City, M. Knoedler and Co., "What Is American in American Art," 1971, no. 25 / Washington, D.C., Corcoran Gallery of Art, "Wilderness," 1971, no. 71 / Jacksonville, Fla., Cummer Gallery of Art, "1822: Sesquicentennial Exhibition," 1972, no. 4 / New York City, Whitney Museum of American Art, "The American Frontier: Images and Myths," 1973, no. 18 / Milwaukee, Wis., Milwaukee Art Center, "From Foreign Shores: Three Centuries of Art by Foreign-Born American Masters," 1976, no. 13 / Wadsworth Atheneum, "The Hudson River School: Nineteenth-Century American Landscapes in the Wadsworth Atheneum," 1976, no. 8 / Kansas City, Mo., William Rockhill Nelson Gallery of Art, "Kaleidoscope of American Painting," 1977 / Paris, Galeries Lafayette, "Deux Cents Ans de Peinture Américaine: Collection du Musée Wadsworth Atheneum," 1989

EX COLL.: Daniel Wadsworth, Hartford, in 1827; willed to Alfred Smith, Hartford, in 1848; to the Wadsworth Atheneum in 1868

Bequest of Alfred Smith, 1868.3

Cole's painting *The Last of the Mohicans* was inspired by a passage from James Fenimore Cooper's popular novel of the same title, which became an instant bestseller after its publication early in 1826. In the summer of that year, Cole went on an extended trip to the area of Lake George in northern New York State and visited Fort Ticonderoga, a location that had recently been made famous by Cooper's novel.[1] Following this trip, one of Cole's major patrons, Robert Gilmor, of Baltimore, wrote to him on August 1, 1826, requesting a painting of "some known subject from Cooper's novels to enliven the landscape."[2] Cole did not immediately act on this request, but in the following year, for the National Academy of Design exhibition in New York City, he painted a picture entitled *Scene from the Last of the Mohicans* (1827, University of Pennsylvania, Philadelphia).

Also in 1827 Cole painted another scene from Cooper's novel, but before he could ship it to Gilmor, Daniel

Wadsworth purchased it. Titled *Scene from "The Last of the Mohicans," Cora Kneeling at the Feet of Tamenund*, it was exhibited at the National Academy of Design in 1828, at which time it was already owned by Wadsworth. Cole identified the subject for the viewer with an inscription on the back of the painting, noted above. Inasmuch as the painting conveys little narrative detail, Cole seemed to rely on the viewer's familiarity with Cooper's description:

> Magua cast a look of triumph around the whole assembly before he proceeded to the execution of his purpose. . . . He raised Alice from the arms of the warrior against whom she leaned, and beckoning Heyward to follow, he motioned for the encircling crowd to open. But Cora, instead of obeying the impulse he had expected of her, rushed to the feet of the patriarch, and raising her voice, exclaimed aloud— "Just and venerable Delaware, on thy wisdom and power we lean for mercy! Be deaf to yonder artful and remorseless monster who poisons thy ears with falsehoods to feed his thirst for blood. . . ." The eyes of the old man opened heavily, and he once more looked upwards at the multitude. As the piercing tone of the supplicant swelled on his ears, they moved slowly in the direction of her person, and finally settled there in a steady gaze. Cora had cast herself to her knees; and, with hands clenched in each other and pressed upon her bosom, she remained like a beauteous and breathing model of her sex, looking up in his faded, but majestic countenance with a species of holy reverence.[3]

A series of letters between Cole and Wadsworth reveals that Wadsworth allowed the artist to delay delivery of the painting in order to paint a similar scene for Robert Gilmor. Wadsworth wrote to Cole on November 5, 1827, "Will you order such a frame for the 'Last of the Mohicans' as you would like best to see it in,—and send it with the Picture by the Steam Boat, as soon as you have done the Copy entirely to your mind."[4] The Wadsworth painting retains its original frame. Drawings for both paintings exist in the Cole sketchbooks at the Detroit Institute of Arts.

Despite the fact that Cole had visited the area of Lake George (the site Cooper had selected for this pas-

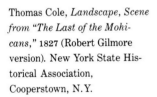

Thomas Cole, *Landscape, Scene from "The Last of the Mohicans,"* 1827 (Robert Gilmore version). New York State Historical Association, Cooperstown, N.Y.

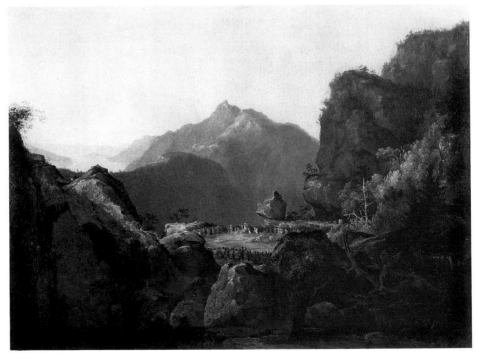

sage) in the early summer of 1826, the artist chose to use White Mountain scenery (a region Wadsworth had introduced to Cole in the summer of 1827), including Mount Chocorua and Lake Winnipesaukee, in both the Wadsworth and Gilmor versions of *The Last of the Mohicans*.[5] White Mountain scenery had assumed a primary position in Cole's mind at this time, replacing the Catskill Mountains; Mount Chocorua, for instance, dominated Cole's single-view paintings in the years 1827 and 1828.[6] In addition, by using a scene that he had described in a letter to Wadsworth as "far beyond my expectation and . . . the finest one I have ever beheld," Cole created a "composition" that carried the message he wished to convey rather than merely a transcription of nature.[7]

Cole combines the real and the ideal in this work—a faithful rendering of White Mountain scenery in the background with idealized geological features enhancing the minute narrative scene in the foreground. The circular stage, set on a rocky ledge, the vast rock outcroppings, and the dramatic chiaroscuro combine to enhance the theatrical effect of the scene. The result delighted his patron, who understood the picture in the larger terms Cole intended. On receiving it, Wadsworth wrote Cole on December 4, 1827:

> I can hardly express my admiration, the Grand & Magnificent Scenery,—the Distinctness with which every part of it, is made to stand forward, & speak for itself.—The deep Gulfs, into which you look from real precipices,—The heavenly serenity of the firmament, contrasted with the savage grandeur, & wild Dark Masses of the Lower World,—whose higher pinnacles only, catch a portion, of the soft lights where all seems peace. . . . And all these objects so exquisitely finished, that it appears as if each one had been the object of particular care. . . . It seems to me that nothing can improve [this painting].[8]

Wadsworth paid Cole $100 for the painting and $15 for the frame.[9]

Cole's interest in science has been well documented in recent years.[10] He was acquainted with Benjamin Silliman (1778–1864), a leading professor of natural history and chemistry at Yale College and the brother-in-law of Daniel Wadsworth, himself an avid amateur geologist. Cole's interest in science is evident in the landscape features with which Cole chose to surround the narrative scene, particularly the round boulder or "rocking stone," as it was known at this time—an object of great curiosity in New England and discussed at length in Silliman's writings.[11] It is important to remember that such natural phenomena were considered by Silliman and others of the period to be divine aspects of nature. Here the rocking stone is precariously resting atop a high pinnacle (in the Gilmor version, a large rocking stone is on a ledge) marking the sacred spot for the tribal gathering of the Delawares. The feature is associated with pagan ritual and serves to dwarf further the figures below.[12] The rock formations used by Cole in Wadsworth's version, particularly the phallic pinnacle and, to its right, a large cave behind the group of figures, evoke the sexual tension in Cooper's novel.[13]

Wadsworth also owned a painting by Cole of Mohawk Valley scenery; it is listed in his inventory as *Scene in the Valley of the Mohawk* and valued at $150 (the same amount as *Last of the Mohicans*).[14] This work, which was undoubtedly the same as that bearing the more familiar title *View of l'Esperance on the Schoharie River* (1826–1828, private collection), was left in Wadsworth's will to his relation, Joseph Trumbull.[15]

Wadsworth allowed *Last of the Mohicans* to be engraved and published in a giftbook, *The Token: A Christmas and New Year's Present* (Boston, 1831).[16] He willed the painting to his close associate, Alfred Smith, who later left it to the Wadsworth Atheneum. EMK

1. Ellwood C. Parry III, "Thomas Cole's Early Career, 1818–1829," in *Views and Visions: American Landscape before 1830*, exh. cat., ed. Edward Nygren, with Bruce Robertson (Washington, D.C.: Corcoran Gallery of Art, 1986), 172.
2. Appendix 1 in *Annual II: Studies on Thomas Cole, an American Romanticist* (Baltimore: Baltimore Museum of Art, 1967), 44.
3. James Fenimore Cooper, *The Last of the Mohicans* (1826; rpt., Cambridge, Mass.: Riverside Press, 1958), 324.
4. J. Bard McNulty, ed., *The Correspondence of Thomas Cole and Daniel Wadsworth* (Hartford: Connecticut Historical Society, 1983), 17.
5. Gilmor wrote to Cole on December 5, 1827: "I can see no ob-

jection to your going anywhere for a part of your scenery though the tale is located near Lake George, so all that is necessary is that it should be appropriate." When Gilmor's version was shown in Philadelphia in 1828, the title included the following description: "A composition of real scenes— The mountain is Corroway Peak, and the Lake is Winisioge Lake with Rattlesnake Island, in N. Hampshire." Both quotations from Ellwood C. Parry III, *The Art of Thomas Cole: Ambition and Imagination* (Newark: University of Delaware Press, 1988), 65.

6. Parry, "Cole's Early Career," 178–179.
7. Thomas Cole to Daniel Wadsworth, August 4, 1827, in McNulty, *Correspondence*, 12.
8. Ibid., 22–23.
9. Ibid., 25.
10. Ellwood C. Parry III, "Acts of God, Acts of Man: Geological Ideas and the Imaginary Landscapes of Thomas Cole," in *Two Hundred Years of Geology in America*, ed. Cecil J. Schneer (Hanover: University of New Hampshire, 1979), 53–71; and Barbara Novak, *Nature and Culture: American Landscape Painting, 1825–1875* (New York: Oxford University Press, 1980), 54–57.
11. Parry, "Acts of God," 57 n. 10.
12. Parry, *The Art of Thomas Cole*, 64–65.
13. Richard Slotkin, introduction to James Fenimore Cooper, *The Last of the Mohicans* (New York: Penguin, 1988), ix–xxviii.
14. Inventory of the estate of Daniel Wadsworth, September 30, 1848, Connecticut State Library, Hartford, copy in curatorial painting file, Wadsworth Atheneum.
15. "The Will of Daniel Wadsworth," April 10, 1847, 2, copy in curatorial painting file, Wadsworth Atheneum. For the identity of the painting, see McNulty, *Correspondence*, 27–28, and Ellwood C. Parry III to Wadsworth Atheneum, July 7, 1992, curatorial painting file, Wadsworth Atheneum.
16. Parry, "Acts of God," 67, fig 4.

126 (see plate 34)

THOMAS COLE

View of Monte Video, the Seat of Daniel Wadsworth, Esq., 1828

Oil on wood; 19³/₄ × 26¹/₁₆ in. (50.2 × 66.2 cm)

Signed and dated at lower right: Cole / 1828.

Signed on back: Cole / 1828

EXHIBITED: New York City, National Academy of Design, "Annual Exhibition," 1829, no. 37, as "View of Monte Video, the Seat of Daniel Wadsworth, Esq." / Wadsworth Atheneum, "Landscape Painting," 1931, no. 89 / Wadsworth Atheneum, "Thomas Cole: One Hundred Years Later," 1948–1949, no. 11 / Hartford, Connecticut Historical Society, "Connecticut Views on Staffordshire China," 1955, no. 91 / New York City, M. Knoedler and Co., "Masterpieces from the Wadsworth Atheneum, Hartford," 1958 / Seattle, University of Washington, "The View and the Vision: Landscape Painting in Nineteenth Century America," 1968, no. 8 / New York City, Paul Rosenberg and Co., "The American Vision—Paintings 1825–1875," 1968, no. 79 / Wadsworth Atheneum, "The Hudson River School: Nineteenth-Century American Landscapes in the Wadsworth Atheneum," 1976, no. 9 / Wadsworth Atheneum, "'The Spirit of Genius': Art at the Wadsworth Atheneum," 1992

EX COLL.: commissioned by Daniel Wadsworth, Hartford, 1828

Bequest of Daniel Wadsworth, 1848.14

Between 1805 and 1809 Daniel Wadsworth, in conjunction with his uncle-in-law, John Trumbull, designed and built his country estate, called Monte Video, on the top of Talcott Mountain in Avon (then Farmington), Connecticut.[1] Wadsworth continued to acquire land on the site, and at the time of his death the estate comprised two hundred and fifty acres. The Gothic features on the house and outbuildings made Monte Video among the earliest and certainly most elaborate Gothic Revival country estates in America.[2]

One of Wadsworth's many sketches of his estate was engraved and published by his brother-in-law, Benjamin Silliman (1779–1864) in *Remarks Made, on a Short Tour, between Hartford and Quebec* (1820). The sketch supplemented Silliman's written description of scenery: "The diameter of the view in two directions, is more than ninety miles, extending into the neighboring states of Massachusetts and New York, and comprising the spires of more than thirty of the nearest towns and villages. The little spot of cultivation surrounding the house and the lake at your feet, with its picturesque appendages of boat, winding paths, and Gothic buildings, compose the foreground of this grand Panorama."[3]

Alan Wallach has recently explored the development of the panoramic mode in nineteenth-century thought and landscape art, writing "in the panorama . . . the world is presented as a form of totality; nothing seems

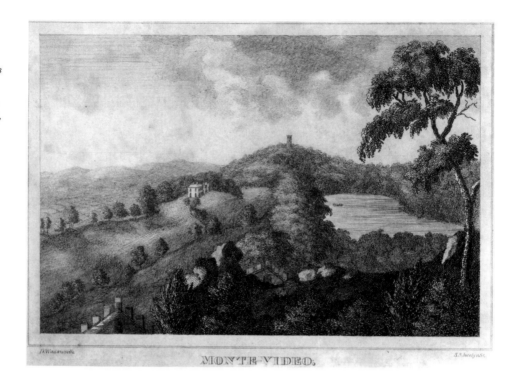

MONTE-VIDEO.

hidden; the spectator, looking down a vast scene from its center, appears to preside over all visibility."[4] At Monte Video, the focal point was a fifty-five-foot hexagonal wooden tower, completed by Wadsworth in 1810.[5] Wadsworth's selection of a spectacular mountain site for his estate and the even greater viewing power provided by the grand height of his tower allowed him and the many visitors to the site to experience sublimity and a sense of power.

One of the frequent guests at the estate was Silliman's eleven-year-old daughter, Maria Trumbull Silliman, who, while on a visit to her uncle's country home in 1821, wrote to her parents describing her impressions:

> On the way here we saw pieces of rocks that had rolled off the mountain, Papa said, thousands of years ago, some of them nearly as large as the house. Uncle has made gravel walks all over the mountain. This morning we went up to the tower & could see as far as the Taconic, which is in Massachusetts & a mountain in the state of New York, and Mount Carmel near New Haven.
>
> The top of the tower is 800 feet above the valley.[6]

Her mention of the large rocks that had rolled off the mountain is interesting in light of Cole's fascination with rocking stones, shared also by his friends Wadsworth and Silliman, which he often incorporated into his American landscapes—*The Last of the Mohicans* (cat. 125), for example.[7]

Wadsworth's house was situated in such a way that from any room one could contemplate to the east a vision of the American wilderness in its primeval state and to the west, down the valley, a view of the rapid cultivation and settlement of the American landscape. Silliman described this phenomenon as follows: "Beyond the water, and the open ground in the immediate neighborhood of the house, rocks and forests alone meet the eye, and appear to separate you from the rest of the world. But at the same moment you are contemplating this picture of the deepest solitude, you may without leaving your place, merely by changing your position, see through one of the long Gothic windows of the same room . . . the glowing western valley, one vast sheet of cultivation, filled with inhabitants."[8]

In July 1827 Thomas Cole visited his friend and pa-

tron, Daniel Wadsworth, at Monte Video. Correspondence between them indicates that in the latter half of 1827, Wadsworth commissioned Cole to paint a view of his country estate. Having completed the painting, Cole wrote to Wadsworth on December 1 of that year that it would be sent by steamboat that afternoon; of the work itself, Cole commented: "I think it has as much truth in it as any picture I have ever painted."[9]

The vantage point for the painting was the base of the tower.[10] The artist placed Monte Video within the grand panorama of Wadsworth's landholdings with the pond and bathhouse visible on the left and the main house at the right. In the distance, Cole included what appears to be the tenant's house (noted by Silliman in his detailed description of the estate and also appearing in the foreground of the engraving after Wadsworth's drawing), with smoke emerging from its chimney. Honoring the two visions of the American landscape described by Silliman, he prominently placed a seated female figure in the foreground—a poetic muse, perhaps suggesting Wadsworth's creativity—symbolic of the sense of harmony Wadsworth had achieved in his estate. The figure is attired in period dress, suggesting that it may have been based on a woman known to Wadsworth or Cole. The blasted tree at left symbolizes the fast-disappearing wilderness landscape, while on the right the view opens up to a settled scene, looking south down the valley toward Farmington Village, marked by the town's church steeple.

This painting and *View on Lake Winnipiseogee* (cat. 127), which was based on a drawing by Wadsworth, were conceived as a pair and hung together in the library at Monte Video during Wadsworth's lifetime.[11] Of similar size, both are on chamfered wood panels primed on the back with a salmon color. Cole may also have referred to Wadsworth's drawing (or the published engraving after his drawing) of Monte Video, which was a view from the opposite direction, looking north toward the tower.

Cole would later remember his visits to Wadsworth's country seat with fondness, writing to Wadsworth during a trip to Italy with his "recollection" of their friendship and of "the many happy hours I spent at Hartford

& Monte Video—also those rambles—those sunsets I enjoyed with you [that] have never faded in my mind & I look at those pleasures as 'flowers that never will in other garden grow.' . . . I anticipate the pleasure of seeing with you another sunset from the *Tower*—One of the views of Monte Video I had engraved in England & I intended to send you a number of the proofs."[12]

Monte Video became a popular tourist attraction during Wadsworth's lifetime, as the *Hartford Courant* noted: "The place has been long and extensively known by the public."[13] Although Cole's painting of Monte Video is perhaps the most famous depiction of Wadsworth's estate, many other artists and writers were also inspired by Monte Video and its lands. As early as 1791, John Trumbull painted a landscape of the site that later became part of Wadsworth's estate (see Introduction and fig. 1 there).[14] John Warner Barber illustrated the estate and included a detailed description in his book *Connecticut Historical Collections* (New Haven, 1836), and the English china manufacturers W. Adams and Son, as well as Enoch Wood, depicted the estate on their china.[15] Alvan Fisher (q.v.), who visited the Hartford area first in 1817 and later in the early 1820s, painted four views of Monte Video (unlocated) for Daniel Wadsworth.[16] In the later decades of the century, after Cole's visit to the estate, the Hartford area artist Charles DeWolf Brownell (q.v.) and New Haven resident Robert Bakewell sketched views of the estate.[17] The American poet John G. Whittier (1807–1892) wrote "Monte Video," published in 1830.[18] And long after Wadsworth's death, the *Crayon* published a lengthy article on Monte Video, proclaiming it "a favorite resort of the tasteful" and including a poem entitled "Monte Video" by the Hartford poet Lydia Sigourney, a friend of Wadsworth (cat. 467).[19] EMK

1. Although Wadsworth left no explanation for his choice of name for his country estate, it was highly appropriate for his intentions. In Latin *monte* means "mountain" and *video* means "having the power to see."
2. Richard Saunders, with Helen Raye, *Daniel Wadsworth: Patron of the Arts* (Hartford: Wadsworth Atheneum, 1981), 18–19, reproduces the following newspaper advertisement, which appeared in the *Connecticut Courant*, August 19, 1848, announcing the sale of Monte Video after Wadsworth's

death: "More than forty years ago, the late Col. Trumbull united with Mr. Wadsworth in the design to adorn this picturesque mountain top—with each a rural lodge and corresponding cultivation. Col. Trumbull's part was never executed, but Mr. Wadsworth carried out his plan even more fully than he at first intended. A beautiful villa—shaded walks surrounding the crystal lake—a commanding tower on the highest rock with a horizon of a hundred miles in diameter, forms an object of attraction for all the surrounding country; connected too with the sober results of agriculture and horticulture in an extensive farm, which forms an appendage to the villa of Monte Video."

3. Benjamin Silliman, *Remarks Made, on a Short Tour, between Hartford and Quebec* (New Haven: S. Converse, 1820), 15.

4. Allan Wallach, "Making a Picture of the View from Mount Holyoke," *Special Issue: The Drawings of Thomas Cole, Bulletin of the Detroit Institute of Arts* 66, no. 1 (1990), 38.

5. S. C. Wadsworth, "The Towers of Talcott Mountain," *Connecticut Quarterly* 1 (January 1895–December 1895), 180–181.

6. Maria Trumbull Silliman to Mrs. Benjamin Silliman, September 1, 1821, archives, Wadsworth Atheneum.

7. Ellwood C. Parry III, "Acts of God, Acts of Man: Geological Ideas and the Imaginary Landscapes of Thomas Cole," in *Two Hundred Years of Geology in America*, ed. Cecil J. Schneer (Hanover: University of New Hampshire, 1979), 53–71.

8. Silliman, *Remarks*, 14. My thanks to John Teahan, head librarian at the Wadsworth Atheneum, for bringing this passage to my attention.

9. J. Bard McNulty, ed., *The Correspondence of Thomas Cole and Daniel Wadsworth* (Hartford: Connecticut Historical Society, 1983), 50.

10. For a discussion of Cole's use of this vantage point from above in his landscapes, see Albert Boime, *The Magisterial Gaze: Manifest Destiny and American Landscape Painting, c. 1830–1865* (Washington, D.C., and London: Smithsonian Institution Press, 1991), 48–57.

11. J. Bard McNulty, *Correspondence*, 31–32, was the first to suggest that these two paintings were conceived as a pair. A list of the paintings in Wadsworth's collection at Monte Video appears in "Probate Inventory of the estate of Daniel Wadsworth," September 30, 1848, Connecticut State Library, Hartford.

12. Thomas Cole to Daniel Wadsworth, Florence, Italy, July 13, 1832, quoted in McNulty, *Correspondence*, 56–57. The engraving of Monte Video appears in John Howard Hinton, *The History and Topography of the United States*, vol. 2 (1832), facing p. 481. The engraving is dated 1831 and shows a view of the estate from south to north.

13. "Monte Video," *Hartford Courant*, August 17, 1848.

14. For a discussion of John Trumbull's *View on the West Mountain near Hartford* (c. 1791, Yale University Art Gallery) and *Study for View on the West Mountain near Hartford* (1791, Yale University Art Gallery), see Bryan Wolf, "Revolution in the Landscape: John Trumbull and Picturesque Painting," in *John Trumbull: The Hand and Spirit of a Painter*, ed. Helen A. Cooper (New Haven: Yale University Press, 1982), 220–221.

15. "Monte Video," *Connecticut Historical Society Bulletin* 19 (January 1954), 22–32.

16. Four paintings by "Mr. Fisher" are listed in "Codicil to Last Will & Testament of Daniel Wadsworth," 1848, Probate Records, Connecticut State Library, Hartford: "A view of what is called the house rock, on the Turnpike near the road leading to Monte Video, done by Mr. Fisher. / A View from the east side of the lake of D. Wadsworth's house at Monte Video. No. 1 / By Mr. Fisher. / A view from the south end of the lake of the tower at Monte Video. No. 2 / By Mr. Fisher. / A view from the east side of the lake half way down (at Monte Video) No. 3 / By Mr. Fisher." For biographical information on Fisher's visit to Hartford, see Fred Barry Adelson, *Alvan Fisher (1792–1863): Pioneer in American Landscape Painting* (Ph.D. diss., Columbia University, 1982; Ann Arbor, Mich.: University Microfilms International, 1985), 1:205–208.

17. Charles DeWolf Brownell, *Wadsworth Tower "South Rock,"* pencil on paper (Hartford, Wadsworth Atheneum, 1925.22), and Robert Bakewell, *Wadsworth Tower Monte Video*, pencil on paper board (Hartford, Wadsworth Atheneum, 1925.21).

18. The poem appears in *Connecticut Quarterly* 1 (January–December 1895), 187.

19. "Monte Video," *Crayon* 2 (August 15, 1855).

127 (see plate 35)

THOMAS COLE

View on Lake Winnipiseogee, 1828

Oil on wood; $19^{3}/_{4} \times 26^{1}/_{8}$ in. (50.2 × 66.4 cm)

Signed and dated at lower center: T. Cole 1828

Signed and dated on the back: T Cole / N.Y. 1828

EXHIBITED: New York City, National Academy of Design, 1829, no. 54, as "View on Lake Winnepisseogee" / Baltimore Museum of Art, "Romanticism in America," 1940 / Sarasota, Fla., John and Mable Ringling Museum, "American Painting," 1949, no. 11 / Wadsworth Atheneum, "The Hudson River School: Nineteenth-Century American Landscapes in the Wadsworth Atheneum," 1976, no. 10

EX COLL.: commissioned by Daniel Wadsworth, Hartford, 1828

Bequest of Daniel Wadsworth, 1848.13

Cole painted *View on Lake Winnipiseogee* in 1828 in New York City, and correspondence between the artist and his patron Daniel Wadsworth indicates that Cole used a sketch by Wadsworth for inspiration. He wrote to Wadsworth on December 1, 1828: "The Pictures will be sent by Steam Boat that starts this afternoon—One is the view of Monte Video . . . the other is from your sketch of Winnipiseogee with a little variation. I have imagined it in its wild state—it is a morning view in Indian Summer. Those who have seen the pictures seem highly pleased with them."[1]

As Wadsworth does in his drawing, Cole presents a view of Lake Winnipesaukee looking south from Meredith, New Hampshire, but encloses the view and includes a foreground. The artist painted a light-filled scene of the lake with the sun, shown as a tight ball of heat in the center of the painting, attempting to break through the atmosphere. Haze and low-hanging clouds hovering above the lake soften the view of the distant mountains. Cole captures the dry heat of an Indian summer day with these atmospheric effects, as well as the heightened autumnal colors of the foliage surrounding the lake. The addition of a single Native American (similar to the figure in *Kaaterskill Falls*, cat. 122) in the foreground, surveying the pure wilderness scene before him, completes the picture—an evocation of the nation's distant past.

Additional correspondence between Cole and Wadsworth suggests that Cole intended *Monte Video* (cat. 126) and *View on Lake Winnipiseogee* as companion pieces.[2] Cole wrote Wadsworth on November 10, 1828: "With respect to your pictures I shall be able to send two before the river closes (in two weeks at farthest) one is the view of Meredith—which I think will please you—the other is the view of Monte Video—the price is fifty dollars each if agreeable to you to pay so much."[3] Almost identical in size, both are painted on chamfered wood panels, an unusual but not exceptional support for Cole. Wadsworth promptly sent Cole a check for $100, but, as Cole's response indicates, Wadsworth had some reservations about *View on Lake Winnipiseogee:*

> I know you will excuse me if I differ with your critique on the picture of Winnipisogee if I assign what

Daniel Wadsworth, *Coroway Peak, Lake Winnipiseogee*, 1826. Wadsworth Atheneum. Photograph: E. Irving Blomstrann.

I think are good reasons—One great characteristic of a hazy morning is the *absence of dark shadows*. (Comparatively) I could easily explain why this is so, but perhaps I should be speaking of that with which you are well acquainted—When the shadows are not deep it necessarily follows that there are no violent contrasts of light and shade; and the absence of strong oppositions of light & shade & colour—is the source of the soul soothing power of an Indian Summer's morning . . . there is nothing to cause this depth of shadow in the foreground it is *in an open situation*—on the shore of a Lake & not in the deep woods where the matted foliage might exclude the suns rays.[4]

Cole intended to stress the spiritual quality of the wilderness scene through his use of light.

As a pair of landscapes, *Lake Winnipiseogee* and *Monte Video* complement each other and provide a testament to the friendship that existed between artist and patron. At the time of Wadsworth's death the two works hung together in the library of Monte Video, the first conveying the purity of the American wilderness devoid of civilization, as exemplified by the White Mountain scenery that both men revered, and the latter offering a pastoral view of Wadsworth's sunlit country estate in harmony with and situated between the wilderness at left and the ongoing cultivation of the landscape seen at

right in the settled valley below. In both paintings, figures preside over the landscape. The Indian in *Lake Winnipiseogee* kneels in the foreground at ground level and surveys the lake and mountain scene before him; the muse in *Monte Video* is similarly positioned but perched on high ground, with her back turned to the landscape, instead gazing upward to the sky, perhaps symbolic of the inevitable progress of culture.[5]

Cole painted another version of *Lake Winnipiseogee*, which was engraved by Asher B. Durand and published in the first (and only) volume of the magazine *American Landscape*.[6] The engraving accompanied William Cullen Bryant's description; of "WINNIPISEOGEE, the smile of the Great Spirit," he wrote: "A few traces of the red men only remain. The hum of industry and the sounds of joy and peace echo over the graves of the sons of the wilderness; but the beauties of the lake can never be lost: they are a feature of nature that civilization may slightly change but never destroy."[7] EMK

1. See J. Bard McNulty, ed., *The Correspondence of Thomas Cole and Daniel Wadsworth* (Hartford: Connecticut Historical Society, 1983), 7–9.
2. Ibid., 31–32. McNulty notes that *View on Lake Winnipiseogee* and a painting referred to as a view of Squam Lake are one and the same and are discussed in Thomas Cole to Daniel Wadsworth, New York, January 9, 1828, 31–32.
3. Ibid., 40.
4. Thomas Cole to Daniel Wadsworth, New York, December 8, 1828, in ibid., 52–53.
5. For a discussion of Cole's landscapes as signifying Manifest Destiny, Albert Boime, *The Magisterial Gaze: Manifest Destiny and American Landscape Painting, c. 1830–1865* (Washington, D.C., and London: Smithsonian Institution Press, 1991), 48–57.
6. *The American Landscape* 1 (New York: Elam Bliss, 1830), unpaged, reproduced in Ellwood C. Parry III, *The Art of Thomas Cole: Ambition and Imagination* (Newark: University of Delaware Press, 1988), 69.
7. Ibid., 15–16.

128

THOMAS COLE
The Mullein Stalk, 1836
Oil on wood; 18¹/₂ × 12³/₈ in. (47.0 × 31.4 cm)

EX COLL.: commissioned by Luman Reed, New York City, in 1836; to his business partner, Jonathan Sturges, New York City, in 1836; to his son, Frederick Sturges II, Fairfield, Conn., in 1874, to 1977; to his son, Frederick Sturges III, Old Lyme, Conn., by 1978

Gift of Mr. and Mrs. Frederick Sturges III, 1979.171

129

THOMAS COLE
Ruined Castle, 1836
Oil on wood; 18⁹/₁₆ × 12¹⁵/₁₆ in. (47.1 × 32.9 cm)
Technical note: Infrared reflectography revealed extensive underdrawing: an artist change to the top of the ruin, a horizontal line drawn across the composition to mark the center of the ruin and the top of the door into the ruin, and a semicircular compass line arcing upward from one end of the horizontal line to the other.

EX COLL.: commissioned by Luman Reed, New York City, in 1836; to his business partner, Jonathan Sturges, New York City, in 1836; to his son, Frederick Sturges II, Fairfield, Conn., in 1874; to his son, Frederick Sturges III, Old Lyme, Conn., in 1977

Gift of Mr. and Mrs. Frederick Sturges III, 1978.113

130

THOMAS COLE
Balloon Ascension, 1836
Oil on wood; 20⁷/₈ × 13⁷/₈ in. (53.0 × 35.2 cm)
Technical note: Underdrawing revealed by infrared reflectography shows a second balloon in the center of the composition, as well as line drawings marking the foliage in the foreground.

EX COLL.: commissioned by Luman Reed, New York City, in 1836; to his business partner, Jonathan Sturges, New York City, in 1836; to his son, Frederick Sturges II, Fairfield, Conn., in 1874; to his son, Frederick Sturges III, Old Lyme, Conn., in 1977; to his sister, Mrs. Phippen Sanborn, Morrill, Maine, in 1978

Gift of Mr. and Mrs. Phippen Sanborn, 1978.114

128

129

130

Thomas Cole was commissioned to paint these three panel paintings at the request of Luman Reed (1784–1836), an important early patron of Cole and other American artists.[1] Reed had created a private art gallery of European and American paintings on the third floor of his house at 13 Greenwich Street in New York City. In 1835 Reed conceived a collaborative project involving the decoration of his gallery by the four artists from whom he had commissioned individual works for the gallery. Concluding that the six doors leading into the gallery "make too much space," he wrote to the artist William Sidney Mount (1807–1868) on November 23, 1835, "I intend to have them painted . . . not highly finished paintings but good Sketches, a single figure, a head, a cat, hen & Chickens, in short anything to cover the surface & produce a pleasing effect. Cole has one door, [Asher B.] Durand [q.v.] one, [George Whiting] Flagg [Washington Allston's nephew, 1816–1897] one and you the other, the large Doors that divide the Rooms are also under consideration."[2]

Flagg and Durand finished first, completing their panels between November 1835 and February 1836; Cole followed with his four panels.[3] Mount was unable to participate at the time, and his brother Henry Smith Mount (1802–1841) assumed the responsibility.[4] Luman Reed died on June 7, 1836, thus all of the panels for the gallery were not completed.[5] Sixteen of the original panels survive, including examples by Mount.[6]

Cole's ideas for his door panels are outlined on a surviving sheet of drawings and notations entitled "Mr. Reed's Doors."[7] Correspondence between the two men indicates that Cole planned to do sixteen panels that were to be "Illustrations of Nature." Reed had envisioned a less formal conception, but encouraged Cole to pursue his ideas on a smaller scale. "The plan would please me as well as any thing & I think better than any that could be suggested," he replied, "if the space was sufficient to carry it out."[8] In addition to the three panels in the Atheneum's collection, Cole painted *Seascape with a Waterspout.*

Cole had been working on his *Course of Empire* series for Reed's gallery for three years when he received the commission for the door panels, and undoubtedly he welcomed the diversion of a new project that would allow him to develop another series of images. Judging from his notes, he intended each of the sixteen panels to deal with some aspect of humankind's place in nature. At the top of his page of drawings, Cole wrote "The Four Great Elements" and decided on landscape images as follows:

First Fire represented by a volcano
2nd— Air represented by / sky + / flying clouds—
 The tops of trees waving in the wind—
 birds—
3rd Earth—
 Rocks— / Caves / Mountains
4th Water—the Ocean—Waterspout[9]

Thomas Cole, *Seascape with a Waterspout,* 1836. Alexander Gallery, New York City.

Only the fourth element corresponds directly with a finished panel, *Seascape with a Waterspout*, although *Balloon Ascension* may represent the second element—air. (Cole's underdrawing reveals that he originally placed the hot air balloon in the center of the panel but moved it to the right in the final composition to create a harmonious balance with the tree at left and the curved string of birds that link the two forms.) EMK

1. Ella M. Foshay, *Mr. Luman Reed's Picture Gallery: A Pioneer Collection of American Art*, introduction by Wayne Craven, catalogue by Timothy Anglin Burgard (New York: Abrams, in association with the New-York Historical Society, 1990); and Wayne Craven, "Luman Reed, Patron: His Collection and Gallery," *American Art Journal* 12, no. 2 (1980), 40–59.
2. Luman Reed to William Sidney Mount, The Museums at Stony Brook, November 23, 1835, quoted in Ellwood C. Parry III, "Thomas Cole's Ideas for Mr. Reed's Doors," *American Art Journal* 12, no. 3 (1980), 34.
3. Foshay, *Mr. Luman Reed's Picture Gallery*, 67–70.
4. Timothy Anglin Burgard, "Two Painted Door Panels From Luman Reed's Gallery," *American Art Journal* 23, no. 1 (1991), 71.
5. See Alfred Frankenstein, *William Sidney Mount* (New York: Abrams, 1975), 68; and David Lawall, *Asher B. Durand: A Documentary Catalogue of the Narrative and Landscape Paintings* (New York: Garland, 1978), 8–11.
6. See Foshay, *Mr. Luman Reed's Picture Gallery*, 68, 119–120; and Burgard, "Two Painted Door Panels," 70–74.
7. Burgard, "Two Painted Door Panels," 34, 40–41.
8. Luman Reed to Thomas Cole, December 29, 1835, Thomas Cole Papers. New York State Library, Albany, N.Y., reproduced in Foshay, *Mr. Luman Reed's Picture Gallery*, 68.
9. Parry, "Thomas Cole's Ideas," 33–45.

131

THOMAS COLE

Landscape with a Round Temple, c. 1832–1838
Oil on paper board attached to canvas; 8½ × 12½ in.
(21.6 × 31.8 cm)
Technical note: Examination using infrared reflectography revealed that the artist drew a complete grid, apparently free hand rather than ruled. There is underdrawing throughout the composition: squiggly lines define the clouds in the upper right corner, foliage to the left of the bridge, and the tree at the upper left, and straight lines define the columns of the temple.

EXHIBITED: Wadsworth Atheneum, "Landscape Painting," 1931, no. 90 / Wadsworth Atheneum, and New York City, Whitney Museum of American Art, "Thomas Cole: One Hundred Years Later," 1948–1949, no. 45 / Wadsworth Atheneum, "The Hudson River School: Nineteenth-Century American Landscapes in the Wadsworth Atheneum," 1976, no. 14

EX COLL.: to Elizabeth Hart Jarvis Colt, Hartford, about 1867

Bequest of Elizabeth Hart Jarvis Colt, 1905.12

This imaginary arcadian landscape was probably executed following Cole's first tour of Italy, from 1831 to 1832. Although a secure date has not been established for this work, its Italianate subject matter—the temple, bucolic figures, and Claudean landscape features—relate to Cole's great series *The Course of Empire* (New-York Historical Society, 1833–36).[1] The complete grid across the composition and the extensive underdrawing suggest that the artist intended to enlarge this work; however, no known composition directly relates to it.

This is the only work by Cole that was part of the private picture gallery of American and European paintings formed by Elizabeth Hart Jarvis Colt in the later half of the nineteenth century. Most of the works for this gallery were acquired directly from the artists. In this instance, as the artist was no longer living, it is possible that Colt acquired the work with the assistance of her friend and adviser Frederic Church (q.v.), who implemented the sale of a number of Cole's paintings, which he obtained directly from the Cole family (cat. 118). Colt placed the painting in her gallery next to Frederic Church's *Vale of St. Thomas, Jamaica* (cat. 116) (see Introduction and fig. 13 there). EMK

1. Ellwood C. Parry III to Amy Ellis, July 7, 1992, curatorial painting file, Wadsworth Atheneum. Parry suggests a date of 1832 to 1838, a time when Cole was exploring all kinds of architectural elements in preparation for *The Course of Empire*.

131

132 (see plate 36)

THOMAS COLE

Evening in Arcady, 1843

Oil on canvas; 32⅝ × 48⁵⁄₁₆ in. (82.9 × 122.7 cm)

Signed on rock at lower center: T Cole

EXHIBITED: New York City, National Academy of Design, "Pictures by Thomas Cole, A.N.A.," 1843–1844, no. 12, as "'An Evening in "Arcady"' owner: Miss Hicks" / New York City, American Art-Union, "Exhibition of Paintings of the Late Thomas Cole," 1848, no. 65, as "'An Evening in Arcadia,' owner: Miss Hicks" / Wadsworth Atheneum, "Thomas Cole: One Hundred Years Later," 1948–1949, no. 39 / Detroit Institute of Arts, "Travelers in Arcadia: American Artists in Italy, 1830–1875," 1951, no. 36 / Cambridge, Mass., Busch-Reisinger Museum, Harvard University, "Rivers and Seas: Changing Attitudes Towards Landscape, 1750–1962," 1962, no. 9 / Wadsworth Atheneum, "The Hudson River School: Nineteenth-

Century Landscapes in the Wadsworth Atheneum," 1976, no. 11 / Paris, Grand Palais, "A New World: Masterpieces of American Painting, 1760–1900," 1984, no. 30

EX COLL.: acquired from the artist by Miss [Sarah?] Hicks, by 1844; acquired from a private owner in California by the Dalzell-Hatfield Galleries, Los Angeles, by 1935; to Clara Hinton Gould, Santa Barbara, Calif., before 1948; to the Wadsworth Atheneum by 1948

Bequest of Clara Hinton Gould, 1948.190

133 (see plate 37)

THOMAS COLE

Roman Campagna, 1843

Oil on canvas; 32½ × 48 in. (82.6 × 121.9 cm)

Signed at lower left: T. Cole

EXHIBITED: New York City, National Academy of Design, "Pictures by Thomas Cole, A.N.A.," 1843–1844, no. 11, as "'View of the Ruined Aqueducts in the Campagna di Roma,' owner: Miss Hicks" / New York City, American Art-Union, "Exhibition of the Paintings of the Late Thomas Cole," 1848, no. 59, as "Ruins of Aqueducts in the Roman Campagna" / Wadsworth Atheneum, "Gould Bequest of American Paintings," 1948, as "Orpheus Greeting the Dawn" (the painting entered the Gould collection with this title) / Detroit Institute of Arts, "Travelers in Arcadia: American Artists in Italy, 1830–1875," 1951, no. 35 / New London, Conn., Lyman Allyn Museum, "Romantic Painting," 1955 / Detroit Institute of Arts, "Painting in America, The Story of Four Hundred Fifty Years," 1957, no. 80 / Brooklyn, N.Y., Brooklyn Museum, "Victoriana: The Arts of the Victorian Era in America," 1960, no. 185 / Syracuse, New York State Exposition, "125 Years of New York State Painting and Sculpture," 1966, no. 10 / Rochester, N.Y., Memorial Art Gallery, University of Rochester; Utica, N.Y., Munson-Williams-Proctor Institute; Albany, N.Y., Albany Institute of History and Art; and New York City, Whitney Museum of American Art, "Thomas Cole," 1969, no. 48 / Atlanta, Ga., High Museum of Art, "The Beckoning Land," 1971, no. 16 / Lawrence, University of Kansas Museum of Art, "The Hudson River School: Nineteenth-Century Americans in Italy," 1972, no. 13 / Wadsworth Atheneum, "The Hudson River School: Nineteenth-Century Landscapes in the Wadsworth Atheneum," 1976, no. 12

EX COLL.: acquired from the artist by Miss [Sarah?] Hicks, by 1844; acquired from a private owner in California by the Dalzell-Hatfield Galleries, Los Angeles, by 1935; to Clara Hinton Gould, Santa Barbara, Calif., before 1948

Bequest of Clara Hinton Gould, 1948.189

In August 1841 Thomas Cole embarked on his second European trip, during which he stayed briefly in London, Paris, and Switzerland and then traveled south to Rome and later Sicily. He returned to New York City in 1842 and in the following year painted a series of Italian landscapes, including *Roman Campagna* and a companion piece, *Evening in Arcady*. The pair was painted for Miss Hicks, as Cole indicated in a letter to Charles Parker, on January 8, 1844: "I have just finished two pictures for Miss Hicks. The one is a view of Aqueducts in the Campagna di Roma, the other a fancy picture. Her

Brother seems to be much pleased with them & I trust they will meet with her approbation when she sees them."[1]

Roman Campagna, featuring the Roman Aqueduct and the Apennine Mountains in the distance, was one of several views that Cole painted of this site, which was among the Italian landmarks most recognizable to Americans. His earlier *Aqueduct Near Rome* of 1832 (Washington University Gallery of Art, St. Louis) was engraved by James Smillie as the frontispiece for Henry T. Tuckerman's popular *Italian Sketch Book* (1835). The site, with its meandering progression from foreground to middle distance and mountainous far distance, provided an ideal Claudean setting. The countryside also held strong historical associations with the fallen Roman Empire and so spoke to Cole's deep interest in Roman antiquities. This particular ruin was the most popular subject for American artists who stopped in Rome in the nineteenth century.[2] Henry Tuckerman later wrote of *Roman Campagna*, "[Cole's] Roman aqueduct breathes the very loneliness and sublime desolation of the Campagna. It is not a few barren fields of arches and decaying brick that we behold, but the silent arena of a vanished world."[3] Cole depicts the Campagna at dawn, with dramatic shadows cast by the ruins in the foreground. The warm golden glow of the rising sun spreads across the middle ground and the sky above. A goatherd tends his flock among the ruins.

In his funeral oration for Cole in 1848 William Cullen Bryant praised this work as one of the pictures "which we most value and most affectionately admire . . . with its broad masses of shadow dividing the sunshine that bathes the solitary plain strewn with ruins, its glorious mountains in the distance and its silence made visible to the eye."[4] Several drawings of the Roman countryside exist in Cole's sketchbooks (Detroit Institute of Arts).

The companion painting *Evening in Arcady*, which Cole termed a "fancy picture," complements *Roman Campagna* as to time of day (one depicts dawn; the other, evening) as well as historic time (one is current; the other set in an idealized past). The arcadian scene, characteristic of the artist's romantic nature, includes a winding river in a mountainous countryside dominated

by an immense natural bridge, intended to denote the presence of the Almighty. The bridge is covered with trees and other vegetation; beneath it, a herd of deer stands on the far bank of the river while swans glide across the water. In the foreground a young woman dances to the music of a lyre played by her companion. The figures evoke the legend of Orpheus and Eurydice, an impression reinforced by the presence of a serpent gliding toward the dancer.[5] Cole included this theme in his 1827 list of possible subjects for pictures as "no. 99 Evening in Arcadia & Morning—."[6] The natural arch form was explored earlier by Cole in his drawing *The Bridge of Fear* (Detroit Institute of Art, 39.219). EMK

1. Thomas Cole to Charles M. Parker, New York, January 8, 1844, Thomas Cole Papers, New York State Library, cited in Louis L. Noble, *The Life and Works of Thomas Cole*, ed. Elliot S. Vesell (1853; rpt., Cambridge, Mass.: Harvard University Press, Belknap Press, 1964), 266. This letter contains the first reference to the original owner, whose identity is otherwise unspecified. The name "Miss Sarah Hicks" appears in Theodore E. Stebbins, Jr., *The Hudson River School: Nineteenth-Century American Landscapes in the Wadsworth Atheneum* (Hartford: Wadsworth Atheneum, 1976), 27, though the source for the first name is not provided and remains unknown.
2. William L. Vance, *America's Rome: Classical Rome* (New Haven and London: Yale University Press, 1989), 1:69.
3. Henry T. Tuckerman, *Book of Artists: American Artist Life* (New York: Putnam, 1867), 232.
4. William Cullen Bryant, *A Funeral Oration, Occasioned by the Death of Thomas Cole, Delivered before the National Academy of Design, New-York, May 4, 1848* (pamphlet) (New York, 1848), 21.
5. Trevor J. Fairbrother, entry for Thomas Cole, *Evening in Arcady*, in Theodore Stebbins, Jr., Carol Troyen, and Trevor J. Fairbrother, *A New World: Masterpieces of American Painting, 1760–1910*, French ed. (Boston: Museum of Fine Arts, 1983), 360.
6. "Thomas Cole, N York, 1827," Thomas Cole Papers, New York State Library, Albany, N.Y., reproduced in *Annual II: Studies on Thomas Cole, An American Romanticist*, ed. Howard S. Merritt (Baltimore: Baltimore Museum of Art, 1967), 98.

134 (see plate 38)

THOMAS COLE
Mount Etna from Taormina, 1843
Oil on canvas; 78⅝ × 120⅝ in. (199.7 × 306.4 cm)
Signed and dated at lower left: T. Cole 1843

EXHIBITED: New York City, "National Academy of Design Annual Exhibition," December 1843–March 1844, no. 6, as "Mount Aetna From Taormina, Sicily" / Art Institute of Chicago, "The Hudson River School," 1945, no. 67 / Rochester, N.Y., Memorial Art Gallery; Utica, N.Y., Munson-Williams-Proctor Institute; Albany, N.Y., Albany Institute of History and Art; and New York City, Whitney Museum of American Art, "Thomas Cole," 1969, no. 5 / Wadsworth Atheneum, "The Hudson River School: Nineteenth-Century American Landscapes in the Wadsworth Atheneum," 1976, no. 13 / Boston, Museum of Fine Arts, and Houston, Museum of Fine Arts, "The Lure of Italy," 1992, no. 46

EX COLL.: purchased from the artist by Alfred Smith, Daniel Wadsworth, and the original subscribers to the Wadsworth Atheneum

Museum purchase, 1844.6

During his second trip to Italy in 1842, Cole visited many of the famous Greek and Roman sites in Sicily. He was especially struck by the juxtaposition of the ruins with the eternal features of the landscape. At Taormina, Cole saw the spectacular ruins of the ancient theater set against the awesome shadow of the volcanic Mount Etna. Accompanied by the English artist Samuel J. Ainsley, Cole ascended the great Sicilian volcano. In two articles based on his Sicilian travels, published in the *Knickerbocker* in 1844, he described his impressions as he reached the volcano's summit: "It was a glorious sight which spread before our eyes! We took a hasty glance into the gloomy crater of the volcano, and throwing ourselves on the warm ashes, gazed in wonder and astonishment. . . . Sicily lay at our feet. As the sun rose, the great pyramidal shadow of Aetna was cast across the island, and all beneath it rested in twilight gloom."[1]

Cole returned to the United States in July 1842, and over the course of the next six years, he painted at least

six known versions of the volcano.[2] The Atheneum's version, the third and largest of the group, was made for an exhibition of Cole's works in New York in 1843. Cole worked on it in the newer rooms of the National Academy of Design on the fifth floor of the New York Society, or Atheneum, Building, where the exhibit was held.[3] He had hoped to obtain *The Course of Empire* series for the show, but the owner, Mrs. Luman Reed (cats. 128–130), would not lend the paintings. In a burst of energy and inspiration, Cole painted *Mount Etna from Taormina* to take the place of the great series. With enthusiasm, he announced to his wife on December 9, 1843: "I have finished two-thirds of it, and have only painted on it two days. I never painted so rapidly in my life."[4] The show opened to the public on December 18, 1843. Cole issued special invitations to his important patrons, and visitors received a four-page pamphlet listing the twelve works on view.[5]

Cole completed the work in only five days, working from detailed drawings that he had made on the spot. In one drawing, light from the west is cast on the column seen at the far left, indicating that it was drawn at sunset. Cole noted at the top of this drawing: "What a magnificent site! Aetna with its eternal snows towering in the heavens—the ranges of nearer mountains—the deep romantic valley—the bay of Naxos . . . I have never seen anything like it. The views from Taormina certainly excel anything I have ever seen."[6] The finished canvas is a tour de force. Despite its grand scale and complexity of composition, the work is painted with great assurance (only minor changes are evident). The viewer's eye enters the scene at the lower left and is led past the ruins and the hooded figure of a monk in the foreground and then back toward the volcano's summit, which, though snow-capped, emits smoke into the sky above. Cole conveyed his fascination with the hidden might of the volcano in a poem entitled *Mt. Etna*, which he wrote on his return to America in 1842 and later published in the *Knickerbocker* in 1844:

> But for yon filmy smoke, that from thy crest
> Continual issues; there would be no sign
> That from thy mighty breast bursts forth at times

> The sulphurous storm—the avalanche of fire;
> That midnight is made luminous and day
> A ghastly twilight, by thy lurid breath.
> By thee tormented Earth is tossed and riven;
> The shuddering mountains reel; temples and towers
> The works of man and man himself, his hopes
> His harvests, all, a desolation made!
> Sublime art thou O Mount! . . .
> Thought reaching far above thy bounds; from thee
> To HIM who bade the central fires construct
> This wond'rous fabric; lifted by thy dread brow
> To meet the sun while yet the earth is dark,
> And ocean with its ever murmuring waves.[7]

For Cole, the volcano was a manifestation of God.

Cole achieved exceptionally fluid brushwork in this painting, a result of the rapidity of its execution. In addition, he used an unusually hot, red ground, which he allowed to show through the paint film. With this technique, along with his rendition of the brilliant sunlight highlighting the ruins in the foreground, he was able to capture the intense heat of the Sicilian climate. In the distance, the cool, snowcapped Mount Etna is crowned by a column of smoke, a reminder of its latent destructive force.

On January 5, 1844, Cole wrote to his wife that the original subscribers to the Wadsworth Atheneum were interested in acquiring *Mount Etna:* "The Hartford people wish to have my picture of Aetna for their new Lyceum, where they have a fine exhibition-room. They will give me $500 for it. Pretty good for five days work."[8] Letters between Cole and Alfred Smith, Daniel Wadsworth's lawyer, the business manager for the newly opened Wadsworth Atheneum, and one of its original subscribers, document the negotiations for the purchase of *Mount Etna from Taormina* for the new gallery.[9] Smith made clear that the financial constrictions suffered by the museum as a result of rising building costs left little money for purchasing paintings. Wadsworth was not being asked to contribute toward the purchase, Smith explained, because "our most munificent donor [Wadsworth], has already contributed so much, that we should be reluctant to ask or even to receive more from

Thomas Cole, *Mt. Etna from Taormina or Ruins at Taormina*, 1842. Founders Society Purchase, William H. Murphy Fund, Detroit Institute of Arts.

him."[10] In the end, Wadsworth voluntarily contributed $50 toward its acquisition and, while convalescing after a fall, wrote to Cole to express his interest: "I rejoice in the hope of seeing your *Etna* & trust the arrangement will result in the mutual advantage of yourself, & the Atheneum."[11] Cole assured Smith that in purchasing *Mount Aetna* "you will have one of the finest pictures I have ever painted and one of the grandest scenes in the world."[12] The painting, which symbolized European culture and civilization, provided a balance to Cole's many landscapes of the New World that hung in the Atheneum gallery.

In 1855 a writer for the *Crayon* reviewed the new "permanent gallery of the Fine Arts," at the Wadsworth Atheneum and commented on Cole's landscapes, in particular "Mount Etna from Taormina . . . a large landscape, and remarkable on account of its having been painted in about a week's time; it is, in fact, little else than a gigantic sketch . . . it illustrates Cole's feeling and power, and is one of the most interesting pictures painted by him during the later part of his life."[13] The grand scale of the work (one of the largest canvases Cole produced) created a precedent embraced by Cole's successors, particularly Frederic Church (q.v.) and Albert

Bierstadt (q.v.), who gained fame for their enormous canvases during the latter half of the century. EMK

1. Thomas Cole, "Sicilian Scenery and Antiquities," *Knickerbocker* 13 (February and March 1844), 112.
2. Other examples are in the collections of the Virginia Museum of Fine Arts, Richmond; the IBM Corporation, New York; the Lyman Allyn Museum, New London, Conn.; and two private collections. For a discussion of Cole's Mount Etna paintings, see Franklin W. Kelly, "Myth, Allegory, and Science: Thomas Cole's Paintings of Mount Etna," *Arts in Virginia* 23 (November 1983), 2–18.
3. As Ellwood Parry points out, Cole's biographer, Louis L. Noble, erroneously wrote that the artist's solo exhibition was held in the old quarters of the National Academy of Design in Clinton Hall. See Noble, *The Life and Works of Thomas Cole*, ed. Elliot S. Vesell (1853; rpt., Cambridge: Harvard University Press, Belknap Press, 1964), 264; and Ellwood C. Parry III, *The Art and Life of Thomas Cole: Ambition and Imagination* (Newark: University of Delaware Press, 1988), 291–292.
4. Quoted in Noble, *Life and Works of Cole*, 264.
5. Copies of the brochure, entitled *Catalogue of Pictures by Thomas Cole, A.N.A. [sic] Now Exhibiting in the Rooms of the National Academy, Corner of Broadway and Leonard Street. Open from 9 A.M. until 10 P.M.*, are in the collections of the Cole Papers, New York State Library, Albany, N.Y., and the Detroit Institute of Arts Library. The works in the show included nos. 1–4, *The Voyage of Life*, no. 5, *An-*

gels Ministering to Christ in the Wilderness, no. 6, *Mount Aetna from Taormina, Sicily*, nos. 7 and 8, *The Past and The Present*, no. 9, *A View of the Notch in the White Mountains, New Hampshire*, no. 10, *An Italian Scene, a Composition*, no. 11, *A View of Ruined Aqueducts in the Campagna di Roma* (cat. 133, *Roman Campagna*), and no. 12, *An Evening in "Arcady"* (cat. 132, *Evening in Arcady*).

6. For a discussion of this drawing, see the entry for this painting by Eleanor Jones in Theodore E. Stebbins, Jr., with William H. Gerdts, Erica E. Hirshler, Fred S. Licht, and William L. Vance, *The Lure of Italy: American Artists and the Italian Experience, 1760–1914*, exh. cat. (New York: Abrams, in association with the Museum of Fine Arts, Boston, 1992), 262. *Ruins at Taormina*, an oil study for the Atheneum's painting, was sold at Christie's as lot 15 in the auction "*Important American Paintings, Drawings, and Sculpture of the Eighteenth, Nineteenth, and Twentieth Centuries*," held in New York on May 25, 1989. For Noble's discussion of the importance of this painting, see his *Life and Works of Cole*, 264–265.

7. Thomas Cole, *Thomas Cole's Poetry*, ed. Marshall B. Tymn (York, Pa.: Liberty Cap Books, 1972), 134–135. Cole's two-part article "Sicilian Scenery and Antiquities" recounts his experiences in Sicily; the poem appears on p. 34.

8. Noble, *Life and Works of Cole*, 265.

9. Thomas Cole to Alfred Smith, January 29 to March 11, 1844, archives, Wadsworth Atheneum.

10. Alfred Smith to Thomas Cole, January 29, 1844, archives, Wadsworth Atheneum.

11. McNulty, *Correspondence of Cole and Wadsworth*, 69. The receipt for Wadsworth's contribution of $50, dated March 7, 1844, is annotated "to pay in part for the M. AEtna" ("Receipts of Wadsworth Atheneum Gallery," archives, Wadsworth Atheneum).

12. Thomas Cole to Alfred Smith, February 24, 1844, archives, Wadsworth Atheneum.

13. "Sketchings," *Crayon* 1 (May 23, 1855), 331.

135

ATTRIBUTED TO THOMAS COLE
Roswell Butler Ward, c. 1830
Oil on wood; 26³/₄ × 22⁵/₈ in. (67.9 × 57.5 cm)

EXHIBITED: Wadsworth Atheneum, and New York City, Whitney Museum of American Art, "Thomas Cole: One Hundred Years Later," 1948–1949, no. 1

EX COLL.: subject's daughter, Catherine Ward, Hartford

Gift of Catherine Ward, 1863.6

This portrait was given to the Atheneum during the sitter's lifetime by his daughter; though it is unsigned, the donor presented it as a portrait by Cole. It was exhibited in the picture gallery of the Wadsworth Atheneum in the nineteenth century, beginning in 1863.[1]

Cole is known to have painted portraits early in his career in Ohio.[2] One of the few documented portraits by Cole, *Self-Portrait* (c. 1832–1836, New-York Historical Society), is unfinished, with only the face completed. The lack of known portraits by Cole does not allow for stylistic comparison with the Ward portrait.

Cole may have painted *Roswell Butler Ward* on a visit to Hartford in the late 1820s—he visited Daniel Wadsworth in the summer of 1827, for instance—or the sitter may have gone to Cole's New York City studio. Cole's conventional portrayal of Roswell Ward, simply posed against a plain background, exhibits a loose handling of the brush and presents a competent likeness.

The subject of this portrait, Roswell Butler Ward (1804–1883), was the son of the Hartford silversmith Colonel James Ward (see cat. 91) and Ruth Butler Ward (1776–1844). For two years he attended Yale College, leaving to complete his studies at Captain Alden Partridges's Military School, at Norwich, Vermont. Captain Ward served as a commanding officer of the Hartford Light Infantry Guard. He formed a mercantile business, R. B. & W. A. Ward, in partnership with his brother William. Their store on State Street in Hartford carried such goods as paints, oils, and dyes. Roswell married Catherine Mary Webb (d. 1870) of Litchfield, and the couple had two daughters, Catherine Webb and Mary Clement Maison. The Wards lived in Hartford until 1868, when they moved to New London.[3]

Roswell and his brothers James and William were among the nine original subscribers of the Wadsworth Atheneum. He was elected a trustee from 1854 to 1856, and in 1855 he gave the Atheneum $100, which represented his "interest in the Gallery of Paintings."[4] EMK

1. *Catalogue of Paintings Now Exhibiting in Wadsworth Gallery Hartford* (Hartford: Case, Lockwood, 1863), no. 56, as "Portrait of Roswell B. Ward," annotated in pencil in contemporary script, "By Thos. Cole," library, Wadsworth Atheneum.

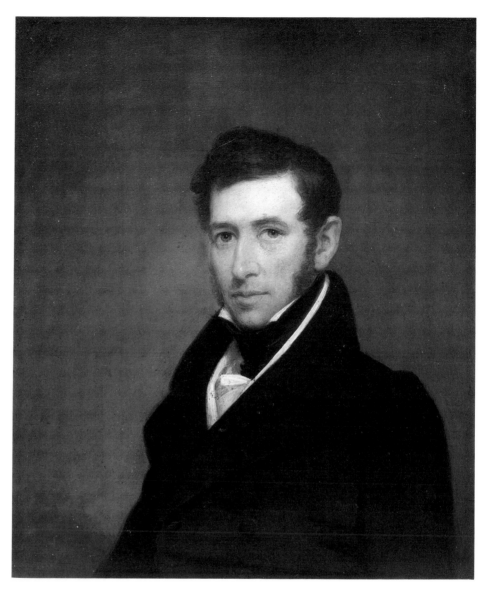

135

2. Ellwood C. Parry III, "Thomas Cole's Early Career: 1818–1829," in *Views and Visions: American Landscape before 1830,* exh. cat., ed. Edward J. Nygren, with Bruce Robertson (Washington, D.C.: Corcoran Gallery of Art, 1986), 164–165.

3. J. Hammond Trumbull, ed., *The Memorial History of Hartford County, Connecticut 1633–1884* (Boston: Edward L. Osgood, 1886), 1:186; and *Commemorative Biographical Record of Hartford County, Connecticut* (Chicago: J. H. Beers, 1901), 753.

4. Trustee Minutes, June 24, 1854, June 8, 1855, June 10, 1856, and November 15, 1855, archives, Wadsworth Atheneum. My thanks to Anne Brandwein for locating this information.

Alfred Collins

Born in Portland, Maine, 1855; died in Cambridge, Mass., 1903

A portrait painter of the late nineteenth century, Collins received artistic training in Paris at the Académie Julian and in the atelier of Léon Bonnat. On his return to the United States, he practiced his realistic portrait style in San Francisco, Buffalo, and Boston before settling in New York City in the late 1880s. He became a member of the Society of American Artists in 1889.

SELECT BIBLIOGRAPHY

Doreen Bolger Burke, *American Paintings in the Metropolitan Museum*, ed. Kathleen Luhrs (New York: Metropolitan Museum, 1980), 3:176–178

136

ALFRED COLLINS

James J. Goodwin, 1902

Oil on canvas; 30⅛ × 25 1/16 in. (76.5 × 63.7 cm)

Signed and dated at upper left: A Q Collins 1902

EXHIBITED: Wadsworth Atheneum, "Portraits of Hartford Men," 1926, no. 26

EX COLL.: descended in the Goodwin Family to Mrs. Walter L. Goodwin by 1953

Gift of Mrs. Walter L. Goodwin, 1953.1

James J. Goodwin (1835–1915), the son of James and Lucy Morgan Goodwin, was a major benefactor of the Wadsworth Atheneum. A business partner of his first cousin, J. Pierpont Morgan, Sr., in New York City from 1861 to 1871, after the death of his father in 1878, he managed the Goodwin family estate in Hartford with his brother Rev. Francis Goodwin. As an amateur historian and genealogist, James Goodwin was active in many Hartford organizations, including the Connecticut Historical Society. Shortly after his death, his wife, Josephine S. (Lippincott) Goodwin, established a fund at the Atheneum in his memory for the purchase of major works of art.[1] EMK

1. Biographical information provided by Eugene Gaddis, archivist, Wadsworth Atheneum.

Samuel Colman

Born in Portland, Maine, in 1832; died in New York City, in 1920

Colman grew up in New York City, where his father, a successful bookseller and publisher in Portland, had moved his family and started a publishing house when Colman was still quite young. Nathaniel Parker Willis

136

and Henry Wadsworth Longfellow were just two of the authors whose works his father published in illustrated editions. His uncle was William Colman, who introduced John Trumbull (q.v.), William Dunlap, and Asher B. Durand (q.v.) to the work of Thomas Cole (q.v.).

It is not known where or with whom Colman received his training in art. Some sources suggest that he studied for a short time with Durand around 1850, but this stands unconfirmed, although some of Colman's early landscapes do share a compositional similarity with Durand's work. Henry Tuckerman credits Colman's father's Broadway bookshop with giving the young boy aesthetic appreciation, writing that Colman "must have been familiar, in boyhood, with the most select specimens of foreign illustrated works; he inherited a refined organization, and a fine sense of the beautiful" (Tuckerman, *Book of the Artists*, 559). As early as 1851 Colman exhibited at the National Academy of Design in New York City. In 1854 he was elected an associate there and, eight years later, an academician.

In the 1850s Colman sketched and painted the scenery of the Hudson River, Lake George, and the White Mountains. By 1856 he had established a summer studio in North Conway, New Hampshire, which he shared with Aaron Draper Shattuck (q.v.) (who later married Colman's sister, Marian), Daniel Huntington (q.v.), William Sidney Mount (1807–1868), Sanford R. Gifford (q.v.), and Richard W. Hubbard.

Colman took the first of many trips abroad in 1860, traveling to France and Switzerland. He also visited Spain and was one of the first American artists to sketch there. He was gone for one year, gathering visual material that would serve as the basis for the many paintings of Spanish sites he made and exhibited in the 1860s. During this decade, the artist also painted in the Genesee region of western New York State, where relatives of Daniel Wadsworth owned two estates (see Introduction).

In 1866 Colman helped found—with William Hart (q.v.), among others—the American Society of Painters in Water Colors and was elected its first president, an office he held until 1871. The same year he was one of a number of artists—including Durand, Frederic E. Church (q.v.), and Albert Bierstadt (q.v.)—to contribute to an album of sketches in honor of William Cullen Bryant.

Colman tried his hand at etching in 1867. He wrote, "I have for many years been a collector of etchings, and first attempted etching in 1867, but after several years of trial gave it up on account of difficulty in having plates printed in a satisfactory manner. When the New York Etching Club was founded, in 1877, and its members came into possession of presses of their own, I took it up again with new zest, and etched the first plate from nature, *Mount Desert*, the following season" (quoted in Koehler, "The Works of the American Etchers," 387). Colman was to become adept at the art of etching. One contemporary reviewer proclaimed, "It may unhesitatingly be affirmed that Mr. Colman's plates are among the most interesting of the works so far produced by the etchers of America" (Koehler, "The Works of the American Etchers," 388).

In 1870, the year following the completion of the Union Pacific Railroad, Colman probably traveled west, to Wyoming and possibly California. He took at least three additional trips west in 1886, 1888, and from 1898 to 1905, also visiting Canada and Mexico. Throughout the period from 1864 into the 1870s, Samuel P. Avery was Colman's New York dealer.

Colman left the United States in 1871 for a four-year tour of Europe and Africa, visiting such places as Italy, France, Holland, Algeria, Morocco, and Egypt. Two years after his return to America in 1875, he joined with George Inness (q.v.), Thomas Moran (1837–1926), and others to form the Society of American Artists. In 1878 he became a member of the New York Etching Club and an associate of Tiffany and Company, for which he was an interior decorator until 1890. He built his own home in 1883 in Newport, Rhode Island, and decorated others there in this period. Around this time, he also began collecting Asian art and gradually came to possess a wide array of objects, particularly Japanese, including brocades, swords, porcelains, and prints.

During the last portion of his life, Colman devoted himself to writing theoretical treatises. In 1912 he wrote *Nature's Harmonic Unity* and in 1920 he cowrote (with C. A. Coan, editor of his first book) *Proportional Form.*

SELECT BIBLIOGRAPHY

Henry T. Tuckerman, *Book of the Artists: American Artist Life* (New York: Putnam, 1867), 559–560 / "American Painters: Samuel Colman, N.A.," *Art Journal* (1876), 264–266 / S. R. Koehler, "The Works of the American Etchers: 11. Samuel Colman," *American Art Review* (1880), 387–388 / G. W. Sheldon, *American Painters*, rev. ed. (New York: D. Appleton, 1881), 72–76 / S. G. W. Benjamin, *Our American Artists* (Boston: D. Lothrop, 1886), 134–147 / Clara Erskine Clement and Laurence Hutton, *Artists of the Nineteenth Century and Their Works*, rev. ed. (1884; rpt., St. Louis: North Point, 1969), 1:147–148 / Marchal E. Landgren, *American Pupils of Thomas Couture*, exh. cat. (College Park, Md.: University of Maryland Art Gallery, 1970), 28–29 / Nancy Dustin Wall Moure, "Five Eastern Artists Out West," *American Art Journal* 5, no. 2 (1973), 15–31 / Wayne Craven, "Samuel Colman (1832–1920): Rediscovered Painter of Far-Away Places," *American Art Journal* 8, no. 1 (1976), 16–37 / Barbara Novak and Annette Blaugrund, eds., *Next to Nature: Landscape Paintings from the*

National Academy of Design, exh. cat. (New York: National Academy of Design, 1980), 67–69 / William David Barry, *Samuel Colman: East and West from Portland* (Portland, Maine: Barridoff Galleries, 1981) / Gloria-Gilda Deák, *The Romantic Landscapes of Samuel Colman*, exh. cat. (New York: Kennedy Galleries, 1983) / Natalie Spassky, *American Paintings in the Metropolitan Museum of Art*, ed. Kathleen Luhrs (Princeton, N.J.: Princeton University Press, in association with the Metropolitan Museum of Art, 1985), 2:349–355 / Barbara Novak, *The Thyssen-Bornemisza Collection: Nineteenth-Century American Painting* (New York: Vendome Press, 1986) / John K. Howat, *American Paradise: The World of the Hudson River School*, exh. cat. (New York: Metropolitan Museum of Art, 1987), 302–305 / Patricia C. F. Mandel, *Fair Wilderness: American Paintings in the Collection of the Adirondack Museum* (Blue Mountain Lake, N.Y.: Adirondack Museum, 1990), 46–47

137 (see plate 39)

SAMUEL COLMAN

Gibraltar from the Neutral Ground, c. 1863–1866

Oil on canvas; 26⅛ × 36⁵/₁₆ in. (66.4 × 92.2 cm)

Signed at lower left: S. Colman

EXHIBITED: Hartford, Mark Twain Memorial, "Exhibition of Paintings by the Associated Artists," 1974–1975

EX COLL.: purchased from the *Judge* newspaper by George H. Story for the Wadsworth Atheneum in 1901

Gallery Fund, 1901.35

Colman was one of the first American painters to venture off the traditional European route and to visit Spain, where he sketched monuments such as Granada and Gibraltar.[1] Early on, the artist expressed an interest in port activity, and, as George Sheldon wrote in 1881, "at an early age [Colman] was often seen sketching the ships and the shipping, the waters and the sky, the wharves and the wharfmen."[2] It is not surprising then, that he should be drawn to Gibraltar, an impressive site as well as an important port of call in southern Spain. What is surprising, however, is that the Atheneum's picture, unlike a number of Colman's other depictions of the monument, is supposed to be a view from the north side, where the peninsula joins the Spanish mainland, and is probably an imaginary or composite view.[3] The setting of *Bay of Gibraltar* (c. 1863, Knoedler Gallery, New York), one of Colman's most critically acclaimed paintings set in Gibraltar, is southeast of the view in the Atheneum's picture.[4] A second treatment of this view, *Gibraltar*, is dated 1866 and is in the collection of the George Walter Vincent Smith Museum, Springfield, Massachusetts.

During the time that Colman was visiting the area, Gibraltar was controlled by Great Britain. The Neutral Ground was the sandy strip of land at the boundary between Spain and the British territory. One biased travel writer highlighted Spanish tobacco smuggling as the most distinctive feature of the Neutral Ground.[5]

A contemporary critic contrasted Colman's treatment of the famous monument in *Bay of Gibraltar* with J. M. W. Turner's painting of the same, writing, "A naked mountain rock, surrounded by water is not a promising object for picturesque treatment. Turner, in his admirable picture, has made it almost a subordinate object, struggling for notice amidst a splendid array of sunlit clouds and sea. . . . But Colman . . . shows us the grand old historical monument as it appears on a tranquil summer's day, lifting its majestic summit from a calm, unruffled sea, into a serene and cloudless sky, and glowing in the golden rays of the noonday sun. We regard the picture as a splendid success." The critic continued, "it has also all the fidelity to the actual that we could desire."[6]

In the Atheneum's painting, Colman takes not atmosphere as his subject, but the rock itself. The scene appears to be of the ruins of a Moorish castle at the base of the north side of the rock. Colman's interest in the Moorish architecture of this part of southern Spain is evident in the care he took to define the blocky solidity of the buildings, which were probably made of the limestone indigenous to the area and of which the Rock of Gibraltar itself is composed. Colman treats the buildings, the rock, and the foreground with equal attention; the middle ground and background are engulfed in the haze of a summer's day.[7] AE

Samuel Colman, *Gibraltar*, 1866. George Walter Vincent Smith Art Museum.

1. Sadakichi Hartmann wrote, "Samuel Colman was one of our first painters of Oriental phenomena" (*A History of American Art*, rev. ed. [1932; rpt., New York: Tudor, 1934], 1:77). Amasa Hewins (q.v.) preceded Colman to Granada and Gibraltar by about thirty years, but no known work by Hewins draws on Spanish subject matter.

2. G. W. Sheldon, *American Painters*, rev. ed. (New York: D. Appleton, 1881), 73, quoted in Wayne Craven, "Samuel Colman (1832–1920): Rediscovered Painter of Far-Away Places," *American Art Journal* 8, no. 1 (1976), 18.

3. Based on her research and travel, M. Elizabeth Boone has determined that *Gibraltar from the Neutral Ground* is not an accurate view, despite the specificity of the title. See M. Elizabeth Boone to Amy Ellis, January 29, 1995, curatorial painting file, Wadsworth Atheneum

4. One contemporary critic called Colman's *Bay of Gibraltar* (1863, Knoedler Galleries, New York) "perhaps, one of the best of his early works" ("American Painters—Samuel Colman, N.A.," *Art Journal* [1876], 264). S. G. W. Benjamin, writing about *Bay of Gibraltar* or another, similar work, said, "One of Mr. Colman's most successful works is a painting of Gibraltar. . . . This grand and effective object Mr. Colman painted as it appears at noonday, with the broad sunlight of the southern sea flooding its majestic precipices, while at the base of the tremendous cliff the calm waters of the Mediterranean repose, beautifully blue, and reflecting the white lateen-sails of the picturesque craft that give animation to the scene" (*Our American Artists* [Boston: D. Lothrop, 1886], 141–142).

5. See A. Gallenga, *Iberian Reminiscences: Fifteen Years' Travelling Impressions of Spain and Portugal*, vol. 2 (London: Chapman and Hall, 1883). I thank M. Elizabeth Boone for bringing this material to my attention and for sharing with me her research on Samuel Colman in Spain.

6. Anonymous critic quoted in Henry T. Tuckerman, *Book of the Artists: American Artist Life* (New York: Putnam, 1867), 560; and in Sheldon, *American Painters*, 74. My thanks to M. Elizabeth Boone, who brought this quote to my attention. Although the critic compares the two works as though standing before them, there is no known painting of Gibraltar by J. M. W. Turner.

7. The season can be identified by the rock, which appears barren in summer and green with foliage in spring and fall. See Richard Ford, *A Hand-Book for Travellers in Spain, and Readers at Home*, 2:517, brought to my attention by M. Elizabeth Boone, photocopy of pertinent section in curatorial painting file, Wadsworth Atheneum.

138

SAMUEL COLMAN
Granada, c. 1865
Oil on canvas; 19⅝ × 27⅛ in. (49.8 × 68.9 cm)
Signed at lower right: Granada S. Colman
Technical note: The surface is badly abraded.

138

EXHIBITED: Hartford, Mark Twain Memorial, "Exhibition of Paintings by the Associated Artists," 1974–1975

EX COLL.: with Childs Gallery, Boston, by 1959, as "Italian Scene"; with Vose Galleries, Boston, by 1977; to Jared I. Edwards, Smith Edwards Architects, Hartford, in 1977; on loan to the Wadsworth Atheneum, 1977–1983

Gift of Jared Edwards, Hartford, Conn., 1983.23

Colman probably painted *Granada* sometime after his first trip to Spain in 1860. Colman's interest in the country has been traced to his knowledge of the work of American writers of his day. Washington Irving, for example, was the author of two books especially pertinent here: *The Alhambra* (1832) and the *Chronicle of the Conquest of Granada* (1850).[1] In *Conquest of Granada*, Irving described the city as "sheltered as it were, in the lap of the Sierra Nevada, or Snowy Mountains. Its houses, seventy thousand in number, covered two lofty hills with their declivities, and a deep valley between them, through which flowed the Darro. . . . One of the hills was surmounted by the Alcazaba, a strong fortress, commanding all that part of the city; the other by the Alhambra, a royal palace and warrior castle, capable of containing within its alcazar and towers a garrison of forty thousand men."[2]

The specific subject matter of the Atheneum's painting has not been identified. It does not appear to be either of the two palaces mentioned by Irving, both of which were imposing structures. Colman painted more than one picture of the Alhambra, and one of these, *Alhambra*, resembles the Atheneum's view superficially, in that it features a stone arched bridge with Moorish buildings behind it. The differences—aside from the absence of the Alhambra in *Granada*—lie, in part, in the depiction of the terrain, which is lush and verdant in the Hartford work and arid in the New York painting.

Unlike Colman's *Alhambra*, which, following Irving's *Alhambra*, is a romantic history,[3] the Atheneum's painting seems to be about daily life in Granada. Near the arch of the bridge, on a sandy flat in the river, women are washing clothing.[4] Figures are visible on the bridge above them, but they are not participating in a procession, and so a specific event does not seem to be depicted.[5]

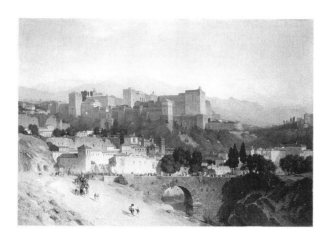

Samuel Colman, *Alhambra*, 1865. Metropolitan Museum of Art, gift of Mrs. Oswald C. Hering, 1968.

The characteristically clear and detailed buildings to the left of the bridge reflect Colman's interest in the Moorish architecture of southern Spain. AE

1. S. G. W. Benjamin mentions Irving in his chapter on Colman in *Our American Artists* (Boston: D. Lothrop, 1886), 138. See also Natalie Spassky, *American Paintings in the Metropolitan Museum of Art*, ed. Kathleen Luhrs (Princeton, N.J.: Princeton University Press, in association with Metropolitan Museum of Art, 1985), 2:350.
2. Washington Irving, *Chronicle of the Conquest of Granada from the Mss. of Fray Antonio Agapida* (New York: Putnam's, 1850), 22–23.
3. Spassky, *American Paintings*, 2:350–351.
4. The river pictured in the Atheneum's painting may or may not be the river Darro mentioned by Irving.
5. In *The Alhambra*, Irving includes a chapter on street processions during the time of Ferdinand and Isabella. See Spassky, *American Paintings*, 2:351.

139

139

SAMUEL COLMAN

The Saw Mill Valley, near Ashford, Westchester County,
 c. 1865

Oil on wood; 7 × 16⁵⁄₁₆ in. (17.8 × 41.4 cm)

Signed at lower left: Sam. Colman.

Label on back: The Saw Mill Valley Near Ashford,
 Westchester Co. Late Summer / Sam'l
 Colman / Pinx / A Study from Nature

Inscribed on back: No. 30 Saw Mill Valley Near Ashford

EXHIBITED: possibly New York City, Somerville Art Gallery, "Artists' Sale: Catalogue of Messrs. Samuel Colman and Geo. H. Hall's Entire Collection of Paintings and Water Colors, Comprising Sketches and Studies from Nature, Never Before Offered," April 3, 4, 5, 1872, no. 164, as "Autumn, Saw Mill Valley" / Hartford, Mark Twain Memorial, "Exhibition of Paintings by the Associated Artists," 1974–1975

EX COLL.: possibly at auction at Somerville Art Gallery, New York City, April 1872; to Mrs. Benjamin Knower, Hartford, by 1922

Gift of Mrs. Benjamin Knower, 1922.150

This summer scene of the pastoral valley near the Saw Mill River, like the Atheneum's other small landscape from the period, *Landscape: Looking Across Country at Irvington-on-Hudson* (cat. 140), is rendered with the loose brushwork that replaced Colman's earlier, finely detailed depictions. It may also reflect the influence of the artist's trip to Europe in 1860–1861, as well as his work in watercolor.[1]

Colman painted at least two other paintings of the area depicted in the Atheneum's painting.[2] One of these, a painting titled simply *Saw-Mill River*, was exhibited in New York City in 1875 and measured 30 by 15½ inches (76.2 × 39.4 cm), suggesting that *Saw Mill Valley, near Ashford* could be a study for a larger work.[3] The label on the back of the Atheneum's painting, reading, in part, "Late Summer / Sam'l Colman / Pinx / A Study from Nature" indicates that the landscape was painted en plein air. AE

1. Wayne Craven, "Samuel Colman (1832–1920): Rediscovered Painter of Far-Away Places," *American Art Journal* 8, no. 1 (1976), 22.
2. See Gloria-Gilda Deák, *The Romantic Landscapes of Samuel Colman*, exh. cat. (New York: Kennedy Galleries, 1983), cat. no. 42. An undated *Saw Mill Valley, Ashford* was in the collection of Colman's descendants until 1983, when it was placed with Kennedy Galleries. The painting, measuring 6⅜ × 8 inches (16.2 × 20.3 cm), is smaller than the Atheneum's *Saw Mill Valley*. Another painting is listed in James L. Yarnall and William H. Gerdts, *The National Museum of American Art's Index to American Art Exhibition Catalogues from the Beginning through the 1876 Centennial Year* (Boston: Hall, 1986), 1:789.
3. Yarnall and Gerdts, *Index*, 1:789. *Saw-Mill River* was in the collection of Robert Hoe, New York City, when it was exhibited in 1875.

140

SAMUEL COLMAN

Landscape: Looking Across Country at Irvington-on-Hudson, 1866
Oil on wood; 9¼ × 16¹⁵/₁₆ in. (23.5 × 43.0 cm)
Signed and dated at lower right: Sam Colman. 1866.

EXHIBITED: New York City, Somerville Art Gallery, "Artists' Sale: Catalogue of Messrs. Samuel Colman and Geo. H. Hall's Entire Collection of Paintings and Water Colors, Comprising Sketches and Studies from Nature, Never Before Offered," April 3, 4, 5, 1872, no. 32 / Hartford, Mark Twain Memorial, "Exhibition of Paintings by the Associated Artists," 1974–1975 / Wadsworth Atheneum, "The Hudson River School: Nineteenth-Century American Landscapes in the Wadsworth Atheneum," 1976, no. 41

EX COLL.: at auction at Somerville Art Gallery, New York City, April 1872; to Mrs. Benjamin Knower, Hartford, by 1922

Gift of Mrs. Benjamin Knower, 1922.151

In 1875 a critic wrote, "Mr. Colman from his early life has been remarkable for his pure and rich coloring, which shows in his delicate and beautiful skies, in the soft meadows of our own country, and in our variegated autumn forests."[1] The writer could well have been refer-

140

ring to this painting or the other small domestic landscape by Colman in the Atheneum's collection, *The Saw Mill Valley* (cat. 139). Colman painted this autumn view of the Hudson River at Irvington the same year he was elected the first president of the American Society of Painters in Water Colors. The fluidity and looseness of the brushwork in *Looking Across Country*, which was probably executed en plein air—in contrast to his earlier detailed compositions in the tradition of the Hudson River school—reflect his experience as a watercolorist, as well as his 1860–1861 trip to Europe, and indicate the direction in which his work would move.[2] The small size of the canvas is typical of second-generation Hudson River school painters, among whom Colman is counted, and the signature suggests that Colman may have considered the landscape a finished painting.[3]

At some point, Colman lived in Irvington-on-Hudson, during which time he probably painted the Atheneum's painting, as well as several other landscapes, both in watercolor and oil, which were exhibited between the years 1866 and 1875.[4] In 1865–1866, around the time Colman may have lived in the area, Albert Bierstadt (q.v.) built his imposing home, called Malkasten, in Irvington-on-Hudson. AE

1. "The Arts," *Appleton's* (1875), 763, photocopy in curatorial painting file, Wadsworth Atheneum. This article was brought to my attention by M. Elizabeth Boone.
2. Wayne Craven, "Samuel Colman (1832–1920): Rediscovered Painter of Far-Away Places," *American Art Journal* 8, no. 1 (1976), 22.
3. At least one of Colman's studies or sketches was comparable in size to the Atheneum's painting, however. See James L. Yarnall and William H. Gerdts, *The National Museum of American Art's Index to American Art Exhibition Catalogues from the Beginning through the* 1876 *Centennial Year* (Boston: Hall, 1986), 1:787–793. On 1:789, Yarnall and Gerdts list *Study at Irvington*, owned by Robert Hoe, New York City, and measuring 18 × 9 inches (45.7 × 22.9 cm).
4. The entry on Colman in *DAB*, reads, in part, "At one time he lived at Irvington-on-Hudson, where he painted some charming river views" (4:314). Yarnall and Gerdts list *Study from Nature, Irvington, N.Y.*, cat. no. 334, exhibited at the Artists' Fund Society, New York City, in 1866; *Study from Nature, near Irvington, N.Y.*, cat. no. 446, exhibited at the American Society of Painters in Water Colors, New York, 1867–1868; *Study from Nature, Irvington, N.Y.*, cat. no. 12,

exhibited for sale at the Artists' Fund Society, Philadelphia, in 1868; *Study from Nature, Irvington, N.Y.*, cat. no. 534, owned by Samuel Colman, exhibited at the American Society of Painters in Water Colors, New York City, January 22, 1869; *Sketch from Nature—Irvington on Hudson*, cat. no. 374, exhibited at the American Society of Painters in Water Colors, New York City, 1869–1870; and *Study at Irvington*, owned by Robert Hoe, New York City, exhibited in 1875 with other works from Hoe's collection (*Index*, 1:789, 790, 793).

J[ohn] Cooper

Active in England (and possibly in America) from about 1705 to 1750

For much of this century, there was no evidence to suggest that the little-known artist John Cooper, who produced a sizable number of paintings from about 1714 to 1750, ever spent time in America. Cooper was the son of an English art dealer and print seller, Edward Cooper (c. 1660–1725), who was responsible for publishing more than two hundred prints. Following in his father's profession, John Cooper worked in England as a mezzotint engraver, painter and publisher. He relied on prints as sources for his paintings, which were executed from about 1705 to 1750 in England and possibly, for a time, in America. Many of his paintings were found in America, and this led to the supposition that he had spent time here. His paintings are crudely executed and represent the aristocratic and royal personages that were the subjects of mezzotint prints of the period. Many are signed "J. Cooper" and dated by the artist.

More recently, evidence that Cooper spent time in Boston as a painter, from about 1715 to 1720, has been more firmly suggested by the discovery of a document bearing John Cooper's signature that deals with Cooper's legal wrangling with a Boston-based tradesman, Jean Berger.

SELECT BIBLIOGRAPHY

John Chaloner Smith, *British Mezzotint Portraits* (London, 1878–1883) / Bartlett Cowdrey, "J. Cooper: An Early New England Portrait Painter," *Panorama* 1 (November 1945), 2–7 / George C. Groce, "Who Was J[ohn?] Cooper (b. ca. 1695–

living 1754?)" *Art Quarterly* 18 (spring 1955), 73–82 / Robert A. Leath, "Jean Berger's Design Book: Huguenot Tradesmen and the Dissemination of French Baroque Style," in *American Furniture*, ed. Luke Beckerdite (Hanover, N.H.: University of New England Press, for the Chipstone Foundation, 1994)

141

J[OHN] COOPER
Man and a Horse, 1715
Oil on canvas; 30¼ × 25¼ in. (76.8 × 64.1 cm)
Signed and dated at lower left: J. Cooper / 1715

EX COLL.: with Tillou Galleries, Litchfield, Conn., by 1981

The Ella Gallup Sumner and Mary Catlin Sumner Collection Fund, 1981.40

J[ohn] Cooper likely drew on one or more print sources for his *Man and a Horse*. In a somewhat crudely executed work, the artist presents an aristocratic figure of a young man attired in a long flowing wig, red ermine-lined cape, and white lace collar, with his arms and shoulders protected by gleaming armor. He holds a sword in his left hand, and the head of his horse, an ornate engraved bit in its mouth, leans toward him at the right. The artist paints in broadly applied, linear strokes and uses a bright palette. EMK

George Cope

Born in East Bradford, Pa., in 1855; died in West Chester, Pa., in 1929

George Cope spent most of his life in West Chester, Pennsylvania, painting still lifes and some landscapes. Raised on a farm, he received his earliest artistic training in 1876 in Philadelphia, from the German-trained artist Herman Herzog (1831–1932); the two men became life-long friends. In the same year, Cope made a trip out west, which resulted in his painting a number of western landscapes; he made a second western trip in 1879, during which he continued to paint landscapes.

By 1880 Cope had established a studio in West Chester, where, in addition to painting, he offered art instruction. He also had a studio in Philadelphia in 1881. By the mid-1880s Cope had begun to produce sporting pictures and still lifes of dead game. Although there is no record of direct contact, Cope's still lifes show the impact of the works of William Harnett (q.v.) by 1887, one year after Harnett returned from Europe. One of his first trompe l'oeil still lifes, *The Hunter's Yellow Jacket* (private collection), painted in 1891, owes a marked debt to William Harnett's fourth version of *After the Hunt* (1885), which hung in a New York City saloon owned by Theodore Stewart.

In 1890 Cope received a patent for a stretcher key he invented that is found on a number of his paintings. In the same year, he was established in New York City and had expanded his repertoire of still lifes to include table-top arrangements, as well as continuing to render his favored outdoor sporting scenes, sporting animals, and hunting paraphernalia hanging on doors; he also painted trompe l'oeil depictions of currency. In 1894 Cope painted his most famous work, *Buffalo Bill's Traps* (unlocated), which, according to a contemporary account, depicted "the hunting jacket, rifles, hat, lariat, etc. of the famous Buffalo Bill" (*Daily Local News [Westchester, Pa.]*, June 21, 1894), seen hanging from a wooden door.

Cope continued to paint until late in life. He died at his home in West Chester.

SELECT BIBLIOGRAPHY

Henry Pleasants, Jr., "Our Own George Cope: 1855–1929," *Yesterday in Chester County Art* (West Chester, Pa.: Chester County Art Association, 1936) / Joan H. Gorman and Gertrude Grace Sill, *George Cope, 1855–1929*, exh. cat. (Chadds Ford, Pa.: Brandywine River Museum, 1978)

142

GEORGE COPE
The Hunter's Gun (Dead Birds in a Landscape), 1898
Oil on canvas; 20⅞ × 33¼ in. (53.0 × 84.5 cm)
Signed and dated at lower left: Geo. Cope. 1898

141

EXHIBITED: New York City, James Graham and Sons, "Exhibition: Commemorating the Hundredth Anniversary of the Birth of the West Chester, Pennsylvania, Realist George Cope," 1955, no. 19, as "The Hunter's Gun" / Wadsworth Atheneum, "Harvest of Plenty," 1963, no. 11 / Chadds Ford, Pa., Brandywine River Museum, and Dayton, Ohio, Dayton Art Institute, "George Cope: 1855–1929," 1978, no. 15

EX COLL.: with James Graham and Sons Gallery, New York City, by 1942

The Ella Gallup Sumner and Mary Catlin Sumner Collection Fund, 1942.32

As a follower of William Harnett (q.v.), who returned from Europe to Philadelphia in 1886, Cope executed hunting and game still lifes that included close-up views of hanging game birds and rabbits. He often worked in a vertical format, placing hanging game and hunting paraphernalia against a door.[1]

The Hunter's Gun is a painting of a day's bag, and here Cope abandoned the usual detachment of trompe l'oeil objects against a flat surface. Instead, the dead game birds, hunting gun, and spent shells (objects that were undoubtedly in his "collection of relics") are scat-

142

tered across the ground in a haphazard manner against a landscape background.[2] Cope painted landscapes early in his career, and for this work he drew on his skill in both still-life and landscape painting. EMK

1. William H. Gerdts, *Painters of the Humble Truth: Masterpieces of American Still Life, 1801–1939,* exh. cat. (Columbia and London: University of Missouri Press, in association with the Philbrook Art Center, 1981), 190; Joan H. Gorman and Gertrude Grace Sill, *George Cope, 1855–1929,* exh. cat. (Chadds Ford, Pa.: Brandywine River Museum, 1978); and Gertrude Grace Sill, "George Cope, Painter of West Chester, Pennsylvania," *Antiques* 67 (November 1979), 1138–1149.
2. Alfred Frankenstein found the following clipping in the *Daily Local News* (West Chester, Pa.), November 12, 1897: "George Cope, of West Gay Street, has in his possession a curiosity in the shape of a huge pistol with flint lock which he discovered somewhere out in Bradford . . . and he added it to his collection of relics" (curatorial painting file, Wadsworth Atheneum).

John Singleton Copley

Born in Boston, in 1739; died in London, in 1815

The son of humble Irish immigrant parents, Copley's innate artistic genius allowed him to rise quickly in his profession; he became the leading artist in colonial America before experiencing travel abroad. When he was ten years old, his mother married Peter Pelham (1697–1751), a London-trained mezzotint engraver based in Boston; thus Copley was exposed as a young man to the tools of the artist's trade. In the 1750s he experimented with a variety of artistic endeavors, first scraping a mezzotint and then painting mythological works drawn from print sources, producing anatomical drawings, and painting a variety of portraits, including oil on copper in miniature, pastels, and life-size works in oil. His portraits at this time show the influence of such artists of the day as the English-trained painter Joseph Blackburn (q.v.) but are marked by a strong linearity, contrasts of light and shade, and a directness of approach.

By the early 1760s Copley had attained an unchallenged position as Boston's leading artist, bringing portraiture in America to a new level of sophistication. Longing for international acclaim, he tested his skills in 1766 by sending a portrait of his half brother Henry Pelham (1749–1806), known as *Boy with a Squirrel* (1765, Museum of Fine Arts, Boston), to the Society of Artists in London; he received positive notices.

On November 16, 1769, Copley married Susanna Clarke, the daughter of a wealthy and influential Boston merchant, and he began acquiring property for a new residence adjacent to that of John Hancock on the top of Beacon Hill. The artist achieved a new level of success in the years preceding the Revolution, enjoying liberal patronage from Boston area merchants and politicians, Whig and Tory alike. He also spent a profitable season painting thirty-five portraits in New York City in 1771.

In the spring of 1774 the rising political turmoil in Boston induced Copley to depart for England. After being welcomed to London by Benjamin West (q.v.), in August 1774 he set off on a year of travel on the Continent, studying the works of the old masters in Paris, Florence, Naples, Rome, Venice, the Tyrol, and Cologne and returning to London in September 1775, when he settled in a large house in Leicester Square.

In London, Copley pursued a prosperous career painting portraits and aspired to succeed as a leading painter of historical and, to a lesser extent, religious subjects. In 1778 he gained attention with his first large-scale history painting, *Watson and the Shark* (National Gallery of Art, Washington, D.C.), which treated a provocative subject. The following year he attained admission to the Royal Academy and began work on his great history painting, *The Death of the Earl of Chatham* (1779–1781, Tate Gallery, London), the public exhibition of which brought him wide popular acclaim. It was followed by another powerful, heroic modern history piece, *The Death of Major Pierson* (1783, Tate Gallery, London), which marked the height of his career.

Copley continued to paint portraits and history paintings until the end of his life, though his skills began to diminish. He died at the age of seventy-seven.

SELECT BIBLIOGRAPHY

Jules David Prown, *John Singleton Copley*, 2 vols. (Cambridge: Harvard University Press, for the National Gallery of Art, Washington, D.C., 1966) / *Letters and Papers of John Singleton Copley and Henry Pelham, 1739–1776,* ed. Guernsey Jones (1914; rpt., New York: Da Capo Press, for Kennedy Graphics, 1970) / Trevor J. Fairbrother, "John Singleton Copley's Use of British Mezzotints for His American Portraits: A Reappraisal Prompted by New Discoveries," *Arts Magazine* 55 (March 1981), 122–130 / Ellen Miles, *Watson and the Shark* (Washington, D.C.: National Gallery of Art, 1993)

143

JOHN SINGLETON COPLEY
The Reverend Samuel Fayerweather, c. 1758
Oil on copper; $3^{3}/_{16} \times 2^{1}/_{2}$ in. (8.1 × 6.4 cm)
Technical note: Areas of paint loss are evident throughout the background and along the left side of the subject's face.

EX COLL.: Mr. and Mrs. John M. Washburn, West Hartford

Gift of Mr. and Mrs. John M. Washburn, 1968.15

During Copley's formative years in Boston in the 1750s, he experimented with a variety of art forms, including life-size and miniature portraits. He executed a number of oil-on-copper miniatures during the latter part of the decade. *The Reverend Samuel Fayerweather* is a sensitive portrayal of this prominent minister. With its strong contrasts of light and shade and touches of rich color, seen in the red cape over the subject's right shoulder, the heightened flesh tones, and a rich brown background, Copley's miniature has all the fine qualities admired in his life-size portraits of this period. Like his other known miniatures, this portrait was likely conceived as an independent work, although according to family record, a full-scale portrait of Fayerweather was also painted by Copley; this remains unlocated.[1]

A second version of this miniature in oil on copper of similar dimensions is in the collection of the Yale University Art Gallery. The pose in the Atheneum version varies slightly from that in the Yale version; the Rever-

143

end Fayerweather faces the viewer more directly in the Atheneum's and his cap is placed higher on his head, while in the Yale miniature he is turned more sharply to the right, with the left side of his face in shadow. In both versions, he is shown in academic garb—a black gown, white collar, and red cape—and wears an academic black cap.

Rev. Samuel Fayerweather was raised in Cambridge, Massachusetts, and graduated from Harvard College in 1743. He continued his studies at Oxford and Cambridge, England, in 1756 to 1758. Following his ordination in London, the Reverend Fayerweather served as rector of St. Paul's Church, in Narragansett, Rhode Island, from 1760 until his death in 1781.[2] EMK

1. Richard H. Saunders and Ellen G. Miles, *American Colonial Portraits: 1700–1776,* exh. cat. (Washington, D.C.: Smithsonian University Press, for the National Portrait Gallery, 1987), 230–231. The full-scale portrait is noted in Frank W. Bayley, *A Sketch of the Life of John Singleton Copley* (Boston: Garden Press, 1910), 107.
2. Frank W. Bayley, *John Singleton Copley* (Boston: Garden Press, 1910), 104; John Langdon Sibley and Clifford K. Shipton, *Biographical Sketches of Graduates of Harvard University* (Cambridge, Mass., 1873–1956), 6:105–106.

144 (see plate 40)

JOHN SINGLETON COPLEY

Jeremiah Lee, 1769

Oil on bed ticking; 95 × 59 in. (241.3 × 149.9 cm)

Signed (monogram) and dated at left center: JSC p. 1769.

Signed (monogram) and dated on back of canvas: JSCopley pinxt: Bos: 1769

EXHIBITED: Boston, "Revolutionary Relics Exhibition," June 1875, no. 271 (owner: William R. Lee) / Washington, D.C., National Gallery of Art, and New York City, Metropolitan Museum of Art, "John Singleton Copley: A Retrospective Exhibition," 1965, no. 41 / Los Angeles County Museum of Art, and Washington, D.C., National Portrait Gallery, "American Portraiture in the Grand Manner: 1720–1920," 1981

EX COLL.: Mr. and Mrs. Jeremiah Lee, Marblehead, Mass.; to their daughter, Mary Lee Tracy, and her husband, Nathaniel Tracy, in 1775; to their son Patrick Tracy, Newburyport, Mass., a bequest of Martha Swett Lee to her grandson in her will of 1791; to his sister, Hannah Tracy, and her husband, General William Raymond Lee, Boston and Roxbury, Mass., in about 1850 to 1891; to their son Robert Ives Lee by 1908; to his son, Thomas Amory Lee, Topeka, Kans., by 1912; on loan from Thomas Amory Lee, Topeka, Kans., to the Museum of Fine Arts, Boston, from 1912 to 1940; to Mrs. Thomas (Mary Helen) Amory Lee, in 1941; with M. Knoedler and Co., New York City, in 1945

The Ella Gallup Sumner and Mary Catlin Sumner Collection Fund, 1945.58

145 (see plate 41)

JOHN SINGLETON COPLEY

Mrs. Jeremiah Lee (Martha Swett), 1769

Oil on canvas; 95 × 59 in. (241.3 × 149.9 cm)

Signed (monogram) and dated at lower left: JSC p. 1769

Signed (monogram) and dated on back of canvas:

JSCopley pinxt: Bos: 1769–

EXHIBITED: Boston, "Revolutionary Relics Exhibition," June 1875, no. 272 (owner: William R. Lee) / Washington, D.C., National Gallery of Art, and New York City, Metropolitan Museum of Art, "John Singleton Copley: A Retrospective Exhibition," 1965, no. 42 / Los Angeles County Museum of Art, and Washington, D.C., National Portrait Gallery, "American Portraiture in the Grand Manner: 1720–1920," 1981

EX COLL.: Mr. and Mrs. Jeremiah Lee, Marblehead, Mass.; to their daughter, Mary Lee Tracy, and her husband, Nathaniel Tracy, in 1775; to their son Patrick Tracy, Newburyport, Mass., a bequest of Martha Swett Lee to her grandson in her will of 1791; to his sister, Hannah Tracy, and her husband, General William Raymond Lee, Boston and Roxbury, Mass., in about 1850 to 1891; to their son Robert Ives Lee by 1908; to his son, Thomas Amory Lee, Topeka, Kans., by 1912; on loan from Thomas Amory Lee, Topeka, Kans., to the Museum of Fine Arts, Boston, from 1912 to 1940; to Mrs. Thomas (Mary Helen) Amory Lee in 1941; with M. Knoedler and Co., New York City, in 1945

The Ella Gallup Sumner and Mary Catlin Sumner Collection Fund, 1945.59

Copley's grand portraits of Jeremiah and Martha Lee mark the culmination of a series of portraits of Boston area merchants and their wives that the artist painted in the later years of the 1760s. The Lee portraits are distinguished by their monumental scale and elaborateness, likely dictated by the fact that they were commissioned by the Lees for the couple's newly built (and equally opulent) mansion house: the artist conceived the paintings to accord with the overall building plan.

In portraits of such Boston merchants as Nicholas Boylston (1767, Harvard University, Cambridge) and his sister Rebecca Boylston (1767, Museum of Fine Arts, Boston), Copley created an environment for his sitters in which they seem entirely comfortable. In his portraits of the Lees, however, this naturalism is replaced by the formality of the full-length presentation, a format Copley had not attempted since painting the portraits five years earlier of two other prominent merchants, Nathaniel Sparhawk (1764, Museum of Fine Arts, Boston, on deposit from the estate of Frederick H. Rindge) and Thomas Hancock (1764–1766, Harvard University, Cambridge). The Lees may have got the idea for their full-length portraits from the portraits of Mr. and Mrs. William Browne (c. 1738, Johns Hopkins University, Baltimore) that hung in Browne Hall in nearby Danvers

and were likely known to the Lees. Thirty-five years earlier, the Brownes had built a mansion that was as opulent for its day as the house the Lees built in 1768; at that time they had commissioned John Smibert (q.v.) to paint full-length portraits.[1]

In their portraits, the Lees are shown in elaborate, stagelike settings. Jeremiah wears an elegant brown velvet suit with gold trim—according to tradition, his wedding suit of twenty-four years earlier. His business affairs are evoked by the paper held in his left hand and the silver inkstand and papers on the table. The marble-top pier table with gilded figures of a nude female torso on the table legs is derived from an English mezzotint portrait, *Queen Caroline* (1739), by John Faber, Jr., after J. Vanderbank; the table also appears in Copley's *Thomas Hancock*. Lee stands on a lavish Turkey carpet, and his pose is enhanced by the great swag of damask drapery behind him.

Mrs. Lee is attired in an imagined gold satin gown and an ermine-trimmed cape and wears strands of pearls in her hair and around her neck. The mother of six children at the time the portrait was painted, she carries an assortment of fruit as a sign of fertility. Within a formal architectural space of columns and an arch, Mrs. Lee ascends a flight of stone steps; her figure fills the foreground, while a generalized landscape is seen in the distance. The plainness of the Lees' features and the lack of elegance in their poses associate them with the New England mercantile society of which they were a part; their position in life belies the elaborate settings in which they are placed, which are more appropriate to a grand English country house.

Jeremiah Lee (1721–1775) was a leading shipowner and merchant in Marblehead, Massachusetts. With his impressive fleet, Lee profited from the triangular trade between New England, the West Indies, and Europe, building one of the greatest fortunes in the Colonies. In 1745 he married Martha Swett (1726–1791), the daughter of a prominent Marblehead merchant, and she bore him nine children.

While maintaining his international mercantile business, Lee participated actively in the growing political turmoil of the early 1770s, serving on a number of committees as an ardent patriot. Celebrated for his role as a member of the Committee of Safety and Supply for Massachusetts, the occasion when he and several other members were forced to flee British troops after a meeting at the Black Horse Tavern in Concord, on April 17, 1775, earned him particular attention.[2] He died the following month and was remembered as "one of the most eminent merchants on this Continent, and a distinguished, resolute Asserter and Defender of the Liberties of his oppressed and much injured Country."[3]

With the help of his brother Samuel, who was the leading builder in Marblehead, Jeremiah built what was considered in its day to be one of the grandest and most fashionable late Georgian mansions in New England, completed in 1768 (the year the portraits were painted), reportedly at a cost of ten thousand pounds. The Lees filled the mansion with lavish furnishings and fabrics; Jeremiah's probate inventory of 1775 lists no less than eighteen looking glasses, several items of japanned furniture, a mahogany desk and bookcase, yards of fine damask fabric, and expensive carpets. The Lees also owned several slaves.[4]

The mansion is still held to be the "largest New England dwelling of its generation," as well as the most stylish, fitted out with interior architectural elements and furnishings in the latest rococo style.[5] The walls on both floors of the main stair hall and in the two front chambers have their original paper hangings, which were painted to order in England, and depict classical ruins and romantic landscapes from engravings after Giovanni Paolo Pannini (c. 1691–1765) and Joseph Vernet (1714–1789) and shown within rococo trompe l'oeil frames.[6] Many of the architectural features were drawn from Abraham Swan's *British Architect* (1745).[7]

Copley conceived the portraits as the crowning element of the house, planning them to hang in specific locations on the landing between the first and second floors of the grand entrance hall, sixteen feet wide, with Mr. Lee's on the right facing Mrs. Lee's, in which she seemingly ascends the short flight of steps leading to the second floor.[8] A large window in the center of the landing wall gave out onto a landscape that echoed the landscape in Mrs. Lee's portrait. These are the only lo-

John Singleton Copley, *Thomas Hancock*, 1764–1766. Harvard University Art Museums.

cations in the house that accommodate the portraits, which fit between the wainscot and the cornice.

The Lee portraits have retained their original rococo frames, which echoed the rococo wallpaper against which they were hung. The frames relate to a series carved for Copley by the Boston carver John Welch (1711–1789) that also includes those for *Thomas Hancock* and *Thomas Hollis* (Portrait Collection, Harvard University), which are surmounted by cartouches like those originally found on the Lee portraits.[9]

Copies of the Lee portraits with copies of the frames including the cartouches are in the collection of the Jeremiah Lee Mansion, Marblehead. According to family tradition, the copies were painted by Chester Harding (1792–1866) as a wedding present from General William Raymond Lee to his daughter Elizabeth on the occasion of her marriage to General Oswald H. Ernst in 1866.[10]

Copley painted two watercolor miniature portraits on ivory of Jeremiah Lee in 1769 (Metropolitan Museum of Art and Marblehead Historical Society, Marblehead, Mass.).[11] EMK

1. These portraits are discussed at some length in Jules David Prown, *John Singleton Copley* (Cambridge: Harvard University Press, for the National Gallery of Art, Washington, D.C., 1966), 1:60, 70–72; and Michael Quick, "Princely Images in the Wilderness: 1720–1775," in *American Portraiture in the Grand Manner: 1720–1920*, exh. cat., ed. Michael Quick (Los Angeles: Los Angeles County Museum, 1982), 101, 104–105.
2. Thomas Amory Lee, "The Lee Family of Marblehead," *Historical Collections of the Essex Institute* 52, no. 4 (October 1916), 329–343.
3. Obituary notice, reproduced in Lee, "The Lee Family of Marblehead," 337.
4. Jeremiah Lee, Probate Inventory, Marblehead, Mass., June 17, 1779, xerox copy supplied by Mrs. John P. Hunt, Jr., Marblehead Historical Society, Marblehead, Mass.
5. Morrison H. Heckscher and Leslie Greene Bowman, *American Rococo, 1750–1775: Elegance in Ornament* (New York: Abrams, 1992), 20; see also Narcissa G. Chamberlain, "History in Houses: The Jeremiah Lee Mansion in Marblehead, Massachusetts," *Antiques* 112 (December 1977), 1164–1173.
6. Catherine Lynn Frangiamore, "Landscape Wallpaper in the Jeremiah Lee Mansion," *Antiques* 112 (December 1977), 1174–1179.
7. Abraham Swan, *The British Architect; or, the Builder's Treasury of Stair-Cases* (1758; rpt., New York: Da Capo Press, 1967). See Heckscher and Bowman, *American Rococo*, 20–21.

Lee Mansion, Marblehead, Massachusetts. Photograph: courtesy the Lee Mansion.

8. This theory was first put forth by Stuart Feld, "Copley Portraits Rehung," May 1960 (unpublished paper, painting files, Metropolitan Museum of Art). Support for the theory is provided in a letter from the sitter's great-great-great grandson, which states that, according to family tradition, the portraits "were painted to fill two especial places in the great hall of the Lee Mansion" (Thomas Amory Lee to Maynard Walker, April 17, 1940, curatorial painting file, Wadsworth Atheneum).

9. The cartouches that surmounted the frames on the Lee portraits were removed by the family, probably in the nineteenth century, and are now lost. Thomas Amory Lee noted, "[The portraits] are in their original frames . . . which are complete except for the fact that the coat-of-arms at the top of the frames were removed many years ago because the portraits were too long for the drawing room in which they hung in our Boston home" (Thomas Amory Lee to Maynard Walker, April 4, 1940, Wadsworth Atheneum). Reproductions of the cartouches have recently been fabricated based on the example found on the frame of *Thomas Hollis*.

10. Narcissa G. Chamberlain to Charles Cunningham, October 5, 1965, curatorial painting file, Wadsworth Atheneum.

11. Prown, *John Singleton Copley*, 1:221; and Louise Burroughs, "Colonel Jeremiah Lee: A Miniature by Copley," *Bulletin of the Metropolitan Museum of Art* 35 (December 1940), 236–237.

146 (see plate 42)

JOHN SINGLETON COPLEY

Portrait of a Lady (*Mrs. Seymour Fort*), c. 1780
Oil on canvas; 49½ × 39⅝ in. (125.7 × 100.6 cm)

EXHIBITED: possibly London, Royal Academy, 1780, no. 97, as "Portrait of a lady" / New York City, Metropolitan Museum of Art, "The Hudson-Fulton Celebration," 1909, no. 13, as "Portrait of Mrs. Fort" / Art Institute of Chicago, "A Century of Progress," 1933, no. 414 / New York City, Metropolitan Museum of Art, "An Exhibition of Paintings by John Singleton Copley: In Commemoration of the Two-Hundredth Anniversary of His Birth," 1936–1937, no. 37 / Boston, Museum of Fine Arts, "John Singleton Copley, 1738–1815," 1938, no. 30 / Paris, Musée du Jeu de Paume, "Trois Siècles d'Art aux Etats-Unis," 1938, no. 32 / Pittsburgh, Pa., Carnegie Institute, "Survey of American Painting," 1940, no. 61 / New York City, Wildenstein, "Fashion in Headdress, 1450–1943," 1943, no. 60 / Grand Rapids, Mich., Grand Rapids Art Gallery, "Art of the American Colonial and Revolutionary Period," 1943 / London, Tate Gallery, "American Painting from the Eighteenth Century to the Present Day," 1946, no. 46 / St. Louis, Mo., City Art Museum,

"Forty Masterpieces," 1947, no. 7 / New York City, Knoedler Galleries, "Masterpieces from the Wadsworth Atheneum, Hartford, Conn.," 1958

EX COLL.: with the Dowdeswell Galleries, London, by 1901; purchased by George H. Story, New York City, in 1901

Gallery Fund, 1901.34

When this portrait was acquired by the Wadsworth Atheneum, the subject was identified as Mrs. Seymour Fort, as suggested by a paper label attached to the back that reads: "John Singleton Copley R. A. Portrait / of Mrs. Seymour Fort / From the Morgan Collection." However, a letter from a descendant of the Fort family and a careful genealogical search both suggest that Mrs. Seymour Fort could not have been the subject.[1]

The portraits that Copley painted in England demonstrate that he retained his ability to depict his sitters with great immediacy. This elderly woman's features are vibrantly captured by the artist, who presents her with a flushed complexion, a likeness full of character and wisdom, and a direct gaze out at the viewer. She is seated in an elegant gilt and upholstered armchair, busily engaged in knotting, her hands gracefully occupied with a small shuttle and thread. A silk bag hangs from her left arm. The woman's attire, including the large lace cap, is suitable for an older woman of social standing and is masterfully depicted by Copley. The subject is placed against elaborate red drapery that adds richness to the portrait.

The artist borrowed the costume details and accessories from this work to complete the portrait of Elizabeth MacIntosh, *Mrs. Isaac Royall*, that he had started in America in 1769, a year before the sitter's death, and did not complete until 1780 while in London.[2]

Jules Prown provides a date of about 1778 for *Portrait of a Lady*, suggesting that it may have been the three-quarter-length portrait Copley exhibited at the Royal Academy in 1778 along with *Sir William Pepperrell and His Family* (1778, North Carolina Museum of Art) and *Watson and the Shark*.[3] The Atheneum's portrait is a half-length (50 × 40 in. [127.0 × 101.6 cm]) rather than three-quarter-length (30 × 25 in. [76.2 × 63.5 cm]) canvas, however, so it could not have been the

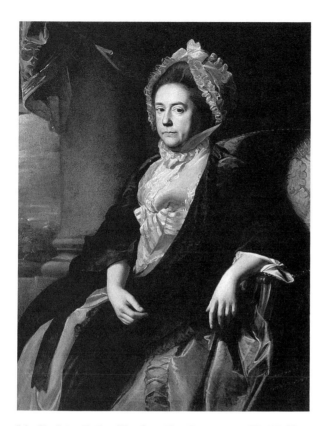

John Singleton Copley, *Mrs. Isaac Royall*, 1769–1780. Virginia Museum of Fine Arts, gift of Mrs. A. D. Williams, 1949.

ting] were invented, in order that women even in a large group could appear to be occupied with a petit ouvrage in the manner most suited to them."[7]

Reynolds often painted women at their domestic work, as in the portrait *Anne, Countess of Albemarle*, which shows his elderly sitter knotting.[8] Gainsborough's *Mrs. Charles Tudway* (c. 1765, Baltimore Museum of Art) also shows a seated woman engaged in knotting, holding a bag on her left arm. Although the Atheneum's portrait is the only known instance where Copley used knotting as a pastime for a sitter, he had occasionally shown women at work in his American portraits; for example, in the double portrait *Mr. and Mrs. Thomas Mifflin* (1773, Historical Society of Pennsylvania), Mrs. Mifflin is shown pausing from her work at a fringe loom.

A reduced copy of this portrait (36 × 28 in. [91.4 × 71.1 cm]) was sold as lot 83 at Christie's, London, on

work exhibited in 1778 (unless a mistake was made in the catalogue entry).[4] The Atheneum's portrait may, however, be the "Portrait of a lady" (with no size given) exhibited at the Royal Academy in 1780.[5]

That the subject is occupied with the pastime of knotting adds an exciting visual element to this portrait and also points to the sitter's social standing. Costume expert Aileen Ribeiro has written, "Knotting, that is making, with the aid of a small shuttle, a decorative linen braid which could be sewn on to fabric, was a pastime acceptable at Court and on many social occasions, providing with the excuse of work, a chance to show off the graceful attitudes of the hands."[6] Madame de Genlis, a lady-in-waiting to the duchesse de Chartres, provides a contemporary explanation of the merits of knotting in France: "A seated woman, entirely idle, takes the attitude of a man and loses her characteristic grace. That is why formerly navettes [ornamental shuttles for knot-

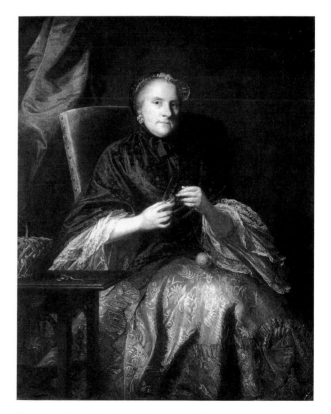

Sir Joshua Reynolds, *Anne, Countess of Albemarle*, c. 1760. National Gallery, London.

July 17, 1931, as a work by the English artist John Opie, "Portrait of Mrs. Foot, wife of Jesse Foot, Esq." A family of surgeons by that name were in London in the late eighteenth century.[9] This copy was later in a sale of the collection of Arnold Seligmann, Rey and Co., held at Parke-Bernet, New York, January 23–25, 1947, listed as lot 278, a work by John Singleton Copley, of Mrs. Seymour Fort (later in the collection of James Thompson, Farmington, Conn.).[10] A second copy, painted by Russell Cheney (q.v.) in 1947, is in a private collection.[11] EMK

1. G. Seymour Fort wrote to the Wadsworth Atheneum, "With reference to your question about Mrs. Seymour Fort's portrait by Copley I will tell you the facts as I remember them. When the portrait first appeared in the sphere of Sept 1. [19]06 I was naturally amazed as I am the only Seymour Fort who can ever have existed—and I was then unmarried. I . . . was sent to a small dealer's shop in some slum or another. The people there told me that they had the portrait in their possession for many years before selling to the dealers— They were however unable to decipher the name of the lady, but in their opinion the name was much more like Mrs. Susan Foote than 'Mrs. Seymour Fort.' Who deciphered it as the latter, I have never been able to find out" (G. Seymour Fort to Edith Beach, London, February 15, 1909, curatorial painting file, Wadsworth Atheneum). Research conducted by the Society of Genealogists, London, has confirmed that the identity of this subject remains in question (Anthony J. Camp to Elizabeth Kornhauser, August 4, 1993, curatorial painting file, Wadsworth Atheneum).

2. Jules David Prown, *John Singleton Copley* (Cambridge: Harvard University Press, for the National Gallery of Art, Washington, D.C., 1966), 2:70, 266–267.

3. Ibid., 2:264–265; and Gertrude Townsend, "Portrait of John Singleton Copley of a Lady 'Knotting,' *Wadsworth Atheneum Bulletin* 2 (fall 1966), 13.

4. Listed in Algernon Graves, *The Royal Academy of Arts: A Complete Dictionary of Contributors and Their Works from Its Foundation in 1769 to 1904* (London: Henry Graves, 1905), 2:159, entry for 1778, no. 64, "Portrait of a lady; three-quarters."

5. Ibid. Copley explained his system of pricing portraits based on their sizes in a letter of 1771 to Stephen Kemble: "I may be able to engage 12 or 15 half lengths, or in proportion to that, reck[on]ing whole Length as two half Length[s], and half Length Doub[le] the busts. . . . The pric[e] of Whole Lengths 40 Guineas, half Length 20, ¼ pieces or Busts 10" (quoted in Richard H. Saunders and Ellen G. Miles, *American Colonial Portraits: 1700–1776*, exh. cat. [Washington, D.C.: Smithsonian Institution Press, for the National Portrait Gallery, 1987], 62).

6. Nicholas Penny, ed., with Diana Donald, David Mannings, John Newman, Aileen Ribeiro, Robert Rosenblum, and M. Kirby Talley, Jr., *Reynolds* (New York: Abrams, 1986), 195.

7. Mme la comtesse de Genlis, *Dictionnaire Critique et Raisonné, des Etiquettes de la Cour* (Paris, 1818), 2:3, quoted in Townsend, "Portrait of John Singleton Copley," 13.

8. Penny et al., *Reynolds*, 195.

9. Jesse Foot (1744–1826) practiced as a surgeon and wrote several medical treatises in London in the late eighteenth century; see Sir Leslie Stephan and Sir Sidney Lee, eds., *Dictionary of National Biography* (London: Oxford University Press, 1882–1953), 1:450. As he would have been only thirty-six years old in 1780, he may have been the son of this sitter.

10. *French and Italian Furniture and Works of Art . . . Property of Arnold Seligmann, Rey and Co., Inc.*, Parke-Bernet Galleries, Inc., New York, January 23–25, 1947, lot 278, 91, ill.

11. Curatorial painting file, Wadsworth Atheneum.

147 (see plate 43)

JOHN SINGLETON COPLEY

Samuel Relating to Eli the Judgements of God upon Eli's House, 1780

Oil on canvas; 78½ × 61⅜ in. (199.4 × 155.9 cm)

Signed and dated at lower left: J. S. Copley Pinx. / 1780

EXHIBITED: London, Royal Academy of Art, 1780 / Wadsworth Atheneum, "Art of the Bible in Five Centuries," 1952

EX COLL.: Mr. Ashton, Moldnear, Liverpool, England, in 1882; Sidney Clarke, London; with G. M. Cherry, London; sold at Christie's, London, February 16, 1934 (various properties); with Leger Gallery, London, by 1936

The Ella Gallup Sumner and Mary Catlin Sumner Collection Fund, 1941.590

Copley's highly praised showing of his masterful *Watson and the Shark* (1778, National Gallery of Art, Washington, D.C.) established his position as an important modern history painter and led to his election to full membership in the Royal Academy in February 1779. At that time, he began a more ambitious project that largely occupied him during 1779 and 1780: the preparation for and execution of the monumental history painting *The Death of the Earl of Chatham* (1779–1780, Tate

Gallery). It was at this time that the artist painted *Samuel Relating to Eli the Judgements of God upon Eli's House*. The choice of subject and the manner in which *Samuel* is painted reflect Copley's admiration for Rembrandt, whose paintings, as well as engravings after his works, were held in high esteem in late-eighteenth-century England.[1] The choice of subject acknowledges Rembrandt's work as an illustrator of the Bible; in addition, both the strong lighting and the thickly painted passages, particularly the breastplate and the vessels, are indicative of Rembrandt's influence.

The work may have been intended as a diploma piece for the Royal Academy. Evidence for this supposition is provided by a mention in the *Morning Post* discussing the new building of the Royal Academy in which hung the "masterly picture of Eli and Samuel by Copley."[2] A second review of the work appeared the following week: "We [may not] dismiss this article without noticing [Copley's] historical picture below stairs, of *Samuel and Eli*, on which too much commendation cannot well be bestowed, it is in every respect a *picture*; finished in every part, with a precision, and roundness, which makes the whole an outline; and the character of the child Samuel, is so divine, and has such an air of truth and simplicity about it, that this picture alone, is a considerable acquisition to the Arts in this country."[3]

The artist's son John Singleton Copley, Jr. (1772–1863), served as a model for Samuel, and according to tradition, a maimed beggar who had lost both legs in battle was the model for Eli.[4] Allen Staley has pointed out, however, that Copley's copy (private collection) of the figure of St. Peter that appears in Benjamin West's *St. Peter Denying Christ* (1778–1779, St. John's Church, Perlethorpe, Nottinghamshire, England) bears a marked resemblance to the figure of Eli in his *Samuel and Eli* and that West's original was likely the model for both works.[5]

An engraving of the painting by Valentine Green was published September 21, 1780, and a mezzotint by James Daniel was issued January 1, 1805. A replica of the work painted by Copley in 1810 was exhibited at the British Institution in 1811 and sold in the Lord Lyndhurst (John Singleton Copley, Jr.) Sale, in 1864 at the

Royal Academy; it was destroyed by fire in 1867.[6] The image was also reproduced in ivory relief and on porcelain.[7] There is also a stained-glass window in the cathedral in Milan, Italy, based on this work.[8] EMK

1. For a discussion of Rembrandt's influence on English art, see Christopher White, David Alexander, and Ellen D' Oench, *Rembrandt in Eighteenth Century England* (New Haven: Yale Center for British Art, 1983).
2. Letter to the editor, *Morning Post*, May 15, 1780, 4, compilation of newspaper reviews of the Royal Academy exhibitions, assembled by Clare Lloyd Jacob, Paul Mellon Centre, London.
3. *Morning Chronicle, and London Advertiser*, May 22, 1780, 2, compilation of newspaper reviews of the Royal Academy exhibitions, assembled by Clare Lloyd Jacob, Paul Mellon Centre, London.
4. Martha Babcock Amory states, "A remarkably handsome old man, with a fine, silvery beard, and a complexion as pure, in its red and white tints, as a baby's, was a poor, maimed beggar, in the streets of London, who had lost both legs in battle, and used to hobble into the painting-room on his wooden crutches for the portrait of the Jewish high-priest" (*The Domestic and Artistic Life of John Singleton Copley* [1882; rpt., New York: Da Capo Press, 1969], 173).
5. Helmut von Erffa and Allen Staley, *The Paintings of Benjamin West* (New Haven and London: Yale University Press, 1986), 356–357.
6. Jules David Prown, *John Singleton Copley* (Cambridge: Harvard University Press, for the National Gallery of Art, Washington, D.C., 1966), 2:276, 382 n. 29, 388. The work was listed in the British Institution catalogue as "76. Samuel relating to Eli the judgments of God upon Eli's house. . . . 'Then Eli called Samuel, and said, What is the thing that the Lord hath said unto thee? And Samuel told him every whit, and hid nothing from him, and he said, it is the Lord: Let him do what seemeth him good.—one Sam. ch. 3, ver. 16, 17, 18" (reproduced in Prown, *John Singleton Copley*, 2:388).
7. Elizabeth Wilson, Sotheby's, London, to the Wadsworth Atheneum, October 10, 1985, curatorial painting file, Wadsworth Atheneum; enclosed with the letter was a photograph of a round ivory relief carving after Copley's *Samuel and Eli*.
8. Prown, *John Singleton Copley*, 2:446.

Michele Felice Corné

Born on the island of Elba, in 1752; died in Newport, R.I., in 1845

Little is known of Corné's early life beyond the fact

that he was raised in Italy and in 1779 was in the service of the Neapolitan army during a war that resulted from the French invasion of Naples. Corné was probably trained in Italy as an ornamental painter. He was taken on board the ship *Mount Vernon*, owned by the wealthy Salem, Massachusetts, merchant Elias Haskett Derby and commanded by Derby's son. After an eight-month voyage, the ship landed in Salem in 1799. The artist settled in Salem, where the Derby family provided him with local commissions for portraits of area citizens and ships, as well as landscapes, overmantels, fireboards, and wall frescoes. Examples of his decorative work are still extant in several New England houses including the Sullivan Dorr house in Providence, Rhode Island.

Corné is known for his marine paintings and ship portraits, as well as for a number of landscapes and history paintings, often based on print sources. He did, however, also paint descriptive landscapes of American scenery, such as a detailed view of the Salem Derby farm, *Ezekiel Hersey Derby Farm* (c. 1800, private collection), purchased in 1800 by Ezekiel Hersey Derby from his father, Elias Hasket Derby. With such paintings, he made an important contribution to early landscape painting in America.

Corné moved to Boston in about 1807 and later settled in Newport, Rhode Island, in 1822, where he died at the age of ninety-three.

SELECT BIBLIOGRAPHY

William Bentley, *The Diary of William Bentley, 1784–1819* (Salem, Mass., 1905–1914) / Philip Chadwick Smith and Nina Fletcher Little, *Michele Felice Corné*, exh. cat. (Salem, Mass.: Peabody Museum, 1972) / Nina Fletcher Little, "Michele Felice Corné," *Antiques* 102 (November 1976), 262–269 / Nina Fletcher Little, *Paintings by New England Provincial Artists: 1775–1800,* exh. cat. (Boston: Museum of Fine Arts, 1976) / Edward J. Nygren, with Bruce Robertson, eds., *Views and Visions: American Landscape before 1830,* exh. cat. (Washington, D.C.: Corcoran Gallery of Art, 1986)

148 (see plate 44)

MICHELE FELICE CORNÉ
Sea View of the British Channel, 1804
Oil on canvas; 35⅞ × 72 in. (91.1 × 182.9 cm)
Signed and dated at lower left: M Corne. pinxit 1804

EXHIBITED: Newport, R.I., Art Association of Newport, "The Coast and the Sea: A Loan Exhibition from the Collections of the Wadsworth Atheneum," 1964, no. 10

EX COLL.: Daniel Wadsworth, Hartford, before 1848

Bequest of Daniel Wadsworth, 1848.25

This view is taken from an engraving by William Woollet after *The Fishery,* by the English artist Richard Wright (1730–1774). Wright's painting gained him a premium of thirty guineas from the Royal Society of Arts in 1764.[1] Wright painted several versions (dating from 1764) of this scene, in some of which the cart bears the inscription *Fish Machine,* as it does in the engraving by Woollet.[2] The seascape appears to be somewhat imaginary, not necessarily representing an English harbor. The engraving by Woollet is inscribed: "To Sir John Hort / His Majesty's Consul General at Lisbon."

Corné undoubtedly worked from the engraving, which he followed faithfully, down to inscribing the back of the horse-drawn wagon with the words "Fish / Machine." However, he simplified the ship's sails and landscape details and eliminated many other details seen in the engraving, including figures on the shore and onboard ship. At the same time, he emphasized the still life of fish on the dock in the foreground and rendered a more turbulent sea and a dramatic stormy sky. Corné also altered the scale of the scene by increasing the length considerably. It is possible that the work was intended to serve as an overmantel, which would explain its horizontal dimension.

This painting was acquired by Daniel Wadsworth, who hung it in the dining room of his country estate Monte Video.[3] He listed the work in his will as "A Sea View in the British Channel, done by Corné, an Italian, formerly of Salem, Mass."[4] It later hung in the Wadsworth Atheneum, beginning in 1849. There are two

William Woollet, engraving after Richard Wright, *The Fishery*. Yale Center for British Art, Paul Mellon Collection. Photograph: Richard Caspole.

other versions of this subject by Corné, one in the collection of the Peabody Museum, Salem (1803, *The Fishery*), and a second in a private collection in Boston (*Black Prince Entering Port* or *The Fishery*.)[5] EMK

1. For a biography of Richard Wright and a discussion of his sea piece *The Fishery*, see Mary Bennett, ed., *Merseyside Painters: People and Places* (Liverpool, England: Walker Art Gallery, 1979), 236–237.
2. A version of Richard Wright's *Fishery* in the collection of the Walker Art Gallery, Liverpool, England, is dated 1764 and measures 19½ × 26½ inches (49.5 × 67.3 cm); another, at the British Center, Yale University, New Haven, measures 35¾ × 54 inches(90.8 × 137.2 cm). Yet another version is illustrated in Colonel Maurice Grant, *Old English Landscape Painters*, vol. 3 (1958), plate 101, and a version by Henry Ninham (1793–1874) after Richard Wright is listed in *Important British Pictures*, Christie's, London, July 12, 1990, lot 64, 97.
3. Daniel Wadsworth, Probate Inventory, Hartford, September 30, 1848, Connecticut State Library, Hartford.
4. "The Will of Daniel Wadsworth," Hartford, 1847, archives, Wadsworth Atheneum.
5. Curatorial painting file, Wadsworth Atheneum.

Joseph Cornell

Born in Nyack, N.Y., in 1903; died in Flushing, N.Y., in 1972

Joseph Cornell never received any formal art education and instead relied on his natural talent and the inspiration of metropolitan New York's rich cultural context in creating his boxes and collages. Following his father's death, Cornell began attending Phillips Academy at Andover, Massachusetts, in 1912, returning home in 1921 to work at various jobs. In 1929 his mother moved the family to Flushing, New York, where Cornell resided for the rest of his life.

During the 1920s Cornell became sensitive to the dynamics of life and culture in New York City, where he absorbed modern French art and classical music. In the 1930s he began to make his first contacts with the existing artistic circle through the Julien Levy Gallery, which opened in 1931. In November of that year Cornell watched Levy unpack the surrealist works to be sent to the Wadsworth Atheneum for its landmark "Newer Super-

Realism," the first exhibition devoted to this movement (Deborah Zlotsky, "'Pleasant Madness,' in Hartford: The First Surrealism Exhibition in America," *Arts Magazine* 60 [February 1986], 55). He soon became familiar with the painters and writers associated with the surrealist movement, foremost among them, Salvador Dalí, who first exhibited at Levy's gallery in 1933. Nevertheless, although Cornell supported the surrealist movement throughout his lifetime, he claimed neither to follow the group's tenets nor to participate in their activities. However, he was clearly affected by their work (Dawn Ades, "The Transcendentalism Surrealism of Joseph Cornell," in McShine, *Joseph Cornell*, 23).

Inspired by the works of Max Ernst and driven by his personal feelings about spontaneity and naturalism, Cornell began working with collage and in 1932 showed his work at the Julien Levy Gallery exhibition, "Surréalisme," which launched the movement in New York. The same year he held his first one-artist show at the Levy Gallery, at which he showed his three-dimensional formats and shadow boxes. By the midthirties Cornell was constructing his own wooden boxes, in which he juxtaposed unrelated images and objects in fantastical arrangements. Levy later said of Cornell's works: "I always feel enchanted and basically innocent before an object by Cornell" (Julien Levy, *Memoir of an Art Gallery* [New York: Putman's, 1977], 79). Cornell's work always retained the naïveté that distinguished his unique personal style.

Throughout his career, Cornell exhibited in numerous solo and group shows. In 1936 he was featured in a major exhibition, "Fantastic Art, Dada, Surrealism," at the Modern Museum of Art, in company with the movement's leading European and American surrealists. He actively exhibited at several galleries, including Peggy Guggenheim's Art of This Century Gallery and later the Egan Gallery, both in New York City. Through the Egan Gallery, Cornell gained recognition as an important avant-garde artist and had his works placed in major galleries and museums.

In the 1940s Cornell sought various part-time jobs and freelanced for magazines to augment his family's small income. Though tied to his home life in Flushing,

New York, he did maintain a small, tightly knit group of friends, including artists, writers, dancers, filmmakers, and photographers, all living in New York City. Besides pursuing his art, Cornell was a follower of photography and ballet, as well as an amateur filmmaker.

By the early 1950s Cornell had begun to focus once again on pure collage, creating two-dimensional works with clippings from contemporary books, magazines, and commercial art reproductions. The declining health of his mother and brother made responsibilities at home more burdensome, however, which limited his production of work, particularly his boxes. In 1968, following retrospective exhibitions of his work, Cornell received three awards in recognition of his contribution to American art. Always concerned about the future of his works and source materials, Cornell spent the last seven years of his life placing his boxes and collages in museums for exhibition and study, hoping to preserve and communicate the poetry of assembled objects and images.

SELECT BIBLIOGRAPHY

Ellen H. Johnson, "Arcadia Enclosed: The Boxes of Joseph Cornell," *Arts Magazine* 39 (September–October 1965): 35–37 / Dore Ashton, *A Joseph Cornell Album* (New York: Viking, 1974) / Diane Waldman, *Joseph Cornell* (New York: Braziller, 1977) / Kynaston McShine, ed., *Joseph Cornell*, exh. cat., with complete bibliography (New York: Museum of Modern Art, 1980) / Brian O'Doherty, *Joseph Cornell*, exh. cat. (New York: Pace Gallery, 1986)

149 (see plate 45)

JOSEPH CORNELL
Soap Bubble Set, 1936
Mixed media construction; 14³/₁₆ × 5⁷/₁₆ × 15¹/₂ in. (36.1 × 13.8 × 39.4 cm)

EXHIBITED: New York City, Museum of Modern Art, "Fantastic Art, Dada, Surrealism," 1936–1937, no. 309, as "Soap bubble set, 1936" / Wadsworth Atheneum, "Painters in Attendance," 1942, no. 4 / Brooklyn, N.Y., Brooklyn Museum, "Revolution and Tradition," 1951–1952, no. 66 / New York City, Museum of Modern Art, "The Works of Joseph Cornell," 1981

EX COLL.: artist, 1936; with Julien Levy Galleries, New York City, by 1938

Purchased through the gift of Henry and Walter Keney, 1938.270

Cornell was attracted to the surrealist fascination with dreams and their use of real objects to materialize their fantasies into poetic arrangements. First realized in his collages of the early 1930s, Cornell took this idea a step further in his first major work, the box construction *Soap Bubble Set*, which took him a summer to complete.[1] The work was reproduced in the catalogue for the Museum of Modern Art's 1936 exhibition "Fantastic Art, Dada, Surrealism," captioned *"Soap bubble set, 1936."*[2] Photographed with additional effects by George Platt Lynes, the work appeared in the exhibition in its final assembled form, with each object placed both within its own glass compartment and in a fixed relationship to the others.[3] As one scholar describes the configuration: "Soap bubbles equal planets equal their orbits equal the entire curving of the sky, the universe. Every cork ball, sun face, doll's head, metal ring, circle-disk, and sky chart is brought into the equation."[4]

In *Soap Bubble Set*, each of the objects symbolizes an aspect of Cornell's cosmic world of childhood and fantasy: the clay pipe, his childhood recollections and Dutch ancestry; the egg, a symbol of life; the wine glass, the cradle of life; the doll's head, himself; and the four cylindrical weights, his family.[5] The geographical map of the moon above the pipe is a soap bubble and the celestial world, a theme echoed by the images of other celestial bodies on two of the cylinders. For Cornell, soap bubbles symbolized cosmic reverie.[6] Circular shapes are repeated throughout in various aspects, creating an assemblage of soap bubbles: the egg, the shape of the doll's head, the round pieces of glass, and the planet Saturn. Cornell's use of glass accentuates depth and reflects the sensual world; it also shows his interest in the Dutch masters' use of light, particularly Vermeer's.[7] The white miniature pedestal and cylinders, which originally stood against a blue background, also evoke light and celestial skies.[8]

George Platt Lynes, Installation view of the exhibition "Fantastic Art, Dada, Surrealism," Museum of Modern Art, New York City, December 7, 1936, through January 17, 1937, showing Joseph Cornell, *Soap Bubble Set*, as photographed with additional effects by George Platt Lynes. Photograph courtesy Museum of Modern Art, New York.

Installation view of the exhibition "Fantastic Art, Dada, Surrealism," Museum of Modern Art, New York City, December 7, 1936, through January 17, 1937. Photograph courtesy Museum of Modern Art, New York.

Cornell called *Soap Bubble Set* "a real 'first-born' of the type of case that was to become my accepted milieu"; the objects and the arrangement became a prototype for his future boxes.[9] The artist produced numerous other soap bubble sets, reflecting his obsession with the theme of childhood and cosmic reverie. Cornell later said of his soap bubble sets: "Shadow boxes become poetic theatres or settings wherein are metamorphosed the elements of a childhood pastime. The fragile, shimmering globules become the shimmering but more enduring planets—a connotation of moon and tides—the association of water less subtle, as when driftwood pieces make up a proscenium to set off the dazzling white of seafoam and billowy cloud crystallized in a pipe of fancy."[10] Among the richest of his creations, the soap bubble sets show the way in which the artist visualized the imagination at work in games and childhood fantasy.[11] Familiar objects such as the clay pipe, cylindrical weights, glasses, and maps of the moon and world are repeated again and again in various poetic arrangements in intimate settings.

Julien Levy introduced Cornell's work to the Wadsworth Atheneum and its director, A. Everett Austin, Jr., in 1935, when two of the artist's works were included in the museum's show "American Painting and Sculpture of the Eighteenth, Nineteenth, and Twentieth Centuries."[12] Three years later, the Atheneum was the first museum to acquire one of Cornell's works when it purchased, through Julien Levy, *Soap Bubble Set*. It is not surprising that the surrealist elements of Cornell's *Soap Bubble Set* would have appealed to Austin for his museum's collection.[13] Not only was he a leading advocate of surrealism, he and Cornell shared mutual friends, including Lincoln Kirstein and Pavel Tchelitchew (cat. 435), and furthermore both men shared a strong interest in film and filmmaking.[14]

Concerned about the preservation and conservation of his boxes, Cornell provided owners with advice on how to maintain them (sometimes he would inscribe instructions on the works themselves). The year the Wadsworth Atheneum purchased *Soap Bubble Set*, the artist wrote a letter to the museum in which he discussed how to preserve the shining whiteness of the enameled paint so as to retain its luster.[15] Fifteen years later, Cornell again wrote the museum to comment on the condition of *Soap Bubble Set* and to caution about the box's "inevitable tendency . . . to become smokey" despite thorough cleaning.[16] ERM

1. Julien Levy to Chick Austin, Director, Wadsworth Atheneum, c. 1938 (undated), curatorial painting file, Wadsworth Atheneum.
2. Kynaston McShine, ed., *Joseph Cornell*, exh. cat. (New York: Museum of Modern Art, 1980), 99.
3. Diane Waldman, *Joseph Cornell* (New York: Braziller, 1977), 14.
4. Carter Ratcliff, "Joseph Cornell: Mechanic of the Ineffable," in *Joseph Cornell*, ed. Kynaston McShine (New York: Museum of Modern Art, 1980), 48.
5. Diane Waldman, *Joseph Cornell*, exh. cat. (New York: Solomon R. Guggenheim Museum, 1967), 12.
6. Dore Ashton, *A Joseph Cornell Album* (New York: Viking, 1974), 93.
7. Kynaston McShine, "Introducing Mr. Cornell," in *Joseph Cornell*, ed. Kynaston McShine (New York: Museum of Modern Art, 1980), 11.
8. The color of the fabric lining has faded to a light gray.
9. Ashton, *Joseph Cornell Album*, 91.
10. Written for the catalogue for Cornell's exhibition at the Copley Galleries in 1948, quoted in Waldman, *Joseph Cornell* (1967), 12.
11. Dawn Ades, "The Transcendental Surrealism of Joseph Cornell," in *Joseph Cornell*, ed. Kynaston McShine (New York: Museum of Modern Art, 1980), 31.
12. Lynda Roscoe Hartigan, "Joseph Cornell: A Biography," in

Joseph Cornell, ed. Kynaston McShine (New York: Museum of Modern Art, 1980), 103.

13. In 1941 Austin purchased from the Julien Levy Gallery two other works by Cornell, *Defense D'Afficher* and *Theatricals of the Grandson of M. Phot* (1942), for his own collection. Joseph Cornell to Wadsworth Atheneum, May 25, 1953, Charles E. Buckley, curator, Wadsworth Atheneum, to Joseph Cornell, June 8, 1953, and receipt, Julien Levy Gallery, January 31, 1941, curatorial painting file, Wadsworth Atheneum.

14. See Joseph Cornell to Wadsworth Atheneum, March 6, 1940, curatorial painting file, Wadsworth Atheneum.

15. "This being my first acceptance by a museum it becomes quite an occasion for me. . . . I should also like to make a suggestion in connection with [*Soap Bubble Box*]. A great deal of its effectiveness depends, I think, on the shining whiteness of the paint. I applied at least six coats of the best enamel obtainable, and under glass it will retain its lustre indefinitely. Over a long period of years, however, it might need the protection of some kind of varnish which would not at the same time discolor it. Of course it might be just as easy to repaint the white parts at some distant future date, and I may seem too fussy about it, but I just thought I would make this point" (Joseph Cornell to Wadsworth Atheneum, July 5, 1938, curatorial painting file, Wadsworth Atheneum).

16. Joseph Cornell to Wadsworth Atheneum, May 25, 1953, curatorial painting file, Wadsworth Atheneum. Cornell also asked about the condition of the two works purchased by A. Everett Austin, Jr., for his private collection.

John Denison Crocker

Born in Salem, Conn., in 1823; died in Norwich, Conn., in 1907

Crocker was one of seven children born to George Crocker and Nancy Lamphere. When he was young, the family moved to Norwich, where the artist spent most of his life.

Early on, Crocker displayed the mechanical ingenuity that would later lead to such inventions as the canvas stretcher he patented in 1870 (Katlan, *American Artists' Materials*, 2:79–84; I am grateful to William H. Gerdts, in whose file on Crocker I found this information); among the other items he invented and patented was something called "Crocker's Vitalizing Cordial," purported to check the spread of cholera. His first employment was at the age of nine with a wagonmaker; at twelve he learned the trade of silversmith. By the time he was seventeen, he was working at a chair manufactory, and it was there, when a customer sent in a portrait to be varnished, that he was first exposed to art. According to H. W. French, Crocker was so taken with the canvas that he was determined to become a portraitist. He received some advice on painting from Charles Lanman (1819–1895), who was working in Norwich when Crocker began painting, but otherwise he was self-taught.

His first work was a self-portrait, and he continued to take portraits throughout his life. It was not long, however, before he began painting the landscapes with which his name is now associated. Many of these are set in the Connecticut area, but it is known that he traveled to the Catskills, there visiting the Mountain House where Thomas Cole (q.v.), among other Hudson River school artists, sketched. Crocker also traveled to the Adirondacks, where one of the Atheneum's Crockers is set.

In addition to landscapes and portraits, Crocker explored other subjects for his paintings as well, experimenting with still life, as can be seen in the Atheneum's *Still-Life, Peaches* (cat. 150), and with genre, as in the Brooklyn Museum of Art's *Barn Scene* (1847). The Slater Memorial Museum owns a history painting by Crocker, *The Capture of Miantonomo* (before 1880), which depicts the defeat of a Narragansett chief by Uncas, chief of the Mohegans, an event that took place in Norwich.

SELECT BIBLIOGRAPHY

Research files, Slater Memorial Museum, Norwich, Conn., and biographical details provided by Marie E. Noyes of the Slater Museum / H. W. French, *Art and Artists in Connecticut* (Boston: Lee and Shepard; New York: Charles T. Dillingham, 1879), 121–122 / John Gordon, "J. Denison Crocker (1823–1907): Painter of Norwich, Connecticut," *Brooklyn Museum Bulletin* 18 (winter 1957), 11–15 / Society of the Founders of Norwich and the Friends of the Slater Museum, *Craftsmen and Artists of Norwich*, exh. cat. (Stonington, Conn.: Pequot Press, 1965), 37 / Alexander W. Katlan, *American Artists' Materials: A Guide to Stretchers, Panels, Millboards, and Stencil Marks* (Madison, Conn.: Sound View Press, 1992), 2:79–84

150

J. D. CROCKER
Still-Life, Peaches, c. 1885
Oil on paper; 6½ × 9½ in. (16.5 × 24.1 cm)
Signed at lower left: J.D.C.

EXHIBITED: Norwich, Conn., Slater Memorial Museum,
"Craftsmen and Artists of Norwich," 1965, no. 56

EX COLL.: descended in the artist's family to the artist's son
Charles D. Crocker; to the artist's granddaughter Faith F.
Crocker, West Hartford, by 1960

Gift of Miss Faith F. Crocker, 1960.198

151

150

151

J. D. CROCKER
The Stranded Barge, c. 1890
Oil on canvas; 8 × 12 in. (20.3 × 30.5 cm)
Signed at lower left: J. D. Crocker
Technical note: Painting has Aaron Draper Shattuck
 (q.v.) patent stretcher keys.

EXHIBITED: Norwich, Conn., Slater Memorial Museum,
"Craftsmen and Artists of Norwich," 1965, no. 57

EX COLL.: descended in the artist's family to the artist's son
Charles D. Crocker; to the artist's granddaughter Faith F.
Crocker, West Hartford, by 1960

Gift of Miss Faith F. Crocker, 1960.197

152

J. D. CROCKER
Mountain Crags, c. 1890
Oil on composition board; 7½ × 13⅛ in. (19.1 × 33.3 cm)
Signed at lower left: Crocker

EXHIBITED: Norwich, Conn., Slater Memorial Museum,
"Craftsmen and Artists of Norwich," 1965, no. 58

EX COLL.: descended in the artist's family to the artist's son
Charles D. Crocker; to the artist's granddaughter Faith F.
Crocker, West Hartford, by 1960

Gift of Miss Faith F. Crocker, 1960.196

152

153

153

J. D. CROCKER

Scene in the Adirondacks, 1896

Oil on composition board; $17^{1}/_{8} \times 23^{3}/_{16}$ in. (43.5 × 58.9 cm)

Signed at lower left: J. D. Crocker/96.

EXHIBITED: Norwich, Conn., Slater Memorial Museum, "Craftsmen and Artists of Norwich," 1965, no. 55

EX COLL.: descended in the artist's family to the artist's son Charles D. Crocker; to the artist's granddaughter Faith F. Crocker, West Hartford, by 1960

Gift of Miss Faith F. Crocker, 1960.195

Still-Life, Peaches is thought to be the earliest work by Crocker in the Atheneum's collection, but it falls late in the artist's career; he would have been around sixty years old in 1885. The inexpert treatment in the painting of the drapery in particular suggests that Crocker had not experimented much with still-life painting before this time. His investigation of the cloth as folded, as draped, and as lying, a little rumpled, on the table indicates that this is a study, as does, perhaps, the juxtaposition of the two peaches resting at different angles.

More successful is Crocker's *Stranded Barge*. Here, the artist dramatically emphasizes the light in the sky, which is reflected in the water. The tall trees at the left and the detailed barge in the center cast dark shadows on the water, the shadow of the barge being a sharp, black, flat shape. Flowers dot the meadows on the banks of the river or stream. The careful observation and heightened color featured in this painting compare with the work of artists such as John Fitch (q.v.), as well as with the work of the White Mountain painters, who frequently used a high-keyed palette.[1]

Mountain Crags draws its inspiration from what has been called the "romantic sublime" in Thomas Cole's (q.v.) work, as does Crocker's *Capture of Miantonomo*.[2] As Cole did in paintings such as *St. John in the Wilderness* (cat. 123), Crocker positioned a figure (possibly an Indian) on a precipice, in this case, overlooking a ravine punctuated with dead trees and bounded on either side by the jagged rock walls of the mountains. As he was in

The Stranded Barge, Crocker was interested in light in this painting, and the mountain walls provided an opportunity to show one in shadow and the other catching the full force of the sun.

Scene in the Adirondacks displays the influence of the Hudson River school tradition of recording nature. The varied landscape features foreground detail of flowers and grasses, a broken branch in the middle ground, and a mountainous background.[3] A winding stream draws the eye into the painting. Crocker included groups of figures: a couple and a child strolling at the left, a sailboat at center, and two figures on the shore at right. The large tree at the left center of the composition overpowers the other elements and, silhouetted against the sky, recalls Asher B. Durand's (q.v.) great tree portraits.[4] AE

1. For information on this group of nineteenth-century American painters, see Donald Keyes, with Catherine H. Campbell, Robert L. McGrath, and R. Stuart Wallace, *The White Mountains: Place and Perceptions*, exh. cat. (Hanover, N.H., and London: University Press of New England, for the University Art Galleries, University of New Hampshire, 1980).
2. For more on the romantic sublime in American painting, see Barbara Novak, "Sound and Silence: Changing Concepts of the Sublime," ch. 3 in *Nature and Culture: American Landscape and Painting, 1825–1875* (New York: Oxford University Press, 1980). For information on *The Capture of Miantonomo*, see John Gordon, "J. Denison Crocker (1823–1907): Painter of Norwich, Connecticut," *Brooklyn Museum Bulletin* 18 (winter 1957), 15.
3. For a discussion of the foreground detail in earlier landscape paintings and drawings, see Barbara Novak, "The Organic Foreground: Plants," ch. 6 in *Nature and Culture: American Landscape and Painting, 1825–1875* (New York: Oxford University Press, 1980).
4. See Asher B. Durand, "Letters on Landscape Painting" (1855), excerpts in John W. McCoubrey, *American Art, 1700–1960: Sources and Documents* (Englewood Cliffs, N.J.: Prentice-Hall, 1965), 110–115, especially letter 2, where Durand discusses drawing a tree.

Jasper Francis Cropsey

Born in Rossville, S.I., N.Y., in 1823; died in Hastings-on-Hudson, N.Y., in 1900

Cropsey was born to farmers of Dutch and Huguenot ancestry. As a boy, he worked on his father's farm, in his spare time, developing an interest in architecture. In 1837, at the age of thirteen, he won a diploma at the Mechanics Institute of the City of New York for his model of a country house. Not long after, Cropsey pursued his interest in architecture as an apprentice at the firm of Joseph Trench in New York City, where, by the fourth year of his five-year term, he was painting backgrounds for finished architectural renderings. At this time, he studied watercolor painting with an Englishman named Edward Maury and began to attend the annual exhibitions at the National Academy of Design, where he took classes in life drawing in 1847. In 1841 he began to make oil paintings after his watercolors. Just two years later, in 1843, Cropsey's first painting—an imaginary Italian landscape—was exhibited at the National Academy, and in 1844 he exhibited a view of Greenwood Lake, New Jersey, thereby gaining election as an associate of the academy. (In 1851 he would be elected academician.) The following year, Cropsey addressed the American Art-Union, praising and encouraging the study of nature in an essay called "Natural Art," the themes of which would recur in his 1855 essay for the *Crayon*, "Up Among the Clouds."

Cropsey made two trips to Europe. On the first (a honeymoon trip with his wife, Maria Cooley, from 1847 to 1849), he nearly followed in the steps of Thomas Cole (q.v.), traveling to England, France, and Italy and even taking Claude Lorrain's studio in Rome, as Cole had some twenty years earlier. On his return to the United States, he made a number of sketching trips to the White Mountains, New Hampshire; Newport, Rhode Island; Greenwood Lake, New Jersey; the Ramapo Valley; and in 1855 Michigan and Canada. The following year, he set off on his second trip to Europe, this one for a much longer period: in 1856 he set up a studio at Kensington Gate, London, and did not return to New York City until 1863. While in London, Cropsey studied a variety of work, including paintings by Constable, Turner, and the Pre-Raphaelites. He also became involved in book illustration, illustrating the poems of

Edgar Allan Poe and Thomas Moore, and painted American landscapes, which were published by Gambert and Company. Back home, he helped found the American Watercolor Society. Having obtained financial security from the sale of *The Valley of Wyoming* (1865, Metropolitan Museum of Art) and *Starrucca Viaduct* (1865, Toldeo Museum of Art), he bought forty-five acres of land in Warwick, New York, in 1866. There, he designed and built a Gothic Revival mansion and studio, which he called Aladdin.

To supplement his income from the sales of paintings, Cropsey taught art and continued to accept architectural commissions—among these, platforms and stations for the New York City Sixth Avenue elevated subway—but by 1884 he was in financial straits and was forced to sell Aladdin (it later burned to the ground in 1909). In 1885 he moved to Hastings-on-Hudson to a house he named Ever Rest, where he duplicated the studio he had built at Aladdin. He remained there until his death.

In addition to paintings, the Wadsworth Atheneum has two drawings by Cropsey in the collection, *Thomas Cole's Studio—Catskill, N.Y.* (pencil and chalk on green paper, $3^3/_8 \times 8^7/_8$ in. [8.6 × 22.5 cm]) and *Greenwood Lake, N.J.* (1873, pencil and gouache, $12^1/_2 \times 17^1/_8$ in. [31.8 × 43.5 cm]).

SELECT BIBLIOGRAPHY

Jasper F. Cropsey, "Up among the Clouds," *Crayon* 2 (August 8, 1855), 79–80 / Henry T. Tuckerman, *Book of the Artists: American Artist Life* (New York: Putnam, 1867), 532–540 / G. W. Sheldon, *American Painters*, rev. ed. (New York: D. Appleton, 1881), 82–84 / Peter Bermingham, *Jasper F. Cropsey, 1823–1900: A Retrospective View of America's Painter of Autumn*, exh. cat. (College Park: University of Maryland Art Gallery, 1968) / William S. Talbot, *Jasper F. Cropsey, 1823–1900*, exh. cat., foreword by Joshua C. Taylor (Washington, D.C.: Smithsonian Institution Press, 1970) / William S. Talbot, *Jasper F. Cropsey, 1823–1900* (New York and London: Garland, 1977) / Kenneth W. Maddox, *An Unprejudiced Eye: The Drawings of Jasper F. Cropsey* (Yonkers, N.Y.: Hudson River Museum, 1980) / Carrie Rebora, *Jasper Cropsey Watercolors*, exh. cat., introduction by Annette Blaugrund (New York: National Academy of Design, 1985) / Ella M. Foshay and Barbara Finney, *Jasper F. Cropsey: Artist and Architect*, exh. cat., cat. by Mishoe Brennecke (New York: New-York Historical Society, 1987) / Nancy Hall-Duncan, *A Man for All Seasons: Jasper Francis Cropsey*, exh. cat. (Greenwich, Conn.: Bruce Museum, 1988)

154 (see plate 46)

JASPER F. CROPSEY

Winter Scene—Ramapo Valley, 1853
Oil on canvas; 22 × $36^1/_8$ in. (55.9 × 91.8 cm)
Signed and dated at lower right: J. F. Cropsey / 1853

EXHIBITED: Cooperstown, N.Y., New York State Historical Association; Rochester, N.Y., Rochester Memorial Art Gallery; Albany, N.Y., Albany Institute of History and Art; Utica, N.Y., Munson-Williams-Proctor Institute; Syracuse, N.Y., Syracuse Museum of Fine Arts; and New York City, New-York Historical Society, "Rediscovered Painters of Upstate New York," 1958, no. 30 / Hamilton, Canada, Art Gallery of Hamilton, "American Realists," 1961, no. 15 / Geneseo, N.Y., State University College, "Hudson River School," 1968 / Santa Barbara, Calif., Santa Barbara Museum of Art; San Diego, Calif., Fine Arts Gallery of San Diego; Fort Worth, Tex., Amon Carter Museum of Western Art; and New Haven, Conn., New Haven Colony Historical Society, "George Durrie and the Winter Landscape," 1978 / Wadsworth Atheneum, "The Hudson River School: Nineteenth-Century American Landscapes in the Wadsworth Atheneum," 1976, no. 32 / Houston, Meredith Long and Co., "Americans at Work and Play," 1980

EX COLL.: George H. Clark from 1853 to 1901

Gift of George H. Clark (through Charles Hopkins Clark, before 1901), 1901.37

Cropsey, most often recognized as a painter of autumn scenes, was one of the few artists connected with the Hudson River school to try his hand at pictures of winter.[1] The Atheneum's painting, originally thought to depict the Hudson River valley, is a scene in the Ramapo Valley. Henry T. Tuckerman, having seen *Ramapo Valley* in Cropsey's studio, wrote that in the painting there is "much truth to nature" and that the painting

recalled an important moment in early American history: "In this vicinity Washington made his headquarters during the fearful episode of our revolutionary struggle identified with Valley Forge: and from the summit of his abrupt and lofty mountain, he often gazed toward New York, thirty miles distant, visible on a clear day. With how many months of weary and intensely anxious vigil is that bleak and isolated observatory associated; and how vividly the terrible ordeal through which the scanty and famished army passed, reappears to the mind while contemplating the scene in all its wintry desolation!"[2] The frontier scene also points up the virtues of industry in a difficult climate associated in the nineteenth-century mind with the founding of the American colonies. This didactic aspect is in keeping with Cropsey's moralist tendencies and the early Hudson River school connection between landscape and morality.[3] The cross between landscape and genre painting in *Ramapo Valley*—a combination that was not common in Cropsey's oeuvre—may be due to the influence of a French painter, Régis Gignoux (1816–1882), who frequently painted winter scenes and was active in the New York area from 1841 to 1870.[4]

Although he attended drawing-from-life classes in New York City in the late 1840s, Cropsey, like other artists primarily concerned with landscape, never became an accomplished figure painter. This is apparent in *Ramapo Valley*, where the figures stiffly pursue their chores about the farm, all pointed in different directions, with no interaction among them.[5]

Vigorous brushwork, a hallmark of Cropsey's painting style, is evident only in the snow on the roofs and barn walls. Long shadows would seem to indicate that the scene is set in the early morning or late afternoon, and Cropsey's attention to light and the hues of the shadows is typical of this colorist's work. With some humor, Cropsey signed his name in the snow as if it were carved into the frozen landscape with a stick.

The scene of the Atheneum's painting compares with a picture by George Henry Durrie (q.v.), *Cider Making in the Country*. The log cabin pictured in Cropsey's painting does not appear in Durrie's and a wood frame house has been added in the background, but the central mountain and the barns in front of it in Cropsey's composition remain in the same spatial relation to one another in the Durrie. In 1878 George Sheldon reported

George Henry Durrie, *Cider Making in the Country*, 1863. New York State Historical Association, Cooperstown.

that Cropsey painted another scene called the *Ramapo Valley* in 1862, for Mr. James McHenry of London.[6]

Cropsey painted a number of seasonal cycles, which, like those of other artists, did not necessarily depict the same scene in different seasons.[7] This probably paved the way for the suggestion that *Winter Scene—Ramapo Valley* may be one of a pair completed by a painting titled *Harvest Scene* (1855, Witte Memorial Museum).[8] AE

1. George H. Durrie (q.v.) was another artist who treated the winter landscape, as did Thomas Birch (q.v.) and Thomas Doughty (q.v.). Peter Bermingham suggests that the Hudson River school painters neglected winter as a subject partly because winters were generally spent in the studio painting from sketches made during the spring and summer months and adds that winter landscapes were not popular as "escapist decorations for the American home," for obvious reasons (*Jasper F. Cropsey, 1823–1900: A Retrospective View of America's Painter of Autumn*, exh. cat. [College Park: University of Maryland Art Gallery, 1968], 19, 19–20 n. 21). Articles dealing specifically with nineteenth-century winter pictures are Helen Comstock, "The American Scene in Winter," *Panorama* 2 (December 1946), 38–42; idem, "Wintering Up—with Currier and Ives," *Portfolio* 5 (December 1945), 75–80; and Martha Young Hutson, "The American Winter Landscape, 1830–1870," *American Art Review* 2 (January–February 1975), 60–78.
2. Henry T. Tuckerman, *Book of the Artists: American Artist Life* (New York: Putnam, 1867), 538–539.
3. Martha Young Hutson discusses Cropsey's *Ramapo Valley* in her monograph *George Henry Durrie (1820–1863), American Landscapist: Renowned through Currier and Ives*, exh. cat. (Laguna Beach, Calif.: Santa Barbara Museum of Art and American Art Review Press, 1977), 78–82.
4. Bermingham, *Jasper F. Cropsey*, 19–20 n. 21. See also George C. Groce and David H. Wallace, *The New-York Historical Society's Dictionary of Artists in America, 1564–1860* (New Haven: Yale University Press; London: Oxford University Press, 1957), 258.
5. Ibid., 25.
6. G. W. Sheldon, *American Painters*, rev. ed. (New York: D. Appleton, 1881), 83.
7. Consider, for example, the series *Four Seasons* in the collection of the University of Maryland Art Gallery: *Spring in England* (1859), *Summer in Italy* (1860), *Autumn in America* (1861), and *Winter in Switzerland* (1861). For autumn and winter, if not spring and summer, each season is paired with the country with which it was most often associated.
8. William S. Talbot, *Jasper F. Cropsey, 1823–1900*, exh. cat. (Washington, D.C.: Smithsonian Institution Press, 1970), 26.

155

JASPER F. CROPSEY
Peaceful Valley, 1870
Oil on canvas; diam. 6⅞ in. (diam. 17.5 cm)
Signed at bottom center: J. F. Cropsey / 1870

EXHIBITED: Wadsworth Atheneum, "Gould Bequest of American Paintings," 1948

EX COLL.: with the Dalzell-Hatfield Galleries, Los Angeles, before 1948; purchased by Clara Hinton Gould, Santa Barbara, Calif., by 1948

Bequest of Clara Hinton Gould, 1948.185

The mountains in this painting have been identified as Mounts Adam and Eve, which would have been visible from Aladdin.[1] This small painting may be one of a cycle.

Cropsey painted a number of seasonal cycles of paintings in the circular format. One cycle was the effort of four artists: an 1844 painting of autumn by Thomas Cole (q.v.) and three paintings commissioned to accompany it, one of summer by Asher B. Durand (q.v.), another, of winter, by Régis Gignoux, and the third, of spring, by Cropsey, all completed in 1847.[2] The autumn and summer pictures from another cycle of paintings, also tondos depicting the four seasons, in the Newington collection, Greenwich, Connecticut, are dated 1855. Both feature mountain scenery, as does the Atheneum's much later work.[3] AE

1. Florence Levins to Amy Ellis, April 27, 1993, curatorial painting file, Wadsworth Atheneum.
2. *Literary World*, June 5, 1847, quoted in Peter Bermingham, *Jasper F. Cropsey, 1823–1900: A Retrospective View of America's Painter of Autumn*, exh. cat. (College Park: University of Maryland Art Gallery, 1968), 9–10. George Austin of New York City was the person who bought the Cole and commissioned the three other works.
3. In 1874 Cropsey painted another four-seasons cycle on brass plates, two of which, *Winter* and *Summer*, are in the collection of the Newington-Cropsey Foundation, Hastings-on-Hudson, New York. Florence Levins, curator at the foundation, has suggested that these might have been stovepipe covers. They measure 13¾ inches (34.9 cm) in diameter. See Levins to Ellis.

155

156

JASPER F. CROPSEY

Autumn on the Susquehanna, 1878

Oil on canvas; 23⅛ × 40⅛ in. (58.7 × 101.9 cm)

Signed at lower right: J. F. Cropsey / 1878

EXHIBITED: Oklahoma City, Oklahoma Art Center, 1965, no. 22 / Hartford National Bank and Trust, "Recent Acquisitions," 1968 / Lincoln, Mass., De Cordova Museum, "Man and His Kine," 1972, no. 21 / Wadsworth Atheneum, "The Hudson River School: Nineteenth-Century American Landscapes in the Wadsworth Atheneum," 1976, no. 33

EX COLL.: artist; Dr. Emerson C. Angell, Tarrytown, N.Y. (friend of the artist); Anne Alice Angell, Tarrytown, N.Y. (daughter of Dr. Angell); Greta Wallian Agutter, Falmouth, Mass. (granddaughter of Dr. Angell and daughter of Anne

Alice Angell and Edward P. Wallian); with unidentified dealer, Falmouth, Mass.; with Vose Galleries, Boston, by 1966; acquired by the Wadsworth Atheneum by exchange and purchase in 1967

The Ella Gallup Sumner and Mary Catlin Sumner Collection Fund, 1967.68

By the midfifties, Cropsey was already considered a master of the autumn landscape, and by 1884 a critic was able to write that he had "no superior as a painter of autumnal scenes."[1] He had exhibited his earliest-known painting of autumn, *Forest on Fire*, in New York City in 1845. In 1856 and 1859 he painted two versions of *Autumn on the Susquehanna* that differ substantially from the Atheneum's later version only in their inclusion of a man rowing a boat.[2] The absence of figures com-

156

Jasper F. Cropsey, *Autumn Landscape with Cattle*, 1879. Virginia Museum of Fine Arts, Museum Purchase: The Adolph D. and Wilkins C. Williams Fund.

bined with an essentially empty middle ground in the Atheneum's painting is typical of post–Civil War views of the area. The viewer is now estranged from the landscape, looking on it from a separate, slightly elevated vantage point.[3]

In keeping with an earlier, midcentury trend toward naturalism, the distant mountains are outlined against the sky as if to bring them into high relief. Cropsey uses an energetic brush for foliage and sky and a fine-tuned hand to delineate details of birds in the foreground. William Talbot has noted that Thomas Cole's (q.v.) "dramatic brushwork" was his legacy to Cropsey.[4]

Cropsey's skill as a colorist is evident in this painting: bold oranges, greens, and golds predominate, and a

round yellow sun is visible through the branches, burning through the hazy atmosphere. The palette is typical of Cropsey's later work, and the painting features unusual juxtapositions of intense colors that may have come directly from the paint tube.

Cropsey's use of color met with mild criticism from at least one contemporary writer. The year that *Autumn on the Susquehanna* was painted, George Sheldon wrote, "Especially of later years, [Cropsey's pictures] have displayed perhaps an undue emphasis of local colors." But Sheldon continued, "Most of them depict autumn scenes, in which the foliage usually approaches splendor; and all of them speak of a refined appreciation of and delight in natural beauty," thus undoing the negative cast of his first remarks.[5] AE

1. William Forman, "Jasper F. Cropsey, N.A.," *Manhattan Magazine*, 1884, 375, quoted in Peter Bermingham, *Jasper F. Cropsey, 1823–1900: A Retrospective View of America's Painter of Autumn*, exh. cat. (College Park: University of Maryland Art Gallery, 1968), 22. In the nineteenth century autumn carried a nationalistic and religious meaning as a beautiful and particularly American season and as a symbol of spiritual illumination after physical vitality is diminished. See Edward Hitchcock, "The Euthanasia of Autumn," in *Religious Lectures on Peculiar Phenomena in the Four Seasons* (Boston, 1853). See also Charles Eldredge and Barbara Millhouse, with Robert Workman, *American Originals: Selections from Reynolda House, Museum of American Art*, exh. cat. (New York: Abbeville and American Federation of Arts, 1990). Autumn was also of interest to other members of the Cropsey family: books in Cropsey's library included L. Clarkson, *Indian Summer* (New York: Dutton, 1883), inscribed "Miss Lilly Cropsey, July 16th, 1883," and Mrs. Edward Thomas, *Autumnal Leaves* (London: W. Walker, 1860), inscribed "Mr[s?] Cropsey with the kind regards of the Authoress." See Stephen J. Zietz, "Annotated Bibliography of Jasper F. Cropsey's Library," in Ella M. Foshay and Barbara Finney, *Jasper F. Cropsey, Artist and Architect*, exh. cat. (New York: New-York Historical Society, 1987), 160, 163.
2. In *Jasper F. Cropsey, 1823–1900*, exh. cat. (Washington, D.C.: Smithsonian Institution Press, 1970), cat. no. 71, William Talbot lists a painting titled *Susquehanna River* (1880, oil on canvas, 12 × 20 in. [30.5 × 50.8 cm], private collection).
3. Roger B. Stein, *Susquehanna: Images of the Settled Landscape*, exh. cat. (Binghamton, N.Y.: Roberson Center for the Arts and Sciences, 1981), 64.
4. William S. Talbot, "Jasper F. Cropsey, Child of the Hudson River School," *Antiques* 92 (November 1967), 713–717.
5. G. W. Sheldon, *American Painters*, rev. ed. (New York: D. Appleton, 1881), 84. Sheldon also quotes an unidentified critic for the London *Times*, who in 1860 wrote of another of Cropsey's autumn scenes—*Autumn on the Hudson River* (1860, National Gallery of Art, Washington, D.C.)—"The singularly vivid colors of an American autumnal scene, the endless contrast of purples and yellows, scarlets and browns, running into every conceivable shade between the extremes, might easily tempt a painter to exaggerate, or revel in variety of hue and effect, like a Turner of the forest. But Mr. Cropsey has resisted the temptation, and even a little tempered the capricious tinting of Nature."

Ferdinand Danton, Jr.

Born in New York City, in 1877; died after 1912

Ferdinand Danton, Jr., was one of a group of artists of French descent who worked in New York City at the end of the nineteenth century specializing in trompe l'oeil still lifes exploring the subject of paper currency. The best-known member of this circle was Victor Dubreuil (active 1880s–1890s); others include Marius A. Gouy (active 1880s) and A. Duran (active 1880s).

Danton was the eldest of five sons of Ferdinand Danton, Sr., and Elizabeth Callahan, an Irish immigrant. His father was the impoverished son of a French officer and a dancer. Danton, Sr., who was trained as a painter of religious and allegorical subjects, emigrated from Vesoul, France, to the United States in 1869. From 1885 to 1899, advertising himself in the New York City directories as an "artist," he made a career of ecclesiastical painting. He was noted for a series of eight large canvases, *The Last Days of the World*, and a large allegorical painting, *Father Time Introducing America* (1900–1901). Danton, Sr., began teaching art at St. John's College (now Fordham University) beginning in 1904, remaining there until his death in 1908.

Ferdinand Danton, Jr., undoubtedly learned his profession as an artist from his father. He painted his most accomplished known work, *Time Is Money*, in 1894, at the age of seventeen, though he was not listed in the New York City directories as an artist until 1900. He married Mary Catherine Greentree of New York in 1898, and by 1911 he was involved in a family business with his four brothers: Vincent and Socrates, also art-

ists; Anthony, a picture dealer; and Harry, a real estate broker. Also beginning in 1911 Danton started using the name Ferdinand D'Or Danton, occasionally signing paintings in this manner. After 1912, the last year of his listing in the city directories, there is no further mention of this artist.

Several signed works by Danton are known, mainly trompe l'oeil still lifes of currency, although a full-length portrait of James Colin McEachen, signed "F. Danton / 1902" (possibly by Danton, Sr.), is in the collection of the New-York Historical Society.

SELECT BIBLIOGRAPHY

New York City directories from 1885 to 1912 / Review of Ferdinand Danton, Sr.'s "grim religious pictures," in *New York Times*, June 26, 1904 / Bruce C. Chambers, *Old Money: American Trompe L' Oeil Images of Currency*, exh. cat., biographical information on the Danton family gathered by B-Ann Morehouse, certified genealogist (New York: Berry-Hill Gallery, 1988), 81–84, 115, 122–123 / Edward J. Nygren, "The Almighty Dollar: Money as a Theme in American Painting," *Winterthur Portfolio* 23 (summer/autumn 1988), 129–150

157 (see plate 47)

FERDINAND DANTON
Time Is Money, 1894
Oil on canvas; 16¹⁵/₁₆ × 21⅛ in. (43.0 × 53.7 cm)
Signed and dated at lower right: F. Danton Jr. / 94
Signed on painted frame at lower right: F. Danton·Jr

EXHIBITED: San Francisco, California Palace of the Legion of Honor, "Illusionism and Trompe L'Oeil," 1949 / Washington, D.C., National Gallery of Art; Berkeley, Calif., University Museum, University of California, Berkeley; San Francisco, California Palace of the Legion of Honor; and Detroit Institute of Arts, "The Reality of Appearance: The Trompe L'Oeil Tradition in American Painting," 1970, no. 98 / Berkeley, Calif., University Gallery; Seattle Art Museum; Honolulu Academy of Fine Art; Santa Barbara, Calif., Santa Barbara Museum; and Denver, Colo., Denver Art Museum, "Reality and Deception," 1975, no. 18 / Katonah, N.Y., Katonah Art Gallery, "Plane Truths: American Trompe L'Oeil Painting," 1980, no. 8 / Columbus, Ohio, Columbus Museum of Art, and West Palm

Beach, Fla., Norton Gallery and School of Art, "More than Meets the Eye: The Art of Trompe L'Oeil," 1985–1986, no. 30 / New York City, Berry-Hill Galleries, "Old Money: American Trompe L'Oeil Images of Currency," 1988, no. 13

EX COLL.: with M. Knoedler and Co., New York City, by 1943

The Ella Gallup Sumner and Mary Catlin Sumner Collection Fund, 1943.93

The peculiarly American specialty of trompe l'oeil images of money, found in American art of the last quarter of the nineteenth century, was first treated by William Harnett (q.v.), the noted trompe l'oeil still-life painter in his 1877 work *Still Life: Five Dollar Bill* (Philadelphia Museum of Art) and later in the century by artists such as John Haberle (q.v.); later it became an obsessive theme for Victor Dubreuil. In all, over a dozen artists, most based in New York City, explored this theme until shortly after the turn of the century.

This category of still-life painting has been the subject of recent scholarly attention, with particular emphasis on the way in which these paintings reveal American values and reflect contemporary economic, political, and social concerns.[1] In the post–Civil War era, money took on political and social significance—as seen in the rise of the Greenback party, the rapid industrialization of the country, and the phenomenon of the robber baron millionaires. In addition to serving as masterful illusions, then, these paintings often provided wry commentary on the materialism of the age.

In *Time Is Money*, the artist makes a direct reference to the preindustrial aphorism first coined by Benjamin Franklin in his "Advice to a Young Tradesman" (1748).[2] The adage had taken on a new meaning by the end of the century, when industrialization had become a science, as typified by the time-motion studies of Frederick W. Taylor that led to the assembly line.[3] In this accomplished example of American money painting, one that Alfred Frankenstein proclaimed to be "an absolute masterpiece of pictorial impudence," Danton conveys his less-than-subtle message by depicting an alarm clock set to go off at about 7:30 A.M. that shortly will begin to

ring.[4] The clock is tied to a green ribbon nailed to a rough wood-plank door and balanced by a stack of five- and ten-dollar silver certificates bound with a red ribbon and similarly affixed to the door. A wood strip between the nails to which the objects are attached conveys the idea of a balanced scale. Between the clock and the money is carved the word *is*; below the grouping, a card reading "TIME / IS MONEY" reinforces the message. By setting the modern symbols of the alarm clock and the silver certificates against a rustic wood door, the artist perhaps intended to contrast modern regimented time with a simpler bygone age. The alarm clock becomes, as Bruce Chambers notes, "the perfect symbol of the tyranny of measured time" for the American worker.[5]

The image is set in a wide, heavy wood frame that the artist painted to match the simulated wood planking on the canvas, to the point of continuing the cracks between the planks. In a square at the lower right that is painted to appear at the same level as the canvas, including painted shadows, Danton signed his name; he also signed the "canvas" at the lower right. To confuse the viewer further, Danton depicted nail holes and nails on both the canvas and the painted frame; some of the holes on the frame are real, while others are painted illusions. Furthermore, both real shadows, cast by the frame, and painted shadows are evident. A keyhole seen at the upper right is depicted, but there is no key to open the door.

This painting was purchased by A. Everett Austin, Jr., as part of a series of acquisitions of American trompe l'oeil still lifes he made in the 1930s and early 1940s, including works by Harnett, Peto, and others, prompted by his interest in surrealism (see Introduction). Danton's painting inspired a second version by the little-known artist A. Duran, *Time Is Money*, painted the following year in 1895 (private collection).[6] EMK

1. See Bruce C. Chambers, *Old Money: American Trompe L'Oeil Images of Currency*, exh. cat. (New York: Berry-Hill Gallery, 1988); and Edward J. Nygren, "The Almighty Dollar: Money as a Theme in American Painting," *Winterthur Portfolio* 23 (summer/autumn 1988), 129–150.
2. Other works by Danton include *The C Note*, signed "F. Danton," which appeared in an advertisement for the Adelson Galleries, Boston, reproduced in *Antiques* 93 (April 1968), 412; *Money, Money, Money*, attributed to F. Danton, Jr., was reproduced in an advertisement for Raymond Agler Fine Arts, North Andover, Mass., in *Maine Antiques Digest* (July 1985), 30B; *Father Time Introducing America*, signed and dated "F. Danton 1900" and "1901," was sold at "Auction of Americana," Sotheby Parke Bernet, New York, sale number 4108, November 16, 1978, lot no. 499.
3. Chambers, *Old Money*, 84–85.
4. Alfred Frankenstein, *After the Hunt*, rev. ed. (Berkeley: University of California Press, 1969), 158.
5. Chambers, *Old Money*, 85.
6. See ibid., 84, ill.

Arthur B. Davies

Born in Utica, N.Y., in 1862; died in Florence, in 1928

Arthur Bowen Davies pursued a long and successful career as an important advocate of modern American art. Displaying a gifted imagination and an early interest in art, Davies began his training at age fifteen with a local Utica landscape painter, Dwight Williams (1856–1949). In 1879 Davies moved to Chicago with his family and continued his studies at the Chicago Academy of Design. In 1885 or 1886 he moved to New York City, where he attended classes at the Art Students League and the Gotham Art Students. Between 1887 and 1889 Davies worked as an illustrator for *Century Magazine* and *St. Nicholas* while at the same time exhibiting his prints and paintings, among other venues, at the National Academy of Design from 1893 to 1899. His nomination for membership to the academy, however, was rejected in 1907.

In the early 1890s Davies became associated with William Macbeth, who became the artist's dealer. In 1893 Macbeth helped arrange the first of Davies's several trips to Europe, and in 1896 he gave the artist his first solo show, followed by a series of successful shows at his gallery. In 1905 Alfred Stieglitz opened his gallery "291," where later Davies had the opportunity to see the works of the European modernists Cézanne, Matisse, and Picasso.

In 1896 Robert Henri (q.v.) became familiar with Davies's individual style and poetic work; later he asked Davies to participate in his independent art movement

composed of the artists who exhibited together as "The Eight" in 1908. After the group had split up, Davies, Henri, William Glackens (q.v.), Ernest Lawson (q.v.), George Luks (q.v.), Maurice Prendergast (q.v.), Everett Shinn (1876–1953), and John Sloan (q.v.) gained wide respect as painters, teachers, and advocates for an art that accurately represented contemporary America. In 1910 Davies participated in the Exhibition of Independent Artists, and in 1912 he became president of the Association of American Painters and Sculptors, a group that was assembled to create an exhibition of American and European art—the Armory Show of 1913—which Davies played a leading role in helping to organize.

Rather than painting the scenes of urban realism championed by some of his colleagues, Davies favored pastoral compositions of fantasy landscapes with decorative rhythmic nudes. His highly personal and visionary works were a response to the romantic tradition in American art and to European and American symbolism, found in the paintings of Pierre Puvis de Chavannes, Albert Pinkham Ryder (q.v.), and Ralph Albert Blakelock (q.v.). Between 1914 and 1917 Davies experimented with elements of cubism, with which he had become familiar through the Matisse and Picasso shows held at "291." During this time he returned to printmaking, for which he gained some recognition.

An important aspect of Davies's interest in promoting modern art was his role as adviser to several influential American collectors, including Lillie Bliss, Abby Aldrich Rockefeller, and John Quinn. He also developed his own collection of art, which included paintings, works on paper, and sculpture by such European and American modernists as Paul Cézanne, Pablo Picasso, Odilon Redon, Henri Matisse, Maurice Prendergast (q.v.), Marsden Hartley (q.v.), Max Weber, and Charles Sheeler, among others. Following his death, his collection was sold and dispersed, with many of the works becoming part of the collection of the Museum of Modern Art, founded a year later by Lillie Bliss and others.

SELECT BIBLIOGRAPHY

Duncan Phillips, *A Collection in the Making* (New York: E. Weyhe, 1926) / William Innes Homer, ed., *Avant-Garde Painting and Sculpture in America, 1910–25,* exh. cat. (Wilmington: Delaware Art Museum, 1975) / Andrea Kirsh, *Arthur B. Davies: Artist and Collector,* exh. cat. (West Nyack, N.Y.: Rockland Center for the Arts, 1977) / Brooks Wright, *The Artist and the Unicorn: The Lives of Arthur B. Davies (1862–1928)* (New City, N.Y.: Historical Society of Rockland County, 1978) / Joseph Czestochowski, *The Works of Arthur B. Davies* (Chicago: University of Chicago Press, 1979) / Charles C. Eldredge, *American Imagination and Symbolist Painting,* exh. cat. (New York: Grey Art Gallery and Study Center, 1979) / Elizabeth Milroy, *Painters of a New Century: The Eight and American Art,* exh. cat. (Milwaukee, Wis.: Milwaukee Art Museum, 1991)

158

ARTHUR B. DAVIES
Four O' Clock Ladies, c. 1900–1905
Oil on canvas; $18\frac{1}{4} \times 30$ in. (46.4 × 76.2 cm)
Signed at lower left: A. B. Davies

EXHIBITED: Art Institute of Chicago, "Paintings by Arthur B. Davies," 1911, no. 9 / Art Institute of Chicago, "Thirty-ninth Annual Exhibition of American Paintings and Sculpture," 1926, no. 3 / New York City, Metropolitan Museum of Art, "Memorial Exhibition: Works of Arthur B. Davies," 1930, no. 31 / New York City, Ferargil Galleries, 1942 / New York City, Ferargil Galleries, "An Exhibition of Works by Arthur B. Davies and Albert P. Ryder," 1946 / Philadelphia, Pennsylvania Academy of the Fine Arts, "In This Academy," 1976, no. 249

EX COLL.: artist to 1905; purchased by Mrs. Chauncey Blair in 1905; with Fred Price, director of Ferargil Galleries, New York City; to Stephen C. Clark, New York City; with Fred Price, Ferargil Galleries, New York City; to Duncan Phillips by 1926; with Ferargil Galleries, New York City, by 1942; with Hirschl and Adler Galleries, New York City, by 1964[1]

The Ella Gallup Sumner and Mary Catlin Sumner Collection Fund, 1964.155

Four O' Clock Ladies is the product of a transitional period when Davies's subject matter shifted from more

158

conventional images of women and children to symbolic and ethereal visions of the female figure. In a dreamlike fantasy, young women are depicted in various graceful poses that are unrelated and difficult to define. The figures are dressed in pastel pinks, yellows, whites, and purples that appear bright against the flat blue-green palette of the water, land, and sky. In the background is a charming and idyllic landscape setting featuring a city on a hill and, to the right, a suspended bridge. Davies painted the city in flat geometric patches of color set against a flat background, reflecting his familiarity with James McNeill Whistler (q.v.).[2]

In its personal subject matter—the unrelated female figures—and fantastical landscape setting, *Four O' Clock Ladies* reflects the influence of the romantic tradition and the symbolist painting on Davies's work. Like the symbolists', his paintings are obscure in theme; there is no known source for the title of *Four O' Clock Ladies*, and most likely the piece represents a poetic idea or fantasy of the artist. The thin paint application and the horizontal format recall the paintings of symbolist painter Albert Pinkham Ryder (q.v.), whom Davies admired.

Recognized as an important work in the 1940s, *Four O' Clock Ladies* is mentioned in favorable reviews of two exhibitions at the Ferargil Gallery in New York City. One of the reviewers praises it as an excellent example of Davies's "poetic, charmingly mooded" paintings in which the "color is subtle and brushwork is at its most fluent. The result is unmistakable Davies, and of a high order."[3] In a later review, *Four O' Clock Ladies* is cited as an example of the market stability and rising prices of Davies's best works.[4] ERM

1. This provenance history is from Margaret Breuning, "What Price Davies," *Art Digest* 20 (March 1946), 6.
2. My thanks to Elizabeth Milroy, professor of art history, Wesleyan University, for providing me with this information.
3. "Davies and Other American Masters," *Art Digest* 17 (November 1942), 13.
4. Breuning, "What Price Davies," 6. From 1905 to 1946 the price of *Four O' Clock Ladies* rose went from $500 to $6,500.

159 (see plate 48)

ARTHUR B. DAVIES

Protest against Violence, c. 1911–1912

Oil on canvas; 40 × 26 in. (101.6 × 66.0 cm)

EXHIBITED: Brooklyn, N.Y., Brooklyn Museum, "Modern French and American Painters," 1926 / New York City, Metropolitan Museum of Art, "Memorial Exhibition of the Works of

Arthur B. Davies," 1930, no. 103 / Springfield, Mass., Springfield Museum of Fine Arts, "Memorial Exhibition in Honor of James Philip and Julia Emma Gray," 1933, no. 108

EX COLL.: to Lillie Bliss by 1931; sold at Sotheby's as part of the estate of Lillie Bliss in 1939; with Ferargil Galleries, New York City; Wright S. Ludington to 1992

The Ella Gallup Sumner and Mary Catlin Sumner Collection Fund, 1992.81

Davies painted *Protest against Violence* during the prolific period when he was promoting modern art to the American public. A regular visitor of Alfred Stieglitz's "291" gallery, where European modernists were represented as early as 1909, Davies purchased works by Cézanne, Picasso, and Matisse. Though he experimented with modernism at this time, however, it did not have a large impact on his works, which retained their own individual style. *Protest against Violence* relates more to Davies's interest in classical Greek and Italian renaissance art, seen here in the frieze of nude figures.

Davies painted and drew several depictions of nude figures placed in active poses set against an unrelated landscape or backdrop. In *Protest against Violence*, nude male figures engaged in combat with knives symbolize violence. Above, smiling male and female figures that recall biblical subjects such as Adam and Eve harmlessly pose standing and on horseback. Above them, spectators fully dressed in blues, greens, and browns sit behind a purple balustrade and watch the two scenes below, as if a drama were being played out. Davies's titles are typically allusive, referring to a fantasy or, in this case, perhaps a play.

For this painting, Davies used a rich palette of dark and bright colors that recalls medieval tapestries. Against a patchwork of earthy browns, purples, and dark greens, he painted tinted, ethereal figures in pale yellows. Across the thinly painted and layered surface he added patches of bright greens and brownish reds. In several of the nude figures, there are traces of outlines, indicating the artist's interest in figurative drawing.

Lillie P. Bliss, who had become one of the most avid collectors of Davies's works, purchased *Protest against Violence*. ERM

Charles H. Davis

Born in Amesbury, Mass., in 1856; died in Mystic, Conn., in 1933

Charles Harold Davis committed himself to an artistic career in 1874 after seeing the Barbizon landscapes of the French artist Jean-François Millet on exhibit in Boston. He first studied drawing, and then, at the age of twenty, he entered the School of the Museum of Fine Arts, where he studied for three years under Otto Grundmann (1844–1890). In 1880 Davis left for France, remaining there for nine years. After studying briefly at the Académie Julian he spent most of his time painting outdoors in the rural areas, including Fontainebleau. Eventually, Davis settled in the village of Fleury, near Barbizon. There he met his first wife, Angèle Geneviève Legarde, whom he married in 1884.

During his stay in France, Davis exhibited at the Paris Salon and, in America, in Boston and at the National Academy of Design in New York City. From 1882 on he was given one-artist shows at the Doll and Richards Galleries in Boston, and in 1887 he held his first major exhibition at Reichard and Company in New York City. In 1886 he became a member of the Society of American Artists.

Returning to America in 1890, Davis settled in Mystic, Connecticut, where he lived for the rest of his life. His early landscapes, with their tonal and poetic qualities, reflect the impact of the Barbizon school. About 1895 Davis ventured into impressionism and painted the New England landscape with a brighter palette and looser brushwork. About the same time, he began to focus on clouds as his main subject matter and studied and painted them under varying conditions.

Davis was a popular and successful artist and exhibited regularly in solo shows and major exhibitions. He received several awards, including a silver medal at the Paris Exposition Universelle in 1889 and bronze medals at the World's Columbian Exposition in 1893 and the Paris Exposition Universelle in 1900. He was elected an academician at the National Academy of Design in 1906.

SELECT BIBLIOGRAPHY

Louis Bliss Gillet, "Charles H. Davis," *American Magazine of Art* 27 (March 1934), 105–112 / David C. Huntington, *The Quest for Unity: American Art between World's Fairs, 1876–1893* (Detroit: Detroit Institute of Arts, 1983) / William H. Gerdts, *American Impressionism* (New York: Abbeville Press, 1984)

160

CHARLES H. DAVIS
Twilight on the Plains of Barbizon, 1885
Oil on canvas; 37 × 58 in. (94.0 × 147.3 cm)
Signed and dated at lower left: C. H. Davis 1885

EXHIBITED: New York City, American Art Association, "Prize Fund Exhibition—86," 1886

EX COLL.: Nelson Hollister, Hartford; to his daughters Mrs. Charles A. Robinson and Mrs. Albert Olmstead by 1897

Gift of Mrs. Charles A. Robinson and Mrs. Albert Olmstead, 1897.8

Captivated by the Barbizon region and the French artists working there, particularly Jean-François Millet, Charles Davis later wrote: "My first morning in Barbizon was spent in finding, one by one, the spots and characteristic things I actually knew by heart from the years of devoted study of Millet's drawings."[1] Davis was still living in France when he painted *Twilight on the Plains of Barbizon*, a poetic landscape exhibiting the characteristics of the tonalist style, as seen in the unified color, somber atmosphere, and quiet effects in nature. In the distance, the river reflects the glowing light of the sky.

The year after it was painted, *Twilight on the Plains of Barbizon* was awarded a gold medal of honor at the American Art Association's Second Prize Fund Exhibition held in New York. ERM

1. Quoted in Thomas Colville, *Charles H. Davis N.A., 1856–1933*, exh. cat. (Mystic, Conn.: Mystic Art Association, 1982), 2.

161

CHARLES H. DAVIS
Twilight—Barbizon, 1885
Oil on canvas; 38⅝ × 57⅝ in. (98.1 × 146.4 cm)
Signed and dated at lower left: Charles H. Davis 1885

EX COLL.: Ambrose Spencer, Hartford, by 1901

Bequest of Ambrose Spencer, 1901.13

160

161

Twilight—Barbizon exemplifies the tonalist style Davis used for his landscapes of the French countryside painted in and around the village of Barbizon. This work is very similar in both its composition and its poetic mood to *Twilight on the Plains of Barbizon* (cat. 160), which was painted in France in the same year. Here, however, Davis added birds and a single glowing star in the sky. ERM

162 (see plate 49)

CHARLES H. DAVIS
Change of Wind, c. 1900
Oil on canvas; 50⅛ × 60⅛ in. (127.3 × 152.7 cm)
Signed at lower left: C. H. Davis

EX COLL.: the artist's second wife, Mrs. Charles (Francis Thomas) Davis, Mystic, Conn., from 1900 to 1943

Gift of Mrs. Charles H. Davis, 1943.328

By the time Charles Davis settled in Mystic, Connecticut, following his return to the United States in 1890, he was an accomplished practitioner of tonalist landscapes. In about 1895, however, his style changed dramatically from the Barbizon mode he used for his depictions of the French countryside to the impressionism with which he portrayed New England landscapes. By 1900 Davis had come "under the spell of sunshine and the influence of the luminists."[1] At this time, Davis became known for his paintings of clouds, and in 1909 he wrote an essay on this theme, entitled "A Study of Clouds."[2]

Change of Wind features the artist's favored composition format, this time with a concentration on the sky rather than on the landscape and the use of a brilliant blue and white palette to depict the luminist sky with floating white cumulus clouds. Along with an impressionist palette, he here used a looser and freer brushwork that evokes the freshness and movement of the wind. *Change of Wind* shows the dramatic change that occurred in Davis's work in the 1890s (cf. cats. 160, 161). ERM

1. "Landscape Paintings by Charles H. Davis at Pratt Institute, Brooklyn," *Artist* 26 (January 1900), lxxxi–lxxxii.
2. Charles H. Davis, "A Study of Clouds," *Palette and Bench* 1 (September 1909), 261–262.

Stuart Davis

Born in Philadelphia, in 1892; died in New York City, in
1964

Stuart Davis left Philadelphia in 1909 to pursue ar-
tistic training at the Robert Henri (q.v.) School of Art in
New York City. From Henri and other members of the
Ashcan School, Davis learned to value social conscious-
ness and the aesthetic content of his everyday urban
environment, values he held throughout his life. Jazz
and ragtime music were other early influences. In 1910
Davis exhibited at the large "Exhibition of Independent
Artists," organized by his close friend John Sloan (q.v.)
and other artists in reaction against the conservative
schools of art. Davis later exhibited five watercolors at
the landmark Armory Show ("International Exhibition
of Modern Art") of 1913, where he was impressed with
and inspired by the European modern works repre-
sented by Van Gogh, Gauguin, and Matisse. At this
point, the artist resolved to become a modernist painter.

Through his close friendship with Sloan, Davis be-
came one of the young illustrators for the socialist mag-
azine *The Masses* until 1916, when he left following a
dispute over captions and content. In 1917, he held his
first one-artist show, in New York City, and his second
the following year, at the well-known Ardsley Gallery in
Brooklyn. At this time, he also began exploring Eu-
ropean cubist theory and color, which he incorporated
into his scenes of Gloucester, Massachusetts, where his
family and Sloan's summered. In the early 1920s, leav-
ing behind the sketchy realism of his earlier American
teachers, he dedicated himself to the abstract, orderly,
and structural aspects of cubism, the culmination of
which resulted in his *Eggbeater* series of 1927–1928.
Eventually, Davis developed a distinctive vernacular cu-
bist vocabulary of a sophistication unmatched by any
other American modern artist of the time.

Davis attracted the attention of many New York
City galleries and art organizations. Among those show-
ing his works were the Whitney Studio Club, the
Société Anonyme, and Edith Halpert's Downtown Gal-
lery. Important collectors of modern art, such as William
H. Lane and Juliana Force, began buying his works,
which enabled him to go to Paris in 1928. For over a
year, he absorbed modernist culture and art, including
the works of Braque and Picasso. He also became famil-
iar with the circle of avant-garde American expatriate
artists, among them, Isamu Noguchi, Alexander Calder,
and Marsden Hartley (q.v.).

When Davis returned to New York City in 1929, he
committed himself to interpreting subjects of American
culture and life—jazz music, industrial objects, gas sta-
tions, skyscrapers—through abstract forms. Through-
out his life, he was a leading proponent of modernism,
believing that modern art could best speak to public
needs and express the dynamics of contemporary Amer-
ica. Davis wrote extensively on modern art and on his
own exploration of the theories of cubist color and com-
position. His strong advocacy encouraged a generation
of younger artists, including Arshile Gorky and Willem
de Kooning (q.v.), who were working with cubist ele-
ments.

In 1933 Davis was one of the first artists to join the
federal government's Public Works of Art Project, work-
ing both in the Graphic Arts Division and as a muralist
until 1939. Always socially conscious, Davis was an ac-
tive advocate of artists' causes and organizations such as
the Artists Union and the American Artists Congress.
He never had any tolerance for propaganda, however,
strongly believing that art was not a political tool. Con-
sequently, he was highly critical of social realism, the
American Scene painters, and later, abstract expres-
sionism.

Davis continued until his death to hold exhibitions
and retrospectives at prestigious galleries and mu-
seums, including the Downtown Gallery, the Whitney
Studio Club and Galleries, the Whitney Museum, and
the Museum of Modern Art. He taught at the New York
School for Social Research from 1940 to 1950 and in 1951
accepted a post as a visiting art professor at Yale Uni-
versity. Davis also received numerous awards and honors.

SELECT BIBLIOGRAPHY

H. Harvard Arnason, *Stuart Davis Memorial Exhibition*, exh.
cat. (Washington, D.C.: National Collection of the Fine Arts,

Smithsonian Institution, 1965) / Diane Kelder, ed., *Stuart Davis* (New York: Praeger, 1971) / John R. Lane, *Stuart Davis: Art and Art Theory*, exh. cat. (Brooklyn, N.Y.: Brooklyn Museum, 1978) / Patterson Sims, *Stuart Davis: A Concentration of Works from the Permanent Collection of the Whitney Museum of American Art*, exh. cat. (New York: Whitney Museum of American Art, 1980) / William C. Agee, *Stuart Davis (1892–1964): The Breakthrough Years, 1922–1924*, exh. cat. (New York: Salander-O'Reilly Galleries, 1987) / Karen Wilkin, *Stuart Davis*, exh. cat. (New York: Abbeville Press, 1987) / Lowery Stokes Sims, *Stuart Davis*, exh. cat., with comprehensive bibliography (New York: Metropolitan Museum of Art, 1991)

163

STUART DAVIS

Still Life—Three Objects, 1925

Oil on canvas; $26^{1}/_{16} \times 34^{1}/_{16}$ in. (66.2 × 86.5 cm)

Signed and dated at lower right: Stuart Davis 1925

EXHIBITED: New York City, Whitney Studio Club, 1926 / Minneapolis, Minnesota State Fair, 1947 / Iowa City, University of Iowa, 1948 / Columbia, Mo., Lewis James and Nellie Stratton Davis Art Museum, Stephens College, 1949 / Portland, Oreg., Portland Museum of Art; Santa Barbara, Calif., Santa Barbara Museum; and San Francisco, Calif., Circuit de Young Memorial Museum, "Davis, Kuniyoshi, Watkins," 1949 / Winter Park, Fla., George D. and Harriet W. Cornell

163

Fine Arts Center Museum, Rollins College, 1951 / Cincinnati, Ohio, Cincinnati Art Museum, 1951 / Art Institute of Chicago, "Sixty-first American Exhibition: Paintings and Sculpture, 1954," 1954, no. 33 / New Haven, Yale University, Department of Design, "Visiting Critics," 1955 / Minneapolis, Walker Art Center; Des Moines, Iowa, Des Moines Art Center; San Francisco, Calif., San Francisco Museum of Art; and New York City, Whitney Museum of American Art, "Paintings by Stuart Davis," 1957, no. 38 / Washington, D.C., National Collection of Fine Arts, Smithsonian Institution, "Roots of Abstract Art in America, 1910–1930," 1966, no. 24

EX COLL.: Mr. and Mrs. Stuart Davis, New York City, to 1957

Gift of Mr. and Mrs. Stuart Davis, 1957.605

The period from 1922 to 1924 marked the turning point in Davis's maturity as an artist.[1] No longer aspiring to follow the example of his early teachers, Davis seriously began to explore and assimilate the many possibilities of European modernism, particularly that offered by French cubism. Influenced by the works of Cézanne and the postcubists Léger and Picasso that he had seen at the 1913 Armory Show, Davis formulated his innovative cubist style using still-life elements, developing an intellectual approach to his subject matter and striving to create a cubism that was American in subject matter, context, and style rather than totally derivative of French influences.[2] His still lifes of the 1920s may be considered the first works to reflect his successful move toward this goal, which he reached in his works of the thirties and forties.[3]

In Still Life—Three Objects, Davis isolates and alters ordinary domestic objects—glass, vase, and bottle—placing them in an unfamiliar environment.[4] His choice of contemporary industrial objects reflects the philosophy he learned at Henri's school and the impact of French modernism, under both of which the monumentalization of the mundane becomes suitable subject matter and metaphors for modern American urban life.[5] Objective in his approach to his subject matter, Davis translates the objects into the reality of paint and canvas through structural elements: lines, planes, and colors.[6] His use of contrasting colors separates the

planes as distinct geometric shapes. Reflecting his awareness of Léger, the artist uses bold black lines to realize the forms and shapes of the objects, the lines becoming planes in themselves, particularly where they stand free.[7] The wavy white and gray lines create the feeling of movement within the orderly structural context. Behind the various types of glassware is a square picture plane, representing a mirror or an abstract painting.

In keeping with the tradition of early cubism, Still Life—Three Objects is a combination of muted, earthy grays and browns and black and white.[8] The surface of the canvas is painterly and full of rich, warm texture. These painterly surfaces located within tightly outlined spaces later became a Davis trademark.[9] Already recognized as a talented modernist painter, Davis exhibited Still Life—Three Objects and other cubist still lifes at his retrospective at the Whitney Studio Club in 1926.

Davis's paintings become more monumental in scale and organization as he developed his sophisticated, uniquely American cubist vocabulary. By the 1950s he had achieved simplification and geometric control combined with vibrancy of color, represented in the Atheneum's later work Midi.[10] ERM

1. William C. Agee, Stuart Davis (1892–1964): The Breakthrough Years, 1922–1924, exh. cat. (New York: Salander-O'Reilly Galleries, 1987), 1.
2. Patterson Sims, Stuart Davis: A Concentration of Works from the Permanent Collection of the Whitney Museum of American Art, exh. cat. (New York: Whitney Museum of American Art, 1980), 4.
3. Agee, Stuart Davis, 3.
4. Davis also used glassware as the subject for his ink drawings, in which he experimented with form and mass by means of outline. See Sims, Stuart Davis, 18.
5. Karen Wilkin, Stuart Davis exh. cat. (New York: Abbeville Press, 1987), 93.
6. H. H. Arnason, Stuart Davis, exh. cat. (Minneapolis: Walker Art Center, 1957), 14.
7. Agee, Stuart Davis, 4.
8. Agee, Stuart Davis, 3.
9. Ibid.
10. Arnason, Stuart Davis, 27.

Plate 1 (Cat. 3). Ivan Albright, *I Slept with the Starlight in My Face* (*The Rosicrucian*), 1930.

Plate 2 (Cat. 7). Washington Allston, *The Death of King John*, 1838.

Plate 3 (Cat. 11). Milton Avery, *The Green Settee*, 1943.

Plate 5 (Cat. 22). George Bellows, *Pulpit Rock*, 1913.

Plate 4 (Cat. 16). James Bard and John Bard, *The Armenia*, 1848.

Plate 10 (Cat. 42). Thomas Birch, *Landscape with Covered Wagon*, 1821.

Plate 6 (Cat. 38). Albert Bierstadt, *In the Yosemite Valley*, 1866.

Plate 7 (Cat. 39). Albert Bierstadt, *In the Mountains*, 1867.

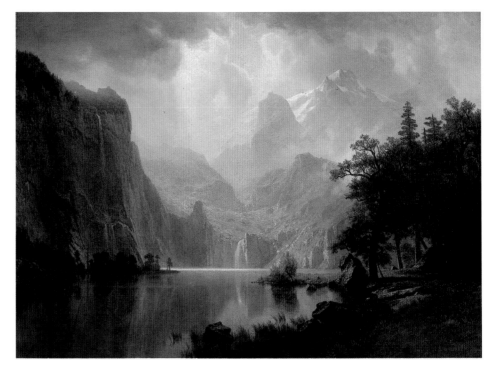

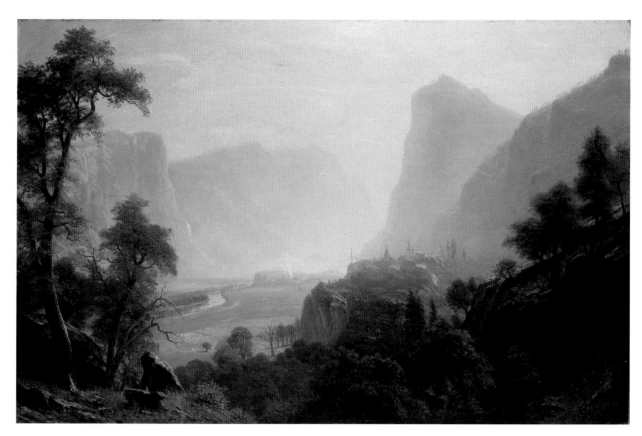

Plate 8 (Cat. 40). Albert Bierstadt, *The Hetch-Hetchy Valley, California*, c. 1874–1880.

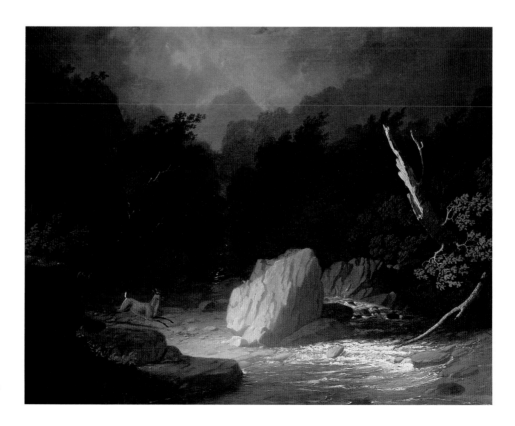

Plate 9 (Cat. 41). George
Caleb Bingham, *The Storm*,
c. 1852–1853.

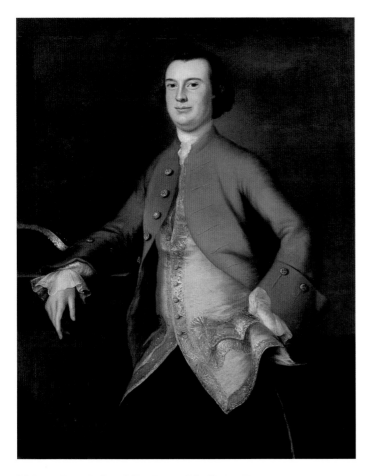

Plate 11 (Cat. 45). Joseph Blackburn, *John Erving, Jr.*, 1755.

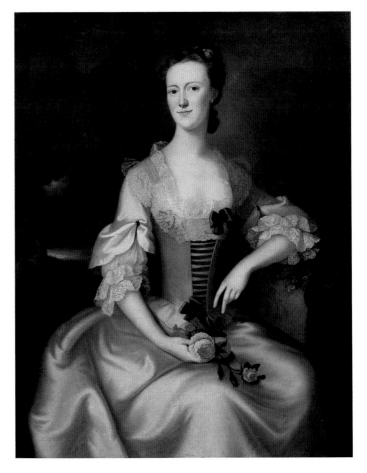

Plate 12 (Cat. 46). Joseph Blackburn, *Mrs. John Erving, Jr. (Maria Catherine Shirley)*, 1755.

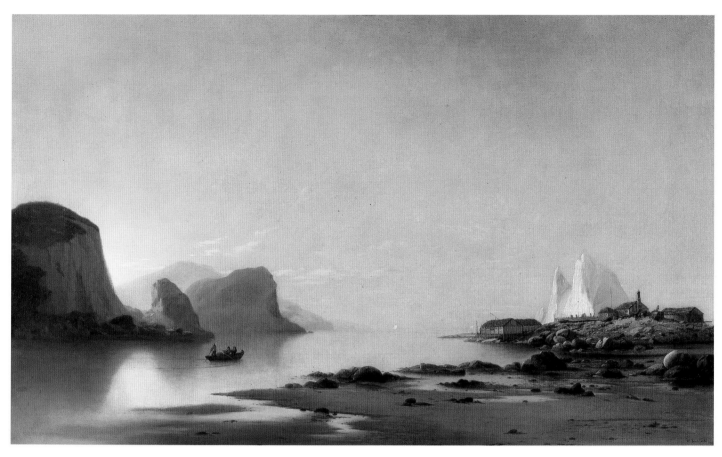

Plate 13 (Cat. 50). William Bradford, *Coast of Labrador*, 1868.

Plate 14 (Cat. 59).
Mather Brown,
*Louis XVI Saying
Farewell to His
Family*, c. 1793.

Plate 15 (Cat. 62). Charles DeWolf Brownell, *The Charter Oak*, 1857.

Plate 16 (Cat. 70). William Gedney Bunce, *Venetian Days*, c. 1874.

Plate 17 (Cat. 93). Emil Carlsen, *Summer Light*, c. 1913.

Plate 18 (Cat. 95). John William Casilear, *Lake George*, 1860.

Plate 19 (Cat. 97). Thomas Chambers, *Niagara Falls*, c. 1835.

Plate 22 (Cat. 101). William Merritt Chase, *Shinnecock Hills (A View of Shinnecock)*, 1891.

Plate 20 (Cat. 99). William Merritt Chase, *Boy Smoking (The Apprentice)*, 1875.

Plate 21 (Cat. 100). William Merritt Chase, *Portrait of a Woman*, 1878.

Plate 23 (Cat. 111). Frederic E. Church, *Hooker and Company Journeying through the Wilderness from Plymouth to Hartford, in 1636*, 1846.

Plate 24 (Cat. 112). Frederic E. Church, *Grand Manan Island, Bay of Fundy*, 1852.

Plate 25 (Cat. 113). Frederic E. Church, *Mountains of Ecuador*, 1855.

Plate 26 (Cat. 114). Frederic E. Church, *Niagara Falls*, 1856.

Plate 27 (Cat. 115). Frederic E. Church, *Coast Scene, Mount Desert*, 1863.

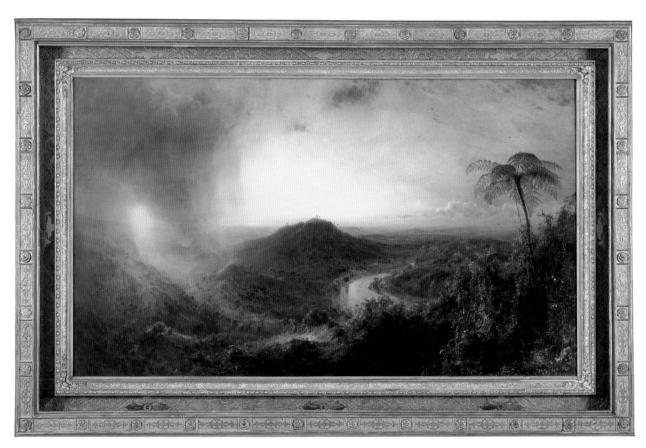

Plate 28 (Cat. 116). Frederic E. Church, *Vale of St. Thomas, Jamaica*, 1867.

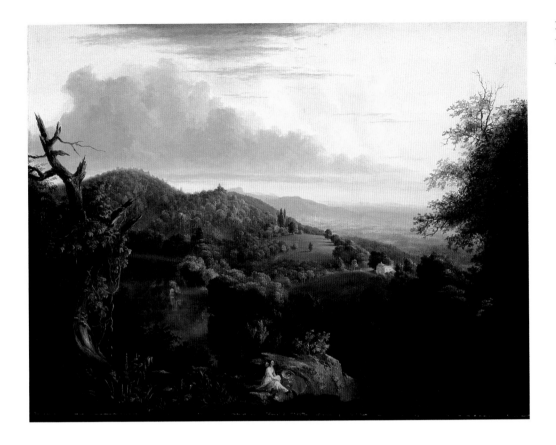

Plate 34 (Cat. 126). Thomas Cole, *View of Monte Video, the Seat of Daniel Wadsworth, Esq.*, 1828.

Plate 35 (Cat. 127). Thomas Cole, *View on Lake Winnipiseogee*, 1828.

Plate 36 (Cat. 132). Thomas Cole, *Evening in Arcady*, 1843.

Plate 37 (Cat. 133). Thomas Cole, *Roman Campagna*, 1843.

Plate 33 (Cat. 125). Thomas Cole, *Scene from "The Last of the Mohicans," Cora Kneeling at the Feet of Tamenund*, 1827.

Plate 39 (Cat. 137). Samuel Colman, *Gibraltar from the Neutral Ground*, c. 1863–1866.

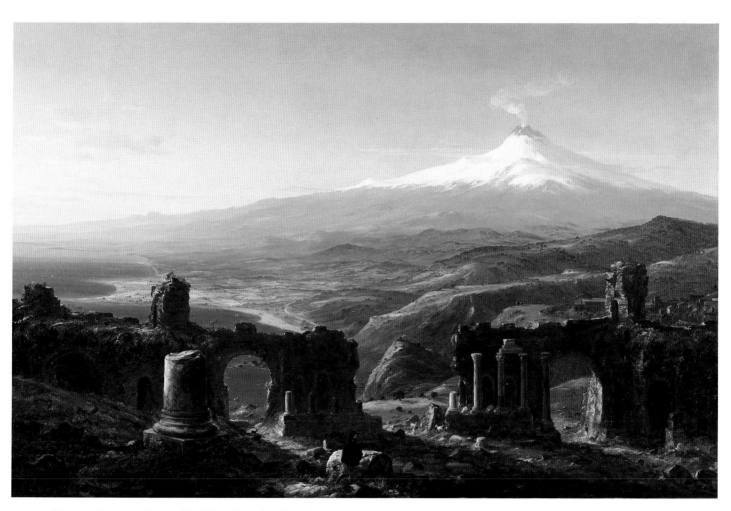

Plate 38 (Cat. 134). Thomas Cole, *Mount Etna from Taormina*, 1843.

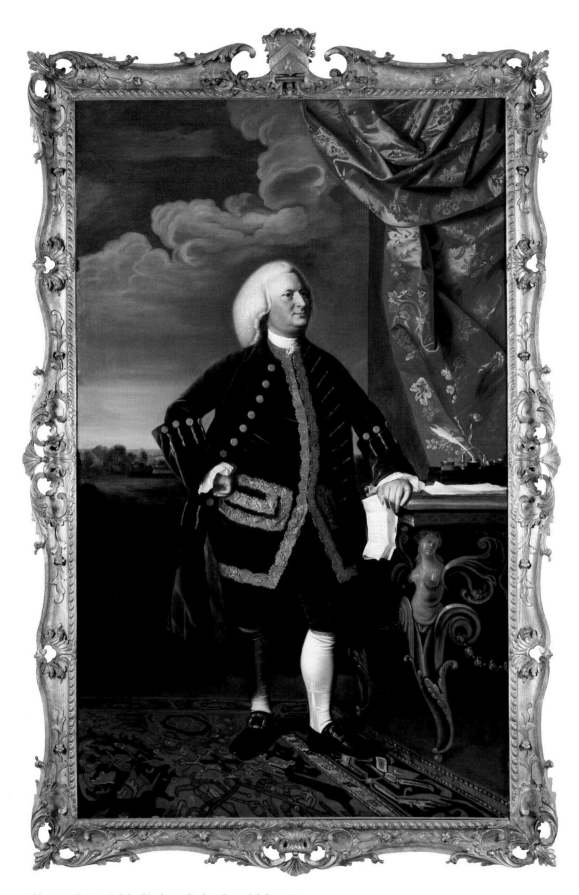

Plate 40 (Cat. 144). John Singleton Copley, *Jeremiah Lee*, 1769.

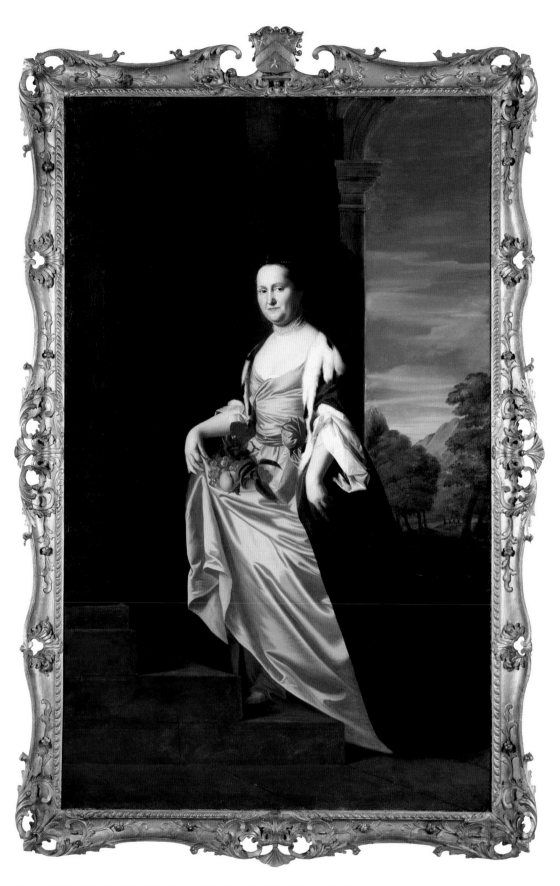

Plate 41 (Cat. 145). John Singleton Copley, *Mrs. Jeremiah Lee (Martha Swett)*, 1769.

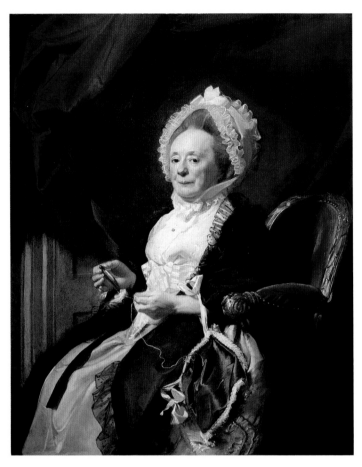

Plate 42 (Cat. 146). John Singleton Copley, *Portrait of a Lady (Mrs. Seymour Fort)*, c. 1780.

Plate 43 (Cat. 147). John Singleton Copley, *Samuel Relating to Eli the Judgements of God upon Eli's House*, 1780.

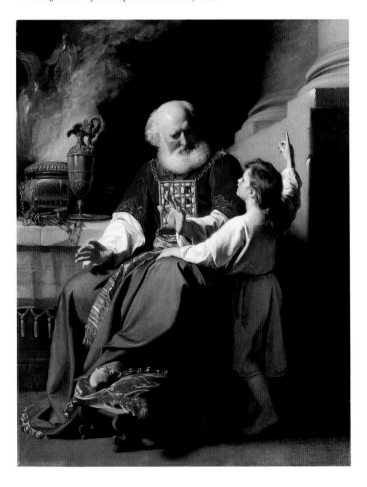

Plate 44 (Cat. 148). Michele Felice Corné, *Sea View of the British Channel*, 1804.

Plate 45 (Cat. 149). Joseph Cornell, *Soap Bubble Set*, 1936.

Plate 46 (Cat. 154). Jasper F. Cropsey, *Winter Scene—Ramapo Valley*, 1853.

Plate 47 (Cat. 157). Ferdinand Danton, *Time Is Money*, 1894.

Plate 48 (Cat. 159). Arthur B.
Davies, *Protest against Violence*,
c. 1911–1912.

Plate 49 (Cat. 162). Charles H.
Davis, *Change of Wind*, c. 1900.

Plate 50 (Cat. 165). Thomas Dewing, *The Days*, 1884–1886.

Plate 51 (Cat. 169). Arthur Dove, *Approaching Snow Storm*, 1934.

Plate 52 (Cat. 172). Robert S. Duncanson, *Recollections of Italy*, 1864.

Plate 53 (Cat. 174). Asher B. Durand, *View toward the Hudson Valley*, 1851.

Plate 54 (Cat. 180). George Henry Durrie, *Old Grist Mill*, 1853.

Plate 55 (Cat. 183). Thomas Eakins, *On the Delaware (Becalmed)*, 1874.

Plate 56 (Cat. 184). Thomas Eakins, *John McLure Hamilton*, 1895.

Plate 57 (Cat. 185). Ralph Earl, *Colonel Samuel Talcott*, c. 1791–1792.

Plate 58 (Cat. 186). Ralph Earl, *Oliver Ellsworth and Abigail Wolcott Ellsworth*, 1792.

Plate 59 (Cat. 189). Francis W. Edmonds, *The Epicure*, 1838.

Plate 64 (Cat. 205). Alvan Fisher,
Niagara Falls, 1823.

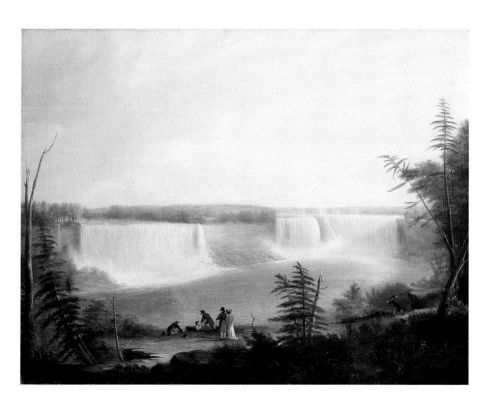

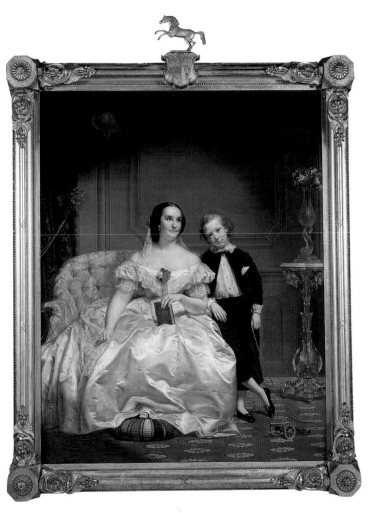

Plate 61 (Cat. 196). Charles Loring Elliott, *Mrs. Elizabeth Hart Jarvis Colt and Son Caldwell*, 1865.

Plate 60 (Cat. 195). Charles Loring Elliott, *Colonel Samuel Colt*, 1865.

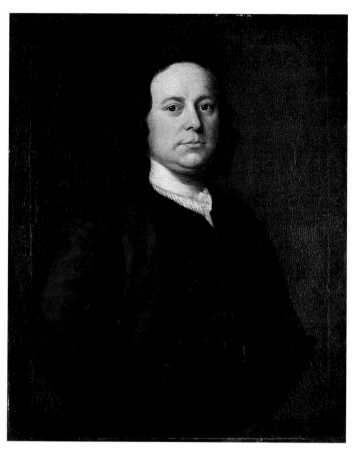

Plate 62 (Cat. 203). Robert Feke, *Gershom Flagg IV*, c. 1741–1747.

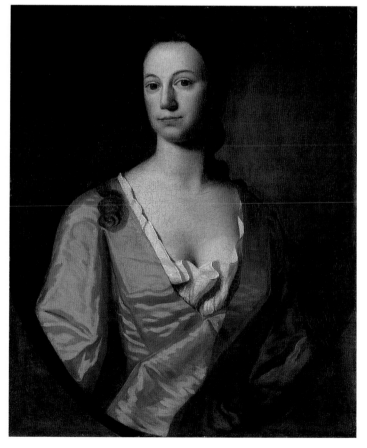

Plate 63 (Cat. 204). Robert Feke, *Mrs. Gershom Flagg IV (Hannah Pitson)*, c. 1741–1747.

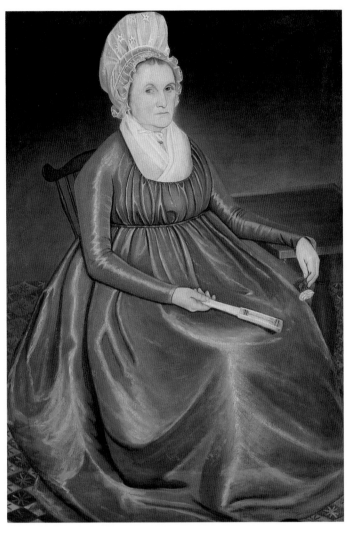

Plate 66 (Cat. 212). Simon Fitch, *Mrs. Ephraim (Hill) Starr (Hannah Beach)*, 1802.

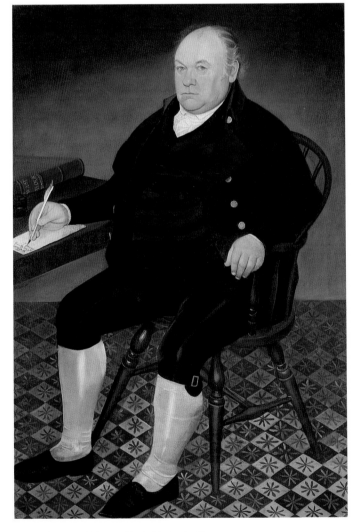

Plate 65 (Cat. 211). Simon Fitch, *Ephraim Starr*, 1802.

Stuart Davis, *Midi,* 1954. Wadsworth Atheneum. Photograph: E. Irving Blomstrann.

Charles Delin

Born in Doornijk (now Tournai), Belgium, in 1751; died in Amsterdam, in 1818

Christened Carolus Bruno Douat Delin, the portrait painter later known as Charles Delin was the son of Albert Delin, a harpsichord maker, and Ann Marte Delin. At the age of sixteen, he was sent with his brother, Nicholas J. Delin, to the Royal Academy of Art in Antwerp, where he received instruction from 1771 to 1775. He married Carolina Gertrudis van den Broeck in 1775 and painted small-scale portraits in the major port city of Maastricht from 1775 to 1799. Carolina died in the latter 1790s, and the artist was remarried in about 1799, to Johanna Gertui Engering. Delin continued to paint portraits in Maastricht until the end of his life.

Approximately fifty portraits have been ascribed to Delin, either signed or attributed. As a leading port painter, Delin executed likenesses of military officers and seamen, among them, many American sea captains who chose to have their portraits painted while in Am-

sterdam. Delin signed his canvases "C. Delin," and in nearly all his portraits he adhered to a small-scale, bust-length format. His portraits, which are largely of male subjects, have a formulaic quality. Executed in a stiff, linear manner, they feature pleasant, often smiling likenesses of the sitters. At the time of his death, Delin's son, Caspar, filed his father's occupation as *fijnschilder,* or painter of small-scale portraits.

SELECT BIBLIOGRAPHY

Artist file, C. Delin, Frick Art Reference Library, New York City / Frank MacGregor Smith, "Notes on Portraits of American Sea Captains Attributed to C. Delin," unpublished manuscript, curatorial painting file, Wadsworth Atheneum / Howard C. Sherwood, "Sea Captains' Portraits," *Antiques* 61 (May 1952), 433 / Peter Benes, *Old-Town and the Waterside,* exh. cat. (Newburyport, Mass.: Historical Society of Old Newbury, 1985) / Peter Benes, *Charles Delin: Port Painter of Maastricht and Amsterdam,* exh cat. (Old Newbury, Mass.: Historical Society of Old Newbury, 1987)

164

ATTRIBUTED TO CHARLES DELIN
William Williams, c. 1810–1818
Oil on canvas; 19¾ × 16⅝ in. (50.2 × 42.2 cm)

EXHIBITED: Newburyport, Mass., Historical Society of Old
Newbury, "C. Delin: Port Painter," 1985, no. 50

EX COLL.: descended in the family of William Williams, Essex, Conn.; to the subject's grandson Jared E. Redfield, Essex, Conn., in 1935; Fred E. Dayton, Essex, Conn., to 1943

Gift of Fred E. Dayton, 1943.329

The subject of this portrait, William Williams (1783–1835), was an Essex, Connecticut, sea captain who probably had this portrait painted while on a voyage. The portrait is attributed to Charles Delin based on its stylistic similarity to two signed examples (private collection).[1] Williams is presented in a pleasing likeness at bust length, executed in a broadly painted, linear manner. A watercolor drawing of Captain William's ship, *Emulation*, entering the port of Le Havre in 1815 is in the Atheneum collection (1943.330). EMK

1. Peter Benes, *Old-Town and the Waterside*, exh. cat. (Newburyport, Mass.: Historical Society of Old Newbury, 1985), 123.

164

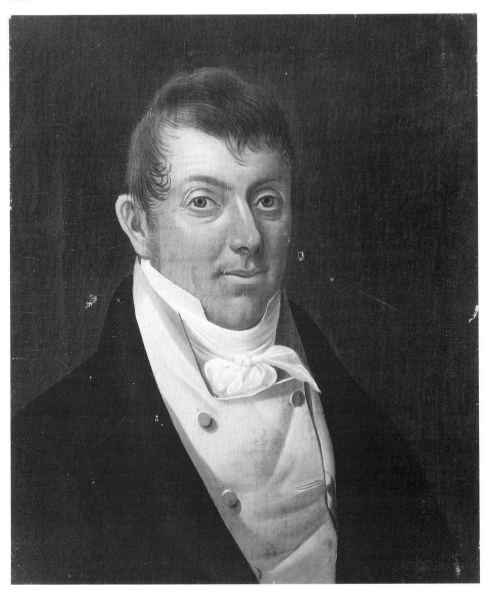

Thomas Dewing

Born in Boston, in 1851; died in New York City, in 1938

Thomas Wilmer Dewing was a leading exponent of aestheticism, painting delicate works that were among the most poetic paintings in late-nineteenth-century American art. Born the son of a Boston milliner, he first trained as a lithographer. Showing an early talent in drawing, he may have attended classes in life drawing at the Lowell Institute. He then spent two years as a portraitist in Albany, New York, raising enough money to finance a trip to Europe in 1876. During two years in Paris, Dewing studied at the Académie Julian with Gustave Boulanger and Jules-Joseph Lefebvre, acquiring the precise figural style and controlled brushwork that would bring him critical praise.

Dewing returned to Boston in 1878 and later moved to New York City in 1880. He exhibited his accomplished academic works in exhibitions at the Pennsylvania Academy of the Fine Arts in Philadelphia and at the National Academy of Design in New York City. In 1881 he married the noted flower painter Maria Richards Oakey (1845–1927), whose publications on household art show signs of the influence of the aesthetic movement. The couple spent summers in Cornish, New Hampshire, establishing the area as an artists' colony along with other artists, including Augustus Saint-Gaudens.

Beginning in 1881, Dewing taught at the Art Students League in New York for seven years. His canvases of the 1880s feature winged figures and monumental, classically inspired women, often in a literary context, and demonstrate the influence of the post–Pre-Raphaelite and aesthetic movements in England. He relied on elaborate allegorical devices and literary allusions to convey abstract ideas, moods, and sensations. It was during this period that he painted *The Days* (cat. 165), following the successful exhibition of which he was elected an academician of the National Academy of Design in 1888.

Influenced by James McNeill Whistler (q.v.) and Oriental art during the 1890s, Dewing shifted away from finely drawn allegorical figures placed in elaborate settings to more simple compositions, the ethereal, introspective women for which he is best known. Working in a soft, tonal style, the figures are set in decorative landscapes or austere room interiors that evoke a mysterious mood. The artist also worked in pastel and silverpoint, the latter a medium in which he excelled, to achieve a similar effect.

Dewing was a member of the Society of American Artists beginning in 1880, when he first exhibited his works, until 1897, when he joined a secessionist group, the Ten American Painters, who worked mainly in an impressionist style. He is often associated with the impressionists, with whom he exhibited his works beginning in 1898. He is best described as a tonalist, however, in view of his use of diffused light and subtle gradations of color, predominantly of one or two hues, and his preference for melancholic and nostalgic subjects.

As a colleague of the well-known architect Stanford White, Dewing had many of the frames for his paintings designed by White. His association with White also gained him a number of important patrons, including Charles Lang Freer of Detroit and John Gellatly of New York. Their extensive collections of Dewing's paintings are held in the Freer Gallery of Art and the National Collection of Fine Arts, respectively.

SELECT BIBLIOGRAPHY

Charles H. Caffin, "The Art of Thomas W. Dewing," *Harper's Monthly Magazine* 116 (April 1908), 714–724 / Royal Cortissoz, "An American Artist Canonized in the Freer Gallery—Thomas W. Dewing," *Scribner's Magazine*, 74 (November 1923), 539–546 / Nelson C. White, "The Art of Thomas W. Dewing," *Art and Archaeology* 27 (June 1929), 253–261 / Wanda M. Corn, *The Color of Mood: American Tonalism, 1880–1910*, exh. cat. (San Francisco: M. H. de Young Memorial Museum and California Palace of the Legion of Honor, 1972) / Susan Hobbs, "Thomas Wilmer Dewing: The Early Years, 1852–1885," *American Art Journal* 13, no. 2 (1981), 4–35 / Kathleen Pyne, "Classical Figures, a Folding Screen by Thomas Dewing," *Bulletin of the Detroit Institute of Arts* 59 (spring 1981), 5–15 / Susan Hobbs, "Thomas Dewing in Cornish, 1885–1905," *American Art Journal* 17, no. 2 (1985), 3–32

165 (see plate 50)

THOMAS DEWING
The Days, 1884–1886
Oil on canvas; 43³/₁₆ × 72 in. (109.7 × 182.9 cm)
Signed and dated at lower left: T. W. Dewing 1886

EXHIBITED: New York City, National Academy of Design, 1887, no. 313, as "'Days' (owner: Miss A. W. Cheney)" / Chicago, World's Columbian Exhibition, 1893, no. 698, as "'The Days' (lent by Miss A. W. Cheney and Miss Louise Cheney)" / Pittsburgh, Pa., Carnegie Institute, 1908 / Wadsworth Atheneum, "A Second Look: Late Nineteenth Century Taste in Paintings," 1958, no. 50 / New York City, Durlacher Brothers, "Thomas W. Dewing," 1963, no. 4, as "The Days" / Washington, D.C., National Collection of Fine Arts, "The 150th Anniversary of the National Academy of Design," 1975, no. 119 / Brooklyn, N.Y., Brooklyn Museum, "The American Renaissance, 1876–1917," 1979 / New York City, Metropolitan Museum of Art, "In Pursuit of Beauty: Americans and the Aesthetic Movement," 1986–1987

EX COLL.: purchased by Louise Cheney and Anne W. Cheney, Manchester, Conn., in 1887

Gift of the estates of Louise Cheney and Anne W. Cheney, 1944.328

The most important of Dewing's works in the 1880s was his mural-size painting *The Days*, which reflects the precise, academic style of his French mentors at the Académie Julian. Dewing derived his inspiration for the composition from an American literary motif, taking the title from a sonnet by Ralph Waldo Emerson (1803–1882):

Daughters of Time, the hypocritic Days,
Muffled and dumb like barefoot dervishes,
And marching single in an endless file,
Bring diadems and fagots in their hands.
To each they offer gifts after his will,
Bread, kingdoms, stars, and sky that holds them all.

I, in my pleached garden, watched the pomp,
Forgot my morning wishes, hastily
Took a few herbs and apples, and the Day
Turned and departed silent. I, too late,
Under her solemn fillet saw the scorn.[1]

The five days are represented by tall, elegant women dressed in Greek chitons. Placed in a shallow, relieflike space, the tightly and precisely modeled figures dressed in shades of green and pale blue with touches of lavender march across the canvas surface amid a shallow field of white flowers. The scene is set against a flat tapestrylike foliage of varying tones of green with touches of blue. The decorative quality of the background is further enhanced with areas of applied gilding.

Each of the four female figures carries a symbolic object devised by the artist. Dewing explained the significance of each figure to the Cheney sisters when they acquired the painting in 1887: "Mr. Dewing said that the first figure in the painting carrying the wings signified 'Imagination'; The second, with the mirror meant 'Truth'; the third carrying the sword stood for 'Fortitude.' The fourth with the lyre signified music or the arts. The figure with the wand has brought these attributes and is departing."[2] A contemporary review unfolds the narrative to include the figure at the far left: "One female carries a sword, another a mirror, a third a pair of bird's wings, and so on, while a man on the left departs disgusted at the apathy which has befallen him when these gracious creatures have come in vain to him, each with her gift."[3]

It has been suggested that Dewing's wife, Maria Oakey Dewing, who was better versed in Emerson's writings than her husband was, may have influenced the artist's choice of subject.[4] The couple is known to have exchanged ideas and collaborated on particular works; in *Hymen* (1886, Cincinnati Art Museum), for example, the figure was painted by Thomas Dewing and the leafy background by his wife. In another case, Thomas Dewing's *Summer* (unlocated) illustrated a poem of the same title by Maria Dewing, the two being published together in *Century Magazine* on June 26, 1883.[5]

The artist labored on *The Days* for several years, beginning in 1884.[6] In 1885 he wrote to Sylvester Rosa Koehler (1837–1900), an art critic and the founder and editor of *American Art Review* (1879–1881), that he was still working on *The Days* but had no purchaser for it; in the letter, he related that the qualities he had achieved in an earlier painting, *The Garden* (1883, unlocated),

purchased by Thomas B. Clarke, were only suggested in *The Days*.[7]

Mariana van Rensselaer included an engraving of *The Days* accompanied by Emerson's poem in her *Book of American Figure Painters*, published in 1886, the year Dewing's painting is dated.[8] The following year the painting won the National Academy's coveted Thomas B. Clarke prize for the best figure painting by an American artist, thereby establishing Dewing's reputation. Reviews of the work were divided, however, with some critics faulting the painting as derivative. One commented, "Why Mr. Dewing should have painted according to a threadbare Grosvenor Gallery formula it is impossible to say, for neither the sage-green symphony which he has adopted nor the familiar tall, gaunt, sadfaced figures are in any way indicated by the poem, nor are they original forms of expression, nor are they necessary or best for a decorative work."[9]

The painting was purchased by Anne and Louise Cheney (cat. 166), heirs to their father's silk manufacturing business in Manchester, Connecticut. The Cheney sisters, who never married and devoted much of their life to remodeling their father's Manchester mansion, which they inherited and lived in, developed a long relationship with the architect Stanford White. A review of the twenty-year correspondence between the sisters and White reveals that the Cheneys looked to White for all decisions concerning artistic matters. On his advice, they had purchased *The Days* before its exhibition at the National Academy of Design in the spring of 1887, intending it as the central feature of their salon, which White would extend for the painting in 1888 and 1889. The painting was hung over a gilt sofa or bench also designed by White (Wadsworth Atheneum). When the gilt bench arrived in 1888, Anne Cheney wrote White: "The bench has come & is simply stunning & we are all in a great state of delight over it."[10]

In the habit of collaborating with artists similarly interested in decoration, Dewing engaged his friend Stanford White to design a frame for *The Days*. White produced the elaborate frame with his associate Joseph Wells.[11] It echoes the gilt surface and decorative quality of the painting. White reproduced Emerson's poem on a piece of paper inset in a rectangle at the bottom center of the frame.

In 1903 and 1904 the sisters moved *The Days* to the dining room, and White made a less monumental frame for the painting at that time.[12] Correspondence from 1903 to 1905 between Anne Cheney and White documents the plans for the new frame and its place over the mantle in the dining room.[13] At one point, she explained to White the lengthy negotiations over the remodeling of the house: "When we went to housekeeping together, 22 years ago, we promised not to do anything about our joint property without the consent of all," which included the "Boys," as she called her two brothers.[14]

The Cheney sisters later had their portraits painted by Dewing (cat. 166). EMK

Stanford White, settee, c. 1890. Wadsworth Atheneum, gift of the Estate of Anne Wells Cheney.

1. The poem can be found in *The Norton Anthology of American Literature*, 2d ed. (New York: Norton, 1985), 1:988–989.

2. Excerpt from Louise Cheney's notebook; see Henry E. McCone to Florence Berger, October 30, 1944, curatorial painting file, Wadsworth Atheneum.

3. "The Academy of Design. A Well Chosen Exhibition," *New York Times*, April 2, 1887, 5.

4. Sarah Lea Burns, *The Poetic Mode in American Painting: George Fuller and Thomas Dewing* (Ann Arbor, Mich.: University Microfilms International, 1979), 215.

5. Cited in Susan Hobbs, "Thomas Wilmer Dewing: The Early Years, 1852–1885," *American Art Journal* 13, no. 2 (1981), 31.

6. Dewing's colleague Abbott Thayer (q.v.) noticed the painting on the artist's easel in 1884, writing his wife Kate: "Dewing and Maria took me to the studio nearby and I was truly delighted with what he has done to the 'days.' You would love the picture" (Abbott Thayer to Kate Thayer, August [1884], Nelson White Papers, Archives of American Art, frame 16D, 199). My thanks to Susan Hobbs for this citation.

7. Thomas Dewing to Sylvester R. Koehler, March 31, 1885, Sylvester Rosa Koehler Papers, Archives of American Art, D 184 frame 137–139.

8. Mariana van Rensselaer, *Book of American Figure Painters* (Philadelphia: Lippincott, 1886), n.p. The book also includes works by artists such as H. Siddons Mowbray, Dennis Bunker, Edwin Blashfield, Kenyon Cox, Thomas Eakins (q.v.), and Walter Shirlaw (q.v.), accompanied by American and British poems.

9. Ripley Hitchcock, "Spring Exhibition, National Academy," *Art Review* 1 (April 1887), 2–3, cited in Burns, *The Poetic Mode*, 216–217. Other reviews appeared in the *New York Times:* "The Academy of Design," which noted, "Sentiment of a languid, lotus-eating variety shows in Mr. T. W. Dewing's large figure painting called 'Days' after Emerson's lines about neglected opportunities. . . . It is an ambitious picture, and contains several graceful figures painted in soft and sensuous colors, with avoidance of realism" (5); and "Close of the Academy Exhibition" which commented, "The Thomas B. Clarke Prize fell to Mr. T. W. Dewing for his procession of the 'Days,' a sweet, reflective band of nymphs stepping a mournful measure through the tall and somewhat self-conscious flowers dear to the Pre-Raphaelite Brotherhood" (May 16, 1887, 7).

10. Anne Cheney to Stanford White, May 9, 1888, Stanford White Papers, New-York Histrical Society.

11. Doreen Bolger Burke, Jonathan Freedman, Alice Cooney Frelinghuysen, David A. Hanks, Marilynn Johnson, James D. Kornwolf, Catherine Lynn, Roger B. Stein, Jennifer Toher, and Catherine Hoover Voorsanger, with the assistance of Carrie Rebora, *In Pursuit of Beauty: Americans and the Aesthetic Movement*, exh. cat. (New York: Rizzoli, for the Metropolitan Museum of Art, 1986), 41, 320, 333–334; and *The American Renaissance 1876–1917*, exh. cat. (Brooklyn, N.Y.: Brooklyn Museum, 1979), 46–48.

12. The Atheneum also received this frame from the Cheney sisters. *The Days* was first offered to the Metropolitan Museum of Art but was turned down. Anne Cheney's will refers to *The Days* "owned by us and now in the dining room, together with the frame in which it is now set and the original frame by [Joseph] Wells (now stored on our premises)" (transcription of the will of Anne W. Cheney, May 25, 1944, curatorial painting file, Wadsworth Atheneum). The sisters' lawyer related the following information in 1944: "The Painting 'The Days' was bought of the artist in 1887 and the original frame was designed by Mr. Wells." Later in the letter, he states that the original frame was designed by Stanford White.

13. Anne Cheney to Stanford White, March 18, 1903, December 4, 1903, July 6, 1904, December 30, 1904, and February 6, 1905, Stanford White Papers, New-York Historical Society. My thanks to Nina Gray for these citations.

14. Anne Cheney to Stanford White, July 6, 1904, Stanford White Papers, New-York Historical Society.

166

THOMAS DEWING

Anne Cheney, 1889 or 1890

Oil on canvas; 20 × 15³/₁₆ in. (50.8 × 38.6 cm)

Signed at lower right: T. W. Dewing

Technical note: The painting surface has been flattened and damaged in a lining process.

EX COLL.: commissioned by Anne Cheney, Manchester, Conn., in about 1890; to Horace B. Learned, Avon, Conn., in 1944

Gift of Mr. Horace B. Learned, 1981.34

Anne Wells Cheney (1849–1944) and Louise Cheney (1856–1939) were the daughters of Rush Cheney and Julia Ann (Goodwin) Cheney of Manchester, Connecticut. Rush Cheney (1815–1882) was one of four brothers who developed the family textile industry in Manchester into the leading silk manufactory in America by the end of the nineteenth century. At the time of their father's death, the two sisters, who never married, moved into the family mansion in Manchester and began remodeling the house, hiring the noted architect Stanford White.[1] After acquiring Dewing's masterful painting *The Days* (cat. 165) in 1887 for their salon, the two sisters had Dewing paint their portraits.

166

Dewing's portrait of Anne Cheney is executed in muted, dark tones. Softly outlined, the figure is placed against a dark background and appears to be lost in reverie. A large flower blossom is placed at her waist, and her gloved hands hold a spray of flowers. The painting is set in a Renaissance-inspired frame designed by Stanford White. Louise was also painted by Dewing, in an oval format.

In 1889 Anne wrote to Stanford White thanking him for "the lovely frame" for her portrait but remarking, "I only wish the picture was in it, but circumstances have prevented our sitting lately and we must wait till au-

tumn."[2] The portraits were finished either in the fall of 1889 or early in the following year. EMK

1. Biographical information from the Cheney family, curatorial painting file, Wadsworth Atheneum, and Ellsworth S. Grant, "The Silken Cheneys," *Connecticut Historical Society Bulletin* 44 (July 1979), 65–79.
2. Anne Cheney to Stanford White, June 26, 1889, Stanford White Papers, New York-Historical Society. My thanks to Nina Gray for this citation.

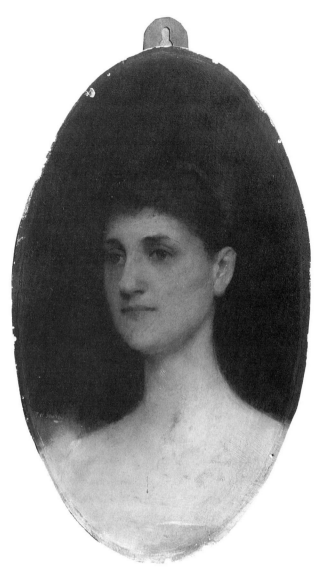

Thomas Wilmer Dewing, *Louise Cheney*, c. 1889. Private collection.

Francis Stilwell Dixon

Born in New York City, in 1879; died in New York City, in 1967

The son of James Wyllys and Frances (Stilwell) Dixon, Francis Dixon studied at the Cooper Union and the Art Students League of New York under Charles Hawthorne (q.v.), Robert Henri (q.v.), and John Twachtman (q.v.). Although he is known to have produced some portraits and still lifes, Dixon was chiefly a painter of landscapes and seascapes. He first exhibited his works in 1917 at the Society of Independent Artists; the same

year, he had a solo show at the Folsom Galleries in New York. Later he became a member of the Salmagundi Club.

During the course of his career Dixon painted in Carmel, California, and the Yosemite Valley, as well as in New England, where he focused on landscape and Maine coastal scenes. He also spent some time in Connecticut and was a member of the Connecticut Academy of the Fine Arts.

SELECT BIBLIOGRAPHY

Paintings of California by Francis Stilwell Dixon, exh. pamphlet (New York: Folsom Galleries, 1917) / *The National Cyclopedia of American Biography* (New York: James T. White, 1931), 52:364 / obituary, *New York Times*, January 7, 1967, 4

167

FRANCIS STILWELL DIXON
The Leaning Tree, 1917
Oil on canvas; 29⅞ × 36 in. (75.9 × 91.4 cm)
Signed at lower left: F. S. Dixon

EXHIBITED: New York City, Folsom Galleries, "Paintings of California by Francis Stilwell Dixon," 1917, no. 4

EX COLL.: descended to the artist's mother-in-law, Mrs. Edward W. Hooker, Hartford, in 1917

Gift of Mrs. Edward W. Hooker, 1917

An early work by Dixon, *The Leaning Tree* was painted during one of the artist's first trips to California. It is a view of the coast of Point Lobos painted in a post-impressionist style. EMK

Thomas Doughty

Born in Philadelphia, in 1793; died in New York City, in 1856

Doughty's first work in Philadelphia was as a leather currier, a career he pursued until 1820 when, after taking a night course in drawing, he turned to landscape painting as a full-time occupation. That year he was listed in the Philadelphia City directory as "Landscape

167

Painter." By 1821 he was receiving commissions for views of area estates, painting in Pennsylvania, Maryland, New York, and New England. Robert Gilmor, Jr., later one of Thomas Cole's (q.v.) patrons, was one of Doughty's early supporters, giving him access to his collection of European paintings for study and copying. By 1824 Doughty was a member of the Pennsylvania Academy. During these early years, Doughty became friends with the engraver Cephas G. Childs and Thomas Sully (q.v.), among others.

Doughty was in Boston from 1826 to 1830, exhibiting at the Boston Athenaeum and at Harding's Gallery. In 1828 he painted *A View Near Hartford, Connecticut* (Pennsylvania Academy of the Fine Arts). Around this time, engravings after Doughty's landscapes began appearing in gift books and guide books. In 1830 he returned to Philadelphia, where he and his brother published the short-lived *Cabinet of Natural History and American Rural Sports*. Hand-colored lithographs after Doughty's drawings of birds, animals, and hunting and

fishing scenes illustrated this monthly publication. Back in Boston in 1832, this time for five years, Doughty began teaching drawing and painting. Compositions from this period—his most productive and lucrative—include both realistic and fantastic landscapes, among them the well-known *In Nature's Wonderland* (1835, Detroit Institute of Arts). One still life from this period has been attributed to Doughty.

Traveling to England in 1837, the artist remained two years, painting idealized views of the English landscape. After returning to the United States, he worked in Newburgh, New York, for two years. (During this period, Nathaniel P. Willis's *American Scenery* [1840] was published; its illustrations included some by Doughty, among other American artists.) In 1841 Doughty moved back to New York City, and in 1845–1846 he went to Europe again, visiting England, Ireland, and France before returning to the United States to take up residence in Oswego, New York. Around this time, a critic wrote, "Doughty's pictures and Cole's pictures should be placed

apart from the rest, we all admit them to be our masters; Cole in one style and Doughty in another. Cole is epical, Doughty is epilogical; Cole in his later studies, is the Painter of Poetry; Doughty, in the study perpetual, is the Painter of Nature. Let us honor both" (*Knickerbocker Magazine*, October 1848). Five years later, in 1853, he stopped painting, the next year moving to New York City, where he lived in poverty until his death.

SELECT BIBLIOGRAPHY

Howard Doughty, "Life and Works of Thomas Doughty," unpublished manuscript, New-York Historical Society, New York City / William Dunlap, *History of the Rise and Progress of the Arts of Design in the United States* (1834; rpt., New York: Benjamin Blom, 1965), 3:175–176 / Henry T. Tuckerman, *Book of the Artists: American Artist Life* (New York: Putnam, 1867), 506–507 / Frederick A. Sweet, *The Hudson River School and the Early American Landscape Tradition*, exh. cat. (Chicago: Art Institute of Chicago, 1945), 35–41 / Frank H. Goodyear, Jr., *Thomas Doughty, 1793–1856: An American Pioneer in Landscape Painting*, exh. cat. (Philadelphia: Pennsylvania Academy of the Fine Arts, 1973) / Barbara Novak and Annette Blaugrund, eds., *Next to Nature: Landscape Paintings from the National Academy of Design*, exh. cat. (New York: Harper and Row, 1980), 35–37

168

THOMAS DOUGHTY

Field and Stream, 1836

Oil on canvas; 18 × 24¼ in. (45.7 × 61.6 cm)

Signed and dated at lower left, on the bank: T Doughty / 1836

EXHIBITED: New York City, American Academy of Arts and Letters, "The Great Decade in American Writing, 1850–60, with Paintings by Friends and Contemporaries of the Authors," 1954, no. 123 / Wadsworth Atheneum, "The Hudson River School: Nineteenth-Century American Landscapes in the Wadsworth Atheneum," 1976, no. 17

EX COLL.: to LeRoy Ireland by June 1946; with Vose Galleries, Boston, from June 1946 to October 1946, as "New England Landscape"; to Leroy Ireland from October 1946 to June 1948; with Vose Galleries, Boston, from June 1948 to December 1948,

168

as "Field and Stream"; purchased by the Wadsworth Atheneum in 1948

The Ella Gallup Sumner and Mary Catlin Sumner Collection Fund, 1949.1

After the failure of *The Cabinet of Natural History and American Rural Sports*, the monthly magazine Doughty and his brother edited in Philadelphia, Doughty moved to Boston and lived there from 1832 until 1837. It was near the end of this period that he painted *Field and Stream*, featuring, as many of his landscapes did, a figure of a sportsman, in this case, a hunter.

Field and Stream is typical of the landscape paintings Doughty completed during the years 1836 and 1837, when he developed an almost formulaic approach. His compositions from this time are generally Claudean in structure, with a foreground dominated by tall, feathery trees, a middle-ground body of water, and hills in the distance.[1] Most of these paintings are of Catskill scenery, but in a 1948 letter from Vose Galleries to the Atheneum, the painting was called "New England Landscape."[2] During this period, Doughty made sketching trips along the coasts of Massachusetts and Maine as well as to the White Mountains in New Hampshire and into the Catskills, and it is possible that the landscape is a composite of observations from one or more of these trips.[3]

As in many of the other paintings Doughty made at this time, the placement of the human figure in *Field and Stream* emphasizes human insignificance in the face of nature. In the Atheneum's work, however, the horizontal of the terrain in *Field and Stream*, although vast, is less diminishing than in those compositions including mountains.[4]

The manner in which Doughty lined up elements in the landscape leads the viewer's eye toward the horizon. The diagonal line of broken branches or truncated saplings interspersed with rocks in the middle of the stream and the dead tree trunk in the right foreground are in keeping with the conventions of picturesque composition. AE

1. Frank H. Goodyear, Jr., *Thomas Doughty, 1793–1856: An American Pioneer in Landscape Painting*, exh. cat. (Philadelphia: Pennsylvania Academy of the Fine Arts, 1973), 27.
2. Robert C. Vose Galleries, Boston, to the Wadsworth Atheneum, September 1948, letter and invoice, curatorial painting file, Wadsworth Atheneum.
3. Goodyear, *Thomas Doughty*, 17.
4. See Barbara Novak, *Nature and Culture: American Landscape and Painting, 1825–1875* (New York: Oxford University Press, 1980), 184–200, for a discussion of the figure in the landscape.

Arthur Dove

Born in Canandaigua, N.Y., in 1880; died in Centerport, N.Y., in 1946

Arthur Garfield Dove was a landscape painter who identified with nature in a poetic way, celebrating the American landscape as did such earlier American artists as Thomas Cole (q.v.). The two major elements of his art are nature imagery and abstract form. As an artist, Dove felt connected to the tradition of American painting, while at the same time he responded to the most advanced twentieth-century ideas in art, making him a pioneer modernist. As an important individualist in the development of abstract art in America, Dove was a prominent member of the circle of modern American artists known as the "Seven Americans" who were promoted by the photographer and art dealer Alfred Stieglitz. The others included John Marin, Georgia O'Keeffe (q.v.), Charles Demuth, and Marsden Hartley (q.v.), as well as two photographers, Paul Strand and Stieglitz himself.

Dove was raised in Geneva, New York, and graduated from Cornell University in 1903. Although his family wished him to pursue a career in law, Dove developed an interest in art. He moved to New York City where he worked as a magazine illustrator for *Collier's*, *Scribner's*, and the *Saturday Evening Post*. By 1907 he had earned enough money to finance a trip to Europe, where he spent two years, mainly in Paris. There he associated with other American artists, including Alfred Maurer, Arthur Carles (q.v.), Patrick Henry Bruce, and Max Weber (q.v.) and exhibited his works at the Salon

exhibitions. Through these contacts, he became conversant with modernism and experimented with the heightened palette of postimpressionism and fauvism.

On his return, Dove settled in Westport, Connecticut, and had his first important showing when Stieglitz included his paintings in the 1910 show *Younger American Painters* at his "291" gallery. (At this time, the two men began a lifelong friendship, of which an extensive correspondence survives.) In about 1910 Dove executed small abstract sketches derived from landscape motifs that are among the earliest abstractions by an American artist. He began creating abstract pastels in 1912, and in the 1920s he produced assemblages, such as *Goin' Fishin'* (1925, Phillips Collection, Washington, D.C.), composed of cut-up denim overalls and pieces of a fishing pole.

After leaving his first wife, Dove moved to Huntington, Long Island, in 1924 where he lived with the artist Helen "Reds" Torr, whom he eventually married. The couple lived on a boat docked in the harbor, and Dove would draw inspiration from the sea for his works of this period, for example, *Fog Horns* (1929, Colorado Springs Fine Arts Center, Colorado).

Dove experienced periods of extreme poverty throughout his career. With the help of Stieglitz, who continued to exhibit his work, and financial support beginning in the 1930s from the major collector Duncan Phillips, Dove managed to sustain himself and continued painting. Following the death of his mother in 1933, he moved to Geneva, New York, in order to settle the affairs of his family, his five difficult years there resulting in some of his most powerful works, including *Approaching Snow Storm*.

Dove returned to Long Island in 1938, moving into a small house in Centerport, where he spent the remainder of his life. He continued to produce important paintings and watercolors despite failing health. Toward the end of his life, he received substantial recognition for his work as a result of a 1940 exhibition at Stieglitz's gallery. Following the deaths of Stieglitz and Dove in 1946, Edith Gregor Halpert continued to promote Dove's work at her Downtown Gallery and brought the artist the recognition he deserved. His reputation has contin-

ued to grow, and he is now widely regarded as one of the greatest American artists of the twentieth century.

SELECT BIBLIOGRAPHY

Duncan Phillips, "Arthur Dove, 1880–1946," *Magazine of Art* 40 (May 1947), 192–197 / Alan Solomon, *Arthur G. Dove*, exh. cat. (Ithaca, N.Y.: Andrew D. White Museum of Art, Cornell University, 1954) / Frederick S. Wright, *Arthur G. Dove* (Los Angeles: University of California Press, 1958) / Barbara Haskell, *Arthur Dove*, exh. cat. (San Francisco: San Francisco Museum of Art, 1974) / Sasha M. Newman, *Arthur Dove and Duncan Phillips: Artist and Patron* (Washington, D.C.: Phillips Collection, 1981) / Sherrye Cohn, *Arthur Dove: Nature as Symbol* (Ph.D. diss., University of Washington, 1982; Ann Arbor: University Microfilm International, 1982) / Ann Lee Morgan, *Arthur Dove: Life and Work, with a Catalogue Raisonné* (Newark: University of Delaware Press, 1984) / Ann Lee Morgan, ed., *Dear Stieglitz, Dear Dove* (Newark: University of Delaware Press, 1988) / Donna M. Cassidy, "Arthur Dove's Music Paintings of the Jazz Age," *American Art Journal* 20, no. 1 (1988), 4–24 / Anne Cohen Depietro, with Ann Lee Morgan, William C. Dove, and Mary Torr Rehm, *Arthur Dove and Helen Torr: The Huntington Years*, exh. cat. (Huntington, N.Y.: Heckscher Museum, 1989)

169 (see plate 51)

ARTHUR DOVE

Approaching Snow Storm, 1934
Signed at lower center: Dove
Oil on canvas; 25¼ × 31½ in. (64.1 × 80.0 cm)

EXHIBITED: New York City, "An American Place," 1934, as "Approaching Snow Storm" / New York City, Terry Dintenfass Gallery, "Stieglitz: A Memoir/Biography," 1983

EX COLL.: held by Edith Gregor Halpert and the Downtown Gallery, shortly after the artist's death in 1946; selected by the artist's son, William Dove, Mattituck, N.Y., from his father's estate; acquired from William Dove via the Terry Dintenfass Gallery, New York City, by the Wadsworth Atheneum in 1992

In memory of Henry T. Kneeland, by exchange, and The Ella Gallup Sumner and Mary Catlin Sumner Collection Fund, 1992.29

Approaching Snow Storm was painted during Dove's years in Geneva, New York, from 1933 to 1938, with his second wife, the artist Helen "Reds" Torr. His subjects at this time were drawn from his direct experiences of the rustic farm where he lived and from the lush, rolling countryside of the Finger Lakes region. Dove and his wife were isolated in this provincial region, living in a drafty farmhouse without central heating and lacking the money to travel to New York City, with the exception of one trip during their entire five-year stay.[1]

In the works from this period, one sees a rich interplay of nature imagery and abstract design. Shapes are drawn from the organic world; colors are warm and earthy. Dove was a superb colorist—he mixed his colors himself—and his works demonstrate his sense of the emotive qualities of color. In this instance, Dove used a limited range of hues to express his subject. With earth tones of burnt sienna, raw umber, gray, and white and areas of various shades of green and a mixture of green and alizarin, Dove created boldly brushed, solid forms that evoke the wind and chill of the upstate New York landscape during a snowstorm.

Painted during the brutal winter of 1934, *Approaching Snow Storm* was one of several new paintings that Dove was diligently working on in preparation for the show to be held at Stieglitz's gallery, An American Place, in the spring. He labored that winter in what he described to Stieglitz as "self-imposed isolation," writing his friend in February, "This is like living in exile. . . . Finished one of the best oils I have done yesterday, and beginning to feel better about this cloudy country. The fogs from the Great Lakes keep it dark all winter."[2] The show opened in April, as Stieglitz announced to Dove: "Your Show is up. Hung today.—There are 8 new oils— 10 new watercolors hung. . . . I had strips put around your new oils. And painted them with aluminum bronze. Look right."[3] The show received critical acclaim in a number of reviews, including a lengthy article by Elizabeth McCausland, in which she addressed the question posed in her title—"What Constitutes His Truly Native Quality?"—with the reply: "Dove sees life as an epic drama, a great Nature myth. . . . He has an appreciation of the wonder and the mystery of color, the subtle and mystic relations of intimate tones. He has in fact what any number of contemporary artists, American or European, otherwise do not have, a deep individual quality and expression." Of the new paintings in the show, she wrote:

> These canvases are transcriptions or remembrances of experience translated into designs which somewhat resemble the natural objects from which they are taken but which have taken on, also, a higher order and organization than the accidents of Nature permit.
>
> "Tree," "Tree Trunks," "Approaching Snow Storm," particularly illustrate this point. If one were to look only at the oils, one would experience them chiefly as abstract entities, color and form and volume and rhythm interrelated and integrated to produce a deep esthetic effect. The value of seeing the slight watercolors from which they have evolved is that one gains a deeper knowledge into the intricacies of the creative process.[4]

Dove's watercolor studies were indeed an integral part of his creative process and reveal much about his thinking. In an existing watercolor study for *Approaching Snow Storm*, earth tones of brown and green are

Arthur Dove, *Approaching Snow Storm*, 1934. Terry Dintenfass, Inc. Photograph: Eeva-Inkeri.

employed to capture the wintry effects of wind and snow against trees. The subtle tones and forms that are lightly brushed in become deeper and more solid in the finished oil.

In the spring of 1935, the artist's son, William, returned home from Europe; he would spend the summer in Geneva with the artist and his wife. William later selected this painting as the only work by his father that he chose to keep, feeling it was one of his father's most powerful works.[5] EMK

1. Ann Lee Morgan, ed., *Dear Stieglitz, Dear Dove* (Newark: University of Delaware Press, 1988), 281.
2. Arthur Dove to Alfred Stieglitz, February 2, 1934, reproduced in Morgan, *Dear Stieglitz*, 295.
3. Alfred Stieglitz to Arthur Dove, April 16, 1934, reproduced in ibid., 304.
4. Elizabeth McCausland, "Dove's Oils, Water Colors Now At An American Place," *Springfield Sunday Union and Republican*, April 22, 1934, 1.
5. William Dove says that when he saw *Approaching Snow Storm* he felt it was "a whopper of a painting" and that it held great sentiment for him, bringing back memories of the time he spent with his father in Geneva (telephone interview with William Dove by Elizabeth Kornhauser, December 16, 1992). Bill Dove chose the painting from a number of works in his father's estate housed at Edith Gregor Halpert's Downtown Gallery.

Dorothea Dreier

Born in Brooklyn, N.Y., in 1870; died in Saranac, N.Y., in 1923

Dorothea A. Dreier, the elder sister of Katherine Dreier (1877–1952), the founder of the Société Anonyme, received her earliest training in art at the National Academy of Design in New York City, where she studied under William Merritt Chase (q.v.) and John H. Twachtman (q.v.). However, it was Walter Shirlaw (q.v.), with whom both Dreier sisters studied, who had the strongest early influence on their art. With her sister, Dorothea spent much of the first two decades of the twentieth century in Europe, where she studied the work of the old masters, as well as that of the European avant-garde. She was particularly drawn to Holland,

and Dutch peasant life became a favorite subject for her work. Later, Dorothea turned to painting realistic scenes of New York City.

In 1914, with her better-known sister, Katherine, Dorothea founded the Cooperative Mural Workshops in New York City. Dorothea's works were frequently included by her sister in the numerous Société Anonyme exhibitions, among them, seven one-artist shows, most of which were held after 1923, when the artist died of tuberculosis.

SELECT BIBLIOGRAPHY

"Brooklyn Museum to Hold Memorial Show for Dorothea Dreier," *Art News* 23 (April 11, 1925), 1 / Wadsworth Atheneum, *Impressionism to Abstraction: Thirteen Women Painters*, exh. cat. (Hartford: Wadsworth Atheneum, 1934) / Theodore E. Stebbins, Jr., and Galina Gorokhoff, *A Checklist of American Paintings at Yale University* (New Haven: Yale University Press, 1982) / Robert L. Herbert, Eleanor S. Apter, and Elise K. Kenney, eds., *The Société Anonyme and the Dreier Bequest at Yale University: A Catalogue Raisonné* (New Haven and London: Yale University Press, 1984), 206–209

170

DOROTHEA A. DREIER
Dutch Spinner, Winding the Wool, c. 1908
Oil on canvas; $17^{7}/_{16} \times 19^{5}/_{8}$ in. (44.3 × 49.8 cm)

EXHIBITED: Wadsworth Atheneum, "Impressionism to Abstraction: Thirteen Women Painters," 1934

EX COLL.: descended in the Dreier family to the sister of the artist, Katherine S. Dreier, West Redding, Connecticut, by 1936

Gift of Miss Katherine S. Dreier, 1936.7

In 1908 Dorothea Dreier was in Laren, Holland, where she may have painted this work and a related painting in the collection of Yale University (*The Spinner*, c. 1908). Brought up in a family that was committed to the American working poor, Dreier empathized and was inspired by the Dutch peasants, whose worn faces

170

and tedious daily life held a strength and beauty for
her.[1] She was also undoubtedly influenced by Vincent
van Gogh's moving peasant studies. Her realistic and un-
idealized treatment of the figure of a Dutch peasant
woman spinning may well be related to van Gogh's
Woman Spinning (1885, Rijksmuseum Vincent van
Gogh, Amsterdam), painted in Neunen, near Laren.[2]

The donor of this painting to the Wadsworth Ath-
eneum was Dorothea's sister, Katherine Sophie Dreier
(1877–1952). Katherine, like others of the Dreier family,
was devoted to social causes and liberal reform.[3] In an
essay written in 1921, she compared Dorothea's empa-
thy to that of van Gogh and Walt Whitman, writing,
"[Dorothea] is a grim realist—like [van Gogh and Whit-
man] she has an understanding of the toilers of this
earth."[4] AE

1. Robert L. Herbert, Eleanor S. Apter, and Elise K. Kenney,
 eds., *The Société Anonyme and the Dreier Bequest at Yale
 University: A Catalogue Raisonné* (New Haven and London:
 Yale University Press, 1984), 206–207.
2. Herbert et al., *The Société Anonyme*, 207. See also Ingo F.
 Walther and Rainer Metzger, *Vincent van Gogh: Sämtliche
 Gemälde* (Cologne, Germany: Benedikt Taschen Verlag,
 1989), 1:81.
3. Herbert et al., *The Société Anonyme*, 210–212.
4. Katherine S. Dreier, *Dorothea A. Dreier* (New York, 1921),
 quoted in Herbert et al., *The Société Anonyme*, 207.

Guy Pène du Bois

Born in Brooklyn, N.Y., in 1884; died in Boston, in 1958

Painter, writer, and critic Guy Pène du Bois studied
at the New York School of Art under James Carroll
Beckwith (q.v.), William Merritt Chase (q.v.), Frank
Vincent DuMond, Robert Henri (q.v.), and Kenneth
Hayes Miller (q.v.) from 1899 to 1905. He made his first
trip to Europe in 1905 and the following year exhibited
at the Salon des Beaux Arts. That same year he re-
turned to America and accepted a position as reporter
and then as art critic for the *New York American*. Later
he worked as an assistant to Royal Cortissoz on the *New
York Tribune* and as a critic for the *New York Evening
Post*.

After du Bois's second trip to Europe from 1924 to
1930, he devoted most of his time to painting. He be-
came a member of the New Society of Artists and an
associate of the National Academy of Design and re-
ceived prizes from the First Pan-American Exposition in
1925, the Art Institute of Chicago in 1930, the National
Academy of Design in 1936, and the Corcoran Biennial
Exhibition in 1937.

Du Bois is the author of numerous articles and mono-
graphs on American artists, including William J. Glackens
(q.v.), Edward Hopper, George B. Luks (q.v.), John
Sloan (q.v.), and Ernest Lawson (q.v.).

SELECT BIBLIOGRAPHY

Richard Carl Medford, *Guy Pène du Bois*, exh. cat. (Hagers-
town, Maryland: Washington County Museum of Fine Arts,
1940) / College Art Association, *The Index of Twentieth Cen-
tury Artists, 1933–1937* (New York: Arno Press, 1970)

171

GUY PÈNE DU BOIS
Conversation, 1942
Oil on composition board; 13⁵/₁₆ × 9⁵/₈ in. (33.8 × 24.4 cm)
Signed and dated at lower left: Guy Pène du Bois 42

EXHIBITED: Wilkes-Barre, Pa., Sardoni Art Gallery, Wilkes
College, "Students of the Eight," 1981

171

EX COLL.: with the Kraushaar Art Galleries, New York City; with Louis Joseph Auction House, Boston; Charles D. Childs, Boston, to 1948

The Ella Gallup Sumner and Mary Catlin Sumner Collection Fund, 1948.117

While a student at the New York School of Art, du Bois was influenced by Robert Henri (q.v.) who believed that an artist's subject matter should be found in real life. Throughout his career du Bois embraced realism over aestheticism in his depiction of the characters that surrounded him—the dowager, the professional, the flapper, the corpulent, and the nouveau riche. He im-

bued his images with satire but avoided heavy commentary on social inequity.

Following his second trip to Europe in 1930, du Bois softened the edges of his subjects, which appear as wooden figures suspended in space. In *Conversation* he depicts two artists, Hendrik William Van Loom and Charles Dana Gibson, in conversation at the clubhouse of the American Academy of Arts and Letters on Riverside Drive in New York City. According to the artist, the scene took place the day that he became a member of the academy.[1] Du Bois uses a limited palette of grays, browns, and white in portraying the two artists, who were engaged, according to du Bois, in "matters of no importance."[2] His brushstroke is soft, particularly in the legs of the figures. Du Bois's use of two colleagues as subject matter reflects his whimsical nature.　ERM

1. Guy Pène du Bois to Mrs. Neuberger, Dorset, Vermont, June 22, 1948, artist file, Wadsworth Atheneum.
2. Ibid.

Robert S. Duncanson

Born in Seneca County, N.Y., in 1821; died in Detroit, in 1872

Robert Scott Duncanson was born in New York State to a racially mixed couple: his mother was a free woman of color and his father, a Canadian of Scottish descent. His childhood was most likely spent in eastern Canada, where his parents would have found an environment less racist than the United States. By 1842, however, Duncanson was living near Cincinnati, Ohio, where he would spend much of his working life. It was there that he met his most important early patron, Nicholas Longworth, who would commission from Duncanson a series of murals for his Cincinnati home Belmont (now the Taft Museum). Duncanson painted a total of twelve panels for the Longworth home, the largest measuring 6½ by 9 feet (2.0 × 2.7 m). The subject matter of the murals reveal Duncanson's versatility: there are four vignettes of still-life compositions, as well as one of an eagle and larger landscape compositions. Duncanson completed the murals some time around 1849 or 1850.

In the forties and fifties, Duncanson was a daguerreotypist, and, in the fifties, he worked with James P. Ball, an African-American who owned a large gallery devoted to this early form of photography. The artist also executed oil paintings after daguerreotypes for display in Ball's gallery. In view of Duncanson's experience as a daguerreotypist, one would expect his landscape paintings to be accurate, detailed representations of actual landscapes, and some of his paintings do reflect this—for example, his *View of Cincinnati, Ohio, from Covington, Kentucky* (c. 1851, The Cincinnati Historical Society), which is said to have been painted after a daguerreotype. However, other works from the same period, such as the Belmont murals, indicate a more romantic sensibility.

Despite a longstanding involvement with the movement to abolish slavery in the United States, Duncanson's connection to white society—and his reliance (although not exclusive) on white patronage—caused some dissatisfaction in the African-American community and among his own family members, who felt he had betrayed a part of his heritage. Even so, throughout the 1840s and 1850s, Duncanson painted a number of portraits in Detroit and Cincinnati, many of abolitionists, and in 1853 he was commissioned by Rev. James Francis Conover, editor of the *Detroit Tribune*, to paint a scene from Harriet Beecher Stowe's novel *Uncle Tom's Cabin*, which had been published the previous year. The painting, *Uncle Tom and Little Eva* (1853, Detroit Institute of Arts), is possibly the only painting by Duncanson in which an African-American figure is central to the composition. It is conceivable that Duncanson knew Stowe, who in 1832 moved with the Beecher family from Hartford to Cincinnati, where her father, Lyman, became the first president of Lane Seminary.

He visited Europe for the first time in 1853, traveling with fellow artists William L. Sonntag and John Robinson Tait to England, France, and Italy, where he saw the paintings of J. M. W. Turner and Claude Lorrain, among others. When he returned to the United States in 1854, he began painting landscapes, many of which compare stylistically to the work of Thomas Cole (q.v.) and Frederic Church (q.v.). As early as 1847,

a painting by Cole was exhibited at the Western Art Union in Cincinnati; at the same venue, the *Arch of Nero* (1846, Newark Museum, Newark, N.J.) was on view in 1849, and *Night Scene* was shown in 1850. In 1852 *Landscape* was exhibited in Detroit at the Fireman's Hall.

The years 1863 to 1865 Duncanson spent in Montreal (probably to avoid the American Civil War), where in 1863 commercial photographer William Notman (1826–1891) held Duncanson's first recorded Montreal exhibition. For an admission fee, the public could gain entry into Notman's studio, there to view works by Duncanson such as *Land of the Lotos Eaters* (1861, H.R.H., the King of Sweden) and *City and Harbour of Quebec* (1863, unlocated). These two paintings represent the poles of Duncanson's subject matter during his Montreal period: fantastic landscapes inspired by literary works—*Land of the Lotos Eaters*, for example, was probably inspired by an 1832 poem by Alfred, Lord Tennyson, "The Lotos-Eaters"—and realistic scenes of the Canadian landscape. Here again he recalls Cole, an early experimenter in both ideal and real landscapes, and Church, with whose *Heart of the Andes* (1859, Metropolitan Museum of Art) *Land of the Lotos Eaters* was compared (*Cincinnati Gazette*, May 30, 1861, 2, col. 5).

Duncanson returned to Europe in 1865, staying primarily in England and Scotland, and again in 1870–1871, when he revisited Scotland. His later paintings reflect these trips; many are Scottish landscapes. He also continued to paint scenes from the poetry and prose of such British authors as Tennyson, Thomas More, and Sir Walter Scott.

Duncanson died at around age fifty at the Michigan State Retreat, after three months of treatment for mental illness. The cause of his death is unknown.

SELECT BIBLIOGRAPHY

James A. Porter, *Robert S. Duncanson: Midwestern Romantic-Realist*, *Art in America* (special issue) 39 (October 1951) / Guy McElroy, *Robert S. Duncanson: A Centennial Exhibition*, exh. cat. (Cincinnati: Cincinnati Art Museum, 1972) / Joseph D. Ketner II, "Robert S. Duncanson (1821–1872): The Late Literary Landscape Paintings," *American Art Journal* 15, no. 1 (1983), 35–47 / Allan Pringle, "Robert S. Duncanson in Montreal, 1863–1865," *American Art Journal* 17, no. 4 (1985), 28–50 / David C. Driskell, *Hidden Heritage: Afro-American Art, 1800–1950*, exh. cat. (Bellevue, Wash.: Bellevue Art Museum, 1985) / Lynda Roscoe Hartigan, *Sharing Traditions: Five Black Artists in Nineteenth-Century America*, exh. cat. (Washington, D.C.: National Museum of American Art, 1985) / John W. Coffey, *Twilight of Arcadia: American Landscape Painters in Rome*, exh. cat. (Brunswick, Maine: Bowdoin College Museum of Art, 1987) / Joseph D. Ketner II, "Robert S. Duncanson (1821–1872)," in *Artists of Michigan from the Nineteenth Century*, exh. cat., ed. J. Gray Sweeney (Muskegon and Detroit, Mich.: Muskegon Museum of Art and Detroit Historical Museum, 1987), 62–67 / Theodore E. Stebbins, Jr., with William H. Gerdts, Erica E. Hirshler, Fred S. Licht, and William L. Vance, *The Lure of Italy: American Artists and the Italian Experience, 1760–1914*, exh. cat. (New York: Abrams, in association with the Boston Museum of Fine Arts, 1992), 186–188 / Joseph D. Ketner, *The Emergence of the African-American Artist: Robert S. Duncanson, 1821–1872* (Columbia: University of Missouri Press, 1993)

172 (see plate 52)

ROBERT S. DUNCANSON
Recollections of Italy, 1864
Oil on canvas; 20½ × 39 in. (52.1 × 99.1 cm)
Signed and dated at lower left: RS.
 Duncanson. / Montreal. 1864
Signed and dated at bottom center: R.S.
 Duncanson / 1864.

EXHIBITED: Boston, Museum of Fine Arts, "The Lure of Italy," 1992, no. 17

EX COLL.: E. Thomas Williams, Jr., New York City, by 1991

The Dorothy C. Archibald and Thomas L. Archibald Fund and a fractional gift of E. Thomas Williams, Jr., and Auldlyn Higgins Williams, 1991.81

Duncanson, though an artist of great versatility, was perhaps best known as a landscape painter. In 1864, when *Recollections of Italy* was painted, the artist was in Montreal, where he painted mostly so-called literary landscapes and Canadian scenery.[1] The Atheneum's painting represents another type of landscape that Duncanson painted throughout his career: the imaginary

landscape. The fundamental composition of *Recollections of Italy* is Claudean: a coulisse (here, a body of water) flanked by two banks, the familiar Claudean clump of trees at the left and a picturesque ruin at the right. A stream snaking toward the viewer acts as a repoussoir, leading the eye into the painting to the lake and finally to the distant mountain. This composition method was commonly used by Thomas Cole (e.g., cat. 127, *View on Lake Winnipiseogee*) and Frederic Church (e.g., cat. 111, *Hooker and Company Journeying through the Wilderness from Plymouth to Hartford, in 1636*), as well as by other artists of the Hudson River school.

Considerably influenced by the work of the Hudson River painters, especially Cole's Arcadian scenes, Duncanson shared their fascination with the ruins of classical Italy. At the right in the Atheneum's painting are the ruins of the Temple of Vesta (or the Temple of the Sibyl) at Tivoli.[2] This temple recurs in at least two other paintings, one of which, *Landscape with Classical Ruins (Temple of Sibilla)* (1859, private collection), compares readily with the Atheneum's *Recollections of Italy*. As Guy McElroy notes, "Duncanson had been 'executing beautiful Italian compositions' from sketches he had made while in Europe. In these works . . . [Duncanson] 'gives extra-ordinary promise.'"[3]

In 1854, after his return from Italy, Duncanson painted an untitled work (now known as *Classical Landscape with Ruins* [*Recollections of Italy*], Howard University Gallery of Art, Washington, D.C.). In 1951 James Porter, suggesting that this painting may have been shown in an 1872 exhibition in Detroit under the title "Recollections of Italy," calls it "a memory painting of classical ruins" and writes, "the very title of the work suggests that it is a composite picture of such ruins as one finds at Tivoli or on the Roman Campagna or in Sicily." The same might be said of the Atheneum's version.[4]

The Atheneum's Duncanson is similar to paintings by William Sonntag from the period after his return from Italy, in particular, such works as *Classic Italian Landscape with Temple of Venus* (n.d., Corcoran Gallery of Art, Washington, D.C.) and *Italian Lake with Classical Ruins* (1858, Dartmouth College Museum and Galleries). In the early 1850s Sonntag was generally thought of as Cincinnati's most important landscape painter. Joseph Ketner has suggested that Duncanson assimilated Cole's influence indirectly through Sonntag.[5]

Duncanson's signature on the sunken capital at the bottom center of *Recollections of Italy* can be compared with Cole's signature on the Atheneum's *Roman Campagna* (cat. 133), which appears on a capital embedded in the earth at a similar angle. Also of interest is the presence of two signatures on the canvas: the one on the capital, and another at the lower left-hand corner of the painting. The latter signature appears unquestionably to be Duncanson's own, since it shows the leftward slant characteristic of this left-handed artist's writing; however, except for the fact that it does not tilt to the left, nothing suggests that the other signature is not authentic.[6] AE

1. For a complete discussion of the works inspired by literary themes, see Joseph D. Ketner II, "Robert S. Duncanson (1821–1871): The Late Literary Landscape Paintings," *American Art Journal* 15, no. 1 (1983), 35–47. For a detailed account of Duncanson's years in Canada and the influence of Canadian artists on his work, see Allan Pringle, "Robert S. Duncanson in Montreal, 1863–1865," *American Art Journal* 17, no. 4 (1985), 28–50.

2. See K. Quinn's entry on the Atheneum's painting in Theodore E. Stebbins, Jr., with William H. Gerdts, Erica E. Hirshler, Fred S. Licht, and William L. Vance, *The Lure of Italy: American Artists and the Italian Experience, 1760–1914*, exh. cat. (New York: Abrams, in association with Museum of Fine Arts, Boston, 1992), 186–188.

3. Guy McElroy, *Robert S. Duncanson: A Centennial Exhibition*, exh. cat. (Cincinnati: Cincinnati Art Museum, 1972), 12–13. McElroy is quoting from a letter written by the American miniaturist William Miller, a friend of Duncanson, to Isaac Strohm. No other information is provided.

4. James A. Porter, *Robert S. Duncanson: Midwestern Romantic-Realist*, *Art in America* (special issue) 39 (October 1951), 130–131.

5. Joseph D. Ketner II, "Robert S. Duncanson (1821–1872)," in *Artists of Michigan from the Nineteenth Century*, exh. cat., ed. J. Gray Sweeney (Muskegon and Detroit, Mich.: Muskegon Museum of Art and Detroit Historical Museum, 1987), 64.

6. James Dallas Parks, *Robert S. Duncanson: Nineteenth Century Black Romantic Painter* (Washington, D.C.: Associated Publishers, 1980), ix.

Asher Brown Durand

Born in Jefferson Village (now Maplewood), N.J., in 1796; died in Jefferson Village, N.J., in 1886

Best known as an influential member of the Hudson River school, Durand was trained as an engraver, not a painter. He began this first career as an apprentice to Peter Maverick in 1812, remaining in that position until 1817, when Maverick made him a partner. The partnership lasted only three years, however: in 1820 Durand accepted a commission to engrave John Trumbull's (q.v.) *Declaration of Independence* without first consulting Maverick. The commission, completed in 1823, cost Durand his job, but it also established him as one of the country's premier engravers. At Daniel Wadsworth's death, a copy of the engraving hung in the dining room at Monte Video (see Introduction).

Durand helped organize the New-York Drawing Association (later the National Academy of Design) in 1825 and the Sketch Club (later the Century Club) in 1829. Soon after, in the early 1830s, he began painting portraits, genre scenes, and a few landscapes. In 1835, with the encouragement of Luman Reed—an important patron of Durand and other American artists—Durand gave up engraving and turned all his attention to oil painting. By 1838, after a trip to the Adirondacks in 1837 with Thomas Cole (q.v.) and Cole's wife, Maria Bartow, Durand was specializing in landscapes, and by 1845, the year he was elected president of the National Academy of Design, he was sending landscapes almost exclusively to the exhibitions.

In 1840 another patron, Jonathan Sturges, made it possible for Durand to visit Europe, where he traveled with John W. Casilear (q.v.), John F. Kensett (q.v.), and Thomas P. Rossiter (1818–1871). While abroad, Durand studied landscapes by Claude Lorrain and John Constable, as well as the work of Dutch painters such as Aelbert Cuyp. He returned to the United States in 1841 to paint a number of large landscapes that reflected some of the influence of the European painters he had studied, combined with that of Cole. After Cole's death in 1848, Durand was considered the leading landscape painter in America.

Durand published nine "Letters on Landscape Painting" in 1855 in the *Crayon*, which was coedited by his son John. These essays advised painting directly from nature and recording it realistically.

In 1869, at age seventy-six or seventy-seven, Durand left New York City and retired to his hometown of Maplewood, New Jersey.

SELECT BIBLIOGRAPHY

Artist file: Asher B. Durand, American Wing, Metropolitan Museum of Art / William Dunlap, *A History of the Rise and Progress of the Arts of Design in the United States* (1834; rpt., New York: Dover, 1969), 285–289 / Henry T. Tuckerman, *Book of the Artists: American Artist Life* (New York: Putnam, 1867), 187–196 / John Durand, *The Life and Times of A. B. Durand* (New York: Scribner's, 1894) / Frederick A. Sweet, *The Hudson River School and the Early American Landscape Tradition*, exh. cat. (New York: Whitney Museum of American Art, 1945), 43–48 / David B. Lawall, *A. B. Durand, 1796–1886*, exh. cat. (Montclair, N.J.: Montclair Art Museum, 1971) / David B. Lawall, *Asher Brown Durand: His Art and Art Theory in Relation to His Times* (New York and London: Garland, 1977) / David B. Lawall, *Asher B. Durand: A Documentary Catalogue of the Narrative and Landscape Paintings* (New York and London: Garland, 1978) / James Thomas Flexner, *Asher B. Durand: An Engraver's and a Farmer's Art*, exh. cat. (Yonkers, N.Y.: Hudson River Museum, 1983) / Linda S. Ferber and William H. Gerdts, *The New Path: Ruskin and the American Pre-Raphaelites*, exh. cat. (New York: Schocken Books, for the Brooklyn Museum, 1985)

173

ASHER B. DURAND
Self-Portrait (after Rembrandt), 1840
Oil on composition board; $21^5/_8 \times 18$ in. (54.9 × 45.7 cm)
Inscribed on reverse: Copy From / Rembrandt / by
 A. B. Durand / Florence Nov. 6 1840
Inscribed on frame: Wil S. Conely / Carver & Gilder /
 plain and ornamental / Framer / Essex St. New
 York

EX COLL.: possibly Jonathan Sturges, New York City, 1840 to 1874; to his son, Frederick Sturges II, Fairfield, Conn., until

173

for Europe in 1840, Sturges commissioned a number of copies to help the artist pay for his trip.[2]

In 1867 Henry Tuckerman wrote that "a fine copy" by Durand of a self-portrait by Rembrandt was in the collection of Jonathan Sturges of New York City.[3] As the frame for the Atheneum's painting was made by a New York framer, it seems likely that the painting was bought by the Sturges family not long after its completion in 1840 and remained in the family until Frederick Sturges III, Jonathan's grandson, donated the work to the Atheneum. AE

1. David B. Lawall, *Asher Brown Durand: His Art and Art Theory in Relation to His Times* (New York and London: Garland, 1977), 735.
2. H. Nichols B. Clark points out that "Sturges also bought copies for their own aesthetic merit" ("A Taste for the Netherlands: The Impact of Seventeenth-Century Dutch and Flemish Genre Painting on American Art, 1800–1860," *American Art Journal* 14, no. 2 [1982], 28–29).

 Jonathan Sturges was the business partner of one of Thomas Cole's (q.v.) important patrons, Luman Reed. Reed commissioned Durand, Cole, Washington Allston's (q.v.) nephew, George Washington Flagg, and William Sidney Mount to paint a series of door panels for his home. See Ella M. Foshay, *Mr. Luman Reed's Picture Gallery: A Pioneer Collection of American Art* (New York: Abrams, in association with the New-York Historical Society, 1990), 25, 119–120. Three of the panels by Cole are in the collection of the Wadsworth Atheneum (cats. 128–130).
3. Henry T. Tuckerman, *Book of the Artists: American Artist Life* (New York: Putnam, 1867), 195.

his death in 1977; to his son, Frederick Sturges III, Old Lyme, Conn., in 1978

Gift of Mr. and Mrs. Frederick Sturges III, 1979.170

Rembrandt probably painted the original self-portrait in the mid-1660s. His work, oil on canvas and measuring 33½ by 24 inches (85.1 × 61.0 cm), hangs in the Uffizi in Florence, Italy, today, as it did as early as 1686 and in the mid-nineteenth century, when Durand saw it. Durand was in Florence in November of 1840, when he made this painting. Many copies of Rembrandt's original by other artists are also known.[1]

Artists often made copies in order to master technical problems, and copies were a reliable source of income. In a world of unscrupulous dealers who sometimes made false attributions to gain sales, many collectors circumvented the risk of being cheated by decorating their homes with copies. Jonathan Sturges—grandfather of the donor of the Atheneum's painting—was among these, but he also bought copies as a way of offering financial support to an artist, and before Durand departed

174 (see plate 53)

ASHER B. DURAND

View toward the Hudson Valley, 1851

Oil on canvas; 33⅛ × 48⅛ in. (84.1 × 122.2 cm)

Signed and dated at lower left, on rock: A. B. Durand 1851

Technical note: There is damage along the top edge of painting and in the central section of sky; at right, there is an L-shaped tear. The painting has been repainted, unevenly cleaned; it is yellowed, with uneven varnish.

EXHIBITED: possibly New York City, National Academy of Design, 1853, no. 39, as "Landscape, View on the Hudson" / Montclair, N.J., Montclair Art Museum, "A. B. Durand, 1796–1886," 1971, no. 65 / Wadsworth Atheneum, "The Hudson River School: Nineteenth-Century American Landscapes in the Wadsworth Atheneum," 1976, no. 30 / Paris, Galeries Lafayette, "Deux Cents Ans de Peinture Américaine: Collection du Musée Wadsworth Atheneum," 1989

EX COLL.: Franklin Murphy, governor of New Jersey, to 1936; American Art Association, Anderson Galleries, New York City, Public Sale, January 23, 1936, no. 95; private collection, New York City, by 1947; sold as no. 65 in "Old Masters and Nineteenth Century Paintings," Parke-Bernet Gallery, May 8, 1947; with M. Knoedler and Co., New York City, to 1948

The Ella Gallup Sumner and Mary Catlin Sumner Collection Fund, 1948.119

In one of his "Letters on Landscape Painting," Durand wrote:

> If your subject be a tree, observe particularly wherein it differs from those of other species: in the first place, the termination of its foliage, best seen when relieved on the sky, whether pointed or rounded, drooping or springing upward, and so forth; next mark the character of its trunk and branches, the manner in which the latter shoot off from the parent stem, their direction, curves, and angles. Every kind of tree has its traits of individuality—some kinds assimilate, others differ widely—with careful attention, these peculiarities are easily learned, and so, in a greater or less degree, with all other objects.[1]

The trees Durand has singled out at the left foreground of *View toward the Hudson Valley*, with the branches "relieved on the sky," are based on a drawing of his inscribed "Catskill" now in the collection of the New-York Historical Society.[2] The landscape was probably invented in the studio: Durand's practice up through the early 1850s was to combine tree studies taken directly from nature with landscape compositions of his own conception.[3]

Foreground passages in the painting include rock studies and plant studies. Durand made several rock studies in the 1850s, usually geologically specific. In the second of his "Letters on Landscape Painting," Durand echoes John Ruskin's advice in *Modern Painters* (also published in the *Crayon*): "Form is the first subject to engage your attention. Take pencil and paper, not the palette and brushes, and draw with scrupulous fidelity the outline or contour of such objects as you shall select, and, so far as your judgment goes, choose the most beautiful or characteristic of its kind."[4]

The structure of this painting compares most readily with that of his *Dover Plains, Dutchess County, New York*, an earlier work that shares the device of a diagonal bank in the foreground behind which the panoramic view lies, somewhat like a distant backdrop.[5] David B. Lawall discusses several paintings within Durand's oeuvre that share the compositional scheme of a chasm separating a foreground and a middleground, with fig-

Asher B. Durand, drawing, *Study of Trees, Catskill*, n.d. Collection of the New-York Historical Society.

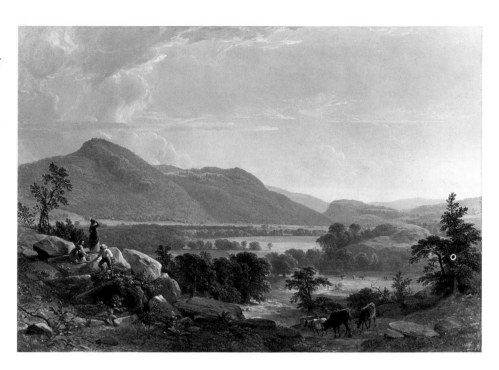

Asher B. Durand, *Dover Plains, Dutchess County, New York*, 1848. National Museum of American Art, Smithsonian Institution, gift of Thomas M. Evans and museum purchase through the Smithsonian Collections Acquisition Program.

ures in the foreground, one of whom points off into the distance.[6]

The figures in the Atheneum's painting (perhaps the artist and his patron, as one scholar has suggested) look out over and toward a cultivated and pastoral stretch of land, in keeping with the figures in *Dover Plains*.[7] Their symbolic position with regard to the valley can be seen as one of domination, implicitly celebrating the Manifest Destiny of the American empire to expand into, control, and civilize the wild in the name of progress.[8] The large size and panoramic vista of *View toward the Hudson Valley* in conjunction with the date of the painting— 1851, the year after the Compromise of 1850—suggests that Durand intended the painting as optimistic.[9] In this case, the two figures in the painting might be standing at the edge of past chaos and surveying the calm and peaceful future that lies before them.[10] AE

1. Asher B. Durand, from "Letters on Landscape Painting," *Crayon*, 1855, letter 2, reprinted in John W. McCoubrey, *American Art, 1700–1960: Sources and Documents* (Englewood Cliffs, N.J.: Prentice-Hall, 1965), 110–111. I am grateful to Franklin Kelly, National Museum of American

Art, who generously reviewed this entry and offered comments and criticism.

2. David B. Lawall, *Asher B. Durand: A Documentary Catalogue of the Narrative and Landscape Paintings* (New York and London: Garland, 1978), 90.

3. David B. Lawall, *Asher Brown Durand: His Art and Art Theory in Relation to His Times* (New York and London: Garland, 1977), 378. Kenneth W. Maddox has pointed out that a similar treatment of trees silhouetted against the sky can be seen in Durand's *Progress* (1853, Warner Collection, Gulf States Paper Corporation, Tuscaloosa, Ala.). See Kenneth W. Maddox to Amy Ellis, April 30, 1993, curatorial painting file, Wadsworth Atheneum.

4. From Durand, "Letters on Landscape Painting," 110.

5. My thanks to Franklin Kelly, who reviewed this entry and suggested this comparison. See Kelly to Amy Ellis, September 14, 1993, curatorial painting file, Wadsworth Atheneum. Maddox has suggested that the composition of Durand's *Progress* also compares with that of the Atheneum's painting. See Kenneth W. Maddox, "Asher B. Durand's *Progress*: The Advance of Civilization and the Vanishing American," in *The Railroad in American Art: Representations of Technological Change*, ed. Susan Danly and Leo Marx (Cambridge, Mass.: MIT Press, 1988), 51.

6. In "Landscape Painting and the Liberation of the Soul," ch. 4 in *Asher B. Durand*, Lawall argues that in these paintings, including *View toward the Hudson Valley, Dover Plains*,

Kindred Spirits (1849, New York Public Library), and *Progress*, only the foreground is physically accessible to the figures—and, by extension, to the spectator—but the middle ground and background are accessible through contemplation and, ultimately, the spirit (411–427). He writes, "It is notable that the scene beyond the foreground ledge in Durand's paintings is, in fact, quite literally, a 'Second Sphere,' totally different in character from the foreground." Lawall identifies this second sphere as consisting of landscape elements found on earth, "plains with rich vegetation, regular and gentle undulations of land, flowers, trees, groves, rivers, but none of the more terrible mountains and deserts of earth"; it is atmosphere and light that lend this scenery its spiritual aspect (ibid., 417 ff).

7. Ann J. Adams speculates about the identities of the figures in her entry for *View toward the Hudson Valley* in Theodore E. Stebbins, Jr., *The Hudson River School: Nineteenth-Century Landscapes in the Wadsworth Atheneum*, exh. cat. (Hartford: Wadsworth Atheneum, 1976), 57.

8. See Albert Boime, *The Magisterial Gaze: Manifest Destiny and American Landscape Painting, c. 1830–1865* (Washington, D.C., and London: Smithsonian Institution Press, 1991), especially 75–76 for Durand. Boime discusses Durand's *Progress* in terms of a diagonal sight line from the uncultivated wilderness on the ledge to the industrialized valley below. In that painting, Durand emphasized the dichotomy between the two domains by placing two Native Americans on a wilderness high ground looking out over a civilized, industrial America.

9. For a complete discussion of the significance of landscape paintings of this size and theme shown by the American Art-Union in this period, see Carole Troyen, "Retreat to Arcadia: American Landscape and the American Art-Union," *American Art Journal* 23, no. 1 (1991), 20–37.

10. See Boime, *The Magisterial Gaze*.

John Durand

Active in America from 1765 to 1782

Thought to be of French extraction, John Durand painted an impressive number of engaging portraits of Americans in the coastal communities along the eastern seaboard during the years 1765 to 1782. Little else has been uncovered about his life, including his birth and death dates. His first recorded portrait was painted in Virginia in 1765 (private collection), where, according to a source of the historian William Dunlap, "[Durand] painted an immense number of portraits . . . ; his works are hard and dry, but appear to have strong likenesses, with less vulgarity of style than artists of his *calibre* generally possess" (Dunlap, *History*, 1:144). He returned to paint in Virginia in 1769, 1771, 1775, and 1780.

As an itinerant portrait painter, in 1765 Durand traveled from Virginia to New York, where he painted portraits for James Beekman. Durand was paid nineteen pounds by Beekman, who recorded in his account book "Monsieur Duran for drawing my six Childrens Pictures," and one pound ten shillings "for Altering my Wife's Picture," (Kelly, "The Portraits of John Durand," 1080). A portrait of Beekman's wife, *Jane Beekman*, had been painted five years earlier by Lawrence Kilburn (1720–1775).

While in New York City, Durand opened a drawing school in 1767, advertising: "Any young Gentlemen inclined to learn the Principles of Design, so far as to be able to draw any objects and shade them with India Ink and Water-Colours, which is both useful and ornamental may be taught by JOHN DURAND . . . at his House in Broad Street, near the City Hall, for a reasonable Price" (*New York Journal*, April 7, 1768). In the same year, Durand advertised his own abilities as an artist, but rather than identifying himself as a portraitist, he offered his skills as a history painter, writing of this genre: "It presents to our View, some of the most interesting Scenes recorded in ancient or modern History; gives us more lively and perfect Ideas of the Things represented, than we could receive from an historical account of them; and frequently recals [*sic*] to our Memory, a long Train of Events, with which those Representations were connected" (Gottesman, *Arts and Crafts in New York*, 2). Despite his aspirations to pursue this highest art form, however, Durand found that in the American colonies he had to adjust to the conditions that he encountered in the regions where he traveled and so was largely dependent on commissions for portraits. While in Virginia in 1770, for example, he advertised his willingness to travel to his sitter's home and accept "country produce" as payment for his portraits (*Virginia Gazette*, June 21, 1770). He also volunteered to paint coaches and design coats of arms for his clients.

Durand is known to have been painting in Connecticut in 1772, when he executed portraits in New Haven (*Benjamin Douglas*, 1772, New Haven Colony Historical Society) and Norwich, as well as possibly in Middletown, where the Atheneum's portraits of the Jarvises (cats. 175, 176) may have been painted.

SELECT BIBLIOGRAPHY

William Dunlap, *History of the Rise and Progress of the Arts of
Design in the United States*, 3 vols. (1834; rpt., New York:
Dover, 1969) / Rita S. Gottesman, *The Arts and Crafts in New
York, 1726–1776* (New York: New-York Historical Society,
1970) / Franklin W. Kelly, "The Portraits of John Durand," *An-
tiques* 122 (November 1982), 1080–1087

175

JOHN DURAND

Reverend Abraham Jarvis, c. 1772

Oil on canvas; 48$\frac{1}{8}$ × 39$\frac{1}{3}$ in. (122.2 × 99.9 cm)

Technical note: Areas of the face were reworked during
 a restoration.

EXHIBITED: Wadsworth Atheneum, "The Great River: Art
and Society of the Connecticut River Valley, 1635–1820," 1985,
no. 40

EX COLL.: descended in the Jarvis family to the subject's son
Rev. Samuel Farmer Jarvis, Middletown, Conn., probably in
1813; to his daughter Lucy Jarvis Smith, Brooklyn, Conn., be-
fore 1929; acquired by William B. and Mary Arabella Goodwin,
Hartford, in 1929

Bequest of William B. Goodwin, 1950.784

176

JOHN DURAND

Mrs. Abraham Jarvis (Anne Billhop Farmer), c. 1772

Oil on canvas; 47$\frac{1}{2}$ × 39 in. (120.7 × 99.1 cm)

Technical note: Large areas of paint loss in sections
 running across the lower portion of the painting were
 recreated at some point during a restoration.

EX COLL.: descended in the Jarvis family to the subject's son
Rev. Samuel Farmer Jarvis, Middletown, Conn., probably in
1813; to his daughter Lucy Jarvis Smith, Brooklyn, Conn., be-
fore 1929; acquired by William B. and Mary Arabella Goodwin,
Hartford, in 1929

Bequest of William B. Goodwin, 1950.795

Abraham Jarvis (1739–1813) was the son of Captain
Samuel Jarvis and Naomi (Brush) Jarvis, who moved
from Huntington, Long Island, to Norwalk, Connecti-
cut, in 1739, the year of Abraham's birth. His parents
were members of the Episcopal Church in Norwalk. As
one of nine children, Abraham attended Yale College,
graduating in 1761. He then went to Middletown, Con-
necticut, where he served as a layreader while
preparing for the Episcopal ministry under the direction
of the Rev. Samuel Johnson. As was the custom, Jarvis
traveled to England in 1763 in order to be confirmed as a
minister of the Church of England. On his return to
Middletown in 1764, he was offered the rectorship of
Christ Church at an annual stipend of seventy pounds;
he served in that position until 1799. Two years after the
appointment, in 1766, he married Anne Billhop Farmer
(d. 1801), the daughter of the New York City merchant
Samuel Farmer and Hannah Peck Farmer, at Trinity
Church in New York City. As a leading figure of the
Episcopal Church in America, Jarvis was consecrated
bishop of Connecticut in 1797.[1]

Durand could have painted the portraits of the Jar-
vises in New York at the time of their marriage in 1766,
when the artist is known to have been working in that
city. It is also possible that the portraits were painted
later, in Middletown, Connecticut, where the couple
returned after their wedding: Durand may have been
in Connecticut as early as 1768 and is known to have
worked in Connecticut in 1772.[2] The portraits, which
feature Durand's characteristic sharp outlines and flat
areas of color, show the sitters at three-quarter length,
in stiff, formal poses and elaborate settings that indicate
the artist's use of English mezzotint prints as sources for
such elements, particularly visible in the inclusion of an
ornate marble-top pier table in the Reverend Jarvis's
portrait and the high back upholstered side chairs that
appear in both portraits.[3]

The Reverend Jarvis, attired in his clerical robes and
a powdered wig, holds a book in his right hand and has
shelves of books to his left symbolizing his learned back-
ground.[4] (The inventory of Jarvis's property at the time
of his death indicates that he owned a "Library contain-
ing 613 volumes.")[5] Mrs. Jarvis is attired in a pale blue
silk gown with strands of pearls at her neck and a sprig
of flowers in her right hand. She is placed against a simi-
lar paneled wall with red drapery at her right.

175

176

William B. Goodwin (cat. 245) gave the Wadsworth Atheneum many of the paintings and family papers he had acquired directly from Lucy A. Jarvis Smith in 1929, including "5 Deeds to Pecks Slip Land in New York City; Deed of Christian Marschalk and Hannah Farmer sisters," many portraits of relations and members of the Farmer and Jarvis families (cats. 424, 4), and papers relating to the Jarvis family. Two Durand portraits at the Winterthur Museum—a half-length portrait, the subject of which is identified as Anne Farmer Jarvis's sister Hannah Farmer (c. 1767–1770) and bears a striking resemblance to Anne Jarvis as she appears in the Atheneum's portrait, and a second, *Mrs. Benjamin (Hannah Farmer) Peck* (c. 1767–1770), of the Farmer sisters' aunt—were also part of this acquisition made by Goodwin in 1929 from Lucy Jarvis Smith of Brooklyn, Connecticut.[7] In addition, the Atheneum received from Miss Ellen A. Jarvis a portrait identified as that of Anne Farmer Jarvis's sister Christine Farmer (Mrs. Francis Marschalk), painted by Cosmo Alexander (cat. 4).[8] EMK

1. Elizabeth Mankin Kornhauser's entry for John Durand's *Reverend Abraham Jarvis*, in *The Great River: Art and Society of the Connecticut River Valley, 1635–1820*, exh. cat. (Hartford: Wadsworth Atheneum, 1985), 147; Franklin Bowditch Dexter, *Biographical Sketches of the Graduates of Yale College* (New York: Henry Holt, 1896), 2:701–706; and William Sprague, *Annals of the American Pulpit* (New York, 1857), 5:237–239.
2. John Durand's signed portrait, *Dr. Leverett Hubbard* (Hirschl and Adler Galleries, New York City), is dated 1768 and depicts a Hartford physician.
3. For a discussion of Durand's use of English mezzotints as sources for his own portraits, see Waldron Phoenix Belknap, Jr., *American Colonial Painting: Materials for a History* (Cambridge: Harvard University Press, Belknap Press, 1959), 296, 326.
4. In 1764 the Reverend Jarvis ordered a clerical robe from the London shop of Shudell and Stone, "Robe Makers to His Majesty and their Royal Highness's the Dukes of York and Cumberland," for which he paid the considerable sum of ten pounds and three shillings(Rev. Abraham Jarvis Papers, General Theological Society Library, New York City; transcription of bill in curatorial painting file, Wadsworth Atheneum).
5. Estate inventory, Abraham Jarvis, New Haven, 1813, New Haven District, file 5893, Connecticut State Library, Hartford.

7. William B. Goodwin, account book, 429–430, archives, Wadsworth Atheneum.
8. E. McSherry Fowble to Elizabeth Kornhauser, December 27, 1983, curatorial painting file, Wadsworth Atheneum. Both Winterthur portraits are reproduced in Belknap's *American Painting* (296, 326); however, Belknap identifies Hannah Farmer as Mrs. Abraham Jarvis. It is unclear whether this was simply an error or based on information that is at this point unknown to the Atheneum.

177

JOHN DURAND

Hannah Farmer, c. 1767–1770

Oil on canvas; 34¼ × 27⅜ in. (87.0 × 69.5 cm)

EX COLL.: descended in the Jarvis family to the subject's nephew, Rev. Samuel Farmer Jarvis, Middletown, Conn., probably in 1813; to his daughter Lucy A. Jarvis Smith, Brooklyn, Conn., before 1929; acquired by William B. Goodwin, Hartford, in 1929

Bequest of William B. Goodwin, 1950.779

This portrait of a mature woman relates to the portraits Durand painted in New York in the later part of the 1760s, a like example being the portrait *Sarah Bogart Ray* (c. 1766, Museum of the City of New York).[1] Presented at three-quarter-length, the subject holds a fan in her right hand and holds out her left hand in such a way as to suggest that the artist intended to place a rose or some other flower between her thumb and first finger, as was common in his portraits of women, for example, that of Sarah Ray. Durand creates a pleasing and relaxed likeness of this subject, with the hint of a smile. The artist emphasized sharp contours and a bright palette, and the treatment of the drapery and the sharply defined folds in the sitter's dress are characteristic of his treatment of fabrics.

This portrait by John Durand descended with documented portraits of *Reverend Abraham Jarvis* and his first wife *Anne Billhop Farmer Jarvis* by the same artist. It has been identified as Hannah Farmer, sister of Anne (cat. 176) and Christine (cat. 4), and as Hannah Peck, daughter of Benjamin Peck and Hannah Farmer Peck of New York City. Although neither of these can be

177

confirmed, it seems likely that the subject was a member of the Farmer or Peck families, given that the portrait descended in the family of Abraham Jarvis and Anne Farmer Jarvis. EMK

1. Franklin W. Kelley, "The Portraits of John Durand," *Antiques* 122 (November 1982), 1082.

George Henry Durrie

Born in New Haven, Conn., in 1820; died in New Haven, Conn., in 1863

Durrie was born into a family of English ancestry. In 1781 his paternal grandfather settled in Hartford, where he met and married Mary Steele, a descendant of John Steele, one of the founders of Hartford. Durrie's father, John, and mother, Clarissa Clark of West Hartford,

179

moved to New Haven, where his father established the firm Durrie and Peck, publishers, booksellers, and stationers.

Durrie was only nineteen when he began traveling around Connecticut in search of portrait commissions. From around 1839 through 1841 he and his elder brother, John, Jr., studied with Nathaniel Jocelyn (1796–1881), a well-known New Haven portrait and miniature painter, and Durrie's first excursions were to Hartford, Meriden, Naugatuck, and Bethany. Later he traveled to Monmouth County, New Jersey, to New York State, and to Petersburg, Virginia. At twenty-one, he married Sarah A. Perkins of Bethany, Connecticut, the daughter of a friend and client. Soon afterward, under the patronage of Judge James S. Lawrence, the artist and his wife returned to New Jersey. There Durrie painted portraits and did other work, including varnishing paintings and decorating window shades.

Before October 1842 the Durries went back to New Haven. Records indicate that Durrie's first public exhi-

178

bition was in 1842: one portrait was shown at the National Academy of Design in New York City, and two others were exhibited at the New Haven Horticultural Society. Two years later, two winter landscapes were shown, and after 1845 Durrie began to shift his focus from portrait to landscape painting. During this period, however, Durrie's portraits still sold quickly for $20 to $30 apiece, although he had trouble selling his snow pieces. Still, he persevered, and, in 1854 he held a sale of winter pictures in his studio.

In 1857, Durrie moved to New York City and opened a studio at 442 Broadway. He exhibited two winter scenes at the National Academy and continued to exhibit there until his death, but he returned to New Haven to live after only one year. Some time in the late 1850s, Currier and Ives began to publish lithographs after Durrie's paintings, bringing his work to the attention of a broad audience. Durrie is also known to have painted genre scenes, pictures with Falstaff as their subject, still lifes with fruit, and a number of self-portraits.

He died after a long illness at age forty-three, leaving a number of unfinished canvases that were completed by his brother John, Jr., and his son, George Boice; this later caused attribution problems for scholars.

In 1947 the Wadsworth Atheneum held the first single-artist exhibition of Durrie's work.

SELECT BIBLIOGRAPHY

Mary Clarissa Durrie, "George Henry Durrie: Artist," *Antiques* 24 (July 1933), 13–15 / Bartlett Cowdrey, *George Henry Durrie, 1820–1863: Connecticut Painter of American Life*, exh. cat. (Hartford: Wadsworth Atheneum, 1947) / Robert M. Lunny, *George Henry Durrie's Snow Pieces: A Loan Exhibition*, exh. cat. (Newark, N.J.: New Jersey Historical Society, 1959) / Colin Simkin, *An Exhibition of Paintings by Durrie, Connecticut Artist*, exh. cat. (New Haven, Conn.: New Haven Colony Historical Society, 1966) / Lyman Allyn Museum, *Landscapes by George Henry Durrie*, exh. cat. (New London, Conn.: Lyman Allyn Museum, 1968) / Martha Hutson, "George Henry Durrie: An American Winter Landscape Painter," *Antiques* 103 (February 1973), 300–306 / Martha Young Hutson, *George Henry Durrie (1820–1863), American Winter Landscapist: Renowned through Currier and Ives*, exh. cat. (Santa Barbara, Calif.: Santa Barbara Museum of Art and American Art Review Press, 1977)

178

GEORGE HENRY DURRIE
Dr. Daniel Polhemus, 1842
Oil on canvas; 30⁷⁄₁₆ × 25¹⁄₂ in. (77.3 × 64.8 cm)
Signed and dated on back: Portrait of Dr. D.
 Polhemus / Painted by G H Durrie / April 1842

EX COLL.: Mr. and Mrs. Harry L. Tepper, South Orange, N.J., to 1959

Gift of Mr. and Mrs. Harry Tepper, 1959.252

179

GEORGE HENRY DURRIE
Mrs. Daniel Polhemus (Margaret Disborough), 1842
Oil on canvas; 30³⁄₈ × 25¹⁄₂ in. (77.2 × 64.8 cm)

Signed and dated on back: Painted from another portrait / by Durrie / April 1842

EX COLL.: Mr. and Mrs. Harry L. Tepper, South Orange, N.J., to 1959

Gift of Mr. and Mrs. Harry Tepper, 1959.253

In 1842, when the Atheneum's portraits were taken, Durrie traveled to Englishtown, New Jersey, where the Polhemuses lived.[1] The artist's account book records the Polhemus portraits as "1842 May Portrait of Dr. Polhemus 10.00" and "1842 May Portrait of Mrs. Daniel Polhemus 5.00."[2] Note, however, that both portraits are dated April 1842 on the back. Mrs. Polhemus died on February 16, 1842; thus Durrie made his portrait, "from another," two months after her death.[3] A letter in the files of the Atheneum indicates that Durrie also painted a portrait of a Miss Catharine Polhemus, probably the Polhemuses' daughter.[4]

In his portraits of the Polhemuses—and in his portraits in general—Durrie paid more attention to clothing and background than is usual for the typical itinerant portrait painter of the period, whose sitters (often farmers) had little time to pose.[5] This care is not so surprising in the case of the Atheneum's portraits, as the Polhemuses, a doctor and his wife, were undoubtedly people of means and station in their community. The figures seem to be seated on either side of the same window, judging by the drapery, yet the landscapes visible through the window in either painting do not match up. The views were probably imaginary, but Durrie may have intended the Polhemuses to appear to be seated in the same room, if not by the same window.

1. Martha Young Hutson, *George Henry Durrie (1820–1863), American Winter Landscapist: Renowned through Currier and Ives*, exh. cat. (Santa Barbara, Calif.: Santa Barbara Museum of Art and American Art Review Press, 1977), 197.
2. Ibid., 213.
3. An advertisement that ran in the *New Haven Palladium*, May and June 1843, read: "G. H. Durrie, having taken the room No. 13 Phoenix Building, would be pleased to wait upon those who may be desirous of obtaining faithful and correct likenesses. Portraits taken after death, if application is made in due season" (quoted in Bartlett Cowdrey, *George Henry Durrie, 1820–1863: Connecticut Painter of American*

Life, exh. cat. [Hartford: Wadsworth Atheneum, 1947], n.p.). In other words, Durrie, on occasion, took portraits directly from the corpse. This was not, however, the case with *Mrs. Polhemus*.

4. Mrs. H. Pauls, secretary to Harry Shaw Newman, The Old Print Shop, Inc., New York, to Charles C. Cunningham [then director of the Wadsworth Atheneum], November 20, 1959, curatorial painting file, Wadsworth Atheneum. This letter notes that, according to a photostat copy of Durrie's account book in the possession of Newman, the May 1842 entries listed "Miss Catharine Polhemus 10.00" in addition to Dr. and Mrs. Polhemus.

5. Colin Simkin, *An Exhibition of Paintings by Durrie, Connecticut Artist*, exh. cat. (New Haven, Conn.: New Haven Colony Historical Society, 1966), 8.

180 (see plate 54)

GEORGE HENRY DURRIE

Old Grist Mill, 1853

Oil on canvas; 25³/₁₆ × 36 in. (64.0 × 91.4 cm)

Signed at lower right: G. H. Durrie

Signed and dated at lower right on back of canvas

(photograph mounted on backing after relining):
G. H. Durrie / N. Haven. 1853

Inscribed with stencil on back of canvas (photograph mounted on backing after relining): GOUPIL & Co / Artists Colourmen / 89 / Broadway / NEW-YORK

EXHIBITED: New Haven, Conn., New Haven Colony Historical Society, "George Henry Durrie: Connecticut Artist, 1820–1863," 1966, no. 33 / New London, Conn., Lyman Allyn Museum, "Landscapes by George Henry Durrie," 1968–1969, no. 7 / Wadsworth Atheneum, "The Hudson River School: Nineteenth-Century American Landscapes in the Wadsworth Atheneum," 1976, no. 31 / Santa Barbara, Calif., Santa Barbara Museum of Art; San Diego, Calif., Fine Arts Gallery of San Diego; Fort Worth, Tex., Amon Carter Museum of Western Art; and New Haven, Conn., New Haven Colony Historical Society, "George Durrie and the Winter Landscape," 1978, no. 33 / New Britain, Conn., New Britain Museum of American Art, "Three Centuries of Connecticut Art," 1981, no. 105

EX COLL.: with Kennedy Galleries, Inc., New York City, in 1961

George Henry Durrie, *Winter in New England*, c. 1852. New Britain Museum of American Art, Stephen Lawrence Fund. Photograph: E. Irving Blomstrann.

The Ella Gallup Sumner and Mary Catlin Sumner Collection Fund, 1961.154

Durrie painted all the seasons, but he is most famous for his winter landscapes or snow scenes, in which he pays special attention to the visual effects of snow and ice. Winter scenes were the least popular seasonal subjects for landscape painters in the native tradition for a number of reasons. Nineteenth-century ideology viewed the seasons in terms of growth and decay, and winter clearly represented the less vital aspects of that cycle. Moreover, landscape was felt to be a conveyer of morality, and winter was thought to be incapable of fulfilling that didactic role. Other reasons were practical: winter was cold, and the weather was bad, and so most artists would take sketching trips in the warmer months, returning home in winter to compose paintings from their sketches.[1] Durrie, as was typical of the time, idealized the American landscape, but he idealized the winter season in particular. As a consequence, the lithography firm Currier and Ives chose his snow scenes for reproduction and distribution.

Old Grist Mill is one of a group of winter landscapes by the artist that includes *Winter in New England* and *Home to Thanksgiving* (unlocated). All three paintings repeated certain elements: buildings at the left of the composition, a central stream or river, and bare trees with broken branches. In his diary, Durrie wrote the following, which may very well describe the scene of the Atheneum's painting: "Took a walk up to the Mill on the River—was much pleased with the scenery which is very wild and exceedingly picturesque." "The scenery along the river where the water rushes over the dam is very bold," and "the ground, trees, etc. were completely covered with ice, which glittering in the sun looked beautiful."[2] Although Durrie tempered the wildness of this scene in *Old Grist Mill*, he did capture the ice-covered water with mastery. The touches of white snow on the sea-green ice, as well as the water coming over the dam frozen into icicles, well convey the raw feeling of a New England winter. It is tempting to compare Durrie's handling of snow and ice to the work of earlier Dutch painters, and it is probable that Durrie was aware of Dutch examples of landscape and genre: several were shown at the Crystal Palace in New York in 1853.[3]

In 1854 Durrie ran an advertisement in the New Haven *Daily Register*: "Having engaged for a few months past in painting a *number of choice Winter scenes*, [the artist] would offer them at public sale to the admirers of the fine arts. . . . It is needless to add that no collection of pictures is complete without one or more *Winter Scenes*. These pictures will always command a sure sale at good prices, but the artist deems this the quickest way of disposing of them."[4] Durrie held his sale on Thursday, May 11, 1854. It seems possible, although not certain, that *Old Grist Mill*, painted some time in 1853, was among the pictures for sale.

Currier and Ives began publishing lithographs after Durrie's paintings in 1861. Among the paintings after which the firm commissioned prints are *New England Winter Scene*, published in 1861; *Winter in the Country, The Old Grist Mill*, published in 1864; and *Home to Thanksgiving*, published in 1867. Martha Hutson notes that another picture by Durrie subtitled *The Old Grist Mill* (1862, private collection), which was sold at auction the year it was painted—possibly to Currier and Ives—may have served as the subject for *Winter in the Country, The Old Grist Mill*.[5] The Atheneum's own files show that its *Old Grist Mill* was published by Currier and Ives under the title *Winter in the Country: "Frozen Up."*[6] Another Currier and Ives lithograph after Durrie, published in 1863, *Winter Morning—Feeding the Chickens*, is in the Atheneum's collection of American prints. The painting has not been located. AE

1. Snow never deterred Durrie. His daughter, Mary Clarissa Durrie, recounted an anecdote in which Durrie braves a "violent snowstorm" to get to church: "He ventured forth and finally reached the church, the only member of the choir present. . . . My father carried the chants, hymns, and the entire musical program" (Mary Clarissa Durrie, "George Henry Durrie: Artist," *Antiques* 24 [July 1933], 13–14). For further discussion of winter landscape painting in America, see Martha Hutson, "The American Winter Landscape, 1830–1870," *American Art Review* 2 (January–February 1975), 60–78.
2. As quoted in Colin Simkin, *An Exhibition of Paintings by Durrie, Connecticut Artist*, exh. cat. (New Haven, Conn.: New Haven Colony Historical Society, 1966), 12.

3. Martha Young Hutson, *George Henry Durrie (1820–1863), American Winter Landscapist: Renowned through Currier and Ives*, exh. cat. (Santa Barbara, Calif.: Santa Barbara Museum of Art and American Art Review Press, 1977), 52.

4. As quoted in Bartlett Cowdrey, *George Henry Durrie, 1820–1863: Connecticut Painter of American Life*, exh. cat. (Hartford: Wadsworth Atheneum, 1947), n.p.

5. Hutson, *George Henry Durrie*, 203–204.

6. *Winter in the Country: "Frozen Up"* was used to illustrate the month of April in the Travelers 1964 Currier and Ives calendar.

Frank Duveneck

Born in Covington, Ky., in 1848; died in Cincinnati, Ohio, in 1919

Duveneck was born Francis Decker to the German immigrants Bernard Decker, a shoemaker, and his wife, Katherine Siemers, who had been a domestic servant to James Henry Beard (1812–1893), the elder brother of William Holbrook Beard (q.v.). After Bernard Decker died in 1849, his widow married Joseph Duveneck, a prosperous businessman. Francis was known by his stepfather's surname but did not legally change his name until 1886.

Duveneck's earliest training was in the craft tradition; at age thirteen, he began working with Johann Schmitt, painting, modeling, and carving church altars. In 1866–1867, he collaborated with Schmitt in painting the stations of the cross for St. Joseph's Catholic Church in Covington, and in 1867 he painted *Madonna and Child*, which he signed and dated, for the sisters of St. Walburg Convent in Covington. His early training continued in 1868 with Wilhelm Lamprecht, under whom he traveled to Pennsylvania and Canada, working on Benedictine churches. It was Lamprecht who encouraged Duveneck to pursue his study of art in Munich, and in 1869 the young artist left for Europe.

Arriving in Munich in December 1869, Duveneck enrolled in the Bavarian Royal Academy on January 10. He first studied drawing from plaster casts of antique sculptures, but he soon graduated to a life class and made a series of portrait studies. During this period, he was strongly influenced by the old masters and the work of the realist Wilhelm Leibl, which drew inspiration from

Franz Hals and Edouard Manet. In 1871 he painted *Portrait of a Young Man Wearing a Red Skull Cap* (Cincinnati Art Museum). The following year, he won a number of prizes in academy competitions and completed his most famous painting, *Whistling Boy* (Cincinnati Art Museum).

In November 1873 Duveneck returned to the United States, and by 1874 he had established a studio with Henry Farny (1847–1916) and Frank Dengler (1853–1879) in Cincinnati. He exhibited his work, taught at the Ohio Mechanics Institute, where he numbered John Twachtman (q.v.) among his students. He also painted portraits on commission. In the spring of 1875 he showed five paintings from Munich at the Boston Art Club and was favorably reviewed by William Morris Hunt (q.v.) and Henry James. It was at this show that Hunt's student Elizabeth Boott, who became Duveneck's student in 1878 and his wife in 1886, first saw the artist's work.

In the fall of 1875 Duveneck, in the company of Farny and Twachtman, returned to Europe, stopping in the Netherlands, among other countries, before arriving in Munich in 1876. That year Duveneck painted *Turkish Page* (Pennsylvania Academy of the Fine Arts, Philadelphia), which was exhibited in Europe and America, including a showing at the National Academy of Design in New York City. In 1877 Duveneck traveled to Venice with Twachtman and William Merritt Chase (q.v.), both of whom also studied at the Royal Academy in Munich. That year he also returned to Munich, where he painted *The Cobbler's Apprentice* (Taft Museum, Cincinnati), which bears a striking resemblance to the Atheneum's *Boy Smoking (The Apprentice)*, painted by Chase in 1875 (cat. 99). Duveneck spent 1878 in Munich and Venice, as well as in Polling, Bavaria, where, under the influence of Joseph Frank Currier (1843–1909), he experimented with plein-air subjects and painted genre and landscape. The two artists founded a painting school in Polling, and Elizabeth Boott enrolled as one of Duveneck's students.

In 1879 Duveneck left for Florence with a group of his followers, who became known as the "Duveneck Boys" and are memorialized as the "Inglehart Boys" in the novel *Indian Summer* (1886) by William Dean

Howells. During this period, Duveneck's style changed dramatically from the dark, bituminous portraits characteristic of the Munich school. In 1880 he went to Venice, where, influenced by Otto Bacher (1856–1909), he began making etchings. He also spent time with James McNeill Whistler (q.v.), Twachtman, and John Singer Sargent (q.v.), who were all in Venice at this time, and began painting in a more impressionistic manner. That same year he was elected to the Society of American Artists.

Duveneck remained in Europe, primarily in Italy and France, through 1888, when his wife, Elizabeth, died, a few days after he had completed a full-length portrait of her (Cincinnati Art Museum). In 1889 he returned to the United States, settling in Cincinnati, where he began work on a sculptural monument for Elizabeth's grave. He started to teach painting again and continued to paint portraits. He also began a series of nudes. In 1891 he returned to Europe for the installation of Elizabeth's monument in the Allori Cemetery in Florence.

The year after he received an award at the 1893 Columbian Exposition in Chicago, Duveneck went to Spain; there, he copied paintings by Velázquez, with whose work his had been compared by James and others earlier in his career. Duveneck was in Paris in 1895. By 1900 he had joined the faculty of the Cincinnati Art Academy. In the final years of his career, he continued to paint nudes and worked in sculpture. In 1906 he was elected an academician of the National Academy of Design. At the 1915 Panama-Pacific International Exposition in San Francisco, he served on the awards jury, and a gallery in the Palace of Fine Arts was devoted to an exhibition of his work. His last award was an honorary L.L.D. from the University of Cincinnati in 1917.

SELECT BIBLIOGRAPHY

Henry James, "On Some Pictures Lately Exhibited," *Galaxy* (July 1875), and "Duveneck and Copley," *Nation* (September 9, 1875), reprinted in Henry James, *The Painter's Eye: Notes and Essays on the Pictorial Arts*, ed. John L. Sweeney (Madison, Wisc.: University of Wisconsin Press, 1989) / G. W. Sheldon, *American Painters*, rev. ed. (New York: D. Appleton, 1881), 213–215 / Samuel Isham, *The History of American Painting* (New York: Macmillan, 1905), 378–381 / L. H. Meakin, "Duveneck: A Teacher of Artists," *Arts and Decoration* I (July 1911), 382–384 / Petronius Arbiter, "Frank Duveneck," *The Art World and Arts and Decoration* 10 (November 1918), 17–23 / Norbert Heermann, *Frank Duveneck* (Boston: Houghton Mifflin, 1918) / Frank E. Washburn Freund, "The Problem of Frank Duveneck," *International Studio* 85 (September 1926), 39–45 ff / Walter H. Siple, *Exhibition of the Work of Frank Duveneck*, exh. cat. (Cincinnati: Cincinnati Art Museum, 1936) / Norbert Heermann, *Paintings by Frank Duveneck*, exh. cat. (New York: Whitney Museum of American Art, 1938) / Mahonri Sharp Young, "The Two Worlds of Frank Duveneck," *American Art Journal* 1, no. 1 (1969), 92–103 / Josephine W. Duveneck, *Frank Duveneck: Painter-Teacher* (San Francisco: John Howell Books, 1970) / Doreen Bolger Burke, *American Paintings in the Metropolitan Museum of Art*, ed. Kathleen Luhrs (New York: Metropolitan Museum of Art, 1980), 3:61–66 / Robert Neuhaus, *Unsuspected Genius: The Art and Life of Frank Duveneck* (San Francisco: Bedford Press, 1987) / Jan Newstrom Thompson, *Duveneck: Lost Paintings Found*, exh. cat. (Santa Clara, Calif.: Triton Museum of Art, 1987) / Michael Quick, *An American Painter Abroad: Frank Duveneck's European Years*, exh. cat. (Cincinnati: Cincinnati Art Museum, 1987) / Elizabeth Wylie, *Explorations in Realism: 1870–1880, Frank Duveneck and His Circle from Bavaria to Venice*, exh. cat. (Framingham, Mass.: Danforth Museum of Art, 1989)

181

FRANK DUVENECK

Charles Dudley Warner, 1877

Oil on canvas; 38¼ × 29⅝ in. (97.2 × 75.2 cm)

Technical note: There is traction cracking throughout.

EXHIBITED: New York City, National Academy of Design, 1877, no. 441, as "Portrait—C. D. Warner" / Wadsworth Atheneum, "Portraits of Hartford Men," 1926, as "Charles Dudley Warner" / New York City, Century Association, 1937

EX COLL.: Charles Dudley Warner from 1877, until his death, in 1900; to Mrs. Charles Dudley Warner (Susan Lee) until her death, in 1921; to Mary C. Barton in 1921

Gift from the Estate of Mrs. Charles Dudley Warner through Miss Mary C. Barton, Executrix, 1921.422

181

pictures that shine in the reputation of the painter of 'The Turkish Page.'"[1] Henry James, reviewing an 1875 exhibition at the Boston Art Club, wrote, "Mr. Duveneck is essentially a portraitist; it is hard to imagine a more discriminating realism, a more impressive rendering of the special, individual countenance."[2] Duveneck's two portraits of Charles Dudley Warner, which capture the scholarly appearance of this man of letters, live up to James's remark.[3]

Warner began his career in newspapers in 1860, when Joseph R. Hawley, then editor of the *Evening Press* in Hartford, entreated him to come to that city to assist him. The following year, when Hawley left to fight in the Civil War, Warner, who was near-sighted, was made editor. In 1867 the *Press* was consolidated with the *Hartford Courant*, and, as Hawley had entered politics after the war, Warner remained editor.[4] He co-authored *The Gilded Age* (1873) with Samuel L. Clemens (Mark Twain) and served as a trustee of the Wadsworth Atheneum from 1874 through 1880. He was also a member of the Hartford Park Commission and the Connecticut State Commissions on sculpture and prisons.[5]

182

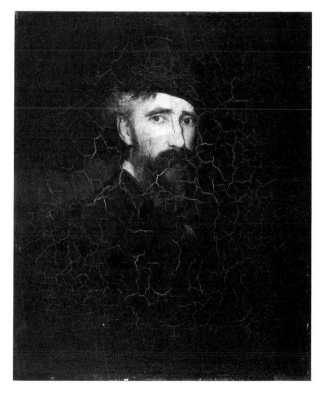

182

FRANK DUVENECK

Charles Dudley Warner, 1877 or later

Oil on canvas; 26 × 21 in. (66.0 × 53.3 cm)

Canvas stamp: Maltuch & Farben / Fabrik / [illegible] / Richard Wurm / München.

Inscribed in pencil on back of stretcher: Charles Dudley Warner

Technical note: Traction cracks cover the surface.

EXHIBITED: Possibly San Francisco, Calif., Panama-Pacific International Exposition, 1915, as "Man with a Red Fez"

EX COLL.: Mr. and Mrs. Charles Dudley Warner, to 1921; to Mary C. Barton in 1921

Gift of Miss Mary C. Barton from the Collection of Mr. and Mrs. Charles Dudley Warner, 1938.183

George Sheldon listed "a portrait of Mr. Charles Dudley Warner, of Hartford" as one of "the principal

The larger, earlier portrait shows Warner seated at a table with a newspaper on it. When it was exhibited at the National Academy of Design in 1877, it met with mixed reviews. One critic commented, "The coloring of the face is somewhat ghastly and the eyes have a tendency to start out and stare, which suggests the proximity of a gibbet. But there is a vast deal of power in the picture—power of the right and the rare sort. The artist has ability to generalize the elements of character, and to depict dominant traits. He is, in a word, a psychologist; and his work is a high endeavor in art."[6] A reviewer for the *Nation* called the painting "a noble-looking half-length of Mr. Charles Dudley Warner."[7] Another, however, though praising Duveneck's work for the "boldness and solidity of his brush," criticized the portrait as "decidedly slight and wanting in finish" and continued, "the likeness is not good."[8]

In the Atheneum's smaller portrait of Warner, Duveneck portrayed his subject wearing a fez, perhaps a reference to Warner's travel in the eastern Mediterranean countries. A prolific travel writer, in 1876 and 1877 Warner published two books about his time in the East: *My Winter on the Nile* and *In the Levant,* in which his sense of humor is amply displayed.[9] Three writers from the first half of the twentieth century refer to a painting as "Man with a Red Fez," and, as no other painting by Duveneck fitting this description has come to light, they were probably alluding to the Atheneum's portrait.[10]

Norbert Heermann, in his monograph of 1918, described "Man with a Red Fez" as "one of the earliest Munich canvases," but, according to the painting's donor, a close friend of the Warners, Duveneck painted this portrait quickly for Mrs. Warner, shortly after finishing the portrait of 1877.[11] On the painting's exhibition at the San Francisco Exposition in 1915, Heermann wrote that "its quiet forceful grasp of character arous[ed] at once a good deal of discussion among Munich artists."[12]

In both portraits, Duveneck used the dark palette of the Munich school, which favored the use of bitumen and inspired the use in the 1870s of the term "brown sauce" to describe dark, opaque paintings such as these.[13] It is not clear where Duveneck painted these portraits. He was in Munich in 1877, but he traveled to Venice, via Innsbruck, before returning to the German city that same year. In 1878 he was again in Munich and Venice. The canvas stamp of the smaller portrait seems to indicate that the portrait was taken in Munich, yet nothing in the available biographical information on Warner indicates that he was in Munich or even in Venice during those two years.[14] An article that appeared in the *Hartford Courant* in 1926, however, states that the Warners met Duveneck while abroad.[15]

Duveneck took the portrait of another Hartford man, artist William Gedney Bunce (q.v.), in 1880. He probably met Bunce in Venice, where both men spent that year. AE

1. G. W. Sheldon, *American Painters*, rev. ed. (New York: D. Appleton, 1881), 213–214.
2. Henry James, "Duveneck and Copley," *Nation* (September 9, 1875), reprinted in Henry James, *The Painter's Eye: Notes and Essays on the Pictorial Arts*, ed. John L. Sweeney (Madison, Wisc.: University of Wisconsin Press, 1989), 106.
3. An early source describes Warner as "something of a scholar in appearance—straight and slender, with a rugged, aquiline head, deep blue eyes under shaggy brows, and carefully cultivated gray hair and beard" (*DAB*, 5:558–561).
4. Biographical information on Charles Dudley Warner is from *DAB*, 19:462–463; and "Mr. Warner's Death," *Hartford Daily Courant*, October 22, 1900, 7.
5. *DAB*, 19:463.
6. "The Academy of Design. Portraits in the Fifty-second Annual Exhibition," *New York Evening Post*, May 5, 1877, 1, cols. 1–2. The reviewer for the *New York Times* essentially agreed: "[In the portrait] the likeness is not literally successful, but he has poured into his work the concentration of all he perceived in Mr. Warner's character. He has made him severe, magisterial, perhaps a good inquisitor, all of them well-known traits in New-England character, even if Mr. Warner's friends do not perceive them in himself" (*New York Times*, April 23, 1877, 4, cols. 6–7). I am grateful to William H. Gerdts for access to his files of reviews of exhibitions at the National Academy of Design, in which I found these clippings.
7. "Notes," *Nation*, no. 624 (1877), 352, National Academy of Design review files in collection of William H. Gerdts.
8. "National Academy of Design. Fifty-second Annual Exhibition—A First View," *New York Times*, April 3, 1877, 5, cols. 5–6. Clipping in National Academy of Design review files in collection of William H. Gerdts.
9. *DAB*, 5:463.
10. Norbert Heermann, *Frank Duveneck* (Boston: Houghton Mifflin, 1918), 70; Frederic Fairchild Sherman, "Frank

Duveneck," *Art in America* 16 (February 1928), 97; and Walter H. Siple, *Exhibition of the Work of Frank Duveneck*, exh. cat. (Cincinnati: Cincinnati Art Museum, 1936), 81.

11. Heermann, *Frank Duveneck*, 70. It may be that Heermann confused the title and was referring to *Portrait of a Young Man Wearing a Red Skull Cap*, which dates to 1871 and is now in the Cincinnati Art Museum. In the context of comments about the larger Atheneum portrait of Warner, one writer said, "Duveneck's system is said to be a rapid one. He paints very fast for fear of losing the spirit of the original sketch" ("National Academy of Design," 5, cols. 5–6, clipping in NAD review files, collection of William H. Gerdts). Regarding the approximate date of the smaller painting, see object card, photocopy in curatorial painting file, Wadsworth Atheneum.

12. Heermann, *Frank Duveneck*, 70.

13. Robert Neuhaus, *Unsuspected Genius: The Art and Life of Frank Duveneck* (San Francisco: Bedford Press, 1987), xii.

14. In *Charles Dudley Warner* (New York: McClure, Phillips, 1904), 84–89, 101, Warner's early biographer, Mrs. James T. Fields, placed Warner in Hartford in the years 1876 through 1877 and not in Munich until December 1881, when Duveneck was in Venice (see chronology in Neuhaus, *Unsuspected Genius*, 141–143).

15. "Choice Treasures at Hartford Art Society This Week," *Hartford Courant*, December 1926, Archives of American Art, roll 2552, frame 509, Wadsworth Atheneum. The reviewer, writing about the portrait and two etchings by Duveneck, notes, "All three are executed in the Dutch master's best style, and about them there is an intimate story. When Mr. and Mrs. Warner were abroad they met Duveneck who was just mounting the ladder to success. He soon became an intimate friend of the Warner family and the etchings, which are inscribed to Mrs. Warner and the painting were among the works which brought him into fame."

Thomas Eakins

Born in Philadelphia, in 1844; died in Philadelphia, in 1916

Thomas Eakins began his formal art training in his native city at the Pennsylvania Academy of the Fine Arts in 1862. In 1866 he went to Paris, where he entered the studio of Jean-Léon Gérôme (1824–1904) at the Ecole des Beaux-Arts. Over one hundred fifty American artists would study with Gérôme between 1863 and his death. His emphasis on drawing had a considerable influence on Eakins's development. In the summer of 1869 Eakins completed his Parisian studies in the atelier of Léon Bonnat. In deteriorating health and in need of a rest, the artist traveled to Spain in 1869, where he was inspired by the realism seen in the works of Velázquez, Ribera, and Goya.

On his return to Philadelphia in 1870, Eakins set up a studio where he painted portraits of family and friends and scenes of sporting activities. In 1874 he began teaching life classes organized by the Philadelphia Sketch Club, and in 1879 he became professor of drawing and painting at the Pennsylvania Academy of the Fine Arts, replacing his former instructor, Christian Schussele (1824–1879). In 1875 Eakins completed his most important work of this time, the masterful and controversial composition *The Gross Clinic* (1875, Medical College of Thomas Jefferson University, Philadelphia). He became director of the Pennsylvania Academy Schools in 1882 and continued to teach there until 1886, when he was forced to resign because of his advocacy of the study of the nude in mixed classes. He continued to teach at the Art Students' League of Philadelphia from 1886 to 1892. Eakins also lectured on anatomy at the National Academy of Design and the Drexel Institute.

In spite of the controversy surrounding his teaching methods and the lack of public support, Eakins continued to paint, mostly portraits. He exhibited at several major exhibitions and received medals at the World's Columbian Exposition in Chicago in 1893, the Louisiana Purchase Exposition in St. Louis in 1904, and at the Pan-American Exposition in Buffalo in 1901. He was invited to exhibit at the Pennsylvania Academy of the Fine Arts in 1884–1885 and sent works there regularly until his death. In 1902 Eakins became both an associate and academician of the National Academy of Design.

SELECT BIBLIOGRAPHY

Lloyd Goodrich, *Thomas Eakins: His Life and Work* (New York: Whitney Museum of American Art, 1933) / Theodore Siegl, *The Thomas Eakins Collection* (Philadelphia: Philadelphia Museum of Art, 1974) / Lloyd Goodrich, *Thomas Eakins*, 2 vols. (Cambridge: Harvard University Press, 1982) / Elizabeth Johns, *Thomas Eakins: The Heroism of Modern Life* (Princeton, N.J.: Princeton University Press, 1983) / Natalie Spassky, *American Paintings in the Metropolitan Museum of*

Art, vol. 2, ed. Kathleen Luhrs (Princeton, N.J.: Princeton University Press, in association with the Metropolitan Museum of Art, 1985) / Kathleen A. Foster and Cheryl Leibold, *Writing About Eakins* (Philadelphia: University of Pennsylvania Press, for the Pennsylvania Academy of the Fine Arts, 1989) / H. Barbara Weinberg, *The Lure of Paris: Nineteenth-Century American Painters and Their French Teachers* (New York: Abbeville Press, 1991) / William Inness Homer, *Thomas Eakins: His Life and Art* (New York: Abbeville Press, 1992)

183 (see plate 55)

THOMAS EAKINS

On the Delaware (Becalmed), 1874

Oil on canvas: 10⅛ × 17⅛ in. (25.7 × 43.5 cm)

Inscribed (probably by Eakins's friend and pupil Charles
 Bregler in preparing the painting for sale or exhibi-
 tion; inscription partially abraded) at lower right: E

Signed on back of canvas at lower right: T. E. 1874

EXHIBITED: Philadelphia, Pennsylvania Academy of the Fine Arts, "Memorial Exhibition of the Works of the Late Thomas Eakins," 1917–1918, no. 59, as "Becalmed"[1] / New York City, Joseph Brummer Gallery, "Paintings and Drawings by Thomas Eakins," 1925, no. 12, as "Becalmed" / Buffalo, N.Y., Albright Art Gallery, 1926, as "Becalmed" / New York City, Babcock Gallery, "Paintings," 1927, as "Becalmed" / New York City, Babcock Gallery, "Eakins' Works," 1930–31, no. 4, as "Becalmed" / New York City, Kleeman Gallery, "Important Paintings," 1937, as "Becalmed" / New York City, Babcock Gallery, "Pictures from the Estate of Mrs. Eakins," 1939, no. 5, as "On the Delaware"[2] / New York City, Art Students League, "Fifty Years on Fifty-seventh Street," 1943 / Wadsworth Atheneum, "Off for the Holidays," 1955, no. 48 / Hamilton, Ontario, Canada, Art Gallery of Hamilton, "American Realists," 1961, no. 17 / Washington, D.C., National Gallery of Art; Art Institute of Chicago; and Philadelphia Museum of Art, "Retrospective Exhibition of Works by Thomas Eakins," 1961–62 / Newport, R.I., "The Coast and the Sea: A Loan Exhibition Assembled from the Collection of the Wadsworth Atheneum, Hartford," 1964, no. 12 / New York City, Whitney Museum of American Art, "Seascape and the American Imagination," 1975, no. 99 / Wadsworth Atheneum, "The Hudson River School: Nineteenth-Century American Landscapes in the Wadsworth Atheneum," 1976, no. 88 / Trenton, N.J., New Jersey State Museum; Wilmington, Del., Delaware Art Museum; and

Binghamton, N.Y., Art Gallery of the State University of New York, "Nineteenth Century Painters of the Delaware Valley," 1983

EX COLL.: estate of Mrs. Eakins to 1939; with E.C. Babcock Gallery, New York City, in 1939; to Henry Schnakenberg, New York, 1939

Gift of Henry Schnakenberg, 1967.36

Sailing, whether for competition or leisure, was a popular sport on the Delaware River. From May to October, hundreds of sailing enthusiasts set their courses from above Philadelphia's northern limits at Torresdale, southward to Chester, and some fifty to sixty miles downstream toward the Atlantic.[3] Eakins himself was a sailing enthusiast and spent much time on the river.[4] From 1874 to 1875, he painted several sailing scenes of the Delaware near Philadelphia, in which he explores the subtle effects of light that infuse and unify the scene.[5] His landscapes and boating scenes, executed in both oil and watercolor, have been linked to the tradition of luminism in American painting.[6]

In *On the Delaware*, Eakins uses a limited palette of monochromatic hues of gray and blue in his depiction of a sailing race on a calm, hazy summer day. The water surface shimmers and reflects the tall-masted boats and the red shirt of the figure in the rowboat to the left. The artist includes a steamboat, a two-masted schooner, a three-masted square-rigger, several catboats, and the spectators seen in the row boat. Eakins's interest, however, is not in the details of the boats and figures, but in the overall tone of the scene.

As Kathleen Foster has noted, *On the Delaware* is one of four compositions Eakins painted recording a single event that occurred in 1874, which Eakins relates in a letter to his good friend Earl Shinn: "A drifting race. It is a still August morning 11 o'clock. The race has started down from Tony Brown's at Gloucester on the ebb tide. What wind there is from time to time is astern & the big sails flop out some one side & some the other. You can see a least little breeze this side of the vessels at anchor. It turns up the water enough to reflect the blue sky of the zenith. The row boats and sail boats in the foreground are not the racers but starters & lookers

Thomas Eakins, *Ships and Sailboats on the Delaware: Study*, 1874. Pennsylvania Academy of the Fine Arts, Philadelphia. Charles Bregler's Thomas Eakins Collection. Purchased with the partial support of the Pew Memorial Trust and the Henry S. McNeil Fund.

Thomas Eakins, *Ships and Sailboats on the Delaware*, 1874. Philadelphia Museum of Art, given by Mrs. Thomas Eakins and Miss Mary Adeline Williams.

on."[7] Eakins first painted a small oil study, *Ships and Sailboats on the Delaware: Study*, in which he depicts three of the sailboats that he includes in his subsequent full oil version *On the Delaware (Becalmed)*.[8] Later in 1874 Eakins revised the composition for a similar painting, *Ships and Sailboats on the Delaware*, which he considered his most satisfying version, sending it to the Paris Salon (via his instructor Gérôme). In this painting,

the artist placed the schooner and square-rigger to the left and achieved a warmer tone.[9]

By 1873 Eakins had become interested in watercolor, perhaps inspired by a large and important exhibition held by the Watercolor Society that year.[10] He followed the practice of painting oils first in preparation for later watercolors. Before he sent *Ships and Sailboats on the Delaware* to Paris, he executed a watercolor of similar

composition, *No Wind—Race Boats Drifting* (1875, private collection), which he exhibited at the Watercolor Society's show in 1875.[11] In the medium of watercolor, Eakins successfully captured the transparent qualities of the still water and the reflections of the boats. Compositionally, *On the Delaware* relates closely to *Drifting*, the only marked difference being that the rowboat is closer in the watercolor. In both versions, the sky and water are unified by monochromatic tones, and the horizon line dominates. ERM

1. *Becalmed* was renamed *On the Delaware* sometime before 1933. In *Thomas Eakins: His Life and Work* (New York: Whitney Museum of American Art, 1933), 167, Lloyd Goodrich lists the painting as *Ships and Sailboats on the Delaware*.

2. A review of this exhibition discussed *On the Delaware* in the context of other landscapes by Eakins and claimed it to be a "better example of the painter's abilities" (*Art News* 38 [November 11, 1939], 11).

3. Gordon Hendricks, "*On the Delaware* by Thomas Eakins," *Bulletin of the Wadsworth Atheneum* 4 (spring/fall 1968), 40–45.

4. Lloyd Goodrich, *Thomas Eakins* (Cambridge: Harvard University Press, 1982), 87.

5. William Inness Homer, *Thomas Eakins: His Life and Art* (New York: Abbeville Press, 1992), 68.

6. Ibid.

7. Thomas Eakins to Earl Shinn, January 30, 1875, quoted in Theodore E. Stebbins, Jr., *The Hudson River School: Nineteenth-Century Landscapes in the Wadsworth Atheneum*, exh. cat. (Hartford: Wadsworth Atheneum, 1976), 88. The original letter is in Friends Historical Library, Swarthmore College, Swarthmore, Pa. See Kathleen Foster, *Thomas Eakins Rediscovered: Charles Bregler's Thomas Eakins at the Pennsylvania Academy of the Fine Arts* (New Haven: Yale University Press, 1994), no. 233; and Kathleen Adair Foster, *Makers of the American Watercolor Movement: 1860–1890*, 2 vols. (Ph.D. diss., Yale University, 1982; Ann Arbor, Mich.: University Microfilms International, 1987), 1:216.

8. For the most up-to-date information on this work and its relationship to the other related works, see Foster, *Thomas Eakins Rediscovered*, cat. 233. In *Thomas Eakins* (1933), Goodrich called this small oil a "study," whereas the catalogue of Eakins's 1944 centennial exhibition at M. Knoedler and Co. called it a "sketch." Both Goodrich and the Knoedler cataloguer said the work was 7 by 10¾ inches (17.8 × 27.3 cm) and on canvas mounted on cardboard. At the time of the 1944 show it belonged to Eakins's pupil Charles Bregler, and, according to Knoedler records, it was returned to the owner after the show (Hendricks, "On the Delaware," 41–42).

9. Goodrich, *Thomas Eakins* (1933), 167.

10. Foster, *Makers of the American Watercolor Movement*, 1:206.

11. Ibid., 1:216, 21. This watercolor is also known as *Drifting* and *Waiting for a Breeze*. See Goodrich, *Thomas Eakins* (1982), 89.

184 (see plate 56)

THOMAS EAKINS

John McLure Hamilton, 1895

Oil on canvas; 80 × 50¼ in. (203.2 × 127.6 cm)

Inscribed, signed, and dated at lower left: To my friend / Hamilton / Eakins 95

EXHIBITED: New York City, National Academy of Design, 1895, no. 430, as "Portrait of J. McL. H." / Philadelphia, Pennsylvania Academy of the Fine Arts, Sixty-fifth Annual Exhibition, 1895 / New York City, Metropolitan Museum of Art, "Memorial Exhibition of the Works of Thomas Eakins," 1917, no. 31 / Philadelphia, Pennsylvania Academy of the Fine Arts, "Memorial Exhibition of the Works of the Late Thomas Eakins," 1918, no. 134 / Philadelphia, "The Sesquicentennial International Exposition," 1926 / Philadelphia Museum of Art, "An Exhibition of Thomas Eakins' Work," 1930, no. 168 / Philadelphia Museum of Art, "The Thomas Eakins Centennial Exhibition," 1944, no. 284 / New York City, Knoedler Galleries, "Thomas Eakins Centennial Exhibition," 1944, no. 51 / Wilmington, Del., Wilmington Society of Fine Arts, "Paintings by Thomas Eakins," 1944, no. 51 / Wadsworth Atheneum, "In Retrospect: Twenty-One Years of Museum Collecting," 1949, no. 30 / New York City, Fifty-Sixth Street Galleries, "Paintings by Thomas Eakins," n.d., no. 1

EX COLL.: John McLure Hamilton, Esq., in 1895; to Mrs. Thomas Eakins, Philadelphia, by 1917; to Stephen C. Clark, Esq., New York City, by 1933, to 1947; to Francis P. Garvan in 1947; with M. Knoedler Galleries, New York City, in 1947

The Ella Gallup Sumner and Mary Catlin Sumner Collection Fund, 1947.399

Eakins began concentrating on portraits after he was forced to resign as director of the schools of the Pennsylvania Academy of the Fine Arts in 1886.[1] From 1891 to 1906 he worked exclusively on portraits, exhibiting many. These large-scale portraits of individuals brought

him recognition from his contemporaries and the new generation of artists.[2] His sitters included Philadelphia's leading citizens—individuals who made contributions in science, art, music, medicine, and education; in his portraits, Eakins sought to honor these eminent citizens, whom he greatly admired and considered heroes.[3] Eakins also painted portraits of family members and friends.

In *John McLure Hamilton*, Eakins painted a thoughtful portrait of his friend and colleague, also a portrait painter. Hamilton (1853–1936), also of Philadelphia, studied with Eakins at the Pennsylvania Academy of the Fine Arts and became a portrait painter of prominent Englishmen, spending most of his time in London, though making frequent visits to the United States.[4] In connection with the memorial exhibition of Eakins's work held at the Metropolitan Museum in New York City in 1917, Hamilton contributed an appreciation, in which he claimed Eakins as a great portrait painter deserving of long-overdue recognition.[5]

John McLure Hamilton is one of a series of full-length standing portraits that includes *The Dean's Roll Call* (1899, Museum of Fine Arts, Boston), *The Thinker* (1900, Metropolitan Museum of Art), and *Portrait of Leslie W. Miller* (1901, Philadelphia Museum of Art).[6] In these single figure portraits, the artist focused on the psychology and character of his subjects rather than their physical and fashionable appearances; his realism extended to asking his sitters to wear egalitarian, worn clothing. Here, the figure stands against an undefined background. As is typical of the artist's standing figures, the subject does not look out at the viewer but gazes introspectively to the side. The somber portrait emphasizes the central role of the human mind, which was paramount for Eakins.

Eakins used a limited palette of browns in his depiction of Hamilton and the background. A soft light from an unknown source illuminates the subject's contemplative face, which is the focal point of the composition. An indefinite space behind the figure carries shadows cast by the legs. Though painted in loose and thinly layered brushstrokes, the portrait was not painted rapidly. There is evidence that Eakins made alterations during the painting's execution. The area around both legs shows signs of changes, as does the bottom left section of the jacket. The inscription and signature were written in perspective as if on the floor, a technique Eakins employed in several of his portraits and figure paintings. The precise, flowing Spenserian style of the lettering recalls that of his father, Benjamin Eakins, a penmanship master.[7]

Eakins made a preliminary oil sketch of the portrait, *Study for Portrait of John McLure Hamilton*, in which he used a drawn grid to establish the composition of the figure and palette. He was not interested in the details of the face and the space surrounding the subject until the final portrait.

John McLure Hamilton was exhibited at the National Academy of Design the year it was painted.[8] ERM

Thomas Eakins, *Study for Portrait of John McLure Hamilton*, c. 1895. Georgia Museum of Art, University of Georgia, Eva Underhill Holbrook Memorial Collection of American Art, gift of Alfred H. Holbrook. Photograph: Michael McKelvey.

1. Darrel Sewell, *Thomas Eakins: Artist of Philadelphia*, exh. cat. (Philadelphia: Philadelphia Museum of Art, 1982), 104.
2. Ibid.
3. Elizabeth Johns, *Thomas Eakins: The Heroism of Modern Life* (Princeton, N.J.: Princeton University Press, 1983), 150, 151.
4. Peter Falk, ed., *Who Was Who in American Art* (Madison, Conn.: Sound View Press, 1985), 258.
5. J. McLure Hamilton, "Thomas Eakins: Two Appreciations," *Bulletin of the Metropolitan Museum of Art* 12 (November 1917): 218–220.
6. Natalie Spassky, *American Paintings in the Metropolitan Museum of Art*, ed. Kathleen Luhrs (Princeton, N.J.: Princeton University Press, in association with Metropolitan Museum of Art, 1985), 2:622.
7. Goodrich, *Thomas Eakins* (1933), 320.
8. In Maria Naylor, *National Academy of Design Exhibition Record: 1861–1900* (New York: Kennedy Galleries, 1973), 1:256, the painting is listed as belonging to John McLure Hamilton, Esq. It is not known exactly when the painting became part of Mrs. Thomas Eakins's collection.

Ralph Earl

Born in Leicester, Mass., in 1751; died in Bolton, Conn., in 1801

Ralph Earl was raised in Worcester County, Massachusetts, the son of Ralph Earll and Phebe Wittemore Earll, farmers. In 1774 Earl, determined to become a painter, turned his back on his agrarian roots and established himself as a fledgling artist in New Haven, Connecticut. There he painted the portraits of a number of leading patriots, including his early masterwork *Roger Sherman* (1775–1776, Yale University Art Gallery, New Haven), which demonstrate his admiration for and emulation of the colonial portraits of John Singleton Copley (q.v.). Earl also collaborated with a New Haven colleague, the engraver Amos Doolittle, to produce sketches for four engravings of the 1775 Battle of Lexington and Concord, among the first historical prints in America. Despite his seemingly patriotic endeavors, Earl declared himself a loyalist, and in 1778, with the assistance of a young British officer, Captain John Money, he fled to England, deserting his first wife, Sarah Gates Earl (1755–1831), and their two children.

During his eight-year stay in England, Earl divided his time between Norwich, the site of Captain Money's country estate in the province of East Anglia, and Lon-

don. His early years were spent painting portraits for the Norwich country gentlefolk. By 1783 Earl was part of the entourage of American artists in the London studio of Benjamin West (q.v.), where he absorbed the lessons of the British portrait tradition. His highly accomplished London and Windsor portraits, many of which he showed at the Royal Academy exhibitions, display a variety of British portrait forms, including military portraits and sporting pictures, as well as a growing interest in landscape art, evidenced in their scenic backgrounds.

Earl became the first of West's students to return to America after the war. In 1785, with his second wife, Ann Whiteside Earl (1762–1826) of Norwich, the artist arrived in Boston, where he introduced his fashionable British portrait style to America. He quickly established a residence in New York City; however, his ambitious start came to a sudden halt when he was confined to debtor's prison there. Earl remained in prison from September 1786 until January 1788. During his incarceration, he attracted the support of a recently formed benevolent organization, the Society for the Relief of Distressed Debtors. Composed of the most illustrious New York families, this group came to the artist's aid by engaging him to paint portraits of themselves, their families, and their friends while he was still in prison. With such elegant works as *Mrs. Alexander Hamilton* (1787, Museum of the City of New York), as well as a series of portraits of recent heroes of the American Revolution, images that celebrated his sitters' membership in the newly formed Society of the Cincinnati, he earned enough money to obtain his release.

Earl's release from debtor's prison marked a turning point in his career. Up to that point, his ambition to succeed as an artist against all odds had led to the degradation of his personal life, involving bigamy, imprisonment, and alcoholism. His court-appointed guardian, Dr. Mason Fitch Cogswell, convinced the artist to leave New York City and follow him to Connecticut, where Cogswell provided him with portrait commissions. With this change, Earl regained stability for himself and his family (he and Ann had had two children). He modified his artistic ambitions, moving away from his English experience in order to ply his trade as an itinerant artist in

the agriculture-based society of Connecticut. He found his greatest success in this region, where, with Cogswell's impressive connections, he painted for ten years, from 1788 to 1798.

Earl furthered the formation of a national imagery by portraying a segment of American society that had never before received the attention of a trained and highly gifted artist. More than any other artist of his time, Earl was qualified to create an appropriate style to satisfy the aesthetic sensibilities of his Connecticut subjects. He achieved the desired effect in his portraits by a deliberate rejection of British aristocratic imagery, cleverly tempering his academic style to suit his subjects' modest pretensions. He abandoned the formal qualities of his English and New York portraits in favor of more realistic portrayals of his subjects' likenesses and surroundings, including their attire, locally made furnishings, newly built houses, regional landscape features that celebrated landownership, and emblems of the new nation. In addition, Earl adapted a more simplified technique, using broad brushstrokes and favoring primary colors, which were more widely available in the remote regions in which he worked. The portraits he painted during his occasional visits to New York City clearly demonstrate his ability to alter his style to suit his patron's wishes: in the city, he reverted to the more loosely executed brushwork, subtle palette of pastel hues, and warm glazes that reflected his English experience.

Earl was one of the few American artists in the 1790s to receive commissions for landscape paintings, an art form that was still scarce in his native country. While in England, he had witnessed the rise of the genre as a mode of high artistic expression. When he returned to America, landscape art was already taking on a new artistic and intellectual significance in the young nation. Earl had already contributed to the development of landscape art in New England through the inclusion of regional landscape features in his portraits, thereby establishing a taste for landscape among his sitters. By 1796 he began to receive a number of commissions for pure landscapes of his patron's newly built houses.

In 1798 Earl left Connecticut, moving north to Vermont and Massachusetts in search of new portrait and landscape commissions; his wife and children settled in Troy, New York. (During this period, the artist's son, Ralph Eleasor Whiteside Earl [1785 or 1788–1838], began traveling with his father, learning the art of painting.) During a visit to Bennington, Vermont, in 1798, Earl painted an impressive series of portraits and one landscape that reveal a renewed artistic vitality. The artist then traveled eastward to Northampton, Massachusetts, where he painted another series of portraits and engaged in his final, and perhaps most challenging, entrepreneurial venture. In 1799, with the assistance of two local men, Earl became the first American artist to travel to Niagara Falls, where he took sketches of the "stupendous cataract." Returning to Northampton after this arduous journey, he produced a panorama of the falls that measured approximately 15 by 30 feet (about 4.5 × 9 m). With great fanfare, the panorama was first placed on public view in Northampton and subsequently in New Haven and Philadelphia; eventually, in 1800, it traveled on to London.

In 1800 Earl returned to his native town of Leicester, Massachusetts, where he painted a final panoramic landscape, of the region in which he was raised, entitled *Looking East from Denny Hill* (1800, Worcester Art Museum, Worcester, Massachusetts). The artist's idyllic view, with its seemingly limitless fertile farmlands and prosperous town centers, conveys a sense of well-being and the promise of America. One year later, Earl traveled to Bolton, Connecticut, where he died at the home of Dr. Samuel Cooley. In his diary, a local minister cited the cause of death as "intemperance" (Rev. George Colton, Diary, Connecticut Historical Society, Hartford).

As a result of his popular acceptance, Earl's Connecticut portrait style began to generate a number of imitators by the mid-1790s; indeed, this may have accounted for his decision to leave the state by the end of the decade. Because his innovative portraits were accessible models for his less-trained, less-traveled contemporaries, his style has come to be associated with portraiture in New England, and Earl is now known as the initiator of the so-called Connecticut school of portrait painters.

SELECT BIBLIOGRAPHY

William Sawitsky and Susan Sawitsky, "Two Letters from Ralph Earl with Notes on His English Period," *Worcester Art Museum Annual* 8 (1960), 8–41 / Elizabeth Mankin Kornhauser, "Ralph Earl as an Itinerant Artist: Pattern of Patronage," in Peter Penes, ed., *Itinerancy in New England and New York: Annual Proceedings of the Dublin Seminar for New England Folk Life, 1984* (Boston: Boston University, 1986), 9:172–190 / Elizabeth Mankin Kornhauser, *Ralph Earl: Artist-Entrepreneur* (Ann Arbor, Mich.: University Microfilms International, 1989) / Elizabeth Mankin Kornhauser, with Richard L. Bushman, Stephen H. Kornhauser, and Aileen Ribeiro, *Ralph Earl: The Face of the Young Republic*, exh. cat. (New Haven: Yale University Press, 1991) / Elizabeth Mankin Kornhauser, "'By Your Inimmitable [*sic*] Hand': Elijah Boardman's Patronage of Ralph Earl," *American Art Journal* 23, no. 1 (1991), 4–20

185 (see plate 57)

RALPH EARL

Colonel Samuel Talcott, c. 1791–1792

Oil on canvas; 71¼ × 53¾ in. (181.0 × 136.5 cm)

Technical note: The canvas is in three sections, pieced with two vertical seams; the original frame was tacked directly to the canvas surface.

EXHIBITED: Washington, D.C., National Portrait Gallery; Wadsworth Atheneum; and Fort Worth, Tex., Amon Carter Museum, "Ralph Earl: The Face of the Young Republic," 1991, no. 42

EX COLL.: descended in the Talcott family to Colonel Phillip S. Wainwright; purchased from Wainwright's heirs by the Wadsworth Atheneum in 1963

The Ella Gallup Sumner and Mary Catlin Sumner Collection Fund, 1963.32

Earl's penetrating depiction of this aged Hartford gentleman is a tribute to the artist's ability to convey the conservative and pious values held by many of his Connecticut subjects. Colonel Samuel Talcott (1711–1797), a third-generation scion of a distinguished and wealthy family, was the son of Joseph Talcott, who had served as the colonial governor of Connecticut from 1724 to 1741. Samuel graduated from Yale College in 1733 and six years later married into an equally affluent and prominent family when he wed Mabel Wyllys, the daughter of Hezekiah Wyllys. He inherited his father's mansion house on Main Street and Talcott Lane in Hartford, where he and his family (which eventually included eight children) lived, along with a sizable estate that comprised extensive land holdings. Although he served in various public offices, Talcott's wealth allowed him to devote much of his time to managing his extensive estate.[1] At the time of his death, he owned sixteen hundred acres of land and he owned five houses in addition to the "Old Mansion house."[2]

Earl seems to have taken pleasure in capturing his subject's stern New England visage, which is locked in a humorless scowl. Talcott is stiffly seated in Earl's stock upholstered red armchair, with what appears to be an arthritic right hand resting on the chair arm. A well educated man, Talcott's sizable library is suggested by the bookcase behind him.[3] Of his costume, Aileen Ribeiro points out,

> The portrait is almost Puritan in the austerity of the costume, and the defiantly inelegant pose; here is a man whose plainness of attire is almost a creed. His suit of black silk velvet is formal and rather old-fashioned; the buttons are silk, quartered in the style known as death's head. His white linen cravat is plain, knotted round the neck and poking through the vest unbuttoned at mid-chest level; this is a style dating from the middle of the eighteenth-century. His wig, also, dates from the 1750s, a style—fashionable in his youth—known as a physical wig; it was characterized by a wide frizz of hair standing out round the sides and back of his head from above the ears to the shoulders. From the middle of the eighteenth-century it was usually preferred by members of the learned professions, especially medical. It would have been regarded as extremely old-fashioned at the time Earl painted this portrait. The wig is heavily powdered, much of it falling onto the shoulders of the coat. He wears plain white silk stockings (no fine embroidery here) and plain silver breech and shoe buckles.[4]

Perhaps at the suggestion of his sitter, Earl devoted a large portion of the canvas to the elaborate landscape seen through the window, which depicts Talcott's property, extending to the Connecticut River. The view includes sailboats on the river and the distant eastern bank, dotted with houses. In 1761 Talcott had granted a right of passage for the town's inhabitants through his property to the main street of Hartford.[5] The fenced path in the foreground of the view through the window may represent this public passageway. That Talcott was noted as a strict Congregationalist is insinuated by Earl's inclusion of two church steeples. On the far right of the distant landscape, Earl depicts the famous Charter Oak, where, according to legend, the original charter of Connecticut was hidden in 1687 (cat. 62). The tree stood on the property of Talcott's mother's ancestors, the Wyllys family, and had become by the 1790s a symbol for the state's inhabitants of their spirit of independence.[6] EMK

1. S. V. Talcott, *Talcott Pedigree in England and America* (Albany, N.Y., 1876), 39,46, 85–86; and William G. Wendell, "Colonel Samuel Talcott and His Portrait by Ralph Earl," *Bulletin of the Wadsworth Atheneum*, ser. 6, 1 (winter 1965), 23–25.
2. Probate inventory, Colonel Samuel Talcott, Hartford, 1797, reel 601, Connecticut State Library, Hartford, indicates that his total estate was valued at 9,447 pounds 19 shillings plus $120.25.
3. Talcott's probate inventory indicates that he owned ninety-four books.
4. Aileen Ribeiro, "Costume Note," in Elizabeth Mankin Kornhauser, with Richard L. Bushman, Stephen H. Kornhauser, and Aileen Ribeiro, *Ralph Earl: The Face of the Young Republic*, exh. cat. (New Haven: Yale University Press, 1991), 184.
5. John R. Campbell, "Governor Talcott's Mansion and the City of Hartford's Claim," *Connecticut Magazine* 6 (July–August 1900), 359–361.
6. Kornhauser et al., *Ralph Earl*, 53.

186 (see plate 58)

RALPH EARL
Oliver Ellsworth and Abigail Wolcott Ellsworth, 1792
Oil on canvas; 76 × 86³/₄ in. (193.0 × 220.4 cm)
Signed and dated at lower left: R. Earl Pinxt 1792

Technical note: The canvas is in three sections, pieced with two vertical seams that run along the outer window moldings.

EXHIBITED: New Haven, Yale University Art Gallery, "Connecticut Portraits by Ralph Earl," 1935, no. 14 / New York City, Metropolitan Museum of Art, "Life in America," 1939, no. 47 / Pittsburgh, Pa., Carnegie Institute, "Survey of American Painting," 1940, no. 10 / New York City, Whitney Museum of American Art, "Art of the United States: 1670–1955," 1966, no. 86 / Waterville, Maine, Colby College Art Museum, "American Arts of the Eighteenth Century," 1967 / Storrs, Conn., William Benton Museum, "The American Earls," 1972, no. 10 / Fort Worth, Tex., Amon Carter Museum of American Art, "The Face of Liberty," 1975 / College Park, Pa., Pennsylvania State University Museum of Art, "Portraits USA 1776–1976," 1976 / Wadsworth Atheneum, "The Great River: Art and Society in the Connecticut River Valley, 1635–1820," 1985–1986, no. 45 / Washington, D.C., National Portrait Gallery; Wadsworth Atheneum; and Fort Worth, Tex., Amon Carter Museum, "Ralph Earl: The Face of the Young Republic," 1991, no. 41

EX COLL.: commissioned by Oliver and Abigail Ellsworth, Windsor, Conn., in 1792; descended in the Ellsworth family, remaining in the house, Elmwood, in Windsor, Conn., from 1792 to 1903

Gift of the Ellsworth Heirs, 1903.7

With great elation, Oliver Ellsworth reported to his wife, Abigail, on June 7, 1790, that "the Constitution is now adopted by all the States, and I have much satisfaction & perhaps some vanity in seeing at length a great work finished for which I have long labored incessantly."[1] Two years later, the Ellsworths commissioned Earl to paint a monumental double portrait of them that celebrated their respective roles in the formation of the new nation—Oliver as an ardent patriot and leader of the new republic and Abigail as the keeper of their domestic world. One of Earl's greatest efforts, this portrait is an icon of the constitutional period and served as a model for many Connecticut painters of the period.[2]

Oliver Ellsworth (1745–1807), the second son of a Windsor, Connecticut, farmer, attended Yale College in preparation for the ministry. After his expulsion from Yale at the end of his sophomore year, he completed his

education at Princeton College in 1766. Eventually rejecting a career in the ministry in favor of the law, he rapidly emerged as one of Connecticut's most powerful political figures and successful lawyers. He further strengthened his position by marrying into one of the state's prominent families when, in 1772, he wed Abigail Wolcott (1756–1818), second cousin of Oliver Wolcott, Sr. During the Revolutionary War, he served as delegate to the Continental Congress; after the war, his service would ascend to a national and international level.

At the Constitutional Convention, Oliver Ellsworth was instrumental in securing the famous Connecticut Compromise, which ended the struggle between large and small states over representation, and he was also responsible for the use of the term *United States* in the Constitution. Under the pseudonym "A Landowner" he published a series of letters in favor of ratification. When his portrait was painted, he was an active member of the U.S. Senate, responsible for drafting the Judiciary Bill and an up-and-coming leader of the Federalist Party. He abandoned his seat in the Senate when Washington appointed him chief justice of the Supreme Court in 1796. In 1800, at the request of President John Adams, he served as a special minister in Paris, charged with preventing a Franco-American war.[3]

The Ellsworths were painted at their home in Windsor, which had been built between 1781 and 1783 by Samuel Denslow.[4] During the 1780s, while active in national politics, Oliver managed at the same time to improve his modest financial situation by building a thriving law practice, acquiring lands and real estate on speculation and lending money.[5] When their portrait was painted, the Ellsworths were able to have their house enlarged and modernized by the local architect Thomas Hayden.[6] Originally painted red, the house was repainted white, to match the newly added south wing. Oliver and Abigail are seated in two of a set of six Federal shield-back chairs (Ellsworth Homestead and Wadsworth Atheneum collections) designed by Aaron Chapin of Hartford and recently acquired for their new Palladian-style parlor. The chairs are the earliest datable examples of neoclassical seating furniture in the Connecticut River Valley. Earl's portrait of the Ellsworths, which

hung in the new, fashionably furnished parlor, was the final symbol of their ascendancy to a position of political and social leadership.

Earl's ingenious composition chronicled the most important aspects of his sitters' lives, including an illogical view through the window of their newly renovated house. The view accurately represents the recently built south wing. The neatly painted fences, sapling elm trees "set out by [Ellsworth's] hand," and the distant view of the houses on the eastern bank of the Connecticut River complete the scene.[7] Toward the end of his life, Oliver expressed his great sense of regional pride, a sentiment that Earl beautifully communicated in this portrait: "I have been in all the states, and Connecticut is the best state. Windsor is the pleasantest town in the state of Connecticut, and I have the pleasantest place in Windsor. I am content to die on the banks of the Connecticut."[8]

Rather than making a reference to Ellsworth's current position as a U.S. senator, here Earl celebrates Oliver Ellsworth's role in drafting, ratifying, and amplifying the Constitution. Staring boldly out at the viewer with his piercing blue eyes, he holds a copy of the new Constitution in his left hand; on it, Earl has inscribed passages from the last two articles. Behind the figure of Oliver, red drapery is drawn back to reveal shelves of books, a reference to his extensive library, one of the largest in the state: when he died, he owned 632 volumes, most dealing with law and political philosophy.[9]

Earl portrays Abigail Wolcott with a stern visage, in sharp contrast with her rich surroundings. Earl shows the effects of her arduous life in this truthful likeness: she was only thirty-six when the portrait was painted, but she had borne the last of her nine children the year before and appears much older than her years. In addition to tending to her children, Abigail arranged for the construction and later renovation of the house and supervised the maintenance of the property and gardens because Oliver was away from the family home for extended periods of time. His letters to his wife, particularly in the 1780s, when he was in Philadelphia for lengthy periods, express occasional alarm at her "low spirits" and reveal the conflict between his love for his wife and children and his desire to serve the public.[10]

Oliver Ellsworth homestead, Windsor, Connecticut. Photograph:David Stansbury.

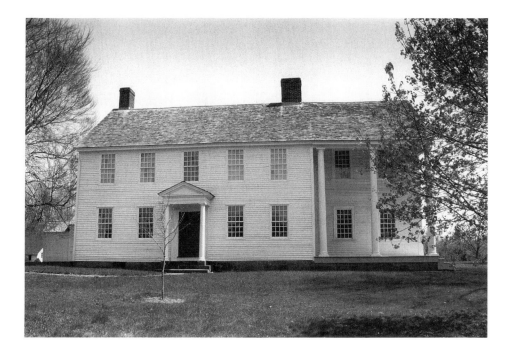

Earl softened somewhat the severity of Abigail's likeness by using voluminous red drapery as a backdrop. Symbolically, he related her figure more directly than her husband's to the detailed view of the newly renovated house and cultivated fields: perspective directs the viewer's eye from Abigail's figure to the landscape beyond, whereas the window molding cuts off Oliver's figure from the exterior. In addition, the drapery joins the figure of Abigail Ellsworth to the view of the house and property. (An artistic alteration can be seen behind the figure of Oliver; Earl originally placed red drapery there as well but later changed the backdrop to a bookcase.) The copy of the Constitution placed between the couple symbolizes the personal sacrifices each had made to bring about its ratification.

Oliver Ellsworth wears a dark blue frock coat decorated with brass buttons, a white silk vest, black silk breeches, white silk stockings, and black leather shoes with the large Artois buckles first seen in fashionable footwear in the 1780s and worn by most men at the time the portrait was painted. The coat has an unusual feature (for American dress): a red collar. Dark blue coats with red collars were popular in England during the 1770s, and in 1778 George III introduced the Windsor uniform at court, which included a coat of dark blue with a collar and cuffs of red. Whether the similarity between the Windsor uniform and Oliver's coat is intended as a sartorial reference to his much-loved home in Windsor, Connecticut, is not clear.[11]

Abigail Ellsworth's costume is slightly old-fashioned but with some modish features. The rather formal open gown is white silk, possibly lustring, a fabric that had largely replaced heavier silks during the 1790s; it consists of a robe (the contemporary word) with long tight sleeves to the wrist and a skirt of matching silk.[12] The bodice front cannot be seen behind the starched muslin collar tucked into the waist sash to cover the décolletage of the dress. Over her hair—either naturally gray or made so with a dusting of pale powder—Abigail wears a starched muslin mobcap; this type of headdress was virtually a uniform among women of her age and class. EMK

1. Oliver Ellsworth to Abigail Ellsworth, June 7, 1790, Oliver Ellsworth Papers, Connecticut Historical Society, Hartford.
2. Elizabeth Mankin Kornhauser and Christine Skeeles Schloss, "Painting and Other Pictorial Arts," in *The Great River: Art and Society of the Connecticut Valley, 1635–1820,* exh. cat. (Hartford: Wadsworth Atheneum, 1985), 137, 154–55.
3. For biographical information, see William C. Brown, *The Life of Oliver Ellsworth* (New York: Macmillan, 1905); and

Ronald John Lettieri, *Connecticut's Young Man of the Revolution: Oliver Ellsworth* (Deep River, Conn.: American Bicentennial Commission of Connecticut, 1978)

4. See Adams and Roy, *Oliver Ellsworth Homestead, Windsor, Connecticut, Historic Structure Report: Physical Investigation Prepared for the Ellsworth Memorial Association* (Portsmouth, N.H.: Adams and Roy, 1990); and Samuel Denslow and Oliver Ellsworth, Articles of Agreement, February 2, 1781, private collection, which outline the details of the house's construction. My thanks to Rose-Marie Ballard, curator, Oliver Ellsworth Homestead, who is engaged in overseeing a major research and renovation project of the Ellsworth Homestead and has provided updated reports on the house.

5. Oliver Ellsworth's estate at the time of his death totaled the very high sum of $126,674.32.

6. See architectural drawings by Thomas Hayden, private collection, photoduplicates in the Connecticut River Valley Archive, Wadsworth Atheneum. See also Kornhauser and Schloss, "Painting and Other Pictorial Arts," 113; and Oliver Ellsworth, Account Book, private collection, which contains receipts itemizing the expenses for Hayden's renovation in 1788 and 1789, as well as listing the furniture Hayden made for the house. Again, my thanks to Rose-Marie Ballard for bringing this information to my attention.

7. John W. Barber, *Connecticut Historical Collections* (New Haven, Conn.: John W. Barber, 1836), 129. This source also includes an engraving of the house. According to family tradition, Ellsworth planted thirteen elms to signify the thirteen original states.

8. The Oliver Ellsworth Homestead has a facsimile of the quotation that has been handed down from the nineteenth century; the original source remains unlocated.

9. Oliver Ellsworth, probate inventory, Windsor, 1807, reel 509, Connecticut State Library, Hartford. A catalogue in the inventory lists each book, providing a fascinating document of Oliver Ellsworth's intellectual interests. The books were valued at $806.62.

10. Oliver Ellsworth to Abigail Ellsworth, February 3, 1779, Ellsworth Papers, Connecticut Historical Society, Hartford.

11. For the details on both figures' clothing, see Aileen Ribeiro's costume notes in Elizabeth Mankin Kornhauser, with Richard L. Bushman, Stephen H. Kornhauser, and Aileen Ribeiro, *Ralph Earl: The Face of the Young Republic*, exh. cat. (New Haven: Yale University Press, 1991), 181.

12. Even Abigail Adams, conservative in her sartorial tastes, mentions a white lustring gown and petticoat in 1799; she found the fabric, although light, to be more modest than the muslins that were all the rage among younger women. See S. Mitchell, ed., *New Letters of Abigail Adams, 1788–1801* (Boston, 1947), 218, 242.

187

Benjamin S. Judah, 1794

Oil on canvas; 48⅝ × 34½ in. (123.5 × 87.6 cm)

Inscribed on the original stretcher: "Ralph Earl pinxt 1794"

EXHIBITED: Washington, D.C., National Portrait Gallery; Wadsworth Atheneum; and Fort Worth, Tex., Amon Carter Museum, "Ralph Earl: The Face of the Young Republic," 1991, no. 48

EX COLL.: descended in the Judah family to Hildegard Whitehead Reed, the sitter's great-great-granddaughter

The Ella Gallup Sumner and Mary Catlin Sumner Collection Fund, 1984.90

In 1794 Ralph Earl left Connecticut for New York City, where he painted a number of portraits that demonstrate his flexibility as a portraitist. The return to a more elegant style is seen in the formal manner he employed for his portrait of this prominent city merchant. Earl may have been responding to the presence of Gilbert Stuart (q.v.), who arrived in New York in 1793 and was painting such fashionable, aristocratic portraits as *Don Josef de Jaudens y Nebot* (1794, Metropolitan Museum of Art) and his wife *Matilda Stoughton de Jaudens y Nebot* (1794, Metropolitan Museum of Art) in the year that Earl painted *Judah.*

Benjamin Judah (1760–1831) was born in New York City, the son of Samuel Judah and Jessie Simcha (Jonas) Judah.[1] The Judahs were one of the most notable Jewish families in the city. Benjamin's grandfather, Baruch Judah (1678–1774), helped to establish the first synagogue in New York, Congregation Shearith Israel. His father, Samuel, was a successful merchant and ardent patriot. Benjamin expanded the family trade connections established by his father and was a member of the prestigious Marine Society of New York. His extensive mercantile business was nearly destroyed during the War of 1812.[2]

The portrait of Benjamin Judah is far more stylish than Earl's Connecticut portraits (cats. 185, 186). Here, the artist was concerned with establishing the prominence of his subject. Judah is formally posed, seated on

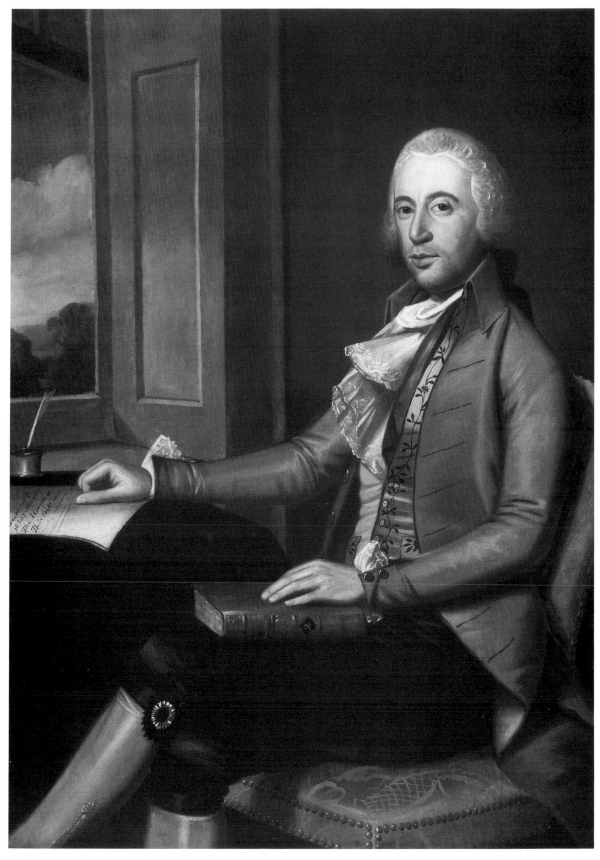

187

a side chair upholstered in red brocade. Rather than depicting regional attributes, Earl created a generalized effect in the landscape seen through the window. By indicating the receipt on which Judah rests his right hand, which is inscribed "Exchange for / 16507 Marks / The Usance on / This Bill is . . . " the portrait makes reference to the subject's international trade connections. Judah's urbanity is echoed also in his attire. Aileen Ribeiro comments that this is

> a portrait of a man of fashion, with a touch of flamboyance in his appearance. His own personal taste must have dictated the formal powdered tye wig, a style at variance with the preference of most of his fellow-Americans. The high-collared blue silk frock coat, the embroidered silk vest and black satin knee-breeches, are elegant and formal. The artist has taken care to pick out such details as the glittering diamond paste buckles on the knee-breeches, the tight cuffs on the coat sleeves which have to be unbuttoned so that the embroidered ruffles can be seen, the billowing white cravat, and the touch of blue silk, a glimpse of undervest on his chest.[3] EMK

1. Jessie Judah was also painted by Earl in 1794; see Elizabeth Mankin Kornhauser, *Ralph Earl: Artist-Entrepreneur* (Ann Arbor, Mich.: University Microfilms International, 1989), 298–299.
2. *The Marine Society of the City of New York* (New York: Marine Society, 1933); Malcolm H. Stern, *First American Jewish Families* (Cincinnati: American Jewish Archives, 1978), 139–140; and George Cohen, *The Jews in the Making of America* (Boston: Stratford, 1924), 156.
3. There was a fashion for wearing two vests in the 1790s; they were usually of contrasting colors, the top one buttoned to reveal the edge (or sometimes the lapel) of the one underneath. According to Flavius Josephus in *Jewish Antiquities* (Cambridge: Harvard University Press; London: Heinemann, 1958), in the first century A.D. colors were assigned to the twelve sons of Jacob, and azure was the color given to Judah. It is anyone's guess as to whether the azure vest in the portrait, chosen by the sitter or suggested by the artist, pays tribute to the tribe of Judah. See Aileen Ribeiro, "Costume Note," in Elizabeth Mankin Kornhauser, with Richard L. Bushman, Stephen H. Kornhauser, and Aileen Ribeiro, *Ralph Earl: The Face of the Young Republic*, exh. cat. (New Haven: Yale University Press, 1991), 197.

Wyatt Eaton

Born in Philipsburg (Quebec), Canada, in 1849; died in Newport, R.I., in 1896

At the age of eighteen Wyatt Eaton arrived in New York, where he studied at the National Academy of Design. In 1872 he left for Europe, where he was a student of Jean-Léon Gérôme and studied at the Ecole des Beaux-Arts in Paris. Eaton spent a great deal of time in the Barbizon region as well, where he became closely acquainted with Millet. He returned to the United States in 1876 and taught at the Cooper Union School in New York City. Active in forming the Society of American Artists, he served as the group's first secretary and later as its president. After a second trip to France from 1883 to 1886, during which Eaton again painted in Barbizon, he spent the remainder of his life in New York City and Canada.

SELECT BIBLIOGRAPHY

G. W. Sheldon, *American Painters*, rev. ed. (New York: D. Appleton, 1881), 169–174 / George S. Hellman, "Wyatt Eaton," *Art World* 3 (December 1917), 204–209 / Frederic F. Sherman, "Figure Pieces by Wyatt Eaton," *Art in America* 7 (June 1919), 171–178 / William H. Gerdts, *The Great American Nude: A History in Art* (New York: Praeger, 1974), 105–108, 111, 118, 125 / Peter Birmingham, *American Art in the Barbizon Mood*, exh. cat. (Washington: Smithsonian Institution Press, for the National Collection of Fine Arts, 1975)

188

WYATT EATON
The Reader, 1887
Oil on canvas; 10⅝ × 9 in. (27.0 × 22.9 cm)
Signed and dated at upper right: Wyatt Eaton 1887

EXHIBITED: Brooklyn, N.Y., Brooklyn Museum, "The Nude in American Painting," 1961, no. 19

EX COLL.: Clara Kellogg Strakosch, New Hartford, by 1914

Gift of Clara Kellogg Strakosch, 1914.14

188

Although Eaton produced portraits and some land-scapes, his major artistic interest was, in the words of his wife, "to become a painter of the nude."[1] Using the technique and a feeling for nature derived from his Barbizon studies, Eaton produced several poetic canvases that integrated the nude figure into the landscape. *The Reader* places the nude in a landscape and presents the figure, who is engaged in reading a book, in a modest pose, turned away from the viewer. The year after painting it, Eaton produced his best-known nude, *Ariadne* (1888, National Museum of American Art, Washington, D.C.), which, along with the Atheneum's example, prompted Clarence Cook to write in the same year: "Of late [Eaton] has produced several poetic subjects in which the nude is treated in connection with the land-scape. . . . The pictures, mostly of small size, have been eagerly welcomed by amateurs and have excited the liveliest interest among the artists."[2] As William Gerdts has pointed out, the acceptibility of the nude as a subject in nineteenth-century America "depended—in addition to the general lessening of the proscription against nudity—on the sense of poetic feeling that contemporary critics discerned in the figure."[3] ERM

1. Quoted in William H. Gerdts, *The Great American Nude: A History in Art* (New York: Praeger, 1974), 125.
2. Ibid., 105.
3. William Gerdts, *The Great American Nude*, 105.

Francis William Edmonds

Born in Hudson, N.Y., in 1806; died in Bronxville, N.Y., in 1863

Throughout his career, Edmonds's primary inspiration was seventeenth-century Dutch genre painting, often via engravings by Americans such as John Burnet. This work reveals as much about American society as it does about day-to-day life in the second quarter of the nineteenth century and exhibits a sympathy that may reflect his political stance as a Democrat. Edmonds also painted some portraits, as well as a painting called *Felix Trembled* (1855, St. Paul's Episcopal Church, Eastchester, New York) for a church, the composition of which painting was inspired by Washington Allston's (q.v.) *Belshazzar's Feast.*

Edmonds showed an early interest and talent in drawing. At age fifteen, he left school, and his father investigated for him an apprenticeship with an engraver. The price of apprenticeship was too high, however, so nothing came of the inquiry. At seventeen, the young Edmonds went to New York City to work as a clerk at the Tradesmen's Bank, where his uncle worked as cashier—a high post in nineteenth-century banking. In 1826 Edmonds was boarding with George W. Hatch, an engraver who was studying with Asher B. Durand (q.v.). Hatch encouraged Edmonds to enroll at the National Academy of Design, where he took night-time classes in art. There he met Durand, William Sidney Mount (1807–1868), and William Page (1811–1885). He soon became involved in banknote engraving, drawing designs on wood for the engravers to carve. Edmonds wrote of this work, "I cannot help but think it was an excellent practice as it compelled me to Study composition, light and shade and drawing" (Edmonds, "'The Leading Incidents,'" 8).

In 1829 Edmonds was appointed cashier of the Hudson River Bank in Hudson, New York. The rigors of this

new position forced him to give up his art for two years. In order to relearn painting, sometime in the early 1830s he commissioned William Page to paint his portrait with a mirror behind him so that Edmonds could watch Page as he worked. As he painted, Page talked to his subject, and Edmonds took notes after each session ended. The first picture Edmonds completed after this portrait was taken was *Sammy the Tailor* (1836, Art Institute of Chicago), which he exhibited at the National Academy of Design under the pseudonym E. F. Williams. The painting was well received, and, encouraged, Edmonds exhibited two more paintings at the academy in 1837. Again, his work met with praise from the critics. The painter's true identity was revealed, and Edmonds was elected associate at the academy that year. Despite this honor, however, the artist continued to exhibit his work under the name E. F. Williams until 1839. Two contemporary sources—Henry T. Tuckerman, in *Book of the Artists* (411–412), and Clara Erskine Clement, in *Painters, Sculptors, Architects, Engravers, and Their Works* (262–263)—erroneously list the artist as John W. Edmonds.

Edmonds exhibited a version of *The Epicure* (cat. 189) and two other pictures in 1838 at the National Academy; he exhibited another pair in 1839 and two more in 1840, when he was elected academician. That year, his first wife, Martha Norman, died, and Edmonds suffered a nervous breakdown. In November he left for Europe, traveling to London, where he visited the National Gallery, and to Paris, where he went to the Louvre. Edmonds was not impressed at first by the works of the old masters, but after several visits to museum galleries, he came to admire them. Edmonds also spent a few weeks in Naples with Durand and John William Casilear (q.v.), another artist who had worked in engraving. Together, they traveled to Pompeii, Herculaneum, and Paestum, among other places. On viewing contemporary European art, Edmonds was again disappointed and could not compare the art he saw in Europe favorably with that of their American counterparts (Edmonds, "'The Leading Incidents,'" 9).

After eight months, Edmonds returned to Great Britain, making an excursion to Scotland but spending most of his time in London. There, he had the opportunity to view several watercolor exhibitions and to visit the Royal Academy. In July 1841 he sailed for New York City. He remarried the following year and resumed his work in the banking industry, advancing in his position until in 1855 a political scandal forced him to resign. He also continued to work in banknote engraving and painting, exhibiting his genre scenes at the National Academy of Design, the Pennsylvania Academy, and the Boston Athenaeum.

Edmonds moved with his family to Bronxville, New York, in 1850, where he suddenly died at home in 1863.

SELECT BIBLIOGRAPHY

Henry T. Tuckerman, *Book of the Artists: American Artist Life* (New York: Putnam, 1867), 411–412 / Thomas S. Cummings, *N.A., Historic Annals of the National Academy of Design . . . from 1825 to the Present Time* (Philadelphia: George W. Childs, 1865), 317–320 / Clara Erskine Clement, *Painters, Sculptors, Architects, Engravers, and Their Works* (New York: Hurd and Houghton, 1874), 262–263 / Clara Erskine Clement and Laurence Hutton, *Artists of the Nineteenth Century and Their Works*, rev. ed. (1884; rpt., St. Louis: North Point, 1969), 1:235 / Maybelle Mann, "Francis William Edmonds: Mammon and Art," *American Art Journal* 2, no. 2 (1970), 92–106 / Maybelle Mann, "Humor and Philosophy in the Paintings of Francis William Edmonds," *Antiques* 106 (November 1974), 862–870 / Maybelle Mann, *Francis William Edmonds*, exh. cat. (Washington, D.C.: International Exhibitions Foundation, 1975–1976) / Francis W. Edmonds, "'The Leading Incidents & Dates of My Life': An Autobiographical Essay by Francis W. Edmonds," *American Art Journal* 13, no. 4 (1981), 4–10 / H. Nichols B. Clark, "A Fresh Look at the Art of Francis W. Edmonds: Dutch Sources and American Meanings," *American Art Journal* 14, no. 3 (1982), 73–94 / H. Nichols B. Clark, *Francis W. Edmonds: American Master in the Dutch Tradition*, exh. cat. (Washington, D.C., and London: Smithsonian Institution Press, in association with the Amon Carter Museum, Fort Worth, 1988)

189 (see plate 59)

FRANCIS W. EDMONDS

The Epicure, 1838

Oil on canvas; 26⅝ × 33½ in. (67.6 × 85.1 cm)

Technical note: The canvas was severely torn in and
 around the figure of the meat seller in 1955; the tear
 was about a foot long. A new canvas lining was at-
 tached and some retouching done when the painting
 was repaired in 1955–1956.

EXHIBITED: possibly New York City, National Academy of
Design, 1838, no. 286, under the artist's pseudonym, E. F. Wil-
liams, as "The Epicure" / possibly Philadelphia Art Associa-
tion, 1841, no. 139, as "The Epicure" / possibly Brooklyn, N.Y.,
Brooklyn Institute, 1848, no. 84, as "The Epicure"

EX COLL.: descended in the artist's family to artist's grand-
son, Philippe Coudert, Jr.; sold to Kennedy Galleries, New
York City, in 1976

The Ella Gallup Sumner and Mary Catlin Sumner Collection
Fund, 1977.38

Pieter de Hooch, *Girl Drinking with Two Soldiers*, 1658. Louvre. ©
Photo R.M.N.

Edmonds first exhibited *The Epicure* in 1838, proba-
bly soon after it was completed, at the National Acad-
emy of Design, New York City. There, it and two other
paintings he submitted received less than favorable re-
views.[1] One critic, in the *New-York Mirror*, wrote that
the artists in the exhibition should "form a school for
themselves, and that school must be built upon nature—
nature carefully studied, analyzed, and understood."[2]
H. Nichols B. Clark has interpreted this quotation to
mean that the critic did not approve of Edmonds's re-
liance on literary themes and wanted him instead to
choose indigenous American subjects for representa-
tion.[3] Although it has been suggested that the subject of
The Epicure is based on a literary source—possibly the
writings of Tobias Smollett or Sir Walter Scott—none
has been identified conclusively.[4]

The composition of *The Epicure* is taken from a
painting by seventeenth-century Dutch artist Pieter de
Hooch, *A Girl Drinking with Two Soldiers*. Edmonds
would have seen an engraving of this painting in John
Burnet's *Treatise on Painting*, first published in 1827.[5]
He saw the original de Hooch in London at the Hope

John Burnet, engraving after de Hooch, from part 3, plate 8, figure
1, of John Burnet, *Treatise on Painting*, London, 1827.
Courtesy Winterthur Library, Printed Book and Periodical Collection.

Collection in 1841 and jotted down in his diary that the work was "in Burnet."[6] The basic setting in *The Epicure*—a single-corner interior with two successive open doors at the left—matches the Burnet engraving (a reverse of the de Hooch painting), as do elements such as the cloth-covered table with the seated man at the right, and the map hanging on the back wall.[7]

The Epicure is unique in Edmonds's oeuvre in that it is the only subject known to exist in two versions, the Atheneum's and one in a private collection. Differences between the two paintings, particularly those that indicate a move away from de Hooch toward a more original composition, have led Clark to believe that the Atheneum's *Epicure* is the earlier of the two.[8] Radiographs of the Atheneum's version, however, show that the painting once shared some of those elements that distinguish the other composition from the de Hooch. X-rays reveal on the right-hand side of the painting a fireplace and hearth with a rug on which what appears to be a cat lies. Edmonds painted these elements out, perhaps not yet confident enough to depart from de Hooch's model.[9] When he exhibited *The Epicure* in 1838, he was, after all, exhibiting under a pseudonym, E.F. Williams.

The existence of two versions of *The Epicure* throws into question the exhibition history of the Atheneum's painting. If the Hartford work is Edmonds's first attempt at the theme, it might stand to reason that the version that was exhibited was the second and perhaps more advanced of the two. With only titles to go by in the contemporary exhibition catalogues and without sufficiently descriptive reviews, it has not yet been possible to resolve this question. AE

1. Strangely, an early chronicle of the National Academy of Design does not list *The Epicure*—or any other painting by Edmonds—as having been exhibited in 1838. *Comforts of Old Age* and *Ichabod Crane Teaching Katrina Van Tassel Psalmody*, the two other paintings believed to have been submitted with *The Epicure* in 1838, are listed under 1837 along with two others, *The Skinner* and *Dominie Sampson*. See Thomas S. Cummings, *Historic Annals of the National Academy of Design . . . from 1825 to the Present Time* (Philadelphia: George W. Childs, 1865), 319. Edmonds listed the three paintings exhibited in 1838 as "The Epicure," "Comforts of old age," and "Ichabod Crane & Katrina Van Tassal" (Edmonds, "'The Leading Incidents & Dates of My Life': An Autobiographical Essay by Francis W. Edmonds," *American Art Journal* 13, no. 4 [1981], 9). The critic for the *New York Herald*, in contrast to the others, wrote that *The Epicure* is "a well conceived and executed work" ("National Academy of Design," *New York Herald* [June 1, 1838], 2, col. 4; I am grateful to William H. Gerdts for access to his National Academy of Design files, where this clipping was found).
2. "The Fine Arts: National Academy of Design," *New-York Mirror and Literary Gazette*, June 30, 1838, 6, as quoted in H. Nichols B. Clark, *Francis W. Edmonds: American Master in the Dutch Tradition*, exh. cat. (Washington, D.C., and London: Smithsonian Institution Press, for the Amon Carter Museum, Fort Worth, 1988), 44.
3. Clark, *Francis W. Edmonds*, 44.
4. See Henry T. Tuckerman, *Book of the Artists: American Artist Life* (New York: Putnam, 1867), 412; Maybelle Mann, *Francis William Edmonds*, exh. cat. (Washington, D.C.: International Exhibitions Foundation, 1975–1976), 14–15; and Clark, *Francis W. Edmonds*, 46.
5. See H. Nichols B. Clark, "A Taste for the Netherlands: The Impact of Seventeenth-Century Dutch and Flemish Genre Painting on American Art, 1800–1860," *American Art Journal* 14, no. 2 (1982), 23–38, especially 32, for John Burnet and the importance of his *Treatise on Painting*. A part of the *Treatise* was distributed by the National Academy of Design in 1832 as a premium for the antique class. Burnet, a student of David Wilkie (1785–1841) in Edinburgh, featured engravings of Dutch and Flemish paintings in his *Treatise*, many of them genre scenes, and emphasized the study of nature rather than drawing from memory. See also Clark, *Francis W. Edmonds*, 46–47.
6. Francis W. Edmonds, "Travel Diary, 25 November 1840–17 July 1841" (2 vols., on deposit at the Columbia County

Francis W. Edmonds, *The Epicure*, 1838. Private collection.

Historical Society, Kinderhook, N.Y.), vol. 2, June 10, 1841, as quoted in H. Nichols B. Clark, "A Fresh Look at the Art of Francis W. Edmonds: Dutch Sources and American Meanings," *American Art Journal* 14, no. 3 (1982), 75.

7. Clark, "A Fresh Look," 74–75; and idem, *Francis W. Edmonds*, 46–48.

8. Clark, *Francis W. Edmonds*, 46.

9. These elements are thought to be part of the original composition and not part of a discontinued painting. See Richard H. Saunders, [then] Associate Curator, Wadsworth Atheneum, to H. Nichols B. Clark, March 28, 1979, curatorial painting file, Wadsworth Atheneum. See also H. Nichols B. Clark to Elizabeth Kornhauser, July 29, 1986, curatorial painting file, Wadsworth Atheneum.

Louis Michel Eilshemius

Born in Arlington, N.J., in 1864; died in New York City, in 1941

Louis Michel Eilshemius grew up in a wealthy family that provided him with an excellent education and the opportunity to travel abroad. After two years at Cornell University, he persuaded his father to finance his artistic training at the Art Students League in New York City from 1884 to 1886. Simultaneously, he studied under the landscape painter Robert C. Minor (1839–1904). In 1886 Eilshemius continued his art studies at the Académie Julian in Paris, spending a summer in Antwerp with the landscape painter Joseph Van Luppen. In France, he became familiar with the Barbizon landscape artists whom he admired, John-Baptiste-Camille Corot in particular, and who had an impact on his early landscapes.

Back in New York City in 1888, Eilshemius exhibited his work at the National Academy of Design and, two years later, at the Pennsylvania Academy of the Fine Arts. In 1892 he received a substantial inheritance from his father that enabled him to travel extensively, including trips to Europe, North Africa, and Samoa. By 1894 Eilshemius had settled in the family's brownstone home on 118 East Fifty-seventh Street in New York City, where he pursued a diversified career in painting, writing, and composing.

Eilshemius was a prolific painter, but he did not enjoy the reputation and admiration he believed he de-served from the art world and the public. In response to the world's indifference, he began to write letters to newspapers and to issue handbills that proclaimed his genius as an artist. Disillusioned, he moved from studio to studio, and by 1910 his abilities as a painter had begun to suffer. A turning point came in 1917, when Marcel Duchamp (1887–1968), seeing one of his works in the Society of Independent Artists exhibition, proclaimed it as one of the few important paintings there. This praise sparked a flurry of interest in Eilshemius's works, but unfortunately wide recognition did not come until after he had stopped painting in 1920. Beginning in 1932 galleries began to show his works, and a number of museums acquired his paintings; however, Eilshemius did not benefit financially from this new popularity. Paralyzed by a car accident in 1932, he spent the remaining years of his life confined to his home and indifferent to the fame he had finally achieved.

SELECT BIBLIOGRAPHY

William Schack, *And He Sat Among the Ashes* (New York: American Artists Group, 1939) / *Masterpieces of Eilshemius*, introduction by Hugh Stix (New York: Artists' Gallery, 1959) / Charles C. Eldredge, *American Imagination and Symbolist Painting* (New York: Grey Art Gallery and Study Center, New York University, 1980) / Paul Karlstrom, *Louis Michel Eilshemius, 1864–1941: A Monograph and Catalogue of the Paintings*, 2 vols. (Ann Arbor, Mich.: University Microfilms International, 1973) / Paul Karlstrom, *The Romanticism of Eilshemius* (New York: Bernard Danenberg Galleries, 1973) / Paul Karlstrom, *Louis Michel Eilshemius* (New York: Abrams, 1978) / Doreen Bolger Burke, *American Paintings in the Metropolitan Museum of Art*, ed. Kathleen Luhrs (New York: Metropolitan Museum of Art, 1980), 3:455–464

190

LOUIS MICHEL EILSHEMIUS
Landscape, after 1890[1]
Oil on canvas; $14^{1}/_{2} \times 20^{1}/_{2}$ in. (36.8 × 52.1 cm)
Signed at lower left: L. L. Elshemus

EX COLL.: with Valentine Gallery, New York City, by 1933

190

Purchased through the gift of Henry and Walter Keney, 1933.94

Eilshemius's two years with the landscape painter Robert C. Minor followed by two more years in France familiarized him with the tenets and paintings of the Barbizon school. His landscapes of the 1880s and early 1890s show the influence of the Barbizon painters, particularly Jean-Baptiste-Camille Corot.[2] In *Landscape*, Eilshemius adopts Corot's clear, bright light and compositional structure of broad bands that are parallel to the picture planes.[3] This soft and intimate landscape also aligns Eilshemius with the poeticism of the Hudson River school.[4] Eilshemius was familiar with the tonalist works of Hudson River artist George Inness (q.v.); like his, Eilshemius's early landscapes are subdued, with indistinct forms and limited color.[5]

Though the location depicted in *Landscape* is not identified, some speculate that the view is of the Delaware Water Gap, a subject the artist painted frequently during this period.[6] Interestingly, it was also a popular subject for Hudson River artists, including Inness. During 1889 and 1890 Eilshemius is known to have traveled to his favorite town of Milford, Pennsylvania, near the Delaware Water Gap.[7]

As in many of his paintings up to 1913, he signed *Landscape* "Elshemus" so that his name would be easier for the public to remember.[8] ERM

1. Eilshemius scholar Paul Karlstrom dates the painting "after 1890." See Paul J. Karlstrom to Elizabeth McClintock, August 7, 1986, artist file, Wadsworth Atheneum.
2. Doreen Bolger Burke, *American Paintings in the Metro-*

politan Museum of Art, ed. Kathleen Luhrs (New York: Metropolitan Museum of Art, 1980), 3:455.
3. Ibid., 3:456.
4. Paul Karlstrom, *The Romanticism of Eilshemius*, exh. cat. (New York: Bernard Danenberg Galleries, 1973), 6.
5. Ibid., 4, 6.
6. Paul J. Karlstrom to Elizabeth McClintock, August 7, 1986.
7. William Schack, *And He Sat Among the Ashes* (New York: American Artists Group, 1939), 53.
8. Paul Karlstrom, *Louis Michel Eilshemius, 1864–1941: A Monograph and Catalogue of the Paintings* (Ph.D. diss., University of California, Los Angeles, 1973; Ann Arbor, Michigan University Microfilms International, 1973), 1:23.

191

LOUIS MICHEL EILSHEMIUS
Nymph on Rock, 1916
Oil on cardboard mounted on masonite panel; 40³⁄₈ ×
 61¹⁄₂ in. (102.6 × 156.2 cm)
Signed at lower right: Eilshemius

EX COLL.: Roy R. Neuberger, New York City, in 1961

Gift of Roy R. Neuberger, 1961.31

Eilshemius was obsessed with young women and adopted the female nude as a main subject in his art.[1] Most of his nudes are posed in landscape settings, in accordance with nineteenth-century tradition.[2] The nudes are innocent Arcadian nymphs only by association, however; there is a conscious element of eroticism in them that reflects the artist's troubling views toward women.[3]

191

Nymph on Rock is one of several works that Eilshemius did of this particular subject. By 1916 Eilshemius's style had changed from soft, poetic, Barbizon-inspired landscapes to more lyrical, stylized, and unconventional images of nature and figures. In *Nymph on Rock*, he used simple lines to outline the nude figure and the trees. Loose, rapid brushstrokes indicate the flat background.

Frustrated at his failure to gain public recognition, by the time this work was painted he had returned to signing his name "Eilshemius" and chose to paint everything and anything that interested him. ERM

1. Paul Karlstrom, *Louis Michel Eilshemius, 1864–1941: A Monograph and Catalogue of the Paintings* (Ph.D. diss., University of California, Los Angeles, 1973; Ann Arbor, Michigan University Microfilms International, 1973), 1:216, 217.
2. Ibid., 1:228.
3. Ibid., 1:226–228.

192

LOUIS MICHEL EILSHEMIUS
Birds and Flowers, 1917
Oil on cardboard (on masonite panel); 40½ × 30½ in.
 (102.9 × 77.5 cm)
Signed at lower left: Eilshemius

EX COLL.: with Valentine Gallery, New York City; to Roy R. Neuberger, New York City, in 1961

Gift of Roy R. Neuberger, 1961.30

In a loose and broken brushstroke, Eilshemius depicts an interior forest scene in *Birds and Flowers*. The figure at the bottom left adds some perspective to the forest floor and the winding stream; Eilshemius's focus, however, is on the lyricism and freedom. ERM

193

LOUIS MICHEL EILSHEMIUS
The Fjord, c. 1920
Oil on academy board; 11 × 22½ in. (27.9 × 57.2 cm)
Signed at lower left: Eilshemius

192

EX COLL.: purchased from the artist by Julius Zirinsky, New York City, in 1936; sold to Mr. and Mrs. James N. Rosenberg, New York City, by 1947

Gift of Mr. and Mrs. James N. Rosenberg, 1947.19

In the later works of Eilshemius, the figure plays a less prominent role and diminishes in scale in relation to the landscape.[1] In *The Fjord*, the tiny, isolated figures are overwhelmed by the surrounding ocean and land. The alienation of the figures from the setting may correspond to the alienation Eilshemius increasingly felt during this time. ERM

193

1. Paul Karlstrom, *Louis Michel Eilshemius, 1864–1941: A Monograph and Catalogue of the Paintings* (Ph.D. diss., University of California, Los Angeles, 1973; Ann Arbor, Michigan University Microfilms International, 1973), 1:238.

194

LOUIS MICHEL EILSHEMIUS
Girl Standing in Water, c. 1920
Oil on paper; 10½ × 13⅝ in. (26.7 × 34.6 cm)
Signed at lower right: Eilshemius

EX COLL.: to Julia Rubenstein, New York City, by 1973

Bequest of Julia Rubenstein, 1973.74

194

In *Girl Standing in Water*, Eilshemius reduces the landscape setting to rapid, painterly strokes. Typical of his later works, the nude bather has been reduced in size to emphasize the dominance of the surroundings. ERM

Charles Loring Elliott

Born in Scipio, Cayuga County, N.Y., in 1812; died in Albany, N.Y., in 1868

Following Elliott's funeral, the journalist Samuel Stillman Conant noted that "his death leaves a vacancy in American art which no portrait painter living can fill" (*Galaxy* 6 [October 1868], 574). Elliott had assumed his role as New York City's premier portraitist after the untimely death of his colleague Henry Inman (q.v.) in 1845. He enjoyed great success during his career, developing a mature style that exhibited an objective naturalism sought by many of America's wealthiest patrons.

As a young man, Charles Elliott worked for his father, an architect, who wished his son to follow in his career. Determined to become a painter, however, in 1829 Elliott went to New York City, where he briefly studied with John Trumbull (q.v.) and John Quidor (1801–1881). For the next ten years, he worked as an itinerant portrait painter in upstate New York, on one occasion stopping at Hamilton College in Oneida County to paint portraits of faculty members. His works at this

time show the influence of Gilbert Stuart (q.v.). He eventually returned to New York City, where he made the acquaintance of Henry Inman and began working in Inman's romantic style. Beginning in 1839 he exhibited his portraits at the National Academy of Design.

Elliott was elected an academician of the National Academy of Design in 1846. For the next two decades he painted prominent politicians, merchants, fellow artists (including Frederic Church [q.v.], Asher B. Durand [q.v.], and the photographer Mathew Brady), and literary figures. He customarily worked from photographs, often producing relentlessly realistic portrayals, and found particular success among the newly rich merchant-industrialists, who paid the artist handsomely for his factually objective portrayals. Tuckerman noted of the artist, "At the height of his fame . . . when the War for the Union suddenly enriched so many speculators, he set up his easel in William street, and dashed off upon the canvas, at high prices, the cotton-merchants who sat to him, in the hurried intervals of their restless speculations" (Tuckerman, *Book of the Artists*, 303).

Although Elliott painted a few landscapes and figural compositions, he focused mainly on portraiture and, according to Tuckerman, produced approximately seven hundred portraits during his career (*Book of the Artists*, 302). Speaking in defense of his chosen profession,

Elliott commented, "After all, there is nothing in all nature like a fine *human face*. Portrait painting is a big thing when it *is* portrait painting" (Lester, "Charles Loring Elliott," 47). He specialized in bust-length portrayals, concentrating on capturing a penetrating and detailed likeness. Tuckerman praised the faithfulness of Elliott's likenesses, as well as the exuberance of his style: "Elliott is a man of will rather than of sensibility, one who grasps keenly his subject, rather than is magnetized thereby: his touch is bold and free; he seizes the genuine, and pierces the conventional; he has a natural and robust feeling for color; he is more vigorous than delicate" (Tuckerman, *Book of the Artists*, 300). In addition to the bust-length portraits in which he excelled (including several compelling self-portraits), Elliott also painted a number of important full-length portraits, both civic and private commissions, the complexity of which sometimes led to awkward execution.

SELECT BIBLIOGRAPHY

Henry T. Tuckerman, *Book of the Artists* (New York: Putnam, 1867), 300–305 / Gaylord Lewis Clark, "Charles Loring Elliott," *Lippincott's Magazine* 2 (December 1868), 652–657 / Charles Edward Lester, "Charles Loring Elliott," *Harper's New Monthly Magazine* 38 (December 1868), 42–50 / *DAB*, 3:95–96 / Theodore Bolton, "Charles Loring Elliott: An Account of His Life and Work, with a Catalogue of His Portraits," *Art Quarterly* 5 (winter 1942), 58–96

195 (see plate 60)

CHARLES LORING ELLIOTT
Colonel Samuel Colt, 1865
Oil on canvas; 84 × 64 in. (213.4 × 162.6 cm)
Signed and dated at lower right: Elliott 1865

EXHIBITED: Wadsworth Atheneum, "Victorian Furnishings From Armsmear and the James J. Goodwin House," 1975

EX COLL.: commissioned by Elizabeth Hart Jarvis Colt, Hartford, 1865

Bequest of Elizabeth Hart Jarvis Colt, 1905.8

196 (see plate 61)

CHARLES LORING ELLIOTT
Mrs. Elizabeth Hart Jarvis Colt and Son Caldwell, 1865
Oil on canvas; 84 × 66 in. (213.4 × 167.6 cm)
Signed and dated at lower right, on toy cannon:
 Elliott / 1865

EXHIBITED: Wadsworth Atheneum, "Victorian Furnishings from Armsmear and the James J. Goodwin House," 1975

EX COLL.: commissioned by Elizabeth Hart Jarvis Colt, Hartford, 1865

Bequest of Elizabeth Hart Jarvis Colt, 1905.9

Following the untimely death of her husband, Samuel Colt (1814–1862), the renowned arms manufacturer, Elizabeth Hart Jarvis Colt (1826–1905) became the wealthiest woman in New England (see Introduction). She assumed a prominent role in Hartford as the largest stockholder of her husband's arms manufactory, overseeing the running of the company, and became a leader in civic and social affairs in the city. One of the boldest ventures she undertook during her lifetime was to construct an elaborate private picture gallery in the years 1866 to 1868 in Armsmear, her home on Wethersfield Avenue in Hartford.[1] Her plans for acquiring suitable paintings for the gallery were first initiated when she wrote to her close friend, the Hartford artist Frederic Church (q.v.), in December 1863, thanking him for contacting Charles Loring Elliott on her behalf. Church negotiated a commission and price for a portrait of Colt's deceased husband. Although Church cautioned her that the price would be $3,000, she was undeterred, responding: "The price does seem a large one for a portrait to be sure, but if he can make it such a one as I have in mind, twice the sum would not be enough for me to relinquish it."[2]

Busy with other portrait commissions, Elliott did not travel to Hartford to take the portrait until February 1865, at which time Colt's father, Rev. Samuel Jarvis, wrote: "Mr. Elliott the great artist, is painting a full length portrait of Col. Colt from several pictures, photographs and busts taken of him in his lifetime. It will be a splendid affair."[3] Apparently Elizabeth Colt orches-

trated the elements to be included in the grand-scale portrait, providing the artist with personal possessions that served as symbols of Samuel Colt's historic role as a great inventor and industrialist. It was her intention that the portrait glorify her husband's memory, that it serve as a reminder to the public of his achievements on behalf of the city, the nation, and the world.

Elliott depicted Colt as a much younger and thinner man than he appeared at the time of his death in 1862. His likeness was largely taken from a miniature portrait of Colt painted by Gerald S. Hayward (see Introduction,. fig. 11) at the time of Colt's wedding, in 1856. Colt stands with his left hand resting on an ornate marble-topped rosewood armoire, on which rest a cup and bowl of gilt brass, a gift from the first and second kings of Siam. In his right hand, he holds a copy of a paper he presented before the London Institution of Civil Engineers, inscribed with the date of the lecture, "4th day May 1852," and marking his induction as a member of that body (he was the first American to receive this honor). Colt's historic collection of arms is seen in a case behind him at the right. He had begun assembling a study collection of European and American firearms as early as 1847, and the collection numbered over one hundred objects at the time of his death. Beyond the elaborate drapery and balustrade is a detailed view of the central building of the Colt manufactory, including the famous onion dome and rampant colt ornament that crowned its top, as well as billows of smoke, indicating that the factory was in operation. The tree in the foreground may have represented the seedling of the historic Charter Oak that Colt planted shortly after the tree fell in 1856. On its completion, the Reverend Jarvis praised the portrait and related, "More than a thousand persons came to see it yesterday by invitation. Mrs. Colt and Collie are to be painted by the same artist, Elliott."[4]

Elliott's portrait of Colt and her only surviving child, Caldwell, was an equally grand conception, again, likely with input from Colt. Attired in a voluminous gown of a regal blue, Colt's portrayal bears a marked resemblance to the queenly portraits of Victoria with her children—for example, John Callcott Horsley's *Portrait Group of*

Queen Victoria with Her Children (c. 1854, Forbes Magazine Collection, New York City). On her right hand, Colt wears the enormous diamond ring (Wadsworth Atheneum) given to her by her husband. Known as the "stone of fire," it was a gift to Colonel Colt by Charles Albert, King of Sardinia. In contrast, as a religious woman, Colt holds a book of scripture in her hand. Her son leans toward his mother and holds the string of a miniature cannon, a memento of Colonel Colt's from the Mexican War. The subjects are surrounded by the elaborate furnishings of Armsmear.

The portraits were installed on the two end walls of the picture gallery on its completion in 1867. Elizabeth Colt's vision for her deceased husband's portrait was fulfilled: the massive image of Sam Colt allowed his powerful presence to live on after his death. The portraits dominated the space that became a major focal point for civic and social events in Hartford until the end of the century. In 1866 Elliott also painted Colt's friend and neighbor, Joseph Church (1793–1876), a wealthy Hartford insurance adjuster, who was the father of Frederic Church. Elliott would paint his fellow artist Church in the following year. EMK

1. Although a definitive biography of Samuel Colt and Elizabeth Hart Jarvis Colt has yet to be written, helpful biographical sources are provided in note 69 of the Introduction.
2. Elizabeth Hart Jarvis Colt to Frederic Church, December 18, 1863, Olana State Historic Site, Hudson, N.Y.
3. Rev. William Jarvis to his nephew William Jarvis, March 10, 1865, Jarvis Family Papers, Connecticut Historical Society, Hartford.
4. Ibid., March 29, 1865.

James Sanford Ellsworth

Born in Windsor(?), Conn., in 1802 or 1803; died in Pittsburgh, Pa., possibly in 1874

James Sanford Ellsworth, who produced over 265 likenesses, is best known as a prolific painter of miniature portraits, primarily small watercolor profiles on paper. He is also known to have painted a small number of oil portraits. Although a large body of work by the artist is known, details concerning his life remain scarce.

Ellsworth was baptized in West Hartland, Connecticut, on June 26, 1807, and married Mary Ann Driggs of Hartford on May 23, 1830. The couple had one child, but the marriage ended in divorce in nine years. Ellsworth painted mainly in the Connecticut River valley, but by 1861 he had traveled through New York, Pennsylvania, and Ohio. The artist's death remains undocumented, but one source, Henry R. French, who may have known the artist, indicates that he died in an almshouse in Pittsburgh (French, *Art and Artists*, 73).

Ellsworth developed a distinctive individualized formula for his profile portraits: he took realistic likenesses of his subjects, in profile, presented at half-length, and framed their heads with scalloped cloudlike formations.

SELECT BIBLIOGRAPHY

H. W. French, *Art and Artists in Connecticut* (Boston: Lee and Shepard; New York: Charles T. Dillingham, 1879), 72–73 / Lucy B. Mitchell, *The Paintings of James Sanford Ellsworth: Itinerant Folk Artist, 1802–1873,* exh. cat. (Williamsburg, Va.: Abby Aldrich Rockefeller Folk Art Center, 1974)

197

ATTRIBUTED TO JAMES SANFORD ELLSWORTH

George Washington, c. 1842–1844

Oil on canvas; 98 × 60 in. (248.9 × 152.4 cm)

Technical note: The canvas is in two pieces with a seam running down the right side.

EX COLL.: commissioned by Daniel Wadsworth, Hartford, in about 1842–1844

Bequest of Daniel Wadsworth, 1848.12

In preparation for the opening of his new museum in 1844, Daniel Wadsworth is thought to have commissioned James Sanford Ellsworth to paint this copy of Gilbert Stuart's full-length portrait of Washington, known as the Munro type, which then hung in the Hartford State House (and still hangs there).[1]

According to H. W. French, Ellsworth was the son of "one of the officers in charge of the State House" in Hartford, and he "first displayed a taste for art in mak-

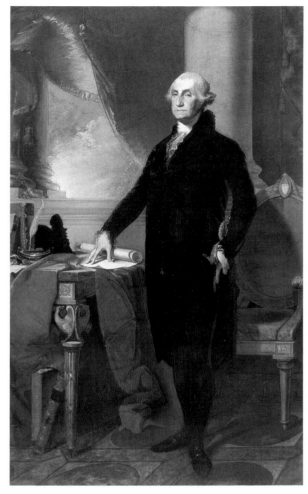

197

ing several copies of Gilbert Stuart's full-length of Gen Washington. The copies are neither extraordinarily good nor very bad: one hanging in the Wadsworth Gallery shows chiefly a lack of experience and information."[2] EMK

1. Richard Saunders, with Helen Raye, *Daniel Wadsworth: Patron of the Arts* (Hartford: Wadsworth Atheneum, 1981), 37, 95; and Lucy B. Mitchell, *The Paintings of James Sanford Ellsworth: Itinerant Folk Artist, 1802–1873,* exh. cat. (Williamsburg, Va.: Abby Aldrich Rockefeller Folk Art Center, 1974), 16.
2. H. W. French, *Art and Artists in Connecticut* (Boston: Lee and Shepard; New York: Charles T. Dillingham, 1879), 72.

Mabel Bacon English

Born in Hartford, in 1861; died in Hartford, in 1944

The Hartford artist Mabel Bacon Plimpton English received early artistic training at the Connecticut League of Art Students under William Merritt Chase (q.v.) and Charles Noel Flagg (q.v.). She exhibited at the National Academy of Design in New York City from 1891 to 1897, listing her address as 12 Fern Street, Hartford, where she resided throughout her life. English was an active member of the Connecticut Academy of Fine Arts and the Women Painters and Sculptors of Hartford, where she actively exhibited her work, mainly landscapes, from about 1910 to 1935. As well as painting in the Hartford area, the artist worked in Vermont and on the Rhode Island shore.

SELECT BIBLIOGRAPHY

Curatorial painting file, Wadsworth Atheneum / Maria Naylor, *The National Academy of Design Exhibition Record, 1861–1900* (New York: Kennedy Galleries, 1973), 274 / Mantle Fielding, *Dictionary of American Painters, Sculptors, and Engravers*, rev. ed. (Poughkeepsie, N.Y.: Apollo, 1983), 279

198

198

MABEL BACON ENGLISH
Moors at Weekapaug, Rhode Island, c. 1920
Oil on composition board; 18¼ × 24 in. (46.4 × 61.0 cm)
Signed at lower left: M. B. English

EX COLL.: the artist, Hartford, to 1927

Gift of the artist (Mrs. Joel L. English), 1927.266

Mabel English spent most summers at her second home in the resort town of Weekapaug, Rhode Island, where she painted landscapes of the surrounding coastline. In *Moors at Weekapaug, Rhode Island*, she worked in a softly executed postimpressionist style, depicting the hills and sand dunes typical of the region.[1] EMK

1. Workers for the Federal Writer's Project of the Works Progress Administration for the State of Rhode Island, *Rhode Island: A Guide to the Smallest State* (Boston: Houghton Mifflin; Cambridge: Riverside Press, 1937), 345. My thanks to Robert Workman, assistant curator, Museum of Art, Rhode Island School of Design, for this reference.

Jimmy Ernst

Born in Cologne, Germany, in 1920; died in New York City, in 1984

A noted painter in his own right, Jimmy Ernst was the son of the surrealist Max Ernst (1889–1976), a founder of the dada movement. Ernst grew up in Europe among the avant-garde artists of the era and at the outbreak of World War II fled with his father to settle in the United States.

The artist created delicate, spiky abstractions, but his works did not exclude specific subject matter. His later paintings drew on a variety of experiences, including the horrors of the war (his mother died in a cell at Auschwitz) and his research among the Hopi Indians.

SELECT BIBLIOGRAPHY

Reflections on the Inner Eye: Paintings by Jimmy Ernst, exh. cat. (New York: Norlyst Gallery, 1943) / Paul Cummings, ed., *Dictionary of Contemporary American Artists* (New York: St. Martin's Press, 1977), 110–111 / obituary, *Time*, February 20, 1984, 84

199

199

JIMMY ERNST
Vagrant Fugue, 1941
Oil on canvas; 35 × 30 in. (88.9 × 76.2 cm)
Signed and dated at lower right: Jimmy Ernst 41

EXHIBITED: Manchester, N.H., St. Anselm's College, "The Greater Reality," 1968, no. 17

EX COLL.: acquired from the artist in 1941 by the Wadsworth Atheneum

The Ella Gallup Sumner and Mary Catlin Sumner Collection Fund, 1942.338

Vagrant Fugue draws on the surrealist movement established by the artist's father, Max Ernst. He painted this canvas in New York City during the early years of World War II. In largely fantastic imagery, the artist included two anthropomorphic figures, one a female, set in a barren landscape. They appear to be engaged in move-ment, perhaps a dance. At the time of the artist's first solo show after his arrival in New York, at the Norlyst Gallery in 1943, it was noted of his recent paintings, "Having lived under Hitler for four years . . . [Ernst's] painting is an expression of the freedom and joy he has found here in America."[1]

A. Everett Austin, Jr., purchased this painting in 1941, a decade after his landmark exhibition of surrealism, "Newer Super-Realism," the first to be held in America (see Introduction). In the following year, Austin purchased Max Ernst's famous work *Europe after the Rain* (1940–1942), a traumatized wartime vision of the destruction of Europe. The Atheneum has two other works, on paper, by Jimmy Ernst: *Eastern Standard Time* (1952) and *Among the Stones* (1957). EMK

1. Press release for "Reflections on the Inner Eye," Norlyst Gallery, New York City, 1943, curatorial painting file, Wadsworth Atheneum.

Stephen Etnier

Born in York, Pa., in 1903; died in South Harpswell, Maine, in 1984

Stephen Etnier first studied at the Pennsylvania Academy of the Fine Arts and then served an apprenticeship for a year with Rockwell Kent (q.v.) and for several years with John Carroll (q.v.). Following his early training in Philadelphia, Etnier worked in New York City in the 1930s and 1940s and then spent the greater part of his life on the coast of Maine near South Harpswell. The artist and his second wife lived on an island in the Kennebec River, where they had built a house. His first solo show was held at the Dudensing Galleries in New York City in 1931. Many of his paintings are drawn from maritime subjects. Etnier received many awards, including the Saltus Gold Medal of the National Academy of Design in 1955.

SELECT BIBLIOGRAPHY

"Etnier: Remoter Realism," *Art News* 44 (January 1946), 24 / Wade Lawrence, *Stephen Etnier: A Retrospective* (York, Pa.: York Historical Society of York County, 1989)

200

STEPHEN ETNIER
The Bird Houses, 1937
Oil on canvas; 24³/₁₆ × 20¹/₈ in. (61.4 × 51.1 cm)
Signed and dated at lower right: Stephen Etnier 1938

EXHIBITED: Wadsworth Atheneum, "The Painters of Still Life," 1938, no. 80 / New York City, Milch Gallery, "Stephen Etnier," 1938 / Rockland, Maine, William A. Farnsworth Library and Art Museum, "Stephen Etnier," 1953 / Wadsworth Atheneum, "A. Everett Austin, Jr.: A Director's Taste and Achievement," 1958, no. 27 / Bristol, R.I., Bristol Art Museum, "Stephen Etnier," 1965, no. 16 / Portland, Maine, Canal National Bank, "Stephen Etnier: Paintings," 1974

EX COLL.: purchased from the artist through the Milch Gallery, New York City, in 1938

The Ella Gallup Sumner and Mary Catlin Sumner Collection Fund, 1938.249

Much of Stephen Etnier's inspiration grew from his lifelong love for the coast of Maine. His parents, Mr. and Mrs. Carey Etnier, took their son to Maine nearly every summer of his childhood, and the artist and his teacher, the artist John Carroll (q.v.), sailed along the coast in the early 1930s. Etnier eventually settled on an island at the mouth of the Kennebec River, in South Harpswell.

The Bird Houses depicts a characteristic Maine coast scene: idiosyncratic birdhouses on long thin poles reaching toward a deep blue sky. The birdhouses rise above the shingled roofs, on one of which is a whale weathervane.

This painting was acquired by the Atheneum's director, A. Everett Austin, Jr., who was a cousin of the artist. Austin included the work in his 1938 exhibition "The Painters of Still Life."[1] EMK

1. A. Everett Austin, Jr., *The Painters of Still Life* (Hartford: Wadsworth Atheneum, 1938), no. 80.

James Guy Evans

Active from 1835 to 1860

The marine painter James Guy Evans is known to have worked in New Orleans from about 1844 to 1852. In addition to painting ship portraits and seascapes, Evans also advertised, along with a partner, Edward Everard Arnold (1824 or 1826–1866), that he executed portraits and landscapes. He has been recorded as executing over one hundred paintings and watercolors; however, few details concerning his life are known.

SELECT BIBLIOGRAPHY

Anglo-American Art Museum, *Sail and Steam in Louisiana Waters*, exh. cat. (Baton Rouge: Anglo-American Art Museum, Louisiana State University, 1971) / Natalie Spassky, *American Paintings in the Metropolitan Museum of Art*, ed. Kathleen Luhrs (Princeton, N.J.: Princeton University Press, in association with the Metropolitan Museum of Art, 1985), 2:5–8

200

201

JAMES GUY EVANS

Ship John P. Harwood of Providence, R.I., c. 1846

Oil on canvas; 29 × 36⅛ in. (73.7 × 91.8 cm)

Signed at lower right: Evans

Inscribed across bottom of canvas: John P. Harwood of
 Providence R.I. Washington Read Comr off the
 Balize 28 of Dec. 1846

James Guy Evans created a detailed rendition of the
ship in this painting. The inscription indicates that the
ship is shown in the Gulf of Honduras at the mouth of
the Belize River off the coast of Belize (then British
Honduras) in Central America. The *John P. Harwood*
was built in Bath, Maine, in 1844 and was owned by

201

Zachariah R. Tucker, James Tucker, Jr., Adirah Sackett, William Matherson, and Bradford Allen, all of Providence, Rhode Island.[1] The portrait is characterized by a relatively static depiction—though there is some indication of movement—a lack of perspective, and the presence of two tiny sailboats and a lighthouse in the flat, distant seascape. EMK

1. Edouard A. Stackpole to Charles Cunningham, 1958 (curatorial painting file, Wadsworth Atheneum), provides information on the ship from records at Mystic Seaport, Mystic, Connecticut.

Philip Evergood

Born in New York City, in 1901; died in Bridgewater, Conn., in 1973

Philip Howard Francis Dixon Evergood was educated in England at Eton and Cambridge before pursuing his art studies at the Slade School in London from 1921 to 1923. Afterward, he returned to America and was a student at the Art Students League under George Luks (q.v.). From 1924 to 1926 he spent time traveling and studying in Europe, and in 1927 he held his first solo exhibition in the United States. In 1931 the artist settled in New York City.

Evergood formed an alliance with other artists concerned with social issues. During the 1930s he was employed by the Public Works of Art Project and was active in the Artists' Union, of which he became president in 1937. In 1938 he joined the ACA American Heritage Gallery, with which he exhibited throughout the 1940s. Evergood became well known for his biting paintings portraying social injustice and the plight of the common person. In his works of the late 1930s and 1940s, he aimed to present themes with universal connotations. His later paintings have a more humanistic tone, and their subjects are more imaginative and dreamlike.

Evergood received numerous grants, prizes, and honors, including gold medals from the Pennsylvania Academy of the Fine Arts in 1949 and 1958 and the Benjamin Altman Prize from the National Academy of Design in 1971.

SELECT BIBLIOGRAPHY

Lucy R. Lippard, *The Graphic Work of Philip Evergood: Se-
lected Drawings and Complete Prints* (New York: Crown,
1966) / Patricia Hills, "Philip Evergood's *American Tragedy*:
The Politics of Ugliness, the Politics of Anger," *Arts Magazine*
54 (February 1980): 138–143 / Patricia Hills, *Social Concern
and Urban Realism: American Painting of the 1930s* (Boston:
Boston University Art Gallery, 1983) / Kendall Taylor, *Philip
Evergood: Never Separate from the Heart*, A Center Gallery
Publication (Lewisburg, Pa., and London: Bucknell University
and Associated University Press, 1986)

202

PHILIP EVERGOOD
Boating, c. 1934
Signed at lower left: Philip Evergood
Oil on composition board; 10⅝ × 11¾ in. (27.0 × 29.8 cm)

EX COLL.: to Robert L. Foreman, Weston, Conn., by 1961

Gift of Robert L. Foreman, 1961.464

In his small work *Boating*, Evergood depicted a
scene of fishermen working on a wharf, most likely
in New York City, where he was living at the time.
Through the use of strong diagonal and vertical shapes,
the artist charged the painting with suggestions of the
fishermen's strength and masculinity. In addition to the
wood pillar at right, the focal point is the rear-end view
of a man leaning over. Evergood here used the expres-
sionistic black graphic line that can be seen in not only
his paintings but his prints. When he painted this work,
Evergood was just beginning to recognize the potential
of art used as political and social propaganda, though
Boating does not make any direct comments on social
injustice.

A related work, *The Old Wharf* (Brooklyn Museum),
is dated 1934, which helps to date the Atheneum's
painting. ERM

202

Robert Feke

Born probably in Oyster Bay, N.Y., in about 1707; died in 1751

Robert Feke emerged during the 1740s as the most gifted native-born artist working in America, just at the time that John Smibert (q.v.) retired from portrait painting. He was raised on Long Island, the son of a Baptist preacher. Little is known about his early life, other than that he may have lived in New York City for a time in the 1730s. He married the daughter of a tailor, Eleanor Cozzens of Newport, Rhode Island, on September 23, 1742.

A diary entry by Dr. Alexander Hamilton, written in 1744, while visiting Newport, provides revealing information about Feke's early career. Hamilton was taken to visit the young artist by Dr. Thomas Moffatt, the nephew of John Smibert, and recalled: "He carried me to see one Feykes, a painter, the most extraordinary genius I ever knew, for he does pictures tollerably well by the force of genius, having never had any teaching. I saw a large table of the Judgement of Hercules, copied by him from the frontispiece of the Earl of Shaftesbury's, which I thought very well done. This man had exactly the phizz of a painter, having a long pale face, sharp nose, large eyes with which he looked upon you stedfastly, long curled black hair, a delicate white hand, and long fingers" (Bridenbaugh, *Gentleman's Progress*, 102). Three years before Hamilton wrote this, Feke had painted his ambitious and skillful group portrait *Isaac Royall and His Family* (1741, Harvard Law Art Collection, Harvard University).

There are approximately sixty known portraits by Feke, of which twelve are signed and dated and help to establish his presence in Newport in 1745 and 1748, in Philadelphia in 1746 and 1749 to 1750, and in Boston in 1741 and 1748. The portraits show the influence of Smibert in the poses, but Feke adopted a more fashionable rococo palette of pastel colors and satin fabrics. His modeling was stiff and somewhat wooden, revealing his native-born status and lack of formal training.

SELECT BIBLIOGRAPHY

Henry Wilder Foote, *Robert Feke, Colonial Portrait Painter* (Cambridge: Harvard University Press, 1930) / Lloyd Goodrich, *Robert Feke*, exh. cat. (New York: Whitney Museum of American Art, 1946) / Carl Bridenbaugh, ed., *Gentleman's Progress: The Itinerarium of Dr. Alexander Hamilton, 1744* (Chapel Hill: University of North Carolina Press, 1948), 102 / R. Peter Mooz, "The Art of Robert Feke" (Ph.D. diss., University of Pennsylvania, 1970) / R. Peter Mooz, "Robert Feke: The Philadelphia Story," in *American Painting to 1776: A Reappraisal*, ed. Ian M. B. Quimby (Charlottesville: University Press of Virginia, 1971), 181–216 / Richard H. Saunders and Ellen Miles, *American Colonial Portraits: 1700–1776*, exh. cat. (Washington, D.C.: National Portrait Gallery, 1987), 165–169

203 (see plate 62)

ROBERT FEKE

Gershom Flagg IV, c. 1741–1747

Oil on canvas; 30⅛ × 24⅞ in. (76.5 × 63.2 cm)

Technical note: Radiographs taken at the Philadelphia Museum of Art Conservation Studio in 1972 reveal that the original portrait size was 28½ × 24½ in. (72.4 × 62.2 cm). The paint surface was later increased by about one-and-a-half inches at the bottom, using the original canvas tacking edge. The original oval spandrel was about two inches higher. The subject was originally painted in an embroidered waistcoat and lace jabot and wore a white wig. Magnification reveals that the waistcoat was red with gold trim; it now appears dark green and is buttoned to the neck, hiding the jabot. The white wig has been painted over, and the subject now has brown hair (curatorial painting file, Wadsworth Atheneum).

EX COLL.: Gershom and Hannah Flagg, Boston; to their daughter, Mary Flagg Wilder, Lancaster, Mass., in 1784; to her daughter Mary Wilder White; to her daughters Eliza Amelia White Dwight and Mary Wilder White Foote in 1861; to Mary Foote's son, Reverend Henry Wilder Foote, Belmont, Mass., in 1878; with Vose Galleries, Boston, in 1972

The Ella Gallup Sumner and Mary Catlin Sumner Collection Fund, 1972.21

X-ray photograph showing changes made in Robert Feke, *Gershom Flagg IV*. Conservation Department, Wadsworth Atheneum.

204 (see plate 63)

ROBERT FEKE

Mrs. Gershom Flagg IV (Hannah Pitson), c. 1741–1747
Oil on canvas; 30 × 25⅛ in. (76.2 × 63.8 cm)

EX COLL.: Gershom and Hannah Flagg, Boston; to their daughter, Mary Flagg Wilder, Lancaster, Mass., in 1784; to her daughter Mary Wilder White; to her daughters Eliza Amelia White Dwight and Mary Wilder White Foote in 1861; to Mary Foote's son, Reverend Henry Wilder Foote, Belmont, Mass., in 1878; with Vose Galleries, Boston, in 1972

The Ella Gallup Sumner and Mary Catlin Sumner Collection Fund, 1972.22.

Although not signed by the artist, the portraits of the Flaggs can be assigned with certainty to Robert Feke by their documentation in the 1861 will of Judge Daniel Appleton White, a descendant of the subjects.[1] The Flagg portraits descended in the Flagg family,

along with *Self-portrait* by Feke (c. 1741–1745, Museum of Fine Arts, Boston), to Reverend Henry Wilder Foote, the historian and an early biographer of the artist. As Peter Mooz has noted, the descent of the artist's self-portrait in the Flagg family suggests a close association between the artist and the Flaggs.[2]

Gershom Flagg was born in Boston in 1705 and died there in 1771. Described in genealogical records as a housewright, glazier, builder, and architect, he is known to have built Fort Western in Augusta, Maine, in 1754 and the Pownalborough Court House in Maine in 1761. He owned considerable land in Boston and was a proprietor of the Plymouth Company, owning much of the lands that now make up Augusta, Maine. His first wife, Lydia Callender, of Newport, Rhode Island, was the sister of Rev. John Callender, who married Robert Feke and Eleanor Cozzens in 1742 in Newport. It is through this connection that Flagg and Feke may first have met, and it has been suggested that the portraits of Flagg and his second wife, Hannah Pitson Flagg (1711–1784), whom he had married in 1736, were painted at the time of Feke's marriage.[3] (Hannah was the daughter of James Pitson, a Boston merchant.) Flagg later settled in Boston on the corner of Hanover and Sudbury Streets adjacent to the house of John Smibert (q.v.). Feke was working in Boston in 1748, and it is possible that at this time he made the changes in the costume and size in Gershom Flagg's portrait described in the technical note above.

According to Peter Mooz, the style of the Gershom Flagg portrait is similar to Feke's *Isaac Royall and His Family* completed September 15, 1741 (Harvard University), as seen in the use of light and shade on the face and the handling of the neckcloth. In the portrait of Hannah Flagg, Feke's palette and emphasis on contours and rendering of costume detail relate to his other Newport portraits of 1747.[4]

Portraits by Feke of two of the Flaggs' children were discovered recently by Vose Galleries.[5] EMK

1. The will reads: "I bequeath to my said daughters, Eliza Amelia and Mary Wilder [White] jointly all . . . property in my possession which once belonged to their first mother [Mary Wilder], including the portraits of their great-grand-parents

Gershom and Hannah Flagg, painter of them, Feeks" (quoted in R. Peter Mooz, "New Acquisitions: Hannah and Gershom Flagg by Robert Feke," *Wadsworth Atheneum Bulletin* 2 [spring and fall 1972], 62). Each portrait has a paper label attached to the stretcher bar that further documents the provenance. For Gershom Flagg, the label reads: "This portrait [] / Flagg was left to me and [] / by my Father. I leave it to []vd / Henry Wilder Foote. / Eliza A. Dwight / April 3d 1878"; for Hannah Flagg, the paper label is inscribed: "This portrait of [] & grandmother / Flagg was left to m[] []ly sister Mary / by my father I [] to the Revd / Henry Wilder Foote. / Eliza A. Dwight / April 3d 1878."

2. Mooz, "New Acquisitions," 62–73.
3. Ibid.; and Earle G. Shettleworth, Jr., *A Biographical Dictionary of Architects of Maine: Gershom Flagg, 1705–1771*, vol. 5, no. 9 (Augusta: Maine Historic Preservation Commission, 1988).
4. Mooz, "New Acquisitions," 63–64.
5. Robert Vose to Gregory Hedberg, March 4, 1982, curatorial painting file, Wadsworth Atheneum. The portraits of James Flagg, a boy of about two or three years of age, and a second child of the Flaggs, an infant, were offered for sale in 1982 by Vose Galleries as works by Feke.

Alvan Fisher

Born in Needham, Mass., in 1792; died in Dedham, Mass., in 1863

With Thomas Doughty (q.v.), who became a close friend and sketching companion, and Joshua Shaw (c. 1777–1860) of Philadelphia, Alvan Fisher was one of the first American artists to specialize in landscape painting. Inspired by the British landscape painters of the picturesque, Fisher and his American colleagues sought the ideal, poetic aspect of natural scenery in their early depictions of the American landscape. Fisher's work served as a modest prelude to the heroic compositions of the Hudson River school, led by Thomas Cole (q.v.).

Fisher grew up in Dedham, Massachusetts, and decided to become an artist at the age of eighteen, when he was placed under the instruction of the ornamental painter John Ritto Penniman (1782?–1841). Fisher related the following details of his early career to William Dunlap: "In 1814 I commenced *being* an artist, by painting portraits at a cheap rate. This I pursued until 1815. I

then began painting a species of pictures which had not been practiced much, if any, in this country, viz.: barn-yard scenes and scenes belonging to rural life, winter pieces, portraits of animals, etc. This species of painting being novel in this part of the country, I found it a more lucrative, pleasant and distinguished branch of the art than portrait painting" (Dunlap, *History*, 2:264).

In the 1820s Fisher traveled through Connecticut, Vermont, western Massachusetts, and upstate New York, recording his observations of American wilderness scenery in his notebook (Museum of Fine Arts, Boston). He produced canvases of such popular sites as Niagara Falls, the Connecticut River valley, and Monte Video, Daniel Wadsworth's country estate outside Hartford (cat. 126). Imbuing his landscapes with a distinctly American flavor, the artist presented a pastoral vision of the young country.

In 1825 Fisher went to Europe, traveling in England, France, Switzerland, and Italy. In Paris he studied the old masters, copying these works at the Louvre. Claude Lorrain, in particular, impressed Fisher. He reported to Dunlap that in Paris he "studied drawing at a private life academy" (Dunlap, *History*, 2:265). He returned to the United States in 1826, settling in Boston, and continued until midcentury to paint the American landscape, including White Mountain scenery and views of Mount Desert, Maine, as well as genre paintings and portraits. As late as 1852, newspapers announced for sale at the Art-Union Rooms in Boston "the finest collection [eighty-three paintings] that Mr. Fisher has ever offered at Public sale." The collection included "views of American Scenery, painted on the spot, or from sketches taken by the artist himself. There are also Rural Scenes, Barn Yards, Stable Scenes, Dogs, and other subjects, all suited to the parlor or drawing-room" (*Hartford Daily Courant*, October 19, 1852). He moved to Dedham in 1840 and at the time of his death had a substantial estate, a tribute to his entrepreneurial ability as an artist.

SELECT BIBLIOGRAPHY

William Dunlap, *History of the Rise and Progress of the Arts of Design in the United States* (1834; rpt., New York: Dover,

1969), 2:264–265 / Mabel M. Swan, "The Unpublished Notebooks of Alvan Fisher," *Antiques* 68 (August 1955), 126–129 / Robert C. Vose, Jr. "Alvan Fisher, 1792–1863: American Pioneer in Landscape and Genre," *Connecticut Historical Society Bulletin* 27 (October 1962), 97–129 / Fred Barry Adelson, *Alvan Fisher (1792–1863): Pioneer in American Landscape Painting*, 2 vols. (Ph.D. diss., Columbia University, 1982; Ann Arbor, Mich.: University Microfilms International, 1985)

205 (see plate 64)

ALVAN FISHER

Niagara Falls, 1823

Oil on canvas; 23⅛ × 29⅞ in. (58.7 × 75.9 cm)

Signed and dated at lower center, on rock: A Fisher / pixt / 1823

Technical note: The surface was broken up during a cleaning that took place at an undetermined date in this century.

EXHIBITED: possibly Hartford Gallery of Fine Arts, 1825, as "Niagara Falls" / Wadsworth Atheneum, "Off for the Holidays," 1955, no. 19 / Buffalo, N.Y., Albright-Knox Art Gallery, "Three Centuries of Niagara Falls: Oils, Watercolors, Drawings, and Prints," 1964, no. 33 / Hartford, Austin Arts Center, Trinity College, "Nineteenth and Twentieth Century Landscape Painting," 1965–1966, no. 3 / Omaha, Nebr., Joslyn Art Museum, "A Sense of Place," 1973 / Coral Gables, Fla., Lowe Art Museum, University of Miami, "Nineteenth-Century American Topographical Painters," 1974–1975, no. 44 / Wadsworth Atheneum, "The Hudson River School: Nineteenth-Century American Landscapes in the Wadsworth Atheneum," 1976, no. 16 / Paris, Galeries Lafayette, "Deux Cents Ans de Peinture Américaine: Collection du Musée Wadsworth Atheneum," 1989

EX COLL.: E. F. Coffin, Worcester, Mass.; purchased by Robert C. Vose Galleries, Boston, in 1934; sold to the Macbeth Gallery, New York City, in 1938; with the Dalzell-Hatfield Galleries, Calif.; purchased by Clara Hinton Gould, Santa Barbara, Calif., before 1948

Bequest of Clara Hinton Gould, 1948.199

Alvan Fisher traveled to Niagara Falls during the summer of 1820, having received a commission from Judge Daniel Appleton White of Salem, Massachusetts, to paint views of the falls.[1] He produced a large number of sketches on the trip and from them created at least ten known oil paintings of the falls. Relying strongly on the example of John Vanderlyn (q.v.), who had produced several of the earliest views of Niagara during the first decade of the century, Fisher produced fairly conventional compositions, taken from the Canadian side.[2] Most were versions of the two original paintings, *A General View of the Falls of Niagara* and *The Great Horseshoe Fall, Niagara* (1820, National Museum of American Art), painted for Judge White. Fisher first sent two studies for the paintings to his patron with the following comments: "I do not send these hasty sketches as correct drawings of the Falls of Niagara but as keys to [the] Paintings. They will serve to point out the most important parts of the scenery to those who have not visited them."[3]

The Atheneum's *Niagara Falls* is the smallest of Fisher's known canvases of the falls and is based on the earlier *General View of the Falls of Niagara*. In both works, Fisher combines an accurate representation of the distant falls taken from the Canadian side with a picturesque foreground filled with framing devices in the form of trees at left and right and a detailed genre scene filled with figures. In the Atheneum's version, a couple stands calmly by as a man is pulled up from the ledge overlooking the falls by a second man wearing a black top hat, while a third crouches over the edge to assist. To the far right, a single figure of a man looks over the edge with arms outspread in awe of the scene before him. A small boat filled with figures is seen in the waters below.

In this work and several others, Fisher conveys the fact that the site had become a popular attraction for tourists. As Jeremy Adamson points out, by 1820 a number of comfortable hotels on both the American and Canadian shores accommodated the hundreds of tourists that visited the falls on a given day.[4] EMK

1. It used to be generally thought that Fisher first traveled to Niagara in 1818, but this has proven erroneous. See Fred Barry Adelson, *Alvan Fisher (1792–1863): Pioneer in Amer-*

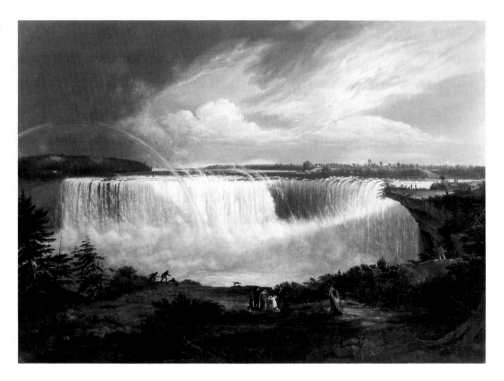

Fisher, *A General View of the Falls of Niagara*, 1820. National Museum of American Art, Smithsonian Institution.

ican Landscape Painting (Ph.D. diss., Columbia University, 1982; Ann Arbor, Mich.: University Microfilms International, 1985), 1:167–188.

2. Jeremy Elwell Adamson, with Elizabeth McKinsey, Alfred Runte, and John F. Sears, *Niagara: Two Centuries of Changing Attitudes, 1697–1901,* exh. cat. (Washington, D.C.: Corcoran Gallery of Art, 1985), 35–36, 139.

3. Alvan Fisher to Judge D. A. White, November 18, 1820, National Museum of American Art, along with nineteen drawings made by Fisher at Niagara in 1820. The letter is quoted in Adelson, *Alvan Fisher,* 1:171.

4. Adamson, *Niagara,* 35 n. 90.

206

ATTRIBUTED TO ALVAN FISHER

John Watson, c. 1826

Oil on canvas; $29^{7}/_{8} \times 25$ in. (75.9×63.5 cm)

EX COLL.: descended in the collection of the sitter, East Windsor, Conn., to Rosa Watson and Cecile A. Watson, to 1948

Bequest of Miss Rosa Watson and Miss Cecile A. Watson, 1948.526

206

207

ATTRIBUTED TO ALVAN FISHER

Mrs. John Watson (Anna Bliss), c. 1826

Oil on canvas; 29¾ × 24¾ in. (75.6 × 62.9 cm)

EX COLL.: descended in the family of the sitter, East Windsor, Conn., to Rosa Watson and Cecile A. Watson, to 1948

Bequest of Miss Rosa Watson and Miss Cecile A. Watson, 1948.527

Fisher favored landscape and genre painting, but like many American artists, he continued to paint portraits throughout his career, driven by the necessity to make a living. As the artist noted, "By [portrait painting] I have *lived* and must live, for after all my industry, study, and I believe some skill in Landscape, animals and compositions of various kinds—I have never been able to get a living without the aid of portrait painting."[1] As William Dunlap observes, the artist considered portrait painting his "principal business."[2]

Fisher's portraits of the Watsons are sympathetic likenesses of this elderly couple. Mrs. Watson stares alertly out at the viewer; her pose and the shawl thrown over her left arm relate to Fisher's portrait of her daughter, Anna Watson Bliss (cat. 208). The artist placed his subjects against a dark background with the suggestion of a paneled wall.

A graduate of Yale College in 1764, John Watson (1744–1824) of East Windsor, Connecticut, was a prominent merchant and gentleman farmer. He married Anna Bliss of East Windsor in 1757. The portraits of the Watsons, along with that of their daughter, are attributed to Alvan Fisher based on family tradition and stylistic similarity to other documented portraits by the artist. In addition, it is known that Fisher received commissions from Watson shortly after his return from Europe in the fall of 1826. Fisher's notebook lists the following as the first entry for portraits of Watson's prize cattle in 1826, "Two portraits of Watson's Bull Wye & Comet at East Windsor, Connecticut".[3] Although the portraits are not mentioned in the account book, they were likely executed at this time. EMK

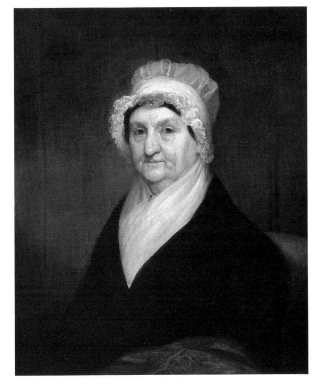

207

1. Alvan Fisher to Charles C. Wright, Boston, March 8, 1831, Alvan Fisher Papers, New York Public Library, quoted in Fred B. Adelson, *Alvan Fisher (1792–1863): Pioneer in American Landscape Painting* (Ann Arbor, Mich.: University Microfilms International, 1985), 2:780.

2. William Dunlap, *History of the Rise and Progress of the Arts of Design in the United States* (1834; rpt., New York: Dover, 1969), 2:264.

3. In September 1826 Fisher began to keep a record of his sales. See "A Catalogue of Paintings Executed after My Return from Europe in 1826," private collection. The Watson entry is mentioned in Mabel Munson Swan, "The Unpublished Notebooks of Alvan Fisher," *Antiques* 65 (August 1955), 128; and in Adelson, *Alvan Fisher*, 306.

208

ATTRIBUTED TO ALVAN FISHER

Mrs. John Bliss (Anna Watson), c. 1826

Oil on wood; 29½ × 25 in. (74.9 × 63.5 cm)

Technical note: On the reverse of the wood panel, the artist sketched a head with color notations for the features, noting "blue Trans" with a line drawn to

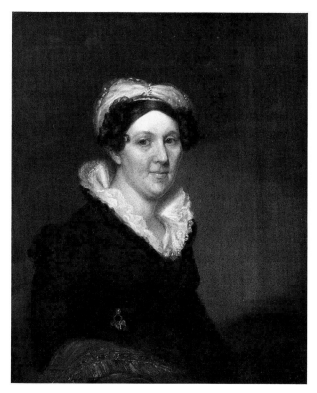

208

areas of the face. The panel is pieced together with a strip of linen glued to the seam, on the back.

EXHIBITED: Boston, Museum of Fine Arts, "Alvan Fisher, 1792–1863: American Pioneer in Landscape and Genre," 1963

EX COLL.: descended in the family of the sitter, East Windsor, Conn., to Rosa Watson and Cecile A. Watson, to 1948

Bequest of Miss Rosa Watson and Miss Cecile A. Watson, 1948.528

Fisher's portraits reflect the impact of the Boston artist Gilbert Stuart (q.v.), who was an important influence, as well as the works of Fisher's friend and colleague Chester Harding (1792–1866). This portrait has been attributed to Alvan Fisher on the basis of family tradition—it was given to the Wadsworth Atheneum as a portrait by Fisher by descendants of the sitter—and its stylistic similarity to Fisher's other portraits. It was included in an exhibition of the artist's works held in 1963 and compared to such documented portraits by Fisher as *Aaron Fisher* (private collection).[1] William

Warren noted the fact that for his portraits Fisher frequently used wood panels pieced together with linen strips glued to the back, as described in the technical note above.[2] Finally, Fisher had received commissions from other members of this family (cats. 206, 207) at about the time this portrait was probably painted.

Anna Bliss stares out at the viewer and is dressed in a black dress with a white muslin ruff collar and a white tulle-and-lace turban ornamented with a pearl clasp. A paisley shawl is thrown over her right arm. She is placed against a dark wall with the hint of a column at the right. Anna Watson Bliss (1772/3–1836) was the daughter of John and Anna (Bliss) Watson of East Windsor, Connecticut, and married her first cousin John Bliss in about 1793. EMK

1. See Robert C. Vose, Jr., "Alvan Fisher, 1792–1863: American Pioneer in Landscape and Genre," *Connecticut Historical Society Bulletin* 27 (October 1962), 112, ill. 117.
2. William Warren to Charles Cunningham, March 7, 1963, curatorial painting file, Wadsworth Atheneum.

John Lee Fitch

Born in Hartford, in 1836; probably died in Yonkers, N.Y., in 1895

John Lee Fitch, called the "forest painter" by H. W. French, was the son of a Hartford lawyer. He began his study of art in his birthplace under the tutelage of German-born Julius Busch, a drawing teacher who in 1855 painted a picture of Daniel Wadsworth's great uncle hiding the colony's charter in the Charter Oak. After studying with Busch but before 1855 Fitch studied with portrait painter George F. Wright (q.v.). In 1855 he traveled to Europe, remaining in Munich for three years to study drawing before going on to paint for a year in Milan, all under Professor Albert Zimmerman and his brothers, Richard and Max Zimmerman. Fitch returned to Hartford in 1859 and painted full-time there until 1866, when he moved to New York. He continued to maintain a second studio in Hartford until around 1875. In 1867 the artist became a member of the Century Club. In 1870 he was elected an associate of the National Academy of Design, where he had begun exhibiting

paintings as early as 1860, and at some point he joined the Artists' Fund Society.

From the mid-1860s through the mid-1870s, Fitch spent time in Keene Valley in the Adirondacks. He was one of a number of artists working in the region, R. M. Shurtleff (1838–1915) and Alexander Helwig Wyant (q.v.) among them (cat. 504). (Shurtleff credited Fitch with the artistic discovery of the Adirondacks.) Fitch also made trips to the White Mountains in this period; a painting by Winslow Homer (q.v.), *Artists Sketching in the White Mountains* (1868, private collection), pictures Fitch, Homer Dodge Martin (q.v.), and himself at work on what may be the top of Mount Washington. The artist took a second trip to Germany in 1871 but stayed only a short while.

By 1872 and through 1890 Fitch listed his address as 51 West Tenth Street (the Tenth Street Studio) in the National Academy of Design's exhibition records. Some of his fellow tenants were Homer, Martin, Eastman Johnson (q.v.), and John LaFarge (1835–1910). In 1894 Fitch was living in Yonkers, New York.

SELECT BIBLIOGRAPHY

Hartford Daily Courant, September 14, October 8, and October 11, 1855; April 1 and September 28, 1859 / H. W. French, *Art and Artists in Connecticut* (Boston: Lee and Shepard; New York: Charles T. Dillingham, 1879), 145 / Charles Hunter Owen, "Art and the Artist: An Appreciation of John Lee Fitch," *Connecticut Magazine* 10 (April–June 1906) / Clara Erskine Clement and Laurence Hutton, *Artists of the Nineteenth Century and Their Works*, rev. ed. (1884; rpt., St. Louis: North Point Press, 1969), 1:254–255 / George C. Groce and David H. Wallace, *The New-York Historical Society's Dictionary of Artists in America, 1564–1860* (New Haven: Yale University Press; London: Oxford University Press, 1957), 229 / Donald D. Keyes, with Catherine H. Campbell, Robert L. McGrath, and R. Stuart Wallace, *The White Mountains: Place and Perceptions*, exh. cat. (Hanover, N.H., and London: University Press of New England, for the University Art Galleries, University of New Hampshire, 1980) / Annette Blaugrund, "The Tenth Street Studio Building: A Roster, 1857–1895," *American Art Journal* 14, no. 2 (1982), 64–71 / Hildegard Cummings, *The Hartford Art Colony, 1880–1900*, exh. cat. (Marlborough, Conn.: Connecticut Gallery, 1989), 16 / William H. Gerdts, *Art Across America: Two Centuries of Regional Painting, 1710–1920* (New York: Abbeville Press, 1990), 1:182 / Patricia C. F. Mandel, *Fair Wilderness: American Paintings in the Collection of the Adirondack Museum* (Blue Mountain Lake, N.Y.: Adirondack Museum, 1990), 56

209

JOHN L. FITCH
Mount Washington, 1866
Oil on canvas; 11⅝ × 17½ in. (29.5 × 44.5 cm)
Signed at lower right: J.F. 66
Label on original spring-loaded stretcher: PATENT
 APPLIED FOR

EXHIBITED: Hartford Club, on view from 1947 through 1955

EX COLL.: Elizabeth Hart Jarvis Colt, Hartford, at least to 1879; to Dr. Samuel Hart, Old Saybrook, Conn.; to Mrs. C. L. F. Robinson, Hartford, by 1906

Gift of Mrs. C. L. F. Robinson, 1906.3

Fitch made sketching trips to the White Mountains in the 1860s. Mount Washington is the tallest peak in the White Mountains, which extend from north-central New Hampshire into western Maine. Artists began traveling to the White Mountains as early as the 1780s, but it was during the latter half of the 1800s that large numbers of artists, as well as tourists and writers, flocked to the White Mountains to enjoy the spectacular scenery.[1] Thomas Cole (q.v.) was probably the first to bring the mountains to the attention of the greater public with paintings such as *View in the White Mountains* (cat. 124), depicting Mount Washington as treacherous and stormy. John F. Kensett (q.v.) also painted in the White Mountains (cat. 310).[2] His painting *The White Mountains—Mount Washington* (1851, Wellesley College Museum) presents a different view of the area, one that became more and more common in the second half of the century: that of an agrarian arcadia with neatly tended fields and picturesque houses.[3] The group of artists that worked there, many of them Hudson River school artists, became known as the White Mountain school.

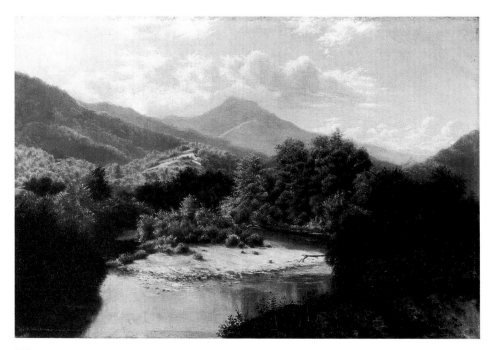

209

Fitch's painting falls somewhere between the two poles here represented by the work of Cole and Kensett. He depicts the mountain in wilderness, untouched by the creeping civilization and industry that had resulted from the railroad's introduction to the area in the 1840s, and yet, aside from a scattering of clouds, there is no real hint of the climactic extremes for which the mountain was famous (partly as a result of images like Cole's). The high-keyed blue of the water—which could be the Saco River in North Conway—in the foreground of the Atheneum's painting may simply be a convention of the White Mountain painters, who, Samuel Isham wrote, "usually strove to key the sky up to the brightest possible tone."[4] Fitch's *Mount Washington*, judging from its size as well as the composition, was probably aimed at a middle-class audience that may have wanted an image that confirmed their notion of the mountain as unthreatening but free from the less aesthetic effects of the growing tourist industry.[5]

Fitch's *Mount Washington* was in the collection of Elizabeth Colt, a benefactor of the Wadsworth Atheneum (see Introduction) in 1879, when H. W. French wrote about the painting, "Mrs. Samuel Colt of Hartford has one of [Fitch's] finer pieces in her gallery."[6] The painting's stretcher is of particular interest. Joel E. Todd of Middletown, Connecticut, applied for a patent for his self-expanding stretcher in 1866, the year Fitch painted *Mount Washington*.[7] AE

1. See Donald D. Keyes, with Catherine H. Campbell, Robert L. McGrath, and R. Stuart Wallace, *The White Mountains: Place and Perceptions*, exh. cat. (Hanover, N.H., and London: University Press of New England, for the University Art Galleries, University of New Hampshire, 1980).
2. John K. Howat, ed., *American Paradise: The World of the Hudson River School*, exh. cat. (New York: Metropolitan Museum of Art, 1987), 149–151.
3. Keyes et al., *The White Mountains*, 11, 44.
4. Samuel Isham, *The History of American Painting*, new ed. (New York: Macmillan, 1936), 258.
5. Keyes et al., *The White Mountains*, 44–55.
6. H. W. French, *Art and Artists in Connecticut* (Boston: Lee and Shepard; New York: Charles T. Dillingham, 1879), 145.
7. United States Patent Office, patent no. 58.154, issued to Joel E. Todd, Middletown, Conn., for Artist's Stretcher, September 18, 1866. See curatorial painting file, Wadsworth Atheneum.

Simon Fitch

Born in Norwich, Conn., in 1758; died probably in
Lebanon, Conn., in 1835

Simon Fitch is noted for a small number of masterful
portraits painted in Connecticut in the later part of the
eighteenth century that demonstrate the influence of the
major Connecticut portraitist of the period, Ralph Earl
(q.v.). Fitch was a descendant of the Reverend James
Fitch, one of the first settlers of the artist's native town
of Norwich. When he was a young boy, Fitch's family
moved to nearby Lebanon, where he and the artist John
Trumbull (q.v.) attended the school of Nathan Tisdale.
During the Revolutionary War, Fitch served as a captain
in the militia, and in 1783 he married Wealthy Hunt-
ington of Norwich. With the exception of his trips to
various Connecticut towns, as well as a documented trip
to Keene, New Hampshire, in search of portrait commis-
sions, Fitch spent most of his life in Lebanon.

Although the details of Fitch's early artistic training
remain unknown, he had the opportunity to view the
portraits John Trumbull had painted of his family in the
early 1770s that hung in Trumbull's parents' house in
Lebanon at that time (cat. 449). In addition, in the 1770s
the Woodstock, Connecticut, portrait painter Winthrop
Chandler (1747–1790) had painted portraits of the Hunt-
ington family of Norwich, Fitch's in-laws, and in 1796
Ralph Earl, too, painted portraits of members of the
Huntington family. Fitch undoubtedly drew inspiration
from these examples.

Little is known of Fitch's career. His brother-in-law,
Dan Huntington, referred to him as a "portrait painter"
(Warren, "Starr Portraits," 13); however, only fifteen
works are assigned to Fitch, and these date from 1795 to
1802. Because the artist is not known to have signed his
paintings, firm attributions are based on contemporary
sources.

SELECT BIBLIOGRAPHY

Dan Huntington, *Memories, Counsels, and Reflections by an
Octogenary* (Cambridge, Mass., 1857) / William L Warren,
"Captain Simon Fitch of Lebanon, 1758–1835: Portrait Painter,"
Connecticut Historical Society Bulletin 26 (October 1961) /

William Warren, "The Starr Portraits by Simon Fitch of Leb-
anon," *Wadsworth Atheneum Bulletin*, ser. 5, no. 9 (winter
1961), 7–17 / Elizabeth Mankin Kornhauser, with Richard L.
Bushman, Stephen H. Kornhauser, and Aileen Ribeiro, *Ralph
Earl: The Face of the Young Republic*, exh. cat. (New Haven:
Yale University Press, with the Wadsworth Atheneum, 1991)

210

SIMON FITCH
General Henry Champion, c. 1795–1800
Oil on canvas; $46^{1}/_{4} \times 36^{1}/_{2}$ in. (117.5 × 92.7 cm)

EXHIBITED: Wadsworth Atheneum, "The Great River: Art
and Society of the Connecticut River Valley, 1635–1820," 1985–
1986, no. 49

EX COLL.: descended in the Champion/Huntington family to
Richard Huntington Cole and his wife, Alice G. Eno Cole; to
their daughter, Mrs. Charles Anthony, Bloomfield, Conn., be-
fore 1983

Given in memory of Richard Huntington Cole and Alice Eno
Cole by their daughter, Mrs. Charles H. Anthony, 1985.159

Henry Champion (1751–1836) was the son of Colonel
Henry Champion of Westchester, Connecticut, where he
was born and eventually died. A hero in the Revolution-
ary War, he achieved the rank of general and fought in
the battles of Bunker Hill and Long Island. After the
war, he became a member of the Connecticut chapter of
the Society of the Cincinnati, made up of officers of the
war. He returned to Westchester, and entered politics,
serving as a deputy from Colchester to the Connecticut
Assembly. In 1781 he married Abigail Tinker of East
Haddam, Connecticut. In the postwar years, Champion
was an important figure in the development of the Con-
necticut Land Company, subscribing more than $85,000
for land that was part of the Ohio Western Reserve. The
towns of Champion, New York, and Champion, Ohio,
are named for him.[1]

Presenting Champion in a composition similar to that
of his portrait of Ephraim Starr (cat. 211), the portrait
demonstrates the influence of the Connecticut portrait-
ist Ralph Earl (q.v.). Champion is seated in a locally

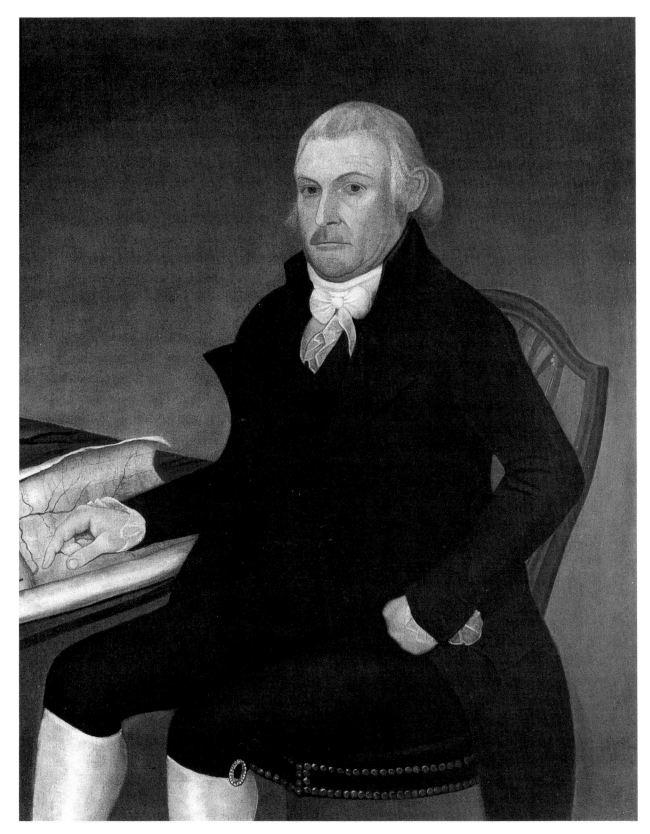

210

made federal shield-back chair, placed next to a table on which he points to a map of the Ohio Western Reserve, a reference to his land investments in that territory. The portrait is thinly painted, and the subject carefully delineated in a straightforward manner. The palette is subdued, and the subject is placed against a plain background.

The portrait of Henry Champion is listed in a distribution list of family effects as a family portrait of "Henry 2 d"; no value is assigned to this and the other family portraits on the list, as they held no exchange value. This document and other Champion family papers, along with several furnishings from the Champion estate, are in the collection of the Connecticut Historical Society.[2] A companion portrait Fitch painted of Champion's wife and daughter, *Abigail Tinker Champion and Daughter Maria* (c. 1795–1800), was destroyed in a fire in the 1970s.[3] EMK

1. For biographical information, see Francis Bacon Trowbridge, *The Champion Genealogy: A History of the Descendants of Henry Champion* (New Haven: printed for the author, 1891); and Elizabeth Mankin Kornhauser's entry "General Henry Champion," in *The Great River: Art and Society of the Connecticut River Valley, 1635–1820,* exh. cat. (Hartford: Wadsworth Atheneum, 1985), 160–161.
2. My thanks to Robert Trent for bringing this information to my attention.
3. The portrait *Abigail Tinker Champion and Daughter Maria* descended in the Champion family. For an illustration, see William L. Warren, "Captain Simon Fitch of Lebanon, 1758–1835: Portrait Painter," *Connecticut Historical Society Bulletin* 26 (October 1961), 122.

211 (see plate 65)

SIMON FITCH

Ephraim Starr, 1802
Oil on canvas; 59 × 39¹⁵/₁₆ in. (149.9 × 101.4 cm)
Inscribed on paper label on back of stretcher: Portrait of
 Ephraim Starr / taken in the 57th year of his Age /
 by Simon Fitch in Feby 1802–

EXHIBITED: Hartford, Connecticut Historical Society, "The Works of Simon Fitch," 1962, no. 1 / New York City, Museum of American Folk Art, "American Folk Painting and Sculpture," 1966 / New York City, M. Knoedler and Co., "What Is

American in American Art?" 1971, no. 14a / Boston, Museum of Fine Arts, "Paintings by New England Provincial Artists, 1775–1800," 1976, no. 44 / Washington, D.C., National Portrait Gallery; Wadsworth Atheneum; and Fort Worth, Tex., Amon Carter Museum of Art, "Ralph Earl: The Face of the Young Republic," 1991–1992, no. 72

EX COLL.: Ephraim and Hannah Starr, Goshen, Conn.; to their daughter, Abigail Starr, Goshen, Conn., in 1826; to Erastus and Abigail (Starr) Lyman; to Frederick Lyman, Hartford; to Frederick Gold Lyman, Hartford, and Montreal, Canada; to John Lyman, Montreal, Canada, to 1961; purchased by the Wadsworth Atheneum through the Montreal Museum of Art, Canada, in 1961

The Ella Gallup Sumner and Mary Catlin Sumner Collection Fund, 1961.460

212 (see plate 66)

SIMON FITCH

Mrs. Ephraim (Hill) Starr (Hannah Beach), 1802
Oil on canvas; 58⁵/₈ × 40¹/₄ in. (148.9 × 102.2 cm)
Inscribed on paper label on back of stretcher: Portrait of
 Hannah Starr / taken in the 56th Year of her Age /
 by Simon Fitch in Feby 1802

EXHIBITED: Hartford, Connecticut Historical Society, "The Works of Simon Fitch," 1962, no. 1 / New York City, Museum of American Folk Art, "American Folk Painting and Sculpture," 1966 / New York City, M. Knoedler and Co., "What Is American in American Art?" 1971, no. 14a / Boston, Museum of Fine Arts, "Paintings by New England Provincial Artists, 1775–1800," 1976, no. 44 / Washington, D.C., National Portrait Gallery; Wadsworth Atheneum; and Fort Worth, Tex., Amon Carter Museum of Art, "Ralph Earl: The Face of the Young Republic," 1991–1992, no. 73

EX COLL.: Ephraim and Hannah Starr, Goshen, Conn.; to their daughter, Abigail Starr, Goshen, Conn., in 1826; to Erastus and Abigail (Starr) Lyman; to Frederick Lyman, Hartford; to Frederick Gold Lyman, Hartford, and Montreal, Canada; to John Lyman, Montreal, Canada, to 1961; purchased by the Wadsworth Atheneum through the Montreal Museum of Art, Canada, in 1961

The Ella Gallup Sumner and Mary Catlin Sumner Collection Fund, 1961.461

Ephraim Starr (1745–1809) came from Middletown, Connecticut, a major port town on the Connecticut River, from which he went to sea as a young man, and where he later came into contact with the Goshen, Connecticut, merchant Uri Hill. Ephraim worked as a clerk in Hill's Litchfield County store, and after his employer died of smallpox in 1766, he took over the business and in 1769 married Hill's widow. Hannah Beach Starr (1745–1826) spent her entire life in Goshen where she assisted her husband and bore nine children during her lifetime.

Ephraim Starr was so successful as a merchant that he was able to retire by the age of forty-eight. His most profitable venture occurred at the close of the American Revolution, just before the evacuation of the British, when he purchased a wide variety of goods in New York City at a low price and then sold this merchandise in his store in Goshen at a sizable profit. In his portrait, the artist shows his subject seated near a table on which rests a large account book inscribed "Wast[e] Book." Ephraim is writing on a piece of paper: "20 shares / New York / Bank"—words symbolic of his many investments. When he died, he left an estate worth over $65,000.[1]

The Starrs could well afford to have large-scale portraits of themselves painted by Fitch, and they are the finest known examples of the artist's work. The portraits are documented by paper labels inscribed in ink with the names and ages of the sitters, the artist's name, and the date of the portraits and attached to the original stretcher bars of each canvas. The inscriptions were likely made by the artist; 1802 is the latest-known date for a work by Fitch.

The Starr portraits display the conservative aesthetic associated with Connecticut portraiture of the eighteenth century, which is embodied in the works of such artists as Winthrop Chandler and to which Ralph Earl (q.v.) responded in his Connecticut portraits of the 1790s. Their scale and composition—the full-length figures seated in Windsor chairs next to tables and the decorative, patterned floors—relate these works to the compositions made popular by Earl (cats. 185, 186).[2]

Fitch adheres to a subdued palette on the thinly painted canvases and concentrates on the painstaking delineation of his subjects. The Starrs are shown in forthright depictions, devoid of flattery. Ephraim is seated in a green Windsor armchair, solid enough to support his considerable bulk, of which he was evidently proud; Fitch made no attempt to conceal the stress placed on the buttons of his stout subject's plain black vest. Hannah, depicted with a visage as stern as her husband's, like him stares boldly out at the viewer. She is dressed modestly in a voluminous green silk gown and a white cap with embroidered stars. In her right hand, she holds a closed fan; in her left, a moss rose. Again like her husband, she leans on a country cherrywood table. EMK

1. Ephraim Starr, probate inventory, Goshen, Conn., 1809, reel 706, no. 5453, Connecticut State Library, Hartford, cited in Elizabeth Mankin Kornhauser, with Richard L. Bushman, Stephen H. Kornhauser, and Aileen Ribeiro, *Ralph Earl: The Face of the Young Republic*, exh. cat. (New Haven: Yale University Press, with the Wadsworth Atheneum, 1991), 250.
2. Ephraim Starr's inventory lists "12 Elbow Windsors," "8 Common [Windsors]," and "6 fanned backed [Windsors]."

Charles Noel Flagg

Born in Brooklyn, N.Y., in 1848; died in Hartford, in 1916

Charles Noel Flagg painted at an early age in the New Haven studio of his father, Jared B. Flagg (q.v.). Other members of the family were also artists: his brother Montague Flagg (1842–1915), his uncles George Whiting Flagg (1816–1897) and Henry Collins Flagg (1811–1862), and his half-great uncle, Washington Allston (q.v.). In 1868 Charles moved to Hartford to paint portraits, and in 1872, in company with Montague and his friend Robert B. Brandegee (q.v.), he traveled to Paris. He lived there for the next two years and then returned to the United States in 1874, staying until 1877. During this period he began to exhibit at the National Academy of Design, continuing to do so until 1911. In 1877 Flagg returned to Paris, remaining there until 1882.

In 1872, like other Connecticut artists who went to Paris—among them, Dwight William Tryon (q.v.),

J. Alden Weir (q.v.), Charles Porter (q.v.), and Samuel Isham (q.v.)—Flagg entered the studio of Louis-Marie-François Jacquesson de la Chevreuse (1839–1903), the well-known student of Ingres and Gérôme. These Americans received individual attention from the French painter, who particularly emphasized the principles of drawing and modeling. Jacquesson's instruction would later inspire Flagg's own teaching methods.

After a second trip to Europe, Flagg returned to America, eventually settling in Hartford in 1887. He began to paint portraits of prominent Connecticut citizens, including the state's governors. In 1888 he began to teach, founding the first formal art school in Connecticut, the Flagg Night School of Drawing for Men (now the Connecticut League of Art Students). Students who attended the school included James Britton (q.v.), Henry C. White (q.v.), and James Goodwin McManus (q.v.).

Flagg, along with his friends and fellow artists, including William Gedney Bunce, Robert Brandegee, James Britton, and James McManus, formed the center of an artistic community in Hartford in the late-nineteenth and early-twentieth centuries. Throughout his life Flagg remained involved in and supportive of the artistic community in Hartford. He collected works by local artists, including Robert Brandegee, William Gedney Bunce (q.v.), and Jared and Montague Flagg. He was also a founder of the Society of Hartford Artists, formed in 1892, and in 1904 was elected president of the recently formed Municipal Art Society of Hartford. He became president of the Connecticut Academy of Fine Arts in 1910.

Flagg received the Proctor Prize of the National Academy of Design in 1908 and the following year was elected an associate of the academy.

SELECT BIBLIOGRAPHY

Charles Noel Flagg, "Art Education for Men," *Atlantic Monthly* 86 (September 1900), 393–399 / *Paintings by the Flagg Family*, exh. cat. (Hartford: Wadsworth Atheneum, 1944) / Junior Seminar in Art History, *Charles Noel Flagg, 1848–1916*, exh. cat. (Hartford: Trinity College, 1974) / Helen D. Perkins, "Charles Noel Flagg, A.N.A., 1848–1916," *Connecticut Historical Society Bulletin* 40 (October 1975), 97–153

213

CHARLES NOEL FLAGG
Austin Dunham, 1880
Oil on canvas; 45½ × 27⅝ in. (115.6 × 70.2 cm)
Signed and dated at lower right: C. N. Flagg / Paris 1880

EXHIBITED: Wadsworth Atheneum, "Paintings by the Flagg Family," 1944, no. 16 / New London, Conn., Lyman Allyn Museum, "Eighty Eminent Painters of Connecticut," 1947, no. 117 / Hartford, Connecticut Historical Society, "Charles Noel Flagg, A.N.A., 1848–1916," 1975, no. 52

EX COLL.: Dunham Hall Library, American Thread Company, Willimantic Mills, Willimantic, Conn., by 1941

Gift of the American Thread Company, 1941.585

213

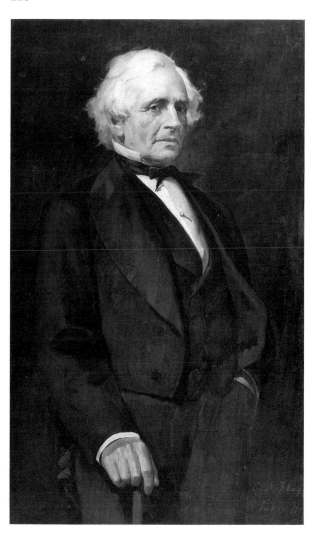

In 1835 Austin Dunham (1810–1877) moved to Hartford, where he lived in Daniel Wadsworth's house on Prospect Street with his family. He served as a vice president of Aetna Life Insurance Company of Hartford from 1863 to 1877, organized the company, Austin Dunham and Sons, wool importers, and served as president of Dunham Hosiery Company and of the Willimantic Linen Company, which, in 1880, became the American Thread Company.[1] Dunham had helped the artist to finance his second trip to Paris for further training.

The Atheneum's portrait is Flagg's second of Austin Dunham, which he executed during his second stay in Paris. It is the largest of the three portraits he completed (the other two—one painted in 1877 and the other undated—remain in private collections) and reflects Flagg's skill in strong modeling and his ability to capture character. The portrait hung in the Dunham Hall Library of The American Thread Company in Willimantic.[2] ERM

1. Helen D. Perkins, "Charles Noel Flagg, A.N.A., 1848–1916," *Connecticut Historical Society Bulletin* 40 (October 1975), 117.
2. S. Moxon, The American Thread Company, to Charles A. Goodwin, August 8, 1941, curatorial painting file, Wadsworth Atheneum.

214

CHARLES NOEL FLAGG
The Bather, 1882
Oil on canvas; 30 1/8 × 25 1/8 in. (76.5 × 63.8 cm)
Signed and dated at lower right: Charles Noel Flagg
1882

EXHIBITED: Wadsworth Atheneum, "Paintings by the Flagg Family," 1944, no. 25 / Wadsworth Atheneum, "The Nude in Art," 1946, no. 25 / Hartford, Trinity College, "Charles Noel Flagg: Portraitist of Mark Twain and His Contemporaries," 1974

EX COLL.: to Mrs. Florence A. Wright, by 1925; loaned to the Wadsworth Atheneum from 1925 to 1927

Henry and Walter Keney Fund, 1927.431

214

Flagg painted *The Bather* either during his second visit to Paris or after his return to America. In this genre painting of a woman, Flagg focuses on modeling through the use of light and shade. Diffuse light illuminates the figure, which is set against a dark background. Flagg learned all these techniques from Jacquesson de la Chevreuse and later taught them in his own school. ERM

215

CHARLES NOEL FLAGG
George Beach, 1882
Oil on canvas; 51 1/8 × 32 1/2 in. (129.9 × 82.6 cm)
Signed and dated at lower left: Chas. N. Flagg 1882

EXHIBITED: Wadsworth Atheneum, "Paintings by the Flagg Family," 1944, no. 18 / Wadsworth Atheneum, "A Second Look: Late Nineteenth Century Taste in Paintings," 1958, no. 52 / Hartford, Trinity College, "Charles Noel Flagg: Portraitist of Mark Twain and His Contemporaries," 1974

EX COLL.: descended in the Beach Family, Hartford, to Mrs. Albert Goodhue, Hartford, by 1942

Gift of Mrs. Albert Goodhue from the estate of Mrs. T. Belknap Beach, 1942.318

George Beach (1812–1899), the brother of Charles Beach (cat. 221), founded the firm of Beach and Company in Hartford, a business that pioneered the importation of dye stuffs from the Caribbean. Beach also served as president of the First National Bank of Hartford.[1] His home was located on Farmington Avenue, where the Aetna Life Insurance building is now.

Flagg presented a dignified image of George Beach that illustrates the subject's intellect and stoic character. As in all his portraits, the artist carefully models the figure with areas of light and shade. ERM

1. Helen D. Perkins, "Charles Noel Flagg, A.N.A., 1848–1916," *Connecticut Historical Society Bulletin* 40 (October 1975), 108.

215

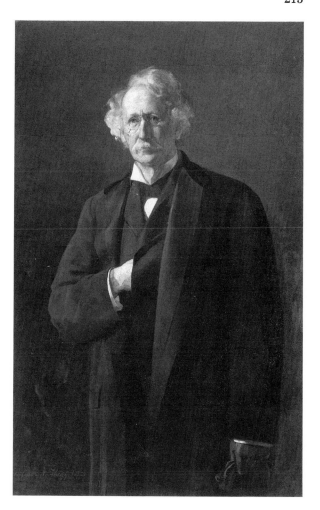

216

CHARLES NOEL FLAGG
Dr. Horace Wells, 1899
Oil on canvas; 57⅛ × 43 in. (145.1 × 109.2 cm)
Signed and dated at lower right: Chas. Noël Flagg.
 1899—
Inscribed at upper left: Horace Wells / Discoverer of / Anethesia / Anno 1844

EXHIBITED: Wadsworth Atheneum, "Connecticut League of Art Students," 1938, no. 7 / Wadsworth Atheneum, "Paintings by the Flagg Family," 1944, no. 14 / Wadsworth Atheneum, "The Medicine Man: Medicine in Art," 1954, no. 385 / Wadsworth Atheneum, "A Second Look: Late Nineteenth Century Taste in Paintings," 1958, no. 16 / Hartford, Connecticut Historical Society, "Charles Noel Flagg, A.N.A., 1848–1916," 1975, no. 143

EX COLL.: the artist, Hartford, to 1899

Gift of the artist, 1899.11

Dr. Horace Wells (1815–1848) worked as a dentist in Hartford from 1836 until his death. He is best known for his discovery of nitrous oxide as an anesthetic in tooth extraction. Wells's claim to be the first discoverer of anesthesia was disputed during his lifetime, and this tragically led to his eventual suicide.

Flagg presented this important portrait to the Atheneum accompanied by the following letter:

> I take pleasure in presenting . . . a portrait of the late Dr. Horace Wells . . . [that] it might make friends for one of the most unfortunate and one of the greatest men who ever lived. The head was painted from a daguerreotype which Dr. Wells took of himself [in 1844] when experimenting with the process, shortly after its invention by Daguerre. . . . The pose was suggested by a silhouette by Dr. Wells. . . . In the cut and color of the costume I have been guided by my father's [Jared Bradley Flagg] description of what he and Dr. Wells wore at the time when they were contemporary and intimate friends. I am prompted to give this picture to the Atheneum by a profound regard for the man who

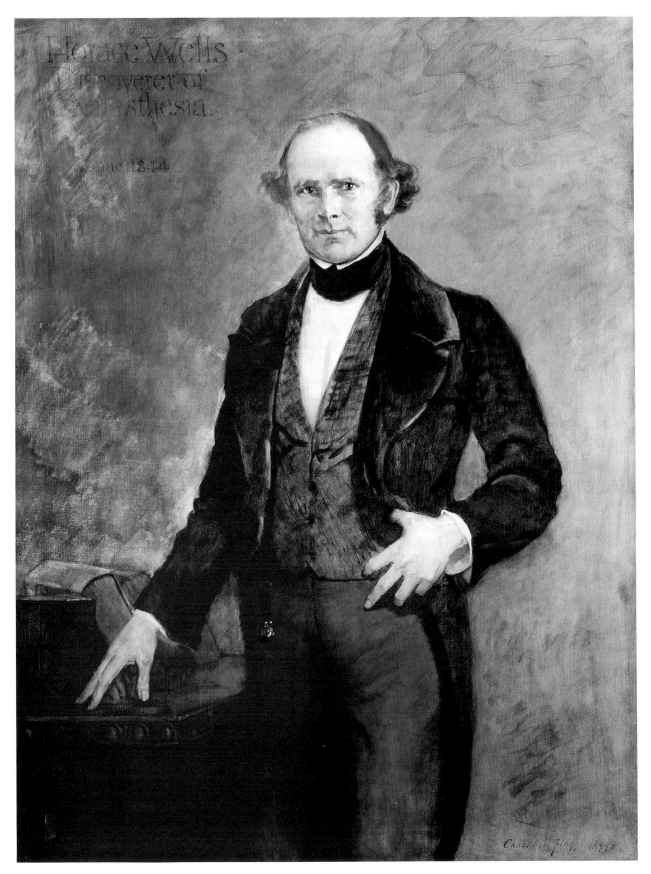

216

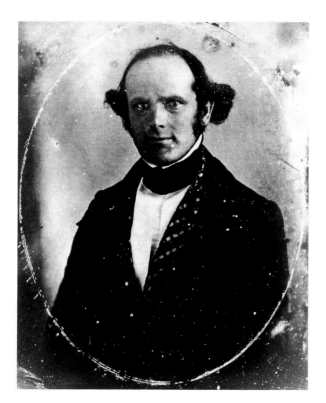

Tintype, *Horace Wells*, probably taken from the daguerreotype done by him, 1844. Boston Medical Library.

217

was able through his genius to prove his love for mankind by the greatest gift ever bestowed by a human being upon his fellows.[1]

Flagg was in the habit of using photographic sources for his portraits. In *Dr. Horace Wells*, he portrayed a person of character and confidence, belying the subject's unfortunate death. The portrait shows signs of Flagg's Chevreuse technique of first drawing the subject and then shading and modeling it. ERM

1. Charles Noel Flagg to Reverend Francis Goodwin, Wadsworth Atheneum, 1899, archives, Wadsworth Atheneum, reproduced in full in Helen D. Perkins, "Charles Noel Flagg, A.N.A., 1848–1916," *Connecticut Historical Society Bulletin* 40 (October 1975), 135.

217

CHARLES NOEL FLAGG
Alfred E. Burr, 1892
Oil on canvas; 40¼ × 32⅛ in. (102.2 × 81.6 cm)
Signed and dated at lower right: Chas. Noel Flagg. '92

EXHIBITED: Wadsworth Atheneum, "Paintings by the Flagg Family," 1944, no. 24 / Hartford, Trinity College, "Charles Noel Flagg: Portraitist of Mark Twain and His Contemporaries," 1974

EX COLL.: descended to the son of the subject, Willie O. Burr, Hartford, in 1923

Bequest of Willie O. Burr, 1939.483

218

CHARLES NOEL FLAGG
Mrs. Alfred Burr, 1892
Oil on canvas; 40 × 32 in. (101.6 × 81.3 cm)
Signed at lower left: Chas. Noel Flagg

EXHIBITED: Wadsworth Atheneum, "Paintings by the Flagg Family," 1944, no. 24 / Hartford, Trinity College, "Charles Noel Flagg: Portraitist of Mark Twain and His Contemporaries," 1974

EX COLL.: descended to the son of the subject, Willie O. Burr, Hartford, in 1923

Bequest of Willie O. Burr, 1939.484

218

Alfred Edmund Burr (1815–1900) of Hartford began his training in the printing trade at the age of twelve in the office of the *Hartford Courant.* In 1937 he left the *Courant* to become part owner of the *Hartford Times*, and by 1941 he was that paper's sole owner. Under his control, the *Hartford Times* covered national issues, and the paper became a voice for the Democratic Party.

Alfred Burr married Sarah A. Booth (1817–1911) of Meriden in 1841.[1] Flagg painted the portraits of the Burrs in their later years. The images are stoic and conservative, reflecting the taste of that period. Following the tenets taught to him by Jacquesson de la Chevreuse, Flagg modeled his subjects using mass and tonal values. Both sitters are seated in Windsor chairs.

The portraits descended to the Burr's son, Willie Olcott Burr, who succeeded his father as editor of the *Hartford Daily Times.* ERM

1. Biographical information on the Burrs comes from Helen D. Perkins, "Charles Noel Flagg, A.N.A., 1848–1916," *Connecticut Historical Society Bulletin* 40 (October 1975), 110–111.

219

CHARLES NOEL FLAGG
Caldwell Hart Colt, 1894
Oil on canvas; 47³/₄ × 60¹/₈ in. (121.3 × 152.7 cm)
Signed and dated at lower right: Charles Noel Flagg. 1894

EXHIBITED: Wadsworth Atheneum, "Paintings by the Flagg Family," 1944, no. 21 / Hartford, Connecticut Historical Society, "Charles Noel Flagg, A.N.A., 1848–1916," 1975, no. 39

EX COLL.: Elizabeth Hart Jarvis Colt, Hartford, from 1894 to 1904

Bequest of Elizabeth Hart Jarvis Colt, 1905.7

Caldwell Hart Colt (1858–1894) was born in Hartford, the only surviving child of Colonel Samuel and Elizabeth Hart (Jarvis) Colt (cats. 195, 196; see Introduction). Samuel Colt founded the Colt Patent Firearms Manufacturing Company, of which Caldwell served as director. Never interested in the business, however, Caldwell pursued sport and travel. He spent much of his time on his yacht *Dauntless* and served as vice-commodore of the New York Yacht Club and commodore of the Larchmont Yacht Club. He died at a young age in Florida.[1]

In what was most likely a posthumous portrait taken from a photograph, Flagg depicted Caldwell in his full regalia as commodore. ERM

1. Helen D. Perkins, "Charles Noel Flagg, A.N.A., 1848–1916," *Connecticut Historical Society Bulletin* 40 (October 1975): 113.

220

CHARLES NOEL FLAGG
Nehemiah Hubbard II, 1909
Oil on canvas; 30 × 25¹/₈ in. (76.2 × 63.8 cm)
Signed and dated at lower right: Chas. Noël Flagg. 1909. / From an engraving

EXHIBITED: Wadsworth Atheneum, "Paintings by the Flagg Family," 1944, no. 15 / Hartford, Connecticut Historical Society, "Charles Noel Flagg, A.N.A., 1848–1916," 1975, no. 78

219

EX COLL.: Elijah Kent Hubbard; to Middletown National Bank, Middletown, Conn., by 1941

Gift of the Middletown National Bank, 1941.332

Nehemiah Hubbard II (1752–1837) of Middletown, Connecticut, was a leading Connecticut River valley merchant involved in trade with the West Indies. During the Revolution, he served as deputy quartermaster general for Connecticut and, after the war, became president of the Middletown Savings Bank. Flagg used an engraving to create this portrait for the Middletown National Bank.[1] ERM

1. Helen D. Perkins, "Charles Noel Flagg, A.N.A., 1848–1916," *Connecticut Historical Society Bulletin* 40 (October 1975), 121–122.

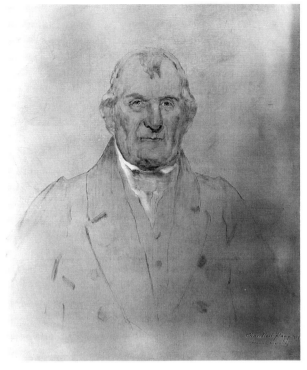

220

221

221

CHARLES NOEL FLAGG
Charles M. Beach, 1909
Crayon and oil on canvas; 30 × 25 in. (76.2 × 63.5 cm)
Signed and dated at lower right: Chas. Noël Flagg. 1909

EXHIBITED: Wadsworth Atheneum, "Paintings by the Flagg Family," 1944, no. 17 / Hartford, Connecticut Historical Society, "Charles Noel Flagg, A.N.A., 1848–1916," 1975, no. 11

EX COLL.: descended in the Beach Family to 1942

Gift of Mrs. Albert Goodhue from the estate of Mrs. T. Belknap Beach, 1942.319

Charles Mason Beach (1826–1911) of Hartford was director of the Phoenix Insurance Company for fifty years and established a sizable dairy farm in West Hartford. His brother was George Beach (cat. 215), with whom he was engaged in a business importing dye stuffs from the Caribbean. A founder of the American Jersey Cattle Club and the American Cattle Club, he married Frances Lyman Belknap, also of Hartford, in 1849.

Flagg painted two other portraits of Beach, both of which are in private collections.[1] In the Wadsworth Atheneum's sketch, *Charles M. Beach*, Flagg captured the subject's intelligent character. ERM

1. Helen D. Perkins, "Charles Noel Flagg, A.N.A., 1848–1916," *Connecticut Historical Society Bulletin* 40 (October 1975), 107.

222

CHARLES NOEL FLAGG
Reverend Dr. Francis Goodwin, 1911
Oil on canvas; 40³⁄₈ × 32¹⁄₈ in. (102.6 × 81.6 cm)
Signed and dated at lower left: Charles Noël Flagg. 1911

EXHIBITED: Wadsworth Atheneum, "Paintings by the Flagg Family," 1944, no. 19 / Wadsworth Atheneum, "Victorian Furnishings from Armsmear and the James J. Goodwin House," 1975 / Hartford, Connecticut Historical Society, "Charles Noel Flagg, A.N.A., 1848–1916," 1975, no. 68

EX COLL.: purchased by the Wadsworth Atheneum in the year of execution

Gallery Fund Purchase, 1911.2

The Reverend Doctor Francis Goodwin (1839–1923) of Hartford graduated from Berkeley Divinity School in Middletown in 1863 and was ordained the same year. He served as rector of Trinity Church from 1865 to 1871 and then devoted himself to the development of Hartford parks and other civic projects. He served as president of the Wadsworth Atheneum from 1890 to 1918. Interested in architecture, Goodwin designed his father's (James Goodwin) house, located on the corner of Asylum Avenue and Woodland Street, known as the Goodwin Castle.[1] The parlor from this house and its furnishings have been installed in the Morgan Gallery of the Wadsworth Atheneum.

In this portrait, Flagg presented a dignified and relaxed portrait of Dr. Goodwin, most likely intended to be hung in the Atheneum. Flagg had painted an earlier portrait of Dr. Goodwin in 1899 (now located in the Trinity Church in Hartford). ERM

1. Helen D. Perkins, "Charles Noel Flagg, A.N.A., 1848–1916," *Connecticut Historical Society Bulletin* 40 (October 1975), 119; and *Paintings by the Flagg Family*, exh. cat. (Hartford: Wadsworth Atheneum, 1944).

222

Jared B. Flagg

Born in New Haven, Conn., in 1820; died in New York City, in 1899

Jared Bradley Flagg was a member of a distinguished artistic family. His half-uncle was the painter Washington Allston (q.v.), under whom he studied painting at age sixteen. His two older brothers, George Whiting Flagg (1816–1897) and Henry Collins Flagg (1811–1862), were also artists. Two of his sons, Montague Flagg and Charles Noel Flagg (q.v.), were artists as well. In 1837, at the age of seventeen, he embarked on a career of portrait painting, first in Bridgeport, Connecticut, and then Newark, New Jersey; in 1840 he settled in Hartford. Beginning in 1837, Flagg exhibited his portraits at the National Academy of Design, a tradition he maintained until the year before his death. In 1850 he was elected a member of the academy.

Flagg enjoyed a successful career in Hartford, supported by prominent citizens of Hartford and from throughout Connecticut. After the death of his first wife, Sarah Montague, he became interested in the ministry, and in 1855 he became rector of Grace Church in Brooklyn, a position he held for eight years. In 1863 he moved to New Haven, where he resumed his career as a portrait and history painter full-time. Later in his life, he compiled *The Life and Letters of Washington Allston* (1892).

SELECT BIBLIOGRAPHY

H. W. French, *Art and Artists in Connecticut* (Boston: Lee and Shepard; New York: Charles T. Dillingham, 1879) / *Paintings by the Flagg Family*, exh. cat. (Hartford: Wadsworth Atheneum, 1944) / Helen D. Perkins, *Portraits by Jared Bradley Flagg, 1820–1899*, exh. cat. (Hartford: Stowe-Day Foundation, 1972)

223

JARED B. FLAGG
Portrait Sketch—John McClellan, c. 1845
Oil on canvas; 30 × 24¾ in. (76.2 × 62.9 cm)
Signed and dated at lower left: Painted by Jared B.

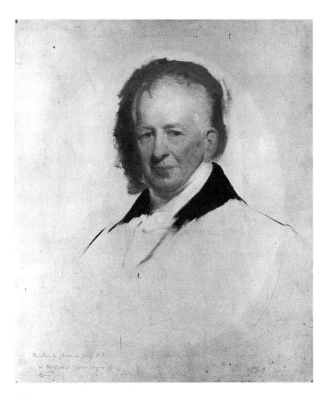

223

Flagg. N.A. / at Hartford Ct. about the year 1845 / C.N.F.

EXHIBITED: Wadsworth Atheneum, "Paintings by the Flagg Family," 1944, no. 4 / Hartford, Stowe-Day Foundation, "Portraits by Jared Flagg," 1972, no. 53

EX COLL.: descended in the Flagg family

Gift of the Artist's Family, 1899.12

John McClellan (1767–1858) of Woodstock, Connecticut, served as a major of the militia during the Revolution. He was also a member of the Connecticut legislature for twenty years and served as justice of the peace in Woodstock. He married Faith Williams, daughter of William Williams and Faith Trumbull Williams.[1]

In *Portrait Sketch—John McClellan*, Flagg depicted his subject's face using a loose brushstroke without attention to detail and employing various flesh tones and light and shade in his modeling. This portrait was originally intended to be an oval. ERM

1. Biographical information from Helen D. Perkins, *An Illustrated Catalogue of Known Portraits by Jared Flagg, 1820–1899*, exh. cat. (Hartford: Stowe-Day Foundation, 1972), 38.

224

JARED BRADLEY FLAGG
Right Reverend George Burgess, c. 1845
Oil on canvas; 34 × 27¼ in. (86.4 × 69.2 cm)

EXHIBITED: Wadsworth Atheneum, "Paintings by the Flagg Family," 1944, no. 9 / Hartford, Stowe-Day Foundation, "Portraits by Jared Flagg," 1972, no. 7

EX COLL.: descended to the artist's son Charles Noel Flagg, Hartford

Endowed by Charles N. Flagg, 1856.4.

Flagg painted several portraits of his fellow Connecticut clergymen, including Reverend George Burgess (1809–1866). Burgess was born in Providence, Rhode Island, and graduated from Brown University in 1826. In 1834 he was ordained a priest and that year began serving as the pastor of Christ Church in Hartford. He stayed at Christ Church until 1847, when he was elected bishop of Maine.[1] Using soft brushwork, Flagg depicted the young priest in traditional clothing. ERM

1. Helen D. Perkins, *An Illustrated Catalogue of Known Portraits by Jared B. Flagg, 1820–1899*, exh. cat. (Hartford: Stowe-Day Foundation, 1972), 12.

225

JARED B. FLAGG
Reverend Horace Bushnell, 1847
Oil on canvas; 34⅛ × 29¼ in. (86.7 × 74.3 cm)
Signed and dated, on pamphlet in subject's hand:
 Painted by J. B. Flagg—1847

EXHIBITED: New York City, National Academy of Design, "Annual Exhibition," 1848, no. 167, as "Rev. Dr. Bushnell" / Wadsworth Atheneum, "Paintings by the Flagg Family," 1944, no. 8 / Hartford, Stowe-Day Foundation, "Portraits by Jared Flagg," 1972, no. 8

EX COLL.: the artist's son Charles N. Flagg to 1850

Endowed by Charles N. Flagg, 1850.10

Reverend Horace Bushnell (1802–1876) became interested in theology while a law student at Yale. He was

appointed the minister of the North Church of Hartford in 1833. Also concerned with civic and social improvements in the city of Hartford, Bushnell was later instrumental in bringing about the creation of one of America's first municipal parks, Bushnell Park, named in his honor.[1]

Flagg painted this portrait of Rev. Horace Bushnell dressed in his civic clothes. ERM

1. Helen D. Perkins, *An Illustrated Catalogue of Known Portraits by Jared B. Flagg 1820–1899*, exh. cat. (Hartford: Stowe-Day Foundation, 1972), 14.

226

JARED B. FLAGG
Youth and Old Age (Grandfather's Pet), 1867
Oil on canvas; 40³⁄₈ × 33 in. (102.6 × 83.8 cm)
Signed and dated at lower right: Jared B. Flagg,
 N.A. / 1867

EXHIBITED: New York City, National Academy of Design, "Annual Exhibition," 1867, no. 422, as "Grandfather's Pet" / New Haven, Yale School of Fine Arts, 1867, no. 23 / Wadsworth Atheneum, "Paintings by the Flagg Family," 1944,

224

no. 7 / Hartford, Stowe-Day Foundation, "Portraits by Jared Flagg," 1972, no. 91

Elizabeth Hart Jarvis Colt purchased *Youth and Old Age* as part of the painting collection she accumulated during the years 1865 to 1867. The work hung in the famous picture gallery in her Hartford home, Armsmear (see Introduction). The subject is an allegory: The man represents old age, and the little girl, youth. "Old age" is content with his reading, and "youth" looks in the distance to the future.

Mary Mitchell Repeson of Santa Barbara, California, sat for the little girl.[1] ERM

1. Mary Mitchell Repeson, Santa Barbara, California, to Mr. Gross [of Hartford], June 29, 1924, curatorial painting file, Wadsworth Atheneum.

225

226

227

ATTRIBUTED TO JARED B. FLAGG

Reverend Peter Schermerhorn Chauncey, c. 1848

Oil on canvas; 34 × 28 in. (86.4 × 71.1 cm)

Technical note: The poor condition of this work does not
 allow it to be illustrated.

EXHIBITED: Hartford, Stowe-Day Foundation, "Portraits by
Jared Flagg," 1972, no. 7

EX COLL.: descended to the artist's son Charles Noel Flagg,
Hartford, by 1850

Endowed by Charles N. Flagg, 1850.11

Reverend Peter Chauncey (1810–1866) was born in
Rye, New York. After his graduation from Columbia
University he became a pastor in a church in his home-
town. Later, from 1848 to 1850, he served as the rector
of Christ Church in Hartford and up to his death was
rector at St. James Church in New York City. Chauncey
was a trustee of Trinity College in Hartford from 1848 to
1851.[1]

In this work, attributed to Flagg on stylistic grounds,
the artist depicted his subject in a direct manner, with a
simple background. ERM

1. Helen D. Perkins, *An Illustrated Catalogue of Known Portraits by Jared B. Flagg 1820–1899*, exh. cat. (Hartford: Stowe-Day Foundation, 1972), 14.

228

ATTRIBUTED TO JARED B. FLAGG

Margaret and Henrietta Flower, c. 1834

Oil on canvas; 36¼ × 29¼ in. (92.1 × 74.3 cm)

Canvas stamp (oval): Prepared / by Edwd.

Dechaux / New York

EX COLL.: descended in the Flower family to Florence Flower Burnham, West Hartford, by 1938

Gift of Mrs. Florence Flower Burnham, 1938.273

Margaret (1819–1834) and Henrietta (1822–1834) Flower, the only children of the Honorable Ebenezer and Ann Flower of Hartford, both died of an undetermined illness in 1834. An idealized portrait, *Margaret and Henrietta Flower* was painted in the same year for the girls' parents, either shortly before or following their deaths. The local Hartford poet, Lydia Sigourney, wrote a tribute to the girls after their untimely deaths.[1] The portrait has been attributed to Jared Flagg on stylistic grounds.[2] ERM

1. Lydia H. Sigourney, *The Lovely Sisters: Margaret and Henrietta* (New York: American Tract Society, 1852).
2. See Helen D. Perkins, *An Illustrated Catalogue of Known Portraits By Jared B. Flagg, 1820–1899*, exh. cat. (Hartford: Stowe-Day Foundation, 1972). Although Perkins did not include this portrait, she did include several portraits of young women that relate stylistically to the Flower portrait, among them, a portrait of Lydia Sigourney (1856), now at the Connecticut Historical Society (49, no. 69).

Edwin Forbes

Born in New York City, in 1839; died in Brooklyn, N.Y., in 1895

The son of a carpenter and his wife, Edwin Forbes began studying art at age eighteen. After 1859 he studied with Arthur Fitzwilliam Tait (1819–1905), an artist who specialized in hunting and sporting scenes as well as western subjects. Under Tait's influence, Forbes was first an animal painter and then branched out into genre and landscape.

In 1861 Forbes was assigned to cover the Army of the Potomac as staff artist for *Frank Leslie's Illustrated Newspaper*. Other artists at the front during the war included Alfred Waud (1828–1891), Thomas Nast (1840–1902), and Winslow Homer (q.v.). Forbes's sketches of battlefields and camp life appeared in *Leslie's* throughout the war and served as source material for later paintings and illustrations. In 1876 he published under the title *Life Studies of the Great Army* a collection of ninety-two etchings that drew on his work for *Leslie's*. Forbes received an award for *Life Studies* at the Philadelphia International Exhibition in 1876 for "his excellent studies from nature and life. Firmness in tone and spirited execution" (Archives of American Art, roll N68–12). The following year, he was elected an honorary member of the London Etching Club.

In 1886 Forbes executed more than ninety etchings to illustrate *General William T. Sherman: His Life and Battles*, written for children by his wife, Ida B. Forbes, and about the same number for *Our Naval Heroes*, also for children, written by Josephine Pollard. The following year he illustrated another children's book—*Life and Battles of Napoleon Bonaparte*, by H. W. Pierson—with eighty-two etchings. In 1891 Forbes published *Thirty Years After: An Artist's Story of the Great War*, for which, it has been suggested, he wrote the text as a vehicle for his remaining sketches (*DAB*, 6:504).

Forbes is perhaps best known as an etcher of scenes of the Civil War, but he also executed at least four oil paintings with Civil War themes: the Atheneum's *Mess Boy Asleep* (cat. 229), *A Lull in the Fight* (c. 1865, location unknown), *Contrabands* (1866, collection of Hermann Warner Williams, Jr.), and *Drummer Boy Cooling His Coffee* (c. 1867, Amherst College, Amherst, Mass.). In Forbes's lifetime, *A Lull in the Fight* was exhibited at the National Academy of Design in New York City and at the Boston Athenaeum. Henry Tuckerman described the painting as "a life-like scene, and one of the best war-pictures which has been exhibited" (Tuckerman, *Book of the Artists*, 491).

EDWIN FORBES 389

SELECT BIBLIOGRAPHY

Archives of American Art, roll N88, frames 755–771, New York Public Library Prints Division / Archives of American Art, roll N68–12, frames 270–365, Pierpont Morgan Library, New York City / *DAB*, 6:504 / Henry T. Tuckerman, *Book of the Artists: American Artist Life* (New York: Putnam, 1867), 491 / Edwin Forbes, *Thirty Years After: An Artist's Story of the Great War* (1890; rpt., Baton Rouge and London: Louisiana State University Press, 1993) / Helen Comstock, "An Exhibition of American Genre Painting," *Panorama* 2 (November 1946), 27–35 / William Forrest Dawson, ed., *A Civil War Artist at the Front: Edwin Forbes' Life Studies of the Great Army* (New York: Oxford University Press, 1957) / National Gallery of Art, *The Civil War: A Centennial Exhibition of Eyewitness Drawings* (Washington, D.C.: National Gallery of Art, 1961), 116–120 / Hermann Warner Williams, Jr., *The Civil War: The Artists' Record* (Washington D.C.: Corcoran Gallery of Art; Boston: Museum of Fine Arts, 1961), 19–20, 71, 90–92 / Museum of Fine Arts, *M. and M. Karolik Collection of American Water Colors and Drawings, 1800–1875* (Boston: Museum of Fine Arts, 1962), 1:28, 163 / Sidney Kaplan, *The Portrayal of the Negro in American Paintings*, exh. cat. (Brunswick, Maine: Bowdoin College Museum of Art, 1964) / Hermann Warner Williams, Jr., *Mirror to the American Past: A Survey of American Genre Painting, 1750–1900* (Greenwich, Conn.: New York Graphic Society, 1973), 150–151 / James L. Yarnall and William H. Gerdts, *The National Museum of American Art's Index to American Art Exhibition Catalogues from the Beginning through the 1876 Centennial Year* (Boston: Hall, 1986), 2:1276–1278 / Guy C. McElroy, *Facing History: The Black Image in American Art, 1710–1940*, exh. cat. (San Francisco: Bedford Arts, in association with the Corcoran Gallery of Art, Washington, D.C., 1990), 61–62

229

EDWIN FORBES

Mess Boy Asleep, 1867

Oil on canvas; 14 × 20¼ in. (35.6 × 51.4 cm)

Signed and dated at lower left: Edwin Forbes 1867.

EXHIBITED: possibly Cincinnati, Ohio, Cincinnati Academy, 1868, no. 18, as "A Watched Pot Never Boils" / New York City, Harry Shaw Newman Gallery, "An Exhibition of American Genre Painting," 1946, as "Off Guard" / Washington, D.C., Cor- coran Gallery of Art, and Boston, Museum of Fine Arts, "The Civil War: The Artist's Record," 1961–1962, no. 68, as "Mess Boy Sleeping" / Brunswick, Maine, Bowdoin College Museum of Art, "The Portrayal of the Negro in American Painting," 1964, no. 48 / Washington, D.C., Corcoran Gallery of Art; and Brooklyn, N.Y., Brooklyn Museum of Art, "Facing History: The Black Image in American Art, 1710–1940," 1990.

EX COLL.: with Harry Shaw Newman Gallery, New York City, in 1946; with Charles D. Childs, Childs Gallery, Boston, in 1948

The Ella Gallup Sumner and Mary Catlin Sumner Collection Fund, 1948.386

Much like Winslow Homer (q.v.), Forbes was inter- ested in the daily life of soldiers in the American Civil War, and many of his sketches, paintings, and etchings illustrate events and activities away from the scene of battle.[1] Just such a painting is *Mess Boy Asleep*, reflect- ing the ancillary role to which African-Americans were consigned in the Civil War before they were considered by whites to be battle worthy.[2] Forbes depicted the fig- ure in a stereotypical and caricatured pose: the youth, neglecting his duties as mess boy, is asleep, his red mouth open to reveal bright white teeth and a pink tongue. African-Americans were often presumed to be lazy and are pictured as idle, if not sleeping, in a number of paintings and periodical illustrations of the time (cat. 540).[3]

Forbes made an etching after his sketch for *Mess Boy Asleep;* it appeared with the inscription "A Watched Pot Never Boils" in an 1876 portfolio of prints titled *Life Studies of the Great Army: A Historical Art Work in Copper Plate Etching Containing Forty Plates* that sold for $25 at the time of publication.[4] This portfolio won the gold medal at the Centennial Exposition in Philadelphia that year. A set of the original prints was sold to Gen- eral Sherman for display in his office in the War Depart- ment.[5]

The etching appeared again in Forbes's *Thirty Years After: An Artist's Story of the Great War*, published in 1890. This time the print, in conjunction with two others of African-American subjects, was published over the ti- tle *The Burnished Livery of the Sun*, which probably

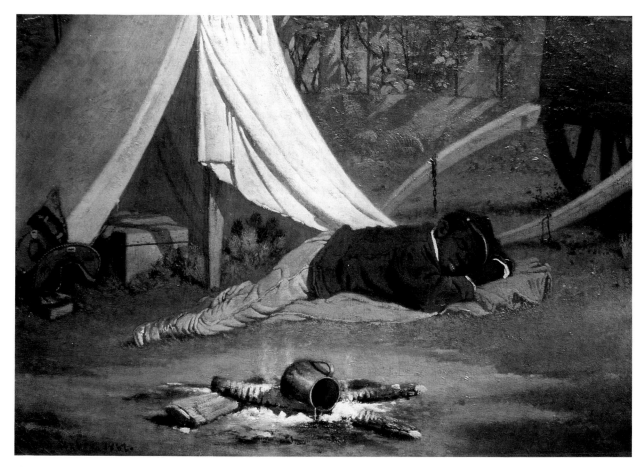

229

referred to all three images.[6] The 1890 impression of the etching does not carry the inscription appearing on the 1876 version.

The figure of the boy in the prints diverges somewhat from the painting in the position of the left leg and some clothing details. The overturned coffee pot and the logs in the fire also differ slightly between the prints and the painting. The background is significantly more complex in the painting: a tent and other objects are pictured; more of the wagon is visible, and it is to the right instead of the left of the figure; a forest background replaces the fence that appears in the prints. What is most interesting, perhaps, is that the figure of the mess boy is not reversed in the print. This may indicate that Forbes used a mirror when transcribing the figure of the boy to the copper plate. AE

Edwin Forbes, *The Burnished Livery of the Sun* (detail), from Edwin Forbes, *Thirty Years After: An Artist's Story of the Great War*, 1890, 151. Photograph: David Stansbury.

1. See Hermann Warner Williams, Jr., *The Civil War: The Artists' Record*, exh. cat. (Washington, D.C.: Corcoran Gallery of Art; Boston: Museum of Fine Arts, 1961), 19–20, ill. 90; Patricia Hills, *The Painters' America: Rural and Urban Life, 1810–1910*, exh. cat. (New York and Washington: Praeger, in association with the Whitney Museum of Art, 1974), 64; and Guy C. McElroy, *Facing History: The Black Image in American Art, 1710–1940*, exh. cat. (San Francisco: Bedford Arts, in association with the Corcoran Gallery of Art, Washington, D.C., 1990), 61 ill.
2. Francis Martin, Jr., entry for *Mess Boy Asleep*, in McElroy, *Facing History*, 61.
3. For a general discussion of stereotypes such as this, see Ellwood Parry, *The Image of the Indian and the Black Man in American Art, 1590–1900* (New York: Braziller, 1974); and Sidney Kaplan, *The Portrayal of the Negro in American Paintings*, exh. cat. (Brunswick, Maine: Bowdoin College Museum of Art, 1964). See also Peter H. Wood and Karen C. C. Dalton, *Winslow Homer's Images of Blacks: The Civil War and Reconstruction Years*, exh. cat. (Austin: University of Texas Press, 1988); and Marc Simpson in Simpson, with Nicolai Cikovsky, Jr., Lucretia Hoover Giese, Kristin Hoermann, Sally Mills, and Christopher Kent Wilson, *Winslow Homer: Paintings of the Civil War* (San Francisco: Bedford Arts, in association with the Fine Arts Museums of San Francisco, 1988), 205 n. 18.
4. William Forrest Dawson, foreword to *A Civil War Artist at the Front: Edwin Forbes' Life Studies of the Great Army*, ed. William Forrest Dawson (New York: Oxford University Press, 1957). Dawson noted that the price of the portfolio was raised to $50 at a later unspecified date and that individual signed impressions brought as much as $300 apiece.

"A Watched Pot Never Boils" may have been the painting's original title. A painting by that name is listed in the painting catalogue for an 1868 exhibition at the Cincinnati Academy in Cincinnati, Ohio. See James L. Yarnall and William H. Gerdts, *The National Museum of American Art's Index to American Art Exhibition Catalogues From the Beginning through the 1876 Centennial Year* (Boston: Hall, 1986), 2:1277.
5. Ibid.
6. Edwin Forbes, *Thirty Years After: An Artist's Story of the Great War* (1890; rpt., Baton Rouge and London: Louisiana State University Press, 1993), 151. My thanks to Lucretia H. Giese for bringing this illustration to my attention.

C. J. Fox

Active in the twentieth century

Nothing is known about this artist beyond the fact that he worked as a portrait painter in the Hartford area in the 1920s.

SELECT BIBLIOGRAPHY

Curatorial painting file, Wadsworth Atheneum

230

C. J. FOX

Frank C. Sumner, c. 1921

Oil on canvas; 40 × 30¼ in. (101.6 × 76.8 cm)

EXHIBITED: Wadsworth Atheneum, "Exhibition of Portraits of Hartford Men," 1926, no. 43

EX COLL.: Mr. and Mrs. Frank C. Sumner, Hartford, to 1924; Mrs. Frank C. Sumner to 1927

Gift of Mr. and Mrs. Frank C. Sumner, 1927.427

Frank Chester Sumner (1850–1924) was very prominent in Hartford, where he served as president of the Connecticut Bank and Trust Company. Although he had no direct interest in art, his wife, Mary Catlin Sumner

230

(cat. 96), was an amateur artist. In addition, his brother, George (1841–1906), had a strong interest in the Wadsworth Atheneum and willed his substantial fortune to his brother Frank with a special provision that the money eventually go to the Atheneum. In his own will, Frank Sumner honored the wishes of his brother and his brother's wife, Ella Gallup Sumner, as well as the artistic interests of his wife, Mary, when he left his estate to the Atheneum, to be transferred to the museum at the time of his wife's death. The bequest, known as the Ella Gallup Sumner and Mary Catlin Sumner Collection Fund, has been designated for use in purchasing paintings for the Atheneum collections (see Introduction). ERM

George Francis

Born in Hartford, in 1790; died in Hartford, in 1873

Born to a Connecticut carriage builder and his wife, George Francis studied drawing under Benjamin West (q.v.) and coloring under Washington Allston (q.v.). When his father died, he went into the family business, giving up a career as a professional artist to design ornamental work for sleighs and carriages. He continued to paint portraits and landscapes as an amateur, however, until his own death from, according to H. W. French, "a paralytic shock, from which he never regained consciousness" (*Art and Artists*, 47).

SELECT BIBLIOGRAPHY

H. W. French, *Art and Artists in Connecticut* (Boston: Lee and Shepard; New York: Charles T. Dillingham, 1879), 46–47 / George C. Groce and David H. Wallace, *The New-York Historical Society's Dictionary of Artists in America, 1564–1860* (New Haven: Yale University Press; London: Oxford University Press, 1957), 238 / Richard Saunders, with Helen Raye, *Daniel Wadsworth: Patron of the Arts* (Hartford: Wadsworth Atheneum, 1981), 62 / Robert F. Trent, "The Charter Oak Artifacts," *Connecticut Historical Society Bulletin* 49 (summer 1984), 125–157 / James L. Yarnall and William H. Gerdts, *The National Museum of American Art's Index to American Art Exhibition Catalogues from the Beginning through the 1876 Centennial Year* (Boston: Hall, 1986), 2:1302–1303 / Glenn B. Opitz, ed., *Mantle Fielding's Dictionary of American Painters, Sculptors, and Engravers* (Poughkeepsie, N.Y.: Apollo Book, 1986), 294

231

GEORGE FRANCIS

Charter Oak and Wyllys House, c. 1858
Oil on steel; 9⅞ × 11¼ in. (25.1 × 28.6 cm)
Inscribed on back: steel $350

EXHIBITED: Hartford, Connecticut Historical Society, "Charter Oak: Hundredth Anniversary of its Fall," 1956

EX COLL.: Target Co., No. 1, by 1858; to John Steel in 1858; descended in the Steel family to William F. Steel, Newark, N.J., by 1931

Gift of William F. Steel, 1931.126

232

GEORGE FRANCIS

Charter Oak, 1871
Oil on composition board; 11½ × 9⅞ in. (29.2 × 25.1 cm)
Inscribed on back: Charter Oak.—painted by George
 Francis of Hartford, Conn.—when 80 years of
 age, the drawing was taken by him from the tree
 more than fifty years before—this was painted.—
 presented to Ella Francis / March 27, 1871

231

232

EXHIBITED: Hartford, Connecticut Historical Society,
"Charter Oak: Hundredth Anniversary of its Fall," 1956 /
Wadsworth Atheneum, "A Second Look: Late Nineteenth Cen-
tury Taste in Paintings," 1958, no. 31

EX COLL.: Ella Francis from 1871; to Mrs. Charles E. H.
Phillips, Glenbrook, Conn., by 1930

Gift of Mrs. Charles E. H. Phillips, 1930.24

George Francis was responsible for some of the
earliest-known depictions, dating from 1818, of the fa-
mous Charter Oak and the Wyllys property on which it
stood.[1] The Atheneum's much-later *Charter Oak* closely
resembles one the artist painted in 1818 for Daniel Wads-
worth, now in the collection of the Connecticut Histori-
cal Society, Hartford, and it is probably based on the
same sketch, as the inscription on the Atheneum's work
suggests.[2]

George Francis, *Wyllys Mansion—Hartford*, c. 1818. Connecticut Historical Society, Hartford.

Attributed to George Francis, *The Charter Oak*, 1818. Connecticut Historical Society, Hartford. Photograph: Arthur Kiely, Jr.

Somewhat crudely painted, both Atheneum paintings probably reflect the fact that Francis was forced to give up his career as a professional painter and could devote only a little time to his art.[3] Nevertheless, it is apparent that Francis worked hard on *Charter Oak*, as alterations are visible in the composition, particularly obvious now in the branches at the lower left. Unlike many of his contemporaries, such as Charles DeWolf Brownell (cat. 62) and Frederic Church (cat. 111), who painted the tree with all or most of its leaves, Francis chose to depict the tree with bare limbs. That Francis did so as early as 1818, long before the oak fell, would seem to discount any latent symbolism or foreshadowing in this choice.

The legend of the Charter Oak revolves around the Connecticut Charter, granted in 1662 by King Charles II, guaranteeing the rights of the citizens of the colony. With the death of Charles in 1685, James II came into power and ordered the surrender of the charter. When the colonists did not comply, James ordered the Charter seized, but Daniel Wadsworth's great-great-great uncle Joseph Wadsworth (1647–1729) hid the charter in the hollow of the oak on the Wyllys property. In 1818 the present constitution of the state replaced the charter, and perhaps this was the occasion of Francis's paintings of the tree.[4]

The Wyllys house also appears in the background of a portrait of *Polly Wyllys Pomeroy* by Ralph Earl (q.v.) and was considered one of the outstanding houses of Hartford. Governor George Wyllys had the nine-room house built in 1636 by twenty indentured servants.[5] When the lot was being cleared for construction, a group of Native Americans, identifying the oak as a centuries-old landmark, requested that the tree be spared.[6] Samuel Wyllys, one of the magistrates of the colony, was the owner of the property when Wadsworth hid the charter in the oak.[7]

The Atheneum's *Charter Oak and the Wyllys House*, dating to around 1858, was executed two years after the fall of the Charter Oak and close to the date of the *Charter Oak* by Brownell (cat. 62). Francis's *Charter Oak*, dated 1871, is but one indication of the revival of interest in the oak in the second half of the nineteenth cen-

tury, after the storm brought it down.[8] The inscription on *The Charter Oak* indicates that it was probably a gift from the artist to a relative, although the identity of Ella Francis remains unknown. AE

1. Robert F. Trent, "The Charter Oak Artifacts," *Connecticut Historical Society Bulletin* 49 (summer 1984), 125.
2. The Historical Society's Francis bears the inscription, "Painted by George Francis 1818 from a [sketch] / original / [Charter] Oak / From a sketch by / himself by request / of Mr. Daniel Wadsworth / Gratuitous." See Richard Saunders, with Helen Raye, *Daniel Wadsworth: Patron of the Arts* (Hartford: Wadsworth Atheneum, 1981), 62. Exhibition records list *Charter Oak*, painted in 1818 by George Francis, as no. 43 in an 1872 Hartford Art Association exhibition in Hartford. See James L. Yarnall and William H. Gerdts, *The National Museum of American Art's Index to American Art Exhibition Catalogues from the Beginning through the 1876 Centennial Year* (Boston: Hall, 1986), 2:1303.
3. H. W. French maintains, however, that despite his aborted career, "[Francis's] pictures have a decided merit, and much artistic skill" (*Art and Artists in Connecticut* [Boston: Lee and Shepard; New York: Charles T. Dillingham, 1879], 47).
4. "The Charter Oak and Its History," reprinted from a pamphlet published in 1856 when the oak fell (Hartford: Press of Finlay Brothers for the Connecticut Chamber of Commerce, 1935), 4–6.
5. J. Frederick Kelly, *Architectural Guide for Connecticut* (New Haven: Yale University Press, for the Tercentenary Commission of the State of Connecticut, 1935), 4.
6. "Fall of the 'Old Charter Oak,'" from the *Hartford Daily Times*, in "The Charter Oak: Its History," 7.
7. Albert E. Van Dusen, *Puritans Against the Wilderness: Connecticut History to 1763* (Chester, Conn.: Pequot Press, 1975), 70.
8. Trent, "Charter Oak Artifacts," 128.

Hermann Fuechsel

Born in Brunswick, Germany, 1833; died in New York City, in 1915

The German artist Hermann Fuechsel was a pupil of Carl Friedrich Lessing (1808–1880) in Düsseldorf before leaving for the United States in 1858. He settled in New York City, where he remained for the rest of his career. A landscape painter, Fuechsel showed his works extensively in exhibitions and galleries in New York, Boston, and Philadelphia beginning in 1859 until the mid-1870s. He was a member of New York's Artist's Fund Society,

where he frequently exhibited landscapes. Most of his works represented Hudson River scenery and various sites in the Adirondack Mountains and the White Mountains of New Hampshire. The artist also returned to the subject of Alpine scenery that he had favored in his youth. His career waned during the post–Civil war era, which brought radical changes to American art and a shift away from the meticulous style of Düsseldorf-trained artists. Fuechsel continued to maintain a studio, however, in the famous Tenth Street Studio Building in New York City from 1882 to 1915.

SELECT BIBLIOGRAPHY

obituary, *American Art Annual* 12 (1915), 258 / Gilbert Brouilette Thieme-Becker, "Two Staten Island Views Painted by Hermann Fuechsel in 1873," *Staten Island Historian* 47 (July–September 1951), 20–21 / Egbert Haverkamp-Begemann, ed., *The Netherlands and German-Speaking Countries, Fifteenth–Nineteenth Centuries* (Hartford: Wadsworth Atheneum, 1978), 142, no. 54 / James L. Yarnall and William H. Gerdts, *The National Museum of American Art's Index to American Art Exhibition Catalogues from the Beginning through the 1876 Centennial Year* (Boston: Hall, 1986), 2:1354–1356 / Annette Blaugrund, *The Tenth Street Studio Building* (Ann Arbor, Mich.: University Microfilms International, 1987), 357

233

HERMANN FUECHSEL

Alpine Scenery—Lake Gosau, 1865
Oil on canvas; 39¼ × 60¼ in. (99.7 × 153.0 cm)
Signed and dated at lower right: H. Fuechsel fet / N.Y. 1865
Inscribed on stretcher in pencil: Alpine Scenery / Lake Gosau / painted by Hermann Fuechsel
Canvas stamp (circular): Goupils / 772 / Broadway

EXHIBITED: New York City, Goupil Art Gallery, "Exhibition," 1865 / New York City, National Academy of Design, "Artists' Fund Society Exhibition," 1865 / Wadsworth Atheneum, "A Second Look: Late Nineteenth Century Taste in Paintings," 1958, no. 65

233

EX COLL.: with the Goupil Art Gallery, New York City, in 1865; purchased by Elizabeth Hart Jarvis Colt, Hartford, in 1866

Bequest of Mrs. Elizabeth Hart Jarvis Colt, 1905.43

Alpine Scenery—Lake Gosau was offered for sale in New York City in the year of its completion at the Goupil Art Gallery and at that year's Artist's Fund Society exhibition. The landscape depicts Lake Gosau in northern Austria with the Dachstein and Gosau glacier seen in the distance. It was purchased by the Hartford collector, Elizabeth Hart Jarvis Colt, for $1,500 before December 1866.[1] Colt eventually hung the monumental landscape in the gallery of American and European paintings that was under construction that year in her home, Armsmear (see Introduction). She had first encountered Fuechsel's work in 1864 while serving as the head of the Hartford Table at New York's Metropolitan Sanitary Fair, to which Fuechsel had donated *On the Saco* to be auctioned for the benefit of the Sanitary Commission.[2]

Fuechsel wrote Colt from his studio—no. 5 in the old Dodworth Dancing Academy Building at 806 Broadway (between Eleventh and Twelfth streets), the site of several artist's studios—expressing his pleasure at learning that his painting had become "part of your valuable collection."[3] He enclosed a newspaper clipping with a highly favorable review that had appeared when the work was on exhibition at the Goupil Art Gallery. The reviewer proclaimed the landscape "one of these truly admirable creations, which recall . . . that favorite resort of artists, Salzburg and the Tyrol, all the lofty grandeur of the Alps, combined with deep poetical repose." He praised the artist for bringing to the viewer:

> One of those blessed spots of which the German poets tell us in their ballads. . . . We see one of these still lakes with its blue water, no movement perceptible on its shining mirror. A soft sunshine lies like a

veil over mountain and watery depth; the air indicates the serene repose of nature, and only a transparent white cloud hovers around the icy desert of the Dachstein, that stands out in its calm majesty, far off in the distance. . . . We are struck at once with the deep poetical feeling that has inspired it, the charming unity in idea and execution, combined with careful manipulation, and complete fidelity to beauty of nature without any forced effects.[4]

The artist includes the lone figure of a mountaineer resting on the rocks at the lower right, a witness to the mystery of the region: "There is a legend attached to every one of these hidden basins, the great heart of the people knows a tale of every summit, short, mysterious, and always deeply poetical."[5] Colt's gallery also included the work of another Düsseldorf-trained artist, the far more renowned Albert Bierstadt (q.v.), who, like Fuechsel, had painted Alpine scenery for the American market. Bierstadt, however, became famous for his views of the American West, one of which Colt acquired at about the same time as this work by Fuechsel. EMK

1. A label on the back of the painting provides the following information: "Alpine Scenery . Lake Gosau / Price for Sale $1500- / Hermann Fuechsel . 806 Broadway / New York."
2. *Catalogue of the Art Exhibition at the Metropolitan Fair in the Aid of the U.S. Sanitary Commission* (New York, 1864), 16, no. 277.
3. Hermann Fuechsel to Mrs. Samuel Colt, 806 Broadway, Studio N. 5, New York, 1866, archives, Wadsworth Atheneum. The artist informs Colt that he had learned of her acquisition of his painting from "Mr. Harvey Young of Boston," probably the Boston portrait painter James Harvey Young (1830–1918). See George C. Groce and David H. Wallace, *The New-York Historical Society's Dictionary of Artists in America, 1564–1860* (New Haven: Yale University Press; London: Oxford University Press, 1957), 710. For information on the Dodworth Dancing Academy Building, see Annette Blaugrund, *The Tenth Street Studio Building* (Ann Arbor, Mich.: University MicrofilmsInternational, 1987), 40–41.
4. Anon., "Fine Arts. Lake Gosau: By Hermann Fueschel," *Weekly Review,* New York, no date, no. 361, p. 2, newspaper clipping, archives, Wadsworth Atheneum.
5. Ibid.

Paul W. Fuerstenberg

Born in Düsseldorf, Germany, in 1875; died in New York City, in 1953

A marine and landscape painter, Paul Fuerstenberg studied with Wayman Adams and George Elmer Browne (q.v.). A member of the Allied Artists of America, he had a solo exhibition at the Montross Gallery in 1937.

SELECT BIBLIOGRAPHY

J.L.D., "Landscapes by Fuerstenberg," *Art Digest* 11 (January 1937), 19 / Peter Hastings Falk, *Who Was Who in American Art* (Madison, Conn.: Sound View Press, 1990), 218

234

PAUL W. FUERSTENBERG
Ship "Young America," c. 1920–1930
Oil on canvas; 28¼ × 32⅛ in. (71.8 × 81.6 cm)
Signed at lower right: P. Fuerstenberg

EX COLL.: to Captain Hugh Ferry, Essex, Conn., before 1937

Gift of Miss Eleanor L. Hull and Edward M. Ferry, 1937.502

235

PAUL W. FUERSTENBERG
The City of Hartford, c. 1930
Oil on canvas; 25 × 33¼ in. (63.5 × 84.5 cm)

EXHIBITED: Springfield, Mass., Connecticut Valley Historical Museum, and Cornish, N.H., Saint-Gaudens Memorial, "Painting of the Connecticut Valley," 1955 / Hartford, Connecticut Historical Society, "History of the Connecticut River," 1981

EX COLL.: Charles A. Goodwin, Hartford, to 1937

Gift of Charles A. Goodwin in the name of Fred E. Dayton, 1937.203

Inscribed across its paddle wheel, the *City of Hartford* is shown on the Connecticut River at Goodspeed's Landing in East Haddam, with Gelston House visible in the background. The *City of Hartford,* built in 1852, collided with the bridge at Middletown in 1876, while on a run on the Connecticut River. The steamboat was re-

234

235

built in 1883, when it acquired a new name, *Capital City*. The boat ran aground near Rye Beach, New York, in 1886.[1] EMK

1. Curatorial painting file, Wadsworth Atheneum.

George Fuller

Born in Deerfield, Mass., in 1822; died in Boston, in 1884

George Fuller was born into a family with an artistic tradition: on his mother's side, his grandfather was an amateur painter; his uncle, a professional painter; and his aunt, a miniaturist. Despite this heritage, his mother tried to dissuade him from becoming an artist, and his father apprenticed him at thirteen to a grocer in Boston. When this failed, Fuller tried his hand at selling shoes, but this, too, was unsuccessful, and he returned to the family farm. A year later, he went to Illinois with a railroad survey. He remained there two years before returning to Deerfield to continue his study at Deerfield Academy. During this time, he began painting portraits, and in 1841 his parents gave him permission to travel throughout western New York State with his half-brother, Augustus Fuller (1812–1873), an itinerant portraitist. That winter, he went to Albany for nine months

to study with the sculptor Henry Kirke Brown (1814–1866), whom he had met on the railroad survey in Illinois. He spent the two following winters in Boston, studying at the Boston Artists' Association. By 1846 he had taken a studio next to that of the sculptor Thomas Ball (1819–1911) on Tremont Row. Washington Allston (q.v.) had died only three years before, and his work was at that time the subject of much discussion and study. Ball wrote, "We were then struggling after Allston's color; I think the effect of his then admiration for that great artist can be traced in all Mr. Fuller's works" (*Boston Evening Daily Transcript*, May 7, 1884, 6, quoted in Spassky, *American Paintings*, 147).

In 1847 Fuller went to New York City, where he enrolled in the life class at the National Academy of Design. Ten years later, he was elected associate at the National Academy; in spite of actively exhibiting at the academy for more than thirty years, however, he was never elected academician. He spent the next twelve years in New York City, where his friends included Daniel Huntington (q.v.), Sanford Gifford (q.v.), and George Inness (q.v.). Fuller traveled to the South from time to time, where he painted portraits and studies of African-Americans.

Fuller went to Europe in 1860, visiting London, Paris, Florence, Rome, and Venice, among other cities. The founder and coeditor of the *Crayon*, William J. Stillman (1828–1901), accompanied him as far as England, where Fuller met the Pre-Raphaelite artists Dante Gab-

riel Rossetti and William Holman Hunt. Throughout Europe, Fuller sketched in the museums; he was particularly interested in the paintings of the Venetian school but also admired the works of Rembrandt, Velázquez, and Turner.

The artist returned to the United States that summer and the following year married Agnes Higginson of Cambridge, Massachusetts. His father having died in 1859, Fuller took over the family farm but continued to paint, turning to his family members and to sketches for subject matter. In 1875 the farm's tobacco crop failed, and Fuller was forced to turn to painting to make a living. An 1876 exhibition of his work at the Doll and Richards gallery in Boston met with critical acclaim and sales. One reviewer aptly defined the appeal of Fuller's paintings, commenting that the pictures exhibited "have the element of unconsciousness that is the more choice for extreme rarity in works of art" ("Art," 631). Fuller began exhibiting at the newly founded Society of American Artists in New York City, whose members appreciated his work for its rejection of the academic realism championed by the National Academy. In 1880 he was elected a member of the society.

Fuller's paintings and his association with William Morris Hunt (q.v.) in Boston as well as his acquaintance with Thomas Dewing (q.v.) and Inness and with the works of Robert Loftin Newman (q.v.) and Albert Pinkham Ryder (q.v.) situate him firmly within the movement away from academic realism and toward the expression of personal vision, a movement that was fast gaining ground in American art in the 1870s, just as Fuller began exhibiting again.

SELECT BIBLIOGRAPHY

"Art," *Atlantic Monthly* 37 (May 1876), 629–633 / "Three Boston Painters," *Atlantic Monthly* 40 (December 1877), 710–718 / G. W. Sheldon, *American Painters*, rev. ed. (New York: D. Appleton, 1881), 186–189 / M. G. Van Rensselaer, "George Fuller," *Century Magazine* 27 (December 1883), 226–236 / "George Fuller," *Harper's New Monthly Magazine* 49 (September 1884), 517–522 / Clara Erskine Clement and Laurence Hutton, *Artists of the Nineteenth Century and Their Works*, rev. ed. (1884; rpt., St. Louis: North Point, 1969), 1:277 / M. G. Van Rensselaer, *Memorial Exhibition of the Works of George Fuller*, exh. cat. (Boston: Alfred Mudge and Son, Printers, for the Boston Museum of Fine Arts, 1884) / Josiah B. Millet, ed., *George Fuller: His Life and Works* (Boston and New York: Houghton Mifflin, 1886) / Samuel Isham, *The History of American Painting* (New York: Macmillan, 1905), 390–394 / William Howe Downs, "George Fuller's Pictures," *International Studio* 75 (July 1922), 265–273 / Augustus Vincent Tack, *Centennial Exhibition of the Works of George Fuller*, exh. cat. (New York: Metropolitan Museum of Art, 1923) / Sarah Lea Burns, "The Poetic Mode in American Painting: George Fuller and Thomas Dewing" (Ann Arbor, Mich.: University Microfilms International, 1979) / Sarah Burns, "A Study of the Life and Poetic Vision of George Fuller (1822–1884)," *American Art Journal* 13, no. 4 (1981), 11–37 / Natalie Spassky, *American Paintings in the Metropolitan Museum of Art*, ed. Kathleen Luhrs (Princeton, N.J.: Princeton University Press, in association with the Metropolitan Museum of Art, 1985), 2:147–149

236

GEORGE FULLER
Ideal Head, 1877
Oil on canvas; 20 × 14 in. (50.8 × 35.6 cm)
Technical note: The painting is in the original frame, which may have been designed by Stanford White.

EXHIBITED: Boston, Museum of Fine Arts, "Memorial Exhibition of the Works of George Fuller," 1884, no. 23

EX COLL.: the artist until his death in 1884; to estate of George Fuller and then sent to Chickering's Hall, Boston, to be sold at auction by Williams and Everett on May 9, 1884; possibly to Mrs. Amos Barnes, Boston; to Dr. Kenneth Moscowitz, Los Angeles, c. 1963; with American Masters Gallery, Los Angeles; to Edward Goldfield, Los Angeles; with Goldfield Galleries, Ltd., Los Angeles; to Henry Sage Goodwin, Avon, Conn., 1983

Gift of Henry Sage Goodwin, 1986.73

The Atheneum's *Ideal Head* is one of a group of figure paintings by Fuller that were "never pictures of definite localities and personalities, but idealised visions of shadowy outlines and soft rich colour, rising from

236

vague backgrounds."[1] When Fuller returned to a career as a professional artist in the mid-1870s, these paintings met with mixed reaction: while some lauded him as a colorist and a painter of poetry, others criticized him for lacking technical ability.[2]

Ideal Head, a minor example of Fuller's work in the genre, depicts the generalized face of a young woman, softly painted and emerging from a dark, atmospheric background.[3] According to J. J. Enneking (1841–1916), an artist and Fuller's studio neighbor, "[Fuller] always realized his ideal of a face without resorting much to the use of the model, and when he employed one it was as a means to help him to a desired movement, color, and proportions. When he got too realistic an expression of what he had before him he would take the end of his brush and soften all too strongly defined lines by rubbing back and forth over them until the face grew into something veiled and suggestive, giving him a glimpse of what he was working for."[4]

In 1877, the year Fuller painted the Atheneum's *Ideal Head*, a reviewer wrote, "Mr. Fuller appears to approach the technical difficulties of his art with extreme caution, and to begin by enveloping his subject in a sort of misty obscurity, from which he gradually evolves (this seems to be his method of working) such parts of it as interest him and in which he seeks to interest us."[5] A perceived uniformity in Fuller's painting resulted in a charge of mannerism by such critics as G. W. Sheldon, who complained, "Why [Fuller] is so fond of mistiness is not perspicacious. The fondness long ago resulted in a mannerism. Perhaps Mr. Fuller supposes that mistiness is akin to mystery."[6] The noted critic Mariana G. Van Rennselaer addressed this issue in her essay published in the catalogue for the memorial exhibition of the artist's work held at the Museum of Fine Arts in Boston: "We feel that his fine works are finer than they would have been had he diffused himself more widely, and that his weaker ones would probably not have gained in such a case."[7]

If there was a model for the Atheneum's *Ideal Head*, she has not been identified.[8] AE

1. Sadakichi Hartmann, *A History of American Art*, rev. ed. (1932; New York: Tudor, 1934), 1:210.

2. "Fuller has been said to be more of a poet than a painter. He has even been pitied like Millet for not being able to paint at all, and blamed for not drawing directly from the model. What an extraordinary misapprehension of both the man and his art" (Hartmann, *A History of American Art*, 1:215). After noting that Fuller "may be destitute of rare technical qualities of draughtsmanship, his dominant notes of color may be far from musical, the vibrations of his light may be faint, and his *chiaro-oscuro* [sic] scheme manifestly imperfect," G. W. Sheldon went on to defend, albeit somewhat indirectly, Fuller's emphasis on the spiritual: "The aesthetic spirit of the day is a spirit of laborious and most skillful realism. . . . Art is striving to rival Nature in her physical manifestations; to reproduce Nature in some of her aspects perfectly; to counterfeit Nature. Is there not danger that, in the prosecution of this perplexing and engrossing undertaking, Art may forget her obligations to the ideal?" (*American Painters*, rev. ed. [New York: D. Appleton, 1881], 189).

3. Sarah Burns has suggested that it was William Morris Hunt (q.v.) who, beginning around 1876, contributed to the already-developing tonal atmosphere in Fuller's paintings. See "A Study of the Life and Poetic Vision of George Fuller (1822–1884), *American Art Journal* 13, no. 4 (1981), 33.

4. John J. Enneking, "Fuller's Methods in Painting," in *George Fuller: His Life and Works*, ed. Josiah B. Millet (Boston and New York: Houghton Mifflin, 1886), 77.

5. "Three Boston Painters," *Atlantic Monthly* 40 (December 1877), 715.

6. Sheldon, *American Painters*, 186–187.

7. M. G. Van Rensselaer, *Memorial Exhibition of the Works of George Fuller*, exh. cat. (Boston: Alfred Mudge and Son, Printers, 1884, for the Museum of Fine Arts, Boston), 13. The Atheneum's *Ideal Head* appears as no. 23 in that catalogue.

8. Fuller did attach names to the figures in some of his paintings. For example, the well-known *Winifred Dysart* (1881), now in the Worcester Art Museum in Massachusetts, was exhibited under this title at the National Academy of Design the year it was painted. See Maria Naylor, *The National Academy of Design Exhibition Record 1861–1900* (New York: Kennedy Galleries, 1973), 325. Sarah Burns, however, has suggested that the name Winifred Dysart was probably imaginary; see "The Poetic Mode in American Painting: George Fuller and Thomas Dewing" (Ann Arbor, Mich.: University Microfilms International, 1979), 123. Fuller's *Ideal Head of a Boy* (c. 1884), now in the Metropolitan Museum of Art, was exhibited under this general title in the nineteenth century but has since been identified as the artist's eldest son, George Spencer Fuller. See Natalie Spassky, *American Paintings in the Metropolitan Museum of Art*, ed. Kathleen Luhrs (Princeton, N.J.: Princeton University Press, in association with Metropolitan Museum of Art, 1985), 2:149.